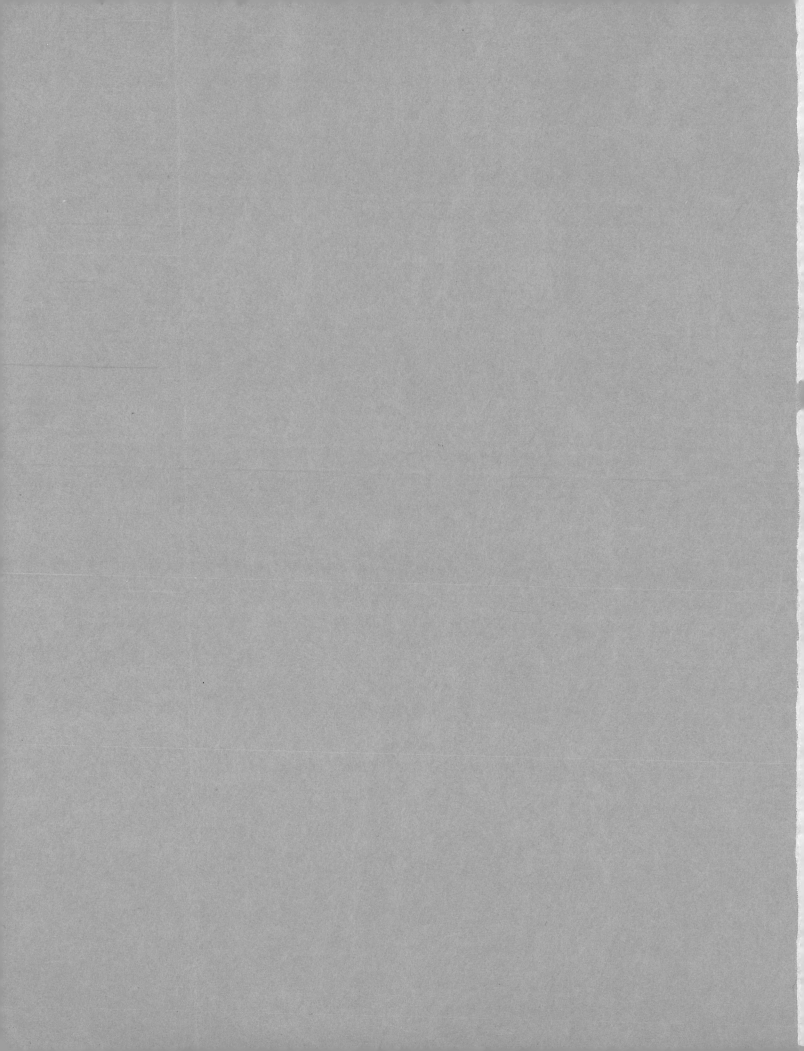

AMERICAN
FOLK
PAINTINGS

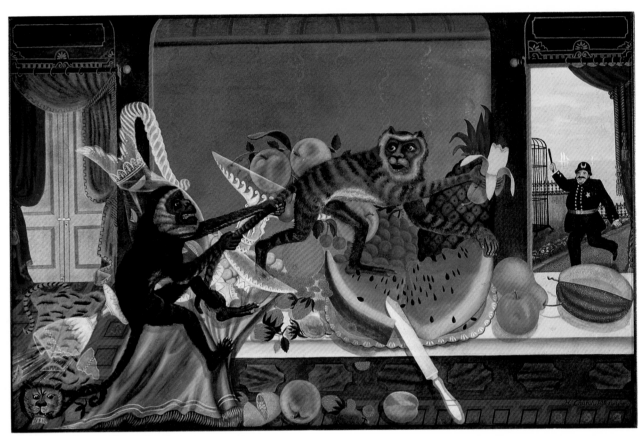

The Monkey Picture, Henry Church, Jr. (cat. no. 97)

THE ABBY ALDRICH ROCKEFELLER FOLK ART CENTER SERIES · II

BEATRIX T. RUMFORD, GENERAL EDITOR

AMERICAN FOLK PAINTINGS

Paintings and Drawings Other Than Portraits

from the Abby Aldrich Rockefeller Folk Art Center

A NEW YORK GRAPHIC SOCIETY BOOK

LITTLE, BROWN AND COMPANY · BOSTON · TORONTO · LONDON

PUBLISHED IN ASSOCIATION WITH
THE COLONIAL WILLIAMSBURG FOUNDATION

This catalog was published with the aid of a grant
from the National Endowment for the Arts in Washington, D.C., a federal agency.

FIRST EDITION

Library of Congress Cataloging-in-Publication Data

Abby Aldrich Rockefeller Folk Art Center.
American folk paintings.

(The Abby Aldrich Rockefeller Folk Art Center series; 2)
"A New York Graphic Society book."
"Published in association with the Colonial Williamsburg Foundation."
Bibliography: p.
Includes index.
1. Primitivism in art — United States — Catalogs. 2. Art, American — Catalogs.
3. Folk art — United States — Catalogs. 4. Folk art — Virginia — Williamsburg — Catalogs.
5. Abby Aldrich Rockefeller Folk Art Center — Catalogs. I. Title. II. Series.
N6505.5.P74A22 1987 759.13'074'01554252 87-26156
ISBN 0-8212-1620-1

New York Graphic Society books are published by Little, Brown and Company, Inc.
Published simultaneously in Canada by Little, Brown & Company (Canada) Limited
Printed in the United States of America

Contents

The Peaceable Kingdom, Edward Hicks (cat. no. 220)

Foreword

"To me art is one of the great resources of my life. I feel it enriches the spiritual life and makes one more sane and sympathetic, more observant and understanding as well as being good for one's nerves."[1]

These words, written by Abby Aldrich Rockefeller to her son Nelson in 1926, evoke clearly and sensitively the joy and enormous personal pleasure that Mrs. Rockefeller both received and gave in forming her various art collections. Like her husband, John D. Rockefeller, Jr., who that same year became actively involved with the restoration of Colonial Williamsburg, Mrs. Rockefeller was deeply interested in America's early art, its cultural heritage, and most especially its folk arts. In 1986 Colonial Williamsburg celebrated its forty-fifth anniversary as the recipient of her superb folk art collection, and 1987 marks the thirtieth anniversary of the opening of the Abby Aldrich Rockefeller Folk Art Center, the museum established and endowed by John D. Rockefeller, Jr., and the oldest institution of its kind in the United States.

Mrs. Rockefeller, who was a founder and active supporter of the Museum of Modern Art in New York City, was first introduced to American folk art by a group of contemporary artists who had learned about the material while summering at Hamilton Easter Field's art school in Ogunquit, Maine. She was immediately attracted to the simple, strong designs and bold use of color, line, and form that characterize first-rate folk art. Assisted by Holger Cahill, Edith Gregor Halpert, and others, Mrs. Rockefeller sought out and acquired over four hundred examples of folk art during the 1930s. In 1930 and 1931 a selection from her painting and sculpture collection was exhibited anonymously at the Newark Museum. The following year the Museum of Modern Art mounted the first comprehensive showing of her collection, titled "American Folk Art: The Art of the Common Man in America, 1750–1900." Holger Cahill was principally responsible for this exhibit and its 225-page catalog, which scholars continue to regard as one of the most concise and perceptive statements ever written on American folk art and its creators.

Few people who visited these early exhibitions realized that the unidentified lender and collector was Abby Aldrich Rockefeller, but that would soon change. The 1932 show was so well received in New York that Mrs. Rockefeller agreed to let the exhibit, which featured 174 items,[2] travel to six other cities over a two-year period in an effort to introduce folk art to a wider audience. Meanwhile, she continued to collect, and when the loaned material was returned to her in 1934, Mrs. Rockefeller realized that she had acquired more folk art than she could house. Thus she loaned the principal part of her collection to Colonial Williamsburg for public exhibition in the Ludwell-Paradise House on The Duke of Gloucester Street. Visitor response was immediate and appreciative. In 1939 the loan became a gift, and folk art remained on view in the historic area until January 1956.

Even after Mrs. Rockefeller had decided to share her collection with the public, her interest in folk art persisted, and she purchased examples, many of museum quality, for family enjoyment at Bassett Hall, the circa 1760 Williamsburg house Mr. and Mrs. Rockefeller furnished for their own use in the mid-1930s. Mr. Rockefeller was supportive; as he explained to a Richmond newspaper reporter in December 1941:

Some people don't care for this amateur art, and don't see any reason for having it. But it looks right in a setting like this, because these are the very pictures people would have hung on their walls at this period. In fact, I think that is one reason why Mrs. Rockefeller is so delighted with Bassett Hall. Now at last she has a chance to use her antiques and paintings in their proper setting.[3]

Mrs. Rockefeller died in 1948. Six years later it was announced that a new museum intended to house the Abby Aldrich Rockefeller Folk Art Collection would be built and maintained with funds provided by John D. Rockefeller, Jr. That Mrs. Rockefeller's folk art would be the nucleus of a museum that nurtured and encouraged research, exhibition, and acquisition

activities was evident to all concerned with the project during the Center's early years of formation. Mitchell A. Wilder was appointed the first director of the new museum in Williamsburg. He and special consultant Nina Fletcher Little were responsible for additional research and cataloging of the collection.[4] Mrs. Little was also engaged to prepare the first in-depth published catalog on the collection, appropriately titled *The Abby Aldrich Rockefeller Folk Art Collection* and published in 1957 by Little, Brown and Company.

Writing from England in August 1958, about a year after the museum's opening, Nina Fletcher Little observed that "intelligent planning can assure the collection a unique function in its own field, and I think this function might tend gradually toward the establishment of a research center and clearing house for folk art information, in addition to display material."[5] Much to her credit, and as evidenced in the 1957 catalog on the collection and in many subsequent papers and published articles relating to folk artists and art in the collection, the Folk Art Center has evolved into a major research repository for American folk art studies. Substantive research and excellence in scholarship have traditionally characterized the programming and interpretive work undertaken by the Center staff, and the results of these endeavors are reflected in the information provided in the series of catalogs of Williamsburg's folk art collection now in preparation, including the introduction and entries for this volume.

These scholarly efforts have revolved around the founding mission of the museum — to foster an appreciation for the aesthetic quality and educational value of American folk art. Major AARFAC exhibitions have contributed new knowledge to the field. "Erastus Salisbury Field, 1805–1900," the exhibition organized by Mary Black in 1963, served as the foundation for her more recent retrospective on this artist. The exhibition "Merchants and Planters of the Upper Hudson Valley, 1700–1750" mounted in 1967 by Peter A. G. Brown (then director of the Center) in collaboration with Mary Black, was one of the earliest and most important shows devoted to the subject. Brown, with Nina Fletcher Little, was also responsible for "Land and Seascape as Observed by the Folk Artist," a large installation of folk art loaned by Nina and Bertram K. Little. The first extensive exhibit of Pennsylvania almshouse paintings was organized in 1968 by Thomas N. Armstrong III, the present director of the Whitney Museum of American Art, who served under Brown as curator. During his tenure at AARFAC Armstrong was also responsible for the initial and extensive research on the Poestenkill, New York, artist Joseph Henry Hidley. The first major exhibits of the work of Edward Hicks and the Pennsylvania nineteenth-century carver

Wilhelm Schimmel were among the host of shows and research projects initiated and organized by the Williamsburg museum during these early years.

In 1972 Graham Hood, vice president and chief curator, the Department of Collections, Colonial Williamsburg Foundation, and Beatrix T. Rumford, then associate director, collaborated with Christine Schloss in organizing the loan show and catalog featuring portraits by the unidentified artist known as the Beardsley Limner.[6] Other noteworthy exhibits organized during the 1970s featured decorated Virginia folk furniture, paintings by Asahel Powers, Queena Stovall, and Zedekiah Belknap, and Virginia frakturs, Shenandoah Valley pottery, and the drawings of Lewis Miller. More recently, the Center has sponsored the first in-depth exhibitions of the work of twentieth-century folk artists Eddie Arning and Karol Kozlowski. Many of these shows were accompanied by essays, articles, and published catalogs that are now a permanent record of the Center's educational efforts and research orientation.

But just as programs and exhibition activities have grown, so has the Center's collection, considered by most scholars to be the most extensive and richest in existence today in terms both of quality and geographical representation. Those involved in the early formation of the Center, principally John D. Rockefeller, Jr., Mitchell Wilder, Kenneth Chorley, then president of Colonial Williamsburg, and his executive vice president Carlisle H. Humelsine, were not only sensitive to the museum's broader goals but also realized that to forge and maintain a leadership position in the field of American folk art the collection must, of necessity, continue to grow by acquiring superior examples that simultaneously expanded and enhanced the original gift of 424 pieces collected by Mrs. Rockefeller.

With that realization came the immediate establishment of an endowment fund provided by Mr. Rockefeller. The folk art museum was therefore able to acquire over one hundred items during its first year of operation. Most of these acquisitions were of exceptional quality and were purchased from the private collections of Edith Gregor Halpert, Holger Cahill, and Mrs. John Law Robertson. Among them were well-known paintings such as Edward Hicks's *Leedom Farm* (cat. no. 229), Joseph H. Hidley's *Noah's Ark* (cat. no. 182), and a number of important oil portraits by other artists including the Beardsley Limner and Charles Peale Polk.

Today the collection numbers over twenty-six hundred pieces of American folk art. Outstanding features include the large number of works by Hicks, Hidley, Erastus Salisbury Field, Ammi Phillips, Wilhelm Schimmel, Lewis Miller, and members of the

Prior-Hamblin family, as well as the only known paintings by Steve Harley, many examples of signed works, and a wide variety of folk art forms dating from the eighteenth, nineteenth, and twentieth centuries. Of the paintings featured in this catalog, 140 were among those collected by Mrs. Rockefeller, while the remaining 243 demonstrate just how significantly the collection has been expanded by others.

As is the case for most museums, the Center's strategy for adding to the collection is guided by refinement and need. Within the area of paintings, we have continued to strengthen the impressive body of work by the Quaker artist Edward Hicks. Four of the paintings featured in this catalog (cat. nos. 218, 220, 226, and 227) were in Mrs. Rockefeller's original collection, while the ten remaining pictures were added to the museum's holdings in the late 1950s and 1960s. Two more examples of Hicks's work added to the collection in 1986 do not appear in this volume since one is a signboard and the other a polescreen that originally functioned as a piece of furniture. These will be included in future catalogs.

The Hicks "collection" is — and will likely remain — the largest gathering of his work in any institution or private collection. It affords scholars and Center staff an exceptional opportunity to study the range of Hicks's painting formats and techniques in depth by comparison and contrast of extant works.

The lively watercolor sketches by Lewis Miller (such as the example shown in cat. no. 90D, from the *1840 Travel Journal* executed while Miller was in Germany) are among the museum's most important nineteenth-century pictorial holdings. Members of the Kain family donated the three important Miller sketchbooks represented in this volume. In addition to the *Travel Journal*, Mr. and Mrs. William H. Kain of York, Pennsylvania, also presented, in memory of the donor's father, George Hay Kain, *Orbis Pictus* (see cat. nos. 92A–92F), an album of sketches dedicated by the artist to the ladies of his hometown. Dr. and Mrs. Richard M. Kain of Louisville, Kentucky, gave the museum the artist's *Sketch Book of Landscapes in the State of Virginia, 1853* (see cat. nos. 93A–93F), also donated in memory of George Hay Kain. Like the Hicks material, the Miller drawings are a remarkable and extensive resource not only for folk art historians but also for social and cultural historians investigating life and customs in nineteenth-century America.

In 1958 the Center used funds provided by Mr. Rockefeller to acquire 347 paintings and drawings that had been collected by J. Stuart Halladay and Herrel George Thomas of Sheffield, Massachusetts. The objects were bought with the understanding that only the best examples would be retained in the permanent collection. *Eagle Mills* (cat. no. 29) and *Fruit in Wicker Basket* (cat. no. 147) are but two of the many fine pieces accessioned from the Halladay-Thomas purchase.

Other particular strengths of Williamsburg's folk art collection documented in this volume include numerous and varied theorem and memorial compositions (sections IV and X), the fraktur drawings of a Virginia German named Jacob Strickler (see cat. nos. 252–255), and the work of contemporary artist Eddie Arning (see cat. nos. 315–320).

As the collection continues to expand, the criteria for acquisition will remain the same as in past years. Additions, whether by gift or purchase, will be reviewed by Colonial Williamsburg's curatorial staff and by its president, Charles R. Longsworth. Rarity, workmanship, and condition are basic criteria used in evaluating potential accessions, but the decisive criterion in any object considered for the Center is its genuine aesthetic quality, not its historical associations or documentary interest. Paintings such as Charles Hofmann's *View of Henry Z. Van Reed's Farm* (cat. no. 52), acquired in 1967, Friedrich Bandel's *Birth and Baptismal Certificate for David Wetzel* (cat. no. 230), purchased in 1984, or Henry Church's *The Monkey Picture* (cat. no. 97), accessioned in 1979, epitomize the quality of the folk paintings we continue to seek and acquire; paintings such as Edward Hicks's *Peaceable Kingdom* (cat. nos. 218 and 220), Alexander Boudrou's *A. Dickson Entering Bristol* (cat. no. 1), Reuben Law Reed's *Washington and Lafayette at the Battle of Yorktown* (cat. no. 161), and the *Grapevine* (cat. no. 117) and *Bountiful Board* (cat. no. 130), the latter two by unidentified artists, all collected by Abby Aldrich Rockefeller, will continue to serve as the high standards for items accessioned by the institution bearing her name.

This catalog represents the combined efforts of Folk Art Center staff over several years. The descriptive entries for the paintings and the biographical sketches of the identified artists have been compiled and written by Patricia A. Hurdle, Martha Katz-Hyman, Linda Landry, Barbara R. Luck, Beatrix T. Rumford, Tori E. Setterholm, and Carolyn J. Weekley, who also wrote the introductory essay. Much credit is also due Ann Barton Brown and Donald R. Walters for their preliminary research on various paintings discussed herein.

We owe special thanks to three colleagues who were unusually generous in sharing their time and knowledge. Betty Ring devoted countless hours to researching school records and obscure genealogies for information about the makers of many of the embroi-

dered pictures in the AARFAC and Bassett Hall collections. Pastor Frederick S. Weiser served as consultant on the fraktur section and, with Pastor Larry Neff, provided all the German transcriptions and English translations.

Editorial assistance has been skillfully supplied by Donna Sheppard of Colonial Williamsburg's Publications Department, Rickie Harvey, Lois Oster, Betty Childs of the New York Graphic Society, and Betsy Pitha and Dorothy Straight of Little, Brown. The excellent photographs were provided by Frank Davis, Hans Lorenz, and Craig McDougal and were checked for clarity and color accuracy by Anne E. Watkins. The tedious task of typing and retyping the manuscript has been cheerfully performed by Sharon L. Newman.

The Folk Art Center is most appreciative of the financial assistance provided by the National Endowment for the Arts, which has enabled the Center to publish the second in its projected four-volume series of catalogs on the museum's holdings. We are also deeply grateful to Mr. and Mrs. William C. Schoettle, whose generous gift made it possible to illustrate many of the paintings in color.

Obviously, the production of this catalog would not have been possible without the cooperation of private collectors and dealers as well as professional colleagues at many museums, libraries, and historical societies, who graciously responded to our many queries by providing photographs, documentation, and other important information. We are particularly indebted to Barbara Austen, Norma D. Beckman, Mary C. Black, Virginia Bonner, Warren F. Broderick, Simon Bronner, Paul Buchanan, Richard Candee, Dr. W. R. Chitwood, Davida Deutsch, Catherine L. Goodwin, Thomas L. Gravell, Grayson Harrison, Trish Herr, Louis C. and Agnes H. Jones, Arthur B. and Sybil B. Kern, John Christian Kolbe, Elizabeth Mankin Kornhauser, Nina Fletcher Little, Gina Martin, Henry H. Newell, Martha Lamarque Sarno, Dr. Alexander Sackton, Bertha R. Scribner, Robert C. Vose, Mark Watson, Sarah Weatherwax, Pastor Frederick Weiser, and Hariette C. Wyman.

We would also like to extend thanks to the following individuals and institutions:

John R. Angell, Free Library of Philadelphia, Pennsylvania

Mary Bell, DAR Genealogical Library, Washington, D.C.

Deborah J. Binder, St. Louis Art Museum, Missouri

Marion V. Brewington, Peabody Museum, Salem, Massachusetts

Georgia B. Bumgardner, American Antiquarian Society, Worcester, Massachusetts

Pamela K. Caswell, Concord Antiquarian Society, Concord, Massachusetts

Kenneth C. Cramer, Dartmouth College Library, Hanover, New Hampshire

Mary Antoine de Julio, Montgomery County Historical Society, Fort Johnson, New York

Nancy Druckman, Sotheby Parke Bernet, Inc., New York, New York

Susan M. Eastwood, Lynn Historical Society, Inc., Lynn, Massachusetts

Cynthia English, Boston Athenaeum, Massachusetts

Nancy G. Evans, Henry Francis du Pont Winterthur Museum, Winterthur, Delaware

Thomas L. Gaffney, Maine Historical Society, Portland, Maine

Anne Golovin, Smithsonian Institution, Washington, D.C.

Russell A. Grills, Lorenzo State Historic Site, Cazenovia, New York

Arnold E. Grummer, Dard Hunter Paper Museum, Appleton, Wisconsin

Thompson R. Harlow, Connecticut Historical Society, Hartford, Connecticut

M. J. Herskovits, Northwestern University, Evanston, Illinois

Frank L. Horton, Museum of Early Southern Decorative Arts, Winston-Salem, North Carolina

Bette Hunt, Marblehead Historical Society, Massachusetts

Elizabeth B. Knox, New London County Historical Society, New London, Connecticut

Royster Lyle, Jr., George C. Marshall Research Library, Virginia Military Institute, Lexington, Virginia

Terry A. McNealy, Bucks County Historical Society, Doylestown, Pennsylvania

Howard S. Merritt, University of Rochester, New York

Steven Miller, Museum of the City of New York, New York

Christopher Monkhouse, Rhode Island School of Design, Providence, Rhode Island

J. Roderick Moore, Blue Ridge Institute, Ferrum, Virginia

Mark Morford, Ohio State University, Columbus, Ohio

A. L. Morrish, De La Rue Co., Ltd., London, England

Barbara J. Morris, Victoria and Albert Museum, London, England

Jane C. Nylander, Old Sturbridge Village, Sturbridge, Massachusetts

Landon Reisinger, Historical Society of York County, York, Pennsylvania

Milton C. Russell, Virginia State Library, Richmond, Virginia

J. Peter Spang, Historic Deerfield, Deerfield, Massachusetts

Marcia D. Starkey, Rensselaer County Historical Society, Troy, New York

Frances P. Tapley, Historical Commission of the Town of Sterling, Sterling, Massachusetts

Lorenzo D. Turner, Roosevelt University, Chicago, Illinois

College of William and Mary, Williamsburg, Virginia:
James Baron
Stuart Ware

Colonial Williamsburg Foundation, Williamsburg, Virginia:
Linda B. Baumgarten
Douglas Canady
Nathan Stolow
Osborne Taylor
James A. Waite

A. G. Edwards & Sons, Inc., St. Louis, Missouri:
Jan Broderick
David W. Mesker

Historical Society of Pennsylvania, Philadelphia, Pennsylvania:
Bruce Laverty
R. N. Williams II

Litchfield Historical Society, Litchfield, Connecticut:
Nan Heminway
Charlotte M. Wiggin

Mariners Museum, Newport News, Virginia:
C. S. Laise
John L. Lochhead
John O. Sands

Mount Vernon Ladies' Association of the Union, Mount Vernon, Virginia:
Christine Meadows
John H. Rhodehamel

New York State Historical Association, Cooperstown, New York:
Charlotte M. Emans
Paul D'Ambrosio
C. R. Jones

Washington and Lee University, Lexington, Virginia:
Pamela H. Simpson
James W. Whitehead

BEATRIX T. RUMFORD

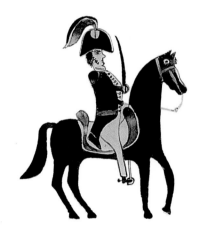

Notes

[1]Letter from Abby Aldrich Rockefeller to Nelson A. Rockefeller, January 7, 1926, Rockefeller Archives.

[2]There were 175 objects in this landmark exhibition; all were owned by Mrs. Rockefeller, except for a carved horse belonging to Cahill that was added to the Williamsburg collection in 1957.

[3]*Richmond Times Dispatch*, December 7, 1941. One hundred twenty-five pieces of folk art that Mrs. Rockefeller acquired for Bassett Hall were accessioned into the AARFAC collection in 1979. This material remains on view at Bassett Hall, which became a Colonial Williamsburg exhibition building in 1980.

[4]In 1939, when Mrs. Rockefeller gave a major portion of her collection to Colonial Williamsburg, she also gave fifty-four pieces to the Museum of Modern Art, which subsequently shared the gift with the Metropolitan Museum of Art. Through the cooperation of these two museums and the generosity of David Rockefeller, 424 examples of nonacademic art collected by Abby Aldrich Rockefeller between 1929 and 1942 were reassembled in Williamsburg prior to the opening of the new museum in 1957.

[5]Nina Fletcher Little to AARFAC, August 1958.

[6]Center staff recognize Colleen Heslip's and Helen Kellogg's research on the artist Sarah Perkins, but do not feel they have found sufficient evidence to date to prove that Perkins is in fact the Beardsley Limner. See "The Beardsley Limner Identified as Sarah Perkins," *Antiques*, XXVI (September 1984), pp. 548–565.

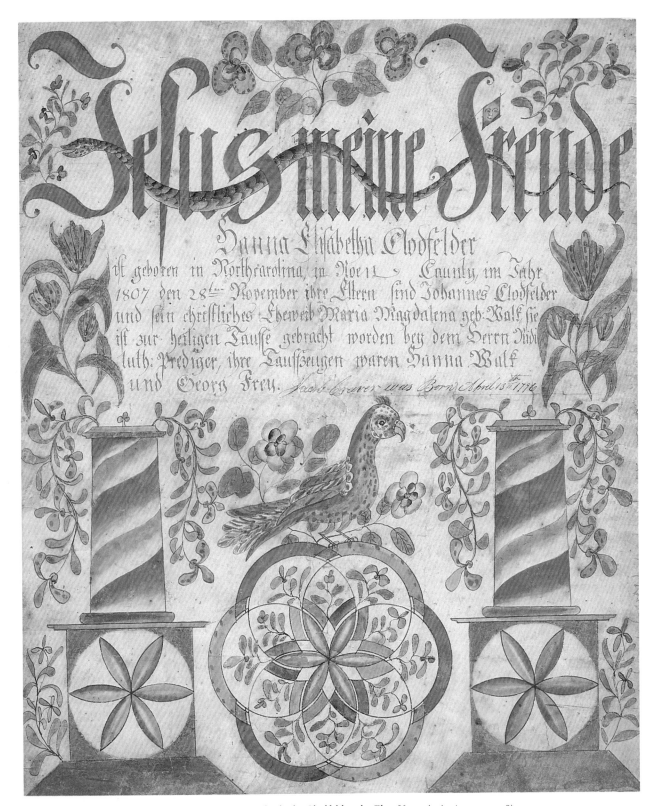

Figure 1 *Birth and Baptismal Certificate for Hanna Elisabetha Clodfelder*, the Ehre Vater Artist (cat. no. 238)

Introduction:
Defining American Folk Art

Innumerable definitions have been offered over the last fifty years in both scholarly and lay circles concerning the nature and range of American folk art.[1] Many types of objects and expressions with aesthetic interest and intent, including music and dance, contribute to this area of our arts heritage. Inevitably, however, it is the folk paintings that continue to invite discussion and debate because they are so numerous, because they were among the first of America's folk art materials to be collected and studied, and because they usually are associated in subject matter and media with the fine arts as broadly defined since the Renaissance. Portrait painting falls in this category, and in colonial and early nineteenth-century America, images of self proliferated in far greater number than other types of painting. By virtue of its surviving quantity and historic popularity, portraiture is better documented than are other forms, and our knowledge of it is more extensive.[2] Nevertheless, often it is the non-portrait paintings and drawings — the subject of this volume — that hold some of the most intriguing considerations for folk art definition and study. Further, non-portrait painting in its many guises continued to proliferate in both rural and urban communities long after portrait painting was almost totally supplanted by the introduction of photography in the 1850s and 1860s.

In the ongoing series of catalogs documenting the Abby Aldrich Rockefeller Folk Art Center's collections, it thus seems appropriate that Volume II address the definition of folk art from the perspective of scholars who have worked with the institution's holdings.

Existing definitions of American folk art and the lively arguments regarding the strengths and weaknesses of any given one tend to revolve around one basic premise — that the material is or perhaps ought to be considered separate and distinct from the more formal and academic works that were produced and that flourished simultaneously. The frakturs produced by Germanic peoples in America, with their roots tied to old-world art of a similar kind, are often discussed in this context. Holger Cahill's landmark exhibition "American Folk Art: The Art of the Common Man in America, 1750–1900," organized in 1932 for the Museum of Modern Art in New York City, was accompanied by a 225-page catalog that included the first perceptive discussion of definition. But his 1931 catalog for an exhibit at the Newark Museum in New Jersey provided an excellent summary statement of his analysis of folk artists' work: "The peculiar charm of their work results sometimes from what would be technical inadequacies from the academic point of view, distortion, curiously personal perspective, and what not. But they were not simply artists who lacked adequate training. The work of the best of them has a directness, unity, and a power which one does not always find in the work of standard masters."[3]

In a somewhat similar vein, Nina Fletcher Little wrote in her 1957 descriptive catalog of the Folk Art Center's collection that "two kinds of art have flourished side by side in nearly all nations. Very often their courses have run independently of each other. One we call fine art. . . . In America it served the gentry of the South and the merchant princes of New England. . . . The other category includes American Folk art. This is the art of the people."[4]

In more recent years, additional definitions of the materials along these lines have been published, for example in Jean Lipman's and Alice Winchester's catalog that accompanied the exhibition "The Flowering of American Folk Art," and in the exhibition organized by Louis C. Jones, Paul D'Ambrosio, and others featuring folk art from the New York State Historical Association at Cooperstown, New York.[5] Most of these perceptions of the material have been formulated by art historians, while ethnographers, anthropologists, folklorists, and culturists have provided much theoretical analysis that they believe supports a more balanced and disciplined approach. Some purists in these fields carry the dynamic concept of "folk versus formal" further by maintaining that folk art must be tradition-bound, that is, passed from generation to generation in a distinct, close-knit society with little or no change in use, method of manufacture, intrinsic or extrinsic meaning and value, and physical attributes.[6]

This is a troubling and essentially nonfunctional theory for several reasons. It disregards those evolutionary processes that are fundamental to mankind, whether intellectual, perceptive, and creative, or purely physiological and in response to survival needs. But more problematic is the underlying assumption that one is able to determine when an object or expression becomes traditional. Such an analysis assumes that nascence can be determined, and therefore that traditionality can be arbitrated by identifying precise lengths of time during which an object or an expression has been repeated in virtually the same way, with the same results, and for the same reasons.

The physical act of painting in an art sense (e.g., applying pigments to a surface to achieve some sort of pleasing visual representation) is traditional and arguably could be traced to the Stone Age, when Paleolithic man embellished cave walls in northern Spain. But the tradition-bound concept demands that we identify which of all succeeding paintings became traditional by determining when one traditional type ends, when another begins, and so forth. Ultimately, we must deal with the transitional material that has attributes of both the old and the new. In summary, the concept assumes that, unlike other art, folk art proceeds vertically from an identifiable point in time and passes within a society from generation to generation, up the genealogical chart without interruption or significant corruption by outside forces that might touch the continuum or intersect its path.

In a more humanistic and broader way, however, all man-made objects are tradition-bound to some degree because, like their makers' tools, they have evolved over time in response to needs and aspirations — borrowing heavily from past knowledge, similar materials, and ideas of things that occurred before. The very act of artistic expression is a traditional human response in this broader sense. Tradition as perceived in this manner has application in folk art definition, but it is neither peculiar to folk art nor its most distinguishing characteristic.

Pictorial art of the kind documented in this volume ties directly and indirectly to ideas, experiences, needs, and practices that existed long before its own creation in concurrent societies and across large geographical areas. Ironically, little cannot be traced to some antecedent in terms of general feature type or function. Yet, folk art is rarely identical to its ancestral prototypes. At the same time, those features or aspects of an artist's work that are too often inaccurately labeled as unique would be better described as idiosyncratic interpretations, innovations, or deviations from the norm of formal period style and its particular criteria.[7] These aberrations do not preclude a given artist's reliance on and use of older ideas and formats within his or her work.

The fraktur drawings mentioned earlier and as practiced over a number of years in the eighteenth and nineteenth centuries in rural communities throughout Pennsylvania — and, to a lesser extent, in Western Maryland and the rural areas of Virginia, North and South Carolina, and Georgia — are a case in point. Examples such as the Ehre Vater Artist's *Taufschein* for Hanna Elisabetha Clodfelder of Rowan County, North Carolina (cat. no. 238 and fig. 1) are often described as typical of traditional Germanic art because of their makers' intent, their usage, and the inclusion of time-honored decorative motifs and Gothic-style scripts. It is undoubtedly true that such drawings are generically similar to ones produced by scriveners in the upper Rhine Valley or in northern Switzerland and eastern France, and that the traditional making of such artwork in America derives from such prototypes, although no comprehensive study of their relationship has ever been made.[8]

Functionally, a majority of American pieces reflect old-world religious values and moralistic teachings as well as an occasional reference to Teutonic legends (see cat. no. 239 and fig. 2, *Easter Rabbit,* by John Conrad Gilbert). Such themes had been incorporated in the Germanic arts for centuries, and some are traceable to more ancient cultures. But American fraktur is neither always iconographically similar nor completely traceable to European antecedents. While this may be explained by the dearth of research existing on European materials or the low survival rate of the same, there are clearly other reasons for some of the distinctive qualities we observe in American frakturs.

Like other paintings and drawings in the Folk Art Center's collections, its frakturs document not only old-world ideas but also the particular concerns, environmental influences, and needs of the men and women for whom and by whom they were made. They therefore contain old and new ideas, all of which were concurrent with their execution dates and conditioned by the American experience.

The *Vorschrift* (cat. no. 252) of Jacob Strickler, made by him in 1787 in Shenandoah (now Page) County, Virginia, when he was sixteen years old, illustrates one Swiss artist's adherence to a basically old-world format, with some traditional motifs and lettering styles. But Strickler's *Daring Hero* (cat. no. 253) has no known physical precedent in European or earlier American fraktur. Its intent probably was as much moralistic as decorative, since it is believed to illustrate a literary theme embracing the Christian virtue of good conquering evil. One could make a case that the horse in this picture may have been derived from a

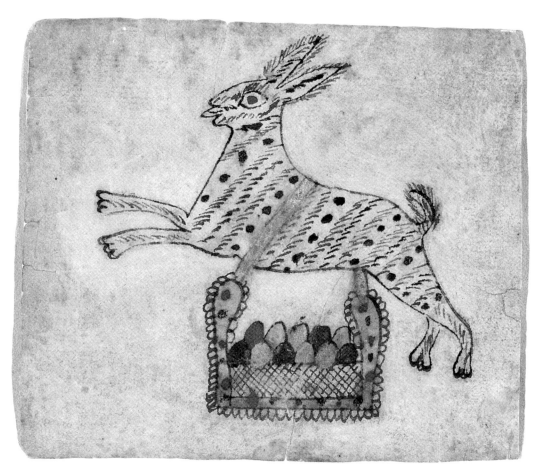

Figure 2 *Easter Rabbit,* attributed to John Conrad Gilbert (cat. no. 239)

print source or inspired by the work of another scrivener since its pose is commonly seen in fraktur work featuring such animals; but the hero and his regalia are not. Interestingly, the hero brandishes an ax instead of a sword, perhaps a visual and contemporaneous reflection of the artist's own religious leanings. As a Mennonite, Strickler would have admonished the use of typical warlike arms — swords and guns, for instance. The sheath for the sword hangs at the hero's side, but is empty.[9]

Some of the work of the Pennsylvania artist Henry Young is more indicative of old and new iconography pictorially combined on time-honored formats. Some of his certificates, such as that for Anna Fritz (cat. no. 260), show the highly stylized flowers, birds, and other devices favored for years by fraktur decorators and a text that records basic information about birth and marriage. But in other certificates, such as Young's marriage record for his daughter (cat. no. 262), he combined traditional motifs with full-length human figures in period dress, showed them gesturing in a manner typical of the times, and included ordinary objects such as vases, tables, and wine bottles — all of

which Young and his commissioners knew and probably used. To them, these objects were representational, although at the same time stylized, versions of contemporary accessories. They were neither traditional in an old-world sense nor nostalgic in appearance, even though the actions portrayed — for instance, presenting a bouquet of flowers (cat. no. 263 and fig. 3) — might be construed as a traditional social phenomenon. Innumerable blendings of the old and what was for the folk art creator and his contemporaries the current mode exist in these little drawings to the extent that they express change and modification of ancestral art to reflect modern viewpoints and lifestyles, which may have been motivated by nothing more complex than the artist's yearning to communicate effectively through commonly understood visual symbols.

Arguably, the method and materials of the fraktur artist may have been the most traditional aspect of his work. A variety of quill pens, pencils (brushes), both homemade and commercially available inks and pigments on laid and wove papers were the essentials of his art. The unfinished fraktur works of Jacob Strick-

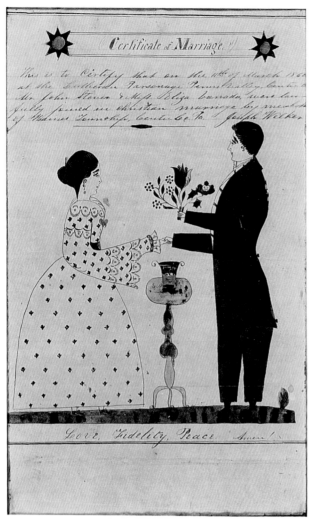

Figure 3 *Marriage Certificate for John Stover and Eliza Vonada Stover*, attributed to Henry Young (cat. no. 263)

pieces made in Scotland, Ireland, or England. For the present, we can observe only that similar motifs are seen on decorative family records and related works by both ethnic groups, and we can speculate only that, like Germanic frakturs, English-oriented records incorporated older cultural ideas and devices as well as new ones.

Various types of both Germanic and English decorated records were an integral part of education and learning in America during both the eighteenth and nineteenth centuries, a concept that is often acknowledged but not fully appreciated by art historians to date. Certificates of merit, bookmarkers and bookplates, *Vorschriften,* and undoubtedly other formats were presented to students as rewards for scholastic achievement and to serve as instructive incentives. Often such works also served the students as appropriate prototypes to emulate — and thus many were copied. In this respect, they relate to the larger category of school art that includes theorem paintings, memorials of several kinds, calligraphy, and occasionally pictorial works in other formats, such as Jenny Emily Snow's *Mount Auburn Cemetery* (cat. no. 22).

School art is a formidable aspect of American folk art, although numerous questions regarding its appropriateness to the subject, or more generally to any sort of art classification, have been and will likely continue to be raised. The fact that a child received some rudimentary instruction in preparing a work precludes the inclusion of the material in folk art studies for some purists. Others maintain that such endeavors cannot be classified as art since they are childlike, immature expressions. Further, much of school art was either directly copied or inspired by print sources, as exemplified by works such as Snow's, or mechanically contrived through the use of preprinted patterns as in theorem pictures such as Mary Bradley's exquisite still life *Basket of Fruit* (cat. no. 95), created ca. 1825, in Lee, Massachusetts.

Any one of these questions has merit, but they represent contradictions in how we historically have perceived art of any kind. Artists have borrowed and copied each other's work and their own for centuries. Artists' tools are an important consideration since they often facilitated copying and drawing. The mechanical devices used by masters in laying out elaborate, accurate perspective views and, in America, the optical equipment employed by both the Peale family and Charles St. Memin to capture true likenesses in profile exemplify the reliance of well-known, accepted academicians on such tools. Finally, art quality cannot be arbitrated on the basis of the maker's age. It is the aesthetic quality of a work that determines its classification as art.

ler, one of which is illustrated in figure 4, are rare and useful survivals since they document how some artists laid out their design before adding text and color.

We know far less about the illustrated family records produced for and probably by persons of Scots, Scots-Irish, or English heritage during the eighteenth and early nineteenth centuries.[10] Examples recorded to date generally comprise birth records of various types and genealogical charts citing the births, deaths, and marriages of family members. Justus Dalee's record for the Potter family (cat. no. 285) is a late manifestation of this practice in America, while Martha Hillier's birth record (cat. no. 288) attests to the existence of such art-making in the mid-eighteenth century. Whether English-speaking makers and their examples were influenced by their own inherited forms or the work of Germanic artists working in America is unknown; nor do we have any documentation of similar

Figure 4 Unfinished fraktur design, attributed to Jacob Strickler

Holger Cahill and many other later folk art historians usually dwell on the circumstances of the maker and his or her level or lack of training and expertise in art techniques. Often, this course of appraisal is followed at the expense of understanding the level of awareness, sophistication, and connoisseurship of the original commissioner or consumer, a factor which is addressed — when known — throughout this catalog. Folk Art Center staff strive to document and explain both aspects of production in their interpretations of objects in the collection, although the limited histories of many objects obviously affect the depth of such analysis. Yet, by segregating the material into broad categories, as has been done in this volume, certain characteristics and patterns emerge and in most cases are reinforced by contemporaneous comments and recorded histories. While these findings do not conflict generally with the early definitions of Cahill and others, they strengthen the obvious relationships that existed between academicians and folk artists, and represent an attempt to place the material within the context of American painting and patronage.

Research indicates that most folk artists were professional tradespeople or craftspeople who developed their pictorial art along with other related work; some received minimal training through contact with other artists and craftspeople, either by apprenticeship or by formal association. Others learned in a parochial or local school as part of their adolescent education. Still others had no sort of training and were self-taught. Where possible, Center staff do distinguish between pieces by amateurs — those who produced pictures as school exercises or as embellishments for self, family, and friends — which constitute nearly a third of the material catalogued here, and those made by professional artists — men and women who earned a living by their artistic endeavors. The levels of expertise among these folk artists varied widely for a number of reasons beyond the obvious considerations of training level and innate artistic talent. Other reasons include monetary incentives, practice, and personal motivation and perception.

Henry Church's memorable *Monkey Picture* (cat. no. 97, ill. p. ii) represents the best of his easel pictures and can be fairly analyzed in terms of expertise since so much documentation of his life survives. Church was a trained blacksmith whose fascination with representational forms led to his casting of figural sculpture, to stone carving, to greater practice in drawing, and to easel painting. Despite a lack of commissions (monetary incentives), he maintained a high level of personal motivation and produced a large number of works. His perception of his art, let alone its purpose and intent, was complex and highly idiosyncratic at times. In this sense, his art-making was sustained and driven more by personal and intellectual needs than by economic concerns or the desire to master the fine art of easel painting through formal training.

Daniel Schumacher served as a Lutheran clergyman for many years. He had only rudimentary skills in both drawing and calligraphy and may have been the only person in his rural Pennsylvania community for a number of years who could provide decorative birth and baptismal records as well as other fraktur formats. While he may have enjoyed his scribing activities as part of his ministerial duties and fulfilled them because of community need, the overall quality of his surviving frakturs does not suggest that he was practiced, had received any degree of training, or was motivated to improve his work.

The same may be true of many other fraktur artists whose purposes were quite different from that of more prolific decorators such as Friedrich Krebs (cat. no. 244), who is documented as having produced birth certificates over a twenty-five-year period (which probably represents only a fraction of the total time he actually produced artwork during his lifetime). By comparison, Krebs's work was quickly drawn and exhibits little of the hesitancy in penmanship observed in Schumacher's and Strickler's frakturs. However, it often lacks the clarity and variety of Strickler's and

many others' work, including Francis Portzline's birth and baptismal certificate for Elisabeth Portzline (cat. no. 247) and John Conrad Gilbert's famous *Easter Rabbit* (cat. no. 239 and fig. 2). Krebs's incentive was as much monetary as anything else, and his drawings were wholesaled across a broad geographical area, whereas Gilbert, Schumacher, and others confined their activities to a rather localized clientele. Some fraktur artists even restricted their output to presentation pieces for family members (see Susanna Hübner, cat. no. 241).

The point here is not that Krebs's work is better or worse than Schumacher's or Gilbert's; it is different from theirs and for a variety of historically documented reasons. Similar comparisons can be made among folk artists who created other types of pictures, including the professional work of Joseph Henry Hidley of Poestenkill, New York (cat. nos. 16 and 17 and fig. 5). Hidley's landscapes, for instance, were produced basically for local townspeople in Poestenkill and neighboring villages. His incentive was essentially monetary, yet his work improved as he became more practiced; thus it appears that his goal was also the mastery of art techniques. Portia Trenholm's view of

Legareville, South Carolina (cat. no. 24) undoubtedly evolved from a different set of needs and aspirations that were more personal and family-oriented.

The words "spontaneous," "fresh," and "innovative" are often used to describe some of the qualities valued in American folk art. As abstract terms, they cannot be measured any more precisely than the word "art" itself; that is why some critics rue their use. With respect to the pictures documented in this catalog, and for folk art in general, however, they have a particular meaning when understood in the context of the artist's background and in comparing formal art with folk art. *Adoration of the Magi* (cat. no. 189 and fig. 6), the early religious picture painted by an unknown artist in upstate New York, possibly about 1740, typifies the confusion surrounding the use of the words "folk" and "formal." It is a very formal picture in its arrangement and conception, undoubtedly was based on a print source, and surely was intended to grace some best room or religious edifice in its time. Thus, its function and its basic conception were and historically remain formal. But function and intent are a thing apart from execution, and it is the obvious lack of academic stu-

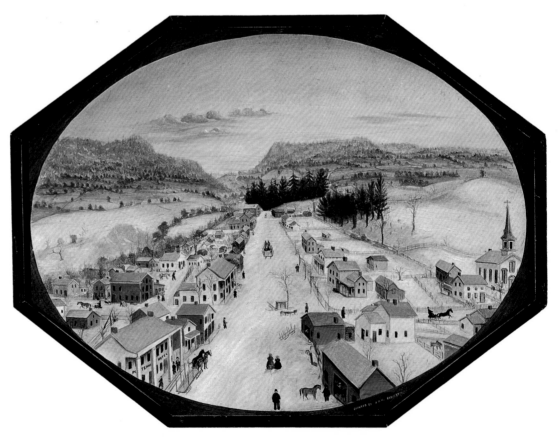

Figure 5 *Poestenkill, New York: Winter,* Joseph Henry Hidley (cat. no. 17)

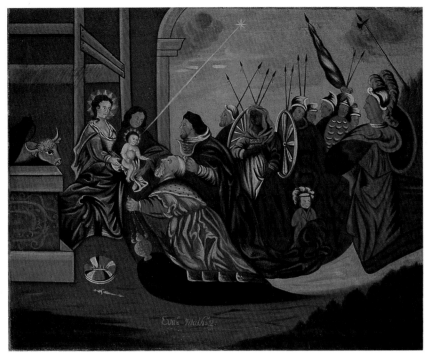

Figure 6 *Adoration of the Magi,* artist unidentified (cat. no. 189)

dio sophistication in the latter that distinguishes this picture from the work of trained masters, whose processes were dictated by prescribed, specific manual techniques based on established (and often published) artistic principles. The degree to which *Adoration of the Magi* deviates from prescribed formal practice in fine arts painting during these years is considerable. It exhibits little understanding of spatial depth, linear or color perspective, anatomical rendering, or the subtle blending of pigments to create light and shade as well as depth. Given the naïveté of the artist in these matters and the resulting picture, what is it then, that makes it art and also folk?

The fact that the *Adoration* painter deviated from studio techniques does not, in and of itself, make the work folk art. Rather, it is folk art because of the success with which the deviation is viewed in terms of overall aesthetics, to a lesser degree because of its original function (which may be complex), and because of the known or attributed circumstances of its creation. Circumstantial evidence tells us that there were few academically trained artists working in America before 1750, none of whom is documented as producing religious pieces in upstate New York. A survey of surviving paintings from the area and dating roughly from the same period clearly indicates that most of these painters were aware of standard poses, compositions, and the rudimentary aspects of grinding, mixing, and applying paint with practical craft skill but

had little understanding of the painting principles taught and learned in European ateliers. While American folk painters often emulated the pictorial and functional aspects of formal art, their means of achieving these were oriented in craft practice rather than in studio theory and techniques. To achieve even a moderate level of success in light of such training — or lack thereof — the folk artist had no recourse but to improvise and formulate methods of his own through experimentation or casual contact with another, more advanced painter. His goal was to paint a pleasing, acceptable picture regardless of circumstance or constraints. The resulting innovations, freshness, and spontaneity observed in the best efforts of such painters are due, in large part, to their personal perceptions and solutions as opposed to knowledge of formal painting techniques. As such, these paintings are often more aesthetically pleasing in their handling of form, patterning, composition, and color than the conventional work produced by second- and lesser-rank academic artists of the same years. These qualities in folk art objects, regardless of type, are judged on their own merit from piece to piece without strict adherence to the formal international, national, or regional styles and techniques of the period, although style and materials used are important criteria in establishing date, provenance, and authentication of parts.

The lack of formal art training and awareness is, of course, a relative matter. Like traditionality, it var-

ies in degree from artist to artist. A number of paintings in this volume demonstrate considerable knowledge of academic procedures, whether borne out by what is known of the artists' backgrounds or not. Paintings such as James Bard's *The Schooner Yacht America* (cat. no. 42) or Charles Hamilton's colorful view of *Charleston Square* (cat. no. 10) are admittedly refined in both technique and perception. Yet they reflect the academic tastes of preceding periods rather than their own. Does this make them folk, or simply retardataire? There is no simple response to this question, since any judgment would lead to additional query and endless debate. Ultimately, we would probably conclude that they are neither strictly formal nor folk, but combine aspects of both as perceived today.

The work of such artists as Edward Hicks, Joseph Henry Hidley, and the almshouse painters John Rasmussen and Charles Hofmann also seems, on cursory glance, highly refined and technically correct. But when their work is compared with historical pieces by Robert W. Weir, landscapes by Thomas Cole, or narrative pictures by John Lewis Krimmel — all practitioners of studio styles and methods — a number of obvious deviations are observed, including Rasmussen's flat, linear development of form and brilliant signboard colors, Hidley's contorted perspective and stylized, patterned treatment of foliage and clouds, and Hofmann's penchant for ornamental framing and other elaborate devices within the composition which had no parallel in academic practice.

Edward Hicks never mastered anatomical drawing and, like Rasmussen, developed a distinctive flat style by using the pure bright pigments and smooth modeling he knew from his professed craft of sign and coach painting. His knowledge of formally painted works of art, acquired through prints and probably by some personal experience, influenced his work only to a small degree and in no way compensated for his basic lack of training in studio easel painting and hence his idiosyncratic style. It was Hicks's ability to render aesthetically pleasing pictures through innovation and experimentation despite his lack of academic training that makes his work so appealing and bona fide art. And it was the circumstances of his self-developed style — which he utilized in making pictures for friends and family in Bucks County, persons with moderate or limited knowledge of formal art — that make his pictures folk.

John Vanderlyn's much quoted comments on the work of Ammi Phillips have significance in this discussion because, in a rarely documented manner, they capture the essence of what we consider folk art today. Vanderlyn, an American academic painter trained abroad, noted that "were I to begin life again, I should not hesitate to follow this plan, that is to paint portraits cheap and slight, for the mass of folks can't judge of the merits of a well finished picture."[11] By "cheap" Vanderlyn presumably meant the low prices for quickly painted portraits charged by artists such as Phillips, while the word "slight" probably referred to their ignorance or disregard of academic techniques. But the key phrase in this quote is "the mass of folks can't judge." Who were the mass of folks? They were the men, women, and children who sat for artists such as Ammi Phillips and who commissioned and, in some cases, produced other works of the kind illustrated in this catalog. In terms of social standing, wealth, and ethnic background, the mass of folks were — to judge by a list of Phillips's sitters — the families of doctors, merchants, farmers, tradespeople, and craftspeople; that is, individuals with modest to upper-middle-class incomes and tastes. They were neither poor nor extraordinarily rich, but were the average citizens of America: "the common man." Where known, the ownership histories and backgrounds of identified folk artists cataloged in the following pages confirm such a social and economic background.

Vanderlyn's regard for folk pictures was shared by others who professed to know something about judging art, and it has persisted to our own time. Ironically, it accounts for the continual misunderstanding of the aesthetics of folk art. Most written surveys and histories of American painting address both formal and folk art by the top-down diffusionist theory, which maintains that those works produced by the most learned and skilled artists for those individuals at the highest socioeconomic levels represent models of correctness by which all related works are judged. There is merit in such an approach if no intellectual and artificial barriers are established to separate objects of varying quality that historically complemented each other and existed in tandem. Unfortunately, that is rarely the case.[12]

Emma Jane Cady's stylized and sensitive rendering *Fruit in Glass Compote* (cat. no. 96 and fig. 7) might be addressed in the larger context of still-life painting in nineteenth-century America. It could be compared to examples by Sarah Peale (1800–1885), Raphaelle Peale (1774–1825), or others who were formally trained in studio techniques. In the process, Cady's "simple" picture might be dismissed as unaccomplished and relegated to the meanest level of artistic performance, but to do so would deny its aesthetic aspects, which have been recognized and valued since the early twentieth century and probably during its period of creation by at least Cady or the picture's recipient. While the exercise affords the systematic ranking of art as one way of establishing or docu-

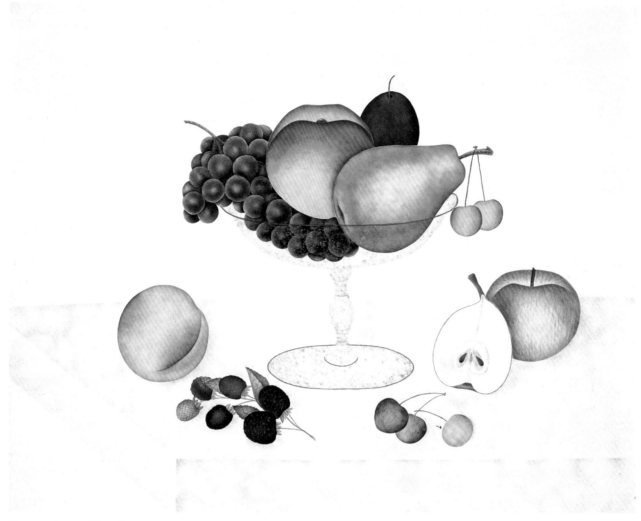

Figure 7 *Fruit in Glass Compote*, Emma Jane Cady (cat. no. 96)

menting levels of taste among corresponding levels of society, it emphasizes rare and exquisite high-style material at the expense of any appreciation of that "below" it.

For the folk art historian, who also sees and evaluates objects according to their relationship to the correct formal model, the process has always extended beyond ranking and is based on the fundamental belief that the aesthetic success or failure of an individual work must be immediate and may also be historic. The aesthetic qualities of folk art are judged principally by twentieth-century criteria, but any successful example must also fulfill the other general principles of connoisseurship as they have applied to art and the decorative arts for many years.[13] A good many historical criteria must therefore be addressed in any evaluation, but overall appearance, mass, line, proportion, color, balance, successful handling of deviant elements, and quality of workmanship are critical.

In America the term "folk art" was never intended to be restricted to peasant arts or Volkunst as popularized in German studies and paralleled by similar work in other European countries beginning in the nineteenth century.[14] As early as 1923, we find evidence of serious scholarly interest in the aesthetics of what we now call American folk painting on the part of Raymond Henniker-Heaton, the noted English art historian who was curator at the Worcester Art Museum and among the first to offer comments on the subject. Regarding an unidentified New England artist's portrait *Mrs. Freake and Baby Mary* (ca. 1674), he noted that "it is not sufficient to dismiss it as amusing, historical, or a mere primitive effort, for in an art sense it is supremely interesting. . . . Our artist's lack of training was an art gain, and resulted in the balance of his work leaning toward the aesthetic rather than the technical. . . . The reason this picture is important from an art standpoint is not because the artist was a painter

by instinct, without academic technical skills, but because he was creative by instinct. . . . and was unconscious of any handicap."[15]

It was also during the early 1900s that the painter and writer Hamilton Easter Field, the sculptor Robert Laurent (a native of Brittany), Marsden Hartley, Bernard Karfiol, Yasuo Kuniyoshi, William Zorach, and other modernists who summered at Field's Ogunquit, Maine, School of Painting and Sculpture first became interested in the materials we call folk art.[16] As a group, these artists attempted to break away from the representational and impressionistic tendencies of late-nineteenth-century academic art. They were also among the first persons who, for purely aesthetic reasons, sought and collected American folk art. The abstract qualities that these modernists saw and appreciated in folk carvings, paintings, and other objects corresponded to their own creative efforts. In an important and revealing way, the growing enthusiasm among American collectors for modernists' painting and sculpture paralleled a rising interest in American folk art. Thus, the intriguing history of these early years, which ultimately led to the formation of this country's premiere collection by Abby Aldrich Rockefeller, is essential to any understanding of aesthetics as applied to American folk art.

A number of the paintings in this volume as well as in *American Folk Portraits* (AARFAC, 1981) were owned in the 1920s by members of the Ogunquit School and their colleagues, principally Edith Gregor Halpert, the owner of the Downtown Gallery in Greenwich Village and the wife of Sam Halpert, a painter. A study of these works, typified by *Outing on the Hudson* (cat. no. 41), illustrates in rather specific ways, the aesthetic qualities valued and judged in the formative years of folk art collecting as well as today.

Not every work collected by Halpert and subsequently Mrs. Rockefeller — or by others who have enlarged the Center's collection in recent years — has extraordinary or unequaled aesthetic quality. The variance is sometimes broad and illustrated by works such as Erastus Salisbury Field's *Death of the First Born* (cat. no. 180), which lacks some of the fine linear quality of his early portraits; or Edward Hicks's *Washington at the Delaware* (cat. no. 228), a dark and rather dull copy of Thomas Sully's 1819 treatment of the subject. Some of Lewis Miller's small watercolor drawings are efficiently developed compositions, while others seem to be of more historic than aesthetic interest. Only a few of the theorem paintings in the collection measure up to Mary Bradley's ca. 1825 *Basket of Fruit* (cat. no. 95). As in any art form, genre, or style, the degree of aesthetic content ranges from low to high, but in folk art, the extraordinary pieces by one

given artist are not the correct models by which the works of all other artists are judged. Rather, they serve the very specific purpose of assessing the aesthetic achievement, development of style, and method of work of the given artist.

Field's *Death of the First Born* has aesthetic interest, but more importantly, it documents the artist's penchant for and handling of biblical themes — matters that illuminate the range of subjects painted by the artist, his ability to handle non-portrait formats, and his artistic aspirations. While Hicks's picture *Washington at the Delaware* is not aesthetically one of the best of his known works, it gives viewers an opportunity to compare his historical painting with his much more successful kingdom and farmscape paintings, all of which Hicks basically evolved through personal introspection and independently. Ultimately, our understanding of Hicks's perception and motivation is enhanced by the distinctions observed among the entire body of his extant works.

On the other hand, one cannot isolate a select handful of Miller's drawings and hope to understand anything significant about his ability as an artist, his experiences in life, or his purpose in his artwork; one must analyze a large corpus of his drawings to comprehend these matters and ultimately address the aesthetics of his work as well as their historical importance as artistic products of the common man. The measurement of aesthetic quality in folk art is purposeful, not arbitrary, but prominent scholars still raise the question of whether there is such a thing as good folk art versus bad folk art. For Center staff, the real issue is whether the work has sufficient aesthetic interest to be called art.

Some of the questions concerning a definition of American folk art are more complex than those reviewed and addressed here, but few of them will be resolved quickly or easily without clear understanding of the objects involved or the broad principles that were established for assessing the material in the early part of this century and which continue to be refined. Center staff fully realize the importance of the materials, whether they be the variety of paintings included in this volume or three-dimensional objects whose primary historic function was utilitarian. We view these paintings and other objects as links in the greater framework of both art and social history and favor an integrated approach that draws on a number of disciplines and scholarly orientations. Our desire is not to perpetuate illogical or meaningless methods of study or interpretation, but rather to explore folk art's aesthetic dynamics in relationship to its present and historic art function.

Folk art as both a derivative and deviant aesthetic

expression of the common people of America, regardless of time and place of making, presents a formidable challenge in humanistic study — one that requires qualitative art judgments while it deserves theoretical analysis provided by those in other scholarly fields. In the end, it may not matter so much whether we agree on what is and what is not folk art; of greater concern is that we continue to seek a more comprehensive understanding of it in the broader context of American art.

CAROLYN J. WEEKLEY

Notes

[1]The first definition of American folk art appeared in an October 1930 pamphlet prepared by Lincoln Kirstein, Edward M. M. Warburg, and John Walker for an exhibition of paintings they organized for the Harvard Society for Contemporary Art. Holger Cahill's exhibition catalog entitled *American Folk Art: The Art of the Common Man in America, 1750–1900* (New York: Museum of Modern Art, 1932), included the first in-depth definition of the material collected as folk art in this country. Subsequent definitions associated with the Abby Aldrich Rockefeller Folk Art Center's collection include Nina Fletcher Little's introduction in AARFAC, 1957, and Beatrix T. Rumford's essay in AARFAC, 1975. In Lipman and Winchester, Folk Art, Jean Lipman and Alice Winchester addressed "What is American folk art?" on pp. 9–10.

[2]See AARFAC, 1981, pp. 19–35, for a discussion of portraits as folk art.

[3]American Primitives, pp. 8–9.

[4]AARFAC, 1957, p. xiii.

[5]Jones's definition as used as label text in the exhibition reads:

American Folk Art includes objects in our culture such as paintings, carvings, metal and needlework which have aesthetic values but were created by men and women who worked outside the traditions and canons of the academies teaching the fine arts.

American Folk Art falls into two groups:

Traditional *Folk Art derives from long standing hand craft traditions, usually brought here from Europe, handed down by word of mouth (not by books), often found among isolated or restrictive societies, created by a single artist.*

Associative *Folk Art includes other non-academic items which have been considered folk art in this country for half a century: school taught arts such as theorems, memorials, needlework pictures, paintings derived from prints, portraits showing some exposure to the academic tradition but still outside that tradition; certain works created by a group of artisans, such as carousel figures or circus carvings. American Folk Art includes both what is known in Europe as Folk Art and what is known as Naive Art.*

[6]See Lipman and Winchester, Folk Art, p. 9. Johannes Fabian and Ilona Szombati-Fabian discuss some of the problems with the tradition-bound theory in their essay "Folk Art from an Anthropological Perspective" in Quimby and Swank, pp. 247–292. James Thomas Flexner, a well-known historian of American art, was among the first to emphasize the importance of tradition in folk art in "What is Folk Art?: A Symposium," *Antiques*, LVII (May 1950), p. 357. Flexner wrote that folk art "is passed down practically without change from generation to generation by simple people who live in a static society that can be expressed by traditional symbols."

[7]For example, Edward Hicks's method of scumbling paint mixed with varnish or some yet-to-be-identified material by using his fingers has no precedent in prescribed academic techniques of his period. It was undoubtedly a method he devised through trial and error to achieve a desired aesthetic effect. Similarly, materials seen in some works, such as the wallpaper border used to surround and visually set off the ship illustrated in cat. no. 60, have no parallels in academic work of the same era.

[8]The general discussions in relation to American frakturs published thus far include such works as Shelley, Fraktur-Writings, and Ethel Ewert Abrahams, *Frakturmalen und Schlönschreiben* (North Newton, Kansas: Mennonite Press, Inc., 1980).

[9]Klaus Wust, fraktur scholar, made the observation about the sword sheath in his lecture "The Americanization of Fraktur in the South," presented at the Learning Weekend, sponsored by the Colonial Williamsburg Foundation, February 27–March 2, 1986.

[10]The most extensive collection of decorated records produced for and mostly by English-speaking persons in early America is owned by the National Archives, Washington, D.C.

[11]As quoted in Barbara C. and Lawrence B. Holdridge, "Ammi Phillips 1788–1865," *Connecticut Historical Society Bulletin*, XXX (October 1965).

[12]See Robert F. Trent's excellent discussion of this in *Hearts and Crowns: Folk Chairs of the Connecticut Coast 1710–1840 as Viewed in the Light of Henri Focillon's Introduction to "Art Populaire"* (New Haven: New Haven Colony Historical Society, 1977), pp. 20–24. Focillon (1881–1943) was a leading art history theorist and at the time of "Art Populaire's" publication in 1931, he was Professor of Art History at the Sorbonne. As Trent points out, Focillon identified most, if not all, the concepts and theoretical questions surrounding folk art study that have persisted to interest scholars in recent years. His work stressed "interrelatedness of all mankind above and beyond any transient particularisms." Trent maintains that Focillon's work was an attempt to "reconcile the two main schools of art historical thinking . . . the positivism of Gottfried Semper (1803–1879) and the idealism of Alois Riegl (1858–1905)." Semper believed that art was largely a result of craft technology and that "materials, technique, and function determine the nature of forms, which are then perceived as having aesthetic qualities." Folk art was considered inferior. Riegl, whose concepts were opposed to Semper's, maintained that "art forms are ideas, largely unrelated to the limitations of craft technology or function." Semper held that man possessed "a will to realize a formal concept, which can overcome any technical obstacles on its way to realization."

[13]See Charles F. Montgomery, *Some Remarks on the Science and Principles of Connoisseurship*, reprinted from the 1961 Walpole Society *Note Book*.

[14]See Beatrix T. Rumford, "Uncommon Art of the Common People: A Review of Trends in the Collecting and Exhibiting of American Folk Art" in Quimby and Swank, pp. 14–15. Central to Rumford's discussion and historical evidence is that early collectors of folk art in America were almost exclusively interested in the aesthetic content of the material. Like Focillon, these collectors did not view the material as inferior to formal art of similar periods — but parallel to it and of distinctive aesthetic value. Nor did they necessarily view it as separate from or unrelated to parallel elitist, high-style art. Early folk art studies in Europe stressed traditionality and the material's having been unspoiled by influence from formal cultural ideas or forms, or by influences that might come from outside a given society or ethnic group and its peculiar context.

[15]Ibid., p. 14.

[16]Ibid., pp. 14–25.

Notes on the Catalog

The paintings and drawings in this catalog are grouped primarily by subject matter. The exceptions are works by Edward Hicks and Lewis Miller, which appear in separate sections under those artists' names. These sections, like the subject groupings, are listed on the contents page.

Within each subject grouping in the catalog, works are divided into those whose artists are identified by name and those whose makers remain unknown by name. The former appear first within their subject grouping and are in alphabetical order by their artists' surnames. The latter follow them and appear chronologically by date of execution. When dates of execution coincide, works are in order by date of acquisition by the Folk Art Center. Parts of names, such as L. W. and Harriet De ——— , are alphabetized like those of fully identified artists. However, when only initials are known, alphabetization is by the first letter rather than the second. Similarly, widely accepted "convenience" names have been alphabetized by the first letter of the phrase in each case; thus, an entry by the C. M. Artist appears under "C," and an entry by the Ehre Vater Artist appears under "E."

When a work is signed, or other period documentation exists, the name is cited without further qualification as to authorship. Otherwise, "attributed to" implies acceptance of authorship on the basis of style, while "probably" and "possibly" denote diminishing degrees of certainty. If only a little biographical information about an artist is known, those facts are incorporated within the object entries for that artist's work. Otherwise, a brief biography of each artist appears preceding the artist's first work listed in the volume. If an artist is represented by more than one work in the catalog and if these entries are separated herein, a cross-reference to the biography precedes subsequent object entries.

The place name or area given in the heading for each entry indicates as specifically as possible the locale where the object is believed to have been created. A circa date indicates the compiler's approximation of the time of execution and spans as much as five years on either side of the year given. The medium used is noted, and where wood supports are used, species are identified only if the wood was microscopically analyzed. Measurements are taken from the right side and lower edge of an object and are cited with height preceding width. Such measurements are given for primary supports that are normally fully flat, such as paper and wood panel, and for stretched canvases. "Sight" measurements are given for pictures on textile grounds stretched over nonrigid auxiliary supports, such as paintings on velvet and needlework pictures on silk. These dimensions reflect what the viewer can actually see of the primary support when the object is in its usual frame and behind its usual eglomise mat, if any.

Any signature, date, or inscription found on a painting or drawing is recorded exactly as it appears, and the location is noted as precisely as possible. Where examination of watermarks on paper supports was possible, these marks are cited and identified as to manufacturer, when known. All documented information detailing the conservation history of a particular work is summarized under *Condition*.

The provenance is given in chronological sequence, starting with the earliest known owner. The last name cited can be assumed to be the source from which the Folk Art Center acquired the work. The first two digits in museum accession numbers indicate the year of the acquisition.

Where and when each piece has been on public view is given under *Exhibited*. The short titles of exhibitions and institutions used in this section are listed alphabetically and spelled out in the exhibitions list on pages 432–434.

Similarly, if the work has been discussed or reproduced in the literature, the pertinent publications are given under *Published*. The short titles used in this section are spelled out in the publications list on pages 434–437, and this list, along with occasionally cited sources in the notes, functions as the catalog's bibliography.

Generally, the use of color for, and the size of, an illustration represent curatorial judgment concerning a work's quality and relative importance to the Williamsburg collection. However, no painting or drawing is pictured larger than its actual size.

AMERICAN
FOLK
PAINTINGS

I On Land and Sea

I

*A*mericans' pride and delight in their nation and in their personal accomplishments are reflected in a large number of landscapes, seascapes, and townscapes and in the portraits they created and commissioned of their homes, farms, ships, and businesses.

The invigorating effect of a frontier pushed ever westward has been explored by many theoreticians and historians and is perhaps most clearly illustrated in the Folk Art Center's holdings by surprisingly late works: Steve Harley's 1920s views of Wallowa Lake and the Wind River basin in the Pacific Northwest (nos. 11 and 13). Untamed aspects of the young nation offered challenge and an awesome beauty to adventurous explorers, and scenes of natural grandeur, exemplified by views of Niagara Falls, echo these allurements. At the same time, gentler views that include allusions to man's imposed order, such as *Palisades along the Hudson* (no. 38), suggest the prospect of opportunity, peace, and prosperity that attracted so many first to America's coast, then inland.

Townscapes often include sweeping vistas that inspire on the level of the frontier; yet here the viewer's attention is usually focused on the hand of man and his "civilizing" stamp of a settlement in the wilderness. Even more obvious records of man's accomplishment and influence are found in portrayals of individual edifices and structures, such as *Train on Portage Bridge* (no. 39) and *View of the Montgomery County Almshouse Buildings* (no. 53). A pride of achievement also frequently motivated the commissioning of depictions of individuals' farms and homesteads, but here perhaps proportionately more weight can be ascribed to a sentimental longing to capture surroundings dear to the heart.

A few views, especially those derived from print sources, probably were attempted as fashionable expressions or artistic exercises, and certainly patriotic impulses played a part in recording places of historical interest, such as the Center's numerous depictions of Mount Vernon.

Views of Towns, Harbors, and Places of Interest

Alexander Boudrou (active 1851–1871)

Allusions to Boudrou's life and career as an artist are tantalizingly brief. They derive primarily from Philadelphia directory entries and from the Folk Art Center's two works believed to have been done by him, an oil and a watercolor dated twenty years apart and differing widely in concept and execution.[1] Philadelphia directory evidence for 1854–1863 is as follows:

1854 Boudrow, A. D., trader, Nicetown Lane
1856 No entry
1857 No entry
1858 Boudrow, Alexander, artist, Nicetown
1861 Boudrow, Alexander, artist, 221 S. 8th
1862 Boudron, Alexander, artist, 914 Chestnut, h[ome] N.W. corner 5th and Diamond
1863 Boudron, Alexander, artist, N.W. Diamond and 5th

These constitute the last known directory references to any Boudrou/Boudrow/Boudron as an artist. In 1864 and 1865, Philadelphia directories list one Alexander Boudron, manufacturer, at Southeast Fifth Street and Susquehanna Avenue, and there is no entry for 1866. Between 1867 and 1895, shifts in Boudrou name spellings, addresses, and occupational listings in the Philadelphia directories make it increasingly unclear whether one or more men are being discussed and whether any is the same man who called himself an artist in 1854–1863. Except for an unlikely "Boudrou, Alex, student, h[ome] 2327 Madison Sq[uare]" in 1897, Philadelphia directories mention no Boudrou/Boudrow/Boudron having a first name beginning with the initial *A* after 1895.[2]

[1]A third Boudrou work was discovered in 1987; the privately owned painting shows a large cow or bull, and it bears these partially legible inscriptions: ". . . at the Franklin Market, Philadelphia/February [illegible material] 18 [illeg.]" and ". . . [p]ainted correctly before slaughtering by the celebrated Artiss [*sic*] Al[illeg.]ndr Boudrou" (private owner to AARFAC, March 6, 1987).

[2]Except for note 1, all information in this entry is taken from John R. Angell, Free Library of Philadelphia, to AARFAC, December 8, 1982.

1 A. Dickson Entering Bristol in 1819 39.101.2

Alexander Boudrou
Philadelphia County, Pennsylvania, 1851
Oil on canvas
21 1/8" x 26 3/16" (53.7 cm. x 66.5 cm.)

Although many folk artists encountered difficulties in depicting correct one-point perspective and consistent scale in their paintings, few ignored these academic niceties as blatantly as Boudrou did in rendering the foreground of his portrayal of Mr. Dickson. Other arresting features of the painting are heavy, drapery-like clouds in the upper sky and a plethora of details related to everyday activity, including an assortment of tools and other objects on the ground at lower left. Among these are a hammer, two axes, a length of chain, and a horseshoe.

Additional interesting details of the painting include five small figures on the porch of the inn, a pump and watering trough in front of the same building, and a flock of white birds rising from behind one of the houses at right. Dickson's wild-eyed horse wears a running martingale, a device designed to help keep his head down while being ridden, and the nails holding shoes to his hooves are decoratively picked out in white. Dickson himself wears rowel spurs; small dots of red paint close by on the horse's side must have been the artist's deliberate attempt to show blood.

The painting was identified as titled by a former owner, who is said to have been a member of the Dickson family. The title's early date cannot be explained in view of the readily legible mid-century date that appears on the reverse of the canvas, unless Boudrou created the scene as a retrospective one.

By 1820 a Bristol Township Inn existed at the intersection of Second Street Pike and Grubtown Lane in McCartersville, or Unionville, one of the communities in Philadelphia County at that date.[1] The building is identified by name on 1839 and 1847 Philadelphia County maps, while J. R. Cook's Smith Shop is shown directly across from it on an 1849 Bristol Township map.[2] The house at lower right in Boudrou's oil can be identified as Boardman property via the 1849 Bristol Township map, and other structures nearby (one

or more of those in the upper right background of the painting) are marked J. Dickson on the map. Research has not yet verified a presumed relationship between the latter property owner and the mysterious A. Dickson of the painting's title.

Inscriptions/Marks: The reverse of the canvas is inscribed: "Alaxandr Boudro [the terminal lettering is illegible because of a paint smear]/Painter/1851/No. 7." Lettered on the inn sign at far left in the painting is "BRISTOL/TOWNSHIP/INN."

Condition: Treatment by an unidentified conservator prior to acquisition included cutting the canvas from its auxiliary support, patching it in two places on the reverse, and inpainting an A-shaped tear at lower left. In 1954 Russell J. Quandt replaced the stretchers, lined the canvas, cleaned the painting, and inpainted small scattered areas of paint loss in addition to three large rents in the support: the A-shaped tear above, a 6-inch vertical tear at lower left, and a 3¾-inch vertical tear in the sky at far left. Period replacement 2-inch splayed, rosewood-veneered frame.

Provenance: The painting was owned by a member of the Dickson family in Pennsylvania; it was purchased from Edith Gregor Halpert, Downtown Gallery, New York, N.Y.

Exhibited: AARFAC, Arkansas; AARFAC, April 22, 1959–December 31, 1961; AARFAC, September 1968–May 1970; William Penn Museum.

Published: AARFAC, 1940, p. 23, no. 41; AARFAC, 1957, p. 10, no. 3, illus. on p. 11; AARFAC, 1959, p. 40, no. 43, illus. on p. 7; AARFAC, 1975, illus. on p. 5; John I. H. Baur, "Painting in the Nineteenth Century," Helen Comstock, ed., *The Concise Encyclopedia of American Antiques* (New York, 1966), illus. as pl. 210 on p. 501; Albert Dasnoy, *Exégèse de la Peinture Naïve* (Brussels, 1970), illus. as pl. 177 on p. 216.

[1]R. N. Williams II, Historical Society of Pennsylvania, to AARFAC, May 6, 1955; and Bruce Laverty, Historical Society of Pennsylvania, to AARFAC, June 21, 1982. The area was incorporated within the expanded limits of the city of Philadelphia in 1854.

[2]All three maps are in the collections of the Historical Society of Pennsylvania; a copy of the third is in AARFAC files. The Bristol Township Inn was located on the first two according to Bruce Laverty, Historical Society of Pennsylvania, to AARFAC, June 21, 1982.

Eliza Howard Simms Burd
(1793–1860)

Eliza Howard Simms (b. 1793) was the daughter of Sarah Hopkins Simms and Woodropp Simms, a Philadelphia shipping merchant. Her father died of yellow fever in 1793, shortly after her birth, and his business partner, Joseph Simms, assumed the girl's guardianship thereafter. The house Joseph built at the southwest corner of Chestnut and Ninth streets in Philadelphia was Eliza's home for many years, during her childhood and after her marriage to Edward Shippen Burd on August 20, 1810.

Eight children were born to the Burds in the period 1811–1822, but several of them died in infancy, and all were deceased by the time their father died on September 17, 1848, leaving his widow the bulk of a great fortune. Mrs. Burd's philanthropic interests were well known in her lifetime, albeit quietly pursued. Thus, Philadelphians were hardly surprised that a significant aspect of her will was the establishment of the Burd Orphan Asylum of St. Stephen's Church. She died April 6, 1860.

Other than a group of thirteen views of springs in Virginia (now West Virginia), no paintings or drawings linked with Eliza Burd's name are known.[1]

[1]Information for this entry has been taken from Harold E. Gillingham, *Notes on the Burds of Ormiston, Scotland & Philadelphia* (reprinted from the Publications of the Genealogical Society of Pennsylvania, XIII [1939]), pp. 190–192. Eliza Burd's portrait is illustrated therein on p. 190. Also consulted was T. Westcott, comp., *Biographies of Philadelphians*, B (n.p., ca. 1860), pp. 354–355.

2

2	**Blue Sulphur Springs,**	61.302.2
	September 9, 1843	
3	**Blue Sulphur Springs,**	61.302.3
	September 15, 1843	
4	**Sweet Springs,**	61.302.1
	September 29, 1843	

Possibly Eliza Howard Simms Burd[1]
Virginia (now West Virginia), 1843
Watercolor and ink on wove paper
8⁵/₁₆″ x 11⁵/₁₆″ (21.1 cm. x 28.7 cm.)[2]
7³/₈″ x 11¹¹/₁₆″ (18.7 cm. x 29.7 cm.)
7″ x 11¹³/₁₆″ (17.8 cm. x 30.0 cm.)

For centuries people have believed that drinking or bathing in natural warm or mineral waters was conducive to good health, and by mid–nineteenth century, resort hotels or spas had grown up around many American springs of this type. Accompanied by retinues of servants, wealthy families made annual pilgrimages to these resorts to "take the waters" and, increasingly, to meet friends in a fashionable setting. A variety of recreational activities, such as carriage and horseback rides, promenades, balls, and games, all catered to this clientele, making social life an important function of the springs — one that outweighed the salubrious aspects of the visits for a great many.

The Folk Art Center's three watercolors were part of a group of thirteen scenes of Virginia (now West Virginia) springs that were advertised by the Old Print Shop in 1947.[3] Eight watercolors in a private collection, the three at the Folk Art Center, one at the New York State Historical Association at Cooperstown,

and one at the Museum of Fine Arts in Boston are believed to be those that were advertised in 1947, with one or two possible exceptions.[4] The privately owned pieces are known only from a list, but their history indicates that they were part of the same group. The pieces in institutional collections are all quite readily identifiable as the work of the same artist.

Sweet Springs is located in Monroe County and Blue Sulphur Springs in Greenbrier County, West Virginia. The artist, possibly Eliza Burd, probably sketched the group as a recreational pastime and kept them as souvenirs of her visits to the resorts. It is hoped that research among Eliza Burd's personal papers may eventually confirm her identity as the creator of these appealing scenes. Numbers 2 and 3 are views taken at right angles to each other. The latter must have been drawn from the end of the second- or third-story porch of the main hotel, which is shown head-on in no. 2.

Inscriptions/Marks: In ink in script in the lower right corner of the secondary support of no. 2 is "Blue Sulphur Springs September 9ᵗʰ 1843." In the upper right corner of the reverse of the primary support of no. 2 is marking in inked script that appears to read the same as the immediately preceding and that may be in the same hand. In ink in script in the lower right corner of the secondary support of no. 3 is "Blue Sulphur Springs — September 15ᵗʰ 1843." In ink in script in the lower right corner of the secondary support of no. 4 is "Sweet Springs — September 29ᵗʰ 1843." In the upper right corner on the reverse of the primary support of no. 4 is marking in inked script that appears to read the same as the preceding and may be in the same hand.

Condition: In all instances, the pictorial compositions cover the primary supports, which appear to be their original sizes, that is, 7⁵/₁₆″ x 10⁵/₈″ (18.6 cm. x 27.0 cm.), 6¹/₈″ x 11″ (15.6 cm. x 27.9 cm.), and 5⁷/₁₆″ x 10¹⁵/₁₆″ (13.8 cm. x 27.8 cm.), respectively. However, all were adhered to larger sheets and had margins added, probably by the artist, in the following manner: each primary support

3

4

was glued to a secondary support of wove paper that is only slightly wider but significantly taller than the primary support, thereby creating very narrow side margins and larger upper and lower margins. Side strips were then glued to the reverse of the secondary support to create extended side margins. The black ink or watercolor border that surrounds each composition was applied to the secondary support. Unspecified treatment by Christa Gaehde was performed in 1962. In 1976 E. Hollyday treated no. 4 only by flattening and, using Japanese mulberry paper, mending two lower edge tears and hinging the secondary support to a backboard. Matching modern replacement 7/8-inch molded cyma reversa frames, painted black, with gold-painted inner edges.

Provenance: May B. Foell (?);[5] Old Print Shop, New York, N.Y.

Exhibited: Only two of the watercolors, no. 4 and one of the other two, were included in Smithsonian, American Primitive Watercolors, and exhibition catalog, no. 24; no. 4 only, Virginia Sampler, and exhibition catalog, no. 25.

[1]When contacted in 1974, the Old Print Shop no longer retained papers detailing its acquisition of the watercolors, with one exception. It had — and provided AARFAC with a photocopy of — a letter dated May 14, 1947, signed by May B. Foell (the transcription of the name may not be entirely correct). This letter, presumed by both AARFAC and 1974 Old Print Shop staff to have been written by the former owner of the watercolors, forms the basis for the possible attribution of thirteen pieces to Eliza Howard Simms Burd's hand. In its entirety, the letter reads: "Dear Mr. Newman: In reply to your letter of May 9th, the watercolors in the album were done by Eliza Howard Burd of Philadelphia (an old distinguished family). Born 1793–Died 1860. She traveled and lived in Europe at different times, but I cannot say positively where she studied. I have written a friend in Phila. and if I get any more information will pass it on to you. She had several children but all died long before she did, also her husband. Sincerely yours, May B. Foell [Postscript:] I have a couple of reproductions of an oil painting of Mrs. Burd if you would care to have one, but perhaps you are only interested in the name. M. F."

[2]Heading measurements include the margins, since these may well have been added by the artist. However, measurements of the pictorial compositions (in this case, the primary supports) are given under *Condition.*

[3]*Antiques,* LII (August 1947), p. 93.

[4]It is perplexing that the private collection reportedly includes no image of Blue Sulphur Springs, which leaves unresolved the present whereabouts of the lower of the two views illustrated in the Old Print Shop advertisement. Equally puzzling is a tiny (2¾" x 1⅝") picture in the private collection that is marked "Chantilly, Nov 1844" (private correspondent to AARFAC, April 14, 1976). If this piece is indeed part of the original group of thirteen, the meaning of the name — and/or its association with a particular spring — remains undetermined. Its date also contradicts the wording of the Old Print Shop advertisement, which calls them "1842–3."

[5]See note 1 above.

Thomas Chambers
(1807/8–after 1865)[1]

Despite early recognition of the boldness and individuality of Chambers's painting style, firm biographical information has eluded researchers for many years.[2] Several recorded data derive from the 1855 New York State census, which indicates that, at that time, Thomas, age forty-seven, and his wife, Harriet, age forty-six, lived in Albany at 343 State Street in a freestone house valued at twenty-five hundred dollars; the birthplace of both was given as London.[3] Thomas was a naturalized citizen, and he and his wife had been in this country for twenty-three and twenty-one years, respectively.

On March 1, 1832, Chambers filed a Declaration of Intention at New Orleans, and the New Orleans City Directory for 1834 (which was printed in December 1833) listed him as a painter.[4] He appeared in New

York City directories for the period 1834–1840, listing himself at various addresses there as a landscape painter (1834–1837) and as a marine painter (1838–1840). In Boston during the years 1843–1851, he was styled simply artist. In the spring of 1851, Chambers relocated again, this time in Albany. Listed as an artist, he appeared in directories published there as late as July 1, 1857, but he must have left Albany later that year or early in 1858, since he appeared in Trow's New York City Directory for the year ending May 1, 1859, at 148 Spring Street. During the following eight years, Chambers moved several times within New York City, and he may have been in Boston in 1860–1861. No mention of him has been found after his listing in Trow's New York City Directory for the year ending May 1, 1867, when an address of 3 Mott Street is given. The place and date of his death remain undetermined.

Chambers's painting style can be characterized as bold. His compositional designs are striking, and when based on print sources, the alterations he makes serve to heighten drama. His tonal contrasts are great and his colors vibrant, some might say even garish. These qualities lend appropriateness to the suggestion that Chambers may have gained experience as a scene painter in London, but in actuality his training remains a matter of conjecture.[5]

Approximately sixty-five works have been ascribed to Chambers, and most of these are attributed on a stylistic basis, since only five signed examples are known.[6] Of these, forty-five are broadly categorized as landscapes, including works of historical interest such as the Folk Art Center's sole painting by him. The Center's view of George Washington's birthplace is also characteristic of a large portion of Chambers's work in its size and medium (approximately twenty-two by thirty inches and oil on canvas).

[1]Merritt, p. 215, uses Chambers's age (forty-seven) in the 1855 New York State census to deduce that the artist was born in 1808, but since the census was taken in June of 1855, Chambers could have been born in the latter part of 1807 and still have been forty-seven years of age (and some odd months and/or days) by the time of the census report. Hence, both birth years are given here. Chambers's death date remains unknown.

[2]Most of this entry is adapted from Merritt, which despite its 1956 date, remains the most complete published summary of Chambers's life recorded in AARFAC files. The thoroughly documented article also provides a good thumbnail sketch of art historians' and critics' discovery and recognition of Chambers in this century.

[3]This contradicts an 1815 birth date, which has been widely circulated for Chambers and which apparently stems from the 1850 U.S. census (Nina Fletcher Little, "More About T. Chambers . . . ," Antiques, LX [November 1951], p. 469). The aforementioned census also describes Chambers as a portrait painter, but no portraits attributed to him have been noted to date.

Merritt, pp. 214–215, indicates that Chambers's wife was Harriet Shellard Chambers, who died of consumption June 28,

1864, age fifty-five, in St. Luke's Hospital in New York City, and was buried in Green-Wood Cemetery. The date of her marriage to Chambers is unnoted.

[4]This information is from entry no. 18 of the catalog called The Genesee Country, which was written by Howard S. Merritt for the exhibition of that same title at the Memorial Art Gallery of the University of Rochester, New York, January 17–February 22, 1976.

[5]Merritt, p. 216.

[6]Merritt, p. 216, gives the count of Chambers's work as "approximately sixty-five," but at the time of his writing, he apparently had not recorded two of the four known versions of the Birthplace of George Washington.

5 Birthplace of George Washington 57.102.5

Attributed to Thomas Chambers
America, probably ca. 1845
Oil on canvas
21¼" x 30¼" (54.0 cm. x 76.8 cm.)

The pink tints in the sky and clouds indicate a sunset view, although the silvery shimmer of the water and cold blue-and-white highlights on the foreground foliage are more suggestive of moonlight. The vines in the foreground strike a rather eerie, macabre note that jars with much of the mood of the rest of the picture. Their creeping configuration and dull, autumnal colors suggest death and decay, whereas many other aspects of the painting convey serenity and peace, if not cheer: the stillness of the air and water, the quiet depths of the middle-ground forest, the smoke that rises lazily from the cottage chimneys, and the warm tones of the distant sky.

Chambers painted at least four other very similar versions of the same scene,[1] and other examples of the subject by other artists have been recorded in the Folk Art Center's files. Those noted all appear to have been inspired by, or very loosely based on, one or more engravings after an 1834 oil painting by John Gadsby Chapman (1808–1889).[2]

Inscriptions/Marks: Painted on the stone in the center foreground is "Birthplace/G. Washington."

Condition: Treatment prior to acquisition included lining the edges of the canvas and, probably, cleaning. Treatment by Russell J. Quandt in 1959 included replacing the earlier strip lining, cleaning, replacing the auxiliary support, and filling and inpainting a minor loss at lower right. Period replacement 2¼-inch gilded cyma recta frame.

Provenance: Old Print Shop, New York, N.Y.

Published: The Old Print Shop Portfolio, XVI (March 1957), p. 166, no. 32.

[1]One of the other three similar Chambers paintings was privately owned as of 1969; another is owned by Fruitlands Museum, Harvard, Mass.; and the third was illustrated as lot no. 31 in Sotheby Parke Bernet, Inc., *The Thomas G. Rizzo Collection of Important*

5

American Folk Art and Related Decorative Arts, catalog for sale no. 4911M, April 29, 1982.

 Howard S. Merritt, University of Rochester, to AARFAC, July 6, 1963, mentions the fourth version of the subject, which was owned at or about that time by the Argosy Gallery in New York City.

²Chapman's oil was illustrated in *The Old Print Shop Portfolio,* XVIII (October 1958), p. 26, no. 2. Engravings based on the oil appeared in T. Addison Richards, *American Scenery* (New York, 1854), opposite p. 41; in Robert Sears, *A Pictorial Description of the United States,* rev. ed. (New York, 1857), p. 321; and in James K. Paulding, *A Life of Washington,* I (New York, 1835), as the title page illustration.

 The house where Washington was born was destroyed by fire in the eighteenth century; a reconstructed mansion was erected on the site on Pope's Creek in Westmoreland County, Virginia, in 1930–1931. Various romanticized and misleading conceptions of the original building's appearance are discussed in Charles Arthur Hoppin and the editors of *Antiques,* "Was Washington Born in a Cabin?" *Antiques,* XIX (February 1931), pp. 98–101.

Rebecca Couch
(1788–1863)

Rebecca Couch was born June 19, 1788, in Redding, Connecticut.[1] She was the eldest child and only daughter of Thomas Nash Couch (1758–1821) and his wife, Abigail Stebbins Couch (1766–1825).[2] Her brothers, Hiram and Nash, were born July 27, 1791, and October 17, 1794.[3] On September 29, 1811,[4] Rebecca married James C. Denison (1779–1853), and the couple lived in his hometown of Lansingburgh, New York, at least until the 1820s.[5] However, the Denisons spent the latter part of their lives in Redding; both

died there (Rebecca on September 4, 1863), and they were buried in Redding Ridge Cemetery. Their seven children were Abigail Jane (1812–1897), William (1814–1814), James Couch (1815–1859), William Thomas (1817–1891), Mary Ann (1819 or 1820–1894), Elizabeth Stebbins (1822–1895), and Clarissa D. (ca. 1823–?).[6]

 Rebecca Couch probably received some instruction in watercolor technique wherever she attended school. She may have studied in Litchfield, Connecticut, although she is not listed in the extant records of students enrolled there at Miss Sarah Pierce's School (1792–1833) or Mr. Morris's Academy (1790–1820).[7] A needlework picture on silk executed by Couch at age fifteen is the only other work of hers that has been recorded to date.[8]

[1]Donald Lines Jacobus, comp. and ed., *History and Genealogy of the Families of Old Fairfield,* II (Fairfield, Conn., 1932), p. 260.

[2]A. S. Wheeler, comp., *An Inquiry as to the Heirs at Law of Maria Stebbins* (New York, 1880), p. 8. Abigail Stebbins Couch's death date comes from Mrs. Robert H. Scribner to AARFAC, August 2, 1983.

[3]Jacobus, p. 260.

[4]Redding Congregational Church Records 2:151, as quoted by Thompson R. Harlow, Connecticut Historical Society, to AARFAC, April 27, 1976.

[5]Mrs. Warren J. Broderick to AARFAC, July 9, 1982.

[6]Ibid. The cemetery name and Clarissa's middle initial come from Mrs. Robert H. Scribner to AARFAC, August 2, 1983.

[7]Thompson R. Harlow, Connecticut Historical Society, to AARFAC, April 27, 1976.

[8]The needlework was advertised by Ruth Troiani in *Antiques,* CXXV (March 1984), p. 549.

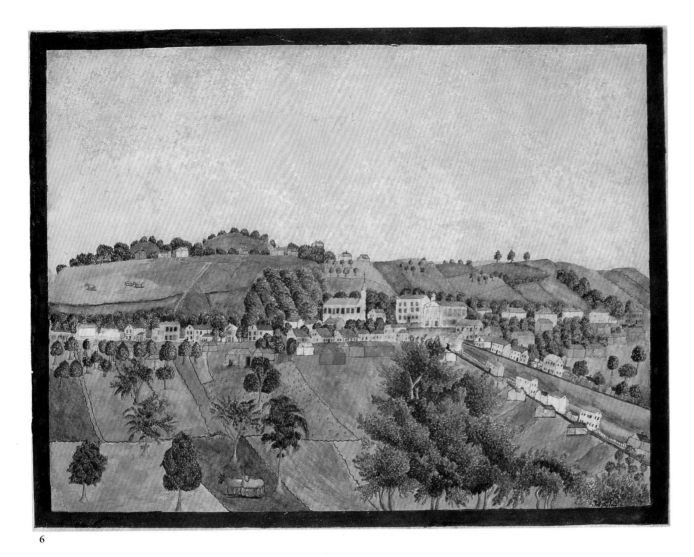

6

6 View of Litchfield (?) 62.302.1

Rebecca Couch
Connecticut, possibly Litchfield, probably
ca. 1805
Watercolor and ink on wove paper
12⅞″ x 16½″ (32.7 cm. x 41.9 cm.)

There has been considerable controversy over whether or not this watercolor represents Litchfield, Connecticut. The original identification of it as such stems from a label inscription that clearly contains some errors,[1] and its assertion that the view is "*said* to be Litchfield [italics added]" obviously suggests uncertainty.

In 1961 the Litchfield Historical Society accession committee judged that the view did not represent their town, but in 1962 the society's curator expressed the opposite opinion, citing similarities to the 1831 aquatint *S. East View of Litchfield, from Chestnut Hill* by or after John Warner Barber and to an 1858 pencil sketch by James B. Parsons.[2] Several factors contribute to the difficulty of rendering a positive identification: the amateur artist's inaccuracies of perspective and relative scale, the distance at which the scene is viewed, and water damage that has obliterated some details of the buildings.

Inscriptions/Marks: An old label, now lost, is said to have read: "By Rebecca Couch, 13 yrs. old/Lived in Redding Conn — Died 85 yrs. old/This drawing said to be — Litchfield, Conn. — 1820."[3]

Condition: Treatment by Christa Gaehde prior to acquisition included repairing numerous tears and inpainting scattered losses throughout, especially in the sky. Treatment by E. Hollyday in 1977 included dry cleaning unpainted areas and removing or reducing insect stains. Treatment by E. Hollyday in 1980 included removing a modern secondary support, repairing several tears, setting down flaking paint in the trees, and backing the primary support with Japanese mulberry paper. Period replacement 1½-inch, gold-leafed frame with acanthus leaf decoration and beading.

Provenance: Old Print Shop, New York, N.Y.

Exhibited: Pine Manor Junior College.

Published: The Old Print Shop Portfolio, XX (February 1961), illus. on back cover.

[1]Rebecca Couch (1788–1863) was not age eighty-five at the time of her death, as the inscription indicates (see *Inscriptions/Marks*

above), nor was she thirteen in 1820. More speculatively, a ca. 1805 date of execution rather than an 1820 one would place the picture within the span of the artist's adolescent years, a time when presumably she would have had more leisure to devote to such pursuits.

[2] Charlotte M. Wiggin, Litchfield Historical Society, to AARFAC, May 14, 1962. The aquatint is now owned by AARFAC (acc. no. 62.1100.1); the Parsons sketch is owned by the Litchfield Historical Society.

[3] The wording is taken from Harry Shaw Newman, Old Print Shop, to AARFAC, December 14, 1960.

Victor Joseph Gatto
(ca. 1890–1965)

The work of Victor Joseph Gatto ranks among the best-known and collected twentieth-century American folk painting, and the artist himself was perhaps as colorful and interesting as his pictures are today.[1] Gatto was already celebrated as a "primitive" artist as early as 1948, when Winthrop Sargeant's rather extensive article on the painter appeared in *Life* magazine.[2] Born in Greenwich Village, New York City, about 1890, Gatto noted that his first drawings were done as a schoolboy when he was eight years old. The artist futher recalled that it was about this time that Theodore Roosevelt visited his classroom and declared that Gatto was "the best drawer" of the group.

Evidently such early encouragement, even from the President of the United States, did not motivate Gatto to pursue a formal artistic career. Instead, he spent much of his adult life working variously as a steamfitter, a professional prizefighter, and a plumber's helper. Financial necessity forced him to take on other odd jobs as a movie extra, dishwasher, and carpenter's assistant.

It was not until 1940 that Gatto began his painting career in earnest, a move that apparently resulted from two events — an injury, incurred while steamfitting pipes, that disabled him; and, soon thereafter, a visit to the semiannual Washington Square outdoor art show in New York City, where his idea to try painting began to take form. According to Winthrop Sargeant, it was about a year later that Mrs. Harry Payne Whitney (Gertrude Vanderbilt), founder of the Whitney Museum, visited one of his sidewalk exhibitions and purchased his painting of wild horses.

By 1943 Gatto's work had come to the attention of the Charles Barzansky Gallery in New York City, where the folk painter began to exhibit on a regular basis. Eventually Gatto concentrated completely on his painting, in fact becoming so obsessed with his creations that he would often work as long as thirty-six hours without interruption. In later years, his eyesight failed, but he continued to paint with the aid of dime-store eyeglasses.

The subjects of his pictures range broadly from notable disaster scenes (no. 8) to memory pictures of events he likely attended, biblical subjects, and various depictions of jungles (no. 7). Gatto was often defensive about his own work, particularly when it was compared to that of other artists. One acquaintance queried him about the pictures of the famous French artist Henri Rousseau, which Gatto had apparently seen at the Museum of Modern Art. His reply was, "I neva hoida da guy. . . . He don't know how to paint noses on lions right."[3]

The New York City artist also feared any accusation that he borrowed ideas from any source for his pictures. He claimed that painters who worked from models were "set-up artists." As for himself, Gatto always maintained that "I paint it all outa my head."[4]

[1] His name has been cited both as Victor Joseph Gatto and Joseph Victor Gatto in previous publications, but the former arrangement is more commonly seen and appears as the artist's signature on nos. 7 and 8.

[2] All biographical information contained in this entry is from Sargeant and Hemphill.

[3] Sargeant, p. 78.

[4] Sargeant, p. 80.

7 **Dark Jungle** 73.101.1

Victor Joseph Gatto
Probably New York City, ca. 1950
Oil on canvas
21½" x 29½" (54.6 cm. x 74.9 cm.)

This jungle painting in the collection at the Folk Art Center is one of several known versions of the same theme that Gatto evidently painted numerous times during the twenty-five years of his career as an artist. Distinguished from the others by a particularly dark-green and lush background of vegetation, the picture includes a lion family, two tigers, and two elephants in the foreground, while two pale-green monkeys sit on a palm tree branch above. A third tiger, barely discernible at first glance, lurks in the deep woods just above the lion group.

Like other works by the artist, *Dark Jungle* is heavily impastoed with foliage and grasses rendered in quick, sure brush strokes. It is simpler in detail than other versions, which usually include a greater number and variety of animals either walking or grazing in open hilly fields against blue skies.[1]

Inscriptions/Marks: Painted in the lower right corner is "Victor Joseph Gatto."
Condition: There is no evidence of any conservation treatment having been performed. Modern replacement 2½-inch splayed frame, painted black.
Provenance: Charles Barzansky Gallery, New York, N.Y.; gift of Mr. and Mrs. John G. Jones, Charlottesville, Va.
Published: "Recent Additions to the Abby Aldrich Rockefeller Folk Collection," *The Newtown Bee* (March 8, 1974), illus. on p. 12.

¹Two of Gatto's jungle pictures of this type are owned by Herbert Waide Hemphill, Jr., and Mr. and Mrs. Elias Getz, all of New York, N.Y.

8 Flood at the Power Dam, 71.102.1
Broad Edge Creek, Pennsylvania

Victor Joseph Gatto
Probably New York City, possibly 1955
Oil on plyboard
11½" x 35" (29.2 cm. x 88.9 cm.)

According to the previous owner, who knew the artist, the "*T.*" following Gatto's signature and date stood for tragedy, an obvious reference to the destructive flood scene depicted. Whether Gatto actually had first-hand knowledge of the event or learned of it through published reports is unknown. Equally questionable is the meaning of the date, "Aug. 1955," since it may refer to the date of the flood, the date of the painting's execution, or both.

While interesting because of its strong horizontal format and the patterns created by the railroad tracks and the swirling water, this picture lacks much of the vibrant coloration and detail seen in Gatto's best work.

Inscriptions/Marks: Painted in the lower left corner is "Victor Joseph Gatto/Aug. 1955 — T."
Condition: There is no evidence of any conservation treatment having been performed. Probably original ¾-inch flat frame, painted black.
Provenance: Sterling Strauser, Stroudsburg, Pa.

7

8

James Austin Graham
(1814/5–1878)

Thanks to extensive newspaper coverage of his trial for a murder charge, many specific details are known about James Austin Graham, although no mention of his artistic ability has been found to date.[1] It has been speculated that some interest in drawing — perhaps even instruction in it — was provided by his older brother, Joseph S., a civil engineer.

The artist was born in 1814 or 1815 in eastern Wythe County, Virginia, in the vicinity of Graham's Forge, the site of an iron-processing enterprise carried on by his uncle, David Graham. James Austin Graham was the fourth of eight children born to John and Mary ("Polly") Crockett Graham. His paternal grandparents had emigrated from County Down, Ireland, about 1770.

Graham attended the Reverend George Painter's School within the present-day boundaries of adjacent Pulaski County. He grew up to be a farmer and exhibited normal mental and emotional patterns until about age twenty-three, when a fall from a horse apparently precipitated an irreversible change to erratic, paranoid behavior and occasional epileptic-like attacks. He never married but continued to farm and conduct normal business activities until the night of March 31, 1855, when he entered Boyd's Hotel in Wytheville and, with his pistol, wounded three men and killed a fourth, William H. Spiller. Testimonies presented during his subsequent trial indicated that Graham was in love with Spiller's daughter, Markham, and that he believed some insult had been offered by Spiller. The wounding of the other men was unintended.

Graham's trial occupied two weeks during October 1855, and nearly two hundred witnesses were examined before Judge A. S. Fulton. Drs. Francis T. Stribling of the Western State Hospital at Staunton, Virginia, and John Minson Galt II, of the Eastern State Hospital at Williamsburg, Virginia, concurred in their opinion that the defendant was insane. Consequently, on October 23, 1855, he was acquitted of the murder charge brought against him. The following November, he was sent to Eastern State Hospital at Williamsburg, and he remained there until his death on March 21, 1878.

A description of Graham published after the shooting states that he was "a man of large frame, about six feet two or three inches high, with black hair, short and rather sandy colored moustache, a good set of teeth, with a laughing, but not a pleasant countenance, when in conversation, and a scar upon either side of the neck a little below the angle of the jaw. Graham usually dresses genteelly, and when he fled, had on a black cloth suit, and a black satin vest."[2] The availability of such specific, personal details contrasts frustratingly with the larger questions that remain unanswered about the inner life of this competent Virginia draftsman.

[1] The vast majority of the information in this entry has been provided by Dr. W. R. Chitwood, who included a summary of Graham's life in his letter to AARFAC of March 23, 1983. Among Chitwood's primary sources were a number of issues of the *Lynchburg Daily Virginian*; those thus far identified by AARFAC staff as containing pertinent information are issues for April 3, 6, and 16, 1855; for October 13, 15, 19, 20, 22, 24, and 25, 1855; and for November 26, 1855. A few minor facts not supplied directly by Chitwood have been taken from one or more of these newspaper accounts.

Biographical information on Graham also appears in Janie Preston Collup French and Zella Armstrong, *Notable Southern Families: The Crockett Family and Connecting Lines*, V (Bristol, Tenn., 1928), p. 73. Graham's exact year of birth is undetermined, and the dates given here are based on the fact that he claimed to be age thirty-five in the 1850 U.S. census report.

[2] *Lynchburg Daily Virginian*, III (April 3, 1855), p. 2.

9 Williamsburg, Va.: South View 56.202.1

James Austin Graham
Williamsburg, Virginia, probably 1859–1862[1]
Pencil on wove paper
11¾" x 65¼" (29.9 cm. x 165.7 cm.)

The artist's fairly accurate perspective indicates that he stood on Eastern State Hospital property in order to create his remarkable panoramic view of Williamsburg. Graham's competency suggests that he may have passed many hours sketching during the nearly twenty-three years he spent as a hospital inmate, but no other works by him are known. The details of his south view of the town of Williamsburg are quite small, but their precision has led architectural historians to identify many structures with assurance.[2]

Inscriptions/Marks: In pencil in script in the lower left corner is "J A Graham." In pencil in block letters in the lower margin is "WILLIAMS BURG, VA.: SOUTH VIEW," followed by the very small letters "A. D."

Condition: Unspecified treatment probably by Christa Gaehde in or about 1956 included replacing a canvas backing with that of a textured Japanese paper, filling losses in the primary support, and providing some image compensation in pencil. In 1979 treatment was administered by P. Morris of the Cooperstown (N.Y.) Graduate Programs for the Conservation of Historic and Artistic Works. This consisted of removing the aforementioned textured Japanese paper backing and a second backing of thick wove paper, along with glue residues. The drawing was separated into its original three pieces (left, 22" wide; center, 11½" wide; and right, 22" wide). These were each given two temporary backings for added strength during cleaning and water baths and bleaching to reduce staining. Both temporary backings were then removed and replaced with fresh backings

9

of Japanese tissue, followed by heavier Japanese etching paper. Support losses were filled, and image losses were inpainted with watercolors. The three separate pieces of the work were joined at the seams with wheat-starch paste and adhered via excess backing paper to a deacidified Japanese paper–covered strainer. Possibly original 1-inch grain painted cyma reversa frame with gilded liner.

Provenance: It appears that the drawing has never left the town it depicts. File notes state that it was presented to John Spencer Charles (1851–1930) of Williamsburg, although it is not known when or by whom.[3] The work then descended to Charles's daughter, Mrs. Hodges M. Christian, thence to her daughter, Mary Wall Christian. Through the intercession of the latter, the piece was acquired by the Colonial Williamsburg Foundation in 1956 from four of Miss Christian's relatives (nieces?): Mrs. R. L. Gilliam, Sr.; Mrs. A. J. Broughton; Mrs. Lelia C. Lawson; and Mrs. Julia C. Comins.

Published: Black, Folk Painting, p. 14, illus. on pp. 14–15.

[1] The appearance of the Wren Building dates this drawing rather accurately, since the two conspicuous Gothic towers on it were added after the structure burned in 1859, and they were not replaced after a second burning in 1862. The building is shown here above the letters "IA" in "WILLIAMS BURG."

[2] Identification of the buildings given has been made through the kind assistance of Paul Buchanan, former Director of Architectural Research for the Colonial Williamsburg Foundation (CWF). Among those that are readily recognizable are a group of Civil War housing, the Wren Building, Brafferton Hall, the President's House of the College of William and Mary, Griffin House, two Eastern State Hospital buildings, Bruton Parish Church, the Greenhow-Repiton Brick Office, the Courthouse of 1770, the Powder Magazine, the Robert Carter Nicholas House (since razed), the Lightfoot House, Cary House (since razed), St. John House (since razed), Tazewell Hall (since moved), and Chiswell House.

[3] S. P. Moorhead to CWF files, August 12, 1947, summarizes a discussion between himself and Mary Wall Christian regarding the drawing. In it, Moorhead states: "She told me [it] is the property of her mother and was made around 1850 by a patient at Eastern State Hospital and presented to her grandfather."

Charles J. Hamilton (1832–after 1880)

Much of what is known about Charles J. Hamilton was researched and published by Frederick Fried in *Artists in Wood* in 1970.[1] It was Fried who discovered that C. J. Hamilton the painter and Charles J. Hamilton the show-figure carver were the same nineteenth-century artist.

Hamilton was born in Philadelphia, Pennsylvania, in 1832. Nothing is known about his early life or training. By 1855 he had apparently gained enough experience in carving to set up his own shop at 423 North Eleventh Street. He moved to number 431 on the same street sometime during the next year, and at the new location he listed himself as a sculptor, a term infrequently used by professional carvers producing show figures. Hamilton and his family made two additional moves during the years he worked in Philadelphia, to 783 Coates Street in 1857 and to 1214 Girard Avenue in 1858. Nothing is known about his immediate family, except that his wife's name was Leila and that they had three children by 1859, presumably the year that the Hamiltons moved to Washington, D.C.

In Washington, Hamilton produced carved figures for tobacconists and other merchants, as documented by a number of surviving sketches by the artist. These watercolor, ink, and pencil renderings show a variety of forms including blacks, Turks, Indians, and Punch figures. They also attest to Hamilton's early skill in drawing and painting. Hamilton was in partnership with Elias W. Hadden, also a carver, during his first six years in Washington. Their shop was located at E Street North, near Thirteenth Street West. What pre-

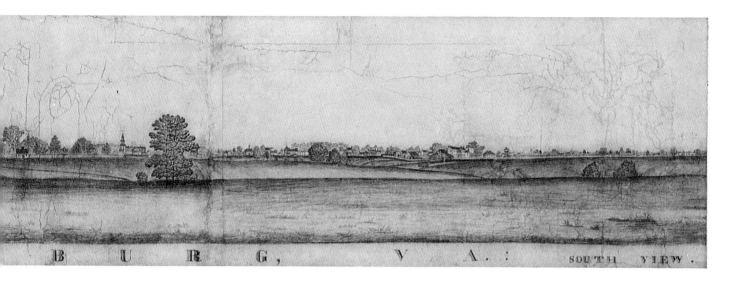

B U R G, V A. : SOUTH VIEW.

cipitated the termination of the partnership is unknown, but by 1865 Hamilton had left the firm.

No details are available about Hamilton's life and work between 1865 and 1872, the year he painted and signed *Charleston Square* (no. 10). The artist probably executed this view in Charleston, South Carolina, where he was living in 1872–1873 at 76 Rutledge Avenue and listed his occupation as painter. Only one other oil painting by Hamilton, a signed still life, has been located.[2] Undoubtedly, other works by him exist and someday will be identified.

Hamilton's whereabouts between 1873 and 1881 still elude scholars. During the latter year, he moved back to Washington and lived at 1536 I Street NW, with either his wife or a daughter named Leila A. Hamilton. His death date and place also remain unknown at this time.

[1]All following information on the artist is from Frederick Fried, *Artists in Wood: American Carvers of Cigar-Store Indians, Show Figures, and Circus Wagons* (New York, 1970), pp. 135–137, unless noted otherwise.

[2]The painting is signed "C. J. Hamilton, artist" and is owned by the Addison Gallery of American Art, Phillips Academy, Andover, Mass.

10 **Charleston Square** 57.101.5

Charles J. Hamilton
Probably Charleston, South Carolina, 1872
Oil on canvas
36⅝″ x 38⅝″ (93.0 cm. x 98.1 cm.)

The central building in Hamilton's view of Charleston Square is the Market, a prominent landmark built in 1841 at the intersection of Meeting and Market streets. This building still stands and now houses a Confederate museum on its main floor, while the space in the arcaded area below continues to be used as a marketplace.

Hamilton recorded in considerable detail a variety of activities associated with mercantile enterprises in Charleston during the 1870s. Black women carrying vegetables in baskets on their heads, a small boy selling papers, food vendors helping their customers, and other descriptive elements abound and give the viewer some idea of the lively street life in Charleston's downtown area.

Given its 1872 execution date, the composition is peculiar in terms of figure arrangement and integration. Most of the people are detached and strung out with little regard for compositional balance. Individually, these figures seem like caricatures and are similar to the sketches for carvings that Hamilton had executed some fifteen years before in Philadelphia. This is especially noticeable in the faces of the black figures at lower left. Establishing a central focal point in *Charleston Square* is difficult because of Hamilton's haphazard placement of the figures and the fact that those at lower left and the horse at lower right are partially outside the picture plane. While the isolated mule cart in the center foreground is a strong diagonal element, it does not lead the viewer's eye completely to the Market building, which is the most prominent element in the picture. Instead, the vignette actually competes with the Market for the viewer's attention.

Despite Hamilton's difficulty in structuring his design, he was able to render three-dimensional forms with some accuracy. His colors are fairly realistic and carefully applied. Architectural elements in complementary shades of browns, ochers, and grays predom-

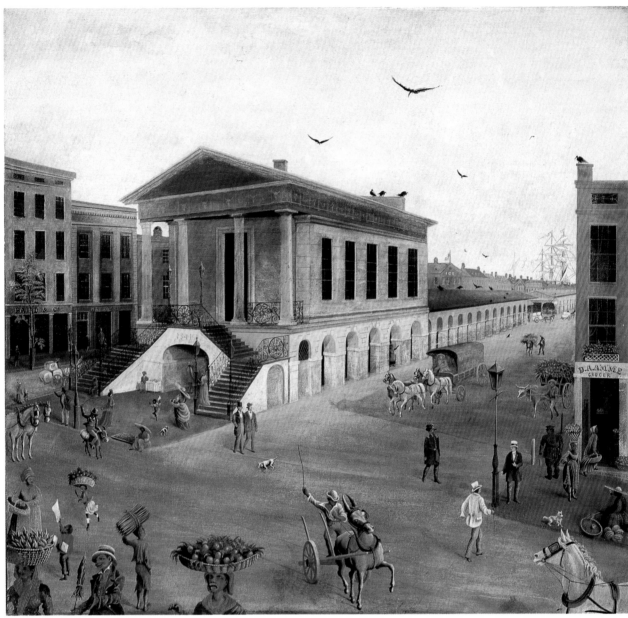

10

inate, but these are relieved by an array of pinks, reds, blues, and greens used for smaller architectural elements and the figures.

Inscriptions/Marks: According to conservator Russell J. Quandt in 1957, an inscription at lower right almost completely hidden by the artist's repaint appears to read: "C. J. Hamilton 1872." The inscription "Market Street/Charleston/ S C/ 1872/ C. J. Hamilton/ Artist" on the reverse of the support is now covered by a lining.

Condition: Restoration by an unidentified conservator prior to acquisition included cleaning, inpainting, and lining. Conservation treatment by Russell J. Quandt in 1957 included cleaning, removing previous inpainting, replacing original stretchers, relining. Mid-nineteenth-century rebuilt 3-inch molded and gilded frame.

Provenance: Mr. and Mrs. John Law Robertson, Scranton, Pa.; M. Knoedler & Co., New York, N.Y.

Exhibited: AARFAC, American Museum in Britain; AARFAC, Minneapolis; AARFAC, June 4, 1962–April 17, 1963; AARFAC, September 15, 1974–July 25, 1976; Artist Sees the City.

Published: American Folk Art, illus. on p. 93; *American Heritage,* XXVIII (February 1977), illus. on back cover; Bishop, illus. as fig. 246 on p. 166; Black, Folk Painting, pp. 14–15; Black and Lipman, p. 98, illus. as fig. 97 on p. 115; Carle E. Schomburg, *Many Americans — One Nation* (Oklahoma City, 1982), illus. on p. 234; T. Harry Williams and the editors of *Life, The Union Restored, 1861–1876,* VI (New York, 1963), illus. on pp. 124–125.

Steve W. Harley
(1863–1947)

Steve Harley is one of those perplexing folk painters whose personal life is well documented, but whose years of artistic development are known by only three oil paintings, two small pencil sketches, and very few references. He was the son of William and Mary Ann Lee Harley and was born in Fremont, Ohio, on December 19, 1863.[1] Only one other child, a son whose name remains unknown, is mentioned in the research materials available.[2]

The date of the Harley family's move to Scottville, Michigan, is also unknown, but this apparently occurred during the 1860s or early 1870s, when Steve was still a child.[3] William Harley owned a farm in Scottville that was later inherited by the artist. Whether the father had other employment is uncertain, but one suspects that he may have been connected with the lucrative lumbering business prevalent in the area during those years. Scholars have traditionally claimed that the artist was witness to the area's extensive timbering boom, which ultimately leveled the western Michigan landscape. Steve Harley's lifelong preoccupation with wilderness camping, trail riding, hunting, and hiking is often considered to have been a nostalgic attempt to reclaim the lush timberlands he saw destroyed during his childhood.

It was probably during the 1880s that Harley inherited the family property in Scottville. Early accounts describe this as a dairy farm with a fruit orchard and indicate that Harley took no interest in its operation.[4] He hired a caretaker for the place and devoted his time to wandering in what remained of Michigan's forest areas. Harley learned taxidermy and ultimately preserved a variety of animals for himself and for friends, and a few were sold for income. Sometime during the late 1880s or 1890s, Harley took a correspondence course in drawing and drafting, but there is no record of the firm or institution that sponsored the course or precisely what instruction was offered. According to his earliest biographer, Robert Lowry, Harley began painting soon after he finished or during the period he was taking the course. His interest in photography may have commenced at the same time.[5]

Early in the 1920s, Harley left Scottville and went to Washington State to visit his brother. A number of factors probably influenced this move, including his desire to see and spend time in the wilderness areas of the American Northwest, his unhappy situation in Scottville (brought on by financial problems and the mortgage of the farm, as well as by Harley's growing addiction to alcohol), and finally his wish to elope with the caretaker's wife. Harley and his female companion traveled to Washington and remained together for several months, but the romantic interlude was short-lived. She returned to Scottville disenchanted with the rigorous camping life, and Harley remained in the Northwest.[6]

During the 1920s, the artist traveled throughout Washington, Oregon, and northern California. He made a trip to Alaska before September 1925, when he had a photograph taken of himself and two camping companions named Joe Hall and C. C. Rice.[7] It was after his return from Alaska to Washington State that Harley painted the three landscape paintings for which he is known today.[8]

The artist returned to Michigan in the early 1930s, bringing with him the three paintings. For some unknown reason, he had stopped painting before leaving the Northwest. One source claims that he suffered from some form of crippling arthritis in his hands, but no mention of this appears in other documents, and Harley's handwriting was still as crisp and precise in the late 1930s as it had been in the 1920s.[9]

Harley had lost the family farm in a mortgage foreclosure some years before he came back to Scottville. With no other source of income, he was forced to rent a shack in town for a few dollars a month and to seek financial aid from the state's Bureau of Old Age Assistance.[10] The bureau initially provided Harley with twenty dollars per month, but this was reduced to eighteen dollars sometime before July 14, 1938. An envelope from the State Welfare Department addressed to Harley on this date bears the following rather indignant, yet private, retort in the artist's neat script:

Owing to advancing Age, God's Agents of adjustment have cut this Assistence from 20. to 18. with the assurance of further Cut as We grow Older figuring Death from Starvation will reach Zero mark[0]? Mich.[11]

Photographs taken of Harley during these late years of his life provide additional evidence of his reduced circumstances. The only bright, cheerful notes apparent in the shack are his three oil paintings, which adorned the walls.

Steve Harley, who once described himself as the Invincible, died in Ludington, Michigan, on November 24, 1947. Causes of death were listed as coronary heart disease and arteriosclerosis. He was buried by the state in an unmarked grave at the Center Riverton Cemetery in Scottville on November 26, 1947.[12]

[1]The parents' names are cited on Harley's Certificate of Death, a copy of which is in AARFAC files.

[2]Lowry, p. 15; Dewhurst and MacDowell, Rainbows, p. 40.

[3]Lowry, p. 12; Dewhurst and MacDowell, Rainbows, p. 40.

[4]Lowry, p. 14.

[5]Ibid., p. 15.

[6]Ibid.

[7]The photograph is in AARFAC files and was acquired in 1957 along with Harley's three paintings and other memorabilia.

[8]Lowry, p. 16.

[9]Ibid.; one example is the inscription in Harley's handwriting on an envelope cited in note 11 below.

[10]Lowry, pp. 16–17.

[11]The envelope and letter are in AARFAC files.

[12]As cited on Harley's Certificate of Death, in AARFAC files.

11 Upper Reaches of Wind River 57.102.3

Steve W. Harley
Near Carson, Washington, 1927
Oil on canvas
21¼″ x 34⅜″ (54.0 cm. x 87.3 cm.)

Steve Harley's knowledge about and interest in the Northwest's wilderness areas are fervently expressed not only in his paintings but also in his miscellaneous notes made during the years in which he traveled and lived amid the rugged, isolated landscape he adored.

Of deer he wrote, "the most beautiful wild animal," and of the canyon area along the Wind River he noted, "Gee, this is a beautiful stretch of country for a drive."[1]

Harley was an intimate, if not intense, observer of nature, attempting to record both its small and large aspects with draftsmanlike precision. His paintings, therefore, appear very realistic and brilliantly executed in delicate, meticulous brushwork. On closer scrutiny, however, one realizes that the overall effect of his work is more idealistic than realistic. Harley's pictures rarely show nature's blemishes. Instead, he depicts the wilderness at its best, with pristine blades of grass and healthy foliage on every living tree. Much of this is the result of his distinctive technique of repeating and overlaying small details, such as leaves, which gives his work an orderly, patterned quality. Where decay is evident, as seen here in leafless sycamore trunks, the emphasis is on impressive coloration of the bark.

Upper Reaches of Wind River was probably the first of the three landscapes executed by the artist since it is the earliest of the two dated examples and represents a location closest to the artist's point of departure. Harley's trek began in Washington, and this is the only painting showing a scene from that state; the two remaining pictures were executed in Oregon, to the south and the east of Wind River. *Upper Reaches*

11

is also different from Harley's other two works in that the scene is closer to the viewer, and small details in the foreground are more highly developed with small details.

Inscriptions/Marks: Written on the reverse of the canvas in blue paint is "Uper Reache of Wind River Wash./14 N. M. E. of Carson, (noted trout streatm)/Cascade Natl, Reserve./Taken July 3, 1927./Painted by S. W. Harley."

Condition: Unspecified conservation treatment by Russell J. Quandt in 1959–1960 probably included cleaning, lining, mounting on new stretchers, and minor inpainting throughout. In 1977 Bruce Etchison reduced buckling in the support by warming and softening the wax and keying out the stretchers. Modern 1-inch wood frame, painted black.

Provenance: Obtained by Robert Lowry from the artist; purchased from an unidentified source by M. Knoedler & Co., New York, N.Y.

Exhibited: AARFAC, American Museum in Britain; American Folk Painters; Amon Carter; U.S. Mission.

Published: Bishop, p. 212, no. 327, illus. on p. 213; Dewhurst and MacDowell, Rainbows, illus. on p. 41; Lipman and Armstrong, illus. on p. 188, Lowry, illus. on pp. 16–17.

[1]These inscriptions in Harley's handwriting appear on two postcards that show scenes of the Northwest. Harley apparently acquired the cards, now in AARFAC research files, during his travels there.

12 South End of Hood River Valley 57.102.2

Steve W. Harley
Near Mount Hood, Oregon, 1927
Oil on canvas
20″ x 33⅜″ (50.8 cm. x 84.8 cm.)

After camping along the Wind River in Washington State, Harley proceeded south to the Hood River valley, where he painted this view about two months later. A snowcapped Mount Hood looms large in the distance, while the center and foreground show a series of rolling hills and neatly sectioned farmlands dotted with red barns and white and yellow houses.

Few details escaped Harley's attention, including the irrigation pipes surrounding a number of the fields. Although not mentioned by the artist in his title inscribed on the back of the picture, the white water at lower right probably represents the Hood River, which traverses this fertile, verdant northwestern valley.

One could hardly call this a wilderness landscape since much of its subject is domestic and related to agrarian pursuits. Except for a dark green stand of forest at center left and the modest scattering of trees across the hills, most of the vegetation represents local field crops and orchards, not unlike the farmlands Harley knew in Michigan. It must have been the prominent view of Mount Hood that intrigued the artist and occasioned the painting.

Inscriptions/Marks: On the reverse in blue paint appears: "South End Hood River Valley, Ore./Mt. Hood in distance, taken/ Aug. 22, 1927./Painted by S. W. Harley."

Condition: Unspecified conservation treatment by Russell J. Quandt in 1959–1961 probably included cleaning, lining, mounting on new stretchers, and minor inpainting throughout. Modern 1-inch molded wood frame, painted black.

Provenance: Obtained by Robert Lowry directly from the artist; purchased from an unidentified source by M. Knoedler & Co., New York, N.Y.

Exhibited: AARFAC, American Museum in Britain; American Folk Painters; Amon Carter; U.S. Mission.

Published: Dewhurst and MacDowell, Rainbows, illus. on p. 41; Donald B. Kuspit, "American Folk Art: The Practical Vision," *Art in America*, LXVIII (September 1980), illus. on p. 95; Lipman and Armstrong, illus. on p. 188; Lowry, illus. on p. 14.

13 Wallowa Lake 57.102.4

Steve W. Harley
Oregon, 1927–1928
Oil on canvas
24¾″ x 36¼″ (62.9 cm. x 92.1 cm.)

Wallowa Lake is probably the last of the three paintings executed by Harley while he was in the mountain and lake areas of Washington and Oregon. It is also the most dramatic of the three in terms of coloration and composition. The usual wealth of detail in Harley's fine brushwork is evident throughout, but here the artist was challenged to record much of his view mirrored in the lake.

Harley's paintings tend to have strong, almost central, focal points, as seen here with the eagle gliding above the lake, with the rushing white water of Wind River emerging out of the middle distance of no. 11, and with Mount Hood rising majestically in the distance in no. 12. With the exception of the eagle, which seems close to being an emblematic device, it is unlikely that these arrangements were contrived by the artist to enhance the impressive imagery of the wilderness he admired. His painting method indicates that he more likely selected a viewing point that approximated or suited the composition he had in mind.

An early account of his life emphasizes that much of his painting was done on site.[1] Harley therefore probably drew and/or painted in most of the major elements of the pictures in the field. His two small pencil sketches of deer contained in the Folk Art Center archives bear a remarkably close resemblance to the animal at extreme lower left and suggest that some of the wildlife shown in *Upper Reaches* and *Wallowa Lake* may have been based on such studies and added later, perhaps while in camp or at his brother's house in Washington State.

It has also been said that Harley worked from

12
13

photographs, particularly during the snowy winter months when on-site painting was impossible.[2] This may have been the case, but there is no evidence at present to support the theory. A few of Harley's photographs exist, but none bears any resemblance to his paintings in either overall composition or detail. Furthermore, all are black and white and would not have provided the artist with any record of the rich colors that typify the places and that account for much of the appeal and realism of his work.

Inscriptions/Marks: On the reverse of the support in red paint appears: "Wallowa Lake in Wallowa Mts.,/Minam Natl., For. Resv. N. E. Ore.,/Painted by S. W. Harley/(The Invincible.)."

Condition: Unspecified conservation treatment by Russell J. Quandt in 1959–1961 probably included cleaning, lining, mounting on new stretchers, and inpainting minor losses throughout. Modern 1-inch wood frame, painted black.

Provenance: Obtained by Robert Lowry directly from the artist; purchased from an unidentified source by M. Knoedler & Co., New York, N.Y.

Exhibited: AARFAC, American Museum in Britain; AARFAC, Minneapolis; AARFAC, South Texas; AARFAC, June 4, 1962–November 20, 1965; AARFAC, September 15, 1974–July 25, 1976; American Folk Painters; Amon Carter; Goethean Gallery; "Rainbows in the Sky: The Folk Art of Michigan in the Twentieth Century," Kresge Art Gallery, Michigan State University, East Lansing, Mich., October 29–December 17, 1978.

Published: AARFAC, 1974, p. 49, no. 42, illus. on p. 46; *Book Preview,* 1966, p. 124, illus. on p. 124; Roger Cardinal, *Primitive Painters* (London, 1978), illus. as pl. 11; Dewhurst and MacDowell, *Rainbows,* illus. on p. 42; Lipman and Armstrong, illus. on p. 187; Lowry, illus. on pp. 12, 13; Howard Rose, "My American Folk Art," *Art in America,* LXX (January 1982), illus. on pp. 124, 125.

[1]Lowry, p. 16.
[2]Ibid.

Anna S. Hart
(active ca. 1870)

14 Landscape with Lake, Tents, 58.102.8
 and Figures

Anna S. Hart
Battle Creek, Michigan, 1870 or possibly 1876
Oil on canvas
15⅛″ x 20¼″ (38.4 cm. x 51.4 cm.)

The somber, dark-hued, towering trees and the sprightly scene below them create vivid contrasts of mood. Note the three different types of tents, the black figure apparently dancing, the woman at right bearing a bough of greens, and the man seated on a stump with a pipe in his hand. The nature of this informal gathering remains unknown. No other works by Anna S. Hart have been recorded, nor have any biographical data been noted to date.

Inscriptions/Marks: In paint in script at lower left is "A. S. Hart/Aug. 1870" (or possibly "1876"). In the center of the top strainer is "Commenced Feb. 6ᵗʰ [illegible material] Anna S. Hart/Battle Creek, Mich."

Condition: In 1976 Bruce Etchison lined the canvas and replaced it on its original strainers, cleaned the painting, and filled and inpainted scattered and very minor losses. Possibly original 2-inch gilded cyma recta frame.

Provenance: J. Stuart Halladay and Herrel George Thomas, Sheffield, Mass.

14

Exhibited: Artists in Aprons; Halladay-Thomas, Hudson Park; "Michigan Folk Art: Its Beginnings to 1941," traveling exhibition organized by the Kresge Art Gallery, Michigan State University, East Lansing, Mich., August 29, 1976–August 31, 1977, and exhibition catalog, p. 40, no. 63.

Published: Dewhurst, MacDowell, and MacDowell, Artists in Aprons, p. 103, illus. as fig. 93 on p. 106.

Joseph Henry Hidley
(1830–1872)

The well-known artist Joseph Henry Hidley was the son of George M. Hidley and Hannah Susanna Simmons Hidley and the great-grandson of John Hidley of Baltmannsweiler, Germany, who was probably the first of his family to immigrate to America, settling initially in Germantown, New York, in 1754. In 1769 the family moved to Greenbush (now North Greenbush) in Rensselaer County, where their children — nine of whom survived childhood — married and became members of the Greenbush and various nearby communities, including Brunswick, Wynantskill, Sand Lake, and ultimately Poestenkill.[1] Most were farmers, and a few were involved in mercantile endeavors. The artist's parents were residing at the Hidley family homestead near Wynantskill when he was born on March 22, 1830.[2] He was the only one of four children born to George and Hannah Hidley to live to adulthood.

The artist's father died when Joseph Henry was four years old, and the next year his mother married William W. Coonradt of Brunswick. Family tradition indicates that the young boy spent the next seven years with his maternal grandparents, Christian and Patience Simmons of Sand Lake. An unidentified source also claimed in the 1950s that Hidley returned in 1841 to the family homestead to live with his grandfather, Michael Hidley.[3] Apparently, the artist moved to Poestenkill before or in 1850, the year that his mother left the area for Monroe County, New York.

In 1853 Joseph Henry Hidley married Caroline Matilda Danforth, the daughter of Lyman and Emeline Kittredge Danforth of Poestenkill. The couple purchased land there during 1853, and the next year set up residence adjacent to the Lutheran church that appears in nos. 16 and 17 and was built in 1865.[4] The couple had five daughters and a son. One child, Emmeline Hidley Hunt, shared information about her father with the New York State Historical Association (Cooperstown) staff in 1950.[5]

The fine quality of Hidley's townscapes and some of his fancy interior architectural paintings suggests that he had training or access to works by other, more accomplished artists, but research in local records has failed to indicate who may have taught Hidley. The only documented references to his professional work are found in two 1870 business directories, where he is listed in one as a house and sign painter and in the other as a taxidermist and painter.[6] His daughter Emmeline also claimed that he made articles of wood and shadow boxes decorated with dried flowers in addition to pursuing taxidermy and painting.[7] There may be some, yet to be discovered, connection between Hidley and the Thomas Wilson who reputedly signed *Eagle Mills, New York* (no. 29), which shows a mill-town crossroads near Poestenkill.[8]

During the relatively short span of Hidley's painting career, from about 1850 until his death, in Poestenkill in 1872, the artist decorated numerous houses in his hometown with grained woodwork and panel pictures of flowers, as well as religious, genre, and allegorical subjects, many of which were probably modeled after published prints.[9] He also painted several portraits of family members. But he is best known for his landscape views of Poestenkill and surrounding towns.[10]

[1]All biographical information on the Hidley family is from "John Hidley of Greenbush, Rensselaer County, New York and His Descendants," an unpublished manuscript compiled by Warren F. Broderick in 1982, Lansingburgh, N.Y., and subsequent correspondence with Broderick, unless noted otherwise.

[2]Thomas N. Armstrong III, AARFAC curator, to Mrs. Lisle Cottrell (Hidley descendant), October 17, 1967. An entry in the West Sand Lake Lutheran Church baptismal records, p. 104, states that Joseph Henry Hidley was born on March 23, 1830, the son of George M. Heidley and Hannah Susan Heidley (*sic*), and was baptised there on July 11, 1830.

[3]Neither of the sources for the two theories regarding where Hidley spent his childhood can be documented by AARFAC correspondence or interview notes with descendants; however, a guardianship bond citing "John M. Hideley [*sic*]," an uncle, and "Michael Hideley [*sic*]," the artist's grandfather, was made out in March 1842; it named "John M. Hideley" of Greenbush as young Joseph's official guardian.

Earlier, in 1835, Philip I. Simmons, the artist's maternal uncle, petitioned for and gained guardianship of Joseph Henry Hidley in the Rensselaer County Court. Warren F. Broderick to AARFAC, 1984.

[4]Rachel W. Cottrell (Hidley descendant) to AARFAC, January 30, 1968. Cottrell's research on the artist revealed a land sales transaction between Nicholas and Sarah Taylor (grantors) and Joseph H. Hidley (grantee) for February 23, 1853, and another for February 22, 1854, whereby the artist acquired a lot of land on which he lived until his death in 1872. It is interesting that Hidley is listed as being from Albia, Rensselaer County, in the 1853 reference.

[5]Emmeline Hidley Hunt furnished the information contained in a letter written by her daughter, Mrs. Carl H. Schermerhorn, to the New York State Historical Association, Cooperstown, N.Y., June 21, 1950. Both Hunt and her daughter are deceased.

[6]Sampson, Davenport and Co., *The New York State Business Directory, 1870, Containing Names, Business and Address of All Merchants, Manufacturers and Professional Men throughout the State* (Boston, 1870), p. 870; Hamilton Child, comp. and pub., *Gazetteer and Business Directory of Rensselaer County, N.Y., for 1870–71* (New York, 1870), p. 187.

15

[7]See note 5 above.

[8]Warren F. Broderick to AARFAC, September 15, 1977. In searching various federal census records, Broderick found a Thomas Wilson listed for Greenbush in 1855, 1865, and 1870 as a painter. Whether this man was the artist responsible for *Eagle Mills* (no. 29) remains speculative.

[9]For a discussion of these, see Thomas N. Armstrong III, "Joseph H. Hidley, His Life and Work" (M.A. thesis, New York University Institute of Fine Arts, n. d.), pp. 4–15.

[10]See note 5 above for source; photographic copies of the portraits, whose locations are now unknown, are in AARFAC research files.

15 Glass Lake, New York 58.102.15

Attributed to Joseph Henry Hidley
Either Glass Lake or Poestenkill, New York,
possibly 1860–1865
Oil on canvas
13⅜″ x 21⅛″ (34.0 cm. x 53.7 cm.)

Glass Lake is about six miles south of Poestenkill and approximately two miles southeast of Sand Lake, another small town in New York State that Hidley frequented and portrayed in landscape views. The two lake towns have been confused by some historians as being the same, but a comparison of the paintings clearly indicates that they were separate, with differing landscape elements and architecture.[1] Also, both mid-nineteenth-century and modern maps show two such locations.

Hidley's characteristic use of deep viridian greens intermingled with varying shades of blue for the far hill, trees, and other vegetation is a prominent feature of this painting since the village is small and nestled in the center of the picture and adjacent to the lake, where various men are fishing and boating. The shape and color of the scattered clouds are not only typical of Hidley's style but also capture the kind of skies known to the region during the warm months of the year. Both the sky and the lush landscape, as well as the architectural renderings, reflect his effort to portray Glass Lake faithfully as it existed in the early 1860s.

The large building at center, near the crossroads, was erected in 1860, but current research findings do not indicate when J. H. Gabler commenced his fishhouse business near or in a portion of the building as recorded on the sign on the side. The less refined brushwork for no. 15 suggests an execution date earlier than those for the Poestenkill views (nos. 16 and 17); however, Hidley's work varied in quality throughout his career, and the dates assigned here remain speculative.

Inscriptions/Marks: Lettered in black paint on the side of the large white building at center and near the crossroads is "Fish House — J. H. Gabler."

Condition: Unspecified conservation treatment by Russell J. Quandt in 1959 included cleaning and filling and inpainting small scattered losses throughout. Probably late-nineteenth-century, 2³/₁₆-inch molded frame, painted black, with gilded liner.

Provenance: The Illings family, Glass Lake, N.Y.; a Dr. Kricker, Glass Lake, N.Y.; a Mr. Woodroof, Glass Lake, N.Y.; A. Leland Lusty, Troy, N.Y.; J. Stuart Halladay and Herrel George Thomas, Sheffield, Mass.[2]

Exhibited: AARFAC, New York, and exhibition catalog, no. 18; Halladay-Thomas, Albany, and exhibition catalog, no. 9; Halladay-Thomas, Hudson Park; Halladay-Thomas, New Britain, and exhibition catalog, no. 44; Halladay-Thomas, Pittsburgh, and exhibition catalog, no. 31; Halladay-Thomas, Syracuse, and exhibition catalog, no. 13; Halladay-Thomas, Whitney, and exhibition catalog, p. 31, no. 31; Pine Manor Junior College; "Selected Masterpieces of New York State Folk Painting," Museum of American Folk Art, New York, N.Y., February 23–May 22, 1977, and exhibition catalog, p. 12, no. 6.

Published: Lipman and Winchester, Primitive Painters, illus. on p. 134.

[1]Compare with *West Sand Lake Village*, attributed to Joseph Henry Hidley, AARFAC, 1974, pp. 49–51, illus. as no. 43 on p. 46.

[2]Interview with Mrs. A. Leland Lusty at AARFAC in 1967 by curator Thomas N. Armstrong III revealed the line of descent. The Illings family owned a house in Glass Lake that subsequently was sold to Dr. Kricker, and then by him to Woodroof. The painting was included as part of the house's furnishings until its purchase by Lusty and subsequent resale to Halladay and Thomas. It is not known whether the picture was installed as an architectural panel in the Illings home, but the possibility exists since Hidley did such work, usually on wood.

16 Poestenkill, New York: Summer 58.102.17

Attributed to Joseph Henry Hidley
Poestenkill, New York, probably 1865–1872
Oil on wood panel
23½" x 22⅛" (59.7 cm. x 56.2 cm.)

This is one of five known views of Poestenkill that Hidley painted during his lifetime, the earliest of which is dated May 10, 1862, and is owned by the New York State Historical Association at Cooperstown.[1] The earliest view differs significantly from no. 16 in both composition and detail, since it was taken from Snake Hill, at the east end of the town. One nearly identical composition showing the town in summer or spring and two winter views (no. 17 is one of these) were composed from a western location.[2] Together, all of the Poestenkill pictures form a remarkable series that documents the physical details and everyday life of the town over a period of about twenty years.

That Hidley's goal was to record in the most meticulous manner the locations and types of buildings and their uses is clear from a thorough study of the paintings along with city directories, other period documents, and the survival of many of the same structures in present-day Poestenkill. A few buildings were destroyed and others erected, while the ownership and function of some buildings changed during the 1860s and early 1870s. For instance, when the New York State Historical Association's version was painted in 1862, the large church in no. 16 at center right had not been constructed.[3]

One of the most interesting aspects of Hidley's approach to townscape painting is seen in this and the next entry. Either intentionally or because of lack of technical skill, Hidley used an unorthodox type of multiple perspective in rendering the town's buildings. There are few common vanishing points, and each structure has been turned so as to give the viewer a fuller pictorial description of its facade. Since these paintings were probably commissioned by townspeople, it was important that each element be accurate and easily identifiable. The elevated viewpoint in each of the Poestenkill pictures also was contrived by the artist and assisted him in achieving his goal, although the detailing and juxtapositions of the buildings, roads, and other elements must have been sketched on site.[4]

The artist's residence, which still stands in Poestenkill, is seen in this and the next view as the house on the far side of the crossroads, at the right corner, across from the large building with a colonnaded porch.[5] According to family tradition, it was in the shed behind this structure that Hidley did his painting and taxidermy work. Although not detailed here, the cemetery where the artist and his family are buried is located on the hillside at left and just above the bridge that crosses the Poestenkill, the stream for which the town was named.

This version of Poestenkill ranks among the artist's finest in terms of overall execution. The radiating clouds in pastel shades of blues, pinks, and yellows were finely developed in a series of small brush strokes blending the colors; Hidley's typical palette of viridian green and soft blues for landscape elements was carefully balanced with the ochers and rich tans used for the banks along the stream and for the roadways.

Condition: In 1959 Russell J. Quandt cleaned the painting, filled small dents in the support, and filled and inpainted small scattered losses throughout. Late-nineteenth-century, 2-inch cyma reversa gilded frame.

Provenance: J. Stuart Halladay and Herrel George Thomas, Sheffield, Mass.

Exhibited: AARFAC, New York, and exhibition catalog, no. 21; American Folk Painters; Halladay-Thomas, Albany, and exhibition catalog, no. 6; Halladay-Thomas, New Britain, and exhibition catalog, no. 104; Halladay-Thomas, Pittsburgh, and exhibition catalog, no. 29; Halladay-Thomas, Syracuse, and exhibition catalog, no. 10; Halladay-Thomas, Whitney, and exhibition catalog, p. 31, no. 30.

Published: AARFAC, 1975, illus. on p. 14; Lipman, Primitive

16

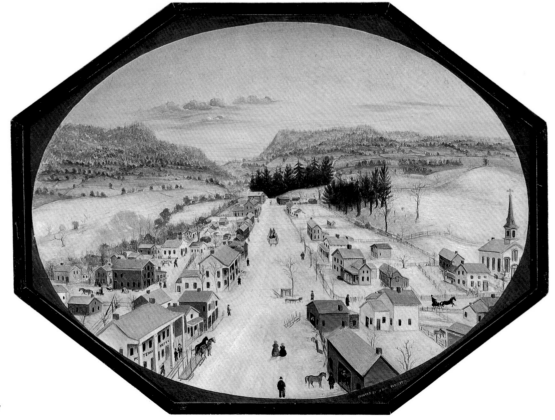

17

Painting, illus. as no. 41; Jean Lipman, "American Townscapes," *Antiques*, XXXXV (December 1944), illus. as fig. 2 on p. 340; Lipman and Armstrong, illus. on p. 100; Lipman and Winchester, Primitive Painters, illus. on p. 133.

[1]The New York State Historical Association's view shows fewer buildings than no. 16, chiefly because it contains more trees in fall foliage within the town and does not view the village from a point in the center of its main street. Scholars have argued that it was actually drawn from Snake Hill and has no contrived elevated viewpoint, but the present-day Snake Hill, which has not been altered in size or topography, does not afford the elevated perspective of the town clearly evidenced in the 1862 picture. This is a critical point deserving further investigation since one theory holds that the lack of the elevated vantage point indicates an early execution date for such paintings. See Thomas N. Armstrong III, "Joseph H. Hidley, His Life and Work" (M.A. thesis, New York University Institute of Fine Arts), pp. 8–11.

[2]Others include no. 17; *Poestenkill, New York*, acc. no. 63.201.5, owned by the Metropolitan Museum of Art, New York, N.Y.; and *Poestenkill, New York — Winter*, in the collection of L. L. Beans (Trenton, N.J.), in 1977, current location unknown. Additionally, a number of lithograph prints published by G. W. Lewis of Albany (ca. 1860–ca. 1870) and after a Hidley painting similar to no. 16 are known, including one example in the Folk Art Center's collections.

[3]The Evangelical Lutheran church shown in no. 16 was built in 1865 and still stands in present-day Poestenkill; information courtesy of Florence Hill, historian, Poestenkill, N.Y., who visited AARFAC on May 8, 1985. The presence of the church in this and similar versions helps in dating the artist's paintings.

[4]See note 1 above. A visit to Poestenkill by AARFAC staff in July 1984 confirmed the existence of a number of structures seen in the Hidley views and that Hidley had carefully recorded their details. It also confirmed that there were no hills in the area sufficiently high enough to afford the kind of perspective Hidley used.

[5]Information courtesy of Florence Hill, historian, Poestenkill, N.Y., who visited AARFAC on May 8, 1985.

17 Poestenkill, New York: Winter 58.102.16

Joseph Henry Hidley
Poestenkill, New York, 1868
Oil on wood panel
18¾" x 25⅜" (47.6 cm. x 64.5 cm.)

Hidley's winter scene of his hometown is distinguished from others by its oval format on an octagonal panel and by the closer range of the view.[1] The third number in the year date is now obscured but must be a six since the Lutheran church seen at right was not built until 1865, and Hidley died in 1872.

The painting affords a better view of the artist's house, which because of its yellow color seems more prominent than most of the other structures surrounding it. Of particular interest are the variety of horse-drawn sledges, the vignette at lower right center that shows a blacksmith shop with a customer and his horse standing before the open door, and a broken wagon partially covered by snow and abandoned just beyond the smithy's shop. Hidley's familiarity with the town and the day-to-day activities of its residents was essential to these scenes, giving them a degree of intimacy and reality that is often missing in the more polished topographical townscapes and cityscapes executed by trained professional artists.

Hidley used his basic palette of colors here but muted them in the far hills to capture the place on a snow-covered, late afternoon winter day. His light source comes from the west and beyond the pale green-blue hills, which are in shadow. His ability to capture the subtleties of changing light in these areas versus the violet-and-blue-tinted hills on the right is noteworthy as one of his best efforts in using color perspective.

Inscriptions/Marks: In white paint on the black border at lower right is "PAINTED BY J. H. H. FEBRUARY 11, 18[6]8." In black paint, the sign on the large white building with a colonnaded porch at lower left is "PO[ES]TENKI[LL] HOTEL."

Condition: Unspecified conservation treatment by Russell J. Quandt in 1959 probably included cleaning, and filling and inpainting scattered losses.

Provenance: Purchased from an unidentified dealer in Troy, N.Y., by A. Leland Lusty, Troy, N.Y., ca. 1940; Clifton Black, location unknown; J. Stuart Halladay and Herrel George Thomas, Sheffield, Mass.[2]

Exhibited: AARFAC, American Museum in Britain; AARFAC, Minneapolis; AARFAC, New York, and exhibition catalog, no. 20; AARFAC, June 4, 1962–April 17, 1963; AARFAC, June 4, 1962–November 20, 1965; American Folk Painters; Artist Sees the City; Flowering of American Folk Art (shown only at the Virginia Museum of Fine Arts, Richmond, Va.); Halladay-Thomas, Albany, and exhibition catalog, no. 7; Halladay-Thomas, New Britain, and exhibition catalog, no. 46; Halladay-Thomas, Pittsburgh, and exhibition catalog, no. 30, illus. opposite nos. 9–12; Halladay-Thomas, Syracuse, and exhibition catalog, no. 11; Halladay-Thomas, Whitney, and exhibition catalog, p. 31, no. 29.

Published: Black and Lipman, illus. as no. 143 on p. 157; Lipman, Primitive Painting, illus. as no. 40; Jean Lipman, "American Townscapes," *Antiques*, XXXXV (December 1944), illus. as fig. 1 on p. 340; Lipman and Armstrong, illus. on p. 101; Lipman and Winchester, Folk Art, illus. as no. 66 on p. 54; Lipman and Winchester, Primitive Painters, illus. on p. 133.

[1]Interview with Mrs. A. Leland Lusty of Troy, N.Y., by Barbara Luck, AARFAC curator, April 26, 1973. Lusty stated that when her husband purchased the painting about 1940 it was larger, with an outside band beyond the black, which was left unpainted. If this information is correct, it suggests that no. 17 was probably installed as an architectural panel in a yet to be identified house.

[2]See note 1 immediately above.

The Baroness Hyde de Neuville
(?–1849)

Anne-Marguerite-Henriette Rouillé de Marigny was born into an aristocratic family in Sancerre, France, at an unknown date.[1] In 1794 she married an ardent supporter of the Bourbon dynasty, Jean-Guillaume

Hyde de Neuville (1776–1857). In 1806 Napoleon exiled the couple because of the baron's unrepentant political views.

Thus the baroness and her husband came to America and traveled in this country from 1807 to 1814. They visited French friends in Delaware and in New York City, where they established the Economical School for the education of French children in exile. Finally they settled on a sheep farm in New Brunswick, New Jersey, remaining there until their return to France in 1814.

With the restoration of Louis XVIII, the baron regained favor in France, and from 1816 to 1822 served as French minister in Washington. Secretary of State John Quincy Adams could not help noting that the baron was an "extremist," but he was a great admirer of the baroness, finding her "a woman of excellent temper, amiable disposition, unexceptionable propriety of demeanor, profuse charity, yet of judicious economy and sound discretion."[2]

Throughout both sojourns in America as well as abroad, the baroness pursued her self-appointed task of recording the scenes around her. In her watercolor drawings, she depicted buildings of architectural and historical interest, scenes of topical note, and the happenings and people of the day that attracted her. On September 12, 1849, she died at Lestang, the couple's country house in the Berry region of France.[3]

[1]Although modern sources usually indicate a birth date of between 1776 and 1779 for the artist, more recent study of her husband's memoirs suggests that she may have been born as early as 1749. (See Richard J. Koke, comp., *American Landscape and Genre Paintings in the New-York Historical Society,* II [New York, 1982], pp. 188–189.)

[2]The statement appears in John Quincy Adams's diary entry for June 2, 1820, as quoted in the *Catalogue of American Portraits in the New-York Historical Society,* II (New Haven, 1974), p. 574.

[3]Information in this entry is taken from the sources indicated in notes 1 and 2 and from Wayne Andrews, "Patience Was Her Reward: The Records of the Baroness Hyde de Neuville," *The Journal of the Archives of American Art,* IV (July 1964), pp. 1–8. Sizable institutional collections of the baroness's works include those of the New York Public Library and the New-York Historical Society, both in New York City.

18 Tomb of Washington at Mount Vernon 31.302.5

Attributed to the Baroness Hyde de Neuville
Mount Vernon, Virginia, 1818
Watercolor, pencil, and ink on wove paper
5 13/16" x 7 3/8" (14.8 cm. x 18.7 cm.)

The watercoloring of this scene is limited to thin washes of brown, contributing to a somber tone in keeping with the subject matter.

The rendering is a good document of the appearance of the original family vault at Mount Vernon prior to relocation of its contents in 1831, when a new

18

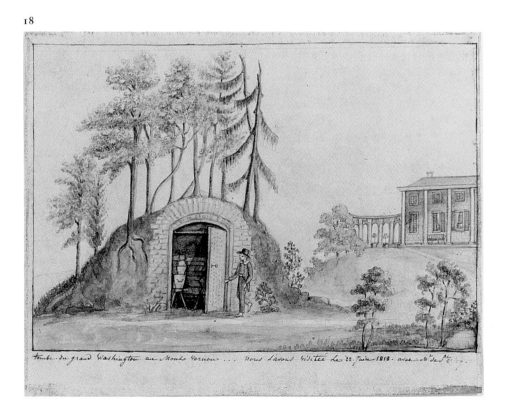

tombe du grand Washington au Mont Vernon ... nous l'avons visitée Le 22 Juin 1818. avec M de N

tomb was constructed several yards southwest of the first site in accordance with the specifications of George Washington's will. The baroness's meticulous drawing is the only known view of the old tomb that shows the interior with its stacked coffins.[1]

The M. da St. Cricy who accompanied the artist to Mount Vernon on June 22, 1818, is known only by the name that the baroness inscribed in the lower margin (see *Inscriptions/Marks*).

Inscriptions/Marks: In ink in the lower margin is "tombe du grand Washington au Monte Vernon . . . nous l'avons visiteé le 22. Juin 1818. avec M [?] da S[t] [?] cricy."
Condition: Unspecified treatment by Christa Gaehde in 1955 included removal of a secondary support and flattening and backing the primary support with Japanese mulberry paper. In 1974 E. Hollyday dry-cleaned unpainted areas of the primary support and hinged same to a modern backing. In 1983 E. Hollyday mechanically removed insect debris, reduced staining and edge ripples, and rehinged the primary support to a modern backing. Period replacement ¾-inch gilded cyma recta frame.
Provenance: De Neuville family member(s), Paris; E. De Vries; I. N. Phelps Stokes, New York, N.Y.; Kennedy & Company, New York, N.Y.; Edith Gregor Halpert, Downtown Gallery, New York, N.Y.[2]
Exhibited: "Baroness Hyde de Neuville: Sketches of America, 1807–1822," Jane Voorhees Zimmerli Art Museum, Rutgers, State University of New Jersey, New Brunswick, N.J., June 10–August 19, 1984, and New-York Historical Society, New York, N.Y., November 8, 1984–March 17, 1985, and exhibition catalog, pp. 29, 36, no. 33, illus. on p. 29; "The Capital Image: Painters in Washington, 1800–1915," National Museum of American Art, Smithsonian Institution, Washington, D.C., October 19, 1983–January 22, 1984; "An Exhibition of Contemporary Drawings of Old New York and American Views," Kennedy & Company, New York, N.Y., April 1–30, 1931, and exhibition catalog, no. 24; Washington County Museum, 1965.
Published: AARFAC, 1957, p. 362, no. 264.

[1]John H. Rhodehamel, Mount Vernon Ladies' Association, to AARFAC, June 3, 1983.
[2]The piece's provenance prior to Halpert is documented by Stokes and Haskell, p. 85, and by the Kennedy & Company exhibition catalog indicated under *Exhibited* above.

Anna Mary Robertson Moses (1860–1961)

Anna Mary Robertson Moses, better known as Grandma Moses, was born September 7, 1860, on a farm in Greenwich, Washington County, New York.[1] She was the third of ten children born to Margaret Shanahan Robertson and Russell King Robertson, a flax mill operator. Anna Mary spent her childhood in this area of New York State.

The opportunities for education were limited, and she spent most of her early years helping with chores on her parents' farm. When she was twelve years old, she left home to work on neighboring farms as a hired

girl. In 1887 she married Thomas Salmon Moses. Shortly thereafter the couple moved to the Shenandoah Valley of Virginia, where they farmed and began raising a family. In 1905, with five surviving of their ten children, the Moseses moved back to New York, to the town of Eagle Bridge, where they operated a dairy farm.

According to her memoirs, Grandma Moses began painting about 1930, after the death of her husband. Sometime later, when she was asked why she began painting, she replied:

Well to tell the truth, I had neuritus and artheritus so bad that I could do but little work, but had to keep busy to pass the time away, I tryed worsted pictures, then tryed oil, and now I paint a great deal of the time, It is a very pleasant Hobby if one does not have to hurry, . . . At first I painted for pleasure. . . . [2]

Her work was first discovered by the New York art collector Louis Caldor, who saw a display of her pictures in a Hoosick Falls drugstore in 1938. By 1940 she had had her first one-woman show at the Galerie St. Etienne in New York City. Hundreds of commissions and shows in this country and abroad followed, as well as numerous awards and presentations.

No one knows precisely how many paintings Moses did before her death at age 101 in 1961. She noted in 1947 that "those that I have kept track of are 1177, but that is not all of them."[3]

[1]All biographical information for this entry is from National Gallery of Art, *Grandma Moses: Anna Mary Robertson Moses (1860–1961)* (Washington, D.C.: National Gallery of Art, 1979.)
[2]Ibid., p. 11.
[3]Ibid., p. 12.

19 Hoosick Falls in Winter 68.101.1

Anna Mary Robertson Moses
Eagle Bridge, New York, ca. 1944
Oil on Masonite
18¹⁄₁₆" x 21¾" (45.9 cm. x 55.2 cm.)

Hoosick Falls is a small town in upper New York State near Eagle Bridge, where Moses lived on a dairy farm. This particular picture is listed in the artist's original journal, which was owned by the late Otto Kallir, a longtime friend of Moses and her most notable biographer.[1] The journal gives the same title and the date December 21, 1944, presumably the day of its sale since a partially illegible price, "30,[?]" follows the title.

Moses's wintertime view of Hoosick Falls combines a rendering of the physical layout of the town

19

and its buildings, which she knew from 1905 to later life, with the bustling, small-town activities she undoubtedly remembered from elsewhere as a child and young woman. Most of the figures wear costumes typical of the late nineteenth century, and the train in the foreground, while lacking in specific detail, also seems similar to nineteenth-century prototypes. Like most of her known pictures, the Hoosick Falls view is filled with small details — children skating, various types of fences and horse-drawn sleds, and numerous small, sticklike people strolling through the snow.

Inscriptions/Marks: Signed in the lower right corner, "Moses."
Condition: This painting was cleaned and various small paint losses along the edges were inpainted at an unspecified date prior to acquisition. Modern replacement 4-inch molded frame, painted a pale gray with a dark gray stripe.
Provenance: Possibly Mrs. Ala Story, New York, N.Y.; probably James Vigeveno Gallery, Los Angeles, Calif.; gift of Mr. and Mrs. George Seaton, Los Angeles, Calif.
Exhibited: AARFAC, September 15, 1974–July 25, 1976; "Art and Life of Grandma Moses," Gallery of Modern Art (now the New York Cultural Center), New York, N.Y., February 20–March 30, 1969; "Grandma Moses: Anna Mary Robertson Moses (1860–1961)," National Gallery of Art, Washington, D.C., February 11–April 1, 1979.
Published: AARFAC, 1974, p. 51, no. 44, illus. as no. 44 on p. 47; National Gallery of Art, *Grandma Moses: Anna Mary Robertson Moses (1860–1961)* (Washington, D.C.: National Gallery of Art, 1979), illus. as no. 13 on p. 20; Otto Kallir, *Art and Life of Grandma Moses* (Cranbury, N.J., 1969), illus. as no. 97 on p. 139.

[1]Otto Kallir to AARFAC, June 18, 1973.

William Matthew Prior
(1806–1873)

William Matthew Prior was born May 16, 1806, in Bath, Maine, the son of sea captain Matthew Prior.[1] Little information survives concerning William Matthew Prior's childhood and youth except for the family legend that, as a small boy, he drew a chalk portrait of his father or grandfather on a barn door, thereby eliciting the admiration of neighbors.[2] Prior's self-acknowledged "first portrait" was executed at age seventeen, but the panel was subsequently cut into smaller sections and overpainted by Prior with landscape scenes that survive, bearing the original inscription fragmented on the versos.[3]

Until recently there has been no evidence of where or from whom Prior might have received his early training; however, the inscription on an 1824 portrait offers a tantalizing tidbit of information: "W. M. Prior, Painter/Formerly of Bath/1824/3 piece on cloth/Painted in C. Codman's Shop/Portland, Maine."[4] Charles Codman was a portrait, landscape, marine, and sign painter who worked in Portland as early as 1823. He may have offered Prior an informal apprenticeship, or he may simply have provided him studio space, as the inscription indicates he did on at least one occasion.

In 1825 young Prior posed with palette and brush in hand for his first self-portrait, rendering it confidently and sensitively in the "academic" style.[5] Although he evidently began painting portraits in 1823, an advertisement in the *Maine Inquirer* dated June 5, 1827, describes only his skills as a fancy, sign, and ornamental painter and decorator. The first recorded mention of Prior as a portrait artist occurs in a *Maine Inquirer* advertisement that appeared February 28, 1828, and ran for some months thereafter: "Portrait painter, Wm. M. Prior, offers his services to the public. Those who wish for a likeness at a reasonable price are invited to call soon. Side views and profiles of children at reduced prices."[6]

Prior's earliest portraits prove that he was capable of painting in a very realistic, polished manner before 1828, and the advertisement offers a preliminary hint of the practice for which he is best remembered today — price adjustment according to the type of work requested by the client. An 1830 notice indicates that his portraits ranged in price from ten to twenty-five dollars, further demonstrating his flexibility in satisfying his customers' needs and simultaneously accommodating their financial limitations. The closing sentence of an April 5, 1831, *Maine Inquirer* advertisement succinctly summarizes his pricing philosophy and describes the works that are perhaps most commonly associated with Prior and other artists who painted in a similar style: "Persons wishing for a flat picture can have a likeness without shade or shadow at one quarter price." Such "flat" portraits are so strongly and popularly linked with Prior's hand that his academic proficiency should be noted in order to keep his abilities in the proper perspective. In the same year that he advertised unshaded likenesses, Prior exhibited a rather accomplished portrait of Abraham Hammatt at the Boston Athenaeum alongside works by some of the most highly respected artists of the day.[7]

Prior seems to have traveled between Bath and Portland in the 1820s. He married Rosamond Clark Hamblin in Bath in 1828, and their first two children were born there, in 1829 and 1831. Prior's brothers-in-law were also painters, and his acquaintance with them developed into an enduring relationship in Portland, where he settled sometime between 1831 and 1834. By 1841 Prior, his family, and his Hamblin in-laws had moved to Boston, and there the artist established himself on a popular level as one of the most versatile and locally influential painters of his day. Prior was listed continuously in Boston business directories from 1841 until he died, in 1873, except for the years 1844–1845, an omission that suggests a period of itinerancy. Later dated and inscribed works show that he traveled and worked in locations as far south as Baltimore on more than one occasion.[8] By 1852 he had established himself at 36 Trenton Street, a location he called the Painting Garret.[9]

As photography continued to encroach on the commissions of many portrait painters, Prior persisted in publicizing his cut-rate category of portraiture as evidenced by a rare printed and partially handwritten label affixed to the back of one of his unshaded likenesses executed about 1848: "PORTRAITS/PAINTED IN THIS STYLE!/Done in about an hour's sitting./Price $2,92, including Frame, Glass, &c./Please call at Trenton Street/East Boston/WM.M.PRIOR."[10] At about the same time, he began to devote more hours to other types of painting. His "fancy pieces," which include historical, imaginary, topographical, and foreign landscape subjects, date from the 1850s.[11] By the 1860s, Prior initiated a series of portraits of famous personages reverse-painted on glass.

The artist also wrote two books as a result of his involvement in the beliefs of William Miller, a chronologist who originated the Adventist movement and prophesied that the second coming of Christ and the end of the world would occur between March 21, 1843, and March 21, 1844. Prior's visionary beliefs enabled him to paint posthumous portraits "by spirit effect," such as the 1865 likeness of his brother Barker, who had been lost at sea with their father in 1815.[12] It is interesting to note that after the artist's death, in Boston on January 21, 1873, his second wife, Hannah Frances Walworth Prior, was described as a clairvoyant in the city directory.

Prior's versatility, productivity, and commercial practices, and the influence he exerted on other artists, make him one of the most interesting subjects in a study of American folk portraitists. Facets of his style and oeuvre are discussed in the following entry.

[1]Much of the biographical information in this entry, including uncited references to advertisements placed by the artist in early newspapers, is from Little, Prior. This entire biographical and notes section first appeared in AARFAC, 1981, pp. 176–177.

[2]Information from an interview with Marion G. Prior, William Matthew Prior's granddaughter, 1975.

[3]The portrait/landscape panels are privately owned.

[4]This privately owned portrait was listed in Parke-Bernet Galleries Inc., *Americana*, catalog for sale no. 3134, December 11–12, 1970, lot no. 116.

[5]The self-portrait is privately owned.

[6]As quoted in Little, Prior, p. 44; Prior's only recorded profile portrait (and only recorded work in watercolor, for that matter) is of a young man, dating to about 1830. It is privately owned.

[7]The portrait of Abraham Hammatt is privately owned. See Introduction to AARFAC, 1981, p. 27 and note 21 on p. 35.

[8]Baltimore works by Prior include a portrait of an unidentified man dated 1852 and a landscape dated 1855, both privately owned.

[9]Prior often used a stenciled or stamped notation on the back of his work at this time; it reads: "Painting Garret/No. 36 Trenton Street/East Boston/W. M. Prior."

20

[10]Little, Prior, p. 45. The label, and the portrait of Nathaniel Todd to which it is affixed, are illustrated in Selina F. Little, "Phases of American Primitive Painting," *Art in America,* XXIX (February 1951), as fig. 2 on p. 8.

[11]Prior's oldest son, Gilbert Stuart Prior, is listed in the Boston directory for 1856 as a landscape painter; he may have collaborated with his father at this point, but ultimately he pursued a career as an engineer, not as a painter.

[12]Barker Prior's portrait is privately owned.

20 Washington's Tomb at Mount Vernon

31.102.2

William Matthew Prior
Boston, Massachusetts, ca. 1855
Oil on canvas
16⅝″ x 25″ (42.2 cm. x 63.5 cm.)

In 1837 the Washington family vault at Mount Vernon, Virginia, was replaced by a tomb, and the formal entranceway depicted by William Matthew Prior in no. 20 was added. The artist S. H. Brooke had sketched the scene in 1838, and in subsequent years, printed versions after his drawing appeared in popular magazines and were sold as individual prints, such as N. Currier's lithograph of 1840. Prior's picture was most likely based on an illustration that appeared in the October 29, 1853, issue of *Gleason's Pictorial.*[1]

Prior probably did a number of these Mount Vernon views, but only one other example, identical in composition to no. 20, has been identified.[2] Both pictures illustrate the stylized, rapid painting technique that Prior consistently employed in landscape painting. Grassy lawns, the distant mountains, and the Potomac River at center right were quickly applied with sweeping, smooth brush strokes; the highlights were worked in while these areas were still wet. The numerous trees and other vegetation were rendered in rapidly applied daubs and dashes of paint to give the effect of foliage, but with no real concern for realistic detail. In fact, Prior may have been using a tool other than a brush to achieve these effects. Some of the leafage on the trees looks more like sponge work than brushwork. The most detailed passages are the dwelling house, Mount Vernon, its outbuildings, and the gate and wall entrance to the tomb at lower left.

Inscriptions/Marks: Stenciled on the reverse of the original canvas support, now lined, is "PAINTING GARRET/NO. 36 Trenton St./ East Boston" and "W M Prior."

Condition: Unspecified restoration by David Rosen during the 1930s probably included cleaning, minor inpainting, and lining. Modern replacement 2¾-inch molded wood frame, painted gold.

Provenance: Edith Gregor Halpert, Downtown Gallery, New York, N.Y.

Exhibited: American Primitives; "Patriotic Folk Art," Yorktown Victory Center, Yorktown, Va., November 19–May 31, 1980; Texas Technological College.

[1]*Gleason's Pictorial,* V, p. 273. No information on the artist S. H. Brooke has been located to date.

[2]The second example was in the collection of Grace Adams Lyman from 1934 to 1956. See *Antiques,* XXVI (November 1934), p. 180; and *Portfolio,* XV (January 1956), p. 116. Its current location is unknown.

Jenny Emily (Merriman?) Snow (active ca. 1850)

Much confusion surrounds the artist credited with one or more of the above names, and efforts to substantiate and clarify the inconsistent references made to her by the previous owners of her paintings have proved fruitless.[1]

Three works now owned by the Folk Art Center were variously ascribed to J. E. Snow, Jenny Emily Snow, and Jenny Merriman Snow when exhibited by J. Stuart Halladay and Herrel George Thomas in the 1940s, and one of them was described as the work of "Miss Emily Snow" in an early letter.[2] No inscriptions have been found on the paintings,[3] and the attributions may rest on family tradition or other verbally relayed information that was not clarified by the time the pictures were acquired by the Center in 1958. A file note and a 1947 newspaper clipping indicate that Halladay and Thomas believed the artist was from Hinsdale, Massachusetts.[4]

The only other information the Center has regarding Snow derives from a letter written by Halladay and Thomas, presumably in the early 1940s. This document indicates that the two of them conferred at that time with a "Miss Shattuck" of either Dalton or Cheshire, Massachusetts, a great-great-niece of the artist.[5] The letter states that "the entire family has been more or less artistically inclined, and a good many years ago, i.e., before the Revolution, they had an artist's colony in Worcester, Massachusetts, headed by one Captain Daniel Merriman, another one of Miss Shattuck's ancestors and whose portrait now hangs in her hall. Miss Shattuck also has a number of . . . paintings done by Miss Snow."

[1]It should be noted that a number of published allusions to Snow stem from Lipman, Primitive Painting, p. 156, which no doubt derives directly from J. Stuart Halladay and Herrel George Thomas; that is, these allusions do not indicate new or additional sources of information. See, for instance, Groce and Wallace, p. 592, which refers to Lipman and Winchester, Primitive Painters, p. 180, which certainly derives from Lipman, Primitive Painting, p. 156. Another repetition of this unverified information appears in J. L. Collins, *Women Artists in America: Eighteenth Century to the Present* (Chattanooga, Tenn., 1973), n.p.

[2]See the catalogs from the following exhibitions: Halladay-Thomas, Albany, nos. 25–26; Halladay-Thomas, New Britain, nos. 6, 11, and 74; and Halladay-Thomas, Syracuse, nos. 15–17. Also, without explanation, dates ascribed to the paintings change from one of these catalogs to another; 1845, 1850, and 1853 variously appear there.

Dated only "June 6" (but probably written in the early 1940s), the letter went from Halladay and Thomas to a Mrs. Keep, an individual who apparently owned *Fairmount Park Waterworks* (no. 21) at that time. AARFAC owns a photocopy of the letter.

[3]However, a photocopy of Halladay-Thomas notes on file at AARFAC states with regard to no. 22: "Signed on back Jenny Merriman Snow

of Hinsdale, Massachusetts 1853." Such an inscription possibly exists, but if so, it has been obliterated by a lining canvas and no further reference to it is known.

[4]The file note is that mentioned in note 3 above. The newspaper article is about Halladay and Thomas and their folk art collection. It appeared on p. 4 of the Pittsfield, Mass., *Berkshire Evening Eagle* for December 11, 1947. It mentions "Jennie [sic] Emily Snow of Hinsdale" and describes her *Belshazzar's Feast* (no. 187) as having been "completed in 1845 when she was 15."

[5]The letter is that mentioned in note 2 above. The Pittsfield, Mass., *Berkshire Evening Eagle* for August 17, 1943, carried an obituary for a Miss Nina W. Shattuck (1865–1943) of Hinsdale, Mass., possibly the woman to whom Halladay and Thomas referred in their letter. The subject of the obituary has been described by Hinsdale historian Leonard F. Swift as the "last descendant of the Snow family." Indeed, the obituary gives Miss Shattuck's mother's maiden name as Jane Snow and describes her as a descendant of the "Merriam [sic]" family. AARFAC files contain a photocopy of the obituary and of a second newspaper reference to this Miss Shattuck.

21 **Fairmount Park Waterworks** 58.102.4

Attributed to Jenny Emily (Merriman?) Snow
Possibly Hinsdale, Massachusetts, possibly ca. 1850
Oil on canvas
28⅛" x 35⅝" (71.4 cm. x 90.5 cm.)

Like at least two other artists, Snow copied William H. Bartlett's engraved view of the waterworks built on the Schuylkill River in Philadelphia.[1] Bartlett's engraving appeared in Nathaniel P. Willis, *American Scenery*, II (London, 1840), opposite page 71, and in at least one later Bartlett publication as well: William H. Bartlett, *The History of the United States of North America*, I (New York, 1856), opposite page 452.

Benjamin Latrobe designed and began building the pumping station shown here in 1799. A source of great pride to Philadelphians, it continued in operation until 1912, when the reservoir on top of the hill was filled to provide a location for the Philadelphia Museum of Art, which was constructed between 1919 and 1928.

Condition: In 1972 Bruce Etchison cleaned the painting; lined the canvas; filled and inpainted numerous scattered areas of paint loss, many of them following the lines of an overall crackle pattern; and replaced the canvas on its original strainers. The 3-inch gilded and molded frame is possibly original but has been extensively repaired.

Provenance: J. Stuart Halladay and Herrel George Thomas, Sheffield, Mass.

Exhibited: "William H. Bartlett and His Imitators," Arnot Art Gallery, Elmira, N.Y., October 23–December 4, 1966, and exhibition catalog, p. 29, no. 32c; Halladay-Thomas, Albany, and exhibition catalog, no. 25 (dated 1845); Halladay-Thomas, New Britain, and exhibition catalog, no. 11 (dated 1845); Halladay-Thomas, Syracuse, and exhibition catalog, no. 16 (dated 1850).

Published: Covered Bridge Topics, XVI (October 1958), illus. on p. 3; A. G. Rud, "One of Nation's Outstanding Collections of

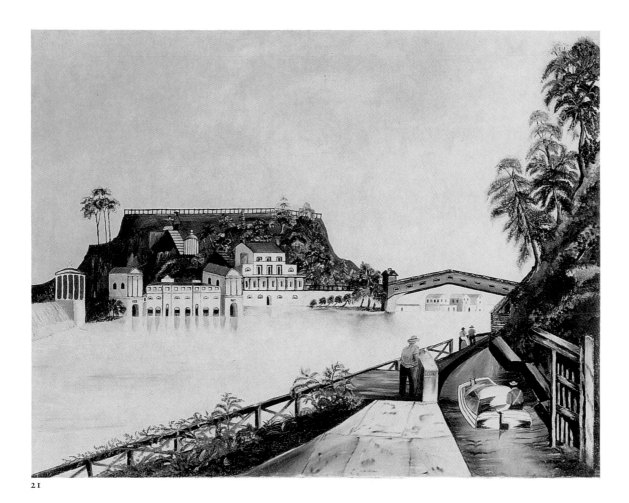

21

Provincials Owned by Sheffield Men," *Berkshire Evening Eagle*, Pittsfield, Mass., December 11, 1947, illus. on p. 4.

[1]A naive watercolor copy of Bartlett's engraving signed by Thomas Tucker and dated 1852 is illustrated in Horace H. F. Jayne, "Tucker Porcelain: Thomas Tucker's Share," *Antiques*, LXXII (September 1957), p. 239. A much more accomplished oil after Bartlett is owned by the Detroit Institute of Arts; it is illustrated in Wolfgang Born, *American Landscape Painting* (New Haven, 1948), fig. 88 on p. 136.

22 Mount Auburn Cemetery 58.102.2

Attributed to Jenny Emily (Merriman?) Snow
Possibly Hinsdale, Massachusetts, possibly 1853
Oil on canvas
28⅛" x 36¼" (71.4 cm. x 92.1 cm.)

This picture's dark tonality and its lugubrious color scheme are in accord with the nature of the subject. Blacks, browns, grays, and dark greens contribute to an air of gloom and oppressiveness built by towering, densely leaved trees and thick, ground-level foliage. Little light penetrates the mournful space of Snow's painting, and one feels that no breath of air stirs there, either.

Yet this interpretation contrasts sharply with what is known of the origins of the actual cemetery in Cambridge, Massachusetts. Mount Auburn was enclosed and consecrated by the Massachusetts Horticultural Society in 1831 as one of the first "rural" or "park" cemeteries to be laid out on a large scale and along a prearranged plan. Effort was made to create a place of natural beauty, which would promote reflection among visitors. In *Mount Auburn Illustrated*, Cornelia Walter wrote: "Rural burial-places are depositories worthy an advanced Christianity; and, as there can be nothing about them to minister to low gratifications, but *everything* to exalt and purify the mind, they are undoubtedly as favorable to morals as to the indulgence of refined taste." The print source used by Snow also appears in Walter's volume.[1] Both the print source and this oil show Forest Pond bordered by Narcissus Path, a particularly noted beauty spot of the park.

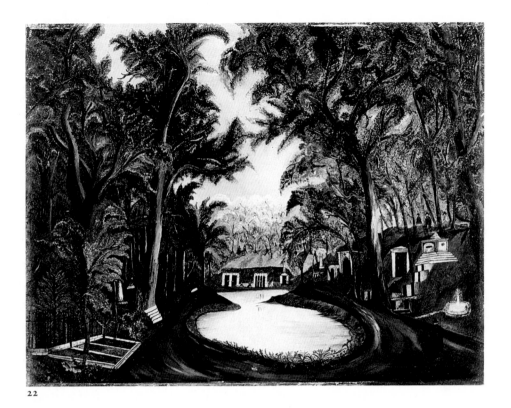

22

Inscriptions/Marks: None apparent at present, but see note 3 of the artist's biography.

Condition: Unspecified treatment by Russell J. Quandt in 1961 and possibly by an unidentified conservator earlier included cleaning, lining the canvas, replacing the auxiliary support, and inpainting a few very minor scattered areas of paint loss. Period replacement 3½-inch gilded molded frame.

Provenance: J. Stuart Halladay and Herrel George Thomas, Sheffield, Mass.

Exhibited: AARFAC, South Texas; Goethean Gallery; Halladay-Thomas, New Britain, and exhibition catalog, no. 6 (titled *Woodlawn Cemetery, New York,* and dated 1845); Halladay-Thomas, Syracuse, and exhibition catalog, no. 15 (titled *Woodlawn Cemetery, N.Y.,* and dated 1853).

[1]The print source, titled *Forest Pond,* appears on p. 94 of Cornelia W. Walter, *Mount Auburn Illustrated in Highly Finished Line Engraving, from Drawings Taken on the Spot, by James Smillie* (New York, 1847). Information beneath the print source indicates that it was "Etched by J. A. Rolph, Drawn & Engraved by J. Smillie," and "Published by R. Martin" in 1847. The text quote given appears on p. 95.

in Fairfax, Vermont, and attended New Hampton Institute, a school that moved from New Hampshire to Fairfax in 1854. Known as Marian, she usually used the signature Marian S. Southard.

After completing her studies at New Hampton Institute, she moved westward to teach in schools in Indiana, Illinois, Ohio, and Wisconsin. She also taught in a school in Connecticut prior to returning to Vermont to marry a widower, Asa M. Forsythe, on September 28, 1875. They lived in North Enosburg, Vermont, where Forsythe was the railroad agent until his death, on August 20, 1887. After her husband's death, she returned to Fairfax and lived with her widowed sister. Marian Southard died November 18, 1916.[1]

[1]Biographical information was provided by the artist's niece (Mrs. E. Frank Cain, Fairfax, Vermont, to Bassett Hall, January 21, 1983).

Sarah Marian Southard (or Southworth) (1833–1916)

Sarah Marian Southard (originally Southworth) was the fifth and youngest child of Jonathan and Samantha Ward Southworth. She was born on April 17, 1833,

23 Mountain Landscape 79.202.1

Sarah Marian Southard (or Southworth)
Fairfax, Vermont, 1854
Pastel on wove sandpaper
14⅝" x 21¾" (37.2 cm. x 55.3 cm.)

The recorded title of this work is not specific, but the landscape of towering cliffs and a vigorous waterfall

23

suggests that the scene may be the Winooski River gorge near Essex, Vermont.[1] Marian Southard probably copied a printed view while attending New Hampton Institute in Fairfax, Vermont. Her use of pastels on sandpaper created a stippled texture similar to that of an engraving.

Inscriptions/Marks: An ink inscription on the verso reads: "M. S. Southard N.H.I./1854 Fairfax, Vt."[2]

Condition: In 1981 E. Hollyday removed an adhered acidic secondary support, mounted the primary support against a non-acidic backing, removed surface dirt, and inpainted with pastels a small abrasion along the left side. Probably original 1-inch molded and gilded frame.

Provenance: Found on Long Island, N.Y.; acquired from Edith Gregor Halpert, Downtown Gallery, New York, N.Y., November 17, 1932, and used at Bassett Hall, the Williamsburg home of Mr. and Mrs. John D. Rockefeller, Jr.

Exhibited: American Folk Art, Traveling.

Published: Cahill, American Folk Art, p. 35, no. 37, illus. on p. 77.

[1]Identification of the scene as the Winooski River gorge near Essex, Vermont, has been suggested by Edmund D. Steele, Treasurer, St. Albans Historical Society, St. Albans, Vermont (writing to Bassett Hall, December 24, 1982).

[2]Affixed to the wooden backboard of this picture is a printed paper label of Arad Evans, a storekeeper in St. Albans, Vermont, from about 1853 until 1865. The label presents a long list of household furnishings, including mahogany and gilt frames; gilt, rosewood, and mahogany moldings for picture frames; and sandpaper. The faded pencil inscription "$14 —— " is barely visible at the left margin of the label. Information about Arad Evans was supplied by Edmund D. Steele, St. Albans Historical Society.

Portia Trenholm (ca. 1813–1892)

Portia Ashe Burden Trenholm was the daughter of Mary Legare Burden and Kinsey Burden and the granddaughter of Thomas Legare of Charleston, South Carolina. Her father was one of the leading developers of sea island cotton and the family ranked among South Carolina's wealthiest during the early nineteenth century.[1]

Portia was apparently an amateur artist who painted for pleasure, since there is no evidence that she had any sort of formal training. Correspondence with her descendants indicates that half a dozen of her pictures survive and range in subject matter from land-

scapes and familiar local scenes to fruit and flower pieces.[2] Her view of the old meetinghouse in Dorchester, South Carolina, done in 1884, is owned by the South Carolina Historical Society in Charleston. Another of Portia's Legareville scenes is owned by the Columbia Historical Society in Columbia, South Carolina.

Her period of painting activity is difficult to ascertain, but existing evidence suggests that she did most of her work in the 1870s and 1880s, well after her marriage to Charles L. Trenholm in 1835.[3] A single published reference to a preliminary pencil sketch of Legareville made in 1852 remains unsubstantiated, since the drawing has not been located.[4]

Portia died in Nashville, Tennessee, on March 23, 1892, according to an inscription on her tombstone in the Magnolia Cemetery in Charleston, South Carolina.

[1]Interview with Mrs. Pierre Bacot Trenholm on July 7, 1973.
[2]Helen B. Muncaster, granddaughter of the artist, to AARFAC, January 17, 1955.
[3]Margaret B. Meriwether, South Caroliniana Library, University of South Carolina in Columbia, to AARFAC, January 15, 1955.
[4]The sketch was listed in 1949 as owned by Bell Burden Walpole. See *The South Carolina Historical and Genealogical Magazine*, L (July 1949), p. 163.

24 Legareville, South Carolina 35.102.1

Portia Trenholm
Probably Charleston, South Carolina, ca. 1875
Oil on canvas
24″ x 46⅞″ (60.9 cm. x 119.1 cm.)

The town of Legareville was situated on John's Island in Charleston County, South Carolina. Trenholm's picture of the place shows its final development as a resort for various wealthy South Carolinians who came there during the summer months to take advantage of the cool sea breezes and escape the heat and malaria-carrying mosquitoes so prevalent inland. Her view shows John's Island at left and James's Island at right. The Stono River is featured in the foreground and Appapoola Creek is visible behind the community and at the end of John's Island.

Legareville was named after the artist's great-grandfather, Soloman Legare, on whose plantation land the community was built and by whom the resort was started. Most of the families who either built homes or visited the island were related to the Legares. The town boasted some twenty-two houses, a store, Episcopal and Presbyterian churches, and a schoolhouse by 1860.[1]

The history of Legareville was short-lived, and today all that remains are a few foundations of houses and wells amid brush, pines, and water oaks.[2] During the Civil War, the Stono River served as an alternate route to Charleston, whereby Union ships could avoid Fort Sumter at the entrance of Charleston Harbor. On December 25, 1863, the USS *Marblehead* attempted the route but was repelled by Confederate troops at Legareville. Continual attempts by Union ships finally forced Major John Jenkins, CSA, to burn the town to avoid capture and encampment there by the enemy. All of the village's buildings were burned on August 20, 1864.[3]

Trenholm's view of Legareville probably was painted after its destruction and probably was based

24

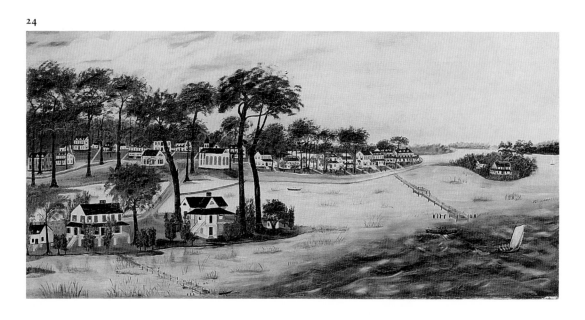

on sketches and her memory of the peaceful, serene little town where she had spent many summers. She incorporated a number of details such as the lattice railing along the dock at right, several small boats with occupants either rowing or sailing, and a variety of architectural features. The artist's concern with capturing the place and invoking the spring or summer season is further enhanced by the various shades of green paint used for foliage and grass, the blue colors of the foreground water, and smaller details such as curtains fluttering in open windows.

Despite Trenholm's inability to render in correct, precise perspective, her *Legareville* is capably painted with the kind of concern for accuracy and ambience that only someone intimate with the subject could express.

Condition: Unspecified conservation treatment by David Rosen before or during 1935 included lining. In 1954 Russell J. Quandt relined, cleaned, and inpainted scattered paint losses throughout. Modern replacement 2¾-inch gilded cyma recta frame.
Provenance: The painting probably descended through the family to Mrs. Y. F. Legare, who reportedly sold it to an unidentified Charleston, S.C., dealer; it was then purchased from the unidentified dealer by Holger Cahill.[4]
Exhibited: AARFAC, Arkansas; AARFAC, September 15, 1974–July 25, 1976; "Art in South Carolina, 1670–1970," Gibbes Art Gallery, Charleston, S.C., April 3–June 21, 1970, Columbia Museum of Art, Columbia, S.C., July 1–September 20, 1970, and Greenville County Museum of Art, Greenville, S.C., October 4–December 31, 1970; Artists in Aprons; Great Ideas, and exhibition catalog, illus. on p. 20.
Published: AARFAC, 1957, p. 32, no. 14, illus. on p. 33; AARFAC, 1974, pp. 47–49, illus. as no. 41 on p. 45; American Folk Art, illus. on p. 92, misidentified as *Southeast View of Greenville, South Carolina;* Francis W. Bilodeau and Mrs. Thomas J. Tobias, comps. and eds., *Art in South Carolina, 1670–1970* (Charleston, S.C., 1970), illus. on p. 150; Holger Cahill, "Artisan and Amateur," *Antiques,* LIX (March 1951), pp. 210–211, illus. on p. 210; Dewhurst, MacDowell, and MacDowell, Artists in Aprons, illus. as fig. 98 on p. 109.

[1]Interview with Mr. and Mrs. Craig M. Bennett, October 9, 1969.

[2]Craig M. Bennett to AARFAC, October 18, 1969.

[3]See note 1 above.

[4]Elinor B. Robinson to William Garnett Chisholm, April 6, 1937.

far the only artwork of his that has been noted other than the Folk Art Center's *South East View of Greenvill[e,] S. C.*[2]

At an unrecorded date, Tucker married Susan L. Morse (b. September 2, 1816), the daughter of Isaac and Miriam Spofford Morse. He traveled south in 1825 and spent the winter of that year teaching at Savannah Academy in Georgia. In Columbia, South Carolina, he was advised to study dentistry by Dr. D. C. Ambler, with whom he practiced in order to gain experience after completing a term of formal training at the Medical College in Charleston. In 1827 he opened his own practice in Sumpterville, South Carolina, and from there he conducted an itinerant practice over a large part of the state. In 1829 he went to Havana, Cuba, where he continued his practice — and also had his portrait painted by Eliab Metcalf (1785–1834).[3] He moved to Boston in 1833 and that same year formed a partnership with Dr. Daniel Harwood. According to his "Reminiscences of Dentistry," their firm was the first in America to produce translucent mineral teeth from quartz and feldspar. Tucker died November 7, 1881, in Winchendon.[4]

[1]November has only thirty days, and it is not known which part of the date is in error. This and some other biographical information in the entry is from AARFAC notes taken from Abijah Perkins Marvin, *History of the Town of Winchendon (Worcester County, Mass.) from the Grant of Ipswich Canada, in 1735, to the Present Time* (Winchendon, Mass., 1868), pp. 369, 462, 473. Marvin's *History* also gives the contradictory information that Joshua's father, Seth, was born January 18, 1760, and died in 1865 at age ninety-eight. Other biographical information in the entry is from Joshua Tucker's "Reminiscences of Dentistry," an unpublished manuscript owned by the Boston Athenaeum.

[2]The portrait of Lafayette is owned by the Museum of Fine Arts, Boston.

[3]Groce and Wallace, pp. 439–440. The portrait is owned by a family descendant. Its appearance is unrecorded at AARFAC, and the ascription to Metcalf is based on information from a second family descendant (private correspondent to AARFAC, after June 22, 1955, and on April 7, 1975).

[4]The death date was provided in Cynthia English, Boston Athenaeum, to AARFAC, March 20, 1985.

Joshua Tucker (1800–1881)

Joshua Tucker was the son of Seth and Jayne Payson Tucker, whose marriage date is recorded as November 31, 1791.[1] He was born in Winchendon, Massachusetts, on August 7, 1800, and trained as a teacher at Hampton Academy in Hampton, New Hampshire. The expertise in penmanship he acquired there is verified by a fine steel-pen portrait of Lafayette, thus

25 South East View of Greenvill[e,] S. C. 40.302.1

Joshua Tucker
Greenville, South Carolina, possibly 1825
Watercolor and ink on wove paper
10⅞" x 16¼" (27.6 cm. x 41.3 cm.)

The small-town view exerts a twofold appeal. Its meticulously executed details render it especially useful as a historical document. At the same time, its visual attraction stems from the vivid color scheme of com-

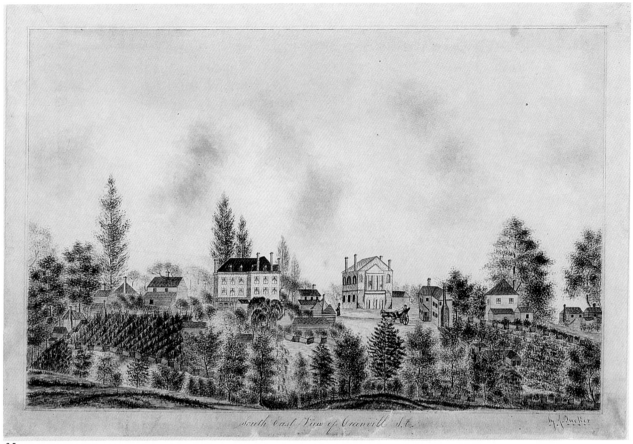

25

plementary warm and cool hues; the rhythm produced by rolling ground and snakelike split-rail fences; and the pleasing contrast between a vast expanse of serene, cloud-studded sky and the fertile, teeming earth below it.

Tucker shows a portion of Greenville's main street bordered by a number of frame edifices and outbuildings and two large structures of brick. The brick building to right of center represents the county courthouse, which was erected between 1820 and 1823.[1] Court sessions were held there until the early 1850s, at which time the building was converted into a repository for county records and thence known as the Record Building. Its design has been attributed to Robert Mills (1781–1855).[2] Diagonally opposite it stood the large brick Mansion House, which was built about 1824 by Colonel William Toney and which served as a well-known hotel when Greenville was a popular resort town.[3] Both these landmark structures were razed in the 1920s.

Inscriptions/Marks: In ink in script in the lower margin is "South East View of Greenvill S. C." and in the lower right corner is "by J. Tucker." In pencil in a different, later script on the reverse of the primary support is "*Joshua Tucker of Boston, Massachusett[s]/drew this picture, 1825." The word "and" is inserted via carat after "Boston" in the preceding. Below this appears "*Grand Uncle of/Arthur A. Shurcliff/of Boston." In still another hand, in ink in the lower right corner of the reverse is "Joshua Tucker — 1825."

Condition: Treatment by Christa Gaehde in 1954 included the removal of adhesive tape, repair of a large tear in the sky at upper left and another through the ground at lower right, fumigation, and cleaning. In 1974 E. Hollyday dry-cleaned where possible, mended tears with Japanese mulberry paper, and hinged the piece to a backboard. Period replacement 1½-inch splayed frame, painted black.

Provenance: Gift of a great-nephew of the artist: Arthur A. Shurcliff, Boston, Mass.

Exhibited: AARFAC, June 4, 1962–April 17, 1963; AARFAC, September 15, 1974–July 25, 1976; "Art in South Carolina, 1670–1970," Gibbes Art Gallery, Charleston, S.C., April 3–June 21, 1970, Columbia Museum of Art, Columbia, S.C., July 1–September 20, 1970, and Greenville County Museum of Art, Greenville, S.C., October 4–December 31, 1970; Washington County Museum, 1965.

Published: AARFAC, 1957, p. 212, no. 108, illus. on p. 213; AARFAC, 1974, p. 41, no. 35, illus. on p. 7; Francis W. Bilodeau and Mrs. Thomas J. Tobias, comps. and eds., *Art in South Carolina, 1670–1970* (Charleston, S.C., 1970), p. 110; Laura Smith Ebaugh, *Bridging the Gap: A Guide to Early Greenville, South Carolina* (Greenville, S.C., 1966), illus. as frontispiece; Mills Lane, *Architecture of the Old South: South Carolina* (Savannah, Ga., 1984), illus. on p. 87; Little, *Country Arts*, pp. 38–39, illus. as fig. 36 on p. 39; Gene Waddell and Rhodri Windsor Liscombe, *Robert Mills's Courthouses & Jails* (Easley, S.C., 1981), p. 9, illus. as fig. 16 on p. 68; Roberta Marshall Wheless and Warren Merereau, eds., *A Greenville*

County Album: A Photographic Retrospective (Greenville, S.C., 1977), illus. as frontispiece.

[1]Unless otherwise noted, information about the buildings is from AARFAC, 1957, p. 212, based on unidentified newspaper clippings of 1924 and 1931 loaned to AARFAC by the Greenville Public Library.
[2]Gene Waddell and Rhodri Windsor Liscombe, *Robert Mills's Courthouses & Jails* (Easley, S.C., 1981).
[3]Charles E. Stow, Greenville Public Library, to AARFAC, July 16, 1955.

E. B. Walker
(active ca. 1835)

26 The Monument of Rev. J. Harvard 79.302.5

E. B. Walker
America, 1828–1850
Watercolor, pencil, and ink on wove paper
10″ x 14¼″ (25.4 cm. x 36.2 cm.)

On September 26, 1828, Harvard College alumni placed a granite marker at the grave of Rev. John Harvard (1607–1638), the principal benefactor of the Massachusetts college that bears his name. Harvard immigrated to Charlestown in 1637, and at his death in 1638, he bequeathed his extensive library and £780 to the new Cambridge seminary.

An unsigned engraving of this Charlestown scene illustrated an article about the monument in *The American Magazine of Useful and Entertaining Knowledge* published in Boston in 1837.[1] The stippled appearance of the vivid blue-green foliage in E. B. Walker's watercolor landscape suggests that the artist was familiar with that engraved view.

Inscriptions/Marks: A title in pencil at the center of the lower margin reads: "The monument of Rev J. Harvard." Signed in pencil at the lower right corner below the image is "E. B. Walker." A plaque on the obelisk at right foreground of the scene is lettered in ink "In memory/of/J. Harvard."
Condition: In 1981 E. Hollyday removed an acidic secondary support, dry-cleaned the surface, set down flaking paint, inpainted with pastel small pigment losses in the foliage at the lower right and in abrasions in the foreground, and backed the primary support with Japanese mulberry paper. Original 1½-inch, mahogany-veneered splayed frame.
Provenance: Found in Waldoboro, Maine; acquired from Edith Gregor Halpert, Downtown Gallery, New York, N.Y., October 3, 1931, and used at Bassett Hall, the Williamsburg home of Mr. and Mrs. John D. Rockefeller, Jr.
Exhibited: American Folk Art, Traveling; "Boston — From 1630 to 1872," Museum of Fine Arts, Boston, Mass., October 27–December 5, 1943.
Published: Cahill, American Folk Art, p. 36, no. 55, illus. on p. 85.

[1]See volume III, number 2, p. 65 (Boston, 1837).

Abigail Warren
(1795–1818)

Abigail Warren was the youngest of three children recorded as having been born to Lieutenant Joseph Warren (ca. 1761–1807) and his wife, Rebecca Spalding Warren (1764–1848), of Chelmsford, Massachusetts.

26

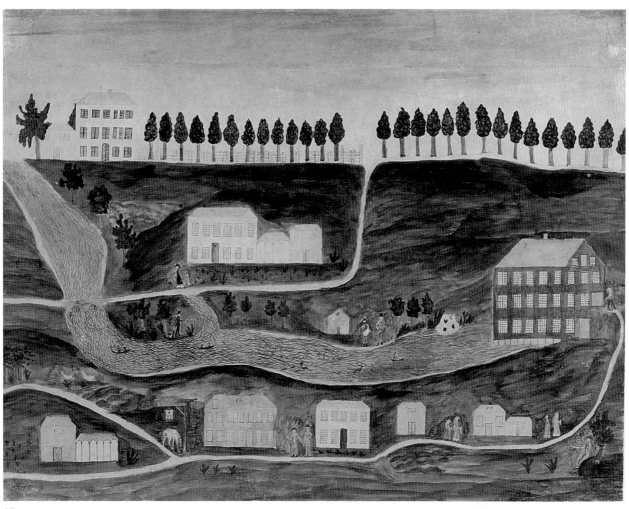

27

The Warrens' eldest daughter, Rebecca (1786–1872), married Aaron Mansur (1776–1859) on December 29, 1807. Their second daughter, Fanny (1791–1872), married Jesse Smith (1781–1848), a "trader," on November 22, 1815. Abigail was born August 11, 1795, and died, apparently unmarried, on June 7, 1818, of "hemerage upon the lungs."[1] No other works by her are known to date.

[1]Mrs. John A. Goodwin to AARFAC, January 2, 1978, included transcriptions providing the data shown here. Her sources were the Vital Records of Chelmsford and the *History of Chelmsford*'s Record of Forefathers' Burying Ground. Abigail's death is noted in the Vital Records, but no record of a grave for her appears in the *History*.

Aaron Mansur was "of Pembroke," according to the Vital Records of Chelmsford, but according to Mrs. Goodwin, all references to him in *Contributions of the Old Residents' Historical Association* (Lowell, Mass., 1874–1896) indicate that he came from Templeton, N.H. Joseph Warren's birth date is given as approximate, based on the fact that he died July 1, 1807, "age 46" (of consumption).

27 Part of the Town of Chelmsford, Massachusetts 57.302.4

Possibly Abigail Warren[1]
Chelmsford, Massachusetts, possibly 1813 or 1814
Watercolor and pencil on wove paper
$15^{11}/_{16}''$ x $20^{1}/_{8}''$ (39.9 cm. x 51.1 cm.)

The amateurish quality of the drawing does not diminish its importance as a rare document of the early appearance of the town of Chelmsford. Indeed, one aspect of this — a flattened perspective — enabled the artist to represent many details that otherwise could not have been included. Moreover, some interesting details are discernible in the crudely executed figures. For instance, the women walking along the road at lower right all wear blue-and-white-checked aprons and all appear to wear some type of flowing headdress. They are approaching the cotton and woolen mill op-

erated by Jonathan Knowles and John Goulding, an enterprise that is said to have employed "about twenty operators (mostly women)."[2] Perhaps they are textile workers who found scarves or other such wraps useful in keeping their hair clean and out of the way of the mill's various mechanisms.

Sundry features of the drawing are numbered and thus correlated to the written description given on the back of the work (see *Inscriptions/Marks*). Abigail Warren lived in Chelmsford Center, about five miles away from the spot shown. However, by 1825 her sister and brother-in-law, Rebecca and Aaron Mansur, lived near the area depicted. Perhaps they were there as early as the date of the drawing, for it appears that their house was situated at or near the spot of the artist's viewpoint.[3]

Inscriptions/Marks: The following inscription is in ink in script on a support that appears to have been used as a backing paper behind the actual picture. Purportedly it duplicates wording inscribed directly on the reverse of the watercolor. This last mentioned verso inscription has been rendered difficult to read by the addition of a Japanese mulberry paper mounting, and the watercolor is at present adhered to a secondary support at all four corners. On the separate backing paper is "Picture painted by/Miss Warren/sister of Mrs. Aaron Mansur, in/1813 or 1814/then, part of the town of Chelmsford, now that/part of Lowell called Belvidere./1. Mr. Gedney's House, afterward occupied by/Judge Livermore, now a part of St. John's Hospital/2. Mr. Brown lived here./3. Cotton Mill carried/on by Mr. Jonathan Knowles and Mr. Golding[,] Mr. K./furnishing the money, Mr. G. managing the works./4. Bridge over the Concord, now East Merrimack St./5. Fish House — 6. Stone — 7. Salmon Fishing/8. Ducks — 9. Geese — 10. Mr. Jonathan Knowles House/where Emmeline was born. 11. Mr. Golding Senior/father of Mr. G. who runs the mill[.] 12. Hotel/kept by/Reuben Butterfield[.] 13. Mr. Golding Jun. and Mr. Jonathan Knowles."[4]

Condition: Treatment by Christa Gaehde in 1958–1959 included removing an old mount; cleaning; filling and inpainting numerous losses and tears, including the upper left and lower right corners and a quarter-size loss near the right corner in the lower edge, a dime-size hole in the lower left corner, a small hole in the left man standing at riverside near middle, an irregular loss through the skirt of the woman at far right, and other, less significant areas; and backing the sheet with Japanese mulberry paper. In 1975 E. Hollyday replaced the mat backboard. Period replacement 2⅜-inch flat mahogany-veneered frame with half-round outer edge.

Provenance: Old Print Shop, New York, N.Y.

Exhibited: "The Landscape of Change: Views of Rural New England, 1790–1865," Old Sturbridge Village, Sturbridge, Mass., February 9–May 16, 1976, and exhibition checklist.

[1] The attribution is based on the lengthy secondary inscription transcribed under *Inscriptions/Marks.* Although both Fanny *and* Abigail would have been called, correctly, "Miss Warren[,] sister of Mrs. Aaron Mansur" in 1813 or 1814, the fact that the inscription on the backing dates from the late nineteenth century predisposes one to favor an attribution to Abigail, since Fanny married a short time after the picture's execution, and Abigail never married. The genealogical research conducted in 1973 by Richard Candee, Old Sturbridge Village, is credited with uncovering the facts needed to identify the artist and her family correctly.

[2] The quote is from Z. E. Stone, "Before the Power Loom...," *Contributions of the Old Residents' Historical Association,* VI (Lowell, Mass., 1896), p. 60. A transcription was provided by Richard Candee, Old Sturbridge Village, to AARFAC, January 16, 1975.

[3] The information provided in this entry has been taken from Mrs. John A. Goodwin to AARFAC, January 2, 1978, and Richard Candee, Old Sturbridge Village, to AARFAC, January 16, 1975. Both writers transcribed and provided with their letters information from a number of sources, some of which are cited in other notes for no. 27 and for the artist's entry. In addition to vol. VI already cited, *Contributions of the Old Residents' Historical Association,* I (Lowell, Mass., 1874), pp. 252–264, contains useful information about the mill shown in the drawing as the building numbered 3; also see Wilkes Allen, *The History of Chelmsford* (Haverhill, Mass., 1820), p. 84. Particularly helpful with regard to the view in general is A. B. Wright, "Lowell in 1826," *Contributions of the Old Residents' Historical Association,* III (Lowell, Mass., 1884), pp. 402–413, 426–433.

[4] Regarding the building numbered 1 in the drawing, Edward St. Loe Livermore (1762–1832) moved to the area upon his retirement, and he purchased the house at upper left from the Gedney family in 1816. Some accounts say he named this house Belvidere, others say the name was applied to a different, new house that he had built. Livermore's newer house was converted into St. John's Hospital in 1867, and his older house was moved and attached to it to form an ell on the main structure. As indicated by the watercolor inscriber, Belvidere eventually became the name for a whole section of the town, including the area depicted (Mrs. John A. Goodwin to AARFAC, January 2, 1978).

The statement made in number 3 is verified in Z. E. Stone, "Before the Power Loom...," *Contributions of the Old Residents' Historical Association,* VI (Lowell, Mass., 1896), p. 60, where it is said that "Mr. Knowles put in the machinery for manufacturing woolen goods — putting his capital against Mr. Goulding's skill as a mechanic and manufacturer." The reference and transcription have been provided by Richard Candee, Old Sturbridge Village, to AARFAC, January 16, 1975.

Susan Whitcomb
(active ca. 1842)

28 **The Residence of Gen.** 31.302.1
 Washington

Susan Whitcomb
Brandon, Vermont, 1842
Watercolor and pencil on heavy wove paper
18″ x 21⅞″ (45.7 cm. x 55.6 cm.)

In the early 1800s, watercolorists often simulated the appearance of embroidery stitches in their work, but as the century progressed and as painting gradually supplanted needlework as the favored fashionable pastime for young women, artists began to discover and exploit the inherent characteristics and technical possibilities of their chosen medium. Whitcomb's watercolor is most unusual in that, despite its mid-century date, it faithfully reproduces the effect of a late-eighteenth- or early-nineteenth-century silk embroidery.

The tiny dots that cover the majority of the painted areas were certainly meant to suggest French

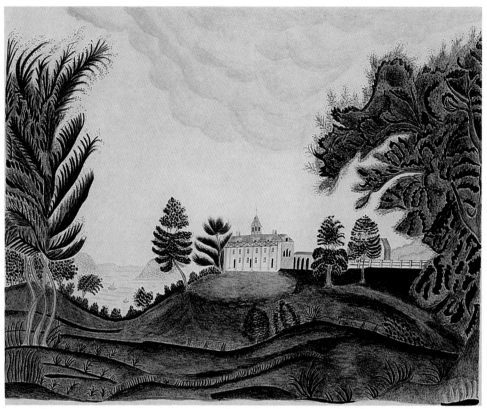

28

knots. Small shrubs and sprouting plants that empha-
size and help delineate rolling contours of land were
often used to give the appearance of spatial depth and
recession in needlework pictures, and the watercolor's
blue, green, and gold-brown color scheme was a fa-
vorite of silk stitchers. The tree at right represents an
even more readily apparent link between the two me-
diums, for it is laid out in erratically shaped areas of
contrasting color, a typical embroidery design to be
filled with satin stitch.

A now unlocated 1816 work may explain Whit-
comb's seeming retrogression. The earlier composition
is quite similar to the Folk Art Center's piece and con-
ceivably may have been used as a model or guide by
Whitcomb. Lovisa Chatterton (1795–1868), who cre-
ated the 1816 piece, later married German Hammond,
and between 1838 and 1846, several of her children
attended the Literary and Scientific Institution at Bran-
don, Vermont, where Susan Whitcomb was a pupil in
1841–1842. The German Hammonds may even have
lived in Brandon at some point, and possibly Whit-
comb had a chance to study and copy the 1816 piece
through her association with one or more members of
that family.[1] At the institution, an extra charge of one
dollar was made for "Drawing or Painting, with use
of patterns."[2]

Inscriptions/Marks: In blue watercolor in the lower margin is
"The residence of Gen. Washington Mt. Vernon Vir./Painted by
Susan Whitcomb at the Lit. Sci. Institution. Brandon Vt. 1842."

Condition: In 1978 E. Hollyday removed wood strips nailed
through the outer margins of the primary support, flattened the
resulting tears, flattened and sized areas of insect damage in the
margins, and dry-cleaned where possible. Probably period replace-
ment 3-inch, mahogany-veneered frame.

Provenance: Found in Boston, Mass., and purchased from
Edith Gregor Halpert, Downtown Gallery, New York, N.Y.

Exhibited: AARFAC, American Museum in Britain; AARFAC,
Minneapolis; AARFAC, South Texas; AARFAC, June 4, 1962–April
17, 1963; American Folk Art, Traveling; Artists in Aprons; Goe-
thean Gallery; Smithsonian, American Primitive Watercolors, and
exhibition catalog, p. 8, no. 32.

Published: AARFAC, 1940, p. 32, no. 121; AARFAC, 1947, p. 29,
no. 121; AARFAC, 1957, p. 140, no. 70, illus. on p. 141; Black and
Lipman, pp. 142–143, illus. as fig. 128 on p. 147; Cahill, American
Folk Art, p. 36, no. 56, illus. on p. 86; Dewhurst, MacDowell, and
MacDowell, Artists in Aprons, p. 65, illus. as fig. 46 on p. 64; Edith
Gaines, ed., "Collectors' Notes," *Antiques,* LXXXIII (March 1963),
p. 325, illus. on p. 324; Lipman, Primitive Painting, illus. as fig. 89
on p. 118; Jean Lipman, "Print to Primitive," *Antiques,* L (July
1946), p. 41; Little, Country Arts, p. 75, illus. as fig. 69 on p. 74;
Francis H. Northrup, "Mount Vernon, Painted in 1816," *Art in
America,* XLV (Fall 1957), p. 77.

[1]The Chatterton work is illustrated, and its connection with Whit-
comb's example is noted, in Francis H. Northrup, "Mount Vernon,
Painted in 1816," *Art in America,* XLV (Fall 1957), p. 77; the
medium of the Chatterton piece is not described therein.

Several errors of a biographical and historical nature in this
Northrup reference were revealed by Philip F. Elwert, Vermont His-
torical Society, to AARFAC, April 2, 1985, which is the source for

such information given here. That the Hammonds may have lived in Brandon is suggested by the statement that German Hammond "was a successful farmer on the old homestead at Pittsford [Vermont], to which he added another farm, but sold both and invested in the iron business at Brandon, Vt., where he met with financial reverses" (Frederick Stam Hammond, *History and Genealogies of the Hammond Families in America*, II [Oneida, N.Y., 1904], pp. 139–140).

[2]The quote is from the *Catalogue of the Corporation, Officers & Students of the Vermont Literary and Scientific Institution: For the Year Ending November, 1842.* AARFAC files contain a copy of the pamphlet, which on p. 9 lists Susan and Elizabeth Whitcomb of Henniker, N.H., in the school's "female department." Except for a student from Quebec, the Whitcombs were the only young women attending the school from out of state at that time. The Board of Instruction listed on p. 4 of the pamphlet shows that Miss Elizabeth Whitcomb, presumably Susan's sister, acted as assistant to the school's preceptress, Miss H. Louisa Briggs.

Elizabeth and Susan Whitcomb may be the same as the girls of those names who were born to Abel and Hannah Hale Whitcomb of Henniker, N.H., on January 10, 1816, and May 11, 1818, respectively. If so, the information that Susan married G[eorge] S. Hamilton of Truro, Mass., may be in error, since that Susan Whitcomb was said to be "of Boston" in the publication of her marriage intention, and she claimed to have been born in Massachusetts in the 1850 census (see Leander W. Cogswell, *History of the Town of Henniker, Merrimack County, New Hampshire*, facsimile of the 1880 edition [Somersworth, N.H., 1973], pp. 776–777; George Ernest Bowman, ed., *Vital Records of the Town of Truro, Massachusetts, to the End of the Year 1849* [Boston, 1933], p. 346; and the U.S. census for 1850 for Truro, Barnstable County, Mass.).

Thomas Wilson
(possibly 1811–possibly 1877)

29 Eagle Mills, New York 58.102.20

Possibly Thomas Wilson
Eagle Mills, New York, 1845
Oil on canvas
35⅞" x 40" (91.1 cm. x 101.6 cm.)

This painting's former owners ascribed *Eagle Mills* to Thomas Wilson and, in one case, stated that it was signed by him.[1] No such signature has been located on the front of the painting, and the reverse is now obscured by lining canvas, leaving confirmation of the inscription's existence unresolved.[2] Albany City directories list one Thomas Wilson, painter, living at 26 Beaver Street as early as 1847–1848;[3] between 1850 and 1855, this artist moved to Greenbush, Rensselaer County.[4] The same Thomas Wilson was listed as a carriage painter from 1870 to 1876.[5] Yet without more explicit evidence, this man's possible authorship of *Eagle Mills* can be neither supported nor refuted.

This painting has been compared to the work of Joseph Henry Hidley. The locale depicted is near Hidley's home of Poestenkill, and both artists utilized bird's-eye views of their landscapes while devoting minute attention to detail. However, technical differ-

ences such as methods of paint application and reliance on linear conceptions distinguish this hand from that of the better-known Rensselaer County artist. The painting's intricate grapevine border indicates a skilled decorative craftsman's work, while the deep pink, blue, and gray hues of the sky — occupying half of the picture plane — give this landscape exceptional color and vitality.

The village was known as Millville when painted. A New York State gazetteer for 1842 described it as having "125 inhabitants, 20 dwelling houses, 1 tavern, 1 store, 1 flouring mill, 1 saw mill and 1 carriage manufactory."[6] The imposing flour mill is obvious. The carriage manufactory was located on the opposite side of the street, beyond the double-barreled covered bridge fording Poestenkill Creek. Examples of its wares can be seen in front of the building.

Tentative evidence describes Edward L. Roberts (1811–1879) as being the Millville resident who commissioned the painting, but no documentation has been found to verify this assertion to date.[7] The house Roberts occupied appears in the far distance and is partially obscured, a somewhat unlikely depiction for inclusion in a town portrait requested by him. Yet Roberts was a carriage painter, at least at one point, and the distinctive decorative qualities of this work certainly would have appealed to him.[8]

Inscriptions/Marks: "1845" appears in black paint in the lower right corner of the front of the canvas. Wording on signs on the mill building include "EAGLE MILL" (twice) and "FLOUR BY THE BARREL" (twice); the "L" and part of the "E" are missing from the end of "BARREL." Also see text regarding the artist's signature.

Condition: Russell J. Quandt's 1958 treatment of the painting included replacing the auxiliary support, lining the canvas, and inpainting small areas in the sky and outer border. The black-painted strips nailed to the sides of the stretchers are modern additions.

Provenance: J. Stuart Halladay and Herrel George Thomas, Sheffield, Mass.

Exhibited: AARFAC, American Museum in Britain; AARFAC, Minneapolis; AARFAC, June 4, 1962–November 20, 1965; AARFAC, September 1968–May 1970; Artist Sees the City; Halladay-Thomas, Albany, and exhibition catalog, no. 11; Halladay-Thomas, Syracuse, and exhibition catalog, no. 2; "Rensselaer County Paintings," Rensselaer County Historical Society, Troy, N.Y., May 12–June 30, 1975.

Published: Black and Lipman, p. 145, illus. as fig. 142 on p. 157; Book Preview, 1966, p. 122, illus. on p. 123; Warren F. Broderick, ed., *Brunswick: A Pictorial History* (Cropseyville, N.Y., 1978), pp. 101 and 120, illus. on cover and on pp. 100–101, 120; "In the Museums," *Antiques*, LXXIII (June 1958), illus. on p. 579; Little, Country Arts, pp. 34–36, illus. as fig. 32 on p. 34.

[1]Two 1949 Halladay-Thomas catalogs, those for their Albany and Syracuse exhibitions, list the artist of the painting as Thomas Wilson, while one of their photographs of the work is inscribed in Thomas's hand: "signed Thomas Wilson."

[2]X-radiography reveals no markings on the reverse, but since only pigments of certain mineral content arrest the passage of these rays, no firm conclusions regarding the existence of a reverse inscription can be drawn from the tests.

[3]Warren F. Broderick to AARFAC, August 24, 1982.

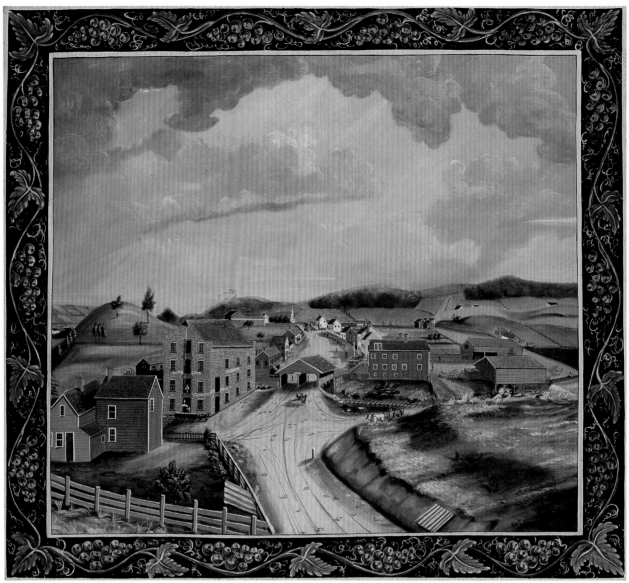

29

[4]Thomas Wilson, "painter," appeared in the 1850 Albany City Directory at 55 Jefferson Street, but the 1855 census reports listed him, again as painter, as living at Greenbush. Other census reports and city directories indicate that Wilson was born about 1811 and died about 1877. Warren F. Broderick to AARFAC, August 24, 1982.

[5]Transcriptions from Albany City directories, as provided by Warren F. Broderick to AARFAC, August 24, 1982.

[6]*A Gazetteer of the State of New-York* (Albany, 1842), p. 249.

[7]AARFAC files contain a man's photograph that presumably was received with Halladay-Thomas records and that is identified as representing "Edward L. Roberts/Millville." Modern script in an unknown hand further identifies this personage as "the man who had the painting of Eagle Mills, N.Y., painted." However, according to Warren F. Broderick to AARFAC, August 26, 1981, no paintings are listed in Roberts's inventory of personal possessions.

[8]Roberts appeared in local business directories as a carriage painter only in 1871; in all other instances, he appeared as a carriage maker or wheelwright, according to Warren F. Broderick to AARFAC, August 26, 1981.

Nicholaus Wirig
(1860–1896)

Nicholaus Wirig was born February 16, 1860, in Alsace-Lorraine, Germany, now a part of France.[1] At an unknown date, he immigrated to America with his parents, John and Elizabeth Wirig, and two brothers and a sister — Henry, Lorenz, and Elizabeth. Photographs of the family still owned by the artist's descendants indicate that Nicholaus was the oldest child.

According to two of Wirig's nieces, he studied at the Art Institute of Chicago, but the extent and nature of any training he received there remains unknown. He married Martha Dour of Chicago at an undeter-

mined date, but probably during the years he was involved in studies at the Art Institute. The couple eventually settled in Rock Island, Illinois, and had at least one child, a son named Emil.

In Rock Island, descendants state that Wirig was a volunteer member of the Wide Awake Hose, Hook and Ladder Company. It is not known whether he was commissioned to paint the large painting featured in no. 30 or whether he donated his artistic services to the fire-fighting company. Other recorded paintings by the artist include floral arrangements, religious subjects, portraits, historical subjects, and a sketchbook of Mississippi River scenes that descended through the family.[2]

[1]All biographical information for this entry is from Madeline R. Edwards, Rock Island, Ill., to AARFAC, December 9, 1977, and June 8, 1983. Part of the information supplied by Edwards was gathered by Marguerite Reidy of Rock Island, Ill., in an interview with Margaret Sikorski and Sister Cecile Marie Bredar, O.S.F., nieces of the artist who were residing in Rock Island in the 1970s.

[2]Two oil paintings, *Columbus Discovering America* (dated 1892 by Wirig) and *Agony in the Garden*, still hang on the second floor of Columbus Hall, St. Mary's School, in Rock Island, Ill.; the sketchbook is now privately owned by the artist's granddaughter; the current locations of the other paintings, which were owned by descendants in the 1970s, are unknown.

30 The Burning of the Opera House 66.101.1

Nicholaus Wirig
Rock Island, Illinois, 1887–1896
Oil on canvas
47¾" x 71⅞" (121.3 cm. x 182.6 cm.)

Until recently this painting was believed to represent the burning of Harper's Opera House in Rock Island, but research gleaned from period city directories and newspapers and through correspondence with local Rock Island historians indicates that such an identification is probably erroneous. Harper's Opera House had a plain brick facade with no columns and did not burn until about 1906–1908;[1] the buildings that stood around the opera house were two stories high or lower, not three and four stories as shown in the painting;[2] an advertisement for the theater, which appeared in the Rock Island *Daily Union* on January 5, 1888, just five days after the date on the painting, indicates that a play titled *Pat's Wardrobe* was in production; finally, there is no mention of an opera house fire in Rock Island newspapers for the date of the painting or before 1887.

30

Wirig was probably inspired by prints of fires and firemen's parades that were published and widely circulated during the 1860s and later, although no specific print has been linked with his picture. Whatever his source, the artist clearly created a spectacular scene that reflects the perils and drama of fire-fighting men. The opera house is fully ablaze, with flames and sparks rising high into the evening sky. Casualties are being removed on stretchers, and two figures dressed like angels, presumably members of the performance, are quickly fleeing the scene. Firemen working with various types of equipment are seen throughout the painting — in the foreground, on the front and right side of the opera house, and on the adjacent left building.

The mottoes of the Wide Awake Hose, Hook and Ladder Company are neatly illustrated and lettered in the upper-right- and left-hand corners on trompe l'oeil banners. Wirig used similar inscription blocks at the left corner, and these, like the motto banners, have either simulated folded, curled, or torn edges. His skill in rendering these motifs is noteworthy.

Inscriptions/Marks: In lettered black paint in the banner at upper left is "THE EYE THAT NEVER WINKS"; in the right upper banner, "THE WING THAT NEVER TIRES"; in the trompe l'oeil paper at lower right is "PAINTED BY/N. Wirig."; above this is "PRESENTED/BY/B. BRAHM & N. WIRIG./THE WIDE Awake/H. H. & L. Co. No. 2/Dec. 31 1887."
Condition: In 1967 treatment by Russell J. Quandt included removing some streaks on the surface left by an unidentified solvent, setting down flaking paint throughout, retouching and filling losses throughout, and strengthening the stretchers. Modern 1¼-inch bolection molded stained frame.
Provenance: David David, Inc., Philadelphia, Pa.
Exhibited: AARFAC, September 15, 1974–July 25, 1976; "Currents of Expansion: Painting in the Midwest, 1820–1940," St. Louis Museum of Art, Mo., February 18–April 10, 1977, and exhibition catalog, illus. as no. 66 on p. 112; "Folk Art of Illinois," a traveling exhibition organized by the Lakeview Museum of Arts and Sciences, Peoria, Ill., November 27, 1981–May 31, 1982.
Published: AARFAC, 1974, p. 57, illus. as no. 55 on p. 58; Bishop, p. 206, no. 315, illus. on p. 207.

[1]Thomas A. Devine, Washington, D.C., to AARFAC, October 7, 1968. Devine contacted Chester C. Thompson, a Rock Island, Illinois, historian who remembered the opera house from childhood visits. A copy of Thompson's September 24, 1968, letter to Devine is also in AARFAC's files.
[2]Ibid.

Unidentified Artists

31 Boston Harbor 62.302.2

Artist unidentified
Possibly Boston, Massachusetts, 1743–1791
Watercolor and ink on laid paper
12⅞" x 14¹/₁₆" (32.7 cm. x 35.7 cm.)

Although there are several distinctions between the two, it is apparent that the primary layout of the Folk Art Center's composition was derived from a detail (specifically the upper right corner) of a third state of an engraved view issued by William Price in 1743 and engraved by John Harris of London after William Burgis's drawing of *A South East View of ye Great Town of Boston in New England in America.* The third state of the print was the first version to include a small view of the Harvard College buildings, with the Meetinghouse of the First Church and surrounding houses, bearing the caption "Cambridge Town & Colleges." These buildings were cut on the upper right corner of the original plate, not formed by separate engravings pasted onto the earlier view.[1] When the Folk Art Center's watercolor was acquired, it was pasted to a page from the Acts of the Massachusetts Legislature dated "Monday 9 o'clock, A. M. March 21, 1791."

Inscriptions/Marks: An illegible inscription in pencil in script appears in the upper left corner in the margin. It appears to begin with the letters "Bel." A partial watermark including the letter *J* appears to be present in the upper left corner.
Condition: In 1975 E. Hollyday removed a secondary support of printed eighteenth-century paper, dried and flattened the primary support, filled losses therein, inpainted these and scattered pigment losses, mended tears with Japanese mulberry paper, backed the sheet with Japanese mulberry paper, and hinged the piece to mat board. Modern replacement 1⅛-inch molded and stained cyma reversa frame with gold painted liner.
Provenance: Old Print Shop, New York, N.Y.
Exhibited: Smithsonian, American Primitive Watercolors, and exhibition catalog, p. 5, no. 13.

[1]Hamilton Vaughan Bail, *Views of Harvard* (Cambridge, Mass., 1949), pp. 40–41. The Henry Francis du Pont Winterthur Museum, Winterthur, Del., owns an impression of the third state of the print.

31

32

32 Landscape with Figures

39.101.1

Artist unidentified
America, ca. 1790
Oil on white cedar panel
21⅛″ x 38½″ (53.7 cm. x 97.8 cm.)

Landscape with Figures is currently installed as an overmantel in one of the Center's first-floor galleries. No physical or documentary evidence has been found to confirm its original usage in such a manner, although paintings of similar quality and horizontal format were frequently hung on, or installed within, the architectural framework above fireplace mantels during the eighteenth and nineteenth centuries. Known as overmantel pictures, they are more commonly called chimneypieces in period advertisements and other documents. Extant examples exist on both wood and canvas supports.

The scene depicted here may have been inspired by or copied from a print source of probable European origin since it relates to conversation pieces popularized by numerous academic painters abroad, including William Hogarth, Johann Zoffany, and Arthur Devis. The European prototype, however, usually included realistic portrayals of family members and friends engaged in one or more leisurely pastimes. A degree of intimacy and careful recording of details in costumes, furnishings, landscape vistas, and other accoutrements generally characterized the small European pictures. By comparison, the faces on these figures seem nondescript and generalized, as does much of the setting. It seems likely that the picture functioned simply as a decorative hanging in imitation of a genre remembered or known from abroad.

Condition: Unspecified conservation treatment by Russell J. Quandt in 1955 probably included cleaning and filling and inpainting scattered losses. Used as an overmantel and set into modern paneling.

Provenance: Purchased from Edith Gregor Halpert, Downtown Gallery, New York, N.Y.
Exhibited: "Origins of American Landscape Painting," Metropolitan Museum of Art, New York, N.Y., October 1952–January 1953.
Published: AARFAC, 1940, p. 20, no. 33, illus. on p. 19; AARFAC, 1947, p. 11, no. 33, illus. on p. 10; AARFAC, 1957, p. 68, no. 35, illus. on p. 69; AARFAC, 1965, illus. as pl. II, n.p.

33 Mt. Vernon 79.302.4

Artist unidentified
America, probably 1804–1810
Watercolor on wove paper
18″ x 24″ (45.7 cm. x 61.0 cm.)

This is the third watercolor acquired by Mrs. John D. Rockefeller, Jr., that was based on the popular Jukes and Robertson aquatint *Mount Vernon in Virginia*.[1] Here the print source provided a point of departure.

33

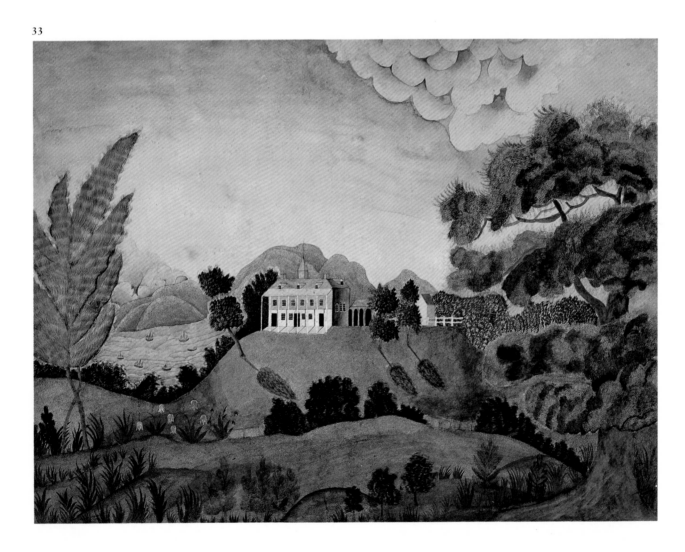

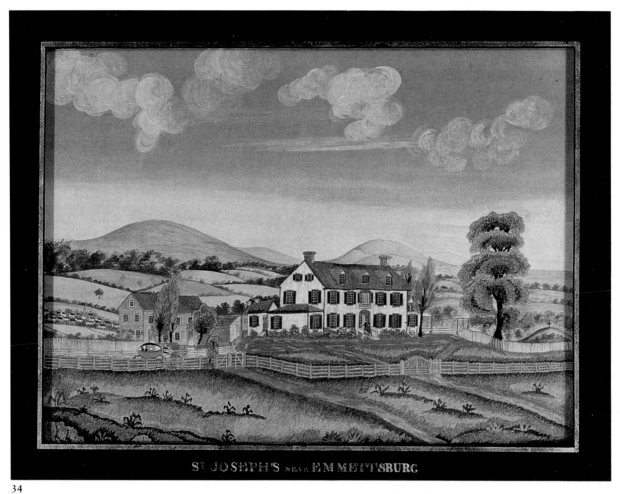

St JOSEPH'S NEAR EMMETTSBURG

34

The watercolor scene with its strong blues and greens and emphasis on rhythmic surface patterns becomes an exciting and imaginative picture in its own right.

The unidentified amateur artist's difficulties with perspective are evident in the distorted architectural features and the relative sizes of the flowers and trees in the foreground. Confusion about the source of light results in shadows for the three trees on the central slope that do not correspond to the shape of the trees and fall almost directly opposite the carefully drawn shadows of the portico columns nearby. Mountains looming behind the house and numerous ships bobbing in the river elaborate upon the engraved source. The artist employed a stippled effect to give the watercolor the texture of an embroidered picture when viewed from a distance.

Inscriptions/Marks: A watermark in the primary support reads: "J WHATM[AN]/1804," probably for the Hollingworths & Balston firm that operated the former Whatman mills until 1806.

Condition: Treatment by E. Hollyday in 1981 included removing an adhered secondary support, dry-cleaning the surface of the primary support, backing it with Japanese mulberry paper, and in-painting small losses in the foreground foliage. Probably original 1½-inch molded and gilded frame.

Provenance: Acquired in May or June 1936 from Katrina Kipper, Accord, Mass., for use at Bassett Hall, the Williamsburg home of Mr. and Mrs. John D. Rockefeller, Jr.

[1]Mrs. Rockefeller had previously acquired *The Residence of Gen. Washington* (no. 28) by Susan Whitcomb and *Mount Vernon in Virginia* by an unidentified artist (not included in this catalog). The aquatint engraving by Francis Jukes (1747–1812) after the drawing by Alexander Robertson (1772–1841) was published in London by Robertson and Jukes on March 31, 1800.

34 St. Joseph's near Emmettsburg 79.602.2

Artist unidentified
Probably Maryland, ca. 1825
Silk embroidery and watercolor on silk
16¼" x 22½" (41.3 cm. x 57.2 cm.)

St. Joseph's Academy in Emmitsburg, Maryland, was established in 1809 as a school for Catholic girls by Elizabeth Ann Bayley Seton (1774–1821). Views of

the school — such as this one of the academy's first building, called St. Joseph's House — were favorite subjects for student needlework projects. The school continued as St. Joseph's College until closing in 1972.[1]

The features of the embroidered foreground combine contrasting textures of smooth silk threads for the house and crinkly chenille silk threads to emphasize the trees and the fence that crosses the lawn. Painted details include the figures of two men in a coach that approaches the house, where two women stand at the entrance. The painted background stretches from the adjacent brick schoolhouse to the town of Emmitsburg, nestled in the valley at left, and to mountains meeting the distant horizon.

Inscriptions/Marks: Painted in gold at the lower center of the black eglomise glass mat is "Sᵗ JOSEPH'S NEAR EMMETTSBURG."

Condition: The primary support mounted on a linen secondary support was placed on a nonacidic backing, and surface dirt was removed by E. Hollyday in 1982. Original 3-inch, scoop-molded, and gilded frame with applied plaster decoration of anthemion leaves along inner edge, rope twist at the center, and applied leaves at midpoints and corners of the outer edge. Original gold-and-black eglomise glass mat.

Provenance: Acquired January 3, 1935, from Arthur J. Sussel, Philadelphia, Pa., for use at Bassett Hall, the Williamsburg home of Mr. and Mrs. John D. Rockefeller, Jr.

Published: Rumford, Bassett Hall, illus. as fig. 5 on p. 58; and Ring, Needlework, illus. as pl. II on p. 476.

[1]An almost identical needlework picture in the collection of the Sisters of Charity, Emmitsburg, Md., was embroidered by Henrietta Virginia Wheeler in 1828 and is illustrated as pl. V on p. 598 in Betty Ring, "Saint Joseph's Academy in Needlework Pictures," *Antiques,* CXIII (March 1978).

35 View of Newburgh 58.102.22

Artist unidentified
America, probably 1830–1845
Oil on canvas
33⅛" x 46" (84.1 cm. x 116.8 cm.)

This painting is clearly based either on William Guy Wall's 1820 watercolor view of Newburgh, New York, or more likely, on a print after Wall. John Hill's engraved rendition, published in 1825 as plate number 14 of the *Hudson River Portfolio,* followed Wall closely, and Hill's work may have served as the unidentified oil painter's model. However, in at least one respect, the oil is compositionally closer to period views of Newburgh transfer-printed on Staffordshire china and also based on Wall; like the oil, the transfer prints incorporate a strong vertical thrust of rock,

35

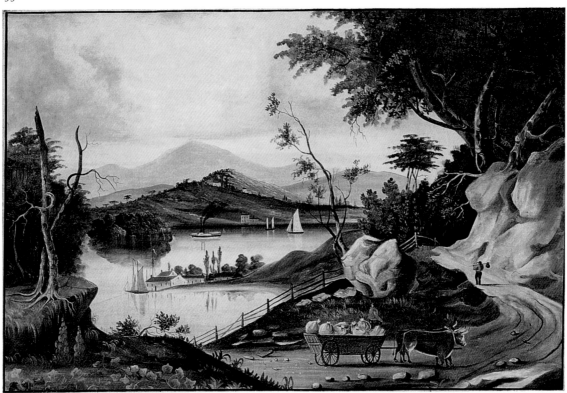

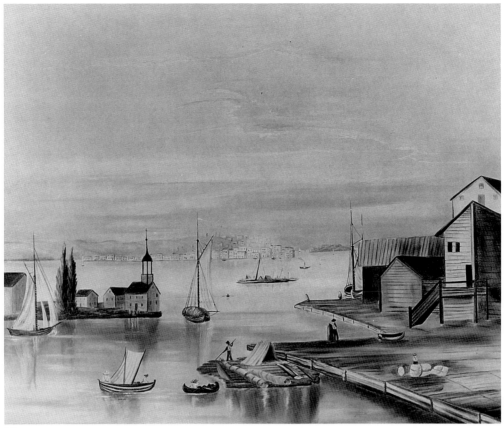

36

earth, and foliage at left foreground, thereby partially enclosing the vista in a tighter, more self-contained format than either Wall's or Hill's depictions, which are open to the left.[1]

Features that are not noted in recorded printed views of the subject and that appear to have been added by the oil painter include the steamboat, towering mountains, and mid-river island. In a further departure, the unidentified artist deleted the town of Newburgh, which in the original and in derivative prints appears on the far shore, just below center in the picture plane.

Newburgh declined when development along the Erie Canal diverted its commercial growth, but establishment of a thriving whaling industry revived it in the 1830s and 1840s. This romanticized scene probably dates from the town's period of renewed vitality.

Condition: The painting was cleaned and patched on the reverse prior to acquisition. Conservation by Russell J. Quandt in 1959 included replacing the stretchers, lining the canvas, and repairing holes at top left in the sky, at center right in the rocks, and a tear at top right in the foliage. The painting was cleaned by trainees in the Graduate Programs for the Conservation of Historic and Artistic Works at Cooperstown, N.Y., in 1978. All three aforementioned treatments included minor inpainting. The 1⅜-inch lath strips

screwed to the outer stretcher edges are painted black and are a modern addition.

Provenance: J. Stuart Halladay and Herrel George Thomas, Sheffield, Mass.

Exhibited: AARFAC, New Canaan.

[1]Wall's work is illustrated in *American Heritage,* X (December 1958), p. 18. Although described therein as "painted in the 1820's," the New-York Historical Society's engraving after Wall by John Hill is titled *View of Newburgh 1820.* A Staffordshire platter transfer-printed with a view of Newburgh after Wall is illustrated in David Arman, *Historical Staffordshire: An Illustrated Checklist* (Danville, Va., 1974), no. 115 on p. 53.

36 View of Prescott from Ogdensburg 58.102.6

Artist unidentified
America, ca. 1850
Oil on canvas
25″ x 30⅜″ (63.5 cm. x 77.2 cm.)

The Canadian town of Prescott, Ontario, situated directly across the Saint Lawrence River from Ogdensburg, New York, is featured in this oil copy after the engraving of the same view by William Bartlett.[1] The unidentified artist, probably an amateur, simplified

the painted composition by eliminating numerous figures appearing in the foreground of the print and by reducing details, such as the rough texture of the wooden buildings, to smooth, rather flat passages of paint. The partial colors of pinks, blues, and greens are well balanced, however, and account for this picture's appeal.

The variety of vessels shown in both the print and the painting, ranging from lateen-rigged sailing ships to log rafts and an early side-wheel steamboat, document the bustling mercantile and pleasure-craft traffic on the Saint Lawrence during the period when it served as the major waterway to the Great Lakes and the North American interior.

37

Inscriptions/Marks: The transcription of an inscription on the original stretcher, now replaced, reads: "View of P[illegible material] from Ogdensburg."
Condition: Conservation treatment by Russell J. Quandt in 1958 included cleaning, lining, mounting on new stretchers, and filling and inpainting minor losses. Probably original mid-nineteenth-century, 4-inch molded wood frame, painted black.
Provenance: J. Stuart Halladay and Herrel George Thomas, Sheffield, Mass.
Exhibited: AARFAC, New York, and exhibition catalog no. 24; Pine Manor Junior College.

[1]The engraving is inscribed: "Prescott from Ogdensburg Harbour/ Wm. Bartlett/J. C. Bentley/ Prescott, Vu du Prot D'Ogdensburg/ Prescott, wie, es sich Ziegt Von Hafen Zu Ogdensburg/London Published for Proprietors by Geo. Virtue 20 Ivy Lane 184." The engraving was widely distributed abroad and in North America in N. P. Willis, *Canadian Views,* I (London, 1840), p. 110. Information courtesy of Mrs. Richard Dillenbeck, Remington Art Museum, to AARFAC, September 13, 1976.

37 Hudson River Scene 58.102.19

Artist unidentified
America, ca. 1850
Oil on wooden keg top
15¾″ diam. (40.0 cm. diam.)

The unidentified folk painter who created this colorful scene used the top of a small wooden keg as a support. Evidence of the support's former use includes a three-quarter-inch area routed out along the back edge and a stenciled blue star. A thin wash of white paint is also apparent on the reverse, as well as a pencil drawing of a house similar to the one at lower right in the picture. The inscription near this, "Kosciusko's Tomb./West Point," appears to have been done at the same time, presumably by the artist, and may denote the subject of the view. Unfortunately, the identity of the scene has yet to be confirmed, and at least one noted scholar of New York views doubts that the inscription and the place shown are the same.[1]

This painting probably reflects the efforts of an amateur artist rather than the more controlled work of a professional folk painter, although both employed similar techniques. William Matthew Prior's *Washington's Tomb at Mount Vernon* (no. 20) is a good example for comparison since his method, though highly refined, approximates what the artist of *Hudson River Scene* was attempting to achieve. Both utilized smooth brush strokes for the sky, grassy areas, and water and offered detailed renderings of buildings and other important features, while they depicted shrubs and foliage in a formularized series of brush strokes or daubs of paint applied with a sponge, a bit of cloth, or some other tool.

Condition: Unspecified conservation treatment by Russell J. Quandt in 1959 probably included cleaning and minor inpainting scattered throughout the picture. Modern 1½-inch circular frame, painted black.
Provenance: J. Stuart Halladay and Herrel George Thomas, Sheffield, Mass.
Exhibited: AARFAC, New York, and exhibition catalog, no. 30; Halladay-Thomas, Albany, and exhibition catalog, no. 76; Halladay-Thomas, Hudson Park; Halladay-Thomas, Syracuse, and exhibition catalog; "Patriotic Folk Art," Yorktown Victory Center, Yorktown, Va., November 19–May 30, 1980, and exhibition catalog, no. 13.
Published: Black and Lipman, p. 145, illus. as fig. 139 on p. 155; Ford, Pictorial Folk Art, illus. on p. 111 (titled *West Point*); John K. Howat, *The Hudson River and Its Painters* (New York, 1972), p. 150, illus. as pl. 35.

[1]Dr. Louis C. Jones, interviews at AARFAC with staff members, April 13–16, 1967.

38 Palisades along the Hudson 60.102.1

Artist unidentified
Probably New England or New York State,
probably 1851–1860
Oil on canvas
27″ x 36″ (68.6 cm. x 91.4 cm.)

The title of this painting was assigned prior to its acquisition by the Folk Art Center in 1960 and may have geographic significance; one nearly identical view signed by the artist Horace Bundy is also referred to as *Palisades along the Hudson*.[1] However, there are more than one hundred other paintings known from the last half of the nineteenth century that bear a close similarity to no. 38 and that carry a variety of other titles.[2] All were copied after engravings based on Jasper Francis Cropsey's celebrated *American Harvesting*.[3]

Cropsey's painting was completed in 1851 and acquired by the American Art Union in New York City. During the same year, James Smillie made an engraving after the painting, and prints from the latter were subsequently published by the Art Union as part of a series distributed in portfolio form to its members.[4] The Smillie version, or perhaps a yet to be identified copy after it, most likely served as the source for no. 38.

Interestingly, many of the known copies have either New York or New England histories, which suggests that artists of Cropsey's reputation who were associated with the Hudson River School were widely known and admired by the general public during their years of activity. Some, if not many, of the copies may have been done as school exercises in both rural and urban areas, as suggested by several examples signed by young women. Two of them, which are especially close in detail to no. 38, were painted in a Salem, New York, academy during the 1850s by Mary Elizabeth Burdick and her school friend, a Miss Goodrich. A third, New England example, was signed by Esther E. Sweet and is dated 1859.[5]

The fine brushwork observed in this version of *Palisades along the Hudson* may indicate that it also was an art exercise whereby the advanced or semi-advanced student was expected to achieve proficiency in copying small details in a careful, precise manner. That a considerable amount of time was devoted to making this a faithful copy is evidenced not only in the meticulous painting technique employed but also in the picture's very strong similarity to the Smillie engraving.

In terms of color, no. 38 remains one of the most appealing of the Folk Art Center's several landscape views executed in the northeastern United States. The

38

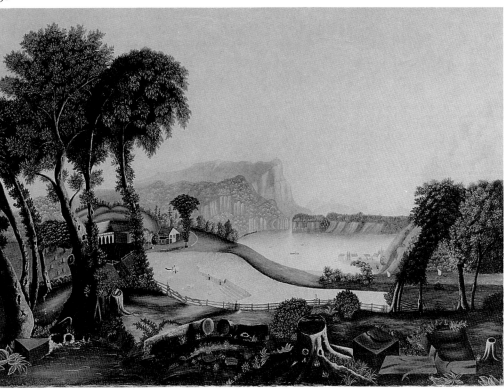

distant background's pastel blue, violet, and pink hues are carefully blended and controlled in equal intensities. These contrast with the middle and foreground greens in various darker, yet complementary colors. The rich yellow-and-ocher haymaking vignette tends to unite these areas visually while drawing attention, again, to the softer colors of the river and its banks in the distance.

Condition: Conservation prior to acquisition performed by an unidentified conservator included surface cleaning and mending two tears in the primary support. Conservation treatment by Bruce Etchison in 1978 included cleaning, lining, and filling and inpainting losses.
Provenance: Old Print Shop, New York, N.Y.
Exhibited: AARFAC, New Jersey; AARFAC, South Texas; American Primitive Art, and exhibition checklist, no. 3; Goethean Gallery; Pine Manor Junior College.

[1]The Bundy painting by this title is privately owned; a similar painting by him, titled *The Blue Mountains,* is owned by the Shelburne Museum, Shelburne, Vt. It is not known when or by whom the title for the latter was assigned.

[2]Some of the other titles include *Rural Landscape, Haymaking, Haymaking on the Hudson,* and *River Landscape.*

[3]Cropsey's *American Harvesting* was completed in 1851 and is owned by the Indiana University Art Museum, a gift of Mrs. Nicholas H. Noyes. Later in the nineteenth century, Currier & Ives offered lithographs based on Cropsey's painting or possibly on an 1851 engraving by James Smillie. The lithograph version differs significantly, however, since details such as the houses, haymakers, and cows are larger. Many of the copy paintings recorded are based on the Currier & Ives print, which does not credit Cropsey as the originator of the scene.

[4]Mary Bartlett Cowdrey, *American Academy of Fine Arts and American Art Union: Exhibition Record 1816–1852* (New York, 1953), p. 98. The exhibition records cite the title as *American Harvesting Scenery.* While no mention is made of the specific location represented in the view, the assumption by scholars over the years has been that this was another of Cropsey's Hudson River scenes.

[5]F. H. Watkins III to AARFAC, 1975–1976, discusses the privately owned Burdick and Goodrich pictures. The Sweet picture, owned from 1959 to 1960 by Vose Galleries in Boston, is currently unlocated.

39 Train on Portage Bridge 58.102.5

Artist unidentified
Possibly New York State, probably 1852–1875
Oil on canvas
33″ x 42″ (83.8 cm. x 106.7 cm.)

The unidentified artist responsible for this view of the Erie Railroad bridge across the Genesee River in New York based the composition on a printed source. Just after the wooden trestle bridge was completed, in August 1852, J. Stilson painted the view.[1] His picture served as the model from which lithographs were made by Compton and Company of Buffalo, New York, beginning in 1852.[2] The printed version was widely distributed, and facsimiles of it appeared in numerous popular magazines such as *Gleason's Pictorial* until the early 1870s. The particular source that inspired the artist for this version of *Train on Portage Bridge* has not been determined.

The railroad structure was acclaimed as the largest wooden bridge in the world at 800 feet in length and 235 feet in height.[3] According to period accounts, leaflets were distributed to passengers on trains as they approached the bridge, announcing that they were about to cross the highest bridge in the world.[4] Officially known as the Portage Bridge, located between the towns of Portage and Castile, New York, it was also touted by the Erie Railroad Company as a "Wonder of the World."[5] It remained in operation until May 6, 1875, when it was destroyed by fire.[6]

The history of the bridge, the proliferation of printed images after its completion and before its destruction in 1875, as well as the materials used by the unidentified artist are, at best, only clues to the date assigned to the painting. Equally unresolved is its provenance, although it is reasonable to suggest a northern locale and perhaps New York State. The stylized treatment of the landscape elements is similar to that observed in other nineteenth-century folk paintings found in, or thought to have been executed in, New York areas (see nos. 37 and 41).

The artist was most interested in capturing the intricate construction of the renowned bridge since it is here, as well as in the passenger train traversing the bridge, that the brushwork is concentrated in small, meticulous details. The rest of the picture, composed of landscape elements and six tiny human figures, was quickly done by first painting large areas of color and then overlaying those with appropriate, but formularized, details.

Condition: Restoration treatment by Russell J. Quandt in 1958 included cleaning, repairing tears located above the train and to the bottom left of the trestle, and inpainting the losses. Period replacement 2⅝-inch, mahogany-veneered frame with a ripple effect that was probably achieved by pressing the wood between dies or through rollers.
Provenance: J. Stuart Halladay and Herrel George Thomas, Sheffield, Mass.
Exhibited: AARFAC, New York, and exhibition catalog, no. 27; AARFAC, South Texas; Goethean Gallery; "The Railroad in American Art," Washington County Museum of Fine Arts, Hagerstown, Md., October 4–November 30, 1968.

[1]No information on the artist J. Stilson has been found except his name as it appears on the lithograph by Compton and Company. AARFAC owns one of the lithograph prints. See also Henry W. Clune and Howard S. Merritt, *The Genesee Country* (Rochester, N.Y., 1976), p. 67.

[2]The firm of Compton and Company in Buffalo, New York, included in 1853, and possibly earlier, James H. Compton and others whose names are unknown; Richard J. Compton, presumably a relative, officially joined the firm in 1855 but may have worked there

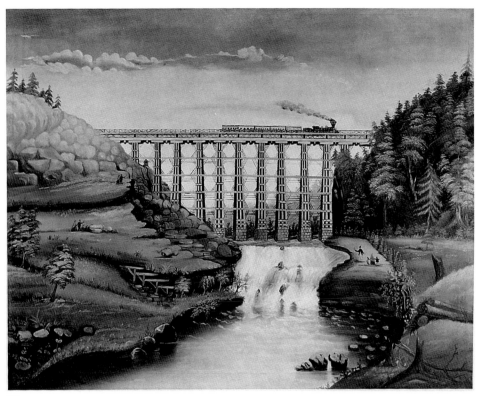

39

as early as 1851, when he was in Buffalo. Both men were lithographers and engravers. See Groce and Wallace, p. 142.

[3]Information supplied by Charles N. Demian, Press Relations Manager of the Erie Railroad Company, 1959, as quoted from an unpublished and undated report by A. M. Knowles, titled "Portage Viaduct Over the Genesee River Gorge, Portage, N.Y.," p. 1.

[4]Sherman Perr, *A Sketch of William Pryor Letchworth* (Castile, N.Y., 1956), p. 1.

[5]See note 3 above.

[6]Ibid.

40 Harpers Ferry 58.102.7

Artist unidentified
America, probably 1857–1865
Oil on canvas
26⅝" x 34½" (67.6 cm. x 87.6 cm.)

This painting is one of several recorded examples based on an undated black-and-white lithograph issued by the firm of Currier & Ives and titled *View of Harpers Ferry, Va.: (From the Potomac Side).*[1] However, the Folk Art Center's work includes a number of compositional details that appear to be original, the most significant of these being the felled tree in the foreground, the sailing vessel near the bend in the river,

and the monument and black-garbed mourning figure at far right.

The work shown here is also notable for its high contrast and garish coloration. In evident portrayal of a vivid sunset, the artist used bright pink to tint not only the horizon, clouds, and distant mountains but also the edges of much of the landscape foliage that normally would have caught the sun's dying rays. Deep shadows further suggest twilight, an hour that echoes the theme of the small mourning vignette.

Harpers Ferry has long been renowned as a spot of natural beauty, but the area attained notoriety of another sort when the abolitionist John Brown seized control of the federal arsenal there in 1859; his subsequent capture, trial, and hanging heightened tensions that led to the Civil War. A smokestack of the armory complex is shown at lower left. The Chesapeake and Ohio Canal and the Baltimore and Ohio Railroad provided important links between East and West via the Ohio Valley and further enhanced the area's importance as a strategic military stronghold during the war. The long covered bridge that runs diagonally across both of them was burned by Confederate forces in 1861. However, since a published image was used as the basis for the composition, the Folk Art Center's unidentified oil painter may well have created this

40

work long after the war's destruction made this particular view outdated.

Condition: Treatment by Russell J. Quandt in 1959 included cleaning, lining, replacing the auxiliary support, and filling and inpainting four punctures and inpainting scattered minor areas of paint loss. Modern replacement 1-inch flat frame, painted black.

Provenance: J. Stuart Halladay and Herrel George Thomas, Sheffield, Mass.

Exhibited: AARFAC, September 1968–May 1970.

[1]An impression of the lithograph is credited to the collections of the Library of Congress in Gale Research Company, comp., *Currier & Ives: A Catalogue Raisonné,* II (Detroit, 1984), p. 707, no. 6908. AARFAC files contain a photograph of the print. According to Groce and Wallace, pp. 159, 342, Nathaniel Currier (1813–1888) and James M. Ives (1824–1895) formed their partnership in 1857, hence the beginning date in the span given for the Folk Art Center's painting that is presumably based on their print. However, it should be noted that AARFAC files contain 1957 correspondence with the private owner of a very similarly composed oil painting that, according to the owner, was executed by a Martha Kent in 1837. No confirmation of this early date had been made yet, and no further information about the artist or the painting is known.

41 Outing on the Hudson 32.101.4

Artist unidentified
Possibly New York State, ca. 1875
Oil on paper mounted on wood panel
18¾" x 24" (47.6 cm. x 61.0 cm.)

This small painting showing ladies, gentlemen, and children enjoying a leisurely excursion along the banks of what is thought to be the Hudson River illustrates a type of landscape painting popularized in mid-nineteenth-century America. The town in the background at left may represent Hudson, although no documentation has been discovered to confirm its identification as such. The picture was found in Woodstock, Ulster County, New York, which accounts for its association with the Hudson River area.

Among the most interesting details recorded are the variety of sailing ships and steamships and the

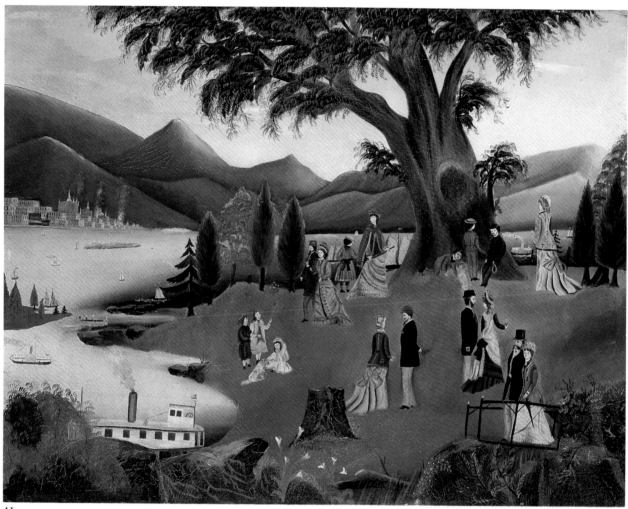

41

women's elaborate Victorian-style dresses. The ladies' poses, particularly those of the women facing away from the viewer, are reminiscent of illustrations commonly seen in popular nineteenth-century periodicals, and the unidentified artist may have used such printed sources as models — although no specific printed sources have been identified.

Outing on the Hudson is especially appealing in its vibrant colors and fairly complex composition. The variety of trees with quickly painted and stylized foliage suggest that the artist was probably an amateur with some knowledge of landscape painting as offered in copybooks or grade school instruction.

Condition: Unspecified conservation treatment by William Suhr in 1936 probably included cleaning and minor inpainting. Period replacement 4¼-inch, cove-molded, and gilded frame.
Provenance: Found in Woodstock, N.Y., and purchased by Mrs. Konrad Cramer; Mr. and Mrs. Elie Nadelman, New York, N.Y.; Edith Gregor Halpert, Downtown Gallery, New York, N.Y.;

given to the Museum of Modern Art in 1939 by Abby Aldrich Rockefeller; transferred to the Metropolitan Museum in 1949; turned over to Colonial Williamsburg in April 1955.
Exhibited: AARFAC, New Canaan; AARFAC, New Jersey; AARFAC, New York, and exhibition catalog, no. 28; American Folk Art, Traveling; American Primitive Painting, and exhibition catalog, no. 36; American Primitives; "Arthur G. Dove: The Years of Collage," University of Maryland Fine Arts Gallery, College Park, March 13–April 19, 1967, and exhibition catalog, p. 50, no. 4; Flowering of American Folk Art.
Published: AARFAC, 1957, p. 93, illus. as fig. 48; American Primitives, p. 64, no. 42, illus. on p. 43; *Antiques*, LXXV (June 1959), illus. on cover; Cahill, American Folk Art, p. 34, no. 27, illus. on p. 72; Cahill, Early Folk Art, illus. on p. 261; Carl Carmer, "The Lordly Hudson," *American Heritage*, X (December 1958), p. 21, illus. on p. 21; Ford, Pictorial Folk Art, p. 123, illus. on p. 123; John K. Howat, *The Hudson River and Its Painters* (New York, 1972), p. 157, no. 46, illus. as no. 46; Lipman, Primitive Painting, no. 54, illus. as no. 54; Lipman and Winchester, Folk Art, no. 93, illus. on p. 71.

Portraits of Homes, Farms, Factories, and Ships

James Bard
(1815–1897)

Although the Folk Art Center's three Bard paintings apparently were the work of James alone, Bard biographies always mention James's twin brother, John (1815–1856), since the two of them worked together in New York City in their early years and cosigned many pictures. The rupture of their partnership, still unexplained, seems to have occurred in the winter of 1849, judging from the cessation of jointly signed works. John's death in 1856 followed stints at the Blackwells Island (now Roosevelt Island) Alms-House and the island's Hospital for Incurables, but James appears to have carried on a thriving painting business both during and after John's confinement.

The earliest Bard work is believed to have been an 1827 watercolor of the side-wheeler *Bellona*, but the depiction remains unlocated at present. Its existence is known only from an obituary for James written by the historian and fellow artist Samuel Ward Stanton (1870–1912). James Bard's last commission was an 1890 watercolor portrait of the steamboat *Saugerties*, signed "J. Bard N.Y. 75 years," while two years later, he created his last known work, a pencil sketch of the steamboat *Westchester*, done for his young friend Stanton.

In the years between, Bard made a name for himself as a meticulous and accurate recorder of the appearance of small sailing craft and especially steamboats. Stanton stated that "before making his drawing, Mr. Bard would measure the boat to be pictured from end to end, and not a panel, stanchion or other part of the vessel, distinguishable from the outside, was omitted; each portion was measured and drawn to scale," a procedure supported by the survival of a number of the artist's annotated sketches, giving precise measurements, descriptions, and color notes. Harold S. Sniffen and Alexander Crosby Brown, two early students of Bard's work, determined that the artist used no constant scale, but established one for each separate work based on the size of his paper or canvas, his fancy, or his client's specifications.

If Stanton is to be believed, James Bard created about four thousand portraits of steamboats in his lifetime, not to mention numerous depictions of schooners, sloops, and other sailing vessels. Today

well over three hundred watercolors, oils, and drawings have been recorded, while some one hundred more are known only through secondary references, such as photographs, tracings, or correspondence. Bard hardly lacked for work, and he was heartily endorsed by the best-known shipbuilders of his day. Nevertheless, his last years were hard ones; he had to rely on the meager support of his daughter Ellen (the only one of his six children to survive after 1870), and he also received financial help from friends. Shortly after the death of his wife, Harriet DeGroot Bard (1809–1897), James died, on March 26, 1897, and no local paper noted his passing. The couple was buried in the Rural Cemetery in White Plains, New York, in a section reserved for indigents, and Ellen was remembered after her own death, in 1919, as the "little old lady who had nothing."[1]

[1]Information for this entry has been gleaned from two sources: Harold S. Sniffen and Alexander Crosby Brown, *James and John Bard, Painters of Steamboat Portraits* (Newport News, Va., 1949); and Peluso. Of the individual works named herein, Peluso indicates that that of the *Westchester* is privately owned, as is one of the two 1890 watercolors of the *Saugerties,* the other being in the collection of the Mariners Museum, Newport News, Va.

42 The Schooner Yacht *America* 68.111.1

James Bard
New York City, 1851
Oil on canvas with penciled details
41⅞" x 62⅜" (106.4 cm. x 158.4 cm.)

The yacht's heel, stiff sails, and flying flags all reflect her speed through the water, as does Bard's usual "signature" of effervescent spray at the bowsprit. This is one of two known Bard portraits of the famed *America,* for whom international yachting's most coveted trophy is named.[1]

The first international exposition was launched in England in 1851, in turn sparking the first formal racing competition between British and American yachts. Hopes were high for the 170-ton *America,* built in the spring of 1851 to the design specifications of Manhattan shipbuilder George Steers and financed by a syndicate under the leadership of John Cox Stevens, one of the founders of the New York Yacht Club. On

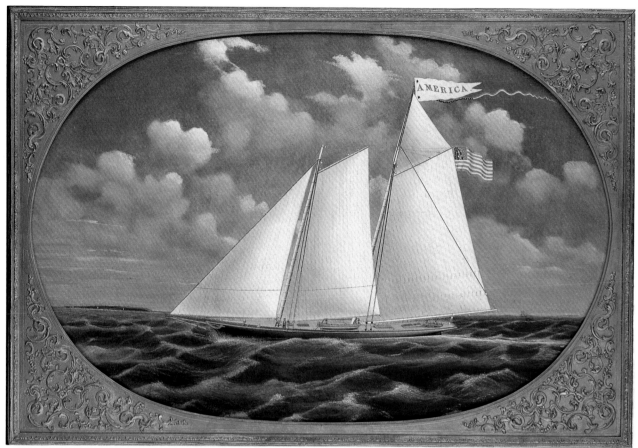

42

August 22, 1851, the *America* made history by finishing first in the fifty-three-mile contest around England's Isle of Wight, and the Royal Yacht Squadron's trophy was known thereafter as the America's Cup.

The *America* had a long history and sailed for both the North and South in the Civil War. In 1921 she was given to the United States Naval Academy, and after an unfortunate accident there during World War II, she was broken up in 1946.[2]

Inscriptions/Marks: "AMERICA" is painted on the yacht's burgee. Painted in script in the lower left painted spandrel of the canvas is "George Steers, Builder, N.Y. 1851," and in the lower right painted spandrel is "Picture Painted by James Bard NY./686 Washington St." These last two inscriptions are hidden by the painting's oval frame.

Condition: Treatment by an unidentified conservator prior to acquisition included lining the canvas, reattaching it to its original

stretchers, and inpainting minor scattered areas of loss throughout, with major areas of inpainting occurring in both upper painted spandrels of the canvas and along the side edges of the compositional oval. Original 1¼-inch gilded and gold-painted molded frame with gold-painted oval insert decorated with netting and applied plaster ornament of scrollwork.

Provenance: The painting is said to have been executed for John Cox Stevens and, later, to have hung aboard a yacht owned by General Butler Ames (b. 1871), a grandson of General Benjamin Franklin Butler (1818–1893), who purchased the actual yacht *America* after the Civil War;[3] Vose Galleries, Boston, Mass.

Exhibited: "America's Cup: 'There Is No Second Place,'" Mariners Museum, Newport News, Va., August 5–December 31, 1983.

Published: Robert N. Bavier, Jr., *The Schooner Yacht America* (New York, 1967), illus. on p. 17; Brown, illus. on p. 735; Samuel Carter III, "The Great Nautical Jam," *Yankee,* XXXI (August 1967), p. 93, illus. on pp. 90–91; Peluso, pp. 9, 96, 112, illus. on p. 40; Vose Galleries of Boston, Inc., *Selections from Our Marine Collection,* V (Boston, n.d.), illus. on cover.

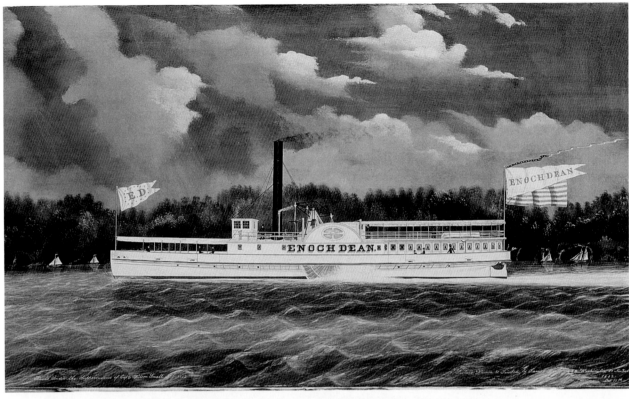

Built Under the Supperindence of Capt. Wilson Small N.Y. 1852

Picture Drawn & Painted by James [Bard] ... Washington St. New York 1852. Oct 11th

43

[3]Stevens's commission of work is noted in Vose Galleries' advertisement of the painting in *Antiques*, XCI (January 1967), p. 10. The painting's later history, as yet unconfirmed, derives from file notes that appear to transcribe a conversation between AARFAC and Morton Vose, Vose Galleries, Boston. Although it is implied that the painting changed hands along with the actual yacht, such history is unverified.

[1]The other depiction of the *America* is a double likeness, one that pairs the schooner yacht with the side-wheeler *Thomas Hunt*. Present ownership of this painting is unrecorded in Folk Art Center files (Anthony Peluso to AARFAC, May 23, 1988).

[2]There are abundant published histories of this most famous of all American racing yachts and the contest named after her. Data for this entry has been adapted from Alfred P. Loomis, " 'Ah, Your Majesty, There Is No Second,' " *American Heritage*, IX (August 1958), pp. 4–7, 104–105; and Robert N. Bavier, Jr., *The Schooner Yacht America* (New York, 1967).

43 The Steamboat *Enoch Dean* 63.111.1

James Bard
New York City, 1852
Oil on canvas
29″ x 49″ (73.7 cm. x 124.5 cm.)

Two areas of broad diagonal strokes through the sky suggest the initial downpour accumulated by gathering storm clouds. Trees covering the far bank were created by impressionistic sponging or dabbing, while at the waterline, smoother arching strokes suggest

cliffs of rock. Both techniques contrast sharply with the heavy, opaque paint coverage and precise detailing of the steamer itself, where even the wood grain of the walking beam is rendered, and touches of impasto further separate the boat from its landscape background.

Bard painted the side-wheeler *Enoch Dean* the year she was built by Benjamin C. Terry of Keyport, New Jersey. The boat ran from New York City on the East River to Flushing and College Point on Long Island,[1] then met her end during the Civil War. The *New York Herald* noted her demise on May 6, 1865, stating "Steamer ENOCH DEAN, Hallett, from Savannah 19th ult.,/for the islands lying S of Savannah, with freedmen and their/families, farming utensils, etc., while passing through a creek/emptying into St. Catherine's Sound, struck a snag and sunk./The E D was about 14 years old, formerly running between/ Peck Slip and Flushing, L I, and was owned by the government."[2]

Inscriptions/Marks: Flags flying fore and aft, respectively, are lettered "E.D" and "ENOCH DEAN." The latter also appears on the side of the steamboat. Painted in script in the lower left corner of the canvas is "Built Under the Supperindence [*sic*] of. Cap⁜ Wilson Small N. Y 1852" and in the lower right corner is "Picture Drawn & Painted by James Bard. 688 Washington St New York/1852./Oct 11ᵗʰ."[3] Remnants of the newspaper clipping quoted in the commentary are glued to the left stretcher on the reverse, and "PREPARED/ BY/ED͟ᵈ DECHAUX/NEW-YORK." is stenciled in oval format on the reverse of the canvas.

Condition: Treatment by an unidentified conservator prior to acquisition included surface cleaning and inpainting minor scattered areas of paint loss. The canvas is on its original stretchers. Original 3-inch, cove-molded, gold-painted frame with two brass hanging rings on the reverse of the side members.

Provenance: Mary Allis, Fairfield, Conn.

Exhibited: AARFAC, September 1968–May 1970.

Published: Don Maust, "Summer of Rediscovery," *Antiques Journal,* XXII (September 1967), p. 20, illus. on p. 19; Peluso, pp. 110, 115, illus. on p. 20.

[1]Peluso, p. 20.

[2]As quoted by John L. Lochhead, Mariners Museum, to AARFAC, May 29, 1963.

[3]The street number is clearly "688," despite Peluso's note that New York City directories for 1845–1854 list James at "686 Washington St., N.Y." (Peluso, p. 107).

44 The Schooner *William Bayles* 63.111.2

James Bard
New York City, 1854
Oil on canvas with penciled details
32¾" x 52" (83.2 cm. x 132.1 cm.)

The schooner's vivid green hull contrasts pleasingly with dull, blue-gray water and a warm, peach-colored sky at the horizon line. Bard created three portraits of the *William Bayles* — two in 1854 and one in 1860

— but to date, the names of the commissioners of these paintings remain unknown.[1] Both 1854 versions bear the sailmaker's name on the mainsails.[2]

The *William Bayles* was built at Nyack, New York, in 1853 under the direction of John B. Voriz, and she was first owned and mastered by Daniel O. Archer of New York City.[3] One unsubstantiated source alludes to the vessel's having been used to haul stone from a Tarrytown quarry to New York City.[4] Although possibly true, the *Bayles* probably served a variety of other purposes as well during her enrollment at the port of New York, for schooners and sloops commonly hauled both passengers and widely assorted goods up and down the Hudson River during the nineteenth century. Fifteen enrollment documents for the *Bayles* indicate numerous changes of owners, masters, and home ports. She operated out of the port of New York until 1862, then saw service out of Bridgeport, Connecticut; Cold Spring, New York; Portsmouth, New Hampshire; Boston; and finally, Gloucester, Massachusetts, from whence she was reported "lost at sea" March 31, 1874.[5]

Inscriptions/Marks: "WILLIAM BAYLES." is painted on the schooner's bow and on one of its flags. In the canvas's lower right corner is painted, in script, "Drawn & Painted by James Bard,/162 Perry St N Y. July 1854." The block lettering on the bottom of the mainsail is partially illegible, but it appears to read "B [illegible material; possibly only the artist's repositioning of the letter B] & B [illeg.]NET. SAIL MAKER. N.Y." Penciled script on the back of upper and lower stretchers is illegible.

Condition: Treatment by an unidentified conservator prior to acquisition included inpainting a few scattered, very minor areas of paint loss as well as adhering the canvas to paper and the paper, in turn, to a second canvas. The painting is on its original stretchers. Modern replacement 3-inch splayed black-painted frame with flat gold-painted outer edge.

Provenance: Martin B. Grossman, New York, N.Y.; Herbert W. Hemphill, Jr., New York, N.Y.; Mary Allis, Fairfield, Conn.

Exhibited: AARFAC, September 15, 1974–July 25, 1976; Museums at Sunrise.

Published: AARFAC, 1974, no. 38 on p. 45, illus. on p. 43; Peluso, p. 123.

[1]The other two versions of the subject are owned by two New York City institutions, the Museum of the City of New York and the New-York Historical Society. The painting owned by the former is on long-term loan to the American Museum in Britain, Bath, England; it was given to the Museum of the City of New York in 1940 by Lydia F. Bayles, but any connection between her and the unidentified William Bayles for whom the schooner was named remains undocumented. The two paintings' inscribed dates are, respectively, 1854 and 1860.

[2]Peluso, p. 36, states that the other 1854 version bears the name of New York City sailmaker B. Bennett, which undoubtedly is the name represented on the Folk Art Center's painting.

[3]This information is derived from an enrollment document issued for the *William Bayles* August 22, 1853, at the port of New York. The *Bayles* was described therein as having a length of 64' 6", a breadth of 23' 7", and a depth of 5' 5". A photocopy of the document is filed at AARFAC; the original is owned by the National Archives, Washington, D.C.

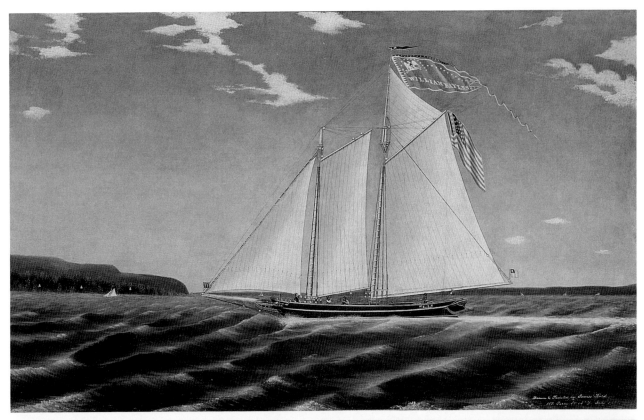

44

[4]Steven Miller, Museum of the City of New York, to AARFAC, July 8, 1982, states that the schooner "is said to have run from Tarrytown, New York, to New York City, carrying stone from a quarry."

[5]Fifteen enrollment documents exist for the *William Bayles*. Photocopies of these are filed at AARFAC, while the originals are owned by the National Archives, Washington, D.C.

M. D. Belcher
(active ca. 1835)

45 **Greenfield High School for Young** 58.302.3
Ladies

M. D. Belcher
Possibly Greenfield, Massachusetts, probably
1829–1840
Watercolor and ink on wove paper
8″ x 11¾″ (20.3 cm. x 29.9 cm.)

Greenfield High School for Young Ladies was established in Greenfield, Franklin County, Massachusetts, in May 1828, and its first term commenced that winter. Although contemporary literature about the institution stressed its educational program, admiring

descriptions of the buildings, grounds, and site indicate that these were a source of local pride and that their beauty was expected to draw prospective pupils. This may have been one of the reasons the school's proprietors used a Pendleton lithograph of the complex as a frontispiece to their 1829 *Outline of the Plan of Education Pursued at the Greenfield High School for Young Ladies.*[1]

The otherwise unknown artist M. D. Belcher closely followed the Pendleton lithograph in rendering his or her own version of the scene; aside from expected earmarks of naive translation, such as wavering architectural lines and askew perspective, very few changes were made, the most notable being Belcher's deletion of string course ornamentation on the far-left building.

Yearly fees assessed by the school for "board, lodging, washing, fuel, lights & instruction in all the branches of an English education" were $150 for those older than twelve years of age and $125 for those under twelve. Along with other optional courses, drawing and painting were offered for an additional fee of $6.[2]

Belcher may have been a pupil at Greenfield, although student attendance lists for 1829 and the several years following include no girl by that name. Family genealogies examined to date also have failed to mention an appropriate M. D. Belcher, and the watercolorist remains identified only by name.

Inscriptions/Marks: In the margin below the composition, "GREENFIELD HIGH SCHOOL FOR YOUNG LADIES." is lettered in ink. In ink script to the right in the same margin appears: "M. D. Belcher."

Condition: In 1958 Christa Gaehde cleaned the watercolor, repaired unspecified tears, and mounted the support on Japanese mulberry paper. In 1980 E. Hollyday reinforced a tear in the bottom margin, straightened and reinforced the creased and replaced lower left corner, and cleaned the primary support. Period replacement 1¼-inch, black-and-gold frame of Hogarth molding.

Provenance: J. Stuart Halladay and Herrel George Thomas, Sheffield, Mass.

[1] A copy of the original catalog is in the collections of the American Antiquarian Society, Worcester, Mass., and it was Jane Nylander who kindly brought the frontispiece therein to the attention of the Folk Art Center staff. The print was probably the product of Boston lithographer William S. Pendleton (1795–1879), or possibly it was produced by William working in conjunction with his brother John B. Pendleton (1798–1866). John is said to have worked in Boston with his brother "until about 1828" but also to have departed there "in 1829" (Groce and Wallace, p. 497).

[2] This information was taken from a transcription of an October 16, 1832, *Greenfield Gazette* notice provided by Gina Martin and Caroline Sloat. The original can be found at Old Sturbridge Village, Sturbridge, Mass.

45

46

Alexander Boudrou
(active 1851–1871)

See Boudrou entry in "Views of Towns" for biographical information.

46 Rosehill 59.302.2

Alexander Boudrou
Bucks County, Pennsylvania, 1871
Watercolor and pencil on wove paper
11³/₁₆" x 16³/₄" (28.4 cm. x 42.6 cm.)

The artist's proficiency is exhibited by exploitation of his mediums. He contrasts the precise penciled draftsmanship of architectural lines with a loose, sketchy treatment of some of the trees and other foliage, while watercolor is used in both thin washes and in thick, opaque applications representing highlights and strong color notes.

Identification of the subject remains a puzzle, despite the painter's relatively extensive inscription. No place named Rosehill has been found in Bucks County records to date, nor has mention of Boudrou been found there. However, the picture's backboard word-ing (see *Inscriptions/Marks*) provides somewhat more fruitful grounds for investigation. Bridgewater can be identified as a village on the old Frankford and Bristol Turnpike, where it crosses Neshaminy Creek between Bensalem and Bristol townships. Unfortunately, an 1871 Bucks County directory lists no William Appleton under the Bridgewater post office. Curiously, it does note a "John Sherwood, Florist and Nursery" at Bridgewater.[1] Whether this reference has any connection with the backboard mention of "Floral buildings at Bridgewater" is undetermined.

Inscriptions/Marks: The watermark in the upper left corner of the primary support is "J Whatman." In watercolor or ink in the lower right corner of the composition is "Alexander Boudrou 1871," and in the lower left corner is "Rosehill/Bucks Co./Pa." The frame's backboard, now lost, is said to have been inscribed in pencil: "House and Floral buildings at Bridgewater Penna. of Wm — Appleton."[2]

Condition: Prior to acquisition, the edges of the primary support were trimmed. In 1961 Christa Gaehde removed an existing mounting, cleaned the painting, and backed the primary support with Japanese mulberry paper. In 1975 E. Hollyday hinged the primary support to rag board. The 1¼-inch period replacement cyma recta molded frame was once painted and is now stained.

Provenance: Mary Jennings, New Hope, Pa.

Exhibited: AARFAC, New Jersey; AARFAC, South Texas; Goethean Gallery.

[1]Terry A. McNealy, Bucks County Historical Society, to AARFAC, May 10, 1977.

[2]Mary Jennings to AARFAC, September 19, 1959.

Rebecca Couch
(1788–1863)

See Couch entry in "Views of Towns" for biographical information.

47 Connecticut House 58.302.1

Rebecca Couch
Connecticut, possibly Litchfield or Redding, probably ca. 1805
Watercolor and ink on wove paper
13″ x 16⅜″ (33.0 cm. x 41.6 cm.)

Like many of her amateur contemporaries, Couch simulated needlework stitches with some of her watercolor brush strokes. The idyllic nature of this scene suggests that she may have referred to a print source in creating her view, but as yet the house depicted remains unidentified, as does the specific locale.

Inscriptions/Marks: A label on the reverse, now lost, is said to have read: "Painted by Rebecca Couch who lived in Litchfield and Redding, Connecticut about 1800. Painting came out of house in back of Library at Sharon, Conn."[1]

Condition: Treatment by Christa Gaehde in 1958 included cleaning, repairing tears in the lower margin, and inpainting losses in the sky, the waterfall, and several trees. Treatment by E. Hollyday in 1975 included dry-cleaning unpainted areas and repairing edge tears and punctures. Period replacement 1½-inch, gold-leafed, cove-molded frame with acanthus leaf decoration and beading.

Provenance: J. Stuart Halladay and Herrel George Thomas, Sheffield, Mass.

Exhibited: AARFAC, April 22, 1959–December 31, 1961; Pine Manor Junior College; Remember the Ladies.

Published: De Pauw and Hunt, p. 167, no. 214.

[1]The "house in back of Library at Sharon" would appear to have been that on Upper Main Street occupied by Mrs. Charles M. Prindle (Anna Elizabeth Morehouse [1858–1952]), a granddaughter of Rebecca Couch. (Prindle was the daughter of Julius Stephen Morehouse [1814–1885] and his wife, Elizabeth Stebbins Denison Morehouse [1822–1895], both of whom were buried at Sharon.) Perhaps coincidentally, another of Rebecca Couch's daughters, Clarissa D. Denison (Mrs. William Chauncey Morehouse [ca. 1823–?]), lived at Sharon Valley, Conn. Mrs. Robert H. Scribner to AARFAC, August 2, 1983.

47

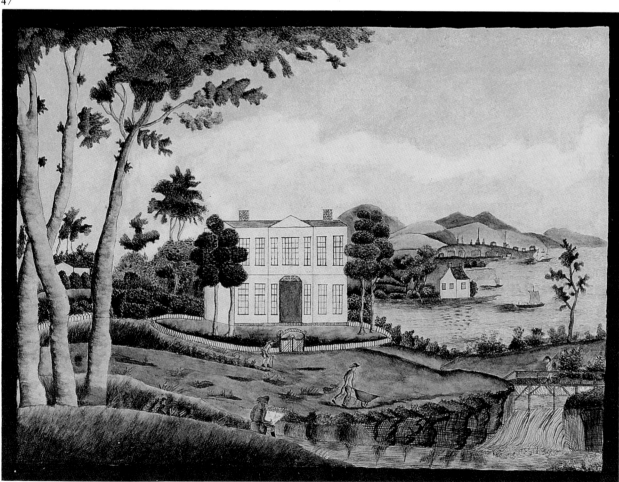

Amy Cox
(active ca. 1800)

48 Box Grove 71.301.1

Attributed to Amy Cox
Monmouth County, New Jersey, ca. 1800
Watercolor, gouache, and pencil on wove paper
13 11/16″ x 17 1/4″ (34.8 cm. x 43.8 cm.)

The flattened perspective, pleasing juxtaposition of blue and green foliage hues, prominently placed grape arbor, and animated figures add great charm to this picture. Yet *Box Grove* is more than an appealing, amateurish rendering of the period. The surmise that it was drawn on location enhances its value as a social and historical document, telling us much, for instance, about architectural styles, landscape planting, and domestic values of about 1800. Note that the enclosed yard is crammed with shrubbery, some of it in tubs. A simple, waist-high railing crosses the porch front and supports a row of potted plants.

According to family tradition and late-nineteenth-century documentation, the figures on the porch at Box Grove are identified as Brigadier General James Cox (1753–1810) and his wife, Ann Potts Cox (1757–1815), while the young man on the walk is their son Thomas. The woman advancing toward Thomas is variously described as his sister and as his fiancée. The girls at far right are the Coxes' twin daughters, Mary and Amy, born about 1783.[1] Family descendants firmly believe the latter to have been the artist of this watercolor,[2] although as yet, no other works by her are known, nor is there period documentary substantiation for the assertion. Box Grove was located near Imlaystown in Monmouth County, New Jersey.

Inscriptions/Marks: "Box Grove" is lettered in the margin below the composition.
Condition: Treatment by Christa Gaehde in 1970 included cleaning, and removing an acidic backing. Period replacement 2-inch, cove-molded gilded frame.
Provenance: Purchased from a family descendant.
Exhibited: AARFAC, New Jersey.
Published: William Van Zandt Cox and Milton Harlow Northrup, *Life of Samuel Sullivan Cox* (Syracuse, N.Y., 1899), pp. 16–17, and illus. between pp. 16 and 17.

[1] General Cox's distinguished service in the Revolutionary War is outlined in William Van Zandt Cox and Milton Harlow Northrup, *Life of Samuel Sullivan Cox* (Syracuse, N.Y., 1899), pp. 11–12. Additional information about the family may be found therein, and *Box Grove* is illustrated between pp. 16 and 17 of the book. The lone woman is described as Thomas's fiancée on p. 17 in this reference, while correspondence of November 20, 1969, with the watercolor's previous owner describes her as a sister.
[2] Correspondence with previous owner, February 23, 1971.

Harriett De ——
(active ca. 1820)

49 The Duck Pond 79.302.3

Harriett De ——
Probably Massachusetts, ca. 1820
Watercolor on wove paper
5 1/4″ x 6 3/4″ (13.3 cm. x 17.1 cm.)

Harriett De —— has not been identified, but the composition of her charming watercolor suggests that she may have received some lessons in drawing. *The Duck Pond* is simply drawn and modeled, giving the elements of the picture a flat quality. Some sense of advancing and receding forms is achieved, however, through the size of the objects. Near, or foreground, objects appear larger in scale as compared to the smaller house and trees on the distant horizon at left. The bulk of the larger house dominates the center and middle ground, while the more decorative details of the scene occupy the right foreground. The postures of the three females focus attention on the seven swimming ducks. A "sponged" effect used for the leaves of the trees contrasts with the artist's careful rendering of the beehives, flowers, and costumes.

Inscriptions/Marks: On the verso of a paper inserted behind the primary support is the partially illegible, faded ink notation: "Painted by/Harriett De —— ." Below this inscription is penciled: "$18.00/IBX/IBX"; and written on a cloth tape in ink is "948/WO-1." Also used as a backing paper was a trimmed billhead picturing the building occupied by the Fitchburg, Massachusetts, *Sentinel*, T. C. Caldwell, proprietor, at 176 Main Street.[1]
Condition: In 1981 E. Hollyday removed an adhered acidic secondary support and reinforced the primary support with Japanese mulberry paper. Original 1-inch gilded frame with beaded inner edge and original black eglomise glass mat.
Provenance: Found in Marblehead, Mass.; acquired from Edith Gregor Halpert, Downtown Gallery, New York, N.Y., June 18, 1931, and used at Bassett Hall, the Williamsburg home of Mr. and Mrs. John D. Rockefeller, Jr.
Exhibited: American Folk Art, Traveling.
Published: Cahill, American Folk Art, p. 37, no. 59.

[1] Thomas C. Caldwell (1815–1904) owned the *Sentinel* building at 176 Main Street after 1871, according to information provided by Eleanor F. West, Curator, Fitchburg Historical Society, Fitchburg, Mass., May 27, 1982. From 1835 until retirement in 1884, Caldwell ran the town's major grocery; perhaps he rebacked and sold this watercolor for eighteen dollars sometime between 1871 and 1884. "Harriett De —— " has not been identified in Fitchburg records.

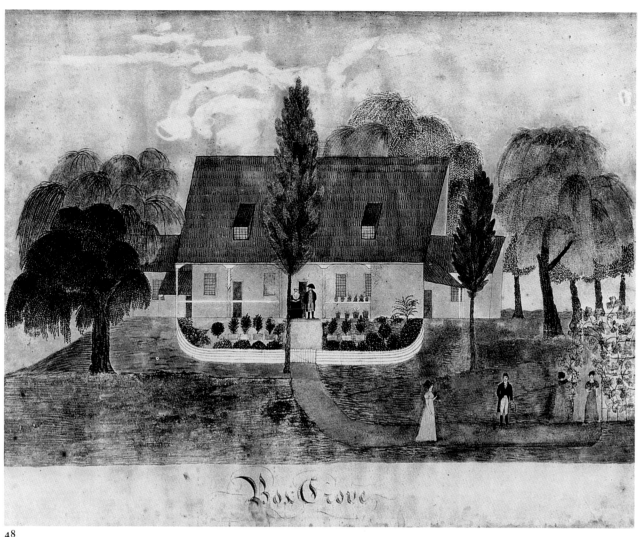

48

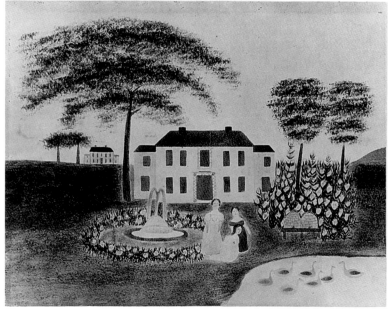

49

John Orne Johnson Frost
(1852–1928)

John Orne Johnson Frost was born in Marblehead, Massachusetts, on January 2, 1852, the son of Mehitable Johnson Frost (1818?–1890) and Amos Dennis Tucker Frost (1817?–1861), both descendants of early settlers of Marblehead.[1] John Frost grew up in Marblehead. His formal education ended by 1868, when he decided to go to sea on one of the fishing vessels that provided a living for many of the townsfolk. He made two trips, in the late summer of 1868 and the spring of 1869, but after the second, Frost acceded to the requests of his sweetheart, Amy Anna Lillibridge (1854–1919), and did not go to sea again.[2]

John Frost and Amy Lillibridge, known as Annie, were married March 5, 1873, and John went into the restaurant business with his father-in-law. Soon after, he began his own restaurant, but when it burned to the ground in December 1888, he joined his brother-in-law at the Lillibridge restaurant until 1893, when Frost left to help Annie with her thriving sweet pea business. John and Annie had several children, but only one, Frank (d. 1947), lived to adulthood. By what evidence remains, their marriage was a happy one, so when John Frost returned home from neighboring Salem one day in late November 1919, he must have been shocked to find that Annie had committed suicide. She had been ill for some time and said in a note left for her husband that she had been unable to endure her great suffering any longer.[3]

With Annie's death, John Frost began that phase of his life that was to bring him renown. He kept busy with household chores and the garden, but these were not enough for this alert and lively man. He began writing letters to the editor of the local paper, the *Marblehead Messenger,* in April 1921, and he continued this occasional correspondence for the next seven years.[4] The letters reveal his interest in the history of his hometown and his intention to keep that history alive for the children growing up there, much as his own mother had related stories of the late eighteenth and early nineteenth centuries to him when he was a child.

A little over a year after he began his letters to the editor, Frost began to paint the history of the town he loved, and he did not cease until his death. His known paintings and carvings number more than a hundred, all of them showing incidents from Marblehead's history or recalling his experiences on the Grand Banks in 1868–1869.

It appears that Frost publicly exhibited his works, perhaps for the first time, in August 1924.[5] Most Marblehead residents thought him a bit eccentric and seldom patronized his new gallery, but a number of tourists did discover the artist and his unusual exhibits. In a small building at the rear of the house, he showed his paintings and a "cabinet of curiosities" — that is, objects and artifacts having some connection with Marblehead's history, such as a shoemaker's bench (representative of the town's shoemaking industry), a trawl of the type used on the Grand Banks, a latch from the home of Judge Samuel Sewall, a harpoon, and some Indian relics — all intended to supplement the historical value of his paintings and carvings. For the pleasure of visitors, he also enjoyed playing his "musical rocks," two piles of assorted stones that, he claimed, produced recognizable tunes when struck with a hammer.

Frost died November 3, 1928, and soon afterward, his son, Frank, offered eighty of the artist's works to the Marblehead Historical Society, which ultimately retained twenty-seven paintings and sixteen carvings, the largest single collection of Frost's works that exists today. The artist's paintings are characterized by strong colors, a clear presentation of the facts as he knew them, and a wealth of detail. Evident throughout is his love for his home and its colorful history.

[1]Birth years for Frost's parents are unconfirmed; dates given are of their baptisms (Mrs. John P. Hunt, Jr., Marblehead Historical Society, to AARFAC, June 4, 1985).

[2]Most of this entry has been adapted from Katz.

[3]*Marblehead Messenger,* December 5, 1919, p. 8.

[4]For a list of Frost's letters to the editor, see Katz, Appendix A, pp. 49–50.

[5]In the preface to Parke-Bernet Galleries, Inc., *Paintings and Folk Art by J. O. J. Frost of Marblehead from the Collection of the Late Betty and Albert L. Carpenter, Boston,* catalog for sale no. 3186 of April 8, 1971, p. ix, James H. Maroney, Jr., states that "in July of 1926, John Orne Johnson Frost held the first public exhibition of his own works in his backyard museum." However, an undated handbill for what seems to have been another showing was transcribed in Nina Fletcher Little, "J. O. J. Frost: Painter-Historian of Marblehead," *Art in America,* XL (October 1955), p. 28. The handbill transcribed by Little is now owned by the Archives of American Art in Washington, D.C. Within its text, it mentions that "the proceeds from admissions on Wednesday, August 13, will be donated to the Marblehead Female Humane Society." A perpetual calendar indicates that August 13 fell on a Wednesday only in 1924 during the 1920s (then again in 1930 and in 1941). Hence, the handbill is presumed to describe an August 1924 exhibition.

50 **Sable Island: The Sailors Grave Yard** 69.101.1

Attributed to John Orne Johnson Frost
Marblehead, Massachusetts, 1922–1928[1]
Water-based paint and pencil on wallboard
22 9/16" x 67 9/16" (57.3 cm. x 171.6 cm.)

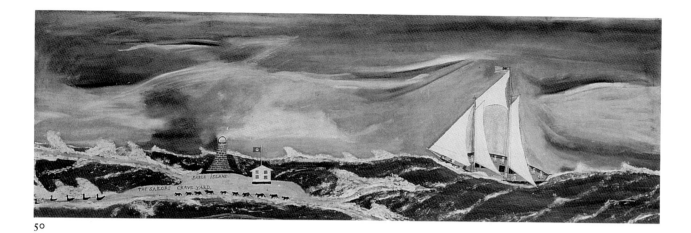

50

Sable Island is a landmark for fishermen off the Grand Banks near Nova Scotia. Frost's strong narrative style and innate pictorial sense combine to give this picture of the place the sense of motion and energy that Frost himself must have felt as a young boy on his first voyage to the area in 1868. In this scene, Frost shows heavy seas and strong winds: the ship runs before the wind, the waves are large and breaking, and all the fishermen wear oilskins. As is typical of Frost's ocean scenes, the waves form strong diagonals, and the sky illustrates the wind's motion through irregular streaks and swirls of blue, white, and gray. Both these facets give energy to what would otherwise be a very static view.

Frost's firmly held desire to record his memories for the benefit of future generations manifests itself here in the care he took to show the details of Sable Island. Although Frost's lack of training is obvious in the simplified bird and animal forms and the basic way in which he painted the buildings, there is no doubt that this scene is much the way he remembered it when he painted it, more than fifty years after his trip there.[2]

Frost painted the sailors' common name for Sable Island on the sand beneath its proper name. Their ominous title combined with the wild seascape serve as a vivid reminder of the difficulties and dangers inherent in fishing off the Grand Banks in the 1860s and indeed, to some extent, to this day.

Inscriptions/Marks: In red paint across the island in the composition is "SABLE ISLAND./THE SAILORS GRAVE YARD."
Condition: Unspecified treatment by an unidentified conservator included cleaning, inpainting scattered scratches and nail holes, bracing the back of the picture with stretchers, and nailing the stretchers into the present frame. Modern 2⅛-inch flat stepped frame, painted black.
Provenance: Frost family; Mr. and Mrs. Frederick Dike Mason, Jr., Marblehead, Mass.; M. Knoedler & Co., New York, N.Y.[3]
Exhibited: AARFAC, September 15, 1974–July 25, 1976; "American Primitive Exhibition," M. Knoedler & Co., New York,

N.Y., February 13–March 1, 1969, and exhibition checklist, no. 22; "J. O. J. Frost," Childs Gallery, Boston, Mass., May 1954, and exhibition checklist, no. 18; "J. O. J. Frost," M. Knoedler & Co., New York, N.Y., June 15–30, 1954, and exhibition checklist, no. 18.
Published: AARFAC, 1974, p. 51, no. 45, illus. on p. 48; Katz, p. 60; Nina Fletcher Little, "J. O. J. Frost: Painter-Historian of Marblehead," *Art in America,* XL (October 1955), p. 29.

[1]Seventy paintings are listed by title in the "CATALOGUE OF PAINT-INGS/By John O. J. Frost/On Exhibition at His Art Gallery, 11 Pond Street/MARBLEHEAD, MASSACHUSETTS," which the artist had printed, reportedly in 1926 (Betty Carpenter to AARFAC, n.d., but probably January 1964). AARFAC files contain photographs of the catalog. Number 40 therein is *Sailing by Sable Island.* If the listed picture is the Folk Art Center's painting, and if a 1926 printing date is correct, then *Sable Island: The Sailors Grave Yard* must have been executed within the narrower range of 1922–1926.
[2]Nina Fletcher Little to AARFAC, March 25, 1954, indicates that the animals in the picture are wild horses.
[3]Both of the Folk Art Center's Frost paintings (see also no. 51) were discovered in 1954 when remodeling of the Frost home was undertaken by its new owners, Mr. and Mrs. Frederick Dike Mason, Jr. The two paintings were among a number of such works found nailed face to the wall, the reverses covered with paper or paint. It is not known whether Frost or some other member of his family effected this.

51 **Mugford in the *Franklin*** 54.111.1
Capturing the *Hope*

John Orne Johnson Frost
Marblehead, Massachusetts, possibly 1923[1]
Water-based paint and pencil on wallboard
28½" x 37" (72.4 cm. x 94.0 cm.)

Although all of Frost's paintings depict aspects of Marblehead's past, the works fall into two general categories: scenes of life as a fisherman and scenes from Marblehead's history. The latter category is exemplified by this picture, a composite of various incidents that took place in and around Marblehead during the years 1774–1776.

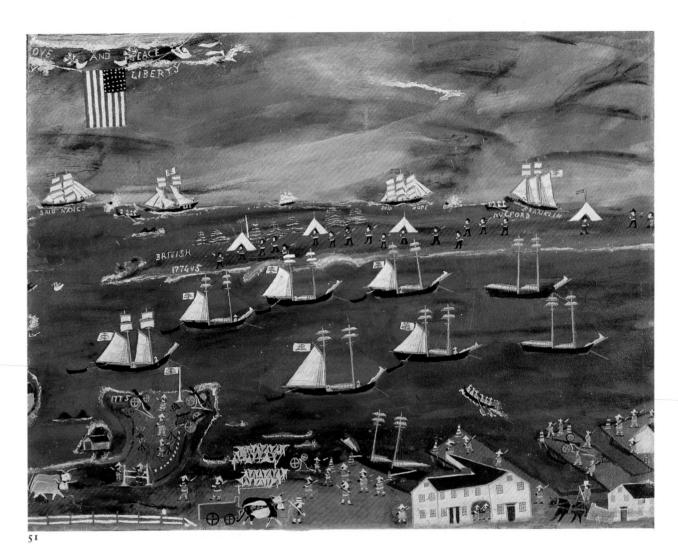

51

In the left background, the British brig *Nancy* is shown being captured in 1775 by the *Lee*, an American ship commanded by Captain James Manly. In the right background, James Mugford commands the American vessel *Franklin* in its 1776 capture of the British ordnance ship *Hope*. In the middle distance are the British soldiers who occupied Marblehead Neck in 1774–1775, while in the harbor lie ships of the fledgling American navy; like the *Lee* and *Franklin*, all of them fly the pine tree flag of Massachusetts. In the foreground, soldiers man the fortifications along the shore, and civilians go about their daily activities.[2]

The Folk Art Center's painting is actually only a portion of Frost's original composition. The left third of the picture was cut off at an undetermined date and purchased by Betty Carpenter in the 1940s.[3] The removed third shows more of the harbor and Captain Manly's house, among other buildings; its numerous inscriptions include the artist's name at lower left and, at upper right, the cut-off lettering "UN," which was probably originally joined with the lone "Y" at upper left on the Folk Art Center's painting to form the word "UNITY." The Folk Art Center's painting has also been cut on the right side, but if another existing picture was originally joined to it there, it has not been so identified.

Inscriptions/Marks: Painted at upper left in the composition is "[L]OVE AND PEACE/[UNIT]Y LIBERTY." Scattered through the composition are the following: "BRIG NANCY," "LEE," "SHIP HOPE," "MUGFORD/FRANKLIN," "BRITISH/1774 & 5," and "1775."

Condition: Unspecified treatment by an unidentified conservator prior to acquisition and/or by Russell J. Quandt in 1956 included cleaning and inpainting scattered scratches, nail holes, and abrasions. Modern replacement 5¼-inch flat stained frame with mortised, doweled butt joints and a gold-painted liner.

Provenance: Frost family; Mr. and Mrs. Frederick Dike Mason, Jr., Marblehead, Mass.; Childs Gallery, Boston, Mass.[4]

Exhibited: AARFAC, Arkansas; Amon Carter.

Published: Katz, p. 60; Robert L. Reynolds, "History in House Paint," *American Heritage*, XIII (June 1962), illus. pp. 10–11.

[1]A painting of the same title, presumably the Folk Art Center's, appears as no. 18 in Frost's "CATALOGUE OF PAINTINGS/By John O. J. Frost/On Exhibition at His Art Gallery, 11 Pond Street/MARBLEHEAD, MASSACHUSETTS," which the artist had printed, reportedly in 1926 (Betty Carpenter to AARFAC, n.d., but probably January 1964).

Photographs of the catalog are in AARFAC files. If the paintings are indeed the same, and if the printing date is correct, then the Folk Art Center's picture must have been completed by 1926. In the same letter indicated above, Carpenter stated about *Mugford in the Franklin Capturing the Hope* that "it was painted in 1923." The reason for her specificity is not known, although she had purchased a cutoff portion of the picture in the 1940s (see note 3 below). Her discussions with the artist's son, Frank, during the period 1943–1947 may have been the basis for her definitive statement.

[2]See Samuel Roads, Jr., *The History and Traditions of Marblehead* (Boston, 1880), for details of this period in the town's past.

[3]During the course of his research for the auction catalog of Parke-Bernet Galleries, Inc., *Paintings and Folk Art by J. O. J. Frost of Marblehead from the Collection of the Late Betty and Albert L. Carpenter, Boston,* catalog for sale no. 3186 of April 8, 1971, James H. Maroney, Jr., discovered that the two paintings had originally been one; the removed third is illustrated therein as lot no. 37 on p. 31. It also appears in Robert L. Reynolds, "History in House Paint," *American Heritage,* XIII (June 1962), p. 14. It is now privately owned.

It is not known who separated the paintings or exactly when Mrs. Carpenter purchased the smaller. In the aforementioned auction catalog, p. ix, Maroney mentions that Carpenter discovered Frost's work in 1943 and that "she had already acquired some pictures" by 1947, when the artist's son, Frank, died and stipulated in his will that the remaining works be sold to the Carpenters.

[4]Both of the Folk Art Center's Frost paintings (see also no. 50) were discovered in 1954 when remodeling of the Frost home was undertaken by its new owners, Mr. and Mrs. Frederick Dike Mason, Jr. The two paintings were among a number of such works found nailed face to the wall, the reverses covered with paper or paint. It is not known whether Frost or some other member of his family effected this.

Charles C. Hofmann
(ca. 1820–1882)

Tom Armstrong's meticulous research on Hofmann remains the basis for current assessments of the artist's life and career, and summaries of Armstrong's file notes at the Folk Art Center can be found in several published forms.[1]

No details are known regarding Hofmann's birth in Germany about 1820 or regarding his life before coming to America through the port of New York in 1860. His skill in lettering, his proclivity for the visual impact of vivid color over a dark ground, and his proficiency in creating three-dimensional architectural effects in the simulated, painted "framing" of his pictorial compositions all point to some experience with sign or other ornamental painting. The word "lithograph" appearing after his name on an 1865 view of the Berks County Almshouse has contributed to the notion that Hofmann also may have been accustomed to preparing drawings for graphic reproduction.

Today Hofmann is remembered chiefly as the earliest of three well-known Pennsylvania almshouse painters. Like Hofmann, his successors — John Rasmussen (1828–1895) and Louis Mader (1842–after 1898) — were fellow German emigrants and almshouse registrants. All three men found a ready clientele among the officials serving the social institutions that sporadically sheltered them and other destitute people. One of Hofmann's 1878 views of the Berks County Almshouse, for instance, is known to have been painted for Jacob Hartgen, the almshouse baker, and an 1874 view of the Montgomery County Almshouse was created for Jacob Wisler, then second steward at that institution.

An undated watercolor of the Northampton County Almshouse is attributed to Hofmann, and it may be his earliest work. Logically, he would have traveled through Northampton County from New York in order to reach Berks County, where two dated views of that local almshouse proclaim his presence there in 1865. Hofmann painted the Berks County Almshouse at least ten times, and it was to that institution that he returned most often. But he also traveled along the Schuylkill River and Canal to paint four known views of the Schuylkill County Almshouse in Pottsville and at least three views of the Montgomery County Almshouse in Norristown. A few landscapes painted by Hofmann in the vicinity of Reading also exist, but the relatively small number of these indicates that his almshouse portrayals found a readier market.

Six entries in the 1872–1882 almshouse records provide fleeting documentary glimpses of Hofmann's life, the "causes of pauperism" listed therein including "intemperance," "no home," "vagrant," and "unable to support himself." He painted the Schuylkill County Almshouse in August of 1881, but in November of that same year, he was admitted to the Berks County Almshouse with a broken arm. Only months later, he died there of dropsy, on March 1, 1882, and he was buried in an unmarked grave in the paupers' lot on the hill behind the hospital building of the institutional complex.

[1]These include Tom Armstrong, "God Bless the Home of the Poor," *The Historical Review of Berks County,* XXXV (Summer 1970), pp. 86–90, 116; the exhibition catalog for Pennsylvania Almshouse Painters; and most recently, Lipman and Armstrong, pp. 103–109. Information for this entry has been adapted from Lipman and Armstrong, which offers an excellent stylistic analysis of Hofmann's work, as well as an expanded summary of his life. However, one deviation here consists of the ca. 1820 birth date given for Hofmann. The artist's death at age sixty-one, recorded in almshouse registers as having occurred on March 1, 1882, and, earlier, his admittance to the almshouse on November 2, 1881, also age sixty-one, would indicate a birth date in the period March 2–November 2, 1820. Yet, as frequently occurs, other records offer conflicting documentation: his admittances to almshouses on October 26, 1872; October 15, 1874; and September 15, 1876; at the recorded ages of fifty-seven, fifty-nine, and sixty, would indicate approximate birth years of, respectively, 1815, 1815, and 1816.

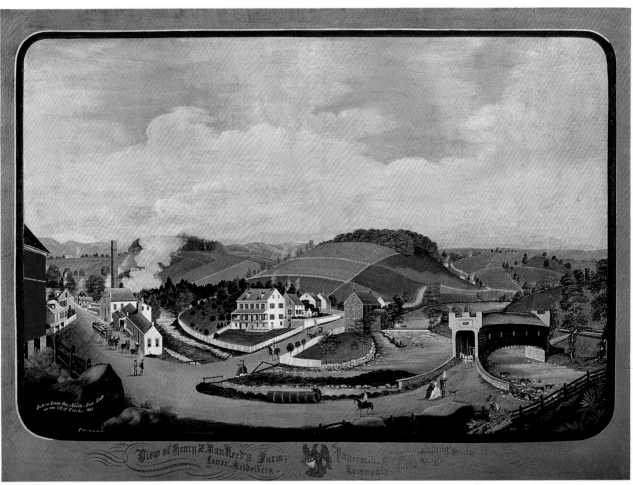

52

View of Henry Z. VanReed's Farm
Lower Heidelberg
Papermill and Surrounding's in
Township—Berks Co. Pa.

Taken from the North-East Side
on the 11th October 1872

52 View of Henry Z. Van Reed's 67.102.2
Farm, Papermill, and Surroundings

Charles C. Hofmann
Berks County, Pennsylvania, 1872
Oil on canvas
39″ x 54½″ (99.1 cm. x 138.4 cm.)

This colorful landscape includes a number of interesting genre details, making it not only a visually pleasing painting, but also an accurate record of a particular Pennsylvania entrepreneur's holdings and an invaluable reference to customs and practices of the time. Note the lightning rods on most of the taller buildings, the ventilated cupolas that allowed heat to escape from some of the structures, and fashionable gingerbread decoration on the plum-colored dwelling in the distance at left. Family histories aided identification of the load on the mule-drawn wagon as rags hauled from Reading to be made into paper at Van Reed's

mill. Further, the two figures standing in front of the team can be identified as the mule driver and Henry Z. Van Reed himself.[1]

The original Van Reed papermill in Lower Heidelberg Township was built by a third-generation Dutch immigrant, Henry Van Reed (b. 1780), but the business soon descended to his son, Charles. In 1850, Charles Van Reed leased the operation to his son, Henry Z. Van Reed (1828–1879), and in 1859, the latter assumed ownership of the property. Henry Z. Van Reed was known as a sagacious businessman, and he was responsible for much of the expansion and improvement of the operation's papermaking facilities, as well as a healthy increase in business. After Henry Z. Van Reed's death, the papermaking enterprise was assumed by his son, Charles L. Van Reed, and — despite an inexorable decline in business rooted in both natural and fiscal causes — the operation remained in family hands until 1901, when it was acquired by the Acme Paper Board Company of Bogota, New Jersey.

The Folk Art Center's view of the Van Reed property is believed to be one of five versions created by Hofmann, an artist better known for his almshouse portraits. The well-publicized story regarding the commissioning of these works is that Henry Z. Van Reed paid five dollars and a quart of whiskey for the first painting, then requested four more — one for each of his children — paying five dollars plus a quart of whiskey for each subsequent canvas.[2]

Inscriptions/Marks: Painted in the lower margin below the pictorial composition is "View of henry Z. Van Reed's Farm, Papermill, and Surounding's in/Lower Heidelberg-Township, Berks Co. Pa." In the lower left corner of the pictorial composition is painted: "taken from the North-East-Side/on the 5ᵗʰ of October 1872." Below that, and slightly to the right, is painted: "C. Hofmann Painter." The date "1872" is painted over the entry of the covered bridge in the painting.

Condition: Prior to acquisition, an unidentified conservator replaced the auxiliary support, lined the canvas, and overpainted extensive areas in the sky and four corners, over the bridge, and in the fields. In 1979 graduate students Floyd, Lawson, Penn, and Wharton of the Cooperstown (N.Y.) Graduate Program in Conservation relined the painting, removed some earlier inpainting, filled and inpainted numerous scattered paint losses, and replaced the previous auxiliary support with an aluminum sheet and Hexcel mount. Modern replacement 1¼-inch flat hardwood frame, painted dark brown.

Provenance: Charles Raymond Van Reed, Penn Side, Pa.; James G. Pennypacker, Reading, Pa.; Peter H. Tillou, Litchfield, Conn.; M. Knoedler & Co., New York, N.Y.

Exhibited: American Folk Painters; Flowering of American Folk Art (exhibited in Richmond, Va., only); "In Virginia," Virginia Museum of Fine Arts, Richmond, Va., January 18–February 14, 1971; Pennsylvania Almshouse Painters, and exhibition catalog.

Published: Blum, no. 8 on p. 201, illus. on p. 200; Brown, illus. on p. 735; Lipman and Armstrong, p. 105, illus. on p. 104; Lipman and Winchester, Folk Art, illus. as no. 69 on p. 56.

[1] This information derives from AARFAC file notes regarding a conversation between James G. Pennypacker and Thomas N. Armstrong III, August 7, 1968, in which Pennypacker relayed the history given him by former owner Charles Raymond Van Reed. This entry's information about the Van Reed family and mill operations comes from Edwin Van Reed High, "The Van Reed Family, and the Van Reed Paper Mills," *The Historical Review of Berks County,* VII (January 1942), pp. 49–51. On p. 50 of this article, High also alludes to the mule-drawn rag loads from Reading, and he specifically identifies the drivers employed by Van Reed over the years as, first, John Sebastian, and later John Mountz and John Unbenhen. Hofmann's depiction of Van Reed in portly profile is corroborated by High (p. 50), wherein the property owner is described as "a heavy, full-blooded man."

[2] The story was told in conversation between Pennypacker and Armstrong, August 7, 1968 (see note 1). One of the five paintings was given to the Historical Society of Berks County by a family descendant, Edwin Van Reed High. According to Pennypacker, at that time one of the remaining three paintings had been destroyed, one was unlocated, and one was in the possession of a cousin of Charles Raymond Van Reed's. The last is presumed to be that sold by Sotheby Parke Bernet as lot no. 305 in its auction no. 5141 of January 26–27, 1984; this painting was subsequently purchased by Hirschl & Adler Galleries, Inc., of New York City and resold to a private collector. On p. 49 of "The Van Reed Family" (see note 1), High identifies Henry Z. Van Reed's children as Emma L. (m. Harrison R. Epler), Charles L. (m. Laura E. Hertzler), Clara L. (m. Daniel K. High), and Joseph L., who died at age twelve. Henry Z. Van Reed's wife was Mary Leinbach of Bern Township.

53 View of the Montgomery County Almshouse Buildings 59.102.2

Charles C. Hofmann
Montgomery County, Pennsylvania, 1878
Oil on canvas
32″ x 45½″ (81.3 cm. x 115.6 cm.)

This Folk Art Center painting is the latest of three recorded Hofmann views of the Montgomery County Almshouse, built in 1870–1872.[1] The earliest, dated March 12, 1874, is in the collection of the Historical Society of Montgomery County, and the second, dated April 30, 1878, is in a private collection.[2] The three are very similar in terms of overall composition but differ in a number of small, interesting details. For instance, the institution's main building seems to have been painted, or repainted, between 1874, when it appeared as dark red, and 1878, when Hofmann rendered it in a vivid pea green. The figural grouping at lower right differs in all three paintings; the latest version is the only one that includes a bearded man raising a bottle, a figure believed to represent the artist himself. One wonders if the reasons for this change are tied to those observed in the labeling of the barge at right: the words "Gay & Happy" appear on its stern board in both earlier versions but are missing from no. 53.[3]

Inscriptions/Marks: Painted in the lower right corner of the canvas is "C. HOFMANN. JUNE 4ᵗʰ 1878," and in the reserve at center bottom is the main title: "View of the Montgomery County Almshouse Building's." Above the main title within the reserve is "(State of Pennsylvania)," and below the main title within the reserve is "Directors of the poor:" followed by the bracketed names and titles "Henry D. Wile, Martin Ruth, John Field, (Clerk: Frank Hoffman.), Steward: G. D. Frontfield, Understeward: C. U. Bean, J. S. Morey, M.D., County-Treasurer, Evan G. Jones, Clerk: Wᵐ· G. Smith." Painted on the side of the barge at far left is "Centennial Fright from/(Canada)," and on the stern of the barge at far right is "READING."

Condition: The canvas is trimmed flush with the edges of the painting, and the whole is mounted on heavy paper, trimmed to the same dimensions. Records are unclear whether the secondary, paper support was applied by the APF Company of New York, N.Y., in the treatment it performed prior to acquisition by AARFAC, or whether the painting was so treated earlier. The APF Company applied a tertiary support (a linen lining), apparently replaced the auxiliary support, cleaned the painting, repaired two large tears in a tree and the field at right and through the sky and horizon line at far left, and — besides areas surrounding the two large tears — inpainted a section beside the main building's cupola reflection in the water, three areas (quarter-size or smaller) below the power plant to left of middle, and parts of the sky in the left half of the composition. Probably twentieth-century replacement 1-inch flat hardwood frame, painted black over red.

Provenance: Robert Carlen, Philadelphia, Pa.

Exhibited: AARFAC, American Museum in Britain; AARFAC, Minneapolis; AARFAC, New Jersey; AARFAC, June 4, 1962–November 20, 1965; Pennsylvania Almshouse Painters, and exhibition catalog.

Published: Bishop, illus. as fig. 190 on p. 132; Black, Folk

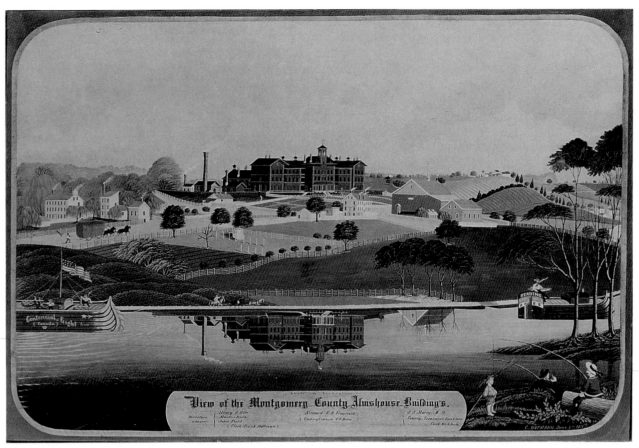

53

Artist, illus. on p. 95; Black and Lipman, illus. as fig. 199 on p. 223; Book Preview, 1966, p. 122, illus. on p. 122; Lipman and Armstrong, p. 105.

[1]Information for this entry has been taken from Lipman and Armstrong, pp. 105–106, and from Armstrong's research notes at the Folk Art Center.

[2]Hope Davis Rost, Knoedler-Modarco S.A., to AARFAC, September 14, 1982. The second painting was owned by M. Knoedler & Co. until May 1971.

[3]The complete right-hand barge stern-board inscriptions read: "Gay & Happy/Pottsville" in the 1874 painting and "Williamsberg/Gay & Happy" in the April 1878 painting.

Karol Kozlowski
(1885–1969)

Karol Kozlowski was virtually unknown to the field of American folk painting until 1980, when Abril Lamarque contacted the Folk Art Center and shared with its staff photographs of the artist's pictures that he had collected in the 1960s. He subsequently gave the two paintings featured in nos. 54 and 55 to the Center, and both he and his daughters worked with staff to organize the first major show on the artist, accompanied by an in-depth published study of his life and work by Martha Taylor Sarno. Because Sarno was able to interview a number of persons who knew Kozlowski and because Lamarque had met the artist and visited his painting shed, our knowledge of the painter is exceptionally detailed and well documented.[1]

Kozlowski was born in the district of Stopnica, about seventy-five miles from Warsaw and near Cracow, Poland, on March 13, 1885. His father, Aleksiej Kozlowski, died when Karol was eight years old, leaving the mother, Maryanna Bobinska Kozlowski, with five children to raise. Two of them, Karol and Andrzej, came to America in 1913, three years after Karol had completed service in the Russian army from January 1, 1907, to October 11, 1910. Whether he did any painting before coming to America is unknown, but unlikely, given the crude quality of his earliest pictures executed in Greenpoint, Brooklyn, where he settled soon after immigrating. Kozlowski had at least one acquaintance in New York whom he had known in the Russian army, and it was this friend, Edward Gronet, who invited the artist to join his family household.

Kozlowski lived with the Gronets for the rest of his life, first at Huron Street and then India Street in Greenpoint. After the elder Gronets' deaths, their daughter (Irene Gronet Urban) and her husband moved to a vacation bungalow they had built in the early 1960s in Congers, New York. Kozlowski spent the last years of his life in this area, and as far as is known, he continued to paint until a few months before his death, on December 4, 1969.

Kozlowski never learned to speak English, never traveled outside the state of New York, relied almost totally on the Gronets and later the Urbans for his care and physical well-being, and had few friends outside his immediate supervisor at work and the Gronet-Urban households. He was a devout Catholic and a meticulous dresser, wearing tailor-made suits when he was not at his job at the Consolidated Edison Company, where he worked as a fire cleaner. Kozlowski had joined the firm in 1923 when it was the Astoria Light, Heat and Power Company and before it became an affiliate of Consolidated Edison in 1936. His work was dirty, hot, and labor oriented, but he apparently found it acceptable, since he remained as a fire cleaner until his retirement in 1950. It was at Consolidated Edison that Kozlowski apparently first showed the world his artistic endeavors by presenting to the company a large view of the plant as a token of appreciation at the time of his retirement. The painting was hung in the lobby of the plant and subsequently seen by Abril Lamarque, who inquired about it and ultimately located the artist.

Twenty-six of the artist's paintings are known today, and they chronicle his development from about 1920 to just before his death. His approach to drawing and painting was distinctly his own. He used expensive paints, brushes, and artist's canvas for most of his pictures, but the brushes were trimmed to short nubs and his canvases were worked unmounted and flat on a large table. Kozlowski drew most of his compositions in pencil before applying the paint. Once the paintings were complete, he would either roll and store them or mount them on homemade strainers.

[1] All information for this entry is from Sarno, pp. 9–34, 36–45.

54 Union Square 82.102.1

Karol Kozlowski
Probably Brooklyn, New York, probably 1945–1960
Oil on canvas
26½″ x 79½″ (67.3 cm. x 201.9 cm.)

Union Square is one of two large views of New York City surviving by the artist. The second picture features the Manhattan skyline, is a pencil sketch on a window shade, and is privately owned. Of the two, *Union Square* is less precisely drawn, and the artist positioned some of the streets and buildings to suit his particular needs rather than striving for an entirely realistic view of the place. But many of the buildings

54

and signs just behind the square are, according to New Yorkers, faithful renderings of shops and stores that existed there in the 1940s to 1960s.

The painting has survived in reasonably good condition despite its years of being rolled up and stored in a damp basement of the Urbans' bungalow in Congers, New York. Like all of Kozlowski's canvas and window-shade pictures, it was worked flat on his table in the shed at Huron Street. For some reason, the artist never mounted it on strainers.

Inscriptions/Marks: In red paint across the top of the painting is "5AVE. 6AVE. 7AVE. 8AVE. UNION. SQUARE. 14STREET. 15STREET. 16STREET."
Condition: In 1983 Karin Knight, a graduate student in the Programs for the Conservation of Historic and Artistic Works, Cooperstown, N.Y., unrolled the painting, faced and transferred paint adhering to the canvas reverse, flattened the support, reduced cupping, repositioned and adhered transferred paint, mended tears and holes in the support, provided a fiberglass lining, mounted the painting on a Hexcel panel, and toned and filled numerous losses.
Provenance: Gift of Mr. and Mrs. Abril Lamarque.
Exhibited: "Karol Kozlowski (1885–1969): Polish-American Folk Painter," New-York Historical Society, N.Y., March 16–August 11, 1985.
Published: Sarno, p. 42, no. 18.

55 The Estate 80.102.1

Karol Kozlowski
Congers and/or Brooklyn, New York, 1960–1962
Oil on canvas
31¼″ x 54⅛″ (79.4 cm. x 137.5 cm.)

In the early 1960s, Irene Gronet Urban and her husband, who took care of Kozlowski, built a summer cottage in Congers, New York. They had vacationed in this area for several years before, and Kozlowski would accompany them on their trips. It was probably the countryside and rural setting of the Congers area that inspired the artist to create his earliest and most complex domestic views — *The Estate, Summertime,* and *The Roadside Mill* — all of which are approximately the same size and format, share identical coloration, and incorporate a number of similar architectural details.[1] The visual aspects of the three pictures, as well as the titles assigned by the artist, evoke warm seasons of the year and the peaceful, if not romanticized, notion that such settings epitomized a highly desirable way of life.

Since Kozlowski never talked about the nature of his work in any detail and left no verbal descriptions of his scenes, one can only theorize about what they meant to him. *The Estate,* for instance, might represent the artist's concept of a wealthy family's summer retreat, where leisurely pursuits such as horseback riding, boating, and other activities were commonplace. Such a theme would have been in sharp contrast with Kozlowski's modest, but comfortable, life in the bustling, labor-intensive world of Greenpoint. Thus, views such as *The Estate* were probably visual manifestations of the manicured, leisurely, and enjoyable world that Kozlowski innately yearned for or believed existed for others.

The Estate ranks as one of the artist's most successful paintings because of its fine execution, carefully controlled color values, complex composition, and depiction of a variety of activities. The sweeping curvilinear and intersecting elements so typical of his best work are abundant here, as are wild and domestic fowl and different types of flowering shrubs and trees. Other characteristics of his personal style and method include the undulating clouds at the top; the conical-shaped mountains picked out in varying shades of tan, blue, and gray; the stylized trees; the rich patterning of elements such as leaves, animals, birds; and his small human figures, all of which stare out at the viewer.

Inscriptions/Marks: Lettered at the top in yellow paint is ".THE.ESTATE."
Condition: The painting remains in its original condition, with its wood and metal strainers hand made by the artist. Modern 1-inch flat frame, painted black.
Provenance: Found in the artist's painting shed at Huron Street, Greenpoint, N.Y., by Abril Lamarque in 1962; gift of Mr. and Mrs. Abril Lamarque.
Exhibited: "Karol Kozlowski (1885–1969): Polish-American Folk Painter," AARFAC, January 15–May 13, 1984.
Published: Sarno, pp. 43–45, no. 22, illus. as pl. XII.

[1]*Summertime* and *The Roadside Mill* are privately owned.

John Rasmussen
(1828–1895)

Much available biographical information about the painter John Rasmussen still derives from Berks County (Pennsylvania) Almshouse records, as cited in earlier studies.[1] These reveal that he was born in Germany in 1828 and immigrated to the United States through the port of New York in 1865. Reading, Pennsylvania, directories list him as a painter or fresco painter in the period 1867–1879, and for a time during these years, he was also in the painting business with a son, Charles, at various locations on Franklin and Sixth streets.

Rasmussen's first recorded admission to the Berks County Almshouse is noted as June 5, 1879. At that

55

time, his place of settlement was listed as "none," his occupation as "painter," his civil condition as "widowed," and his drinking habits as "intemperate." It was also noted that he could write his own name, "had frequented houses of prostitution," was "sane" but "not able-bodied," and was suffering from rheumatism. Vagrancy was indicated as his "cause of pauperism." Rasmussen was discharged by the almshouse steward July 10, 1893, but he was re-admitted March 3, 1894, and this time it was noted that he "had been in jail." He died in the institution June 16, 1895, and a daughter-in-law had him buried in Paterson, New Jersey.

Before 1887, when he became too enfeebled with rheumatism to paint, Rasmussen executed portraits, baptismal certificates, still lifes, and a few landscapes, in addition to nine known versions of the building complex that served as his home in his later years. All of the last undoubtedly were intended for almshouse personnel, and all of them were based on an 1878 composition by Charles Hofmann that evidently hung on the premises. A fellow countryman of Rasmussen's, Hofmann had admitted himself to the almshouse in 1872, and his residence there overlapped Rasmussen's by somewhat less than three years. Details of the working relationship between the two men can only be surmised, but Hofmann continued to execute views similar to his earlier painting, and thus to Rasmussen's

derivations, during their joint almshouse residency. In at least one instance, the two also are known to have worked for the same client, John B. Knorr, a clerk in the institution in 1879–1881. Their styles differed, however, for Hofmann rarely graded colors from light to dark, and Rasmussen seemed to delight in doing so. The figures that people Rasmussen's scenes also seem to be more individualistic and believable than many of Hofmann's shadowy representations. Yet both men used a palette of bright colors, and their almshouse portraits depict a neat, orderly society that seems inconsistent with the dismal existence suggested by the skeletal facts of their actual lives. Perhaps, as Tom Armstrong theorizes, they were intent on painting a world as they wished it to be, rather than one as they knew it.

[1]This summary has been adapted from Thomas N. Armstrong, "God Bless the Home of the Poor," *The Historical Review of Berks County*, XXXV (Summer 1970), pp. 86–90; Lipman and Armstrong, p. 108; and the exhibition catalog for Pennsylvania Almshouse Painters.

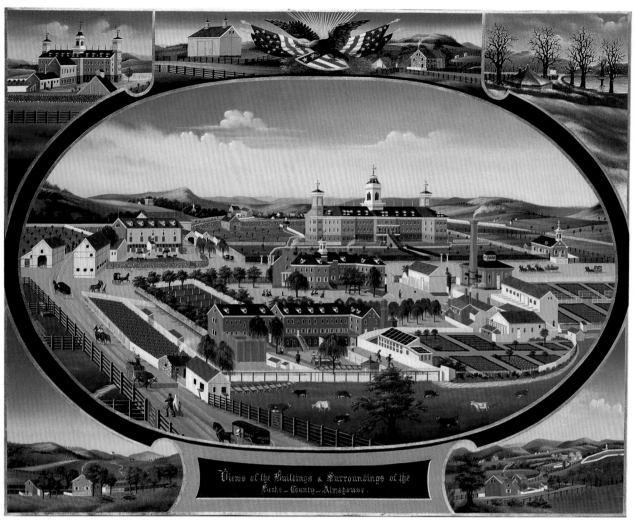

Views of the Buildings & Surroundings of the Berks-County-Almshouse.

56

56 Views of the Buildings & Surroundings of the Berks-County-Almshouse

60.102.2

Attributed to John Rasmussen
Berks County, Pennsylvania, probably 1880–1881
Oil on zinc-coated or tin-coated sheet iron
31" x 39" (78.7 cm. x 99.1 cm.)

Rasmussen painted at least nine versions of this scene, incorporating only slight variations from one to another and apparently basing all upon one of Charles Hofmann's 1878 depictions of the Berks County Almshouse. Hofmann's work probably hung in the institution at the time of Rasmussen's first admittance there in 1879.

Six of Rasmussen's recorded versions are inscribed with his name at lower right, and the other three, in-

cluding this one, are attributed to him on the basis of their similarity to the signed examples. Three of the nine are dated 1880, and two are dated 1881; because of their similarities, it seems likely that all were painted at about this time, although Rasmussen is believed to have worked as late as 1886.

The subjects of the top and corner vignettes are the same in all nine paintings, and although Rasmussen did not identify them on the Folk Art Center's version, others so marked show these almshouse properties to be, clockwise from lower left, tenant house no. II; western view of the new hospital; grain barn; tenant house no. I; kitchen, supplying spring, and reservoir; and tenant house no. III and cemetery.

The most obvious differences among Rasmussen's nine Berks County Almshouse portraits are to be found in the center top and bottom elements; eagles such as that seen here occupy the upper space in six paintings, while the other three examples show a lau-

rel wreath enclosing, in two instances, the names of almshouse personnel, and in one, the poignant plea "God Bless the Home of the Poor." The cartouche beneath the central medallion is inscribed as here in six examples; in the others, it lists the names of almshouse personnel. More subtle differences are to be found within the central medallion, where figures or objects vary slightly, for instance in stance, placement, or clothing details. As yet, no chronology correlating these small changes with dates of execution has been formulated, if indeed one exists.

All of Rasmussen's almshouse portraits are presumed to have been done for staff members at the institution. All are painted on zinc- or tin-coated sheet iron, a support that Hofmann had adopted in 1878 and that he reputedly found in the complex's wagon shop. By corollary, one would assume Rasmussen was similarly supplied and that the almshouse paint shop provided both men with their oil paints, as earlier research has suggested was the case with Hofmann.[1]

Inscriptions/Marks: Painted in the cartouche at bottom center is "Views of the Buildings & Surroundings of the/Berks-County-Almshouse." The words "BAKERY" and "READING/PA." are painted on the wagon in the bottom of the central medallion.
Condition: Unspecified treatment by an unidentified conservator prior to acquisition included inpainting scattered, generally minor paint losses. In 1986 David Goist replaced a sizable area of paint loss in the lower right vignette; inpainted other, smaller scattered losses or retouched existing areas of inpainting; cleaned the painting; and secured it to a Masonite backing. Modern replacement 3-inch molded cyma recta frame, painted black.
Provenance: M. Knoedler & Co., New York, N.Y.; Robert Carlen, Philadelphia, Pa.
Exhibited: Pennsylvania Almshouse Painters, and exhibition catalog; Pine Manor Junior College.

[1]Lipman and Armstrong, p. 106.

Jack Savitsky
(b. 1910)

Jack Savitsky was born on January 24, 1910, in Silver Creek, Schuylkill County, Pennsylvania, the son of John and Anna Savitsky. His father was a farmer, foundry worker, and coal miner. Jack was educated in the local public school and worked as a miner with the Reading Coal, Haddock Mining, and Coaldale Mining companies before his retirement at an undetermined date. Savitsky began painting in his youth, and most of his known works are related to mining, scenes of local interest, or biblical stories.[1] He and his family reside in Lansford, Pennsylvania.

[1]All information for this entry is from Sterling Strauser to AARFAC, June 1971.

57 Miners' Train 71.110.1

Jack Savitsky
Lansford, Pennsylvania, ca. 1970
Oil enamels on plywood
24¾" x 41⅛" (62.9 cm. x 104.5 cm.)

Miners' Train is one of several similar views recalling the typical workday activities that Savitsky knew from firsthand experience in his native Pennsylvania.[1] The large blue building in the background bears the name Silver Creek. The bright colors throughout the picture are typical of Savitsky's work and include a deep me-

57

tallic blue engine with light blue wheels, red gears, and yellow trim. A light pink smoke pours from the stack and diagonally across the complex of bright blue buildings in the background. The yellow moon and the beacon on the train's headlight indicate that this is a night scene. The rows of cone-shaped pine trees just above the train, and the sawtooth-edged hills in the distance, are features seen in other works by the artist.

Inscriptions/Marks: In black paint above the doors in the buildings at lower right are the numbers: "1, 2, 3, 4, 5, 6, 7." Lettered on the train are "Reading," "R.R.," "Miners Train," and "938." The large building in the background bears the words: "Silver Creek."
Condition: The painting remains in its fine original condition. Probably 1971 1-inch flat frame, painted black.
Provenance: Gift of Mr. and Mrs. Alastair B. Martin, Katonah, N.Y.
Exhibited: AARFAC, September 15, 1974–July 25, 1976.
Published: AARFAC, 1974, p. 45, no. 39, illus. on p. 43.

[1]A similar but more elaborate version is owned by Herbert Waide Hemphill, Jr., New York, N.Y.

Paul A. Seifert
(1840?–1921)

The most informative account of Seifert's life and career may be found in reminiscences about him provided by a granddaughter, Myrtle Bennett.[1] He was born into a wealthy family June 11, 1840, in Dresden, Germany, and immigrated to America in 1867.[2] He married Elizabeth Kraft of Richland City, Wisconsin, and settled in nearby Gotham, where he made a living raising fruits, vegetables, and flowers.

Seifert soon took up a secondary career of painting scenes on both paper and glass. At first he worked in his home, but later he had a shop, where he combined painting with the practice of many other arts and crafts, including taxidermy. Some of his portraits of area farms and residences are said to have been completed on the actual sites, where he also helped set out shade trees and other young plants.

The artist's first shop was in Gotham, but later he relocated a mile and a half west of the village. His depictions of neighboring homesteads are precisely designed and meticulously laid out, while broad, sketchy areas of color show a lack of concern for the smooth, even application of his paints. Some scenes have the property owners' names, a location, and the date inscribed in the lower margins, but other paintings are unmarked, and many are now known only as Wiscon-

sin farm scenes. Perhaps he titled such works or not according to clients' wishes.

Seifert painted from the late 1870s until about 1915, and he died in Wisconsin August 8, 1921. He was largely unknown as an artist until his work was published in 1950.[3]

[1]Myrtle Bennett's account is published in Lipman and Armstrong, pp. 160–163, and in a slightly longer version in Lipman and Winchester, Primitive Painters, pp. 149–156. Information for this entry has been taken from Lipman and Armstrong.

[2]The year of Seifert's birth remains questionable. His death certificate, filed August 9, 1921, gives his age as 81 years, 1 month, 28 days, which substantiates Myrtle Bennett's belief in an 1840 birth. However, a family Bible lists his birth as 1846, as does his "Declaration of Intention to Become a Citizen," which Seifert himself filed personally November 18, 1898. The 1880 U.S. Census for Richland County, Wisconsin, gives his age as 33, which, depending upon the date the statistic was taken, could indicate either an 1846 or an 1847 birth. Finally, Seifert's grave marker gives his life span as 1841–1932! The preceding research has been gathered by Norma D. Beckman, a granddaughter of the artist, and is summarized in her letter to AARFAC of October 18, 1985.

[3]Lipman and Winchester, Primitive Painters, pp. 149–156.

58 The Christopher Shirk Farm 71.302.1

Attributed to Paul A. Seifert
Richland County, Wisconsin, probably 1891–1900
Tempera and pencil with gold paint on wove paper
21 15/16" x 27 15/16" (55.7 cm. x 71.0 cm.)

Seifert's colorful farm scene was described as the Christopher Shirk Farm of Gotham (Richland County), Wisconsin, at the time of its purchase. The recent discovery of a closely similar farm scene called *The Chris Shirk Farm* (which is privately owned) lends support to the identification. Comparison between the two shows a number of relatively minor differences, as well as a major distinction among the outbuildings. In the privately owned work, two gray sheds or other buildings occupy the spot where a brown, hipped-roof corncrib and a small white shed stand in the Folk Art Center's example. It is not known which picture was painted first or, specifically, why two were made.[1] A Christopher L. Shirk (1836–1919), who settled in the town of Buena Vista (Richland County) in 1891, may have been the owner of the property depicted. If so, he lived fairly near Seifert.[2]

The hard, precise outlines of many building edges are reflected in ridges on the reverse of the paper, where Seifert's pencil indented the support. He frequently used touches of metallic paint to suggest sunlight or its reflection off other objects. In this case,

58

dashes of gold paint across the sky probably were an attempt to capture the glow of a sunrise or sunset. Seifert created a number of the background trees by laying a brush loaded with green paint flat against the support, then quickly lifting it and repeating the motion slightly to one side.

Condition: The painting appears untouched. Possibly original 2¾-inch molded hardwood frame, later painted black over the earlier stained finish, with gold liner.
Provenance: Mary Allis, Fairfield, Conn.
Exhibited: "American Farm Arts," Shakertown, Pleasant Hill, Ky., September 1–30, 1976.

[1]The similar *Chris Shirk Farm* is not inscribed; it is privately owned by a Seifert descendant.
[2]J. H. Miner, *History of Richland County* (1906), p. 636, as quoted in John O. Holzhueter, State Historical Society of Wisconsin, to AARFAC, June 8, 1982. The unincorporated village of Gotham is located within the town of Buena Vista.

Fritz G. Vogt
(1842–1900)

Records of the Montgomery County Almshouse in Mohawk, New York, indicate that Fritz G. Vogt died there of chronic rheumatism at 2:00 A.M., January 1, 1900, age fifty-eight.[1] He is listed as having been single and as having been born in Germany. Appended to his signature on one of the drawings is the cryptic phrase "Germ. Professor." Few other facts about his life are known, but the recorded comments of several elderly New York State residents who actually remember Vogt reveal that he was short, loved children, played the organ, and had a drinking problem. He is also said to have refused rides from place to place, preferring instead to walk, and to have accepted room and board in partial — if not sometimes total — payment for his drawings.

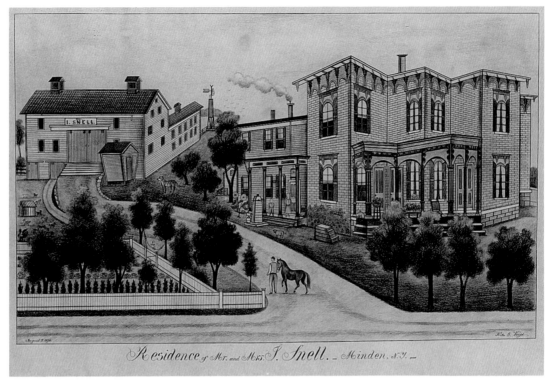

Residence of Mr. and Mrs. I. Snell. — Minden. N.Y. —

59

Vogt generally signed his depictions of farms, town houses, and other buildings at lower right and dated them at lower left. Many are identified in a lower margin inscription also giving the building or farm owner's name and town and sometimes county of residence. Vogt drawings dated from September 25, 1890, to June 15, 1899, have been recorded, and these depict buildings in Herkimer, Montgomery, Schoharie, Otsego, and Fulton counties in upstate New York. Many are executed solely in graphite, but others have been tinted with oil-based colored pencils. Thus far, the reason for coloring some and not others is unknown. One assumes that Vogt charged more for his colored drawings than for his black-and-white ones, but this has not yet been substantiated.

Vogt frequently subordinated principles of perspective to his greater objective of conveying as much architectural information as possible. In a further display of selective realism, he pointedly deleted any reference to the drudgery of wresting a living from the land. Tools and machinery are strangely absent from his rural farmscapes, and regardless of the time of year noted in his inscriptions, it is always a sunny summer day in his depictions. The signs of tidy, well-ordered existence abound, yet Vogt would have us believe that none of this tranquility was achieved by the sweat of the brow. Instead, his drawings summarize an idyllic

existence, one presumably based on his concept of the virtues inherent in rural America in the 1890s.

[1]Much of the material in this summary has been adapted from Karen Wells Lamont, "Fritz G. Vogt: Itinerant Artist"; and Frank A. Scheuttle, "Fritz G. Vogt: the Brookman's Corners Drawings" — both in *New York Folklore Quarterly*, I (Summer 1975), pp. 45–74.

59 Residence of Mr. and Mrs. I. Snell 78.202.1

Fritz G. Vogt
Minden, New York, August 4, 1896
Graphite and colored pencils on wove paper
26¹⁵⁄₁₆″ x 39½″ (68.4 cm. x 100.3 cm.)

This drawing is typical of Vogt's close attention to architectural detail, his disregard of one-point perspective and scale, and his depiction of the upstate New York farm as a scene of rural contentment and prosperity. Graphically illustrating the latter are the farm's immaculate grounds, well-kept garden, pecking chickens, contented domestic pets, potted plants, cheerful sunflowers, and the image of a man in a hammock.

Vogt concentrated his powers of observation on the house, outbuildings, and grounds in the best manner of farm portraiture. Notice particularly his detailed treatment of the Italianate house's windows,

60

eaves, and porches, the prominent placement of the corncrib, and the cupolas, hardware, and banked-earth, second-story entry to the Dutch barn. A distorted perspective of the barn's wing conveniently enables us to glean an idea of its impressive size. As in all Vogt's drawings that include human figures, the Snell family members are shown as subordinate to their setting. Dwarfed by house and farm, frozen and expressionless, they offer only a token reference to the source of the scene's harmony and orderliness.

Inscriptions/Marks: "Fritz G. Vogt." appears in penciled script in the lower right corner of the composition. "August 4. 1896." appears in penciled script in the lower left corner of the composition. "Residence of Mr. and Mrs. I. Snell. — Minden, N.Y. — " appears in penciled script in the lower margin. Penciled in block letters on a sign over the barn doorway is "1866/I. SNELL."

Condition: Unspecified treatment prior to acquisition included the attachment of hinges along the support sides. In 1978 E. Holly-day rehinged the support to a nonacidic backing. In 1978 the original 4½-inch flat frame of alternating gold- and brown-painted molded strips and golden oak bands was replaced with a 2½-inch modern replacement, black-painted frame with cyma recta moldings and raised corner blocks.

Provenance: Richard and Eileen Dubrow, Whitestone, N.Y.

Exhibited: "New York: The State of Art," Albany, N.Y., October 8–November 27, 1977, and exhibition catalog, no. 141.5, illus. on p. 19.

Unidentified Artists

60 Ship with Paper Border 58.111.3

Artist unidentified
America, probably 1805–1825
Oil on canvas
36½" x 45" (92.7 cm. x 114.3 cm.)

The printed paper strips glued to the outer edges of this canvas form an interesting and unusual border for an oil painting. The canvas seems not to have had a conventional wooden frame originally, but the strips offer a visual substitute for one.

The ship itself appears to be the type of frigate used in the first navy of the new American republic, but the simplification of the artist's rendering makes more specific identification and comment untenable. Nevertheless, a lively sense of motion is conveyed by the foamy waves, billowing sails, and streaming flags.

Condition: In 1963 Russell J. Quandt cleaned the painting, replaced the strainers, lined the canvas, and inpainted scattered areas of paint loss, the most significant occurring in the sky along the left

side and in the sky to the right of the right mast. Following Christa Gaehde's 1961 treatment of the paper edge strips, which included filling and inpainting numerous large areas of loss, Quandt also adhered the strips to aluminum backings and reaffixed them to the painting. Modern edge frame of lath strips, painted black.

Provenance: J. Stuart Halladay and Herrel George Thomas, Sheffield, Mass.

Exhibited: AARFAC, American Museum in Britain; AARFAC, June 4, 1962–November 20, 1965.

61 The Yellow Coach 32.101.3

Artist unidentified
America, probably 1815–1835
Oil on canvas
33⅝" x 36⅛" (85.4 cm. x 91.8 cm.)

The Yellow Coach is a favorite painting from Mrs. Rockefeller's original collection. There is clear evidence of an amateur's hand, yet it is a lively and intriguing work. The vehicle body provides an eye-catching spot of color, while the composition is effectively balanced by the bulk of the house set in a grove of trees. The coach's swift motion is indicated by tas-

seled handgrips that fly out behind it and by the horses' galloping postures. Yet in a rather unconventional manner, the carriage moves out of the picture, rather than into it, and one wonders why it departs so hastily without an occupant.

Interesting architectural details of the house, such as its scalloped cornice, crossbar window sashes, paneled doors, and fanlights, hold the viewer's attention and distract concentration from the artist's inability to render correct one-point perspective. The side door of the house is depicted in such a way as to suggest marbleizing.

Condition: Unspecified treatment by David Rosen in or before 1935 and by Russell J. Quandt in 1955 included replacing the auxiliary support; cleaning and lining the canvas; and inpainting several large scattered areas of paint loss, the most notable being a 15-inch long vertical strip in the sky over the coachman's head. Period replacement 4¼-inch splayed gold-leafed frame with flat outer edge.

Provenance: Mr. and Mrs. Elie Nadelman, New York, N.Y.; Edith Gregor Halpert, Downtown Gallery, New York, N.Y.

Exhibited: AARFAC, September 15, 1974–July 25, 1976; American Folk Art, Traveling.

Published: AARFAC, 1940, p. 21, no. 35 (titled *Southern Scene*); AARFAC, 1947, p. 16, no. 35 (titled *Southern Scene*); AARFAC, 1957, p. 106, no. 56, illus. on p. 107; AARFAC, 1974, p. 53, no. 49, illus. on p. 16; AARFAC, 1975, illus. on p. 6.

61

62

62 The Picket Fence 32.302.1

Artist unidentified
America, probably 1828–1835
Watercolor on wove paper
13¹⁵/₁₆″ x 18¼″ (35.4 cm. x 46.4 cm.)

The existence of a virtually identical watercolor composition raises the possibility that this rendering of an unidentified locale may have been copied from a print.¹

Inscriptions/Marks: The watermark in the primary support is "J WHATMAN/TURKEY MILL/1828."
Condition: Treatment by Christa Gaehde in 1956 included backing with Japanese mulberry paper, cleaning, and mending edge tears. In 1977 E. Hollyday dry-cleaned unpainted surface areas and mended edge tears. Period replacement 1½-inch splayed gilded frame with quarter-round outer edge.
Provenance: Found in Bridgeport, Conn., and purchased from Edith Gregor Halpert, Downtown Gallery, New York, N.Y.
Exhibited: American Folk Art, Traveling.
Published: AARFAC, 1957, p. 363, no. 274.

¹The similar watercolor is privately owned; it was acquired by its present owners along with a watercolor of a bird signed by Anne Randall. It is not known whether Randall also painted the house portrait related to *The Picket Fence.*

63 The Mill 33.302.1

Artist unidentified
America, ca. 1830
Watercolor on wove paper
9½″ x 13⅞″ (24.1 cm. x 35.2 cm.)

The predilection for greens, blues, golds, and earth-tone colors reflects an early nineteenth-century proclivity seen in needlework pictures as well as watercolors, but the muted, gray-toned hues of this picture give it an atypical somber appearance that is emphasized by some fading.

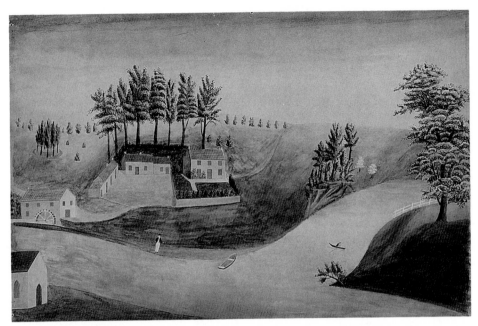

63

64

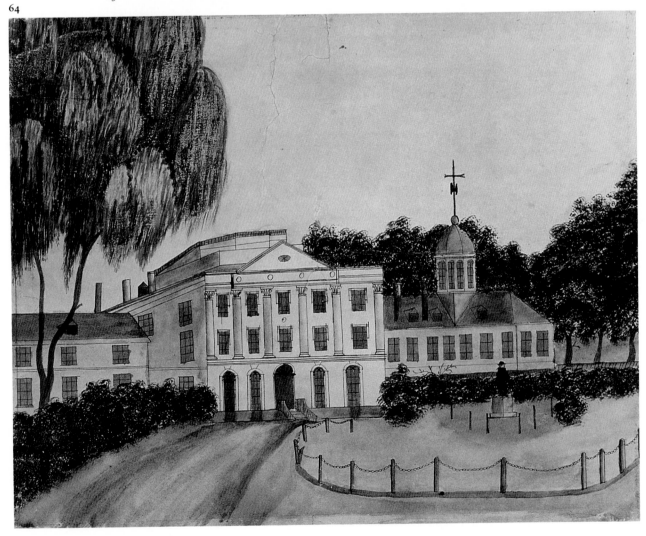

Condition: Treatment by E. Hollyday in 1974 and 1979 included surface dry cleaning, mending small edge and corner tears and nail holes, inpainting small areas of paint loss, and backing the support with Japanese mulberry paper. Unspecified treatment was accomplished at an earlier date by an unidentified conservator. Period replacement 1⅝-inch, cove-molded gilded frame.

Provenance: Isabel Carleton Wilde, Cambridge, Mass.; John Becker, New York, N.Y.

Exhibited: AARFAC, September 15, 1974–July 25, 1976; Washington County Museum, 1965.

Published: AARFAC, 1957, p. 188, no. 94, illus. on p. 189; AARFAC, 1974, p. 42, no. 36, illus. on p. 41.

64 The Pennsylvania Hospital 31.302.3

Artist unidentified
America, ca. 1835
Ink and watercolor on wove paper
6¾" x 8¾" (17.2 cm. x 22.2 cm.)

The design source for this view of the Pennsylvania Hospital probably was a print engraved by Cephas G. Childs, after a drawing by George Strickland, that Childs first published in *Views of Philadelphia and Vicinity* in 1827. Three years later a similar edition, titled *Views of Philadelphia and Its Environs from Original Drawings Taken in 1827–1830,* was issued and included the same view. Smaller volumes on the same subject were published in subsequent years and used the same view in a reduced size.[1]

The Childs print and this unidentified artist's rendering after it show the hospital's original main entrance, which was reached from Pine Street. The statue in the right foreground represents William Penn, and it was presented to the hospital in 1804 by his nephew, John Penn.[2]

The Pennsylvania Hospital was founded by Benjamin Franklin and other Philadelphia gentlemen in 1751, and its construction commenced in 1755.[3] The building was the first of its kind established in the American colonies.[4] The original structure still stands on Eighth and Spruce streets as part of the hospital's greatly enlarged complex.

Much of the detail provided by the unidentified artist was achieved through the use of a straightedge and pen and ink. Other areas, such as the foliage on the trees, the shrubbery, and the capitals of the Corinthian columns, were quickly and freely rendered with pen and ink and watercolors. The uneven quality of the painted areas and the inaccurate perspective of the building suggest that the picture was executed by an amateur for personal enjoyment or by a schoolchild as a class assignment.

Condition: Unspecified restoration by an unidentified conservator included backing the drawing with a sheet of rag paper. Con-

servation treatment by E. Hollyday in 1980 included removing wood strips nailed to edges, cleaning, repairing tears at top center and center, and setting down flaking paint. Modern replacement 1¼-inch flat brown-painted frame with molded inner edge.

Provenance: Found in Boston, Mass., and purchased from Edith Gregor Halpert, Downtown Gallery, New York, N.Y.

Exhibited: AARFAC, New Jersey.

Published: AARFAC, 1957, p. 166, no. 83, illus. on p. 167.

[1]Mabel Zahn to AARFAC, June 14, 1955. The 1830 edition was also published by Cephas C. Childs, engraver, at 80 Walnut Street, Philadelphia.

[2]Dolores Ziff, Director of Public Relations for the Pennsylvania Hospital, to AARFAC, April 14, 1970.

[3]Cephas G. Childs, *Views of Philadelphia and Its Environs from Original Drawings Taken in 1827–1830* (Philadelphia, 1830), p. F and following.

[4]Ibid.

65 New Hampshire Farm Scene 67.102.1

Artist unidentified
Possibly Antrim, New Hampshire, probably
1845–1875
Oil on canvas
24⅝" x 31¼" (62.6 cm. x 79.4 cm.)

The former owner believed this painting represented a scene in Antrim, New Hampshire, but verification of the locale has not been made. The date 1845 on the barn at right probably does not refer to the date of the picture but only to the year of the building's construction; many barns in New York and New England are so inscribed. It is not known why one of the men in the picture is standing on a shed roof and peering into a second-story window of the adjacent house. Note the curious entry tucked into the ell of the house and the grave in the right foreground, marked by a cross in a mound of stones.

Inscriptions/Marks: Painted above the door of the barn at far right is "1845." Writing on the sign on the distant building is illegible.

Condition: In 1968 Russell J. Quandt cleaned the painting, lined it, replaced the stretchers, and inpainted small areas of loss, particularly in the sky at upper left. Modern 3-inch splayed mahogany frame with raised molded edges and gold liner.

Provenance: Morgan Burns, Henniker, N.H.

Exhibited: AARFAC, South Texas; Goethean Gallery.

Published: Brown, illus. on p. 735.

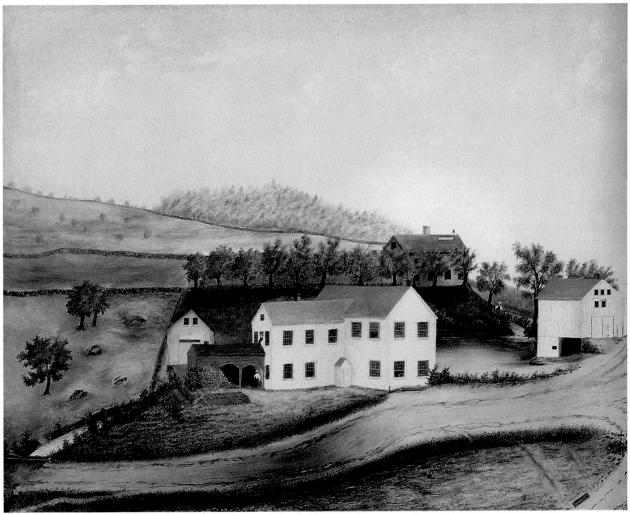

65 *New Hampshire Farm Scene*

66 **The *Charles Belcher*** 56.111.1

Artist unidentified
Possibly St. Louis, Missouri, probably 1852–
1854
Oil on canvas
40″ x 75⅜″ (101.6 cm. x 191.5 cm.)

The unidentified artist's delight in decorative pattern
is apparent in his painstaking depiction of the side-
wheeler's tightly stacked fuel wood and stylized clus-
ters of curling smoke. He probably was commissioned
to execute the *Charles Belcher*'s portrait by her owner
or by the captain who commanded her during her brief
lifespan.

 The six-boiler, paddle-wheel steamboat *Charles
Belcher* was constructed in St. Louis in 1852 over the
extant hull of an older boat, the *Magnolia,* originally

built in Hannibal. Despite the painting's inscription,
customs officials measured the remodeled boat at 823
tons. At the time of completion, the *Charles Belcher*
was considered the finest boat on the St. Louis–New
Orleans trade route, where she was used to transport
sugarcane from Louisiana to a St. Louis refinery con-
trolled by William H. Belcher (1811–1866) and his
younger brother Charles.

 Superstitious Mississippi rivermen held that boats
christened with names beginning with *M* were doomed
to short lives. Thus, when Captain John N. Bofinger
discovered the *Charles Belcher*'s history entwined with
that of the *Magnolia,* he declined to pilot the boat, and
command was assumed by a Captain Carlisle. Bofin-
ger's premonitions proved valid, for on her sixth trip,
the *Charles Belcher* burned at wharf in New Orleans
on February 4, 1854, at which time she was valued at
$94,000 and her cargo at $200,000.[1]

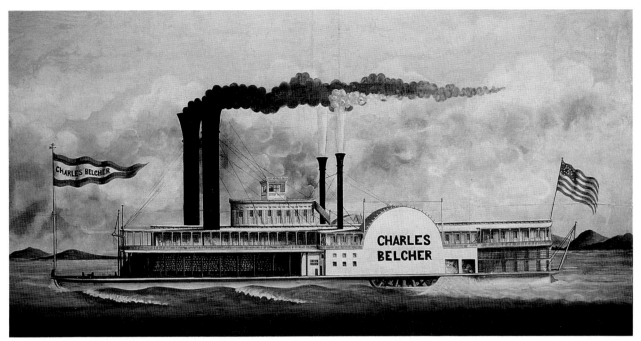

66 *The* Charles Belcher

Inscriptions/Marks: Painted in the canvas's lower margin is "THIS MAGNIFICENT STEAMBOAT IS OF 14,00. TONS, AND $90,000 COST." "CHARLES BELCHER" is painted on the forward pennant and on the side of the pilot house, while "CHARLES/BELCHER" is on the side-wheel cover. Mock writing reminiscent of "CHARLES BELCHER" is on the front of the pilot house.

Condition: Conservation by John F. Venuti in 1956 included lining the canvas, replacing the auxiliary support, and inpainting numerous small scattered areas of paint loss. The painting is unframed.

Provenance: Old Print Shop, New York, N.Y.

[1]The *Charles Belcher*'s tonnage is taken from Marion Brewington, Peabody Museum, to AARFAC, June 17, 1958. Otherwise, information in this entry is taken from W. G. Rule, Boatmen's National Bank of St. Louis, to the Old Print Shop, July 25, 1956; and from E. W. Gould, *Fifty Years on the Mississippi, or Gould's History of River Navigation* (St. Louis, 1889), p. 682.

67 Hotel Schoharie 58.101.7

Artist unidentified
Schoharie County, New York, probably 1852–1865
Oil on canvas
24⁵⁄₁₆" x 36⅛" (61.8 cm. x 91.8 cm.)

The inn pictured still stands about three miles west of Gallupville in Schoharie County, New York. It was called the Yankee Pete Tavern as early as 1802, when it was owned and operated by Peter Mann Snyder (1777–1852). Owner and inn received their

nicknames from the fact that local German-speaking merchants depended upon Snyder for translating their dialogues with passing Yankee (English-speaking) traders.

In his latter years, Snyder lived with his son Philip, and the inn was left to Philip when Peter died in 1852. It is not known at what point the building was named the Hotel Schoharie, but Philip continued to operate it as an inn for several years after he inherited it.[1]

At upper right in the painting, Philip Snyder's name appears, probably as proprietor, not painter. Clearly the work was intended as a record of Snyder's property, particularly the inn's appearance. The apparently unrelated horse-drawn wagon at lower right conveys a sense of thruway activity; its brightly colored wheels and body also add pleasing color notes that relieve the composition's basic earth tones, as does the red dovecote over the horse shed at left. August-growing mullein and teasel help fill in the broad expanse of dirt road and contribute foreground interest.

Inscriptions/Marks: In black paint in script at upper right is "Philip: Snyder/Hotel. Schoharie." The square platform under the arrow weather vane in front of the inn bears the lettering "SNYDER" on its front face and the partially legible date "18[illegible material]" on its left face.

Condition: In 1958 Russell J. Quandt cleaned and lined the canvas, replaced the auxiliary support, and inpainted scattered small areas of paint loss, as well as larger areas at upper and right edges resulting from stretcher pressure and a 5½-inch horizontal loss through the sky above and to left of the dovecote. Period replace-

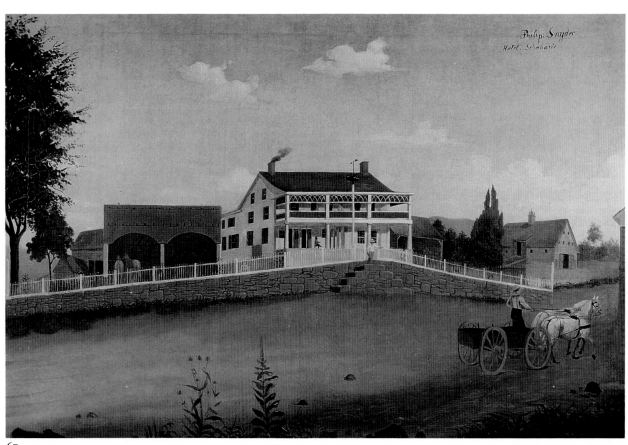

67

ment 3⅛-inch, mahogany-veneered cyma reversa frame with gold-painted liner.

Provenance: J. Stuart Halladay and Herrel George Thomas, Sheffield, Mass.

Exhibited: AARFAC, Minneapolis; AARFAC, New York, and exhibition catalog, no. 26; AARFAC, June 4, 1962–November 20, 1965; AARFAC, September 15, 1974–July 25, 1976; Halladay-Thomas, Albany, and exhibition catalog, no. 13; Halladay-Thomas, New Britain, and exhibition catalog, no. 81; Halladay-Thomas, Pittsburgh, and exhibition catalog, no. 50; Halladay-Thomas, Syracuse, and exhibition catalog, no. 20; Halladay-Thomas, Whitney, and exhibition catalog, p. 33, no. 50; Museums at Sunrise.

Published: AARFAC, 1974, pp. 51 and 53, no. 47, illus. on p. 50; Kathleen W. Proper, "The 'Yankee Pete' Tavern, Schoharie, 1802," *Schoharie County Historical Review,* XXIII (Fall–Winter 1959), p. 5, and illus. on cover.

¹Information about Peter Snyder and the inn comes from Kathleen W. Proper, "The 'Yankee Pete' Tavern, Schoharie, 1802," *Schoharie County Historical Review,* XXIII (Fall–Winter 1959), pp. 3–6. This source reveals that, at least by the 1880s, the structure had become a private dwelling.

68 Locomotive *Star* 58.310.3

Artist unidentified
America, ca. 1857
Watercolor and pencil on wove paper
17¹³⁄₁₆″ x 23¼″ (45.2 cm. x 59.1 cm.)

America's mid-century love affair with the machine is graphically illustrated by dozens of painstakingly drawn lithographed broadsides advertising the latest in technological developments by the country's various locomotive works. Minute attention to detail reflected both public fascination with the intricacies of this booming method of transportation and manufacturers' pride in creating the newest, most efficient, and fastest engines possible. Embellishments of form and surface decoration sprang from a time-honored tradition of coach and ship ornamentation, and in the case of locomotive manufacture, they underscored Americans' romanticized view of technological innovation. Lithographs frequently were brilliantly colored to catch the eye and convey more accurately the gay appearance of their actual subjects.

This watercolor rendering probably was derived from such a widely circulated period lithograph; of those recorded to date, it appears closest in form to a depiction of the *Young America*, a locomotive produced by Breese, Kneeland & Co. of Jersey City, New Jersey, between 1852 and 1857.[1] Since several *Star*s were known in America, the exact identity of the locomotive represented here is uncertain. The amateur artist may have given the drawing a fanciful, possibly imaginary name.

Inscriptions/Marks: "STAR" is lettered on the side of the engine. "BRISTOL/BOARD" appears in an oval blind stamp with a spray of foliage at lower left.

Condition: Treatment by Christa Gaehde in 1958 included cleaning, removing an acidic backing and adhesive tape, and repairing one edge tear on either side. Treatment by E. Hollyday in 1974 included dry-cleaning unpainted areas. Probably period replacement 1⅛-inch, ripple-molded frame, painted brown.

Provenance: J. Stuart Halladay and Herrel George Thomas, Sheffield, Mass.

Exhibited: AARFAC, American Museum in Britain; AARFAC, Minneapolis; AARFAC, June 4, 1962–April 17, 1963; AARFAC, September 15, 1974–July 25, 1976; Halladay-Thomas, Albany, and exhibition catalog, no. 39; Halladay-Thomas, New Britain, and exhibition catalog, no. 80; Halladay-Thomas, Pittsburgh, and exhibition catalog, no. 57; Halladay-Thomas, Syracuse, and exhibition catalog, no. 36; Halladay-Thomas, Whitney, and exhibition catalog, no. 56; "The Railroad in American Art," Washington County Museum of Fine Arts, Hagerstown, Md., October 4–November 30, 1968, and exhibition catalog, no. 43, and illus. on cover; Smithsonian, American Primitive Watercolors, and exhibition catalog, p. 7, no. 25.

Published: AARFAC, 1974, p. 38, no. 31, illus. on p. 39; Ford, *Pictorial Folk Art*, illus. on p. 119; Patricia Boyd Wilson, "Steam Engines and Zero," *Christian Science Monitor*, December 7, 1964, p. 12.

[1]A lithograph of Breese, Kneeland's *Young America* is illustrated in *The Old Print Shop Portfolio*, III (December 1943), p. 90. For more information about the manufacturing firm, see John H. White, Jr., *American Locomotives 1830–1880: An Engineering History* (Baltimore, 1968), pp. 24, 330, 341, 342, 343.

68

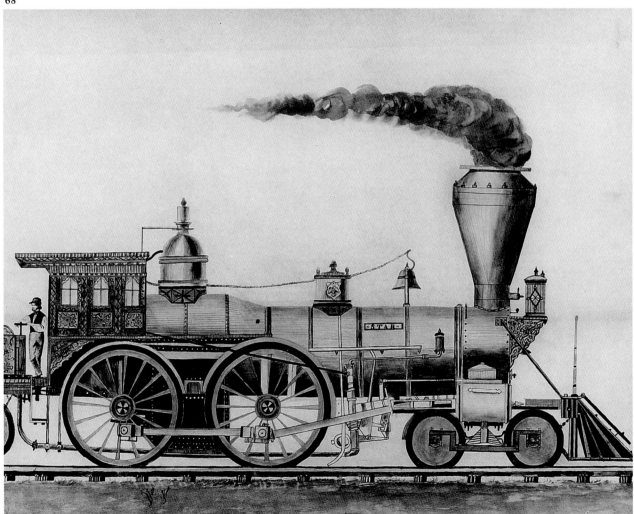

69 The Schooner *Freddie L. Porter* 62.111.1

Artist unidentified
America, probably New England, probably
1865–1888
Oil on canvas
20″ x 26⅝″ (50.8 cm. x 67.6 cm.)

The *Freddie L. Porter* was built in Portsmouth, New Hampshire, in 1865, and made of oak with iron and copper fastenings.[1] Originally she was built as a two-masted schooner, but by 1874 she had been converted into a three-master, a common practice intended to make larger two-masted vessels more manageable. The *Freddie L. Porter* served a number of different owners and masters, being last registered to J. H. McIntyre of Boston in 1887. However, *Lloyd's Universal Register* for 1888 indicates that, by that year, she had been docked and abandoned.

Inscriptions/Marks: "Freddie L. Porter" is inscribed in white paint at lower center on the front of the canvas. An illegible signature in the lower right corner is discernible only under ultraviolet fluorescence.

Condition: Treatment by an unidentified conservator prior to acquisition included inpainting small scattered areas of paint loss, the most significant occurring above and below the lower center inscription and in the schooner's bow decoration. The canvas retains its original tacking edge and is supported by its original pine strainers. Modern replacement 1⅝-inch molded, splayed frame, painted black, with natural wood liner.

Provenance: Old Print Shop, New York, N.Y.

Exhibited: Hollins College, 1974, and exhibition catalog, no. 14.

[1]The information for this entry has been taken from C. S. Laise, Mariners Museum, to AARFAC, March 13, 1974.

69

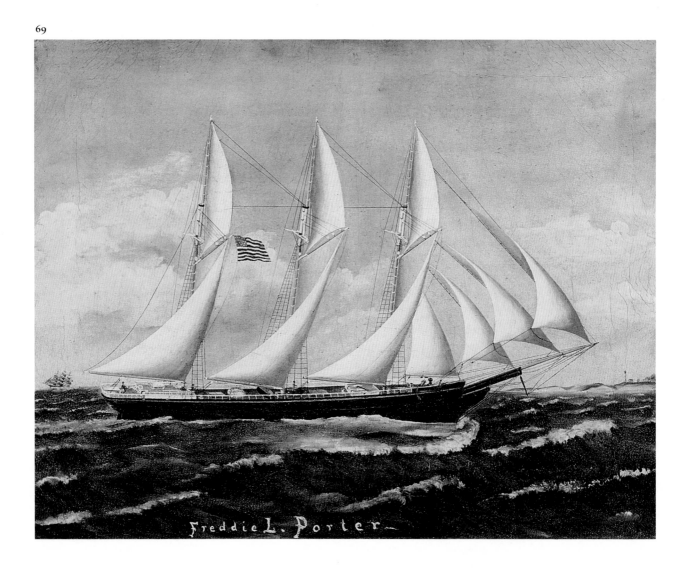

70

70 Victorian House 58.302.2

Artist unidentified
America, ca. 1885
Watercolor, gouache, and ink on wove paper
15¾" x 19½" (40.0 cm. x 49.5 cm.)

Sharp, crisp outlines and precisely drawn details give the superficial illusion that this house portrait is the work of an experienced draftsperson. Yet examination of the architectural lines reveals no adherence to principles of one-point perspective. Instead, two views are shown simultaneously, as in the single-plane depiction of the side and front of the house and in the attachment of the shed.

Closed shutters and the absence of a background give the house a forlorn, isolated appearance. An easily overlooked feature consists of four tree stumps in the front yard, each carefully positioned behind a fence paling and possibly pruned to encourage hedge growth.

Condition: Treatment by E. Hollyday in 1981 included removing masking tape, dry cleaning of front and back, repairing edge tears, minor inpainting, and backing with Japanese mulberry paper. Possibly original ⅞-inch molded hardwood frame.
Provenance: J. Stuart Halladay and Herrel George Thomas, Sheffield, Mass.
Exhibited: AARFAC, New Canaan.

II Scenes of Everyday Life

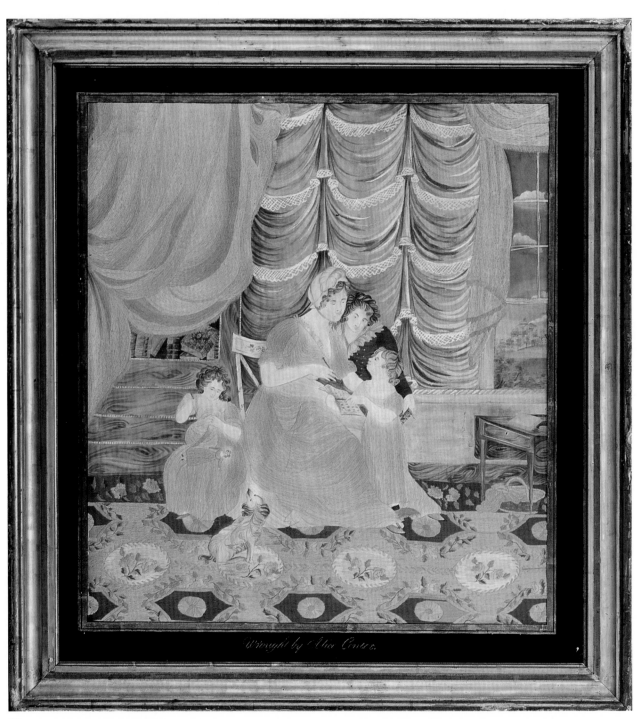

*T*he compositions of many of the pictures grouped here ultimately derive from printed images, yet all show persons engaged in commonplace activities: harvesting, dancing, sewing, playing, teaching, healing, and more. Many such vignettes are contained within paintings and drawings placed elsewhere in this volume because of the predominance of other elements, and the reader should look for them throughout. For instance, many town views, landscapes, and portraits of individuals' homes and businesses contain realistic and enlivening passages of people employed in daily pursuits, and these can be as helpful to the social historian as works that more obviously focus on the activities represented. Note, for example, such details in Hidley's works (nos. 15, 16, 17), in Hamilton's *Charleston Square* (no. 10), or in Hofmann's rendering of the Van Reed holdings (no. 52) — all of which are illustrated in preceding sections of the book. Some of Lewis Miller's drawings (contained in a separate section by themselves) are also classifiable as genre depictions and are especially important for their spontaneity and directness.

Genre works that were drawn from life or actual experience naturally offer the most revealing glimpses of how our ancestors lived. They often describe more vividly than written accounts how livelihoods were made and leisure enjoyed, and through them, numerous details of life in the past are made apparent. Compositions based on print sources can relay much information about the copyist, particularly when deviations from the source were introduced to suit personal needs or wishes; aesthetically they may even surpass their sources. Yet in terms of the activities depicted, unless radical changes are made, derivations almost always reveal more about the original artist's perceptions of life than the copyist's and so must be used advisedly as documents of social history.

Thomas Buckman
(?–1882/3)

Like their date of execution, attribution of two of the Folk Art Center's paintings to Thomas Buckman of Lynn, Massachusetts, has been based on family history passed on by the immediately preceding owner, the Old Print Shop of New York City. This information has never been substantiated, although much has been discovered about two such men, one of whom may well have been the Center's artist.

Two Thomas Buckmans (or, interchangeably, Bucknams), possibly father and son, lived and worked in Lynn in the mid–nineteenth century. In 1841 Thomas J. was listed in directories as a carriage painter and wheelwright on Franklin Street. In 1851 he was joined at that address by Thomas M., a carriage painter. In 1854 Thomas J. was again listed as a carriage painter on Franklin Street; Thomas M. apparently lived at that address but carried on a separate carriage-painting business on Willow Street.

In 1856, still on Franklin Street, Thomas J. was described as a livery stable operator, his occupation thereafter. Thomas M. had moved out of the Franklin Street building by this time but was still working as a carriage painter on Willow Street. By 1858 he had settled several blocks away. In 1863 Thomas M. undertook work for J. A. J. Sawyer, Lynn's carriage manufacturer, as a semi-independent carriage painter. By 1882 he had moved his place of business — and possibly his residence — still listed as a carriage painter. He died on May 31, 1882. In the succeeding year, on February 26, 1883, Thomas J. died. He had retired by 1873 but had continued to maintain his Franklin Street home.[1]

[1]All information in this entry is from Susan M. Eastwood, Lynn Historical Society, Inc., to AARFAC, April 29, 1975.

71	**November Harvest**	59.101.1
72	**January: Night at the Inn**	59.101.2

Possibly Thomas Buckman
Possibly Lynn, Massachusetts, probably 1854/5–1860
Oil on canvas
17″ x 22″ (43.2 cm. x 55.9 cm.)
17¼″ x 21½″ (43.8 cm. x 54.6 cm.)

The pair of paintings appear in identical original frames, which has led researchers to believe that a third painting in a virtually identical frame may also be the work of Buckman.[1] The third painting, which shows three sailing vessels on a tossing sea, is not dissimilar to the Folk Art Center's two canvases in terms of execution, and except for the spacing of its applied ornamentation, the frame is quite like those seen on the Center's two Buckmans. A New York City canvas stamp on the third picture can be dated to the period 1851–1854, thereby lending credence to an 1850s date for the Folk Art Center's pictures.

Compositionally, the Folk Art Center's two paintings are fairly close copies of engravings that appeared in a popular periodical of the day. For some time, *Gleason's Pictorial Drawing-Room Companion* ran engravings symbolizing the particular months of the periodical's issue on its title pages. On November 4, 1854, it carried an engraving by William J. Pierce that apparently inspired Buckman to re-create the scene in oil (no. 71).[2] Buckman's most significant alterations included making the kneeling boy in the foreground black instead of white and adding a spotted dog lying at the oxen's feet.

The inspiration for no. 72 was an engraving by an unidentified artist that appeared on the title page of the periodical (whose name had since been changed to *Ballou's Pictorial Drawing-Room Companion*) for January 6, 1855. Again, the painting and engraving are very similar in terms of composition. One notable change here is that Buckman added the words "Bewick House" to the inn sign in his picture, whereas the signboard in the engraving is blank. The significance of the name has not been determined.[3]

Inscriptions/Marks: The inn sign in no. 72 is lettered: "BEWICK/ HOUSE."

Condition: Unspecified treatment by Russell J. Quandt in 1963 included cleaning the paintings, lining the canvases, filling and in-painting scattered very minor areas of paint loss, and replacing the auxiliary supports. The frames on both paintings are original; that on no. 71 measures 4⅜ inches in width, that on no. 72 is 4⅝ inches. Both are cyma recta moldings painted black, with gold paint applied to flat outer edges and to applied cast-lead ornamentation in the form of a rope twist over the inner edges and scrolling foliate designs in the central sections of each frame member. The applied metal ornament is nailed onto the faces of the frames. The frames are also painted black on the reverse, and the miter joints are reinforced on the reverse with strips of linen glued over them. In the center of each top frame member, a 2⅝-inch-wide strip of twill-weave, black oil-cloth is tacked to the reverse, apparently as a hanging device.

Provenance: Found in South Chatham, Mass., and purchased from the Old Print Shop, New York, N.Y.

Exhibited: Number 71 only: "American Farm Arts," Shakertown, Pleasant Hill, Ky., September 1–30, 1976.

Published: Number 71 only: Joseph Kastner, "The Conundrum of Corn," *American Heritage,* XXXI (August–September 1980), illus. on p. 21.

[1]The third painting is owned by the Heritage Plantation of Sandwich, Mass.

[2]The issue was vol. VII, no. 18 (whole no. 174). Most of the engravers of these depictions of the months remain unidentified, but the

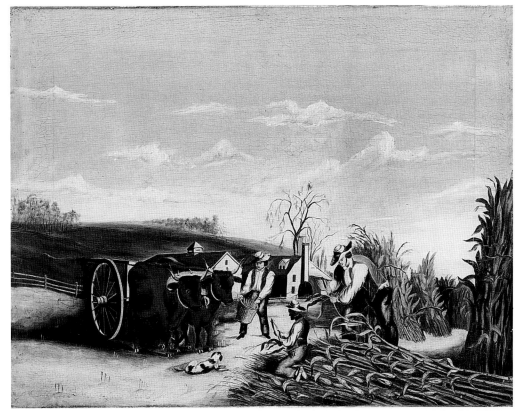

71

72

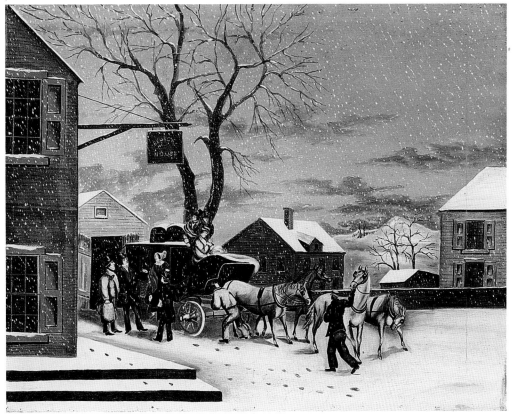

print for November is inscribed within the cornstalks at lower center: "Peirce Sc" (for "Peirce sculpsit"). Cynthia English, Boston Athenaeum, to AARFAC, May 13, 1985, identifies this engraver as William J. Pierce (or Peirce), who is listed in Groce and Wallace, p. 505. AARFAC owns an impression of the engraving (acc. no. 59.1100.3).

[3] The issue of the January engraving is vol. VIII, no. 1 (whole no. 183). AARFAC owns an impression of the print (acc. no. 59.1100.4).

Alice Center
(ca. 1797–before 1866)

A daughter of Cotton and Margaret Taylor Center, Alice was baptized in the First Church of Charlestown, Massachusetts, on March 26, 1797.[1] Her older sister Hannah died in 1836 leaving eight children. Alice married the widower, Marshall Johnson, in Boston in 1837.[2] Johnson operated a West India–goods store and a tavern in Charlestown. Alice Center Johnson probably died prior to 1866, when her husband's will was probated and made no reference to Alice.[3]

[1] Betty Ring to Bassett Hall, September 2, 1980, citing James F. Hunnewell, *A Century of Town Life: A History of Charlestown, Massachusetts, 1775–1887* (Boston, 1888).

[2] *Columbian Centinel*, November 9, 1836, and March 1, 1837.

[3] Thomas Bellows Wyman, *Genealogies and Estates of Charlestown in the County of Middlesex and Commonwealth of Massachusetts, 1629–1818* (Boston, 1879), vol. II, p. 562. The administration of the estate of Marshall Johnson, 1866, is recorded in the probate records of Suffolk County, Mass. (case no. 46919). The biographical information cited above was located by Betty Ring.

73 Family Group 79.601.3

Alice Center
Probably Boston, Massachusetts, ca. 1812
Silk embroidery and watercolor on silk with applied transparent panels (probably mica)
21½" x 19¾" (54.6 cm. x 50.2 cm.)
(Reproduced on page 106)

Alice Center probably completed this embroidered and painted scene while attending a school for fashionable young ladies in the Boston area. She combined closely worked embroidery in the draperies, clothing, and floral-patterned carpet with almost equal areas of painted details — wallpaper with lace-edged swags above a chair rail, dado, and baseboard, a secretary with bookcase, an intricately decorated "fancy" chair, a Pembroke table, and even a small landscape viewed through the open window. A professional artist or Alice's teacher may have supplied these painted details

as well as the facial expressions, the seated spaniel, and the child's alphabet primer. Alice emphasized the window by using transparent panels, probably of mica, to reflect light like glass panes.

An almost identical embroidery entitled *Maternal Instruction* in a private collection, and a very similar ink-and-wash drawing attributed to the Brown family of Newburyport, Massachusetts, indicate the existence of a common print source.[1] Alice Center's version of the scene differs from the others primarily in the addition of the eye-catching, festoon-patterned wallpaper.

Inscriptions/Marks: Inscribed in gold at the lower center of the black eglomise mat is "Wrought by Alice Center." A book in the secretary at left is titled *Holy Bible*, and its cover has the initials "A C." The open book held by the center child reveals letters of the alphabet.

Condition: The primary support had been stitched to a linen secondary support that was nailed to a wooden stretcher and taped around the edges to the glass mat. In 1982 E. Hollyday removed the tape, nails, and stretcher and cleaned the surface of the embroidery. Primary and secondary supports were then remounted on nonacidic backing. Possibly original 2⅛-inch molded and gilded frame with original black-and-gold eglomise glass mat.

Provenance: Acquired from Bessie J. Howard, Boston, Mass., September 28, 1939, for use at Bassett Hall, the Williamsburg home of Mr. and Mrs. John D. Rockefeller, Jr.

Published: Ring, *Needlework*, illus. as pl. IX on p. 480.

[1] *Maternal Instruction* by Abigail Paige is in the collection of Mr. and Mrs. O. Frederick Bates. The Society for the Preservation of New England Antiquities owns the Brown family drawing; it was previously in the collection of Nina Fletcher Little.

Silas Cummings
(1803–1882)

Silas Cummings of Fitzwilliam, New Hampshire, was perhaps best known among his fellow townspeople as an able practitioner of medicine, but like many of his day, he was active in a number of other pursuits as well. He had an influential voice in the administration of the local schools, served as postmaster for more than six years, and represented Fitzwilliam in the state legislature in 1874. He was also an enthusiastic local historian, and several of his manuscripts were consulted by the author of the published volume that forms the basis for most of this biographical entry.[1]

Cummings was born October 7, 1803, in Fitzwilliam, the son of Thaddeus and Anna Collins Cummings. He farmed as a youth, but in 1827 he graduated from Dartmouth College's medical department and thereafter returned to his hometown to practice as a physician. The Folk Art Center owns a

notebook that appears to have been used by Cummings over the period 1824–1830, the bulk of it being composed of notes taken during the course of his medical studies at Dartmouth. Cummings's Price Book, dated June 10, 1826, is also a part of the Folk Art Center's collections; this small booklet lists the cost per ounce of various herbs, tinctures, ointments, etc.[2]

Harriet Underwood was Cummings's first wife. Of their several children, one daughter and two sons appeared to have survived their father, as did a daughter by his second wife, Eliza Poland, the widow of A. D. Simonds.[3]

Cummings practiced medicine in Fitzwilliam until his death, on June 30, 1882, and over his long life he is said to have attended the third, fourth, and even fifth generations of his initial patients.

74

[1]The majority of the information in Cummings's biography is taken from John F. Norton, *The History of Fitzwilliam, New Hampshire, from 1752 to 1887* (New York, 1888), pp. xiii–xv, 439–440.

[2]Cummings's medical notebook bears the AARFAC acc. no. 77.1400.1, his price book the acc. no. 77.1400.2.

[3]Information about Cummings's wives and children is from Harriette C. Wyman to AARFAC, October 4, 1977, based on information from an 1885 Cheshire County gazetteer.

74 Doctor Operating 77.301.1

Possibly Silas Cummings
Fitzwilliam or Hanover, New Hampshire,
probably 1824–1830
Watercolor, pencil, and ink on wove paper
9⅝" x 7¹³⁄₁₆" (24.5 cm. x 19.8 cm.)

This fascinating glimpse of a nineteenth-century doctor's practice originally served as the frontispiece to Silas Cummings's book of medical notes, the bulk of which appear to have been compiled during the period when the young man was a student at Dartmouth, possibly beginning in 1824.[1] After graduating from the college's medical department in 1827, Cummings apparently continued to use his class notes during his later practice in Fitzwilliam, New Hampshire. Since the stamped inscription below the hanging bookshelves may have been added later, it is not known exactly when he created the book's delightful frontispiece. Indeed, whether he himself was the artist remains unsubstantiated.

An assistant appears to hold a rag or sponge ready while his tailcoated mentor bends to the task of closing a laceration in the forearm of a patient. Note the tourniquet applied above the wound. The injured gentleman's vest is yellow with brown stripes, and some of the books on the shelves are yellow. Otherwise, only touches of red on the sponge or rag and in the wound add primary color to the picture, for the rest of the composition is rendered in grays and browns.

Inscriptions/Marks: Stamp printed below the hanging shelves in the composition is "SILAS CUMMINGS./PRACTICE. AUGUST 1830." In ink at the top of the sheet is "1," and in ink at the top of the reverse of the sheet is "2."[2]

Condition: The primary support was removed from a hand-bound book and framed prior to acquisition by the Folk Art Center. In 1977 E. Hollyday dry-cleaned the sheet where possible, sized and flattened it, removed insect debris, and mended edge tears with Japanese mulberry paper. Period replacement 1½-inch flat, black-painted frame, with stenciled decoration in gold.

Provenance: A. D. Pottinger, Bloomfield Hills, Mich.

Exhibited: "Medicine and Science in American Art," Birmingham Museum of Art, Ala., February 7–March 29, 1981, and Mississippi Museum of Art, Jackson, April 10–June 7, 1981, and exhibition catalog, illus. on p. 27.

[1]Kenneth C. Cramer, Archivist, Dartmouth College Library, to AARFAC, October 5, 1977, states that "for many years in order to receive an MD degree a student had to spend 'three years of study under the direction of some approved practitioner of physick' and attend 'two full courses of lectures on the various branches of Medicine taught in this Institution.'" It is conceivable, then, that Cummings initiated his study of medicine in 1824.

[2]The notebook from which the primary support was taken included two different watermarks among its pages: "H & F OF B Vᵗ" and "LATHROP & WILLARD." Thomas L. Gravell to AARFAC, October 6, 1977, states that the former stands for Holbrook and Fessenden of Brattleboro, Vt.; the two men were partners in a mill from 1815 to

1820. Gravell's same letter is less definitive regarding the latter mark, citing J. D. Van Slyck, *Representatives of New England: Manufacturers*, I (Boston, 1879), as the source of the information that "a Howard and Lathrop, dry goods dealers in Springfield, Mass. built a paper mill in South Hadley Falls in 1824." Willard may have been the John Willard who left the Dalton, Mass., firm partnered by Zenas Crane and Henry Wiswell (and later Daniel Gilbert) about 1801. See Lyman Horace Weeks, *A History of Paper-Manufacturing in the United States, 1690–1916* (New York, 1969 reprint of the original 1916 edition), pp. 115, 129.

Eben and his wife, Rhoda Ann Thatcher Davis (1819–1877), lived in Byfield, Massachusetts, but Eben spent his latter years in Worcester and died there April 4, 1902. His occupations and vocations included carpentry, shoemaking, singing, and penmanship, and family descendants recall that he occasionally drew pictures to entertain his grandchildren.[2]

[1]AARFAC, 1981, pp. 81–82.
[2]Interview with family descendants, by Nina Fletcher Little, May 1955.

Eben Pearson Davis
(1818–1902)

Rarely is one identified folk artist portrayed by another, but the Folk Art Center owns a large double watercolor likeness of Eben Davis and his wife by J. A. Davis, possibly created at the time of the sitters' marriage in 1844. The drawing is illustrated in *American Folk Portraits*,[1] and facts of Eben's life are given there, as is clarification of early confusion between the works of Eben and J. A. Davis.

75 Eben Davis's Horse 31.301.4

Eben Pearson Davis
Probably Byfield, Massachusetts, probably 1845–1860
Watercolor, gouache, and pencil on wove paper
11⅞″ x 18″ (30.2 cm. x 45.7 cm.)

Mrs. Rockefeller's early records on this piece call it *The Gay Cavalier*, a title that would reinforce the impression of Davis's reliance on a print source for his

75

76

inspiration, as indicated by the horse's prescribed posture and the architectural complexity of the large building at left. However, family descendants believe the horse pictured may have been Davis's own; hence, in the 1950s, the title was changed to that given above.

Family descendants have no recollection of Eben's having been a painter, but they acknowledge that he drew pictures and especially note his skill as a penman. The minimal coloring of *Eben Davis's Horse* and a plethora of tight linear details corroborate a preference for pen and pencil over paint. Only the man's costume, the horse's tack, the leaves, and some grasses are colored, and the haphazard application of a green wash over much of the foreground tree's foliage indicates little understanding of the effective use of the medium of watercolor.[1]

Inscriptions/Marks: In penciled script at lower left is "By E. P. Davis."

Condition: Treatment by Christa Gaehde in 1955 included cleaning and repairing a lower edge tear. Probably period replacement ½-inch convex molded gilded frame.

Provenance: Found in Boston and purchased from Edith Gregor Halpert, Downtown Gallery, New York, N.Y.

Exhibited: American Folk Art, Traveling; Arkansas Artmobile; Washington County Museum, 1965.

Published: AARFAC, 1940, p. 27, no. 85 (titled *The Gay Cavalier*); AARFAC, 1947, p. 26, no. 85 (titled *The Gay Cavalier*); AARFAC, 1957, p. 158, no. 79, illus. on p. 159; Cahill, American Folk Art, p. 36, no. 47 (titled *The Gay Cavalier*).

[1]Information is from AARFAC archives, including transcriptions of interviews with family descendants in April and May 1955.

Mary Ann Kimball
(active ca. 1825)

76 Courting 31.401.1

Possibly Mary Ann Kimball
America, possibly 1825
Paint on velvet
12″ x 15⅞″ (30.5 cm. x 40.3 cm.)

The meaning of this scene remains undetermined. The postures of the two primary figures — the reaching gesture of the young man and the girl's demure half turn, with her hand over her heart — probably prompted the work's present title in recent times. It has even been suggested that the rake in the lad's hand is symbolic and that the face peering through the cabin's leaded window belongs to an overly protective mother! Yet these colorful theories have no documented basis. A print source surely exists, and once found, the picture's meaning should be more fully revealed. A virtually identical, albeit more finely detailed, composition has been recorded, thereby reinforcing the assumption of the existence of a print source.[1]

Reliance upon stencils to create much of the scene is indicated by sharp gradations of shading and crisp

outlines occasionally echoed or shadowed by fine rims of unpainted velvet, where the artist strove to avoid overlapping her separate theorems, or cutouts. Still-life arrangements were much more commonly the subjects of such paintings in the nineteenth century.

No information about Mary Ann Kimball has been found as yet, and documentation for a specific date of execution also awaits further research.

Inscriptions/Marks: None has been found at present. However, early records indicate that the painting is (or was) signed and dated with the name Mary Ann Kimball and the year 1825. Whether this appeared on a since removed backboard is unknown. If written directly on the reverse of the primary support, the inscription, if such exists, is now obscured by a linen secondary support.

Condition: Unspecified treatment by Kathryn Scott about 1956 included trimming the primary support, stitching same to linen, and stretching the linen over a cardboard auxiliary support. Period replacement 1½-inch splayed gilded frame with molded inner lip and flat outer edge.

Provenance: Found in Bucks County, Pa.; Juliana Force, New York, N.Y.; Edith Gregor Halpert, Downtown Gallery, New York, N.Y.

Exhibited: American Folk Art, Traveling; Arkansas Artmobile; Hollins College, 1975, and exhibition catalog, no. 6.

Published: AARFAC, 1940, p. 36, no. 150; AARFAC, 1947, p. 33, no. 150; AARFAC, 1957, p. 369, no. 315; Cahill, American Folk Art, p. 41, no. 109; Charles Messer Stow, "Primitive Art in America," *The Antiquarian*, VIII (May 1927), illus. on p. 25.

[1]The related work is illustrated as lot no. 169 in Sotheby Parke Bernet, Garbisch II.

Jacob Maentel
(1763–1863)

Jacob Maentel was born in Kassel, Germany, on June 15, 1763, and died nearly a full hundred years later in New Harmony, Indiana, on April 28, 1863. Before he immigrated to America at an unknown date, he served as a soldier and as a secretary under Napoleon; he was also a physician and a farmer, but he is known to folk art enthusiasts as the creator of a large body of distinctive watercolor likenesses, most of them showing residents of southeastern Pennsylvania (Lancaster, York, Dauphin, Berks, and Lebanon counties), where he appears to have situated by 1807, the date of his profile portrait *Mary Kloss*.[1]

The date of his marriage to Catherine Weaver of Baltimore remains undetermined, as does evidence to confirm the possibility that Maentel painted in Baltimore. The couple had moved to Harrisburg, Pennsylvania, by March 2, 1822, when the birth of a daughter (Louisa) was registered there, as was that of a son (William) several years later. In 1826 and 1828, the births of two more children — Wilhelmina Mendel and Amelia — occurred in Schaefferstown, Pennsylvania.

When a move to Texas was interrupted by family illness, the Maentels settled in Posey County, Indiana, probably in 1838. There, in the area of Stewartsville and New Harmony, Maentel is believed to have pursued his interest in painting for at least another twelve years. His last known dated portrait was done in 1846. A body of more than two hundred watercolor portraits currently is credited to Maentel, and two oil on canvas fire screens attributed to him suggest that other works outside his usual medium await discovery.

Maentel's subjects were usually painted in profile until the mid-1820s, when frontal poses began to predominate. His portraits are thought to be fairly accurate representations of the subjects, although he was basically a formula artist who developed and often repeated stock compositional devices. For example, Maentel's full-length figures are often posed on grassy knolls bearing small, distinctive, stippled shrubbery, or they appear in stylized landscapes of rolling hillsides dotted with similarly stippled foliage and stylized architectural elements. Female subjects sometimes carry a rose painted in a characteristic manner, but the array of personalizing accessories used by the artist was broad and included hats, purses, umbrellas, fans, books, songbooks, cats, dogs, parrots, roosters and other birds, and military devices. Interior furnishings included several types of chairs, desks, mirrors, floor coverings, and other objects. The method and palette the artist used in modeling facial features and hands were often somewhat harsh in his earliest work and remained generally consistent throughout his career.

[1]Data in this entry have been taken from Valerie Redler, "Jacob Maentel: Portraits of a Proud Past," *The Clarion* (Fall 1983), pp. 48–55, which provides a thorough summary of recent research on the artist. An earlier investigation of Maentel's life and work may be found in Mary C. Black, "A Folk Art Whodunit," *Art in America*, LIII (June 1965), pp. 96–105. AARFAC, 1981, pp. 139–143, describes the Folk Art Center's seven watercolor portraits by Maentel. His *Schoolmaster and Boys* (no. 77) has been shown in this volume because its setting and action seem more appropriate to the category of genre rather than portrait painting.

77 Schoolmaster and Boys 47.301.1

Attributed to Jacob Maentel
Pennsylvania, probably Lancaster County,
probably 1810–1815
Watercolor and ink on wove paper
13¹⁵⁄₁₆" x 11½" (35.4 cm. x 29.2 cm.)

Because of very extensive repair work, much of it in critical design areas such as the schoolmaster's face, one must exercise selective judgment of the piece as an

77

dein Gott bin/ein starker eifriger/Gott der die Kin = /der heimsucht bis/ins dritte und vierte [Glied]."

One translation of the above reads, "The First Commandment. I am the Lord thy God who has led thee from the land of Egypt; thou shalt not have any other gods before me. This is thy commandment. Thou shalt not worship or fall down before any graven or false images in the sky above and the water and earth beneath. For I, the Lord thy God, am a mighty and jealous god whose wrath is visited upon the third and fourth [generations]."

Condition: Extensive repairs by an unidentified conservator prior to acquisition included providing and inpainting inserts in most of the upper half of the picture, including the schoolmaster's face, and in some lower portions, such as the boys' stockings and areas of the floor in front of them. In 1955 Christa Gaehde cleaned the piece, fumigated it, re-adhered earlier repairs, and mended additional torn areas. It is not known whether Gaehde or the earlier conservator affixed the primary support to a very heavy wove paper backing, which extends beyond the primary support on all sides to form a margin of about ¼ inch. In 1974 E. Hollyday removed wood matting strips and hinged the piece to rag board. Period replacement 1-inch gilded cyma recta frame.

Provenance: Emanuel Keller, York County, Pa.; gift of Dr. Alexander H. O'Neal, St. Davids, Pa.

Exhibited: AARFAC, New Jersey; AARFAC, September 15, 1974–July 25, 1976; Pine Manor Junior College; "Small Folk: A Celebration of Childhood in America," Museum of American Folk Art and the New-York Historical Society, New York, N.Y., November 20, 1980–February 28, 1981, and the First Street Forum, St. Louis, Mo., March 2–April 15, 1981; Washington County Museum, 1965.

Published: AARFAC, 1957, p. 154, no. 77, illus. on p. 155; AARFAC, 1974, p. 42, no. 37; Robert Bishop, *Centuries and Styles of the American Chair, 1640–1970* (New York, 1972), illus. as fig. 283 on p. 208; Mary C. Black, "A Folk Art Whodunit," *Art in America,* LIII (June 1965), illus. on p. 105; Brant and Cullman, illus. as fig. 172 on p. 101; George R. Clay, "The Little Log Schoolhouse," *The Yorker,* XVIII (November–December 1959), illus. on p. 7; Jonas Heinrich Gudehus, "Journey to America," trans. by Larry M. Neff in *Ebbes fer Alle-Ebber, Ebbes fer Dich: Something for Everyone, Something for You,* XIV (Breinigsville, Pa., 1980), illus. on p. 229.

example of Jacob Maentel's technique. The original work is attributed to Maentel on a stylistic basis, and the artist's handling of basically uncompromised portions of the scene, such as the schoolmaster's body and the Windsor chair, compares well with his execution of similar passages in other, less adulterated watercolors that are ascribed to his hand. Likewise, the interior setting strewn with props is not as typical of Maentel's work as landscape backgrounds, but it is represented among his oeuvre by images of a hatter, a druggist, and military officers, etc., who are shown with the accoutrements of their trades.

The unidentified schoolmaster is shown gesturing to two young pupils while reading from a minutely lettered German text, which gives part of the Ten Commandments beginning with the fifth chapter of Deuteronomy, sixth verse. The group portrait possibly includes Maentel's earliest attempt at full-face imagery in the taller of the two boys.

Inscriptions/Marks: The German writing in the schoolmaster's book appears to read as follows: "Das erste Gebot/Ich bin der/Herr dein Gott/der ich dich aus/dem E[g]ypten = /land gefuhret/habe du sollst kei/ne andere Goet/ter neben mir/habe[n]./Das [ist] dein Geboth./Du [sollst] dir kein/B[ild]ness oder/irgend ein Gleichnis/weder des das ueber(?)/dem Himmel oder/des das im Wasser/unter der Erde ist/sollst sie nicht an = /beten noch ihnen dienen. Denn ich der/Herr

Eunice Pinney
(1770–1849)

Eunice Pinney's artistic abilities were brought to public attention quite early in relation to Americans' general reappraisal and renewed recognition of folk art in the twentieth century.[1] Despite the wider awareness and closer scrutiny given her work due to subsequent significant expansion of interest and study in the field as a whole, the artist's position remains one of justly deserved prominence. Although few additional biographical facts have been uncovered since her early "discovery," wider publication of many of her lesser-known pieces and a study of their interrelationships have provided grounds for stylistic analyses and interesting evidence of her sources of inspiration.

Pinney was born in Simsbury, Connecticut, February 9, 1770, the fourth of eight children of Elisha Griswold (1731–1803) and Eunice Viets Griswold

(1742–1823), members of "two of the most prominent families" in the area.[2] Before she was twenty, she married Oliver Holcombe (b. 1769) of Granby, Connecticut, and by him she had two children, Oliver Hector and Sophia. Following her first husband's untimely death, she married Butler Pinney (1766–1850) of Windsor, Connecticut, in 1797, and by him she had three children: Norman, Emeline Minerva, and Viets Griswold. Pinney's recorded works all seem to postdate her second marriage, and probably none was executed before about 1805.[3] Why she took up watercoloring at that time is unknown, but she appears to have pursued the avocation with some continuity at least through 1826, the last date for her work that can be documented with certainty.[4]

Pinney's intense literary interests warranted note within her own lifetime,[5] and they are illustrated by a number of her watercolor subjects, which include Goethe's *Sorrows of Werther*, Homer's *Iliad*, the Bible, Ann Radcliffe's *The Mysteries of Udolpho*, Laurence Sterne's *The Life and Opinions of Tristram Shandy*, and Robert Burns's poem "The Cotter's Saturday Night."[6] Obviously she gave visible shape to her own imaginative re-creation of the written stories through her bright watercolors, but perhaps she also used them to help stimulate her children's literary and artistic interests. If so, Emeline responded, for the daughter taught art at one time, and an 1826 letter written to her by Pinney indicates that an accompanying drawing was to be used as a model by her pupils.

No works assuredly postdating 1826 have been recorded, although Pinney lived another twenty-three years. She died May 12, 1849, and is believed to have been buried in Scotland Cemetery, Simsbury.

[1]Lipman, Pinney, is a 1943 work. This early text on Pinney was reproduced almost verbatim in 1950 in Lipman and Winchester, Primitive Painters.

[2]Glenn E. Griswold, comp., *The Griswold Family: England-America* (Branford, Conn., n.d.), p. 23.

[3]The earliest dated work is the *Todd Memorial* (1809) in the collection of Jean and Howard Lipman; it is illustrated in Lipman and Winchester, Primitive Painters, p. 27. An undated memorial for Lord Nelson (d. 1805) in a private collection may possibly be earlier; it is illustrated in Sotheby Parke Bernet, Inc., *Americana*, catalog for sale no. 3981, April 27–30, 1977, lot no. 397.

[4]The date appears on a privately owned letter that bears a Pinney watercolor on the reverse of the sheet.

[5]Lipman, Pinney, p. 213, quotes from *Memoir of the Life of Bishop Griswold*, published in 1844 by John S. Stone.

[6]Two different watercolors illustrate Goethe's *Sorrows of Werther*; they are *Lolotte et Werther*, which is owned by the National Gallery of Art, the gift of Edgar William and Bernice Chrysler Garbisch, and *Charlotte's Visit to the Vicar*, which is privately owned. AARFAC acc. no. 58.301.9 is from the *Iliad*. A privately owned *Christ's Ascension* is from the Bible. AARFAC acc. no. 58.301.4 is from the Radcliffe novel. A privately owned *Shandy and Maria* is from the Sterne work. Pinney's *Cotters Saturday Night* is in the National Gallery of Art, the gift of Edgar William and Bernice Chrysler Garbisch.

78 Mother and Child in Mountain Landscape 58.301.6

Attributed to Eunice Pinney
Connecticut, probably 1805–1825
Watercolor, ink, and pencil on wove paper
6³⁄₁₆" x 8³⁄₁₆" (15.7 cm. x 20.8 cm.)

No print source has been identified for this scene, and nothing is known regarding its meaning. Perhaps Pinney drew it as a gesture of affection, possibly as a gift for a daughter.

The piece incorporates many clear hallmarks of the artist's early nineteenth-century style. Characteristics include the delineation of hair by means of ink strokes over a watercolor wash; fine lines of accentuation both above and below the eye; wash shading of the eye socket; a relatively straight horizontal line for the mouth, with a second indenting the chin below; elongated, spidery fingers; a two-color, dry, stippled treatment of tree foliage; and delineation of the compositional area by a black line.

Another background house encircled by a white picket fence can be seen in Pinney's *Couple in a Landscape*.[1] Similar strings of flowers woven together appear in several of her mourning pictures, as well.[2]

Condition: Unspecified treatment by Christa Gaehde was accomplished in 1958. In 1981 E. Hollyday removed a secondary support, removed remnants of adhesive from the primary support, set down flaking paint, bleached some foxing, filled edge losses, and backed the primary support with Japanese mulberry paper. Period replacement ⅞-inch molded, gilded (or possibly silver-leafed) frame.

Provenance: J. Stuart Halladay and Herrel George Thomas, Sheffield, Mass.

Exhibited: Halladay-Thomas, Hudson Park; Washington County Museum, 1965.

Published: This may have been one of four Halladay-Thomas watercolors listed only as "descriptions not available" in Lipman, Pinney, p. 221, nos. 51–54.

[1]This privately owned piece is included in Richard B. Woodward, comp., *American Folk Painting: Selections from the Collection of Mr. and Mrs. William E. Wiltshire, III* (Richmond, Va., 1977), p. 49, no. 20, illus. on p. 48.

[2]These include an *Undedicated Memorial* in a private collection; an *Undedicated Memorial* owned by the New York State Historical Association, Cooperstown, N.Y.; *Memorial for Eunice Pinney* and *Undedicated Memorial with Three Women*, both owned by the Museum of Fine Arts, Boston.

79 Children Playing 58.301.2

Attributed to Eunice Pinney
Connecticut, ca. 1813
Watercolor and ink on laid paper
7¹³⁄₁₆" x 9⅝" (19.8 cm. x 24.5 cm.)

This watercolor's undulating mounds and hillocks contribute to an overall sense of rhythm and move-

78

79

ment built up by the whirling arms and legs of the children. The game being played by the youngsters has not been identified precisely, but it would appear to bear marked resemblances to a roughhouse-period pastime called Bait the Bear.[1] However, it should be noted that the four running figures here are repeated nearly exactly in another Pinney watercolor, in which the crouching child is replaced by a seated adult woman. Furthermore, in the related watercolor, the capture of an oversize butterfly hovering near the woman's feet appears to be the determined objective of the two children with raised hats at right. Because of the close similarity of poses, it is assumed that the Folk Art Center's watercolor was produced about the same time as the other, which is signed by the artist and dated 1813.[2]

Around her watercolors, Pinney frequently drew or painted a bordered oval that acts as a visual frame. Most likely she copied the format from period engravings, which often were similarly presented. It is assumed that this watercolor derives from such a print, possibly an illustration in a children's book, but to date the source remains unlocated.

Condition: Unspecified treatment by Christa Gaehde in 1958 included the repair of holes and backing the primary support with Japanese mulberry paper. In 1974 E. Hollyday filled and inpainted a small hole at upper right. Possibly original ½-inch rippled gilded frame.
Provenance: J. Stuart Halladay and Herrel George Thomas, Sheffield, Mass.
Exhibited: American Folk Painters; Halladay-Thomas, Albany, and exhibition catalog, no. 82 (titled Children at Play); Halladay-Thomas, Hudson Park; Halladay-Thomas, Syracuse, and exhibition catalog, no. 63 (titled Children at Play).
Published: Black and Lipman, illus. as fig. 101 on p. 118; Brant and Cullman, p. 129, illus. (reversed) as fig. 249 on p. 144; Lipman and Armstrong, p. 148, illus. on p. 146.[3]

[1] Other names for the game were Buffet the Bear and Badger the Bull. In it, the "bear" would kneel upon the ground, protecting himself as best he could from the blows of the other children, who used knotted handkerchiefs or, as here, hats to strike him. One other child, designated as the bear's "keeper," would strive to catch one of the assailants, who thereupon became the next "bear." Period books on childhood play railed against the boisterous game; Youthful Amusements (Philadelphia, 1810) typified such remarks by calling it "rough play, and hardly proper for children." It also advised that the game "tends to wear out the handkerchiefs, and to make children careless of their clothes." A copy of the book is in the American Antiquarian Society, Worcester, Mass.

[2] The similar watercolor is privately owned and is illustrated in Peter H. Tillou, Where Liberty Dwells: 19th-Century Art by the American People (Litchfield, Conn. [?], 1976), fig. 21.

[3] Children Playing also may have been one of four Halladay-Thomas watercolors listed only as "description not available" in Lipman, Pinney, p. 221, nos. 51–54.

Ferdinand Stucken
(?–1878)

Different dictionaries describe Stucken as a genre and portrait painter and as a historical and portrait painter. He was originally from Minden in Westphalia but traveled to Düsseldorf in 1848 and from there came to America. That he had arrived in the United States at least by 1855 is evidenced by the Folk Art Center's dated painting by him, The Albany–Schoharie Stagecoach (no. 80). He appears in New York City business directories for the period 1856–1860, and he was listed as an exhibitor at the National Academy in 1858 and 1859, his respective addresses being given in those years as 637 Broadway and 627 Broadway. E. Bénézit describes Abraham Lincoln as Stucken's friend and states that the painter returned to Germany in 1865 following the President's assassination.[1]

[1] Stucken's addresses from 1858–1859 and a record of the paintings he exhibited at the National Academy may be found in National Academy of Design Exhibition Record: 1826–1860, II (New York, 1943), p. 144. Otherwise, information in this biography has been taken from Groce and Wallace, p. 613, and from E. Bénézit, Dictionnaire Critique et Documentaire des Peintres, Sculpteurs, Dessinateurs et Graveurs de Tous les Temps et de Tous les Pays par un Groupe d'écrivains Spécialistes Français et Étrangers, IX (Paris, 1976), p. 881.

80 The Albany–Schoharie Stagecoach 58.101.8

Ferdinand Stucken
Schoharie, New York, 1855
Oil on canvas
24⅛" x 30⅛" (61.3 cm. x 76.5 cm.)

This painting probably was commissioned by Orson Root, owner of the Albany–Schoharie Stage Coach Line and said to be the person pictured at far left in the open gateway.[1] The house behind Root is believed to have been the one he occupied, and it is plausible that Stucken depicted Root as the owner often appeared—overseeing the departure of his coach. Stucken dramatized the leave-taking (and emphasized the team's freshness) by depicting the lead horses in a half rear. Billowing dust underfoot shows that the conveyance has set off with alacrity. This is the only extant work by Stucken recorded to date.[2]

According to a notice in the Schoharie Patriot on September 13, 1849, the stage left Albany at 8:00 A.M. every Tuesday, Thursday, and Saturday, and Schoharie at the same time every Monday, Wednesday and

80

Friday.[3] The twenty-six-mile, one-way trip required one change of the four-horse team at James Keenholtz's inn in Knowersville. Invoices for 1855 show that one-way trips cost $1.25 for a passenger, $.25 for a hat box, and $.75 for a barrel of tobacco.

Root had been county inspector of turnpike roads in 1848. The next year, he became one of many area entrepreneurs who, in total, purchased 2,800 shares of stock at $25.00 apiece in order to finance construction of the Schoharie and Albany Plank Road, the tollway subsequently used by Root's stage. It seems ironic that, as owner of the stage line and shareholder in the road, he was sued by the Plank Road Company in July 1863 for unpaid tolls amounting to $479.08. The building of the Albany and Susquehanna (now the Delaware and Hudson) Railroad in 1863, mounting costs of maintaining the road, and Civil War inflation finally forced dissolution of the road company (with an 8 percent dividend to stockholders) in 1867. Root's later occupations are unrecorded until 1878, when he was elected county sheriff.

Inscriptions/Marks: "F. Stucken" is painted at lower right on the front of the canvas. "ALBANY–SCHOHARIE" is lettered along the top of the side of the coach. "O. ROOT" is lettered on the coach doorway, and "MAIN STREET" is lettered on the small sign on the tree behind the coach. Also see note 1.

Condition: The painting was overcleaned in the foreground (with resulting minor paint losses) prior to acquisition. In 1958 Russell J. Quandt lined the painting, replaced the stretchers, and inpainted areas of loss. Probably period replacement 2⅞-inch molded gilded frame.

Provenance: J. Stuart Halladay and Herrel George Thomas, Sheffield, Mass.

Exhibited: AARFAC, American Museum in Britain; AARFAC, Minneapolis; AARFAC, New York, and exhibition catalog, no. 23; AARFAC, June 4, 1962–November 20, 1965; Halladay-Thomas, Albany, and exhibition catalog, no. 30, illus. on cover; Halladay-

Thomas, Syracuse, and exhibition catalog, no. 26; "Selected Master-pieces of New York State Folk Painting," Museum of American Folk Art, New York, N.Y., February 23–May 22, 1977, and exhibition catalog, p. 12, no. 7; William Penn Museum.

Published: Ford, Pictorial Folk Art, illus. on p. 100; A. B. Gregg, "The Albany and Schoharie Plank Road," *Schoharie County Historical Review,* XXVIII (Fall–Winter 1964), pp. 5–6, illus. on cover; A. B. Gregg, "Story of the Albany–Schoharie Plank Road," *Altamont* (N.Y.) *Enterprise and Albany County Post,* p. 1.

[1]Herrel George Thomas (see *Provenance)* is said to have supplied the information that "the painting came out of the Oren [sic] Root house in Schoharie, New York" (Mary C. Black to Oren Root, April 21, 1958). The standing figure in the painting has always been iden-tified as Root in AARFAC files, possibly also on the basis of verbal information from Thomas. (However, an original stretcher from the work is said to have borne a penciled inscription that included the word "Orsen." The stretcher no longer exists, and no record was made of the inscription in its entirety; thus, its possible relevance to the figure's identification remains undetermined [Mary C. Black to Arthur B. Gregg, March 5, 1959].) In 1863, the stage line was de-scribed as the Root-Haskill Stage Co. (see note 3), but it is not known when Root acquired a co-owner. It was probably after 1855, as the coach door here is lettered only "O. ROOT."

[2]Other works of his are listed in *National Academy of Design Ex-hibition Record: 1826–1860,* II (New York, 1943), p. 144, but the present whereabouts of these works are unknown.

[3]Data in this entry have been taken from Arthur B. Gregg to AARFAC, April 6, 1959, and from three newspaper articles by Arthur B. Gregg, "Story of The Albany–Schoharie Plank Road," *Altamont* (N.Y.) *Enterprise and Albany County Post,* pp. 1 and following for May 8, 15, and 22, 1959.

Harriet French Turner
(1886–1967)

Harriet French was born in Giles County, Virginia, in 1886, but she moved with her family to Roanoke, Virginia, when she was thirteen years old. Her early interest in the arts centered on music, although she began copying pictures in oils when she was still in high school. After finishing her education and teaching for two years, she married James R. Turner, a Roa-noke druggist, by whom she had three daughters. Once their children had married, the Turners moved out of the city of Roanoke and into the country. Their new home was situated on a hill with inspiring views of the surrounding Blue Ridge Mountains, and Turner began to contemplate the possibility of trying to cap-ture one of the scenes in oil. She was also stimulated by activity at the newly organized Roanoke Fine Arts Center and wondered if she might be able to exhibit a picture there.

In 1954 Turner painted her first original compo-sition, a view from the front of her own home. To her surprise and delight, it was not only accepted for ex-hibition at the Roanoke Fine Arts Center, but it was also purchased afterward for the permanent collec-tions of nearby Hollins College. Encouraged by her success, she abandoned her efforts to copy the works of other artists and concentrated on her own interpre-tations of the scenes she loved best.

Many of her paintings are landscapes inspired by the country around her, but still-life arrangements are represented, too, and many of her scenes include peo-ple engaged in everyday activities. In 1962 the Folk Art Center in Williamsburg featured Turner's paint-ings in its first exhibition devoted to the work of a living artist. Turner had especially relied on painting to fill her time after her husband's death in 1961, and she continued to work with dedication and enthusiasm until the year of her own death. She died in Roanoke December 7, 1967, at age eighty-one.[1]

[1]Information for this entry is taken from a 1963 interview with Harriet French Turner conducted by John Ballator, then a professor in the art department of Hollins College, and also from an autobio-graphical sketch prepared for a catalog of AARFAC's show of her works in 1962.

81 Benediction 63.101.1

Harriet French Turner
Roanoke County, Virginia, 1963
Oil on Masonite panel
19⅛" x 23" (48.6 cm. x 58.4 cm.)

In an interview, Harriet French Turner indicated that she was inspired to paint this picture because she per-ceived much change within the religious sect of the Dunkards who lived in her area of Virginia, and she wanted to capture their appearance and attitudes as she had known them.[1] She found the Dunkards' cos-tumes "intriguing" and felt that a scene of them grouped for church would make an attractive picture. In her own words, "I first planned the picture with the Dunkards getting out of the buggy, you see, coming home from church, and then it just came to me that the inside of the church would be pretty with the peo-ple sitting in the pews. . . . And I have them in prayer because that way their faces [don't show]. You know I don't make good faces at all."

Turner loved and often painted the landscape scenes that surrounded her in her home in the Blue Ridge Mountains. *Benediction* was the first interior scene she ever executed among her original composi-tions, and she titled it herself, showing the Dunkards in the closing prayer of their service. In the midst of painting the scene, she wrote "I am getting real excited about the church picture and am so anxious to finish it. It is very particular work and has taken me so long. I spent the live long morning making women's *necks.*

81

I waited to finish the women to mix the skin tone. I just have the men including the preacher and the pulpit furniture to make and I don't think that will take me too long."[2] She later wrote that she felt the colors were especially rich in *Benediction* because she had "put on so many coats of paint."[3]

 Inscriptions/Marks: In paint along the lower edge near the right corner is "Harriet French Turner."
 Condition: The painting has not been treated since it was executed. Original 3¼-inch splayed chestnut wood frame.
 Provenance: Acquired directly from the artist.
 Exhibited: AARFAC, September 15, 1974–July 25, 1976; Artists in Aprons; "Harriet French Turner: Folk Artist of the Blue Ridge," Roanoke Fine Arts Center and the First National Exchange Bank of Virginia, Roanoke, Va., April 20–May 15, 1968, and exhibition catalog, p. 9, illus. on p. 6; "Harriet French Turner Remembered," First National Exchange Bank of Virginia and the John Will Creasy Art Society, Roanoke, Va., December 4–31, 1977; "A Share of Honour: Virginia Women, 1600–1945," traveling exhibition organized by the Virginia Women's Cultural History Project, Richmond, Va., November 10, 1984–June 6, 1985.
 Published: AARFAC, 1974, p. 51, no. 46, illus. on p. 48; American Folk Art, illus. on p. 92; Black, Folk Painting, p. 14, illus. as fig. 19 on p. 15; Black and Lipman, p. 220, illus. as fig. 211 on p. 229; Dewhurst, MacDowell, and MacDowell, Artists in Aprons, illus. as fig. 130 on p. 149; Dewhurst, MacDowell, and MacDowell, Religious Folk Art, illus. as fig. 180 on p. 131; Lebsock and Rice, illus. on p. 144.

[1]Except as otherwise indicated, information here is taken from a 1963 interview with Harriet French Turner conducted by John Ballator, then a professor in the art department of Hollins College.
[2]Harriet French Turner to AARFAC, July 17, 1963.
[3]Harriet French Turner to AARFAC, July 31, 1963.

Unidentified Artists

82 **The Old Plantation** 35.301.3

Artist unidentified
Possibly South Carolina, possibly 1790–1800
Watercolor on laid paper
11 11/16″ x 17 7/8″ (29.7 cm. x 45.4 cm.)

This watercolor is detailed and finely executed, the figures highly individualized, and the colors still strong. A plantation complex sited on a river bend forms the backdrop for a cast of characters lined up like actors on a stage. The facades of two small outbuildings frame the central action, whose exact nature, unfortunately, remains speculative.

 Several Afro-American scholars have suggested that possibly a marriage ceremony is being depicted; the act of jumping over a stick, especially a broomstick, has long borne such a connotation, and it is hoped that further study may refute or confirm such a possibility.[1]

 Some authorities feel that the dance or action being depicted is secular in nature. Dancing barefoot with sticks and scarves is common among the Yoruba of northern and southwestern Nigeria, and the cloth

82

headdresses worn by several of the group are clearly of West African derivation, some say specifically Yoruban.[2]

The musician at right may be playing a Yoruba gudugudu, a hollowed piece of wood over which an animal skin is stretched to form a drumhead, which is then tapped by tightly twisted strips of leather. Others have suggested that he is playing a hollow gourd with sticks or bird bones. The stringed instrument is reminiscent of the Yoruba molo, an antecedent of the ubiquitous banjo. Note that three strings attach to tuning pegs at the top of the fingerboard, while a fourth attaches to a peg halfway down the board. The body of this instrument appears to be a hollow gourd.

Inscriptions/Marks: An elaborate watermark in the primary support has been identified as the Strasburg Arms above the script cipher "JW," a combination of mark and countermark used by the English papermaker James Whatman II (1741–1798) during the period 1777–1794.[3]

Condition: In 1954–1955 Christa Gaehde cleaned the piece; flattened creases; mended tears; filled and inpainted extensive losses in the primary support, especially in the upper edge and left side; and backed the piece with Japanese mulberry paper. The most severely abraded areas of the main design portions include the middle of the green dress and the far hand (and the ground above it) of the

woman with the scarf nearest center. In 1977 E. Hollyday hinged the sheet to rag board. Period replacement 1½-inch splayed, black-painted frame with flat outer edge.

Provenance: Purchased for Mrs. Rockefeller by Holger Cahill from Mary E. Lyles of Columbia, S.C.; Lyles advised Cahill that the work had been executed on a plantation between Charleston and Orangeburg by one of her ancestors, a young man who had studied watercolor painting.[4]

Exhibited: AARFAC, April 22, 1959–December 31, 1961; American Primitive Art, and exhibition catalog, no. 6; Great Ideas; "Music Making—American Style," Smithsonian Institution, Washington, D.C., June 1–December 31, 1966; Smithsonian, American Primitive Watercolors, and exhibition catalog, p. 5, no. 15; Southern Book.

Published: AARFAC, 1940, p. 27, no. 79; AARFAC, 1947, p. 25, no. 79; AARFAC, 1957, p. 132, no. 66, illus. on p. 133; AARFAC, 1959, p. 15, no. 2, illus. on p. 14; AARFAC, 1975, illus. on p. 13; James Truslow Adams, ed., *Album of American History,* I (New York, 1944), illus. on p. 208; American Folk Art, illus. on p. 91; American Heritage, illus. on p. 76; Ruth Andrews, ed., *How to Know American Folk Art: Eleven Experts Discuss Many Aspects of the Field* (New York, 1977), illus. as pl. 15 between pp. 76–77; Oto Bihalji-Merin, *Masters of Naive Art: A History and Worldwide Survey* (New York, [1971]), illus. as fig. 42 on p. 55; Bishop, pp. 158–159, illus. as fig. 234 on p. 158; Black, Folk Painting, p. 8, illus. as fig. 2 on p. 9; Black, Watercolors, p. 82, illus. on p. 74; Black and Lipman, p. 97, illus. as fig. 92 on p. 110; Blum, p. 204, no. 22, illus. on p. 205; Booth, illus. on p. 46; Mary Cable, et al., eds., *American Manners & Morals: A Picture History of How We Behaved and Misbehaved* (New York, 1969), illus. on pp. 128–129; Holger Cahill, "Artisan and Amateur in American Folk Art," *Antiques,* LIX

(March 1951), illus. on p. 211; John H. Cary and Julius Weinberg, eds., *The Social Fabric: American Life from 1607 to the Civil War*, 3rd ed. (Boston, 1981), illus. on p. 38; Judith Wragg Chase, *Afro-American Art and Craft* (New York, 1971), p. 53, illus. on p. 52; Cogar, illus. on p. 183; Agnes De Mille, *The Book of the Dance* (New York, 1963), illus. on p. 68; De Pauw and Hunt, pp. 16, 160, no. 7, illus. on p. 17; Dena J. Epstein, "The Librarian as Detective: The Search for Black Music's African Roots," *The University of Chicago Magazine*, LXVI (July–August 1973), illus. on p. 19; Dena J. Epstein, *Sinful Tunes and Spirituals: Black Folk Music to the Civil War* (Urbana, Ill., 1977), illus. on p. 37; Mary Allen Grissom, *The Negro Sings a New Heaven: A Collection of Songs* (1930; reprint ed., New York, 1969), illus. on cover; Robert Hughes, "Whittling at the Whitney," *Time*, CIII (February 4, 1974), illus. on p. 64; Louis C. Jones, *Three Eyes on the Past: Exploring New York Folk Life* (Syracuse, N.Y., 1982), pp. 173–174; Richard M. Ketchum, et al., eds., *The American Heritage Book of the Revolution* (New York, 1958), illus. on p. 80; Jean and Cle Kinney, *How to Make 19 Kinds of American Folk Art from Masks to TV Commercials* (New York, 1974), p. 5, illus. on p. 6; Werner Krum, *USA Ostküste: Atlantische Landschaften von New Hampshire bis South Carolina* (Munich, 1981), illus. as pl. IV on pp. 128–129; Lipman and Winchester, Folk Art, illus. as fig. 92 on p. 71; Brian McGinty, "Jazz: Red Hot & Cool—Part I: From Cotton Fields to Nightclubs, a Uniquely American Musical Form Comes of Age," *American History Illustrated*, XIV (December 1979), illus. on p. 10; Richard C. Malley, "False Teeth: New Problems with Plastic Scrimshaw," *The Log of Mystic Seaport*, XXXII (Fall 1980), illus. on p. 87; Roland Nadeau and William Tesson, *Listen: A Guide to the Pleasures of Music*, 2nd ed. (Boston, 1976), illus. as fig. 40 on p. 344; Gary B. Nash, *Red, White, and Black: The Peoples of Early America* (Englewood Cliffs, N.J., 1974), illus. on p. 171; Gary B. Nash, *Red, White, and Black: The Peoples of Early America*, 2nd ed. (Englewood Cliffs, N.J., 1982), illus. on p. 176; Jessie Poesch, *The Art of the Old South: Painting, Sculpture, Architecture & the Products of Craftsmen, 1560–1860* (New York, 1983), illus. on p. 174; Rumford, illus. on p. 62; Beatrix Rumford, "Folk Art in America: A Living Tradition," *Antiques*, CVII (February 1975), illus. on p. 334; Quimby and Swank, illus. as fig. 14 on p. 38 and as fig. 5 on p. 187; Hugh Tulloch, "But the Cat Himself Knows: Slavery in the Ante-Bellum South—A Historiographical Survey," *History Today*, XXX (May 1980), illus. on p. 59; John Michael Vlach, *The Afro-American Tradition in Decorative Arts* (Cleveland, Ohio, 1978), illus. as fig. 9 on p. 24 and as pl. I between pp. 26–27; Mitchell A. Wilder, "Museum Trends: Recognition for Folk Art," *Art in America*, XLV (Summer 1957), illus. on pp. 48–49; Hermann Warner Williams, Jr., *Mirror to the American Past: A Survey of American Genre Painting: 1750–1900* (Greenwich, Conn., 1973), pp. 32–33, illus. as fig. 15 on p. 33.

[1] Simon Bronner to AARFAC, December 30, 1974, and M. J. Herskovits, Northwestern University, to AARFAC, October 3, 1955. See also Sudie Duncan Sides, "Slave Weddings and Religion: Plantation Life in the Southern States Before the American Civil War," *History Today*, XXIV (February 1974), pp. 77–87.

[2] Lorenzo D. Turner, Roosevelt University, to AARFAC, August 15, 1955, is particularly specific regarding the Yoruba origins of many details of the scene.

[3] Arnold E. Grummer, Dard Hunter Paper Museum, to AARFAC, April 11, 1968. See also Thomas Balston, *James Whatman: Father and Son* (London, 1957), pp. 156–164, especially fig. 9 on p. 158, which shows a mark identical to AARFAC's.

[4] B. Ella Copes and her sister, Grace Copes, noted during a visit to AARFAC in 1976 that they recalled having seen *The Old Plantation* among their family's possessions when their father, Judge Robert Elliot Copes, vacated his home at 15 Amelia Street in Orangeburg. Indeed, an inventory purportedly drawn up by their aunt, Henrietta Copes, in the 1920s or 1930s includes a lot (no. 35) that could well describe AARFAC's watercolor: "One picture of a negro slave dance, done in watercolors, on white drawing paper. Work well preserved but paper is yellow with age and motheaten in places, but work and

coloring is well preserved. I have always been told that this was a drawing from actual life, my great grandfather having sketched his slaves as they were having a dance. All are barefooted. Their cabins are seen in the background. (12 in. x 18 in.)." AARFAC files contain a photocopy of the pertinent portion of the document.

Thus far, Henrietta Copes's several great-grandfathers have not been identified (two possibilities mentioned by Ella and Grace Copes are one James Copes and one Henry Ellis), nor has substantiation of the assertion that such a man was AARFAC's artist been made, either.

83 Making Hay 32.301.4

Artist unidentified
Probably Massachusetts, probably ca. 1810
Watercolor and pencil on wove paper
10⁹⁄₁₆" x 15½" (26.8 cm. x 39.4 cm.)

An almost identical picture in a private collection appears to retain its original frame and eglomise mat, of which the latter is lettered "SPRING" (beneath the left-hand portion of the composition showing a woman and a girl) and "SUMMER" (beneath the right-hand portion showing a woman raking hay). The privately owned picture also bears remnants of a possibly original newspaper backing, which includes the information: "Boston/Friday, December 30, 1808." Part of the original framer's label remains on the related piece, but no name is legible there.

The appearance of needlework—French knots, satin stitches, outline stitches, etc.—is simulated in both the Folk Art Center's picture and in the related watercolor noted in the museum's files. The two must have been based on some common source, probably one of a number of bucolic prints that were popular at the time.

Inscriptions/Marks: A watermark reading vertically in the right-hand margin is "RUSE & TURNE[R]."[1]
Condition: The piece is quite faded but otherwise appears to be in its original condition. Remnants of black and gold paint adhered to the front suggest that the picture was once placed behind an eglomise mat. Period replacement 1½-inch splayed gilded and gold-painted frame with molded inner lip.
Provenance: Isabel Carleton Wilde, Cambridge, Mass.; John Becker, New York, N.Y.
Exhibited: Washington County Museum, 1965; Wilde, and exhibition catalog, no. 51.
Published: AARFAC, 1940, p. 27, no. 81; AARFAC, 1947, p. 25, no. 81; AARFAC, 1957, p. 138, no. 69, illus. on p. 139; Ford, Pictorial Folk Art, illus. on p. 134.

[1] Joseph Ruse operated the Upper Tovil Mill in Kent, England, beginning about 1799. In 1800 he went into partnership with a man who may have been Joseph Turner. Joseph, William, and Richard Turner were all indicated as papermakers in 1796 and 1800, but William and Richard were in business with their sons from 1800 until the 1820s, leaving Joseph as the most likely possibility of the three to have been in partnership with Ruse (Thomas L. Gravell to AARFAC, May 16, 1985).

83 *Making Hay*

84 The Apple Gatherers 32.301.5

Artist unidentified
Probably New England, possibly 1810–1825
Watercolor and pencil on wove paper
9¼" x 13⁵⁄₁₆" (23.5 cm. x 33.8 cm.)

Although some popular print undoubtedly inspired this composition, such a print source has yet to be identified. Late-eighteenth- and early-nineteenth-century depictions of apple pickers abound, and they often symbolized the autumn season or simply the joys of country living. Another example of the Folk Art Center's composition has been recorded; it was worked in paint and embroidery on silk but its lack of a firm history sheds no light on the pieces' common derivation.[1]

The costumes shown here appear to date no later than about 1810, but the style of the rendering suggests that the print may have been copied somewhat later in the century. The crude handling of details, such as fingers, hair, and facial features, and the disproportionate scale of the two left background figures may indicate the work of a relatively young child. A very distinctive feature is found in the vertical hatching over and below an arched eyebrow line that, head-on, may also continue into a nose line. It is hoped that this

unusual technique eventually may help in locating other works by the same artist.

Condition: Treatment by Christa Gaehde in 1955 included providing inserts and inpainting the upper left corner and other small losses along the left side, realigning and repairing a horizontal tear through the middle, backing the sheet with Japanese mulberry paper, and adhering the sheet to a backboard at all four corners. In 1983 E. Hollyday hinged the sheet to a new backboard, reduced creasing, reset several edge tears with wheat-starch paste, and inpainted small scattered pigment losses with pastel or charcoal pencil. Period replacement 1½-inch flat, mahogany-veneered frame.
Provenance: Isabel Carleton Wilde, Cambridge, Mass.; John Becker, New York, N.Y.
Exhibited: Smithsonian, American Primitive Watercolors, and exhibition catalog, p. 6, no. 20; Wilde, and exhibition catalog, no. 55.
Published: AARFAC, 1940, p. 27, no. 82; AARFAC, 1947, p. 25, no. 82; AARFAC, 1957, p. 364, no. 281; Ford, Pictorial Folk Art, illus. on p. 133; Homer Eaton Keyes, "Title-Hunting Americana," *Antiques,* XXIII (February 1933), illus. as fig. 1 on p. 59.

85 By the Sea 79.301.1

Artist unidentified
Possibly Massachusetts, ca. 1820
Watercolor and pinpricking on wove paper
16" x 20½" (40.6 cm. x 52.1 cm.)

The group, probably a family, enjoys a seaside outing. The young man at rear gestures toward a ship flying

84 *The Apple Gatherers*

an American ensign, while beside him stands a man with a telescope; at right, a woman appears to supervise her daughter's reading lesson, and near center, two pairs of young ladies are seated or stroll in peaceful companionship. In the left middle ground, a group of sheep is visible, the texture of whose wool is emphasized by pinpricking.

At least six other watercolors exhibiting similar technique, composition, and motifs are known, and four of the others are memorials. Details differ among them, but the sailing ship on an inlet is apparent in all of the related compositions.[1]

Condition: In 1981 E. Hollyday flattened the primary support and backed it with Japanese mulberry paper. Probably period replacement 1-inch cove-molded gilded frame.

Provenance: Purchased from Katrina Kipper, Accord, Mass., in 1938 for use at Bassett Hall, the Williamsburg home of Mr. and Mrs. John D. Rockefeller, Jr.

[1]The figure of a girl holding a parasol in this watercolor also appears in *Family by the Seashore*, ca. 1815, from the collection of Bertram K. and Nina Fletcher Little, illustrated in Nina Fletcher Little, *Land and Seascape* (Williamsburg, Va., 1969), as no. 16 on p. 14. Clothing styles indicate a later date for *Family Group by the Seaside*, ca.

1835, in the Garbisch Collection, National Gallery of Art, Washington, D.C., and illustrated in Rumford, Memorial Watercolors, as fig. 8 on p. 693.

Certain mourning pictures use the same compositional formula; among them are the *Smith Memorial*, ca. 1830, in the collection of the New York State Historical Association, Cooperstown, N.Y., illustrated in Rumford, Memorial Watercolors, as fig. 7 on p. 693; *Memorial to Daniel Nichols, December 25, 1833*, and *Memorial to Obadiah Nichols, December, 1812*, in the collection of the Shelburne Museum, Inc., Shelburne, Vt., illustrated in Nancy C. Muller, *Paintings and Drawings at the Shelburne Museum* (Shelburne, Vt., 1976), figs. 479 and 480, p. 190; and *Memorial to Edmund Parker, Jr.*, ca. 1816, in the collection of Old Sturbridge Village, Sturbridge, Mass.

[1]The embroidered picture is shown as lot no. 178 in Sotheby Parke Bernet, Garbisch II. Its present whereabouts are unknown. It was also illustrated in Anita Schorsch, *Images of Childhood: An Illustrated Social History* (New York, 1979), p. 134, but it was miscredited therein as being part of the collection of the Henry Francis du Pont Winterthur Museum.

85 *By the Sea*

86 Morgan Addressing His Friends 35.401.1

Artist unidentified
America, possibly 1835–1840
Paint and ink on velvet
15″ x 21¼″ (38.1 cm. x 54.0 cm.)

This complex and highly unusual composition on velvet combines freehand painting and the use of cut stencils. The meaning of the picture remains unclear, but it has been suggested that perhaps two different incidents from the life of Charles Stephen Morgan are shown.

Morgan was born near Morgantown, Virginia (now West Virginia), on June 4, 1799. On May 12, 1833, he married Alcinda Gibson Moss (1811–1880), the daughter of Elisha and Mary Moss of Culpeper County, Virginia. Of the Morgans' seven children, four survived early childhood: Alcinda (1834–1892),

Charles Somerville (1835–1907), Stephen Elisha (1837–1926), and Virginia (1851–1920).[1] Perhaps the couple at right represents the Morgans and the small figure at the base of the liberty pole represents their eldest child, Alcinda. Grave Creek Mound was the name given to an ancient Indian burial ground in present-day Marshall County, West Virginia. The site was explored and publicized in 1838, and this picture may well date from that year or soon after. No firm connection between Morgan and the mound has been made thus far. However, he is known to have taken an early interest in the preservation of historic Virginia sites, and possibly this explains his presence there. Aside from the obvious patriotic allusion of the eagle, the meaning of the assemblage of varied animals, including a monkey, is unknown.

As a young man, Morgan was active in politics. He served as a delegate from the Seventeenth District —composed of Ohio, Tyler, Brooke, Monongalia, and

Preston counties—to the General Convention of the Commonwealth of Virginia in 1829–1830, and he distinguished himself there by brilliant oratory. He served in the state senate during the period 1822–1832, and in the latter year, he accepted the position of superintendent of the state penitentiary in Richmond. He was given the rank of colonel at this time so that he need not depend upon the governor's orders to muster troops from the nearby state armory in the event of fire or riot at the prison. He was well known for humane penal reform and continued in his position as state penitentiary superintendent until his death on February 15, 1859.[2]

The scene at left seems to represent a political speaking engagement from Morgan's early life, perhaps one of the stirring addresses he made at the convention of 1829–1830. Note the tumbler, pitcher, and candle in a brass candlestick on the rostrum.

Inscriptions/Marks: In script across the front of the rostrum is "C. S. Morgan/De[l?]livering an . . . /address to his/friends of/Virginia . ." On the spine of the book in the speaker's hand are the initials "H B." The banner beneath the eagle reads: "LIBERTY . . ." Lettering on the steps of the mound reads: "GRAVE CREEK MOUN."

Condition: It probably was Kathryn Scott in the 1950s who trimmed the edges of the velvet primary support, stitched the piece to a linen backing, and stretched the linen over cardboard. In 1974 E. Hollyday removed wood strips that had been used in the frame as a mat, replacing them with strips of rag board. Period replacement 2-inch gilded and gold-painted molded cyma recta frame.

Provenance: Purchased in Kentucky with a history of having been found in New Jersey; Edith Gregor Halpert, Downtown Gallery, New York, N.Y.

Exhibited: AARFAC, April 22, 1959–December 31, 1961; AARFAC, September 1968–May 1970; AARFAC, September 15, 1974–July 25, 1976; William Penn Museum.

Published: AARFAC, 1940, p. 35, no. 148; AARFAC, 1947, p. 33, no. 148; AARFAC, 1957, p. 242, no. 121, illus. on p. 243; AARFAC,1959, p. 34, no. 33; AARFAC, 1974, p. 55, no. 50, illus. on p. 54; Black, Folk Painting, p. 12, illus. as fig. 10 on p. 11.

[1]Most biographical statistics about the Morgan family come from Milton C. Russell, Virginia State Library, to AARFAC, September 14, 1955, which transcribes a Bible record loaned to the library in 1948 by Alcinda Morgan Slabey, a great-granddaughter of Colonel C. S. Morgan.

[2]See Lyon Gardiner Tyler, ed., *Encyclopedia of Virginia Biography,* IV (New York, 1915), pp. 452–454.

86 *Morgan Addressing His Friends*

87 Beehives in the Garden

32.301.7

Artist unidentified
Possibly New England, probably ca. 1840
Watercolor and pencil on wove paper
5¹³⁄₁₆″ x 5¾″ (14.8 cm. x 14.6 cm.)

Except for rich, deep-green coloring, the foliage, and a pale-blue wash through the upper sky, this piece is executed in grisaille. Considering the small scale of the work, an exceptional amount of detail has been captured. Note, for instance, the architectural elements of the stately house, the flower in a large double-handled pot on the terrace, the small girl presenting a foliage spray to the gentleman with a cane, and of course, the two prominent beehives at lower left. Unfortunately, the subject remains unidentified, and no information has been associated with two names that are penciled on the reverse of the appealing vignette.

Inscriptions/Marks: In pencil in script on the reverse is "Caroline Chandler" (this inscription has been reinforced with darker pencil). Also in pencil on the reverse, but in a different hand and reading in the opposite direction of the first inscription, is barely legible script marking that appears to read: "Sarah G. [?] Stanton/Conway Conn."

Condition: In 1974 E. Hollyday removed a secondary support and tape on the reverse of the primary support, flattened the piece, and hinged it to a new backboard. Period replacement ¼-inch flat gilded frame.

Provenance: Found in Provincetown, Mass.; Isabel Carleton Wilde, Cambridge, Mass.; John Becker, New York, N.Y.

Exhibited: Washington County Museum, 1965; Wilde, and exhibition catalog, no. 91.

Published: AARFAC, 1940, p. 27, no. 87; AARFAC, 1947, p. 26, no. 87; AARFAC, 1957, p. 364, no. 279.

87

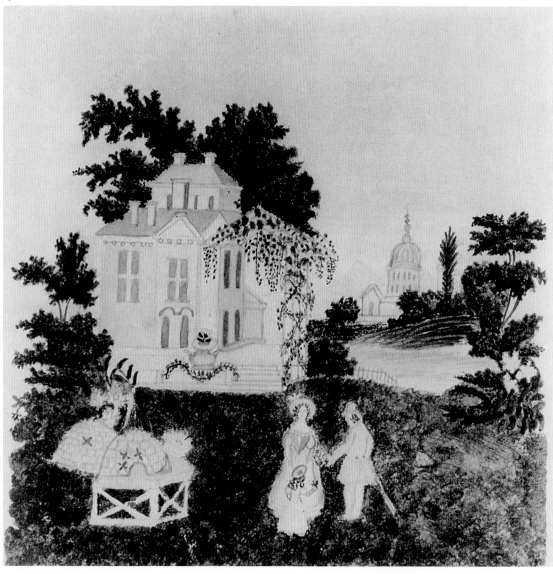

88

88 The Quilting Party

37.101.1

Artist unidentified
America, probably 1854–1875
Oil and pencil on paper adhered to plywood
19¼" x 26⅛" (48.9 cm. x 66.4 cm.)

The brightly painted scene has long been a favorite of museum visitors. It is also well known to folk art scholars since it was among the small number of non-academic works included in two surveys of American paintings exhibited abroad in 1938 and 1946, and it has been widely published since then.

Part of the painting's popularity stems from the naturalness of the scene. A number of separate vignettes are shown within the whole, each a story in itself and, in accord with the nature of a large, informal gathering of intimates, most actions are realistically independent of one another. A brash fellow reaches for his shy girl's hand beneath the table, while in the background, a second suitor puckers up to kiss the object of his affections. Is she raising her hand to

slap him? And is the bespectacled woman near them admonishing him? Or *her?* A group of cronies drink by the stove, a cat and dog spat, grandpa dandles a baby, and a few women work diligently on the ostensible focus of the group's attention, the pieced quilt stretched between them. Painted window shades; a deer's rack, gun, and bag hung over the door; the hat and coat on the wall; and the mixed assortment of seating furniture offer further touches of realism. Converging ceiling timbers and floorboards visually focus attention on the central portion of the work.

The painting is also popular because, like its print source, it offers rare period documentation for the quilting "bee," a social phenomenon that still exists in some areas of America.[1] Traditionally, a young girl finished a dozen quilt tops before making one for her special "bride's quilt." When she became engaged, friends and family were invited to help her quilt the tops, that is, stitch them to backings, usually with a warm layer of batting between. Gossip, music, dancing, and other diversions all speeded the sewing chore and made the event a gay one.

Condition: In 1945 Sheldon and Caroline Keck cleaned the painting, adhered loose edges with Japanese mulberry paper and gelatin, and filled and inpainted numerous scattered areas of paint loss, predominantly along the outer edges; the most significant areas of loss include a 3-inch forked area in the floorboards to left of center at bottom and a large (3-inch long) triangular area in the ceiling. In 1956–1957 Eleanor and Russell J. Quandt examined the painting and submitted a technical report on the materials used and the manner of the work's execution. In 1968 Mr. Quandt completed unspecified conservation work that probably included re-adhering lifting areas of the paper primary support. Period replacement 3-inch gilded cyma recta frame.

Provenance: Bessie J. Howard, Boston, Mass.; given to the Museum of Modern Art in 1939 by Abby Aldrich Rockefeller; transferred to the Metropolitan Museum in 1949; turned over to Colonial Williamsburg in April 1955.

Exhibited: AARFAC, Arkansas; AARFAC, April 22, 1959–December 31, 1961; AARFAC, September 1968–May 1970; "American Painting from the Eighteenth Century to the Present Day," Tate Gallery, London, June 13–August 5, 1946, and exhibition catalog, p. 9, no. 6; American Primitive Painting, and exhibition catalog, no. 31; Art in Our Time, and exhibition catalog, illus. as no. 3 on p. 18; Trois Siècles, and exhibition catalog, p. 52, no. 239; William Penn Museum.

Published: AARFAC, 1959, p. 42, no. 47, illus. on p. 43; AARFAC, 1975, illus. on p. 26; American Heritage, illus. on p. 214; Black and Lipman, pp. 102–103, illus. as fig. 119 on p. 134; Blum, p. 204, illus. on p. 205; Pamela Clabburn, *The Needleworker's Dictionary* (New York, 1976), illus. on p. 220; Dewhurst, MacDowell, and MacDowell, Artists in Aprons, illus. as fig. 31 on p. 52; James Thomas Flexner, "The Cult of the Primitives," *American Heritage,* VI (February 1955), illus. on p. 47; Ford, *Pictorial Folk Art,* illus. on p. 122; Jonathan Holstein, *American Pieced Quilts* (New York, 1973), illus. on p. 4; Jean and Cle Kinney, *How to Make 19 Kinds of American Folk Art from Masks to TV Commercials* (New York, 1974), p. 5, illus. on p. 4; Lebsock and Rice, illus. on p. 81; Ruth Lee, *Shades of History* (Chicago, 1969), p. 10, illus. as fig. 14 on p. 11; Lipman, Primitive Painting, pp. 56–57, illus. as fig. 51; Lipman and Winchester, Folk Art, illus. as fig. 91 on p. 70; MOMA, illus. as no. 3; Musée des Arts Décoratifs, *Quilts* (Lausanne, Switzerland, 1972), illus. on p. 6; Ronald Pilling, "Early American Window Shades You Can Make," *Early American Life,* XIV (February 1983), illus. on p. 57; Elizabeth Wells Robertson, *American Quilts* (New York, 1948), illus. on p. 9; Carleton L. Safford and Robert Bishop, *America's Quilts and Coverlets* (New York, 1972), p. 86, illus. as fig. 95 on pp. 86–87; Robert Secor, general ed., *Pennsylvania 1776* (University Park, Pa., 1975), illus. on p. 249; Marjorie L. Share and Deborah Lerme Goodman, *Bee Quilting* (Washington, D.C., 1983), illus. on p. 24; Sarah B. Sherrill, "Current and Coming," *Antiques,* CV (March 1974), illus. on p. 448; *The Vincent Price Treasury of American Art* (Waukesha, Wis., 1972), p. 104, illus. on pp. 104–105; Alice Winchester, "American Painting in London: A Comment on the Tate Gallery Exhibition," *Antiques,* LI (February 1947), p. 108, illus. as fig. 24 on p. 103.

[1]The print source for the composition (reproduced above), titled *A Quilting Party in Western Virginia,* appeared on p. 249 of *Gleason's Pictorial Drawing-Room Companion,* VII (October 21, 1854).

89 Artist and Indians in Studio 77.101.1

Artist unidentified
America, ca. 1860
Oil on canvas
18¼" x 24¼" (46.4 cm. x 61.6 cm.)

This unusual work provides us with a rare glimpse of nineteenth-century nonacademic portrait painting. Not only does the artist display some of the tools of his trade, he also reveals much about the common props, methods of working, and attitudes of a professional portraitist.

89

An Indian stands at center apparently studying the image on the canvas, conceivably a likeness of himself. The artist seems to await his reaction. At left is the sitter's stand, which is draped in green fabric and fitted out with a plush upholstered chair. The artist's equipment is shown in the window seat, and his interest in music, sculpture, and literature is made obvious through the props in the room. Symbolic rays of enlightenment stream through the window and across the artist's brow and the canvas before him. If the painting was executed by the artist shown in it, the work's mediocre quality would fail to support the pretensions and conceits suggested by the elegantly outfitted studio.

Inscriptions/Marks: In pencil in script on a modern red-bordered label in the upper left corner on the reverse of the strainers is "Shivington/38008."

Condition: Treatment by an unidentified conservator prior to acquisition included cleaning, lining, and filling and inpainting scattered areas of loss. The most significant areas of inpainting appear in the artist's shoes, in the blue robe of the Indian at far left, in two sections of the folding screen, in a large tear at right through the small statue beneath the window, and in a U-shaped area through the round stool on the floor beside the lute at right. Period replacement 2-inch, cove-molded walnut frame.

Provenance: An unidentified museum in Massachusetts; an unidentified collector in Boston, Mass.;[1] Kenneth and Stephen Snow, Newburyport, Mass.

Published: AARFAC, 1981, p. 24, illus. as fig. 15 on p. 25.

[1]Stephen Snow to AARFAC, March 24, 1977, states that the picture "came to us from a collector in metropolitan Boston who told us he acquired it very discreetly from a museum in Massachusetts."

III Drawings by Lewis Miller

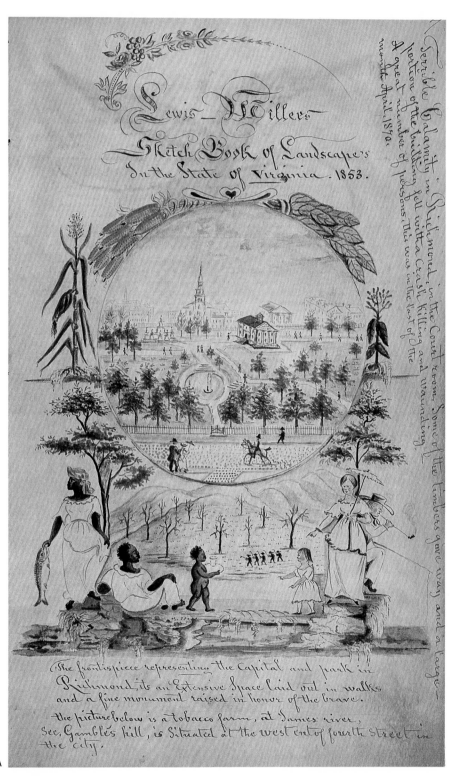

*S*pontaneously and boldly executed yet intimate in scale, Miller's thousands of surviving watercolor and ink drawings exhibit undeniable visual appeal. Yet their value as trustworthy social documents and as uninhibited personal statements makes them much more than charming sketches.

The artist was plainly fascinated by subjects that many of his contemporaries found unremarkable. Hence, Miller's sketches provide valued information about aspects of everyday life that otherwise would remain conjectural in our present-day interpretations of the past. The encyclopedic scope of his subject matter includes such commonplace scenes as slave auctions, dances, and gang marches; fireside visits between friends; farmers catfishing; craftsmen at their daily chores; neighborhood pranks; and family sing-alongs. Similarly, he recorded the appearances of villages nestled in a countryside long since irretrievably altered by the inroads of modern society and the details of simple farms, private homes, and public buildings important only in the lives of a few. In Miller's work, one finds the immediacy and vitality so often and so frustratingly missing from posed portraits, engraved views, and formal commissions. He offers raw material for the vivid re-creation of ordinary lives.

The artist's catholic interests, his zeal in recording them for posterity, his belief in the value of his mission, and his faith in his ability to fulfill his task are factors that sustain appreciation of his drawings and justify the respect accorded them by an ever-widening audience.

Lewis Miller
(1796–1882)

Born May 3, 1796, Lewis Miller was the tenth and youngest child of German immigrants who ultimately settled in York, Pennsylvania — Katharina Rothenberger Miller (1750–1830) and Johann Ludwig Miller (1747–1822), a Lutheran schoolmaster. In 1813 the boy was apprenticed to his brother John, a house carpenter, but about the same time, he initiated a lifelong avocation of far more lasting impact, that of recording the world around him through annotated sketches. Miller is also known to have executed wood carvings, although few such works have been firmly identified as his to date.[1]

For the next thirty-odd years, while Miller worked as a house carpenter,[2] he became increasingly absorbed by his self-appointed task of chronicling the times. He began by sketching local citizens, scenes, and events, but his ties to York seemed to loosen with time, and especially after the deaths of his parents, he indulged a passionate curiosity about the world by traveling and by sketching and commenting, for the pleasure of himself and his friends, on all he witnessed. He remained a bachelor all his life and probably laid aside the greater part of his earnings for his travels. He explored other areas of Pennsylvania as well as Maryland, New Jersey, New York, and Virginia. In 1840 in the company of two friends, Dr. Alexander Small and Henry Hertzog, he set off on a tour of the principal countries of Europe, traveling chiefly on foot on the continent and amassing an impressive itinerary before his return to America in the autumn of 1841.

In 1831 Miller made the first of fifteen documented trips to Virginia, at that time visiting his brother Joseph (1784–1842), a practicing physician in Christiansburg, the thriving seat of Montgomery County in the southwestern part of the state. In a very real sense, Miller adopted Joseph's family as his own.[3] Sketches, poems, letters, valentines, and other tokens of affection make it clear that he doted on his three nieces, and his nephew Charles was his constant traveling companion on exploratory trips through the Virginia countryside.

Miller increased his visits to his sister-in-law and her children following Joseph's death, and in the 1870s, he moved to Christiansburg to live at the family farm, Hans Meadow, with his niece Emmeline Craig Walthall. However, by 1880 at least, he was boarding with Montgomery County farmer Chester Charlton and his wife, Kate,[4] a couple who apparently expected remuneration that Miller was unable to provide. On February 27, 1882, impoverished, lonely, and ill, Miller wrote to his old York friend George Billmeyer to request financial assistance, and in touching gratitude for the fifty dollars Billmeyer sent him, he created more than two hundred portraits of citizens from their old hometown.[5] Visually distinguishing characteristics and incidents recounted from years long past proved that the artist's memory remained sharp to the end. Miller died September 15, 1882, and he was buried near his brother in a family cemetery in Christiansburg.[6]

[1] Two privately owned letters refer to Miller's wood carving. George Billmeyer to Lewis Miller, March 20, 1882, requests that, in return for a favor of money (see note 5 below), "you give to me your curiosities such as carvings, pictures and especially those portraits of our town." Lewis Miller to George Billmeyer, March 24, 1882, states: "I See in your letter of Some Carving figures in wood — I have none no more. all I make is on paper."
A carved wood pediment Miller made for his birthplace in South Duke Street in York is owned by the Historical Society of York County, York, Pa., and illustrated in Shelley, Miller, p. xxii. A privately owned carved walking stick said to have been carried by Miller on his travels in Europe may also be his work.

[2] Miller himself wrote that he worked at the trade of house carpentry for thirty years (Shelley, Miller, p. 100) and, in another place, for thirty-five years (A History of War, collection of the Historical Society of York County, York, Pa., v. III, p. 299). An early biographer of Miller's wrote that "after the completion of his term of apprenticeship, he worked at the business . . . for a period of nearly forty years" (Henry L. Fisher, An Historical Sketch of the Pennsylvania Germans, Their Ancestry, Character, Manners, Customs, Dialect, Etc., 1885, reprinted in John Gibson, History of York County, Pennsylvania [Chicago, 1886], pp. 233–239).

[3] In 1812 Joseph Miller married Matilda Charlton (1786–1854). Their children were Emmeline A. (1813–1892), Amanda Melvina (1815–1874), Mary I. (or possibly J.) L. (ca. 1818–1873), and Charles A. (1819–1893).

[4] 1880 U.S. census report for Montgomery County, Va.

[5] The exchange is documented in Lewis Miller's letters to George Billmeyer dated February 27, 1882; March 24, 1882; and May 8, 1882 — all privately owned. Billmeyer's reply to Miller dated March 20, 1882, is in a second private collection. Miller's portraits of old Yorkers are in a third private collection.

[6] In addition to the Folk Art Center, institutional holders of sizable collections of Miller's works include the New-York Historical Society in New York City; the Virginia Historical Society in Richmond, Va.; the Henry Ford Museum in Dearborn, Mich.; and especially the Historical Society of York County, York, Pa.

90 Travel Journal for Germany 80.301.2

Lewis Miller
Germany, 1840 and possibly 1841
Ink, watercolor, and pencil on wove paper
Most sheets measure approximately 6½″ x 8⅛″
(16.5 cm. x 20.6 cm.)

The thirty-six sketches in this paperbound album were executed as Miller traveled through "the Duchy of Nassau, and hesse, and Rhineish Bavaria, and Baden, divided from the old palatine."[1] This sketchbook is

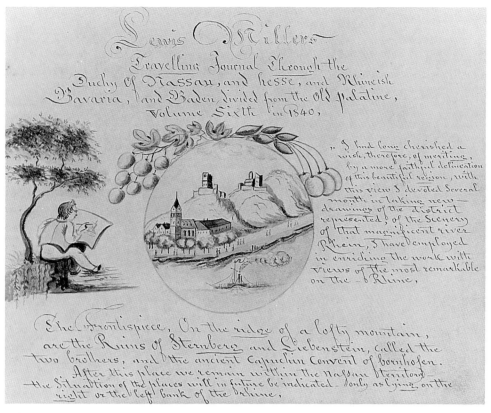

90A

labeled on its title page "volume sixth," and it is one of four of the artist's European travel diaries known to survive from his extensive tour of 1840–1841.[2]

In this book, Miller describes a trip up the Rhine River through sketches of townscapes and individual structures, adding notes of historic or personal interest and generally indicating whether the sights are to be found on the right bank or the left. Floral sprays on the endpapers and a farm scene near Heidelberg add to the total complement of drawings. The farm scene is on ruled paper smaller than the rest of the sheets, with a poem "Translated from the German" on the reverse. Most sketches are in ink with sepia washes; only four include brief passages of more vivid color. Numbers 90A through 90F are selected pages from this travel journal.

Inscriptions/Marks: "John Hays" appears in ink in script on the paper cover.
Condition: Prior to acquisition, the book covers were secured between sheets of long-fibered paper, and the spine was reinforced with cloth tape. Most sheets are loose from their binding.
Provenance: John Hays, York, Pa.; Anna and Mary Hays, York, Pa.; George Hay Kain, York, Pa.; gift of Mr. and Mrs. William H. Kain, York, Pa., in memory of George Hay Kain.[3]

[1]The quote is from the book's title page heading.
[2]A number of European scenes remain interspersed with other drawings as, for example, occurs in the Folk Art Center's *Sketch Book of*

Landscapes in the State of Virginia (no. 93). However, only four albums of Miller's appear exclusively devoted to a European record and are conspicuously numbered by volume and labeled as traveling records on their title pages. The other three's title pages are inscribed in part as follows: "Ludwig Miller's/Reise Journal in Deutschland, 1840 & 1841./Volume Second"; "volume III./Ludwig Miller's/Reise in der Schweitz/Im Jahr 1841"; and "Ludwig Millers/Travelling Journal Through/France, VOLUME/ Fourth, in 1841." It is not clear why the Folk Art Center's "volume sixth" bears an 1840 date on its title page (and on two drawings inside), whereas Miller's other travel books that are numbered second, third, and fourth in the series bear dates of 1841 in two cases and "1840 & 1841" in the third.
[3]See note 3 for no. 93.

90A Title Page 80.301.2, 2

Miller used the format of a porthole view almost exclusively throughout his third travel book, which describes his travels in Switzerland, but it appears here only on the title page, or frontispiece, as he calls it. The blue of the Rhine River is one of the few touches of vivid color in the album. Certainly the figure shown sketching at left represents Miller himself. The inscription at right suggests that the artist returned to the Rhine region after an initial visit, or at least made two sketching expeditions.

Inscriptions/Marks: In ink is "Lewis Millers/Travelling Journal Through the/Duchy of Nassau, and hesse, and Rhineish/Bavaria, and Baden, divided from the old palatine,/volume sixth in 1840,/

The Frontispiece, On the ridge of a lofty mountain,/are the Ruins of Sternberg and Liebenstein, called the two brothers, and the ancient Capuchin Convent of bornhofen./ After this place we remain within the nassau territory — the Situation of the places will in future be indicated only as lying on the/right or the left bank of the rhine." The inscription to the right of the medallion view reads: " 'I had long cherished a/wish, therefore, of meriting,/by a more faithful de-lineation/of this beautiful region, with/this view I devoted Several/month in taking new — /drawings of the district/represented, of the Scenery/of that magnificent river/Rhein, I have employed/in enrich-ing the work with/views of the most remarkable/on the Rhine."

90B The New Theatre in Mentz 80.301.2, 15

Henry Hertzog and Alexander Small set sail for Europe with Miller in June 1840, but they did not accompany the artist through all of his travels abroad. The sketch of the theater in Mentz (Mainz) documents the fact that Hertzog, at least, was there with Miller on July 31, 1840. The artist's comment about "Mr. Herbold" and his involvement with them (see *Inscriptions/ Marks*) is unusual for this album, in which most of the text is devoted to observations about the towns and buildings viewed on the Rhine River trip. The three figures at lower left in the sketch probably are meant to be Miller, Hertzog, and Herbold.

Inscriptions/Marks: In ink at top is "The new theatre in Mentz," and below the sketch is "Mr. Herbold, from mentz, Show-ing all the curiosity's of/the city, to Lewis Miller, and Henry hertzog, July 31, 1840,/he went to all the church's in the place, A cheerful old/fellow — one who has been kind to us,/Opposite to the theatre, Stands the Statue of Gutenberg in/bronze, erected on the 14 of Au-gust 1837. Gutenberg = Square."

90C Mentz 80.301.2, 16

Miller's overview of Mentz (Mainz) and its boroughs is one of the most attractive views in this album. The fortifications around the city are crisply delineated, and their black ink shading stands out in marked con-trast against a white ground. Within the city walls and beyond the zigzag line of fortification, a sepia wash tints most of the landscape. Red watercolor brightens a few structures within the city walls. The black clouds above the river were originally white; their lead oxide paint has darkened irreversibly with age.

This album also contains sketches of two individ-ual buildings in Mainz: the new theater (no. 90B) and St. Martin's Cathedral.

Inscriptions/Marks: In ink at the top of the page is "Mentz, on the left bank, the river is 2100 feet wide here." In ink below the sketch is "Mentz, chief-town of the grand-ducal Hessian province of the rhine,/And a fortress of the German Confederation, it is next to coblence the best/fortified place in Germany, and a chief bulwark against france. it has/32,000 inhabitants, and a garrison of 6000 men. prussians, & Austrians./A bridge of fifty pontons — leads over

it to the borough of cassel, it has Six/citadels — citadel proper and the hauptstein on this Side. Cassal, mars and/montebello beyond the river, and petersaue upon an island."

90D Das Schloss zu Rastadt 80.301.2, 29

Sepia tones offer the only hint of color in Miller's sketch of the palace in Rastadt. His observation that the structure is "overloaded with peopled Statues" is verified by the rendering, although his exact meaning is uncertain. He may have meant that he considered the statues too plentiful to be tasteful, but he may also have meant simply that many statues appear on top of the building. As in numerous other sketches, Miller's depiction of figures in the foreground helps to convey an idea of relative scale and a sense of bustling activity on the scene.

Inscriptions/Marks: In ink above the sketch is "Das Schloss zu Rastadt," and in ink below the sketch is "The Palace, in Rastadt. built by the count Ludwig of/Baden, Baden, its an old noted place. the palace is overloaded/with peopled Statues, flanked and inter-sected in front:"

90E Die Kirche in alt breisach 80.301.2, 31
and Das Kaufhaus in
Frëyburg

This is the only page in this album that features two distinct and unrelated sketches except, perhaps, for the album's page 13, which shows the village of Nieder Walluff and, below it, Fort Montebello — both on the right bank of the Rhine.

Miller's abiding interest in architecture possibly was born of his own experience as a house carpenter. At left here, he meticulously depicts the stonework of the church in old Breisach, but he saves his lengthy commentary for the "singular" town hall building in Freyburg. The scrollwork he mentions is probably that shown just above the statuary.

Inscriptions/Marks: Above the left drawing in ink is "Die Kirche in alt breisach," and below it in ink is "The church in old breisach,/on the right of the rhine, in/baden:" In ink above the right sketch is "Das Kaufhaus in Frëyburg,/im District breisgau, baden." Below the right sketch in ink is "the Arcade in Freyburg, and town/hall, is a very Singular building,/Resting on Arches, and decorated/with metal Statues, and Scroll work/at the corner's are oriel win-dows/in form of a lantern like, and high — /Roofs, small windows, giving that part/of the hause the appearance of a hull of a/three decker."

90F Grünstadt 80.301.2, 33

Miller's flattened view conveys more information about the layout of the town and the relative positions of the buildings than could a more academic sketch

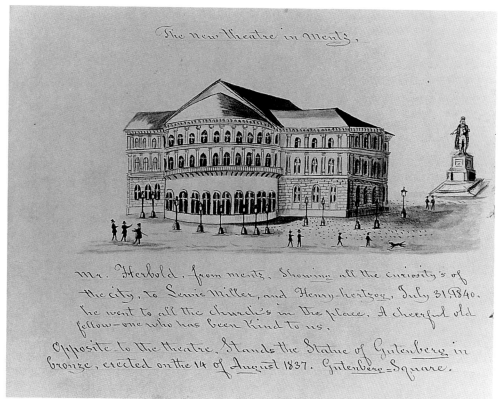

The new theatre in Mentz,

Mr. Herbold. from mentz, showing all the curiosity's of
the city, to Lewis Miller, and Henry hertzog, July 31, 1840.
he went to all the church's in the place. A cheerful old
fellow—one who has been kind to us,

Opposite to the theatre, stands the statue of Gutenberg in
bronze, erected on the 14 of August 1837. Gutenberg Square.

90B

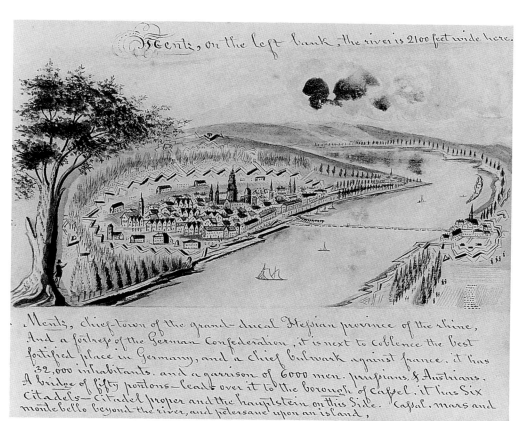

Mentz, on the left bank, the river is 2100 feet wide here.

Mentz, chief-town of the grand-ducal Hessian province of the rhine,
And a fortress of the German Confederation, it is next to Coblence the best
fortified place in Germany, and a chief bulwark against france. it has
32,000 inhabitants. and a garrison of 6000 men. prussians, & Austrians.
A bridge of fifty pontons—leads over it to the borough of Cassel. it has Six
Citadels—Citadel proper and the hauptstein on this side. Cassal. mars and
montebello beyond the river, and petersanc upon an island,

90C

Das Schloß zu Rastadt,

The Palace, in Rastadt, built by the count Ludwig of Baden Baden, its an old noted place, the palace is overloaded with peopled Statues, flanked and intersected in front:

90D

90E

Die Kirche in alt breisach,

Das Kaufhaus in Freyburg, im district breisgau, baden.

The Church in old breisach, on the right of the rhine, in baden:

the Arcade in Freyburg, and town hall, is a very Singular building, Resting on Arches, and decorated with metal Statues, and Scroll work at the Corners are Oriel windows in form of a lantern like, and high Roofs, small windows, giving that part of the house the appearance of a hull of a three decker;

90F

employing the greater optical realism of one-point per-spective. He does mitigate the distortion and achieve some sense of spatial recession by the diminishing scale of the figures and structures and by the omission of detail in the distant mountains.

Although unusual for this travel album, Miller's texts as a whole often juxtapose data of personal importance with those of wider significance; thus, Grünstadt's noteworthiness is seemingly equally enhanced by its having served as the birthplace of a fellow York craftsman, the potter Christopher Stoehr, and of a great painter of international repute, Hans Holbein (d. 1524).[1]

Inscriptions/Marks: In ink above the sketch is "Grünstadt, im Rhein Kreis bairen." In ink below the sketch is "Grünstadt, at the hart mountains, and ruined castle of/the old Earls' and house of Leiningen, its five miles N. west./of frankenthal, it is the birthplace of old christoffer Stoehr, who/is buried in york — pa. And the Great painter Holbein:/been born at this place, its an ancient and venerable town."

[1]Shelley, Miller, pp. 3, 12, 13, 40, 59, depict and/or allude to Christopher Stoehr of York, p. 59 describing him as a potter in South Beaver Street there.

91 Drawing for Jane Edie 81.301.1

Lewis Miller
Probably Montgomery County, Virginia, possibly York, Pennsylvania, probably 1845–1850
Watercolor and ink on wove paper
4^{13}/$_{16}$″ x 8¾″ (12.2 cm. x 22.2 cm.)[1]

Miller must have addressed this drawing to his great-niece Jane Harriet Edie (1826–1912) sometime before her marriage to Captain John Crow Wade on September 18, 1850.[2] The artist had been in Virginia several times before then, including visits in 1846 and 1849, but he may have sent this token to the young woman rather than hand-delivering it.

The floral spray at bottom is applied; it was painted on and cut from a separate sheet, then glued to the main paper before several leaves and tendrils were added in watercolor around and among the cut elements. Two triangular scraps of paper at center are also applied; they partially cover a third applied scrap on which a now illegible inscription appears. The drawing has been trimmed along the top edge, and it is not known how much of the original design is miss-

91

ing. The bottom edge, too, may have been trimmed by someone other than the artist. These factors all make it difficult to guess how Miller intended the token to be folded and unfolded, and in what order he meant the inscriptions to be read. However, the playful nature of the piece's construction is evident, and the sentiment expressed therein is typical of Miller's feelings for his brother's family as revealed in a number of other emblems of affection, such as poems, valentines, May Day and Christmas greetings, birth and baptismal remembrances, and the like.

Inscriptions/Marks: A now illegible ink inscription appears at center. At bottom, within the confines of a painted envelope, is "Miss/Jane Edie/virginia." At top center is "your's faithfully — / Lewis Miller." Running vertically at left is "Let thy mind, love, be at ease:/Rest, and fear not, dream of me/love, love is here." Running vertically at right is "When true hearts lie wither'd/and fond ones are flown./Oh! who would inhabit this world/Alone!"

Condition: Treatment by E. Hollyday in 1982 included dry cleaning where possible, coating colors with a solution of consolidator, floating to reduce stains and impurities, aligning and mending tears with Japanese mulberry paper, filling losses along old creases, and flattening. Modern replacement ¾-inch cyma recta frame, painted black.

Provenance: The piece descended in the family of the recipient to Mr. and Mrs. Donald L. Brown, Christiansburg, Va.

[1] Given measurements do not reflect a sizable triangular projection on the bottom edge at left, an integral part of the primary support.

[2] Jane Harriet Edie was actually a step relative of Miller's, since she was born to Joseph Speers Edie (1797–1887) and his first wife, Elizabeth Randolph White Edie. Not until February 12, 1832, or February 11, 1833, did Joseph Edie marry Miller's niece Amanda Melvina Miller (1815–1874), the daughter of the artist's brother Joseph Miller (1794–1842).

92 Orbis Pictus 78.301.2

Lewis Miller
Pennsylvania and Virginia, ca. 1849
Watercolor and ink on various wove papers
Most sheets measure 9¹¹⁄₁₆″ x 7⅞″ (24.6 cm. x 20.0 cm.)

Although the title page and several drawings scattered throughout this collection bear 1849 dates, Miller may have sketched and inscribed the 146 pages contained in *Orbis Pictus* over a longer period of time; hence a circa date has been given in the heading.[1]

Many of the drawings show young women in various guises, most of them appearing to be generalized representations of feminine qualities rather than actual representations of particular acquaintances of Miller's. Sometimes a first name appears in the idealized, sentimental, or occasionally satirical verses that accompany some of the sketches, but many more are dedicated to nameless female friends referenced only by pronouns.[2] Zoological studies, allegorical figures, and biblical subjects also appear here and there, as do philosophical reflections on death, solitude, love, and the like that are usually illustrated by sketches. Inscriptions are in English, German, and — less frequently — Latin.

Only a few drawings show specific locales. Of these, all that are now at the Folk Art Center are Virginia views (excepting, perhaps, the title page bird's-eye view of a town that was probably intended as

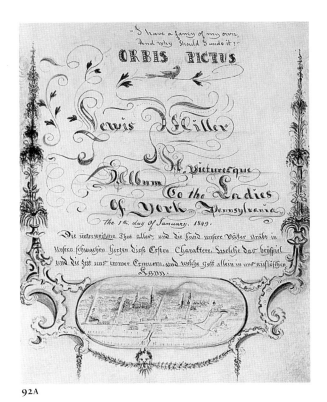

92A

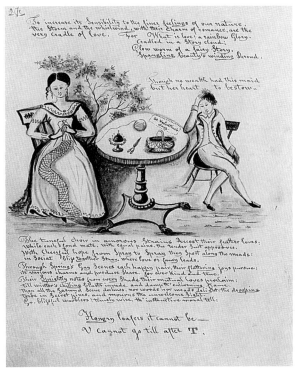

92B

York). Numbers 92A through 92F are selected pages from the *Orbis Pictus* collection.

Condition: In 1979 E. Hollyday dismantled the hand-bound book. She dry-cleaned individual sheets where possible, removed insect debris, lightened darkened areas of white lead paint, mended tears with Japanese mulberry paper, and flattened the sheets and secured each between two pieces of polyethylene film.
Provenance: John Hays, York, Pa.; Anna and Mary Hays, York, Pa.; George Hay Kain, York, Pa.; gift of Mr. and Mrs. William H. Kain, York, Pa., in memory of George Hay Kain.[3]

[1]The page count given includes two endpapers counted as one page apiece. One page in the count is blank, and the following pages were not donated to the Folk Art Center but were retained by the owners: *Orbis Pictus* pages 2–5, 32–33, 36–37, 72–77, 116–117, 128–129, 144–145.
[2]Examples of first-name references include "Grace" (page 60), "Marcia" (page 70), "Jane" (page 83), and "Caroline" (page 121); all page references are to *Orbis Pictus.*
[3]See note 3 for no. 93.

92A Title Page 78.301.2, 6

This *Orbis Pictus* title page is a calligrapher's showcase. The letters of the artist's name are multicolored in red, blue, yellow, and white, and their ornate capitals nearly defy legibility. The subtitle is rendered in two tones of sepia with back shading in orange. Deft handling of the pen is evident in the controlled exuberance of Miller's spirals and curls and in the meticulous

character of the Gothic-style lettering. The mask, swags, tattered shells, C-scrolls, and pinnacles adroop with mossy foliage all betoken Miller's love of Baroque stylizations that were vastly out of date by the mid–nineteenth century. The vignette is undoubtedly intended to show the city of York, Pennsylvania, with the Codorus River running through it.

Inscriptions/Marks: Inscriptions are in ink and in ink with watercolor. At upper right is the number "6." At top in quotes is "I have a fancy of my own,/And why should I undo it?" Below the preceding is "ORBIS PICTUS/Lewis Miller/A picturesque/Album/To the Ladies/of York.. Pennsylvania../the 1th. day of January. 1849." Below the preceding is "Die unterweisung thut alles, und die hand unsrer Väter gräbt in/unsern schwachen herzen diese Ersten Charaktere, Welche das beÿspiel/und die zeit uns immer Erneuern, und welche gott allein in uns auflöschen/Kann."
Translation of the German reads: "Instruction does everything, and the hand of our fathers engraves this basic character in our weak hearts, which example and time renew unto us repeatedly and which God alone can extinguish in us."

92B Lovers in a Garden 78.301.2, 27

Abundant expressions of Miller's irrepressible sense of humor exist and offer healthy balance for the sentimental, introspective, and sometimes melancholy aspect of his personality that also found expression in his writing and drawing. The poem beneath this particular sketch extols the beauties of love in its flower-

ing or springtime and warns of its inevitable decline in winter. The tone is consistently lyrical and elevated until one reaches the last two lines, where Miller suddenly explodes in a terse couplet of mirthful self-mockery that includes two rebuses.

This sketch may not have been intended as a direct illustration of the poem, although the young suitor's dazed mien might well be the result of either Cupid's dart or hunger pangs. A valentine rests on the table by his elbow; perhaps he searches for the nerve to deliver it to his intended, who is preoccupied with her knitting. The pair sit in side chairs with decorated crests around a pedestal table that displays a sewing basket, scissors, and a pincushion.

Inscriptions/Marks: All are in ink. The number "27" is at upper left. Above the couple is "To increase its Sensibility to the finer feelings of our nature,/the Storm and the whirlwind, with their charm of romance, are the/very cradle of love. For What is love! a rainbow Glory,/cradled in a Story cloud; Glow worm of a fairy Story,/Spangling beauty's winding Shroud." Above the man's head is written: "Though no wealth had this maid/but her heart to bestow. ." Beneath the couple is written: "The tuneful choir in amorous Strains Accost their feather loves:/while each fond mate, with equal pains, the tender Suit appro — ves./With Cheerful hope from Spray to Spray they Sport along the meads:/in Sociat [*sic*] bliss together Stray, where love or fancy leads./Through Spring's Gay Scenes each happy pair, their flattering joys pursue:/its various charms and produce Share, for ever kind and true./Their Sprightly notes from every Shade their mutual loves proclaim:/till winter's chilling blasts invade, and damp th' enlivening flame./then all the jacund Scene declines, nor woods nor meads delight: the drooping/tribe in Secret pines, and mourns the unwelcome Sight./Go, blissful warblers! timely wise, th' instructive moral tell:/Hongry loafers it cannot be — /U cannot go till after T."

92C Miscellaneous Sketches 78.301.2, 42

Disparate drawings having no apparent relation to one another appear on many pages of Miller's *Orbis Pictus* and in some of his other sketchbooks as well. They aptly convey the artist's constant urge to express his thoughts and to record the sights around him without particular regard for the formalized conventions by which academic art was defined in his day.

The building at lower left and the stone structure beside it are not identified here, but perhaps they are the "old furnace and mill" that, on the facing page (not shown here), Miller describes as located in Botetourt County, Virginia, between Fincastle and Big Lick (now Roanoke). Drawings of all sorts of trees, herbs, vegetables, fruits, and flowers are sprinkled throughout his texts and are occasionally juxtaposed with useful advice regarding their preparation or practical applications. His bittersweet lines on a flower's transience typify many poignant reflections on the ephemeral nature of man's existence. His lines on "a female

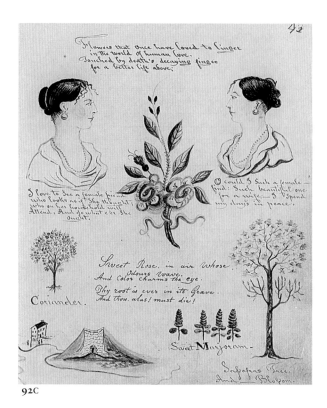

92C

friend" are also typical of much of his writing about the female sex, insofar as they offer few clues to the reasons for the artist's lifelong bachelorhood, unless one speculates that his expectations were overly idealistic. The two bust-length profiles drawn here exhibit several characteristics of Miller's figural drawing, such as sloping foreheads, hooked noses, flaring nostrils, upturned mouths, and sturdy body builds. His women also often show the wispy tendrils of hair seen here.

Inscriptions/Marks: All are in ink. In the upper right corner is "42." Beneath the images they represent are the words: "Coriander," "Sweet Marjoram," and "Sassafras Tree./And — Blossom." Above and below the rose spray at center is "Flowers that once have loved to linger/in the world of human love,/Touched by death's decaying finger/for a better life above;/Sweet Rose, in air whose/Odours wave./And color charms the eye./Thy root is ever in its Grave./And thou, alas! must die!" Beneath the two profiles is "I love to See a female friend/who looks as if She thought;/who on her household will/Attend, And do what e'er She/ought./O could I Such a female — /find: Such beautiful one/for a wife. — I Spend/my days in peace."

92D Die Ehebrecherin 78.301.2, 58

Miller's interpretation of *Die Ehebrecherin* ("The Adulteress") is one of twenty-seven *Orbis Pictus* drawings that specifically illustrate biblical passages. In these, the wording is carefully transcribed and referenced by book, chapter, and verse. Here Miller

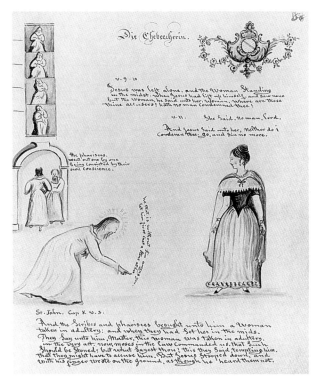

92D

92E

shows Jesus writing on the ground with His finger. The artist probably abandoned any attempt to show the lettering in perspective for the sake of legibility.

At upper left, the vertical row of small portraits may be related to the main scene. Miller used a similar format to portray noted women of the Bible on pages 57 and 130 of *Orbis Pictus,* but on those pages his likenesses are more detailed and the compositions more complex. The medallion and suspended floral garland at upper right are typical examples of Miller's sheer love of ornament, particularly C- and S-scrolls. The only significant touches of color on this sheet are the woman's yellow pelerine, or shoulder cape, and her long blue robe.

Inscriptions/Marks: All inscriptions are in ink. At top is "Die Ehebrecherin." At bottom is "St. John. Cap 8. v. 3./And the Scribes and pharisees brought unto him a Woman/taken in adultery: and when they had Set her in the mids./They Say unto him, Master, this woman was taken in adultery,/in the very act. now, moses in the law commanded us. that Such/Should be Stoned: but what Sayest thou! this they Said tempting him,/that they might have to accuse him. But Jesus Stooped down, and/with his finger wrote on the ground, as though he heard them not." At Jesus' fingertip is "he that is without Sin among you,/let him first cast a Stone at her." Beside the arch at left is "the pharisees,/went out one by one/being convicted by their/ own conscience." Above the woman's head is "v. 9. 10/Jesus was left alone, and the woman Standing/in the midst. when Jesus had lift up himself, and saw none/but the woman, he said unto her, woman, where are those/thine accusers? hath no man condemned thee!/ v. 11. She Said, no man, Lord./And Jesus Said unto her, neither do i/ condemn thee. go, and sin no more." The number "58" appears in the upper right corner of the sheet.

92E Single Indian Pursuing Deer 78.301.2, 107

Nostalgia prompted many of Miller's more memorable drawings. Although Indian atrocities were certainly well known to him, a highly romanticized view of the race and their swiftly disappearing culture is evident in his two *Orbis Pictus* drawings of them and in his writings about them. Page 21 (not shown here) of *Orbis Pictus* shows an Indian family of four in the woods, and the verse below them describes the spell wrought by the sight of an Indian mound.

The fifth verse on no. 92E is repeated in another of Miller's albums, along with a sketch and commentary on the disappearance of the Indian. In that book, he also noted that the Wyandot tribe had been in Virginia as late as 1792 and, in a more practical vein, listed three Wyandot cures for snakebite.[1] Except for green grass in the background, the only strong color notes here are the Indian's boots and waistband, and the sling that runs diagonally across his chest and probably supports his quiver; all these are bright yellow.

Inscriptions/Marks: All inscriptions are in ink. In the upper left corner is "107." At the top of the page is "Like bubble on the fountain,/like Spray upon the river,/like Shadow on the mountain/he has passed away forever./The forests of his childhood/have fallen in their pride/with the beauty of the wild-wood,/that fringed the flowing tide./The lake of Smiling Glances,/in infancy he knew,/no more in beauty dances/around his light canoe./His race is Swiftly hasting/to the Spirit-land away./their images are wasting/neath the finger of

92F

Inscriptions/Marks: All inscriptions are in ink. The number "110" appears in the upper right corner of the sheet. At top center is "Advice to Young Ladies." Beneath the pictorial composition is "Female Education, what painter — /in the drawing room, A delightful/picture, So elegant in the frame." At upper right beneath an insect, possibly a bee, is "prototypus, primum exemplar,/Das erste muster, formular./Sapientia — weissheit./prudentia./Klugheit/Justitia./gerechtigkeit./Fortitudo./Kraft./Temperantia./mässigkeit." Beside the woman's head is "Pruna, ardens est./ein glüende Kolen." Beneath the painting on the easel is "Renovatum — Erneurt." Above the cat is "Sin/'Superbia, hoffahrt.'/Avaritia, geitz./'Luxuria, unkeuschheit.'/Invidia, neid./'Jula, völlerei,/'Ira zorn./'Acedia, Trägheit."

Translation of the Latin and German at upper right reads: "the first example." The virtues listed below this are "wisdom, cleverness, justice, strength, temperance." Beside the woman's head is "a glowing coal." Beneath the painting on the easel is "Renews." Above the cat under the heading "Sin" is "arrogance, parsimony, inchastity, jealousy, gluttony, wrath, indolence."[3]

[1]Prov. 25:21–22 reads: "If thine enemy be hungry, give him bread to eat; and if he be thirsty, give him water to drink: For thou shalt heap coals of fire upon his head, and the Lord shall reward thee." (The charge was rephrased by Paul in Rom. 12:20 as: "Therefore, if thine enemy hunger, feed him; if he thirst, give him drink: for in so doing thou shalt heap coals of fire on his head.")

[2]The Folk Art Center is indebted to Pastor Frederick Weiser for suggesting a link with the biblical verses named, for the order of reading the inscriptions, for the meaning of the picture as a whole, and as in other entries, for providing a translation.

[3]It is not known whether Miller intended to give the English word "sin" or the German word *sinn,* meaning "mind, intention, or will."

decay./His hunting grounds have perished,/his villages are burned:/ by those whom he once cherished,/the indian is Spurned./like the bubble on the fountain,/like Spray upon the river,/like Shadow on the mountain,/he has passed away forever." Just above the drawing is written: "A picture of A Single indian pursuing Deer amid his native forests."

[1]*A History of War,* III, pp. 188–189, collection of the Historical Society of York County, York, Pa., contains Miller's additional sketches and commentary on American Indians.

92F Advice to Young Ladies 78.301.2, 110

The exact meaning of this picture remains unclear, although Miller may have had Prov. 25:21–22 in mind when he depicted the glowing coal in the angel's hand.[1] Within the composition, the German wording repeats the meaning of the Latin it follows. It has been suggested that perhaps Miller intended these inscriptions to be read as a sentence that begins with the list of virtues at upper right, then progresses to the label beside the coal, then moves beneath the painting on the easel, and ends with the list of sins above the cat. If so, the picture might be interpreted as meaning that the angel burns off the young woman's sins — and thereby renews her — with the coal or ember of virtue. Hence, the woman paints herself as she aspires to be, or as she is, in fact, becoming. The glaring cat with a hapless mouse may symbolize the dispatch of the painter's sins.[2]

93 Sketch Book of Landscapes in the 78.301.1
State of Virginia

Lewis Miller
Virginia, 1853–1872
Watercolor, ink, and pencil on various papers
Most sheets measure approximately 12½" x 7½" (31.8 cm. x 19.1 cm.)

The formalized structure of Miller's title page (he calls it the frontispiece; it is now numbered page 7) and its bold proclamation of "Lewis Millers/Sketch Book of Landscape's/In the State of Virginia. 1853" indicate that, at least at some point, the artist made a conscious effort to create a record of the sights encountered on a particular trip. Indeed, the majority of the ninety-six drawings of Virginia subjects in the group appear to date from 1853, and they are rendered in consistent format. However, others are handled differently and were executed later on various types and sizes of paper, and forty-eight European scenes are divided between the beginning and end of the present sequence. Clearly the artist did not envision all of these as a cohesive unit, and certainly someone other than Miller — probably John Hays, whose name appears on the book cover — grouped the collection, numbered the pages in their present order, and had them so bound.[1]

Of the Virginia drawings that postdate 1853, two are dated 1859; seven specifically document a five-day excursion made October 15–19, 1867; and six date from 1870 to 1872. Some are of uncertain date. The problem of ascribing precise individual dates of execution is complicated by the fact that Miller often returned to drawings long finished to add subsequent notes (the aforementioned title page is an example), and occasionally he appears to have inscribed a retrospective date (the scene dated 1846 on the bottom of the sketchbook's page 29 probably was drawn in 1853).

Likewise, one cannot be certain that all the drawings in the grouping were done in Virginia, although it is quite possible that even the European scenes were done there based on Miller's memory, on notes from his 1840–1841 trip abroad, or on illustrations and comments published in guidebooks that he may have brought back with him. The size, color, and texture of the pages used for the European scenes match those used for some of the Virginia drawings.

Especially in later life, Miller used whatever paper he found at hand, and all of the post-1853 Virginia drawings are executed on scraps smaller than the 12½-inch by 7½-inch sheets used throughout the rest of the book.[2] Five drawings from the 1870s were done on both sides of unused railroad bills of lading; on the printed sides, Miller simply drew around or even over the wording.

Condition: In 1978 and 1980, E. Hollyday dismantled the book and removed the endpapers from the pressboard covers. Individual sheets were dry-cleaned where possible, colors were tested for solubility, and the sheets were brushed with a dilute solution of methylcellulose to protect coloration and size the papers. Sheets were flattened, and tears and losses were repaired with Japanese mulberry paper. Each sheet was then secured between two pieces of polyethylene film.

Provenance: John Hays, York, Pa.; Anna and Mary Hays, York, Pa.; George Hay Kain, York, Pa.; gift of Dr. and Mrs. Richard M. Kain, Louisville, Ky., in memory of George Hay Kain.[3]

[1]Forty-nine separate sheets, most often decorated with two drawings on each side, make up the total collection. In addition to the European scenes and Virginia or probable Virginia subjects, there are six pages (each, one side of a sheet) of miscellaneous drawings or script only. Three pages are blank.

[2]A total of four drawings (pages now numbered 32–33 and 45–46) appear on the fronts and backs of two small scraps cut from larger — probably standard size — sheets. The four do not appear to belong together, which suggests that two half sheets are now missing. Their whereabouts are unknown.

[3]Miller and John Hays frequented a tobacco shop near Hays's home in York, and Miller is believed to have sent the *Sketch Book* to Hays in the late nineteenth century as a token of appreciation for money sent by Hays to the artist in Virginia. Anna and Mary Hays were John's daughters, who in 1925, gave the book to George Hay Kain, father of AARFAC's donor.

93A Title Page and View of Richmond

78.301.1, 7

12⁹⁄₁₆″ x 7⁹⁄₁₆″ (31.9 cm. x 19.2 cm.)
(Reproduced on page 132)

Miller often executed medallion or "porthole" views of European scenes, sometimes ornamenting the edges or margins with arrangements of C-scrolls, ribbons, small birds or animals, or floral and foliage sprays in a manner reminiscent of Baroque carving. Here the formal design is softened and personalized by marginal sketches of sights pertinent to Virginia. Corn and tobacco frame the upper half of the medallion. In the distance below is a rare depiction of row hoeing, the methodical cultivation of crops by workers advancing through a field in a line. The physical distance between whites and blacks in the foreground may well reflect the developing unrest of Virginia's pre–Civil War years, although the large fish in the woman's hand is no doubt meant to suggest that the living is easy.

The view of Richmond shows the Capitol building quite prominently. Behind it and slightly to the right is City Hall, while the steeple near center represents the First Presbyterian Church. The tiers of figures in the left middle ground represent an ambitious monument designed by Thomas Crawford.[1]

Inscriptions/Marks: In ink at top center is "Lewis Millers/ Sketch Book of Landscape's/In the State of Virginia. 1853." In the lower margin is "The frontispiece representing the Capital and park in/Richmond, its an Extensive Space laid out in walks/and a fine monument raised in honour of the brave./the picture below is a tobacco farm, at James river,/See, Gamble's hill, is Situated at the west ent of fourth street in/the city." In the side margin is "Terrible Calamity in Richmond, in the Court room, Some of the timbers gave way and a large — /portion of the building fell with a crash Killing and wounding — /A great number of persons, this was in the last of the month April, 1870."

Published: Richard M. Kain, "Stalking Nineteenth-Century Virginia with Sketchbook and Pen," *Colonial Williamsburg Today,* I (Summer 1979), illus. on p. 6; Harry L. Rinker and Richard M. Kain, "Lewis Miller's Virginia Sketchbook: A Record of Rural Life," *Antiques,* CXIX (February 1981), illus. as pl. I on p. 396.

[1]Miller appears to show a single standing figure on top of the Crawford monument, whereas the completed memorial was crowned by an equestrian statue of George Washington with other individual figures on the two tiers below. The discrepancy is explained by the fact that the monument was incomplete in 1853, and evidently Miller filled out the design by conjecture. The cornerstone was laid in 1850, but the eighteen-ton bronze casting of the mounted Washington was not lifted into place until 1858. The four figures on the tier below were not put in place until 1860 and 1867. A lengthier description of the monument of Washington and its erection can be found in Alexander Wilbourne Weddell, *Richmond Virginia in Old Prints, 1737–1887* (Richmond, 1932), pp. 119–120; an illustration of a lithograph of the monument appears therein as pl. XLIII.

A view of Richmond from a perspective similar to Miller's and labeled "An artist's sketch of Capitol Square in 1856" can be found in Francis Earle Lutz, *A Richmond Album* (Richmond, 1937), pp. 42–43.

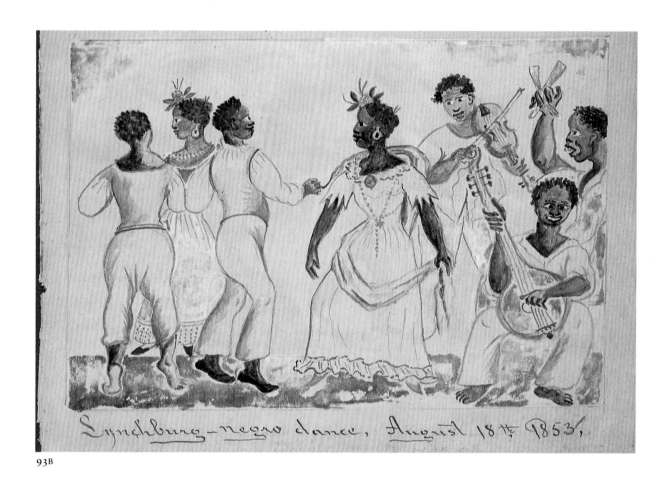

93B

93B Lynchburg Negro Dance 78.301.1, 17b

Pictorial composition: 4⁹⁄₁₆" x 6¹³⁄₁₆" (11.6 cm. x 17.3 cm.)[1]

Miller's value as a social historian is exemplified by a number of carefully detailed drawings of sights so ordinary as to have been overlooked by many of his contemporaries. This depiction of slaves dancing and making music is such an example. At right three men play upon fiddle, banjo, and bones, while at left, two couples are caught in the animated postures of a dance. The women are bedecked in earrings, necklaces, and flowers, and no doubt they wear their best dresses for the occasion.

Lynchburg Negro Dance appears to illustrate the artist's impression that slaves were generally "a contented and a happy race."[2] However, Miller's feelings of ambivalence regarding the institution of slavery become apparent in examining other sketchbook drawings, particularly one showing white drivers gang-walking a company of slaves from Staunton, Virginia, to Tennessee, and another showing three slaves being sold on the auction block. Both express subtle understanding of the slave's plight and concern over the personal and collective trauma the slaves often experienced.

Inscriptions/Marks: In ink in script below the drawing is "Lynchburg — negro dance, August 18th 1853."

Published: Dena J. Epstein, *Sinful Tunes and Spirituals: Black Folk Music to the Civil War* (Urbana, Ill., 1977), illus. on p. 157; Harry L. Rinker and Richard M. Kain, "Lewis Miller's Virginia Sketchbook: A Record of Rural Life," *Antiques,* CXIX (February 1981), illus. as pl. IV on p. 400; James S. Wamsley, "Now O'er the Mountains Waving Green: The Sketchbook of Lewis Miller," *Commonwealth: The Magazine of Virginia,* XLVI (March 1979), illus. on p. 12.

[1]The drawing is one of two that appear on a sheet measuring overall 12⁹⁄₁₆" x 7⁹⁄₁₆" (31.9 cm. x 19.2 cm.). The sketch above this one shows three black figures at work.

[2]Miller's fuller quote actually states: "—no! change but the hateful term Slave, and they were a contented and a happy race, happier far than the labouring class of poor in this country. A comfortable hut which might, without exaggeration, be termed a cottage; a piece of ground to each, exclusively allotted for the cultivation of vegetables; permitted to rear poultry;—fed, clothed, and medical attendance gratis; and moreover, a whole holiday on Saturday to be permitted to sell their produce in the markets. Compare this with the free State's of the labourer and tell me which is the happier man of the two—the Slave as he was, or the pauper as he is!" The quote appears on p. 50 of *Ludwig* [Lewis] *Miller's Album Written in Virginia,* which belongs to the Virginia Historical Society, Richmond.

93C **The Residence of David Laird** 78.301.1, 14b

Pictorial composition: 4⁷⁄₁₆″ x 6⁷⁄₈″ (11.3 cm. x 17.5 cm.)[1]

The house in no. 93C still stands as of this writing. It was built by David E. Laird in 1829, and it remained in Laird hands until the 1890s. The main building is brick, which is indicated in the sketch by tiny dashes of red watercolor. The artist accurately situated the farm close to "the banks of the north fork of James river" (now the Maury River). Classical columns forming a porch on the river side of the house have since been obscured by screening.[2]

Miller often depicted himself in the foreground of his sketches, and he may have intended the approaching horseman to represent his figure. The carpenter to whom Miller refers in the inscription (see *Inscriptions/Marks*) was his brother John (1790–1866), originally his master in the trade of house carpentry. The nature of John's employment on the farm is unknown, but since the house was built twenty years earlier, he must have been involved in repair work or in constructing one of the outbuildings on the property. John left York to settle in Rockingham County, Virginia, at an unknown date.[3] The format of this drawing and its relation to others in the album suggest that, like the majority of its Virginia companion pieces, it was executed in 1853. Thus, Miller's reference to John's 1849 employment is seen as a note of personal historical interest, rather than one of present fact.

Inscriptions/Marks: In ink below the pictorial composition is "The Residence of David Laird, Seven mile from Lexington/on the banks of the north fork of James river, and A chain/of the Blue Ridge, John Miller Carpenter is worken here 1849."

[1]The drawing is one of two that appear on a sheet measuring overall 12½″ x 7⁹⁄₁₆″ (31.8 cm. x 19.2 cm.). The sketch above this one is a town view of Lexington, Va., which is also located in Rockbridge County.

[2]Information about the house is taken from survey no. 81–178 of the Virginia Historic Landmarks Commission, Richmond, Va.; the form was completed by Pamela H. Simpson, August 1978.

[3]John's relocation is noted in Henry L. Fisher, *An Historical Sketch of the Pennsylvania Germans, Their Ancestry, Character, Manners, Customs, Dialect, Etc.*, 1885, reprinted in John Gibson, *History of York County, Pennsylvania* (Chicago, 1886), p. 234.

93C

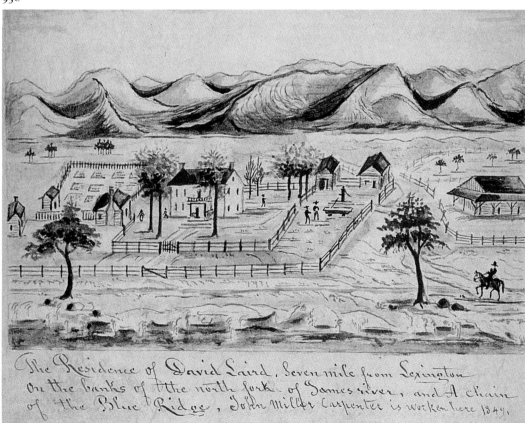

93D

whose maximum height is still noted as about ninety feet.[2] Miller points out that its timber is useful to mechanics, or carpenters, and that its seed is medicinal — observations that are confirmed by a twentieth-century herbal.[3] His Fig. C represents one of the beans enclosed in the pod shown as Fig. B, both being specimens from his "beans tree," probably the Kentucky coffee tree (*Gymnocladus dioica*), which does generally grow west of the Blue Ridge Mountains and does have poisonous properties.[4] Miller drew the same seedpod again on page 146 of his *Orbis Pictus* sketchbook, which is also owned by the Folk Art Center. Jersualem oak (*Chenopodium botrys*) boasts inch-long, oaklike leaves when small, hence its name.[5]

Inscriptions/Marks: In the margin above the drawing in ink is "To learn the Science of Botany, and names of plants/without personal assistance, we ought to direct — — attention/whenever we go into the forest and field," and beside the botanical sketches are lettered "Fig. A.," "Fig. B.," and "Fig. C." Beside the large seedpod is written "four inches long, one and half-broad." Beneath the far right sketch is "Jerusalem = moke/A tea plant[:] leaves/in Segments ringlet/and curly, it grows/on brush mountain./from twenty inches to two feet — high." In the margin beneath the pictorial composition is "Fig. A. the Cucumber, it grows on a tree, Known to the height of/Eighty or ninety feet, the timber is useful by mechanics, the red Seeds/used as Medical, Fig. B. this is in common language called a pod,/and is well Known as the Seed Vessel of beans. it grows on trees, 40 or/50 feet high. the Seed or bean — Fig. C. is black and hard woody/the number of beans in a pod is from five to Six. these trees are very rare/grow at new river. if this beans beat and put in water, it kills flys — a poison,/See — in Shape of a cocklebean, no name given of this tree to me./unknown in this place. See in botanical Order."

[1] The drawing is one of two that appear on a sheet measuring overall 12⁹/₁₆″ x 7⁷/₁₆″ (31.9 cm. x 18.9 cm.). The sketch below this one shows other botanical specimens.

[2] Oscar W. Gupton and Fred C. Swope, *Trees and Shrubs of Virginia* (Charlottesville, Va., 1981), p. 23.

[3] M[aude] Grieve, *A Modern Herbal: The Medicinal, Culinary, Cosmetic, and Economic Properties, Cultivation, and Folk-Lore of Herbs, Grasses, Fungi, Shrubs, and Trees with All Their Modern Scientific Uses*, II (New York, 1971 reprint of 1931 publication), p. 505, states that "in the Allegheny districts the cones [of the cucumber tree] are steeped in spirits to make a tonic tincture. A warm infusion is laxative and sudorific, a cold one being anti-periodic and mildly tonic." Further, the timber of this tree is "sometimes used for large canoes and house interiors. The wood is finely grained, taking a brilliant polish," as noted on p. 506.

[4] The tree's poisonous properties are discussed in John M. Kingsbury, *Poisonous Plants of the United States and Canada* (Englewood Cliffs, N.J., 1964), pp. 322–323.

[5] A lengthier description of the plant is given in Rosetta E. Clarkson, *Herbs: Their Culture and Uses* (New York, 1942), pp. 156–157.

93D To learn the Science of Botany 78.301.1, 56t

Pictorial composition: 4¼″ x 6¹¹/₁₆″ (10.8 cm. x 17.0 cm.)[1]

Miller's drawings generally employ color sparingly but effectively. The "cucumber" shown in his Fig. A here is lightly tinted a maroon hue, with the case burst open in one spot to reveal the scarlet seed beneath. The pod of his Fig. B is colored a pale yellow-green, the interior being more lightly painted in order to reveal the bare outlines of the five seeds or "beans" it encloses. The feathery quality of Jerusalem oak (which Miller spelled "Jerusalem moke") is captured by quick strokes of a dark forest green.

Figure A represents the seedpod of the cucumber tree, or cucumber magnolia (*Magnolia acuminata*),

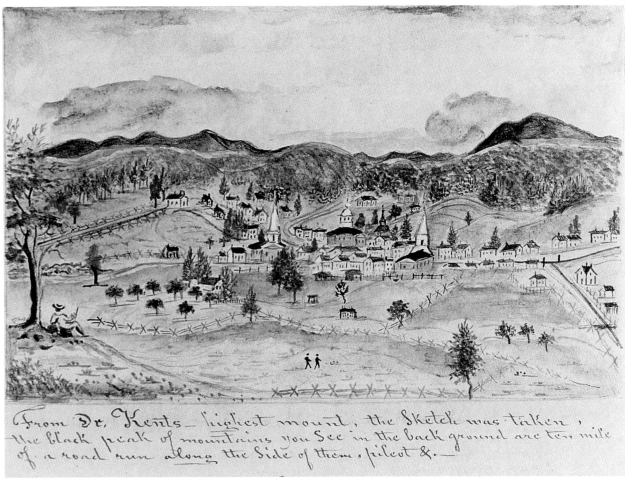

From Dr. Kents — highest mount, the Sketch was taken, / the black peak of mountains you See in the back ground are ten mile / of a road run along the Side of them, pileot &. —

93E

93E A View of Christiansburg[1] 78.301.1, 19t

Pictorial composition: 4⁵⁄₁₆″ x 6⁷⁄₈″ (11.0 cm. x 17.5 cm.)[2]

This sketch of Miller's adopted hometown ranks among his most attractive townscapes, and the prospect must have been one he viewed often and affectionately. He undoubtedly meant the figure reclining beneath a tree at left to represent himself, for he often incorporated such small self-portraits in his larger views. When included, they serve as signatures and confirm for us his personal involvement with the surroundings depicted.

This sketch was done from the approximate site of the present-day Christiansburg Park and Recreational Facility on College Street. The large building at center is the Montgomery County Courthouse, and the white steepled buildings flanking it represent the Methodist (left) and Presbyterian (right) churches. Between the courthouse and the Presbyterian church is a steepled building representing the Montgomery Female Academy. Miller sketched all of these and several more Christiansburg buildings individually.[3] West Main Street extends horizontally to the right in the picture, East Main Street winds back through the center, and North Franklin Street extends horizontally to the left. In the right background, Miller included Pilot Mountain, which was, like Salt Pond Mountain, the site of many of his rambles and excursions in the area.

Inscriptions/Marks: In ink above the sketch is "A view of Christiansburg," and below it in ink is "From Dr. Kents — highest mount, the Sketch was taken,/the black peak of mountains you See in the back ground are ten mile/of a road run along the Side of them, pileot &. — "

Published: John Nicolay, "Lewis Miller: Artist," *Mountainside,* I (Spring–Summer 1981), illus. on p. 8; William M. E. Rachal, "A Trip to the Salt Pond," *Virginia Cavalcade,* II (Autumn 1952), illus. on p. 24.

[1]Because *A View of Christiansburg* is consistent in format and appearance with other works dated 1853 from the same album, it is believed that the sketch was done that year despite the presence of

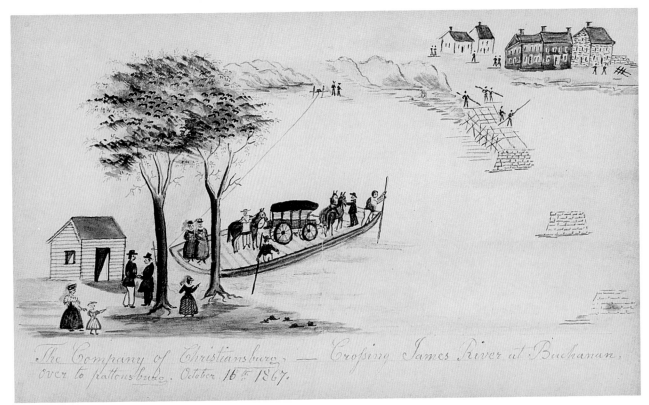

The Company of Christiansburg, — Crossing James River at Buchanan, over to pattons burg. October 16th 1867.

93F

94

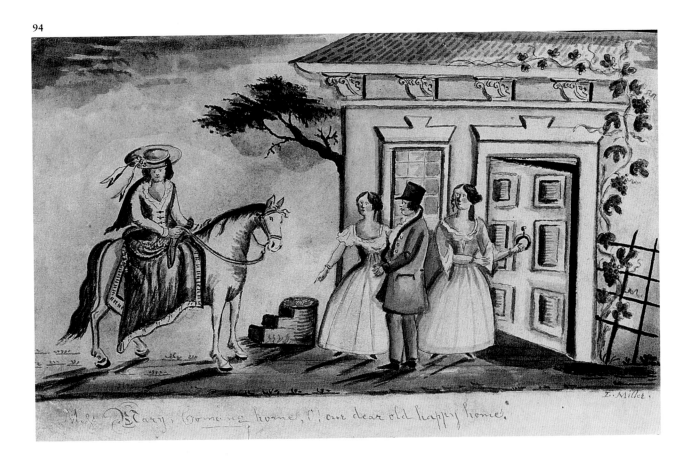

Miss Mary, coming home, O our dear old happy home.

L. Miller.

the new Methodist church building in it. The building shown was not dedicated until July 25, 1856. However, the date actual construction began is unknown; its site was deeded over to the church as early as 1850; and the structure is shown, apparently completed, in a privately owned 1855 oil painting of the town done by Edward Beyer. Miller's sojourns in Christiansburg are documented for 1853 and 1856, but he may have visited the town at other times as well.

[2]The drawing is one of two that appear on a sheet measuring overall 12½" x 7⅜" (31.8 cm. x 18.7 cm.). The sketch below this one shows a view of John Gardner's home and mill.

[3]The town buildings named appear as individual sketches in *Ludwig Miller's Album Written in Virginia*, owned by the Virginia Historical Society, Richmond, on these respective pages: 66, 68, 62, 63. Page 67 of the same album shows the old Methodist church, and Miller's inscription indicates this structure was razed May 13, 1856. Another sketch of Christiansburg's Presbyterian church appears on page 58 in the artist's *Sketch Book of Landscapes in the State of Virginia* at the Folk Art Center.

93F The Company of Christiansburg Crossing James River

78.301.1, 36–37r

6¹¹⁄₁₆" x 10⁹⁄₁₆" (17.0 cm. x 26.8 cm.)

Including this view, Miller's *Sketch Book of Landscapes in the State of Virginia* contains a total of seven drawings that document a five-day, round-trip excursion made by himself and a group of relatives between Christiansburg and Lexington, Virginia, a distance of about eighty miles. As a group, these seven annotated sketches reveal that Miller traveled with his female kinfolk in a wagonette on this particular trip, leaving only his great-nephew James Robert Craig (1850–1875) to ride astride. A black servant named Joseph served as driver. Their female companions were Miller's niece Mary Miller Gardiner (ca. 1818–1873), his great-niece Mary Taylor Craig (1841–1929), his great-niece Elinor S. Lewis Craig [Flagg] (1847–1892), his great-niece Melinda Walton Craig [Taylor] (1836–1911), and his great-niece Annie Fleming ("Vinnie") Gardiner (1859?–1910). Overnight stops were made at Brugh's Inn in Botetourt County; at the Natural Bridge Hotel and at Shaner's Inn, both in Rockbridge County; and at Salem in Roanoke County.

This sketch shows the company of Christiansburg traveling through Botetourt County on the second day of its journey. Buchanan and Pattonsburg are two small towns on opposite banks of the James River that are often considered one community. They were linked by a bridge at least as early 1830,[1] but this crossing was burned by Confederate General John McCausland in June 1863 in an attempt to slow the Union army following his retreat.[2] Miller shows the bridge being reconstructed in the right side of his sketch, and on the left, he and his companions cross the river via ferryboat. The three extra men shown in the drawing must

illustrate the ferry operator and other passengers. The small girl at lower left was almost certainly intended to represent eight-year-old Vinnie, the only young child among Miller's companions.

Inscriptions/Marks: In ink in script in the lower margin is "The company of Christiansburg, — Crossing James River at Buchanan,/ over to pattonsburg. October 16ᵗʰ 1867." A circular blind stamp with a shield appears twice at upper center, having been stamped through the double-fold sheet. A watermark runs diagonally at upper right but is cut off and largely illegible; it appears to read "[illegible material]DGE's" over illegible letters or figures, possibly script.

[1]Henry Howe, *Historical Collections of Virginia* (Charleston, S.C., 1845), p. 203.
[2]Robert Douthat Stoner, *A Seed-Bed of the Republic* (Roanoke, Va., 1962), p. 487.

94 Mary's Homecoming

81.301.2

Lewis Miller
Montgomery County, Virginia, possibly 1856
Watercolor and ink on wove paper
5³⁄₁₆" x 8⁵⁄₁₆" (13.2 cm. x 21.1 cm.)

The identification of Miller's "Miss Mary" remains theoretical, but the young woman riding sidesaddle may have been Mary M. Ingles of Montgomery County, Virginia. In a privately owned drawing, dated 1856 on the reverse, Miller sketched himself with "Miss Mary M. Ingles, and Miss Fanny Ingles,/At — home, July 4th Soft the[y] will go along the river/ Shore, in beautiful nature, of all the rest, I love thee best." In the lower margin of the same sketch, Miller wrote "Miss, mary, Shews us A flower bed, and various herbs/forever green, in beauteous — order terminate the Scene./And A — Cotton plant; Close to the house a Spacious — /garden lies; here are the grape vines on the Sunny Side." One wonders if the grapevine seen twining over the doorway here might not be the very plant mentioned in the dated drawing.

Inscriptions/Marks: In the lower margin in ink is "Miss Mary, Comeing home, O! our dear old happy home." In the lower right corner in ink is "L. Miller."
Condition: Treatment by E. Hollyday in 1982 included dry-cleaning where possible, removing insect stains, coating colors with a solution of acryloid B72, floating to reduce stains and impurities, aligning and mending tears with Japanese mulberry paper, and flattening. Modern replacement ¾-inch cyma recta frame, painted black.
Provenance: Descended in the family of the artist to Mr. and Mrs. Donald L. Brown, Christiansburg, Va.

IV Still-Life Pictures

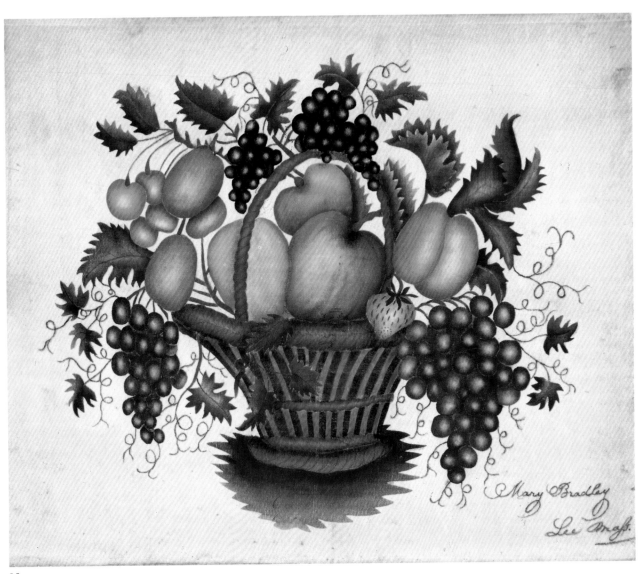

Although related representations had been done for centuries before, still-life painting was first recognized as an independent artistic genre in the seventeenth century, when painters of the Low Countries carried it to a peak of sophistication. There, carefully composed renderings explored the textures, colors, and shading of motionless objects and emphasized the sheer beauty of familiar forms. Favored themes included fruits and flowers, vegetables, game and fish, meals on tables, and precious or natural articles, such as pearls, stones, or shells.

Yet in the hierarchy of painting genres endorsed by the academies of the eighteenth century, still life fell to a rank of little importance because it was deemed so far removed from the noble and enlightening sentiments expressed by other subjects, such as literary or historical ones. Accordingly, still-life motifs were relegated to passages within larger works, or they assumed ornamental functions — appearing, for example, as decoration on furniture or other utilitarian objects. It was mainly through these outlets that the tradition survived through much of the eighteenth century.

During the course of the nineteenth century, the popularity of European prints of flowers and foliage and exhibitions of still-life works by noted American artists were among the factors that stimulated renewed interest in the genre as a legitimate one worthy of the serious artist. On a popular level, still life's appeal was boosted enormously by its appropriateness as a subject of theorem, or stencil, painting, a fad that peaked in America about 1820–1840 and that is particularly well represented in the Folk Art Center's collections.

Mary Bradley
(active ca. 1825)

Town records from Lee, Massachusetts, reveal two Mary Bradleys: Mary, a child of Colonel Jared and Phebe Munson Bradley, born September 5, 1807;[1] and Mary West, daughter of Stephen and Lydia Bradley, born December 29, 1806, and married to Joseph W. Barlow in 1824.[2] It is hoped that future research will determine which — if either — Mary Bradley was the artist who created this superb theorem.

[1]*Records of the Town of Lee from Its Incorporation to 1801* (Lee, Mass., 1900), p. 148.
[2]Grace Wilcox of Stockbridge, Mass., to AARFAC, September 15, 1959.

95 Basket of Fruit 58.403.1

Mary Bradley
Lee, Massachusetts, ca. 1825
Paint on velvet
11⅜" x 14¹¹⁄₁₆" (28.9 cm. x 37.3 cm.)

The expert shading of leaves and fruit gives this composition a strong three-dimensional quality often lacking in less skillfully done theorems. The colors used in this work remain exceptionally fresh and vibrant, particularly the reds and greens. Mary Bradley had mastered the use of her stencils, as indicated by the crisp edges of the leaves and the well-defined forms of the cherries and cherry stems. The sharp outlines of the fruit and basket are accentuated by depressions in the velvet, as if Bradley had traced the edges of some of the shapes with a pointed tool. These lines are most visible around the center green apple, the strawberry, and the basket rim. Bradley's proficiency with a pen is exhibited not only by the abundant grapevine tendrils, but also by her accomplished calligraphic signature.

Inscriptions/Marks: The theorem is signed in the lower right corner "Mary Bradley/Lee Mass."
 Condition: The velvet was removed from a cardboard backing, dusted, and mounted with cotton thread to a cotton muslin-covered sheet of conservation board by E. Hollyday in 1975. Probably period replacement 1⅛-inch cyma reversa frame, painted black, with gilded inner edge.
 Provenance: J. Stuart Halladay and Herrel George Thomas, Sheffield, Mass.
 Exhibited: AARFAC, April 22, 1959–December 31, 1961; "The Chosen Object: European and American Still Life," Joslyn Art Museum, Omaha, Nebr., April 23–June 5, 1977, and exhibition catalog, p. 9, and illus. as no. 17 on p. 9; Halladay-Thomas, Hudson Park; Halladay-Thomas, New Britain, and exhibition catalog, no. 61; Pollock Galleries, and exhibition catalog, no. 1; William Penn Museum.
 Published: Booth, illus. on p. 162; "Still Life Exhibit in Williamsburg," *The Newtown Bee* (June 23, 1978), illus. on p. 58.

Emma Jane Cady
(1854–1933)

Fruit in Glass Compote (no. 96) had been acclaimed since the 1930s as a premier example of theorem painting, but artist Emma Jane Cady remained relatively unknown until Ruth Piwonka and Roderic Blackburn published their research about her in 1978.[1] Their findings led to new attributions and to a revision of possible dates for her work.

Emma Jane Cady was born in 1854, the eldest of three children of Norman J. and Mary E. Bradley Cady. The few details known about her life reveal that she enjoyed farm work and the outdoors and never married. Cady lived in East Chatham, New York, until the deaths of her parents in 1908 and 1911, when she moved to Grass Lake, Michigan, where she remained until her death in 1933.

[1]Information in this entry has been adapted from the research conducted by Ruth Piwonka and Roderic H. Blackburn and summarized in Piwonka and Blackburn, *Cady*.

96 Fruit in Glass Compote 58.303.1

Emma Jane Cady
East Chatham, New York, ca. 1890
Watercolor and mica flakes on wove paper
15⅞" x 19¾" (40.3 cm. x 50.2 cm.)

Cady's rich colors and crisply stenciled renderings seem particularly suited to capturing the austere beauty of these inanimate objects. The white background and the soft gray marbleized tabletop intensify the contrasting jewel-like tones of the purple grapes, berries, and plum, and the yellow-orange of the peaches.

Fruit in Glass Compote is considered among the most impressive of the theorems in the Center's collection for several reasons. Cady capably created a sense of spatial recession, which is particularly noticeable in the blackberries and in the apple at far right. An effectual use of applied mica flakes provided her a workable solution to the difficulties of painting the highly reflective surface of the glass compote. Her expert shading and modeling of the fruit endow the composition with a realism seldom found in theorem painting.[1]

Cady's painting has been dated about 1890 based on the only inscribed example known, a composition of two doves executed for her brother and sister-in-law on the birth of their first son.[2] The Cady attribu-

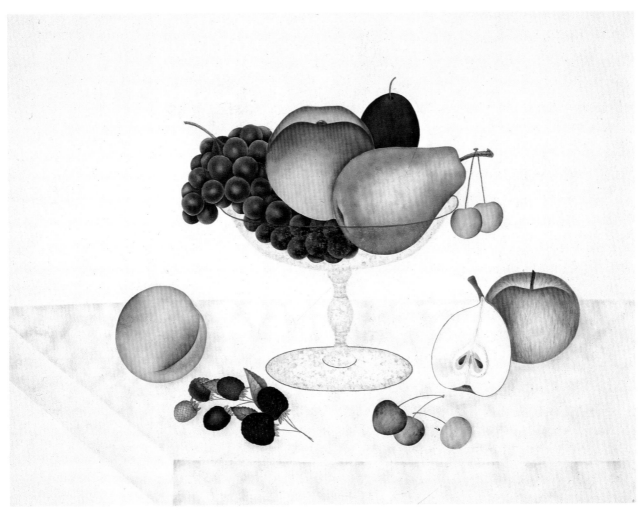

96

tion for *Fruit in Glass Compote* accompanied the painting's history when it was discovered in the 1930s, prior to acquisition in 1958.

Inscriptions/Marks: A paper mark at upper left is partially legible and reads "[illegible material]OLD's/[illeg.]OLBOARD."

Condition: Unspecified treatment by Christa Gaehde in 1958 probably included cleaning, and removing stains. In 1978 E. Holliday dry-cleaned the painting and re-adhered the mica flakes with a gelatin solution. Possibly original 1¾-inch molded and gilded frame.

Provenance: J. Stuart Halladay and Herrel George Thomas, Sheffield, Mass.

Exhibited: AARFAC, American Museum in Britain; AARFAC, New York, and exhibition catalog, no. 32; AARFAC, June 4, 1962– April 17, 1963; "A Century of American Still Life Painting 1813– 1913," American Federation of the Arts, October 1966–October 1967, and exhibition catalog no. 3; Halladay-Thomas, Hudson Park; Halladay-Thomas, New Britain, and exhibition catalog no. 125 (titled *Still Life*); Halladay-Thomas, Pittsburgh, and exhibition catalog no. 58, illus. facing nos. 51–54; Halladay-Thomas, Syracuse, and exhibition catalog no. 5; Pine Manor Junior College; Smithsonian, American Primitive Watercolors, and exhibition catalog, p. 9, no. 39.

Published: Black, Watercolors, p. 81, illus. on p. 69; Marshall B. Davidson et al., *The American Heritage History of the Artists' America* (New York, 1973), illus. on p. 156; Gerdts, p. 78, illus. as fig. 4.10 on p. 79; William Gerdts and Russell Burke, *American Still-Life Painting* (New York, 1971), p. 55, illus. as no. 4.2 on p. 56 and p. 240; Jean Lipman, "The Study of Folk Art," *Art in America,* XXXIII (October 1945), illus. on p. 248; Lipman and Winchester, Folk Art, illus. as fig. 121 on p. 92; Vickie McIntyre, "Theorem Paintings," *Early American Life* (August 1981), p. 28, illus. on p. 29; Piwonka and Blackburn, Cady, illus. as pl. 1 on p. 420; Ruth Piwonka and Roderic H. Blackburn, *A Visible Heritage: Columbia County, New York, A History in Art and Architecture* (Kinderhook, N.Y., 1977), illus. on p. 131; Stebbins, illus. as fig. 66 on p. 97.

[1]For similar compositions, see *Antiques,* CXXIII (January 1983), p. 133; *Antiques,* LXXXVIII (December 1965), p. 730; Sotheby Parke Bernet, Inc., *Americana: Bergen and Various Owners,* catalog for sale no. 4938, October 21–22, 1982, lot no. 571. Three similar works are in private collections. The Folk Art Center owns another version (acc. no. 32.303.1) of the composition that is not included in this catalog.

[2]The picture of doves is owned by Carl John Black and is illustrated as pl. IV in Piwonka and Blackburn, Cady, p. 421.

Henry Church
(1836–1908)

Much has been written about Henry Church, beginning with the account by Sam Rosenberg in Sidney Janis's landmark book, *They Taught Themselves,* and more recently in *American Folk Painters of Three Centuries.*[1] These accounts offer important information about Church's origins and describe a few of his best-known works, but the extent of his artistic skills in a variety of mediums is little understood. Church was a prolific artist who was equally at home working in wood, cast metal, gesso, gilt, stone, plaster, paint, or charcoal. Today some twenty-four pieces of wood, stone, and cast iron sculpture have been documented to him as well as thirty-three paintings, eight drawings in pencil and charcoal, four signboards, and a harp, which he embellished with female figures similar to those he used on a number of his handmade frames.[2] Most of these works still remain with family members, who have generously shared photographs of the pieces and of the artist at work, as well as quantities of genealogical information.[3]

Henry Church, Jr., was the son of Henry Church and his second wife, Clarissa Sanderson Church, of Deerfield, Massachusetts. The father, a blacksmith, was a friend of Noah Graves's, the founder of Chagrin Falls, Ohio. Graves encouraged Church to move west with his family since the area needed a good smithy's shop. In 1834 the family settled in the newly formed town, where Church set up his blacksmith shop and served for an undetermined length of time as justice of the peace. The Churches were staunch abolitionists, and the basement of their home on West Orange Street often served as a night's lodging for runaway slaves headed for Canada and freedom.

The artist's birth in 1836 was soon followed by those of two other sons and four daughters. Henry junior undoubtedly learned the blacksmithing business from his father at an early age. His acquaintance with Archibald M. Willard — the academic painter who created the well-known *Spirit of '76* — began in childhood, since Willard, roughly the same age as Church, grew up about two miles outside of Chagrin Falls. Family tradition also indicates that Church visited Willard in his Cleveland studio in later years and probably learned something about painting from him. At least one of Church's extant drawings was executed when he was still attending school in Chagrin Falls, indicating his early proclivity toward art. Whether he had additional instruction beyond this or beyond his probable contact with Willard is unknown.

Sometime soon after he and Martha Prebel were married in 1859, they moved to Parkman, a small town about seventeen miles from Chagrin Falls. There Henry set up a smithy's shop, but after eighteen months he and his wife returned to Chagrin Falls, where they would reside for the rest of their lives. Both of his children, Jessie and Austin, were born in Chagrin Falls, but their birth dates are unknown.

It is also not known when Church began sculpting or carving in earnest; he probably combined these activities with his blacksmithing, since his cast figural pieces would have required wooden molds, which he likely prepared. By the mid-1880s, he had already produced a number of works in these materials, as well as paintings on wood, tin, and canvas. In 1888 he opened a small building, which he painted with decorative scenes and titled Church's Art Museum, at Geauga Lake Park near his hometown. A sign above the door indicated an admission fee of ten cents. Family members believe that this enterprise was intended to generate greater public awareness of his work with the prospect of future commissions and sales. Apparently Church was not successful in this venture, nor was he substantially patronized by local citizens.

Church has been called an eccentric, and some sources mention that his sculpture was influenced by a form of spiritualism.[4] His large stone piece, dated 1885 and titled *Squaw Rock,* has most often been used to support this theory because its designs reflect Indian lore and culture. But once completed, it would have depicted the westward movement of civilization, not any obsession with spiritualism as related to Indian beliefs. Although the rock was intended to be fully carved on both sides, the side facing the river was never completed.[5] While Indian figures predominate on the finished face, the back side includes roughed-out designs of ships, a log cabin, and the Capitol building in Washington, D.C., elements that relate to Church's intended broad theme. It is known, however, that Church did take an interest in the history of the native Americans who once lived in his area and that he collected Indian relics, many of which are still owned by the family.

As for his eccentricity, Church was an unusually talented and innovative individual whose house was surrounded with his own sculpture and crammed within by many paintings and very likely some smaller carved objects.[6] To the citizens of Chagrin Falls, a small midwestern town of farmers and tradesmen, one can imagine how such a sight might be construed as eccentric or strange. His carving of his own tombstone before his death and securing permission for its placement in the local cemetery must have seemed yet another manifestation of the man's unusual ways.[7] Also,

the fact that he wrote and then recorded on a gramophone cylinder a sermon to be heard by those attending his funeral could only perpetuate the opinion that Henry Church was "the despair of the community."[8]

Many anecdotes about Church have been recorded by Sam Rosenberg, who first discovered Church and who traveled to Chagrin Falls to interview local residents and the artist's daughter, Jessie Church Sargent. These stories, plus Church's surviving works — which feature a broad range of ideas, themes, and subjects — confirm that he was an intense, inventive, and highly energetic individual whose interests in and knowledge about the world went far beyond the confines of Chagrin Falls and his professed occupation as a blacksmith. He was an extraordinary artist and man for his time and place of residence. To that extent, he was eccentric; but he was also deeply religious and patriotic, a good husband and father, and a successful businessman.

[1]See Janis, pp. 99–109; and Lipman and Armstrong, pp. 175–181.
[2]Janis, p. 103; Rosenberg reported a photograph taken in 1870 that was owned by Jessie Church Sargent, the artist's daughter; it showed Church with the town band. Sargent related that her father played the cornet, the alto horn, and the banjo, as well as the harp and the bass fiddle. According to Rosenberg, Church made a bass fiddle in addition to the harp, but family descendants have no knowledge of the fiddle.

[3]The Center is particularly grateful to Mrs. Miriam Church Stem, the artist's granddaughter, for all the information she has shared with staff since 1981, when *The Monkey Picture* (no. 97) was acquired. All biographical information for this entry is taken from letters and phone conversations, as well as from a meeting with Stem and other members of the family on October 23, 1982; much of this information was also related to Sam Rosenberg by the artist's daughter in the 1930s and subsequently has been published in Janis and in Lipman and Armstrong.
[4]Janis, pp. 101–102; Lipman and Armstrong, p. 176.
[5]Miriam Church Stem's photographs shown to AARFAC staff members, October 23, 1982.
[6]Ibid.
[7]See Janis, p. 103, for a summary of what transpired.
[8]Ibid., p. 104.

97 The Monkey Picture 81.103.1

Henry Church, Jr.
Chagrin Falls, Ohio, 1895–1900
Oil on paper mounted on oilcloth
28″ x 44″ (71.1 cm. x 111.8 cm.)

The Monkey Picture is probably the best known and most widely admired of Church's paintings since it has been published and discussed from 1942 to the present. Its subject is unorthodox, if not zany, for its pe-

97

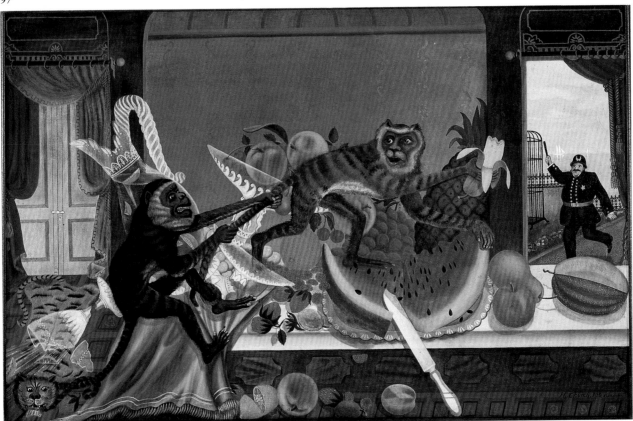

riod, and its colors are brilliant and eye-catching. Two lively monkeys have escaped from their cage, which is seen through the doorway at right. They now invade what must have been an orderly table setting and fight over possession of the only banana. The policeman who runs to the rescue brandishes his club. Note the face of the tiger skin at lower left, which shows disgruntlement at being strangled by one monkey's tail. Beyond the blatant aspects of humor that immediately confront the viewer are other, more subtle and amusing details — such as the profile of a face that is composed of seeds and the right upper edge of the watermelon slice. Another, smaller profile was intentionally worked along the far left strawberry on the table. Church placed his signature prominently at lower right below the table's apron but also incorporated a second, hidden signature within the markings of the cantaloupe rind, on the table at right. One also suspects that Church, who knew much more about perspective than is obvious here, intentionally distorted the lower portion of the painting. The relationship between the lower edge of the table and the rug totally distorts spatial reality.

Church is known to have created a number of still-life pictures without monkeys which incorporate some of the same motifs seen in no. 97.[1] The shape and design of the pitcher, the footed compote, the platter used for the watermelon, and the knife are seen in most of the paintings, but only one of them (which is currently owned by his descendants) closely relates to *The Monkey Picture*. It shows an almost identical interior, with the same table and essentially the same fruits and tableware; there is a tiger skin, but the face of the tiger is calm; the open doorways differ, but the back walls are quite similar. Family descendants believe the two pictures were designed as companion pieces, even though the traditional version was created about twenty years prior to *The Monkey Picture*. Whether this theory is correct is unknown, particularly since there is a third still life by Church, still owned by the family, which also relates in terms of composition.

We also do not know the artist's inspiration or the rationale for *The Monkey Picture*, although most scholars have interpreted the painting as a satirical statement on uninspired Victorian still-life compositions. Such an argument has some merit since Church had little patronage for his work and may have chosen to vent his bitterness by creating an outrageous work that would shock some, amuse others, and draw attention.

Inscriptions/Marks: In black paint in the lower right corner is "H. Church, P¹ʳ. Blacksmith." In the lower right of the cantaloupe rind in yellow paint is "H. Church/Pixt. Painter."

Condition: In 1981 Jean Volkmer cleaned the painting; filled and inpainted areas of loss, the greatest of which were in the left corner, near the tiger skin; set down flaking paint; and secured areas of the primary support. Possibly original 2¼-inch stained bolection molded frame.

Provenance: Jessie Church Sargent, Chagrin Falls, Ohio; Sam Rosenberg, New York, N.Y.; Washburn Galleries, New York, N.Y.

Exhibited: American Folk Painters.

Published: Janis, pp. 106–109, illus. on p. 109; Lipman and Armstrong, pp. 178–180, illus. on p. 178; Lynette I. Rhodes, *American Folk Art from the Traditional to the Naive* (Cleveland, 1978), pp. 26–29, illus. on p. 27.

[1] Two of Church's still lifes, including one thought to be a companion piece to no. 97, bear strong resemblance to a painting by the nineteenth-century academic painter John Vanderlyn II dated about 1860. The Vanderlyn picture was owned by Vose Galleries of Boston in 1984. Whether Church knew Vanderlyn's work or whether both artists were inspired by a common print source is unknown.

Frances Mary Corwith (1809–1874)

The eighth of nine children of Caleb and Fanny Morehouse Corwith, Frances Mary was born February 2, 1809.[1] She married Edward Strong (1814–1872) sometime between 1833 — when she signed her theorem (no. 98) — and 1835, when she received property from her father's estate in her married name.[2] The couple had two daughters. Frances Mary and Edward Strong and members of the Corwith family are buried in the Hayground Cemetery in Bridgehampton, Long Island, New York.

[1] Dorothy T. King, East Hampton (New York) Free Library, to AARFAC, October 5, 1981, citing the Corwith family Bible, now in the property of Helen Rogers Baldwin.

[2] Lois E. DeWall, Suffolk County Historical Society, to AARFAC, September 23, 1981.

98 Basket of Fruit with Garland of Flowers

79.403.13

Frances Mary Corwith
Bridgehampton, Long Island, New York, 1833
Watercolor and ink on silk
16¼″ x 17¼″ (41.3 cm. x 43.8 cm.)

An elaborate garland of pink roses curves above Frances Mary Corwith's version of the "full basket" composition.[1] Profuse freehand hatching adds fernlike fullness to the garland and decorates the surface beneath the basket. In addition to this abundant freehand detail, the basket of fruit itself may have been

drawn on the silk using another theorem as a reference, or perhaps Frances Mary used stencils to trace outlines of fruits, basket, leaves, and roses. After sketching or outlining the objects, she used a fine brush to apply colors.[2]

The verse carefully penned at each side of the basket suggests that this was a wedding present or going-away remembrance for Frances Mary's older brother David, whose marriage took place eighteen days before the date marked on the lower right corner of the composition.[3]

Inscriptions/Marks: The verse at either side of the basket reads, at left: "Adieu, Adieu, Dear Brother Sis[t]er/Friend/May every blessing on your steps/Attend"; and at right: "While from your native Isle far west you roam — /Oh dont forget your distant friends/at home . . ./Frances Mary Corwith/Bridgehampton April 28/Long Island 1833."

Condition: Creases in the silk primary support indicate that at one time it was folded in sixteenths. Scattered losses of the silk primary support have occurred along the fold lines and margins. Previous conservation included mounting the silk on crepeline. In 1981 E. Hollyday placed the primary support between layers of crepeline and mounted it on a nonacidic support. Period replacement 2½-inch molded and gilded frame.

Provenance: Acquired from Edith Gregor Halpert, American Folk Art Gallery, New York, N.Y., February 19, 1936, for use at Bassett Hall, the Williamsburg home of Mr. and Mrs. John D. Rockefeller, Jr.

[1]The Folk Art Center owns a total of seven variations of the "full basket" design. The others, which are not listed in this catalog, are acc. nos. 31.403.5, 31.403.9, 31.403.10, 31.403.11, 32.403.3, and 32.403.4. Signed examples in other collections have been noted in Sotheby Parke Bernet, Garbisch III, p. 58, no. 129; and in Elizabeth C. Hill to AARFAC, August 20, 1975. Unsigned examples of the design have been noted in *Antiques,* C (November 1971), p. 718; Wolfgang Born, *Still-Life Painting in America* (New York, 1947), nos. 50, 51; Erwin O. Christensen, *The Index of American Design* (New York, 1950), p. 84, no. 164; Carl W. Dreppard, "Still Life and Pretty Pieces," *Art in America,* XLII (May 1954), p. 128; *The Old Print Shop Portfolio,* III (September 1943), p. 19, no. 13; Sotheby Parke Bernet, 1978, lot no. 159; Sotheby Parke Bernet, Garbisch II, no. 127; Sotheby Parke Bernet, Garbisch III, p. 75, no. 172; and Sotheby Parke Bernet, Halpert, nos. 16, 45, 217.

[2]Evidence of this technique is most visible in the right side of the basket where the paint does not consistently extend to the edge of the outline of the grape leaf, the basket handle, and the upper edge of the green table.

[3]Dorothy T. King to AARFAC, October 5, 1981.

98

Eleanor L. Coward
(active ca. 1825)

Monmouth County, New Jersey, genealogical records reveal two second cousins named Eleanor Coward, either of whom may have been the creator of this theorem. One of the cousins, daughter of Enoch and Nelly Lloyd Coward, would have completed the theorem before her marriage to Sidney Woodward on May 11, 1828.[1] The other Eleanor Coward (1792–1845), daughter of Jonathan, Jr., and Mary Emley Coward, did not marry and is buried with her parents.[2]

[1]John E. Stillwell, *Historical and Genealogical Miscellany*, III (Baltimore, 1970), p. 477. The date of the marriage was supplied by Gregory J. Plunges, Librarian, Monmouth County Historical Association, to AARFAC, September 24, 1981.

[2]"Monmouth County Gravestones," *The Genealogical Magazine of New Jersey*, XLII (January 1967), p. 4. The will of Jonathan Coward, Jr., was witnessed by Sidney C. Woodward, which indicated that there was some contact between the two families. The original will is in the manuscript collection of the New Jersey State Library, Trenton.

99 Vase of Fruit 31.403.1

Eleanor L. Coward
Freehold, New Jersey, ca. 1825
Paint on velvet
15½" x 16⅜" (39.4 cm. x 41.6 cm.)

The wide, brown compote holding an abundance of fruit stands on a blue, marbleized tabletop.[1] The spindly baluster stem seems an improbable support for the

99

heavy load in the dish above. Eleanor restrained her freehand embellishments to only a few grapevine tendrils.

Inscriptions/Marks: Signed in the lower right corner: "Done by/Eleanor L. Coward."
Condition: Unspecified treatment by Kathryn Scott was done in 1955. Period replacement 2¼-inch gilded molded frame.
Provenance: Found in Freehold, N.J., and purchased from Edith Gregor Halpert, Downtown Gallery, New York, N.Y.
Exhibited: American Folk Art, Traveling.
Published: AARFAC, 1957, p. 369, no. 319; Cahill, American Folk Art, p. 39, no. 82, illus. on p. 97.

[1]A similar composition, worked in watercolor on paper and attributed to Delilah Applegate, appears in *The Kennedy Quarterly*, XIII (February 1975), p. 206, no. 191.

Betsey Davis
(active ca. 1802)

100 Landscape with Urn of Flowers 70.603.1
and Two Baskets of Fruit

Betsey Davis
Probably Providence, Rhode Island, 1802
Silk and chenille embroidery on silk
22¹⁄₁₆" x 28¹³⁄₁₆" (56.0 cm. x 73.2 cm.)

The taste for ornamental silk embroideries temporarily supplanted samplers during the Federal period. The vogue proliferated among schoolgirls, whose instructors probably prepared the designs, as in this example worked at the Balch School. Mary Balch operated her school in Providence, Rhode Island, from 1785 possibly until her death in 1831. It was one of several New England schools that produced distinctive pictorial needlework. Other examples attributed to this academy display the same type of signature block as well as similar chenille hillocks and trees, supporting the theory that students completed designs drawn by their teacher.[1] The fluffy chenille thread, whose name is French for "caterpillar," produced an elegant sculptural effect, while the fine silk threads achieved a smooth, even surface.

Characteristic neoclassic motifs include the blue-and-white fluted urn and the delicate rose garlands. Two baskets of fruit, which closely correspond to designs found in contemporary theorem paintings, complete the symmetrical composition. The Museum of Fine Arts in Boston, Massachusetts, owns a sampler possibly by the same hand that bears the sewn inscription: "Betsy Daviss Work Providence April 1797."[2]

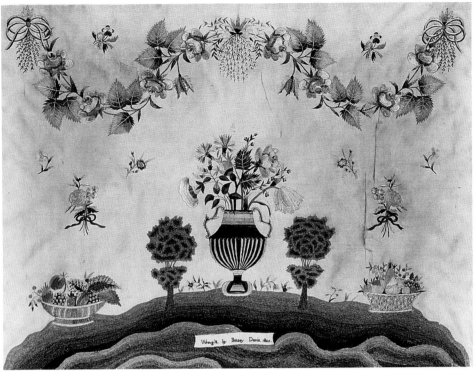

100

Inscriptions/Marks: Sewn below the urn is "Wrought by Betsey Davis. 1802."

Condition: Unspecified treatment by Kathryn Scott about 1976 probably included backing the silk support with linen, crepeline, and mat board and adhering the whole to possibly original strainers. Modern replacement 1½-inch gilded and cove-molded frame with ½-inch gilded anthemion leaf banding on the inner edge.

Provenance: The embroidery descended through the Davis family in Providence, R.I., where it was reportedly bought by an unidentified Connecticut dealer; Leon F. Stark, Philadelphia, Pa.

[1] Two similar compositions made about the same time include one silk embroidery in the collection of Mr. and Mrs. Richard C. Ernst and illustrated in the catalog *The John Brown House Loan Exhibition of Rhode Island Furniture* (Providence, R.I., 1965), p. 145; and another in a private collection which is inscribed: "Wrought by Cynthia Williams. 1803." For discussion of related needlework pictures, see Betty Ring, "The Balch School in Providence, Rhode Island," *Antiques,* CVII (April 1975), pp. 660–671.

[2] The names are spelled differently, and there is no documentation yet that identifies the makers as one and the same, according to Betty Ring, the source of this information.

Matilda A. Haviland
(1817–1853)

Research thus far has revealed only one appropriate Matilda A. Haviland, the wife of Hiram Haviland (1805–1887), a farmer and carpenter of Quaker Hill, Pawling, Dutchess County, New York.[1] Since their first child was born in 1838, Hiram and Matilda were probably married ca. 1835–1837. Matilda is buried at the Hicksite Friends Cemetery at Quaker Hill.[2]

[1] Field Horne to AARFAC, February 10, 1976, citing Josephine C. Frost, *The Haviland Genealogy* (New York, 1914), p. 369.

[2] J. Wilson Poucher and Helen Wilkinson Reynolds, *Old Gravestones of Dutchess County* (Poughkeepsie, N.Y., 1924), pp. 180–181. Matilda A. Haviland was the daughter of Edward and Drusilla Howard.

101 The Tilted Bowl 32.403.1

Matilda A. Haviland
Probably Dutchess County, New York, ca. 1840
Paint on velvet
14⁷⁄₁₆″ x 17⁷⁄₁₆″ (36.7 cm. x 44.3 cm.)

Defying the force of gravity, Haviland's bowl and fruit appear to float above the base. Many examples of this popular theorem design exist with variations in the location of the fruit, indicating that perhaps stencils were made separately for each item in the composition.[1] Haviland's dispersed arrangement of stencils creates a relatively abstract interpretation of this design. Unlike other theorems that have delicately

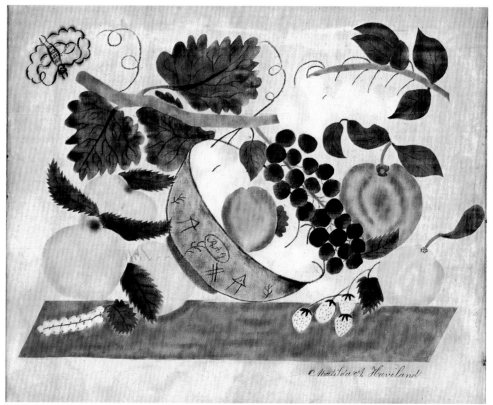

101

shaded leaves, the grape, cherry, and strawberry foliage of this work is uniform in color. The freehand ink-and-yellow butterfly in the upper left is a rare and fanciful addition to this design.

Inscriptions/Marks: The work is signed at lower right "Matilda A. Haviland," and inscribed within the oval on the side of the bowl is "R.A.G."
Condition: There is no evidence of previous conservation treatment. Probably period replacement 2-inch mahogany-veneered frame.
Provenance: Found in New York, and purchased from Mr. and Mrs. Elie Nadelman.
Exhibited: AARFAC, Minneapolis; AARFAC, April 22, 1959–December 31, 1961; AARFAC, June 4, 1962–November 20, 1965; AARFAC, September 1968–May 1970; American Folk Art, Traveling; American Primitives; William Penn Museum.
Published: AARFAC, 1957, p. 248, no. 124, illus. on p. 249; American Primitives, p. 75, no. 72; Cahill, American Folk Art, p. 38, no. 79, illus. on p. 94; Stein, p. 43, illus. on p. 15.

[1]A similar design, acc. no. 32.403.10, owned by the Folk Art Center, is not included in this catalog. Signed examples of this design include one in Wolfgang Born, *Still-Life Painting in America* (New York, 1947), pl. 49, signed "Mary Vincent," ca. 1830. Gina Martin to AARFAC, April 24, 1975, provided documentation of another example signed by Mary Jane Gilbert, Norwich, Conn.
Unsigned examples of this design include: Fairfield Historical Society Collection, Fairfield, Conn., acc. no. 1977.66 (Christopher B. Nevins to AARFAC, November 4, 1981); Karolik Collection, p. 251, no. 1298, illus. as no. 337 on p. 255; Lipman, Primitive Painting, no. 80; National Gallery of Art, *101 American Primitive Water Colors and Pastels from the Collection of Edgar William and Bernice Chrysler Garbisch* (Washington, D.C., 1966), p. 78, no. 63, now in the Philadelphia Museum of Art Collection; Sotheby Parke Bernet, 1978, no. 144; Sotheby Parke Bernet, Inc., *American Heritage Society Auction of Americana,* catalog for sale no. 3438, November 16–18, 1972, lot no. 652; Sotheby Parke Bernet, Inc., *Americana,* catalog for sale no. 4663Y, July 9–10, 1981, no. 369; Sotheby Parke Bernet, Halpert, no. 216; Sotheby Parke Bernet, 1979, lot no. 994; Sotheby Parke Bernet, Garbisch I, no. 164; Sotheby Parke Bernet, Garbisch II, no. 10.

L. W.
(active ca. 1850)

102 **Basket of Flowers and Parrot** 79.305.1

L. W.
America, probably ca. 1850
Watercolor and pencil on blue-ruled laid paper
12¼″ x 15¼″ (31.1 cm. x 38.7 cm.)

Bold coloring, vivid design, and a familiar bird and tulip motif are related to fraktur styles produced by the Schwenkfelder sect in Pennsylvania. Creased in the center and executed on blue-ruled paper, this picture was probably removed from a student's copybook.

A privately owned composition signed "L. W. 1846" shows similar flower formations outlined by decorative dots and is possibly by the same artist.[1] The identity of L. W. has not been discovered.

Inscriptions/Marks: The red script letters "*L*" and "*W*" flank the central vase. Stencil-like numerals and symbols in pencil include "18" to the left of the "*L*" and "63" to the right of the "*W*."

Condition: In 1974 E. Hollyday cleaned the surface and verso of the primary support and added a nonacidic secondary support. In 1983 E. Hollyday cleaned the surface and verso of the primary support and backed it with Japanese mulberry paper to support the brittle paper. Possibly original 2-inch, mahogany-veneered flat frame with brass hanging ring attached at the center back of the top member.

Provenance: Found in New Jersey, and acquired from Edith Gregor Halpert, American Folk Art Gallery, New York, N.Y., December 21, 1935, for use at Bassett Hall, the Williamsburg home of Mr. and Mrs. John D. Rockefeller, Jr.

[1]This related watercolor was advertised by Thomas K. Woodward and illustrated in *Antiques*, CXVII (July 1980), p. 156.

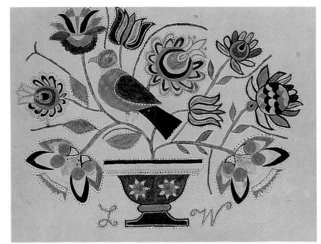

102

H. Millet
(active ca. 1854)

103 Vase of Roses 35.303.3

H. Millet
Probably Louisville, Kentucky, ca. 1854
Watercolor, pencil, and ink on wove paper
20½" x 16" (51.1 cm. x 40.6 cm.)

Cedar Grove Academy began as a boarding school in 1842, founded by the Sisters of Our Lady of Portland Church. Claudius and John Millet are listed among the early parishioners, but their relationship, if any, to this artist remains undetermined.[1]

H. Millet probably produced the subdued hue of the roses by watering down the painted petals before the color dried and by "wiping out the lights" with a soft cloth; one instruction book recommended an old silk handkerchief for the purpose.[2] The stenciling is crisp, but adding the trim on the foot of the vase freehand posed an artistic problem, as did placing the marble base in proper perspective. This may have been a graduation piece, typical of the three or four paintings female students were expected to execute prior to completing their years at school.[3]

Inscriptions/Marks: Handwritten in ink to the left of the vase is "H. Millet" and to the right, "Cedar Grove Academy." The primary support has the watermark "J. Whatman/Turkey Mill/1849" for the Maidstone, Kent, England, firm operated by the Hollingworth brothers between 1806 and 1859. A blind stamp in the upper

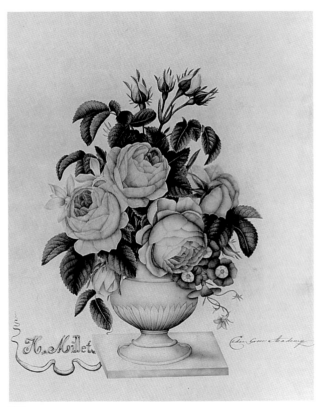

103

left corner shows two griffins supporting a shield and crown with the words: "ABRADED SURFACE" and "DRAWING BOARDS."

Condition: Unspecified restoration treatment by Christa Gaehde about 1956 probably included replacing the secondary support and cleaning. E. Hollyday cleaned the painting in 1976. Possibly original 1½-inch gilded quarter-round frame.

Provenance: Found by Holger Cahill and purchased from the Curiosity Shop, Louisville, Ky.

Published: AARFAC, 1957, p. 365, no. 284.

[1]Benedict J. Webb, *The Centenary of Catholicity in Kentucky* (Louisville, 1884), pp. 515–519.
[2]Urbino and Day, p. 132.
[3]"Miscellany," *Harper's Weekly*, II (March 6, 1858), p. 156.

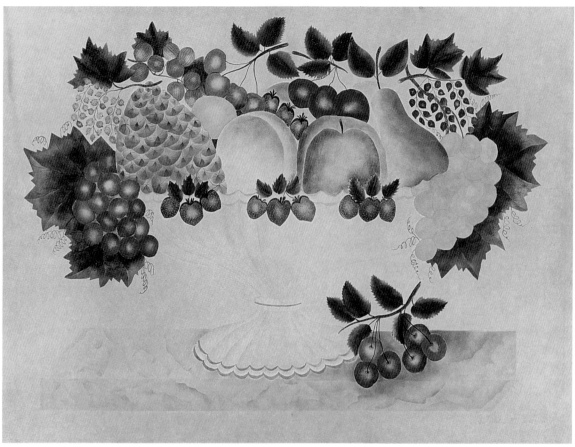

104

Belinda A. Sawyer
(active ca. 1850)

104 Fruit in a White Dish 79.303.7

Belinda A. Sawyer
America, ca. 1850
Watercolor on wove paper
15¼″ x 20½″ (38.7 cm. x 52.1 cm.)

The quiet elegance of Belinda Sawyer's stenciled composition was achieved by deft coloring and patterning. The encircling pattern of dark leaves contrasts with the white compote and colorful array of fruit, which includes a cluster of pale greenish yellow grapes. Interesting patterns are formed by the small leaves and berries, striped currant skins, and sinuous grape tendrils — all of which are juxtaposed with larger fruit forms. Double bands of gold decorate the scalloped upper rim and lower edge of the footed compote, emphasizing its rhythmic vertical lobes. The curves of the grape stems and the fallen sprig of cherries create an illusion of recession.

Similar white fluted bowls appear in three theorems with different arrangements of stenciled fruits.[1] No information about Belinda A. Sawyer has been discovered.[2]

Inscriptions/Marks: The pencil inscription on the front at lower right reads: "Belinda A. Sawyer." A watermark in the primary support on the right side reads: "J WHATMAN/TURKEY MILL/1844."
Condition: In 1974 E. Hollyday removed an acidic backing and cleaned the surface of the primary support. In 1982 E. Hollyday set down flaking paint and backed the primary support with Japanese mulberry paper. Probably original 1¼-inch molded and gilded frame.
Provenance: Collection of Isabel Carleton Wilde, Cambridge, Mass.; acquired from John Becker, New York, N.Y., January 23, 1933, and used at Bassett Hall, the Williamsburg home of Mr. and Mrs. John D. Rockefeller, Jr.
Published: Ford, Pictorial Folk Art, p. 135.

[1]See *Fruit in a Footed Bowl,* no. 54, p. 129, and illus. on p. 69 in *101 American Primitive Water Colors and Pastels from the Collection of Edgar William and Bernice Chrysler Garbisch* (Washington, D.C., 1966); also Tillou, nos. 45, 46.
[2]A watercolor theorem — depicting a bowl of fruit resting on a table with turned legs — bearing the signature "B. A. Sawyer" appears in Sotheby Parke Bernet, Inc., *Americana: Bergen and Various Owners,* catalog for sale no. 4938, October 21–22, 1982, lot no. 567. The relationship to the artist of no. 104 is undetermined.

Mary Ann Olin Scott
(active ca. 1828)

105 Flowers in a Yellow Fluted Vase 62.303.1

106 Flowers in a Blue Bottle 62.303.2

Mary Ann Olin Scott
America, 1828
Watercolor on wove paper
11¹⁵⁄₁₆″ x 8¹⁵⁄₁₆″ (30.3 cm. x 22.7 cm.)
11¾″ x 9½″ (29.9 cm. x 24.1 cm.)

New engraving methods in the nineteenth century led to superb flower books and prints and simultaneously made published flower illustrations available for the delight and instruction of a broad, lay audience. Flowers and fruit were the subjects most frequently depicted at this time in amateur still lifes, reflecting in part an awareness of such published materials and, in a related way, an increasing vogue for ornamental gardening. Young ladies, schooled in the genteel manner, often learned painting and drawing skills by copying French floral engravings, as exemplified here by Scott's use of Roubillac's *Etudes des Fleurs* for her *Flowers in*

a Blue Bottle.[1] A print source probably exists for her other composition, *Flowers in a Yellow Fluted Vase*, but it has not been located. Curiously, the identical tabletop appears in both. Despite the strong similarities observed in schoolgirl artworks derived from common sources, selection of colors and ability to record designs reflect personal interpretations that are often highly individualized and successful.

Inscriptions/Marks: Both works are signed in pencil in the lower right corners: "Mary Ann Olin Scott 1828."
Condition: E. Hollyday cleaned the paintings in 1975. Both probably original ¾-inch, veneered molded frames.
Provenance: Old Print Shop, New York, N.Y.
Exhibited: Hollins College, 1974.
Published: Black, Folk Painting, p. 9, illus. as nos. 7, 8 on p. 10.

[1]The Roubillac print is illustrated as pl. 105 in Gordon Dunthorne, *Flower and Fruit Prints of the 18th and Early 19th Centuries* (Washington, D.C., 1938). Inscribed within the composition of the print is "VIIᵉ Cahier/de Fleurs et Corbeilles,/Dessine's et Grave's,/Par Roubillac/A Paris chez Mondhare et Jean/rue Sᵗ Jean de Beauvais № 4." Roubillac's complete name remains unknown. He is mentioned briefly as a Paris engraver who was born in 1739 in E. Bénézit, *Dictionnaire Critique et Documentaire des Peintres, Sculpteurs, Dessinateurs et Graveurs de Tous les Temps et de Tous les Pays par un Groupe d'écrivains Spécialistes Français et Étrangers,* IX (Paris, 1976), p. 127.

105

106

William Stearns
(active ca. 1825)

Research on William Stearns is incomplete at this time, but he is recorded as the artist of two still lifes other than no. 107: a velvet theorem, titled *Bowl of Fruit*, stamped "PAINTED BY/WILLIAM STEARNS";[1] and a work featuring a basket of flowers that was executed with gouache on paper.[2]

[1] The theorem is in the National Gallery of Art, Washington, D.C.; *Bowl of Fruit* is of the same design as no. 107.
[2] "American Naive and Folk Art," *Kennedy Quarterly*, XIII (January 1974), illus. as no. 36 on p. 39.

107 Still Life with Watermelon 57.403.2

William Stearns
America, possibly New England, ca. 1825
Paint on velvet
17¾″ x 19⅞″ (45.1 cm. x 50.5 cm.)

While most theorems were made by young women, this composition is a rare example of one executed by a man or a boy, indicating the wide appeal of this art form. If this work is any indication, Stearns was well acquainted with stencil technique. The sharp forms of the fruits, particularly the grapes and watermelon seeds, are balanced by the bold design of the orange-and-black basket. Stearns's adept stenciling is at its best in the gracefully curving grape stems. Several other theorems of this design exist, although none of them incorporates the distinctive sawtooth border that outlines three sides of this composition.[1]

Inscriptions/Marks: Stamped under the basket is "PAINTED BY/ WILLIAM STEARNS."
Condition: Unspecified treatment was done by Kathryn Scott in 1957. Probably period replacement 1½-inch silver lacquer molded frame.
Provenance: Found in Boston, Mass., and purchased from Edith Gregor Halpert, Downtown Gallery, New York, N.Y.
Exhibited: "Masterpieces in American Folk Art," Downtown Gallery, New York, N.Y., February 1942.

[1] See no. 113 for a theorem of another design that is outlined in a sawtooth border. Accession no. 35.403.4, which is also owned by the Folk Art Center but is not listed in this catalog, is similar in design to no. 107. Other examples of this design include: *Antiques*, CXV (January 1979), Thos. K. Woodard advertisement, p. 105; Sotheby Parke Bernet, Garbisch II, p. 33, no. 80.

Mary R. Wilson
(active ca. 1840)

108 Fruit in Yellow Bowl 31.303.2

Mary R. Wilson
Possibly Boston, Massachusetts, ca. 1840
Watercolor and gold-foil collage on wove paper
10⅛″ x 17½″ (25.7 cm. x 44.5 cm.)

Mary Wilson's exceptionally well-executed still life illustrates the degree of sensitivity that theorem artists sometimes realized in their work. Her imaginative use of stylized elements is evident in the circular highlighting of the grapes, the stippled shading of the pear, and the delicately rendered diamond motif on the bowl. Applied gold foil embellishes the compote and simulates a tabletop. Wilson attempted a suggestion of depth by painting the open areas between fruit and leaves a rich blue-green color. Nothing is known about the artist.

Inscriptions/Marks: A freehand inscription, probably in ink, on the wooden backboard reads: "Painted by Mary R. Wilson."
Condition: In 1977 E. Hollyday dry-cleaned the surface, set down the gold foil with wheat-starch paste, and backed the primary support with Japanese mulberry paper. Probably period replacement 1¼-inch gilded and molded frame.
Provenance: Found in Boston, Mass., and purchased from Edith Gregor Halpert, Downtown Gallery, New York, N.Y.
Exhibited: AARFAC, American Museum in Britain; AARFAC, Minneapolis; AARFAC, June 4, 1962–April 17, 1963; AARFAC, May 10, 1964–December 31, 1966; American Folk Art, Traveling.
Published: Cahill, American Folk Art, p. 37, no. 65; Rumford, Folk Art Center, illus. on p. 61.

Unidentified Artists

109 Cornucopia of Flowers 35.603.1

Artist unidentified
Possibly Boston, Massachusetts, ca. 1805
Silk threads on silk
12¹⁵⁄₁₆″ x 10⅛″ (32.9 cm. x 25.7 cm.)

This example probably dates from the early 1800s, when learning to embroider in silk was considered a necessary part of a lady's genteel education. The subdued colors and smooth stitchery of *Cornucopia of Flowers* produce a delicate effect, which is heightened by the blossoms' spindly branches. Various colored threads were skillfully used throughout the design elements to give shading and suggest depth.

107

108

109

Condition: Unspecified conservation treatment by Kathryn Scott in 1956 probably included cleaning and repairing two small tears, one located at lower right and another on the right edge. Original glass mat with eglomise border and original 1¼-inch gilded and molded frame with ⅜-inch beaded inner edge.

Provenance: Katrina Kipper, Accord, Mass.

Published: AARFAC, 1957, p. 373, no. 359.

[1]Ring, Looking-Glass, p. 1181.

110 Formal Flowers 32.403.6

Artist unidentified
America, ca. 1820
Paint on velvet
19¼" x 18⁷⁄₁₆" (48.9 cm. x 46.8 cm.)

Distinct stenciled bars repeated around the urn combine with the sharp square base to give the lower portion of this theorem a somewhat abstract, linear appearance.[1] These bold shapes contrast with the stippled spray surrounding the rosebuds and the curving stems of the floral arrangement. The blue and reddish-orange hues of the flowers are repeated in the urn.

Condition: Conservation work, probably by Kathryn Scott in the 1950s, included sewing the velvet to cotton material with a rag-board backing.

Provenance: Isabel Carleton Wilde, Cambridge, Mass.

Exhibited: AARFAC, September 15, 1974–July 25, 1976.

Published: AARFAC, 1957, p. 370, no. 324; AARFAC, 1974, p. 63, no. 60, illus. on p. 62.

[1]A more polished version of this theorem was done by Lydia Hosmer of Concord, Mass. (ca. 1812); it appears in *Antiques*, XX (September 1931), p. 162.

111 Fantasy 57.403.1

Artist unidentified
America, ca. 1820
Paint on velvet
20⁷⁄₈" x 25¾" (53.0 cm. x 65.4 cm.)

The bizarre combination and contrasting scale of the objects in this composition make it one of the most imaginative in the collection. By upending a conventional floral arrangement and placing it in an outdoor setting surrounded by blue sky, picket fence, tree, and ram, the artist has given the work a surrealistic quality. The unidentified maker's ingenuity is also revealed in the unusually shaped leaves of the tree, which were probably painted using individual stencils that were then combined and layered to form the lilac.

110

111

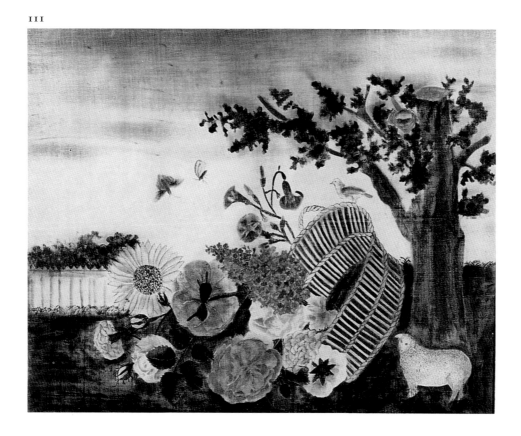

Condition: Unspecified conservation work was done by Kathryn Scott in 1957. Period replacement 1½-inch molded and gilded frame.
Provenance: Found in Greenwich, Conn., and purchased from Edith Gregor Halpert, Downtown Gallery, New York, N.Y.
Exhibited: "Amateur Art," Downtown Gallery, New York, N.Y., September 1952; "American Ancestors," Downtown Gallery, New York, N.Y., October 3–14, 1933, and exhibition catalog, no. 14; "Americans at Home," Downtown Gallery, New York, N.Y., October 1938; Detroit Institute of Arts, Detroit, Mich., October 1935; "Paintings on Velvet," Downtown Gallery, New York, N.Y., October 1939; Trois Siècles, and exhibition catalog, p. 52, no. 235; Wadsworth Atheneum, January 1935.
Published: Schorsch, Pastoral, illus. on p. 27.

112 Formal Still Life 57.403.3

Artist unidentified
America, ca. 1820
Paint on velvet
16⅛" x 19¹⁵⁄₁₆" (41.0 cm. x 50.6 cm.)

A bumpy green hillock provides an unusual outdoor setting for this elaborate and well-executed floral arrangement. Exquisite shading distinguishes the carefully placed flowers, particularly the deep red carnation in the upper right. Though shading lends a softness to most of the blossoms, it is the precise alignment of stencils that accounts for the dahlia's sharp, pinwheel-like petals. The scattered brown leaves among the foliage, the thorns on the rose stems, and the tufts of grass on the hillock reveal the artist's delight in stenciled detail. Multicolored butterflies complete the scene.

Condition: Unspecified conservation work was done by Kathryn Scott in 1957. Original 2¼-inch, bird's-eye maple frame.
Provenance: Found in Downington, Pa., and purchased from Edith Gregor Halpert, Downtown Gallery, New York, N.Y.
Exhibited: Flowers, and exhibition checklist, no. 14.

113 Bright Flowers 78.403.1

Artist unidentified
Probably Conway, Massachusetts, ca. 1820
Paint on linen
17" x 16⅜" (43.2 cm. x 41.6 cm.)

The stenciled character of this theorem can best be seen in the uniform petals of the daisylike flowers, although the stamens of the flowers appear to have been drawn freehand. The evenly scattered mustard-yellow and creamy orange blossoms give the arrangement a delicate and airy look. The limited palette of orange, yellow, and green with a slight touch of blue is distinctive and appealing. Another unusual feature, the yellow-and-green sawtooth border, is present in only one other theorem in the collection, no. 107. Because the border did not meet evenly in the upper right-hand corner, the artist extended the yellow portion to the edge of the linen. The bouquet design is reminiscent of overmantel decorations found in Massachusetts wall stenciling of the early nineteenth century.[1]

Condition: The linen was remounted on rag-board mat wrapped in unbleached muslin by E. Hollyday in 1979. Modern replacement ¹⁵⁄₁₆-inch molded frame, painted black.

112

113

Provenance: Mary Bates of Conway, Mass.; gift of Mr. and Mrs. John F. Staub.

Published: Antiques, LXXIX (May 1961), illus. on cover; "Museum Acquisitions," *Antique Collecting,* II (January 1979), illus. on p 19.

¹See the overmantel set of bouquets from the Josiah Sage House, South Sandisfield, Mass., dating from 1803–1824, in Janet Waring, *Early American Stencil Decorations* (New York, 1937), illus. as fig. 38. Both South Sandisfield and Conway are in western Mass.

114 Basket of Fruit 31.403.6

Artist unidentified
America, ca. 1825
Paint on velvet
8¼″ x 7⅜″ (21.0 cm. x 18.7 cm.)

The cluster of fruits floating above the small blue bowl in *Basket of Fruit* may have been made with stencils borrowed from another theorem, since they are nearly

114

Exhibited: American Folk Art, Traveling.
Published: AARFAC, 1957, p. 369, no. 320; Cahill, American Folk Art, p. 39, no. 86.

[1]Not included in this catalog, the theorem is acc. no. 31.403.9.

115 Yellow Basket with Flowers 31.403.17

Artist unidentified
America, ca. 1825
Paint on velvet
15⁹⁄₁₆″ x 19⁹⁄₁₆″ (39.5 cm. x 49.7 cm.)

Three bands of spiral lines representing straw twists circle this yellow basket of springtime flowers.[1] The freehand petal detail of the iris is delicate and well drawn, as is the detail of the lily at the far left of the basket. The artist was less successful in capturing the delicacy of the roses. The dark foliage behind the flowers is offset by the deep green fringed mat.

Condition: Unspecified conservation work was done by Kathryn Scott in 1956. Period replacement 2½-inch molded and gilded frame.
Provenance: Found in Boston, Mass., and purchased from Edith Gregor Halpert, Downtown Gallery, New York, N.Y.
Exhibited: American Folk Art, Traveling.
Published: AARFAC, 1957, p. 371, no. 339; Cahill, American Folk Art, p. 40, no. 102 (mistitled *Flowers in Blue Bowl*).

[1]Signed examples of this design include one in *Maine Antique Digest*, IX (October 1981), p. 7-B, signed: "Painted by Nancy H. Vose, Castine, Maine in 1823"; and one in Sotheby Parke Bernet, Garbisch II, no. 68, signed: "Presented to J. D. Wingate by Miss Emily C. Shriner." The Sotheby Parke Bernet example is done in reverse.

identical to those used for the popular "full basket" theorem in another still life owned by the Center.[1] The artist improvised the bowl and base.

Condition: No evidence of previous conservation has been noted. Probably period replacement 2-inch molded and gilded frame.
Provenance: Found in Boston, Mass., and purchased from Edith Gregor Halpert, Downtown Gallery, New York, N.Y.

115

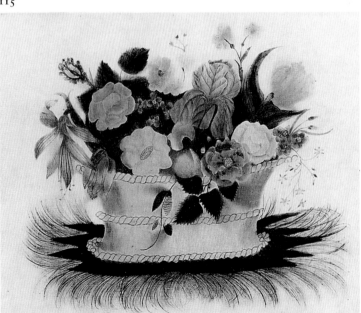

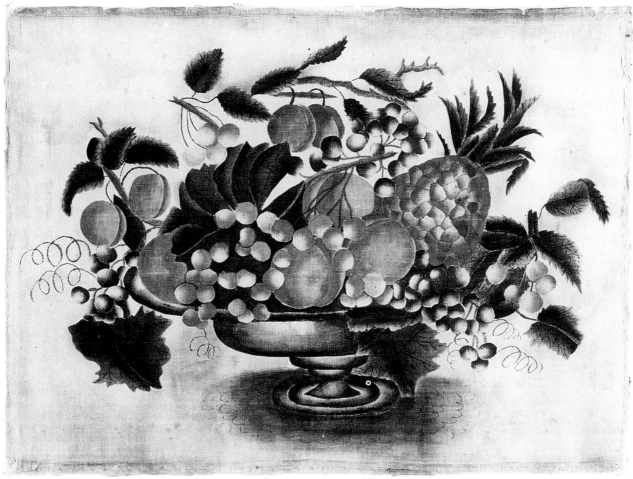

116

Unsigned examples of this design include those found in: June Field, *Collecting Georgian and Victorian Crafts* (New York, 1973), illus. as no. 95 on p. 69; *Kennedy Quarterly*, XI (January 1972), p. 181, no. 138; *Newtown Bee*, March 18, 1977, p. 54; Sotheby Parke Bernet, 1978, no. 156. Anne Pullin cited an example of this design done with gouache on paper to AARFAC, January 25, 1980.

116 Fruit in Footed Bowl 32.403.2

Artist unidentified
America, ca. 1825
Paint on velvet
14 7/16″ x 20 3/4″ (36.7 cm. x 52.7 cm.)

This theorem's artist had a skillful command of the stencils. The fruit is well settled in the bright blue bowl, which rests on a blue mat decorated with blue-inked scallops. Careful shading of brown and blue-green adds a realistic touch to the leaves, which have intricate veining.

Several variations of this theorem composition exist, all with round-based bowls and pineapples in upper right corners, indicating that this was a popular pattern for paintings on velvet and paper.[1]

Condition: Unspecified conservation work was done by Kathryn Scott in 1955. Probably period replacement 2 1/2-inch molded and gilded frame.
Provenance: Found in Boston, Mass., and purchased from Edith Gregor Halpert, Downtown Gallery, New York, N.Y.
Exhibited: American Folk Art, Traveling.
Published: AARFAC, 1957, p. 371, no. 341; Cahill, American Folk Art, p. 39, no. 83.

[1]Not listed in this catalog is another version of the design owned by the Folk Art Center, acc. no. 31.403.2. Signed examples of this same design include: Heritage Plantation of Sandwich and Columbus Museum of Arts and Crafts, *The Herbert Waide Hemphill, Jr., Collection of 18th, 19th, and 20th Century American Folk Art*, 1974–1975, p. 18, no. 21, and illus. on p. 20, signed by "Elizabeth W. Capron," ca. 1840; Sotheby Parke Bernet, Halpert, p. 213, no. 211, *Wisterberg Bowl of Fruit*, signed "Susan M. Shaw," dated 1852.

Unsigned examples of this same design include: Sotheby Parke Bernet, Inc., *Americana*, catalog for sale no. 3834, January 29–31, 1976, lot no. 661; Tillou, no. 54; Janet Waring, *Early American Stencil Decorations* (New York, 1968), p. 142, fig. 165. Gina Martin to AARFAC, April 24, 1975, documented an example of this design done in reverse.

Similar designs done with watercolor on paper include one in the New York State Historical Association, Cooperstown, N.Y., *Fruit on Drop Leaf Table*, ca. 1825.

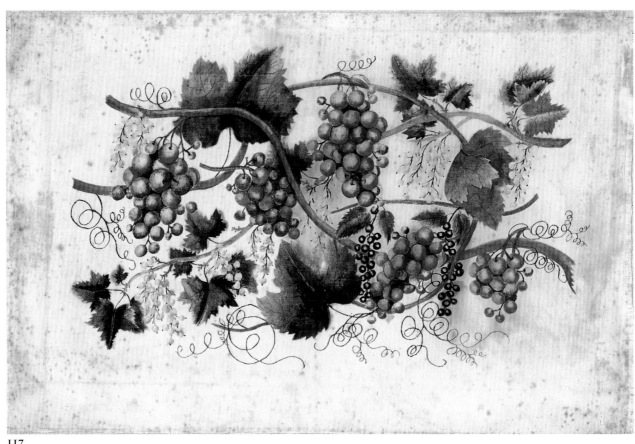

117

117 Grapevine 32.403.9

Artist unidentified
America, ca. 1825
Paint on velvet
14⅞″ x 22⅞″ (37.8 cm. x 58.1 cm.)

Departing from conventional theorem designs, which show fruit mounded in baskets, bowls, and on table-tops, this artist suspended clusters of grapes and currants from curving, unsupported vines. Grapevines that descend from the upper left to the lower right of the composition cross over a currant branch, which slopes to the lower left — creating a balanced and airy composition. The folded leaves in the upper right have been expertly shaded by a confident stenciler. Subtle shading also creates the impression of full, well-rounded fruit. Swirling grapevine tendrils add a final touch to this imaginative and well-executed theorem.

Condition: Conservation work, probably done by Kathryn Scott in the 1950s, included sewing the primary support with a rag-board backing. Wood strips between the velvet and glass were re-placed with rag-board strips by E. Hollyday in 1974. Period replacement 2-inch molded and gilded frame.

Provenance: Isabel Carleton Wilde, Cambridge, Mass.
Exhibited: AARFAC, April 22, 1959–December 31, 1961; AARFAC, September 15, 1974–July 25, 1976; Pine Manor Junior College; William Penn Museum.
Published: AARFAC, 1957, p. 230, no. 115, illus. on p. 231; AARFAC, 1974, p. 63, no. 62, illus. on p. 64; Quimby and Swank, illus. as fig. 4 on p. 21.

118 Varied Fruit 33.403.1

Artist unidentified
America, ca. 1825
Paint on silk
8⅝″ x 10¼″ (21.9 cm. x 26.0 cm.)

The silk support's glossy surface enhances the crisp stencil work evident in this composition of fruits. Resting on a blue, red, and green pedestal, the festive yellow and blue striped bowl is topped with a brown rim that extends to the scroll handles. Barberries and cur-

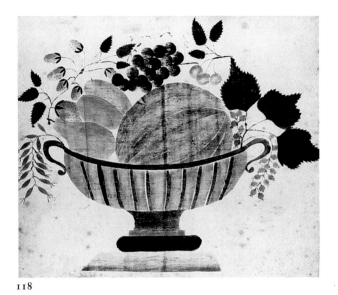

118

119 Basket of Fruit with Bird and Butterfly

79.403.8

Artist unidentified
America, ca. 1825
Watercolor on cotton velvet
13½" x 17½" (34.3 cm. x 44.5 cm.)

By carefully shading the fruit and darkening the left and right edges of the basket, the artist gave the illusion of depth to this composition.[1] These techniques were used to make the theorem more lifelike, but fanciful freehand details belie any preoccupation with realism. The bird's claw, which is outlined but not filled, grasps a free-floating branch at an improbable angle, and the butterfly in the upper left has what appear to be tail feathers! The only grapevine tendrils present fan out from a single point under the bird's throat.

Condition: The primary support has been stitched to a linen secondary support. In 1983 E. Hollyday dry-cleaned the surface and replaced an acidic backing with a nonacidic support. Modern replacement 1½-inch molded and gilded frame.
Provenance: Acquired from Katrina Kipper, Accord, Mass., February 20, 1936, for use at Bassett Hall, the Williamsburg home of Mr. and Mrs. John D. Rockefeller, Jr.

[1]The Folk Art Center owns five additional examples of this design: acc. nos. 31.403.3, 31.403.4, 58.403.4, 58.403.5, and 58.403.6; none of these related examples is included in this catalog. A signed example of this design has been noted in *Antiques*, CVI (November 1974), p. 785. Unsigned examples have been noted in *Antiques*, XVII (April 1930), p. 368; *Antiques*, CXII (September 1977), p.

rants gracefully curve around these scroll handles. The bowl holds an assortment of delicately shaded fruit, including a peach, a pear, and a melon.

Condition: Unspecified conservation work was done by Kathryn Scott in 1956. The silk was mounted on unbleached muslin-covered rag board by E. Hollyday in 1978. Period replacement 1¼-inch molded and gilded frame.
Provenance: Found in Franconia, N.H., with a history of having come from the Saben family of Winchester, N.H.

119

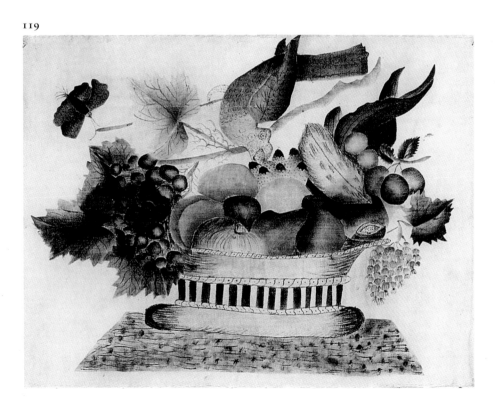

393; *The Old Print Shop Portfolio,* XI (October 1951), p. 33, no. 10; Sotheby Parke Bernet, Inc., *Americana,* catalog for sale no. 3834, January 29–31, 1976, lot no. 295; Sotheby Parke Bernet, *Fine Americana,* catalog for sale no. 4116, April 27–29, 1978, lot no. 847; Sotheby Parke Bernet, Garbisch I, p. 48, no. 100, and p. 68, lot no. 146; and Sotheby Parke Bernet, Garbisch III, p. 31, lot no. 69. Three additional examples were noted in Gina Martin to AAR-FAC, April 24, 1975. A four-sheet set of stencils for making a theorem of this design is owned by the Museum of the Concord Antiquarian Society, Concord, Mass. Tracings made from the stencils and information about their original owner, Harriet Moore, were kindly provided by William Tuttle to AARFAC, July 19, 1978.

120 Shells 60.303.1

Artist unidentified
America, probably 1829–1840
Watercolor on wove heavy drawing board
7⅞″ x 9³⁄₁₆″ (20.0 cm. x 23.3 cm.)

This drawing contains strong passages of yellow, green, and a particularly vibrant blue. Blue rims the far right shell and was also used for some of the squiggles that radiate from the mossy base. The absence of green tint from the lower center frond suggests that the drawing was left unfinished, although the deletion may have been intentional.

One other composition based on the same design source is known: a theorem on paper signed "by M. C. Willard."[1] The print source for the two drawings appears as plate XX in Nathaniel Whittock's 1829 treatise on drawing flowers, fruit, and shells.[2] Shells

were fairly popular as a general decorative motif in the nineteenth century, but they were seldom used as subjects of theorem pictures. The heavy emphasis on fruit and flowers, instead, is reflected in the main body of Whittock's book, where only two of his twenty lessons and their accompanying plates deal with shells — the rest with fruit and flowers.

Inscriptions/Marks: An illegible blind stamp appears in the upper right corner.
Condition: The drawing appears to be in its original condition except that a tear on the right side has been reinforced with tape on the reverse. Period replacement 1-inch molded and gilded cyma recta frame.
Provenance: Edith Gregor Halpert, Downtown Gallery, New York, N.Y.

[1]The Willard drawing is privately owned and was made known to the Folk Art Center through the courtesy of Gina Martin to AARFAC, April 24, 1975.
[2]See Nathaniel Whittock, *The Art of Drawing and Colouring from Nature, Flowers, Fruit, and Shells; To Which Is Added, Correct Directions for Preparing the Most Brilliant Colours for Painting on Velvet, with the Mode of Using Them; Also, the New Method of Oriental Tinting* (London, 1829).
On p. 65, the introduction to Whittock's lesson XIX advises that "the student who can produce faithful representations of fruit and flowers, will feel great pleasure in copying the beauties of nature in her marine productions. Amongst these the shells of various animals, inhabitants of the ocean, form the most conspicuous subjects for the observation of the artist, not only on account of their curious and picturesque forms, but also from the variety, elegance, and brilliancy of their colours." Lesson XX instructs in the drawing of the Folk Art Center's composition of three univalves. The blue of the unidentified artist's cowrie shell represents the most dramatic departure from Whittock's instruction, for the author advises that this specimen be tinted with vermilion "softened into a light wash of yellow ochre," with dark areas colored a rich red-brown.

120

121

122

121 Fluted Bowl with Flowers 32.403.7

Artist unidentified
America, ca. 1830
Paint on velvet
12½" x 15½" (31.8 cm. x 39.4 cm.)

The fanciful image of such spindly stems supporting large, heavy blossoms gives this theorem much of its charm.[1] The artist may have stenciled the flowers first, then added the stems and leaves to attach the blossoms to the bowl. The delicate layers of flower petals are noteworthy, particularly in the elongated side views of the two tulips. Dark outlines around the edges of the petal shapes and their extremely light centers make the flowers appear to be almost transparent.

Condition: Unspecified conservation work was done by Kathryn Scott in 1955. E. Hollyday removed wooden strips from the velvet surface in 1974. Probably period replacement 2½-inch molded and gilded frame.
Provenance: Found in Boston, Mass., and purchased from Edith Gregor Halpert, Downtown Gallery, New York, N.Y.
Exhibited: AARFAC, September 15, 1974–July 25, 1976; American Folk Art, Traveling.
Published: AARFAC, 1957, p. 370, no. 332; AARFAC, 1974, p. 63, no. 61; Cahill, American Folk Art, p. 40, no. 100.

[1]For a similar composition, see Sotheby Parke Bernet, Garbisch II, no. 13.

122 White Bowl of Fruit 58.303.3

Artist unidentified
America, probably ca. 1830
Watercolor on wove paper
18" x 22⅛" (45.7 cm. x 56.2 cm.)

A creative use of patterning enhances the visual appeal of this colorful composition. The ribbed melon rinds echo the fluted design in the footed compote, while the brilliant purple plums all face in the same direction. The artist inaccurately registered the stencils for a lemon at upper left, which should have fitted between the curved leaves above, and for the slightly askew black trim decorating the foot of the compote.

The degree of naturalism attainable with the mechanical aid of stencils depended largely on the artist's adeptness at shading, but here the depth and roundness of the fruits are suggested more by the intensity than the shading of the selected hues, which are unusually well preserved.

Condition: Restoration treatment by Christa Gaehde in 1958 included cleaning and mounting on rag board. In 1982 E. Hollyday dry-cleaned unpainted areas and remounted the painting on Japanese mulberry paper. Original 3½-inch gold and silver lacquer frame.
Provenance: J. Stuart Halladay and Herrel George Thomas, Sheffield, Mass.
Exhibited: AARFAC, June 4, 1962–November 20, 1965; AARFAC, September 1968–May 1970.
Published: Ford, Pictorial Folk Art, illus. on p. 129.

123 Basket of Flowers 73.303.1

Artist unidentified
America, probably ca. 1830
Watercolor on wove paper
16¾" x 20¾" (42.6 cm. x 52.7 cm.)

In lieu of the more frequently seen tabletop or table mat, a well-defined island of grassy earth functions as

123

a base for this floral arrangement. The handling of the work includes an uncommon degree of detail, fine draftsmanship, and sensitive coloring. A nearly identical composition on paper bearing an 1828 watermark has been recorded, but thus far, no information about the presumed mutual source for the two watercolors has been located.[1]

Inscriptions/Marks: At upper left, a partial watermark in the primary support reads: "J WHATM . . . "
Condition: The primary support was originally two to three inches larger in both dimensions and was wrapped around and glued to 1⅝-inch-wide softwood stretchers that were mortised at each corner and secured with two small wooden pegs per joint. In 1982 E. Hollyday removed the primary support from its stretchers and trimmed it to its present size; cleaned the paper; aligned and mended tears; and backed the whole with Japanese mulberry paper. The 1⅜-inch gilded cyma recta frame is possibly original but has been recovered with gold paint.
Provenance: Childs Gallery, Boston, Mass.

[1]The nearly identical composition is owned by Old Sturbridge Village, Sturbridge, Mass. It measures 18¼″ x 22″ and has a glaze over the basket section of the design.

124 The Blue Bowl 79.403.2

Artist unidentified
America, ca. 1830
Paint on cotton velvet
16½″ x 18½″ (41.9 cm. x 47.0 cm.)

Soft striations of brown, yellow, and green representing curved leaves and rounded fruit unify this successful theorem picture. The appealing spectrum of earth colors is repeated in the base and is complemented by the deep sky blue shade of the bowl. The artist was careful not to overlap adjoining segments of the design. The resulting gaps of unpainted velvet produce sharp flutes near the top of the bowl and give the body and leaves of the pineapple a segmented, abstract appearance.[1]

Condition: The primary support is stitched to a linen secondary support. In 1983 E. Hollyday removed an acidic backing, dry-cleaned the surface, and mounted the theorem and the secondary

124

125

support on a nonacidic backing. Possibly original 1⅞-inch molded and gilded frame.

Provenance: Found in Boston, Mass., and acquired from Edith Gregor Halpert, Downtown Gallery, New York, N.Y., November 9, 1931, and used at Bassett Hall, the Williamsburg home of Mr. and Mrs. John D. Rockefeller, Jr.

Exhibited: American Folk Art, Traveling.

Published: Cahill, American Folk Art, p. 39, no. 85.

[1]A signed version of this design is *Bowl of Fruit* in the National Gallery of Art, Washington, D.C.; it is stamped: "Painted By/WILLIAM STEARNS." For another work by William Stearns, see no. 107.

Unsigned examples of this design include the very similar *Fruit in a Blue Waterford Bowl* (acc. no. N-46.61) that was also found in Boston and measures only half an inch larger in each dimension, and *Fruit in a Turquoise Blue Waterford Bowl* (acc. no. N-348.61); both are in the collections of the New York State Historical Association, Cooperstown, N.Y. In addition, the following examples have been published: *The Old Print Shop Portfolio,* XII (March 1953), fig. 9 on p. 153; Sotheby Parke Bernet, Inc., *Fine American Furniture and Related Decorative Arts: The Collection of Mr. and Mrs. John B. Schorsch and Mrs. Marjorie H. Schorsch,* catalog for sale no. 4592Y, May 1–2, 1981, lot no. 210; and Sotheby Parke Bernet, Halpert, lot no. 321.

125 Green and Yellow Basket 79.403.9

Artist unidentified
America, ca. 1830
Paint on cotton velvet
7¾″ x 10⅛″ (19.7 cm. x 25.7 cm.)

The flat, mostly unshaded fruit in this composition seems to rise out of its basket, as if floating in space. Only the central apple is shaded in two colors. The vivid colors used throughout and the whimsical arrangement make this an especially appealing example.

Condition: The primary support has been stitched to a linen secondary support. In 1983 E. Hollyday removed an acidic backing and mounted the theorem on a nonacidic support. Probably original 1-inch molded and gilded frame.

Provenance: Acquired by Holger Cahill on January 31, 1935, from an unrecorded source, and used at Bassett Hall, the Williamsburg home of Mr. and Mrs. John D. Rockefeller, Jr.

126 Peacock on Flowering Branch 79.403.10

Artist unidentified
America, ca. 1830
Watercolor on cotton velvet
19⅜″ x 14¾″ (49.2 cm. x 37.5 cm.)

Proudly displaying a cascade of brown and turquoise plumage, this regal peacock surveys the surrounding foliage. The bird's strong vertical position is countered by horizontal branches, while reddish-orange blossoms and long, thin leaves extend the composition to the edges of the velvet.

The soft, blurred quality of the leaves and the thick branch in the lower left, and the wispy, painterly detail of the feathers, suggest that most of the painting was done without the aid of stencils. However, small green dots around the edges of each flower petal may indicate that the outline was pounced — that is, paint or powder may have been applied through a perforated pattern.

Birds and butterflies are common elements in theorem patterns, but peacocks are rare.

126

Condition: The primary support previously had been adhered to an acidic backing. In 1982 E. Hollyday removed the acidic backing and mounted the theorem on a nonacidic support. Replacement refinished 2-inch molded oak frame with ½-inch gilded inner liner.

Provenance: Acquired fom Katrina Kipper, Accord, Mass., in February 1935, for use at Bassett Hall, the Williamsburg home of Mr. and Mrs. John D. Rockefeller, Jr.

127 Fruit on Table 79.403.12

Artist unidentified
America, ca. 1830
Paint on cotton velvet
12″ x 15¾″ (30.5 cm. x 40.0 cm.)

The top of a four-legged table supports the fruit and overturned basket in this design.[1] The objects were well modeled and realistically placed, but the creator had difficulty depicting the table in correct perspective. In spite of the darker tones shading the inside of the

table legs, it is difficult to tell which are the rear legs of the table. The addition of a grassy background seems to extend the horizontal line of the tabletop and heavily weights the bottom third of the composition. A yellow butterfly skimming the leaf above the melon adds interest to the upper portion of the picture.

Condition: The primary support has been stitched to a linen secondary support. In 1983 E. Hollyday dry-cleaned the surface and mounted the primary and secondary supports on a nonacidic backing. Modern replacement 2-inch gilded splayed frame with half-round molding at outer edge.

Provenance: Found in Boston, Mass., and acquired from Edith Gregor Halpert, Downtown Gallery, New York, N.Y., October 3, 1931, and used at Bassett Hall, the Williamsburg home of Mr. and Mrs. John D. Rockefeller, Jr.

Exhibited: American Folk Art, Traveling.

Published: Cahill, American Folk Art, p. 38, no. 80, illus. on p. 95.

[1]The Folk Art Center owns a similar composition (acc. no. 58.403.9) that is not included in this catalog. A smaller version lacking a butterfly is *Table of Fruit* (acc. no. 57.230) by Mrs. Thomas Cushing (active ca. 1822) in Karolik Collection, no. 1310, on p. 256.

127

128A

128 Watermelon in Blue-bordered Dish

58.303.2

Artist unidentified
America, 1830–1850
Watercolor on wove paper
10⁷⁄₁₆″ x 15¹¹⁄₁₆″ (26.5 cm. x 39.9 cm.)

Visible pencil lines suggest that no. 128 was first outlined with stencils, then painted. Dabbing the wet paint with a cloth produced the softened textures in the scalloped platter edge and the green melon rind at left. The bird's-eye perspective depicts an interesting but improbable array of dark seeds radiating in rows from the melon centers.

A theorem painting on the reverse of the primary support (no. 128A) shows two birds in a tree, suggesting that both still lifes were practice pieces. A center crease and sewing marks identify the sheet as a page taken from a book. Unpainted lines drawn in the center of the platter surrounding the fruit suggest that the composition was never finished; nevertheless, its stylized forms, bright colors, and simple design make it an engaging example of theorem painting.

128

129

stencils were perhaps cut and provided either commercially or by a teacher.

A lithograph of the composition has been noted; while it is undated, its printers — Kelloggs & Comstock — apparently operated only during the brief period of 1848–1850.[2] This print may have inspired at least some of the many known versions of the *Formal Still Life* composition, but some earlier source must have been used for a now unlocated but very similarly designed watercolor on paper, if information about that work's 1831 date is correct.[3] Until additional research clarifies the origin of the composition, a relatively wide date span has been suggested for the Folk Art Center's examples.

Condition: Unspecified treatment by Christa Gaehde about 1955 probably included cleaning. In 1978 E. Hollyday cleaned the primary support and inpainted minor losses. Modern replacement 1 15/16-inch splayed stained pine frame.
Provenance: Found in Boston, Mass., and purchased from Edith Gregor Halpert, Downtown Gallery, New York, N.Y.
Exhibited: American Folk Art, Traveling.
Published: AARFAC, 1940, p. 32, no. 129; AARFAC, 1947, p. 30, no. 129; AARFAC, 1957, p. 366, no. 295; Cahill, American Folk Art, p. 42, no. 119; Stein, p. 43, illus. on p. 14.[4]

[1]Also owned by the Folk Art Center but not included in this catalog are five other examples of the composition: acc. nos. 31.303.13, 31.303.14, 31.403.19, 36.303.1, and 31.508.1. Other examples in other collections are noted in the Folk Art Center's files.

[2]At present, Folk Art Center staff are still trying to obtain an image of the lithograph, which is believed to show the same composition. An example noted in 1977 is recorded as having been inscribed: "Kelloggs & Comstock/150 Fulton St., N.Y. & 136 Main St., Hartford, Conn." and "D. Needham, 12 Exchange St., Buffalo." See Miriam R. LeVin to AARFAC, May 9, 1977. Groce and Wallace, p. 364, gives the operating span for the firm of Kelloggs & Comstock.

[3]The watercolor on paper appears as lot no. 104 in Sotheby Parke Bernet, Halpert, where no mention is made of any inscriptions. However, a photocopy of Halpert's work sheet on the object in Folk Art Center files indicates that the work is "by Henry Forney (signed)" and "dated 1831." The unlocated composition is quite similar to those now owned by the Folk Art Center, although it shows a compote with a simple turned baluster stem, not the much more elaborate construction of the Folk Art Center's and most other recorded examples.

[4]Stein, p. 14, states that this version is a freehand copy; while the detailing has been added freehand, the use of stencils for the basic layout of the design is apparent.

129 Formal Still Life 31.303.5

Artist unidentified
Probably New England, 1830–1860
Watercolor and pencil on wove paper
14½″ x 11¾″ (36.8 cm. x 29.9 cm.)

The survival of numerous examples of this composition in a variety of mediums indicates that it was a popular exercise piece, although no recorded histories link it directly to the school arts tradition.[1] Variations among most of the versions are slight, suggesting that

Condition: Unspecified restoration treatment by Christa Gaehde in 1957 probably included cleaning. Conservation work by E. Hollyday in 1977 including dry cleaning. Modern replacement 1 ¾-inch molded frame, painted black.
Provenance: J. Stuart Halladay and Herrel George Thomas, Sheffield, Mass.
Exhibited: AARFAC, American Museum in Britain; AARFAC, New Canaan; AARFAC, June 4, 1962–March 31, 1965; Flowering of American Folk Art; Halladay-Thomas, Albany, and exhibition catalog no. 90; Halladay-Thomas, New Britain, and exhibition catalog no. 66.
Published: Black and Lipman, p. 206, illus. as no. 188 on p. 209; Booth, illus. as frontispiece; Lipman and Winchester, Folk Art, illus. as no. 124 on p. 95.

130 Bountiful Board 36.103.1

Artist unidentified
America, probably 1830–1860
Oil on bedticking
21¼″ x 35¼″ (54.0 cm. x 89.5 cm.)

This unpretentious tableau is one of the best nonacademic representations of the frequently depicted "abundance" theme. An eye-level vantage point and

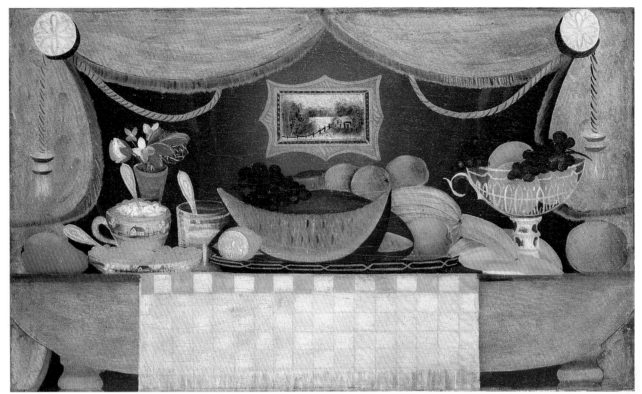

130

the pulled drapery produce a dramatic setting for these homey objects. The painting has a simple, flat style, but the maker compensated for this technical deficiency by an effective use of rich colors, including the receding dark green wall and the lighter-hued checked tablecloth. The inclusion of the china teacup and saucer with a landscape pattern and the framed rural scene above, as well as the use of bedticking for a primary support, suggest that the artist composed this painting at home utilizing personal props.

Condition: Unspecified restoration treatment by Russell J. Quandt in 1955 included lining, cleaning, and minor inpainting. Modern replacement 3½-inch mahogany frame with 1¼-inch gilded inner edge.

Provenance: Found in Rhode Island, and purchased from Edith Gregor Halpert, Downtown Gallery, New York, N.Y.

Exhibited: AARFAC, June 4, 1962–April 17, 1963.

Published: Black and Lipman, p. 206, illus. as fig. 189 on p. 210; Gerdts, p. 78, see note no. 6; "Native Primitives Complement New Acquisitions for Mrs. John D. Rockefeller, Jr.'s Collection of U.S. Folk Art," Art News, XXXVII (April 15, 1939), p. 12, illus. on p. 12; Mitchell A. Wilder, "Recognition for Folk Art," Art in America, XLV (Spring/Summer 1957), illus. on p. 51.

131 Fruit in Two-handled Bowl 77.303.1

Artist unidentified
America, ca. 1835
Watercolor on wove paper
17½″ x 21¹⁵⁄₁₆″ (44.5 cm. x 55.7 cm.)

This composition is stenciled, but the bowl has two mountain landscapes depicting what resemble castellated buildings; both landscapes appear to be freehand additions. The scenes could represent the artist's version of transfer-printed ware, or perhaps they are details from a hand-painted piece the artist owned or admired. The spindly gold handles and the gold sprig-leaf borders create a delicate contrast to the heavy arrangement of fruit at the top. The artist's evident delight in rendering these specifics makes for an unusually pleasing decorative still life.

Inscriptions/Marks: Embossed oval paper mark at upper left corner reads: "DE LA RUE/CORNISH & ROCK/EXTRA/LONDON/BOARD."[1] On the reverse of the support at upper right is faintly penciled: "4R/70."

Condition: There is no evidence of previous conservation treatment. Probably original 2½-inch, concave molded curly maple–veneered frame with raised corner blocks that have carved circular decorations.

Provenance: A. David Pottinger, Bloomfield Hills, Mich.

131

Provenance: Acquired by Holger Cahill from Hawkestone Antique Shop, Charleston, S.C., in March 1935, and used at Bassett Hall, the Williamsburg home of Mr. and Mrs. John D. Rockefeller, Jr.

[1]A. L. Morrish, Archivist, De La Rue Co., Ltd., to AARFAC, November 21, 1977, indicates that the partnership formed by Thomas de la Rue with Samuel Cornish and William Frederick Rock lasted only during the period 1830–1835. The partners in this English firm "were described as 'Cardmakers, Hot Pressers and enamellers.' Hot Pressing was the production of a glossy surface between two plates. The 'enameling' referred to the hard smooth finish given to the board used, for example, for playing cards." Another still life owned by the Center (acc. no. 31.303.1) that is not included in this catalog bears the same blind stamp.

132 Sliced Melon and Other Fruit 79.303.4

Artist unidentified
Possibly South Carolina, ca. 1835
Watercolor on wove paper
16⅛" x 20" (41.0 cm. x 50.8 cm.)

The innovative spreading arrangement of elements in this picture distinguishes it from tightly organized compositions. The alignment of the sliced melon, peaches, and pears suggests that the work may have begun as a tabletop composition, but that the artist ultimately chose to present the colorful fruit and billowy leaves detached from any support.

Luscious fruits are highlighted to indicate the peak of ripeness. Almost lost amid the plump round forms, a pecking bird poised precariously by a bunch of grapes adds a whimsical note to the picture.

Condition: Previous unrecorded restoration treatment included backing the primary support with wove paper and inpainting along mended edge tears. Treatment by E. Hollyday in 1981 included cleaning the verso, inpainting small scattered pigment losses in the fruit, and mending edge tears. Probably original 1-inch gilded frame with half-round moldings.

133 Design for Needlework 35.303.1

Artist unidentified
America, probably 1835–1855
Watercolor and pencil on perforated heavy paper
17¹³⁄₁₆" x 15¹⁵⁄₁₆" (45.2 cm. x 40.5 cm.)

The design of fruit and vegetables in *Design for Needlework* was stenciled onto the perforated ground, while some small details — such as stems and tendrils — were added freehand over penciled guidelines. The maker probably intended to finish the work by stitching directly through the heavy paper ground with silk or fine wool threads, although the subject is not typical of those generally used for the popular pastime of paper embroidery.[1]

The artist had obvious problems with the perspective of the marble slab. Perhaps she also continued the back slab line right through the middle of the basket with the thought that her needlework would cover the visual conflict. Although they somewhat resemble onions, the rounded forms in either side of the basket probably were intended to represent apples.

Condition: Unspecified treatment by Christa Gaehde in 1955 included cleaning. In 1975 E. Hollyday dry-cleaned unpainted areas and hinged the primary support to mat board. Possibly original 1⁷⁄₁₆-inch lap-jointed stained walnut frame.
Provenance: Found by Holger Cahill, and purchased from an unidentified owner in Winston-Salem, N.C.[2]
Published: AARFAC, 1940, p. 32, no. 134; AARFAC, 1947, p. 30, no. 134; AARFAC, 1957, p. 365, no. 289.

[1]The art of paper embroidery is discussed in Harbeson, pp. 128–130; and in the Margaret Woodbury Strong Museum, *A Scene of Adornment: Decoration in the Victorian Home* (Rochester, N.Y., 1975), p. 53.
[2]Early records of Mrs. Rockefeller's indicate that, when acquired, this piece was believed to have been painted by a student at Salem Academy in Winston-Salem, N.C. Thus far, research has not verified this information.

134 Flower Basket 31.303.4

Artist unidentified
Probably New England, ca. 1840
Watercolor and applied gold paper on wove paper
11¾" x 14⅝" (29.9 cm. x 37.1 cm.)

132

133

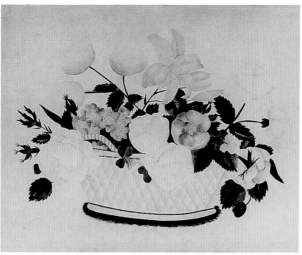

134

which gives no indication of a back rim for the bowl.

Uneven edges, visible sketch lines, and the cramped apple at left indicate that the composition, although mostly stenciled, was completed freehand. The concentric, vibrant blue lines of the footed container dominate the painting and direct the viewer's eye upward to the fruit that appears to be hovering above the compote in a topsy-turvy fashion. This pleasing combination of bold colors and highly stylized forms suggests the innovative potential of the stenciling technique.

Three similar works exist on velvet, implying there was a possible print source.[1]

Condition: Unspecified restoration treatment by Christa Gaehde about 1955 probably included the removal of stains. Possibly original 1¼-inch gilded and molded frame.
Provenance: Isabel Carleton Wilde, Cambridge, Mass.; John Becker, New York, N.Y.; given to the Museum of Modern Art in 1939 by Abby Aldrich Rockefeller; turned over to Colonial Williamsburg in June 1954.
Exhibited: AARFAC, American Museum in Britain; AARFAC, Minneapolis; AARFAC, New Jersey; AARFAC, South Texas; AARFAC, June 4, 1962–April 17, 1963; American Primitive Painting, and exhibition catalog, no. 24; "American Primitive Paintings," Smithsonian Institution Traveling Exhibition Service, June 23, 1958–November 30, 1959; American Primitives; Flowering of American Folk Art; Goethean Gallery; Smithsonian, American Primitive Watercolors, and exhibition catalog, p. 9, no. 40; Wilde, and exhibition catalog, no. 42, illus. on front cover.
Published: American Primitives, p. 76, no. 81, illus. as no. 81 on p. 55; Lipman, Primitive Painting, illus. as fig. 78; Lipman and Winchester, Folk Art, illus. as no. 123 on p. 93; "Notes and News on Antiques and Collecting," The Antiques Journal, XXII (December 1967), illus. on p. 4.

[1]See Sotheby Parke Bernet, 1979, lot no. 1046; Sotheby Parke Bernet, Garbisch II, p. 39, lot no. 95; and *Fruit in Compote* owned by Mr. and Mrs. James Loeb and illustrated in Masterpieces of American Folk Art, unpaginated.

The white crosshatched basket, green mat, and applied gold paper in *Flower Basket* are similar to those in another theorem owned by the Folk Art Center. Both theorems were found in Boston. Similar size and treatment suggest a common stencil for these accessories, but whether they were created by the same artist or under the same circumstances remains undetermined.[1]

Inscriptions/Marks: The watermark in the primary support reads: "J Whatman/ Turkey Mill/ 1834." A portion of an embossed paper mark in the upper left corner reads "[illegible material]APER."
Condition: Unspecified restoration work by Christa Gaehde in 1955 included slight cleaning and an unspecified repair to one corner. Probably period replacement 1-inch gilded and molded frame.
Provenance: Found in Boston, Mass., and purchased from Edith Gregor Halpert, Downtown Gallery, New York, N.Y.

[1]The baskets and mats in the two compositions are the same measure; the handles are on opposite sides of the baskets. The compositionally related theorem, *White Basket of Fruit,* is not included in this catalog.

135 Blue Compote Filled with Fruit 33.303.4

Artist unidentified
America, ca. 1840
Watercolor and pencil on wove paper
13⁷⁄₁₆" x 15¼" (34.1 cm. x 38.7 cm.)

Effective composition, detail, and balance make this free and bold fruit painting an excellent nonacademic still life. Its spirited image reflects the efforts of an unidentified artist whose affinity for gravity-defying fruit and detailed foliage resulted in unintentional abstraction. This effect is heightened by a frontal view,

136 Squirrel and Fruit 35.403.1

Artist unidentified
America, ca. 1840
Paint on velvet
15⁵⁄₁₆" x 18½" (38.9 cm. x 47.0 cm.)

The alert expression on the squirrel's face in no. 136 indicates this artist's drawing expertise. Unlike the stylized birds and butterflies in other theorems, the animal's well-modeled body, sharp claws, and soft bushy tail are realistically portrayed. While the squirrel's proportions are accurately rendered, the brown table seems to be suspended several inches below the animal's feet.[1] Stenciled grapes and leaves — which are given thickness by the short, dark lines along their edges — flank the squirrel.

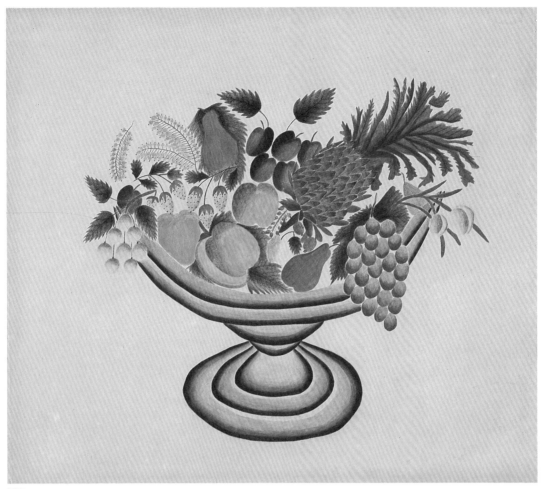

135

136

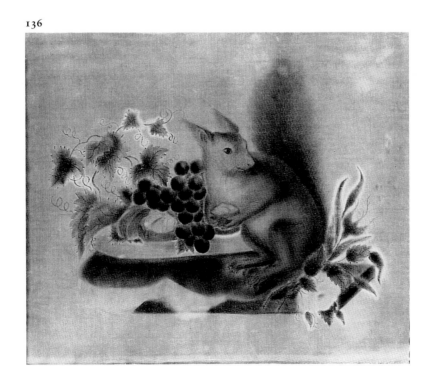

Inscriptions/Marks: A stenciled inscription on the back of the frame is no longer legible, but it is recorded as having read: "John H. Clarke, 138 King Street, Alexandria, Virginia."

Condition: Unspecified conservation treatment was done by Kathryn Scott in 1956. In 1977 E. Hollyday sewed the velvet to washed, unbleached muslin stretched over conservation board. Probably original 2-inch molded gilt frame with series of black-painted horizontal and vertical lines decorating the inside of the molding.

Provenance: Found in Washington, D.C., and purchased from M. Jordan, Washington, D.C.

Published: AARFAC, 1957, p. 371, no. 340.

[1]For the same design with the squirrel resting firmly on the tabletop, see Harbeson, p. 111; there, the squirrel is worked in needlepoint and cross-stitch, and the piece is dated ca. 1850.

137 Fruit and Melon 36.403.1

Artist unidentified
America, probably South Carolina, ca. 1840
Paint on velvet
16″ x 20″ (40.6 cm. x 50.8 cm.)

Casually scattered watermelon seeds and rind, in addition to the upright knife in the melon, suggest that a meal has been interrupted.[1] A shrewd stenciler, this artist made the jagged tops of the light-colored watermelon slices by fraying the edges of the adjacent, darker stencils. Evidence of this technique can best be seen in the lower left of the basket, where the stencils for its twisted weave end unevenly to form the top of the slice of watermelon. Other fruit details are also well executed. For instance, the large melon in the back has small, realistic cracks and veins. By employing contrasting color and detail, the artist has represented two kinds of grapes: a well-shaded blue cluster is on the left, while a green-and-brown cluster rests in the center.

Condition: Unspecified conservation treatment included sewing the velvet to a linen support. Period replacement 2-inch molded and gilded frame.

Provenance: Found in Aiken, S.C., and purchased from Holger Cahill.

Published: AARFAC, 1957, p. 240, no. 120, and illus. as fig. 120 on p. 241.

[1]Other versions of this design include a drinking glass and a Canton pitcher. See Sotheby Parke Bernet, Garbisch II, no. 100. A similar composition having a Bridgeport, Conn., history was mentioned by David L. Chambers to AARFAC, July 19, 1980.

137

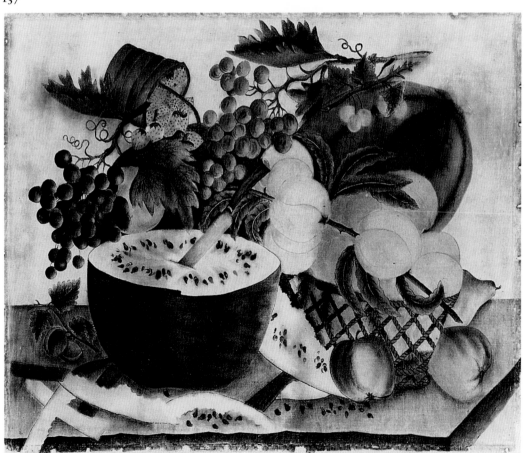

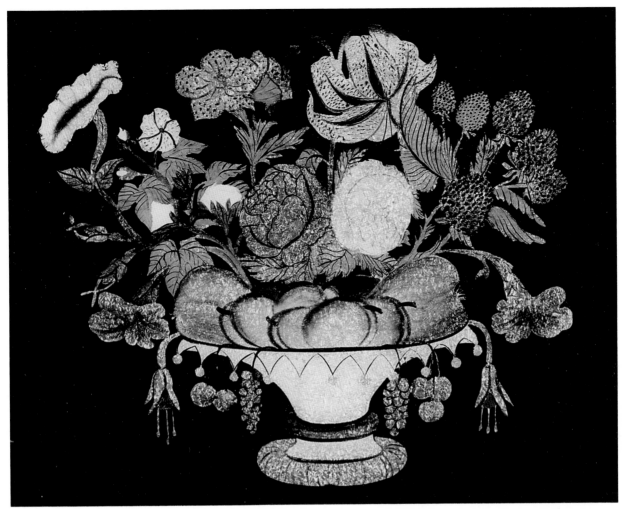

138

138 Tinsel Flowers 57.508.1

Artist unidentified
America, ca. 1840
Tinsel and oil on glass
15½″ x 21¼″ (39.4 cm. x 54.0 cm.)

Perhaps the most striking feature of this still life is the contrast between the tall, profuse bouquet and the more sedately arranged fruit—a juxtaposition that confirms that the artist used stencils intended for two separate compositions. Whether this combination was inspired by fanciful inventiveness on the maker's part or was simply meant to provide practice in rendering both fruit and flowers is unknown. In either event, it posed a problem of balance, since the weight is concentrated on the fruit. Symmetrically arranged cherries, morning glories, and grapes overhang the compote rim; presumably they were added to counterbalance the high flowers.

Crisp rendering of the bowl and distinguishing botanical details in the blooms suggest the artist's familiarity with the technique of tinsel painting, or "oriental work." Tinsel painting is a form of reverse-painting on glass, with the added embellishment of sparkling metal foil.[1] Foil, crinkled for effect and affixed to the back of the glass, serves to highlight subject areas painted in transparent oil washes. The combination of transparent colors and shimmering foil gives the appearance of costly mother-of-pearl. One instruction book described the results as "capable of producing effects of color equal to the colors of Oriental flowers."[2]

Condition: No evidence of previous conservation treatment. Probably original 1¼-inch molded and gilded frame.
Provenance: Old Print Shop, New York, N.Y.

[1]For information on glass painting in America, see Mildred Lee Ward, *Reverse Painting on Glass* (Lawrence, Kans., 1978).
[2]Urbino and Day, p. 200.

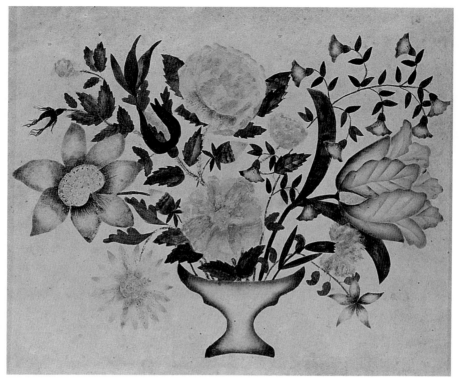

139

139 Flowers in a Small Bowl 79.303.3

Artist unidentified
America, ca. 1840
Watercolor on wove paper
10" x 12⅛" (25.4 cm. x 30.8 cm.)

Sensitive rendering of botanical details — including the use of stippling to simulate the thorns on several branches — and use of strong color make this a pleasing still life. A large bouquet bursts from the diminutive container, suggesting that the artist may have combined stencils intended for two different compositions. The vase's bright blue color juxtaposed with the lively pink flowers compensates for the vase's size and creates a sense of balance in this well-executed floral piece.

Inscriptions/Marks: Inscribed in ink on the verso is "57" inside a circle, and in pencil: "o s P/50."
Condition: Treatment by E. Hollyday in 1982 included removing an acidic secondary support, cleaning the surface of the primary support, repairing minor edge tears, backing the primary support with Japanese mulberry paper, and setting down flaking red paint in the roses. Probably original ⅝-inch gilded frame with rope twist moldings.
Provenance: Acquired by Holger Cahill from Hawkestone Antique Shop, Charleston, S.C., in March 1935 for use at Bassett Hall, the Williamsburg home of Mr. and Mrs. John D. Rockefeller, Jr.

140 Pink Roses 79.303.9

Artist unidentified
America, ca. 1840
Watercolor on wove paper
12⅛" x 10" (30.8 cm. x 25.4 cm.) [1]

The oval format of this stenciled bouquet is dominated by a large pink rose. Flowers in the upper half of the bouquet branch symmetrically from a single stem. The artist reveals the underside of the rose at left while giving the customary view of the opposite rose. Soft, puffy rose petals contrast with the sharp-edged, thickly painted leaves. The tiny vase adds a note of whimsy.

Condition: Small cuts appear on the two flowers at upper left, suggesting use of stencils. The primary support is folded at the sides to fit into the frame. E. Hollyday cleaned the surface of the primary support and mounted it on a nonacidic secondary support in 1974. In 1983 E. Hollyday cleaned the surface and verso of the primary support and backed it with Japanese mulberry paper to strengthen the brittle paper. Possibly original 1⅝-inch cove molded and gilded frame.
Provenance: Found in New York, N.Y., with a reported Connecticut history. Purchased from Edith Gregor Halpert, American Folk Art Gallery, New York, N.Y., on December 21, 1935, for use at Bassett Hall, the Williamsburg home of Mr. and Mrs. John D. Rockefeller, Jr.

[1]The primary support is folded within its frame; measurements given describe the folded rather than the flattened sheet.

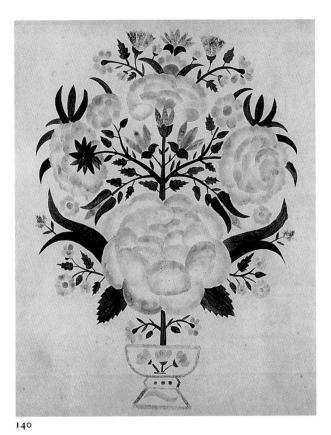

140

141 Cornucopia of Flowers 79.403.3

Artist unidentified
America, ca. 1840
Watercolor on cotton velvet
17½″ x 21⅝″ (44.5 cm. x 54.9 cm.)

Curving upward from its off-center base, this cornucopia holds a lovely selection of flowers. After the cornucopia form was stenciled, the dark lines indicating a woven texture and the lacy leaf design below the lobed rim were applied freehand. Carefully drawn details also enhance the blossoms and leaves, particularly those on the right half of the bouquet. Floral arrangements in cornucopias were less common than those in other types of vases; however, there are a few other theorem examples of this subject.[1] Many Baltimore album quilts incorporate similar designs.[2]

Condition: The primary support has been stitched to a linen secondary support. In 1983 E. Hollyday dry-cleaned the surface and replaced an acidic backing with a nonacidic support. Possibly original 2-inch molded and gilded frame.

Provenance: Acquired from Edith Gregor Halpert, Downtown Gallery, New York, N.Y., February 20, 1936, for use at Bassett Hall, the Williamsburg home of Mr. and Mrs. John D. Rockefeller, Jr.

141

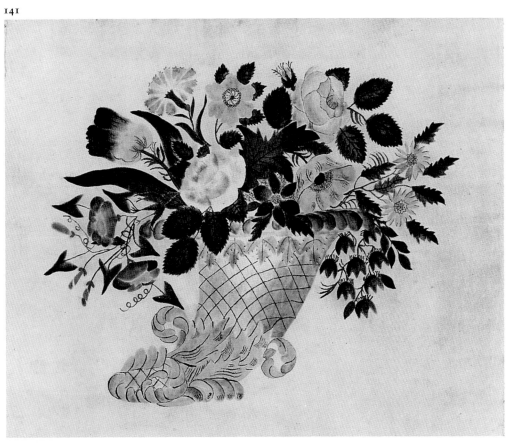

142

[1]For other examples, see *The Old Print Shop Portfolio*, IX (May 1950), fig. 15 on p. 204; Sotheby Parke Bernet, Garbisch I, lot no. 109 on p. 54; Sotheby Parke Bernet, Garbisch III, lot no. 50 on p. 22.

[2]See Dena S. Katzenberg, *Baltimore Album Quilts* (Baltimore, 1981), pp. 37, 87, 97, 99, 107, 109, 117.

142 Still Life with Watermelons 79.403.6

Artist unidentified
America, ca. 1840
Paint on cotton velvet
17″ x 22⅜″ (43.2 cm. x 56.8 cm.)

Vibrant colors and skillful application of paint attest to this artist's expertise in producing theorems. The apple is a particularly fine example of realistic effects achieved by stenciling. Surrounded by bright cherries and strawberries, a glowing yellow peach, and other well-modeled fruit, the apple centers the striking horizontal arrangement on the rich blue marbleized base. In spite of the artist's attention to natural coloring and detail, both heavy watermelons seem to hover above the base. The same effect is seen in other versions of this design.[1]

Condition: The primary support was previously mounted on a linen secondary support. In 1982 E. Hollyday removed an acidic backing, dry-cleaned the surface, and mounted the theorem on a nonacidic support. Probably period replacement 2½-inch molded and gilded frame.

Provenance: Found in Boston, Mass., and acquired from Edith Gregor Halpert, Downtown Gallery, New York, N.Y., on March 30, 1932, and used at Bassett Hall, the Williamsburg home of Mr. and Mrs. John D. Rockefeller, Jr.

Exhibited: American Folk Art, Traveling.

Published: Cahill, American Folk Art, p. 38, no. 81, illus. on p. 96.

[1]The Folk Art Center owns a similar design, acc. no. 31.303.1, which is not included in this catalog. Recorded signed versions of the compositon have been noted in *Maine Antique Digest*, VI (No-

vember 1978), p. 21-C; and in Morrill's Auction, Inc., *Early American Country Antiques at Public Auction, June 20–21, 1974* (Portland, Maine, 1974), p. 19, no. 144. Another, privately owned, example, noted in AARFAC records, is believed to have been the work of Persis Fayette Eastman of Lancaster, N.H., in 1834. Unsigned examples of the design have been noted in Masterpieces of American Folk Art, titled *Still Life with Watermelons*; *The Old Print Shop Portfolio,* IX (May 1950), pp. 204–205, no. 13; and Sotheby Parke Bernet, Inc., *Important American Folk Art and Furniture,* catalog for sale no. 4209, January 20–27, 1979, lot no. 75.

The Concord Antiquarian Museum, Concord, Mass., owns a set of stencils used to create this design; the set was originally owned by Harriet Moore (1802–1878) of Concord.

143 Melons and Other Fruit 35.303.4

Artist unidentified
Probably North Carolina, probably 1840–1860
Watercolor on wove paper
12″ x 16″ (30.5 cm. x 40.6 cm.)

The viewer's anticipation of falling fruit infuses this still life with unusual activity. The toppling grapefruits document the artist's ability to record shapes accurately, but the creator's proficiency in modeling to give three-dimensional form was limited. Profiles are neatly rendered in pencil outline, with shading used sparingly to give depth. Nonacademic painters often used a flat, dark background behind their subjects to suggest rather than specifically define spatial relationships. Although this wicker basket with its copious quantity of fruit appears to have been painted against a black background, the black areas were actually added by the artist after the other elements were painted to enhance the illusion of depth. The use of this technique makes the fruit seem more two dimensional than three, and the forms that were meant to recede into space seem to advance instead.

This unidentified folk artist created interest by the exacting depiction of certain details, including the elongated leaves with their serrated edges that curl playfully around the fruits and the intertwining basketwork that adds a pleasing note of rhythm. The painting retains its original green and blue hues, but the pale carrot and watermelon attest to the considerable fading of the red tints.

Condition: In 1978 E. Hollyday dry-cleaned the front and back and repaired small holes and tears. Original 1¾-inch flat curly maple frame with incised double lines on inner and outer edges.
Provenance: Purchased by Holger Cahill in Winston-Salem, N.C.
Exhibited: Southern Book.
Published: Dena S. Katzenberg, *Baltimore Album Quilts* (Baltimore, 1981), illus. as fig. 41 on p. 42.

143

144

144 Sliced Melons with Grapes 57.303.5

Artist unidentified
Probably Boston, Massachusetts, 1840–1860
Watercolor on wove paper
17⅝″ x 23⅞″ (44.8 cm. x 60.6 cm.)

Simplicity of design and the hard-edged quality of up-right melon slices encircled by grape clusters make this a pleasing decorative fruit piece. The artist's unfamiliarity with the use of stencils is suggested by thick stylized stems, flat unmodeled leaves, and an incomplete bunch of grapes on the verso that probably was a faulty beginning. The paring knife was a prevalent artistic convention in both academic and untutored works, but here it rests unconvincingly on the plate with its blade up. The single scalloped line used to represent the platter serves to unify the symmetrical design. The existence of a similar, slightly smaller composition suggests a possible print source.[1]

Condition: Unspecified conservation treatment by Christa Gaehde in 1961 included mounting on rag board. Probably modern replacement 1¾-inch molded frame, stained brown, with ½-inch gilded liner.
 Provenance: Found in Boston, Mass., and purchased from Edith Gregor Halpert, Downtown Gallery, New York, N.Y.
 Exhibited: AARFAC, New Jersey; Goethean Gallery.

[1]See Sotheby Parke Bernet, Garbisch III, lot no. 139.

145 Wool Embroidery 61.603.1

Artist unidentified
America, probably 1840–1860
Wool embroidery with silk or cotton on linen
16⅝″ x 20¾″ (42.2 cm. x 52.7 cm.)

Silk or cotton was used for only one small detail in no. 145: the tiny anthers of the drooping fuchsia blossoms. Otherwise the entire embroidery was executed in wool, with emphasis on the precise filling of crisply defined shapes in simple satin stitch.

Many of the colors have been deeply affected by fading, especially the rich purple of the drapes. The present effect is quite different from what the artist intended, and it is only with imagination aided by a look at protected areas of stitchery that one regains a sense of the vibrancy of the original palette. Fading has also diminished the contrast between the main colors of the drapes and table cover and the slightly different hues used within them to suggest folds and gathers, thereby giving these portions of the composition a more flattened appearance than they had initially.

The flower arrangement itself is rather sophisticated, with well-shaped leaves and blossoms that are rendered in consistent scale. Several blooms are subtly shaded to suggest dimension and give an impression

of naturalistic coloration. Although no print source has been identified as yet, the artist probably relied on one for this central, primary part of the design. However, the naively conceived perspective of the short-legged dais, or table, and the dramatic conceit of parted drapes suggest that the remainder of the composition was supplied by the artist's fancy. Drawn drapes formed a conventional visual frame for portrait subjects through the late eighteenth and early nineteenth centuries, but they impute aggrandized status to the simple bouquet.

Condition: Unspecified treatment by Kathryn Scott in 1962 included cleaning, flattening, and trimming the primary support; stitching same to muslin; and stretching the mounted piece over mat board. Period replacement 3½-inch splayed and molded gilded frame.
 Provenance: Robert Carlen, Philadelphia, Pa.
 Exhibited: "American Needlework," Museum of American Folk Art, New York, N.Y., February 6–May 31, 1967.

146 Still Life with Compote 70.103.1

Artist unidentified
America, possibly 1840–1870
Oil on canvas
38″ x 34½″ (96.5 cm. x 87.6 cm.)

The spandrels' deftly executed C-scrolls suggest that the artist of this still life was an accomplished ornamental painter, whereas lack of proficiency and experience in still-life depiction is indicated by naive handling of the composition, of its perspective, of the scale of the objects, and of the modeling and shading used to render three-dimensional form. The lack of dark ground lines makes many objects appear to hover over the table. The knife, especially, seems to float; as if in accordance, the shadow cast by the bottle at right passes under the knife blade rather than over it.

 Yet this painting possesses considerable decorative

145

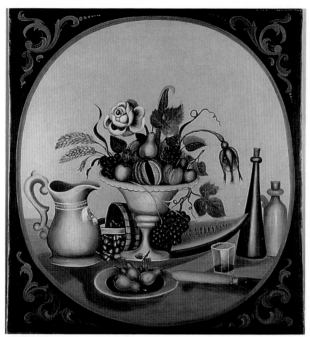

146

example, it bears a decorative edging reminiscent of printed ornament, but thus far no compositional source for the two has been identified.[1]

Despite surface dirt over the design portions, *Fruit in Wicker Basket* remains an unusually vivid painting. Especially notable are the apples, which are segregated from the rest of the composition by narrow rims of intense red that quickly shades to acid green. Only the grapes appear dull and lackluster — the effect, it is thought, of chemical change in their paint structure. Originally they must have rivaled the other fruits in their rich, deep color.

Sharp shadows on the white background behind some of the fruits give the illusion of a two-dimensional pasteboard cutout set up in front of a paper.

Inscriptions/Marks: Lettering on the knife blade is largely illegible but appears to begin with *W.* The paint strokes may have been mock lettering intended to suggest a manufacturer's mark on the blade.
Condition: In 1959 Russell J. Quandt cleaned the border areas of the painting only, lined the canvas, replaced the original strainers, filled and inpainted a small hole at lower left, and inpainted other minor areas of paint loss, especially along the outer edges. Possibly original 2⅞-inch molded white pine cyma recta frame, painted black.
Provenance: J. Stuart Halladay and Herrel George Thomas, Sheffield, Mass.
Exhibited: AARFAC, American Museum in Britain; AARFAC, Minneapolis; AARFAC, New Jersey; AARFAC, South Texas; AARFAC, May 10, 1964–December 31, 1966; AARFAC, September 15, 1974–July 25, 1976; Goethean Gallery; Halladay-Thomas, Hudson Park; "Still Life: Fruits and Flowers," Baltimore Museum of Art, Md., January 8–29, 1961.
Published: AARFAC, 1974, p. 63, no. 64, illus. on p. 65; Black, Folk Artist, illus. on p. 95; Black and Lipman, p. 207, illus. as fig. 191 on p. 212; Book Preview, 1966, p. 126, illus. on p. 128; Ford, Pictorial Folk Art, illus. on p. 127; Gerdts, p. 78.

[1]The related painting is described in correspondence of Nell Esslinger to AARFAC over the period October 18, 1959–February 23, 1960; AARFAC files contain a photograph of it. The composition is a vertical rather than horizontal format, and the basket is set on a fringed table mat. At lower right, the painting bears initials, of which the last letter appears to be *H.*

qualities. Off-center placement of the compote is balanced by an oversize moss rosebud and the height of the taller stoppered bottle. The grapes are portrayed with a high sheen that contrasts pleasingly with the soft skins of the peach, pears, and plums and with the rough textured surface of the cut melon in the compote. The taller bottle at right and the pitcher at left lean outward from the center of the composition and thereby dramatically focus attention on the towering container of fruit, wheat, and flowers. The wide-eyed face on the pitcher seems to register incredulity at this marvel of abundance.

Condition: In 1971 Bruce Etchison cleaned the painting, lined it, remounted it on its original white pine strainers, and filled and inpainted scattered minor areas of paint loss as well as a 3-inch tear through the lowest bunch of grapes. Period replacement 3¾-inch cove molded and gilded fir frame with flat outer edge and applied bead molding on the liner.
Provenance: Mr. and Mrs. John Law Robertson, Scranton and Montrose, Pa.

147 Fruit in Wicker Basket 58.103.1

Artist unidentified
America, possibly 1840–1880
Oil on canvas
22″ x 29⅞″ (55.9 cm. x 75.9 cm.)

A very similar painting to no. 147 was discovered in a private collection in 1959. Like the Folk Art Center's

148 Nature's Bounty 35.103.1

Artist unidentified
Possibly New Hampshire, possibly ca. 1854
Oil on canvas
27¼″ x 39″ (69.2 cm. x 99.1 cm.)

Nothing is known regarding the history of this colorful still life, but a virtually identical composition executed in watercolor has been recorded. The similar version is inscribed on the reverse "Painted in Concord, N.H. 1854," thus forming the basis for the tentative place and date assigned to this oil. The

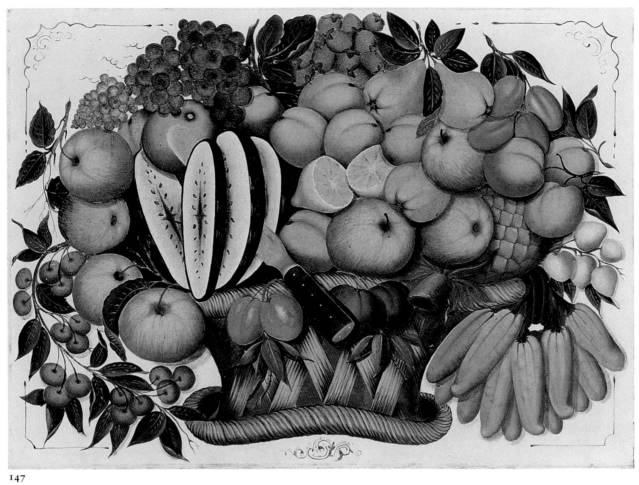

147

148

149

watercolor has a double band of decorative edging around the glass tumbler on the plate, and beside the glass appears a cluster of very small berries instead of the three green grapes perched on the rim in no. 148's plate. Otherwise, the compositions of the two are extremely close.[1]

Condition: Unspecified treatment prior to acquisition and/or possibly by D. H. Young in 1949 included trimming the primary support; lining it; and inpainting numerous scattered losses, especially along the lower left vertical edge, the upper horizontal eighth of the canvas, and in parallel lines diagonally crossing the upper corners. In 1977 Charles Olin cleaned the painting, removed the previous inpainting, replaced the lining canvas, replaced the original strainers, and filled and inpainted areas of paint loss. Modern replacement 2½-inch molded cyma recta frame, painted black.
Provenance: Katrina Kipper, Accord, Mass.
Exhibited: American Primitive Art, and exhibition checklist, no. 8.
Published: AARFAC, 1957, p. 357, no. 228.

[1]The present whereabouts of the watercolor is unknown. It was recorded when it was part of the collection of Edgar William and Bernice Chrysler Garbisch, at which time it was illustrated in *Woman's Day,* XXX (September 1967), p. 29. Measurements given for the watercolor are 29″ x 40⅞″.

149 Basket of Fruit 79.303.8

Artist unidentified
Probably New Jersey, ca. 1855
Watercolor on wove paper
21½″ x 29⅛″ (54.6 cm. x 74.0 cm.)

The unidentified artist of this still life filled the wide, shallow basket to overflowing with a multitude of fruits and vegetables. Depicting sliced melons and sectioned fruit along with knives was a popular variation of nineteenth-century nonacademic still lifes.[1] This stacked arrangement of smaller fruits on top and larger ones teetering on the basket rim was outlined in pencil. The small space at the top of the picture suggests that perhaps the composition exceeded the creator's original intentions. Meticulous attention to detail is evident in the artist's attempts to indicate the textures of various fruits.

Inscriptions/Marks: The watermark in the primary support is "WHATMAN 1849." Records indicate that "1854" once appeared on the reverse of the original frame, which has been replaced.

Condition: Treatment by E. Hollyday in 1982 included removing wood strips and tape, cleaning the surface and verso of the primary support, repairing small losses, flattening the primary support, and setting down flaking paint. Period replacement 2-inch molded and gilded frame.

Provenance: Found in East Orange, N.J., and acquired March 14, 1932, from Edith Gregor Halpert, Downtown Gallery, New York, N.Y., and used at Bassett Hall, the Williamsburg home of Mr. and Mrs. John D. Rockefeller, Jr.

Exhibited: American Folk Art, Traveling.

Published: Cahill, *American Folk Art*, p. 37, illus. as no. 63 on p. 88.

¹Compare a similar composition that is on velvet in Sotheby Parke Bernet, Halpert, lot no. 92.

150 Basket of Fruit and Flowers 58.503.1

Artist unidentified
America, ca. 1900
Reverse oil painting on glass
30″ x 35″ (76.2 cm. x 88.9 cm.)

This highly decorative, unconstrained arrangement of plant materials and oddly perched fruits has been executed in loose, sweeping brush strokes similar to the painterly style more common at the turn of the century. Reverse painting on glass was popular in parts of Europe as early as the sixteenth century. References to the American practice of this technique have been found as early as 1787, and there have been several revivals of interest in its use since then. The large format seen in this example is relatively rare for glass paintings and contrasts with the small and moderate-size works popular in the eighteenth and early nineteenth centuries.

Condition: No evidence of previous conservation treatment. Probably original 4½-inch mahogany frame with a 1-inch gilded inner edge.

Provenance: J. Stuart Halladay and Herrel George Thomas, Sheffield, Mass.

150

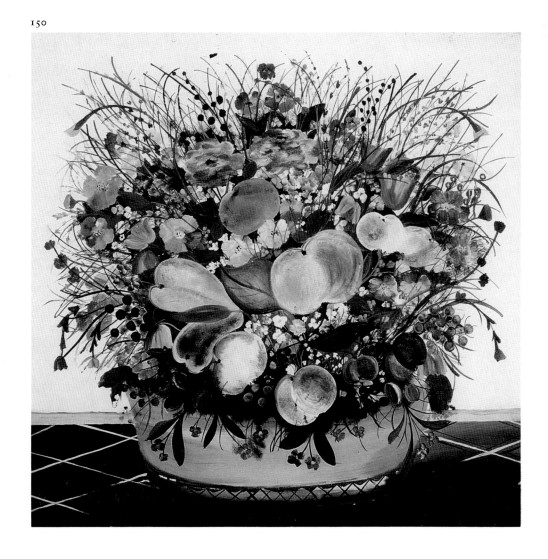

V Literary and Historical Subjects

O heaven! the very same
The soften'd image of my noble friend!
Thomson.

BY SARAH S. DANA.

The pictures grouped here were created from sometimes overlapping and sometimes widely divergent concerns. In the first instance, a burgeoning sense of pride, selfhood, and national identity is reflected in commemorations of military triumphs from America's young past as well as in allegorical symbols of her citizens' objectives through such struggles. Thus, the icon of *Miss Liberty* (no. 168) takes its rightful place beside such idealized historical depictions as *The Peter Francisco Incident* (no. 162) and *Washington and Lafayette at the Battle of Yorktown* (no. 161). The new nation's preoccupation with itself might also be seen in the fact that very few pictures in the collection deal with international historical or political events. Two watercolors show Napoleon, and not surprisingly, both derive from identified print sources. (Eunice Pinney's depiction of the duke of York's mistress surely derives from a print source, too, although the rationale behind the artist's choice of subject is unclear.) Later in the nineteenth century, a painting of a Russian squadron in New York harbor seems to reflect the abandonment of isolationism. Yet even here, an inward eye is evident in the fact that the event was interpreted contemporaneously as a demonstration of support for the Union cause in America's Civil War.

Increasing emphasis on education is evident in the number of paintings and drawings that illustrate literary subjects, and strong tastes for both the classical and the romantic can be documented. On the one hand, ancient mythology and especially Homer's epic poetry exerted considerable influence. On the other, a passion for extravagant sentimentality is discerned in the widespread appeal of authors such as Defoe, Goethe, Radcliffe, Bernardin de Saint-Pierre, Scott, and Sterne. The number of surviving editions of literary works by these and other authors, and the number of drawings and paintings based on them, help to formulate an estimate of their relative popularity in America in the late eighteenth and early nineteenth centuries.

Peter Cobbaugh
(active possibly ca. 1812)

151 *Constitution* and *Guerrière* 59.311.1

Peter Cobbaugh
America, possibly 1812
Watercolor and ink on laid paper
7^{13}/₁₆" x 12⅞" (19.8 cm. x 32.7 cm.)

This small watercolor celebrates the famous victory of the American frigate *Constitution* over her British adversary, the *Guerrière*, southeast of Halifax on August 19, 1812. Besides graphically depicting the latter with mast toppled and sailors afloat, the artist emphasized his point by positioning a triumphant American eagle over inverted symbols of the enemy: the lion, the unicorn, and the seal of Britain. Cobbaugh signed the watercolor twice and dated his celebratory verse 1812. However, whether he was a seaman involved in the battle or simply a patriotic American remains undetermined.[1]

Inscriptions/Marks: At top left is "Yur guerriere an english Ship P Peter Cobbaugh" and at top right is "the Bobob [?] Constitution a Ship of grate fame/Sure each Jolly Sailor Rembered [*sic*]/her Name." Over the eagle in the center is "Fostered under thy wing we die in thy defence." On the banner behind the eagle's head is "PLRIBUS [*sic*] UNUM." Within the upside-down symbol of Britain, on the banner below the lion and unicorn, appears: "MON DRO E conqur [?] DOIT IT." In the rectangle marked off at center bottom of the sheet appears: "Now finding our prize Say a Song on the main A Wreck that could/-erer [ne'er?] be Refitted again[.] we took out the prisoners then Set her on fire/we Soon put an en[d] to the famous gurrier with her doo ra la loo/ Now fill up your glasses my Lads to the Brim and Toast/No[ble?] hull till in toddy you Swim heres a health to/that hero and all his Ship Crew or a Brave Commander/ our Navy Nere [k]new Constitution a grate [against?] guerrier 1812/P Peter Cobbugh."
Condition: In 1960 Christa Gaehde cleaned the sheet and backed it with Japanese mulberry paper. Modern reproduction 1-inch gilded cyma recta frame.
Provenance: Don E. Burnett, East Greenwich, R.I.
Exhibited: Hollins College, 1975, and exhibition catalog, no. 12; Washington County Museum, 1966.

[1]Peter Cobbaugh was not an officer involved in the conflict between the *Constitution* and the *Guerrière*, nor does he appear on lists of those wounded in that battle (Commander Tyrone G. Martin to Anne T. Bull, March 24, 1975).

Sarah Sumner Dana
(1791–1867)

Sarah Sumner Dana was the second daughter and youngest child of Rev. Josiah Dana (1742–1801) and his second wife, Sarah Sumner Caldwell Dana (1754–1805). A Congregational minister, Rev. Josiah Dana held degrees from Harvard, Yale, Brown, and Dartmouth, and lived in Barre, Massachusetts, from 1767 until his death in 1801. His first wife, Mercy Bridgham, died in 1787 at the birth of their twelfth child. In 1788 Rev. Josiah Dana married Sarah Sumner Caldwell. Isabella Caldwell Dana was born August 4, 1789, and Sarah Sumner Dana was born May 13, 1791. Both Isabella and her mother died in Barre in 1805.

In September 1812, Sarah Sumner Dana married Major Thomas Bellows (1779–1825) of Walpole, New Hampshire. They had two daughters, Isabella Caldwell Bellows (1813–1819) and Sarah Isabella Bellows (1820–1866). Sarah Sumner Dana died in Walpole on March 1, 1867.[1]

[1]Elizabeth Ellery-Dana, *The Dana Family in America* (Cambridge, Mass., 1956), pp. 72–74. Betty Ring located the information cited above.

152 The Lovers 79.601.2

Sarah Sumner Dana
Probably Dorchester, Massachusetts,
ca. 1805
Silk embroidery and watercolor on silk
17½" x 11½" (44.5 cm. x 29.2 cm.)
(Reproduced on page 200)

In the lower margin, Sarah Sumner Dana carefully stitched a quotation from "Autumn," a long poem from *The Seasons* by James Thomson (1700–1748). Probably derived from an illustrated edition, this scene depicts Palemon recognizing Lavinia, a gleaner in his fields, as the long-sought daughter of his friend Acasto.[1]

The skillful embroidery is typical of the work performed by students at Mrs. Saunders and Miss Beach's Academy in Dorchester, Massachusetts. An academy advertisement noted that "the Pupils have access to a well chosen Library of above fifteen hundred volumes including the best classic Authors, French and English."[2] Sarah Sumner Dana embroidered the scene in closely worked stitches of smooth silk. Her teacher or a professional artist probably painted the facial expressions and the background landscape.

Inscriptions/Marks: Stitched in black thread in the lower margin of the primary support is the quotation, "O heaven! the very same/The soften'd image of my noble friend!/Thomson." Painted in gold in the lower margin of the black eglomise glass mat is "BY SARAH S. DANA."
Condition: In 1982 E. Hollyday mounted the primary support and the linen secondary support on a nonacidic backing and removed surface dirt. Original 2-inch molded and gilded frame with

151

applied plaster decoration of anthemion leaves along inner edges and a rope twist at the center. Original black and gold eglomise glass mat.[3]

 Provenance: Found in Accord, Mass.; acquired from Katrina Kipper, Accord, Mass., in February 1935, for use at Bassett Hall, the Williamsburg home of Mr. and Mrs. John D. Rockefeller, Jr.

 Published: Ring, Needlework, illus. as pl. IV on p. 477.

[1]*The Seasons* was first published in London in 1730. A similar picture probably derived from the same source was embroidered by Sophia Burpee about 1806. The composition, now titled *New England Couple* (N-121.61), is in the collection of the New York State Historical Association, Cooperstown, N.Y.

[2]*Columbian Centinel* (Boston), May 19, 1819. The attribution to Mrs. Saunders and Miss Beach's Academy is proposed by Betty Ring. For comparison, see works by Saunders and Beach students in Betty Ring, "Mrs. Saunders' and Miss Beach's Academy, Dorchester," *Antiques*, CX (August 1976), pp. 302–312.

[3]The framing is typical of labeled work done by John Doggett (1780–1857) in Roxbury, Mass.

Sarah Vose Forster (1795–1851)

The daughter of Charlestown, Massachusetts, cabinetmaker Jacob Forster (1764–1838) and Rebecca Vose Forster (1765–1841), Sarah Vose Forster was born September 3, 1795. On August 6, 1817, she married Charles Frederick Waldo (1783–1838), a veteran of the United States Navy who had served aboard the *Constitution* during the War of 1812 and lost a leg

from wounds received during the sea battle with the English frigate *Java*.[1] They resided in Charlestown and had seven children. Sarah Vose Forster Waldo died June 8, 1851.[2]

[1]See no. 155 for additional information about this battle between the *Constitution* and the *Java*.

[2]Charles Bellows Wyman, *Genealogies and Estates of Charlestown in the County of Middlesex and Commonwealth of Massachusetts, 1629–1818,* I (Boston, 1879), p. 353; and Waldo Lincoln, *Genealogy of the Waldo Family from 1647–1900,* I (Worcester, Mass., 1902), p. 463. The biographical information cited here was located by Betty Ring.

153 Paul and Virginia 79.601.5

Sarah Vose Forster
Probably Massachusetts, ca. 1810
Silk embroidery and watercolor on silk with applied transparent panels (probably mica)
17¼" x 15" (43.8 cm. x 38.1 cm.)

Like Alice Center (see no. 73), Sarah Vose Forster probably embroidered this picture while attending a young ladies' academy in the Boston area. Her inspiration was the popular novel *L'Histoire de Paul et Virginie* by J. H. Bernardin de Saint-Pierre (1737–1814), originally published in Paris in 1787 and subsequently translated into many languages. She copied an engraving by Charles-Melchior Descourtis (1753–1820) after a painting by Jean-Frédéric Schall (1752–1825).

153

The setting of the tragic romance is an island in the Indian Ocean. The embroidered scene depicts the distraught hero Paul, the Old Man, and the faithful slave Domingo, kneeling in prayer beside Virginia's grave near the church in the Shaddock Grove; Paul's dog, Fidèle, is at left. The mournful scene includes funeral tributes in the form of baskets of fruit and pieces of cloth placed in the trees by island women according to customs of their native lands of Madagascar and Mozambique. Sarah Forster carefully embroidered details of clothing and the exotic trees, but her striving for reality is most evident in her use of mica for the windows of the church.

Inscriptions/Marks: Painted in gold below the center oval of the black eglomise glass mat is "PAUL; & VIRGINIA./Sarah V. Forster."

Condition: The primary support and a linen secondary support were mounted on a nonacidic backing, and surface dirt was removed by E. Hollyday in 1982. Original 1½-inch molded and gilded frame with applied rope twist decoration and original black-and-gold eglomise glass mat.

Provenance: Found in Accord, Mass.; acquired from Katrina Kipper, Accord, Mass., in August 1935 for use at Bassett Hall, the Williamsburg home of Mr. and Mrs. John D. Rockefeller, Jr.

Published: Ring, *Needlework*, illus. as pl. X on p. 480.

The Baroness Hyde de Neuville
(?–1849)

See Hyde de Neuville entry in "Views of Towns" for biographical information.

154 Indian War Dance 31.301.9

Attributed to the Baroness Hyde de Neuville
Washington, D.C., 1821
Watercolor, pencil, and ink on laid paper
7⅝" x 12" (19.4 cm. x 30.5 cm.)

This "Danse Militaire" (see *Inscriptions/Marks*) depicted by the baroness was a friendly demonstration rather than a declaration of war. The scene portrays an occasion during the visit of sixteen leaders of the Pawnee, Omaha, Kansa, Oto, and Missouri tribes to President James Monroe in Washington, D.C., on November 29, 1821. The English traveler W. Faux described the scene as follows:

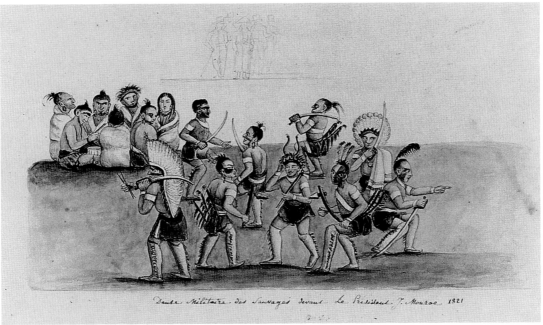

154

These Indians . . . are men of large stature, very muscular, having fine open countenances with the real Roman nose, dignified in their manners, and peaceful and quiet. There was no instance of drunkenness in their stay here.

There was a notice in the papers that the Indians would dance and display their feats in front of the President's house on a certain day, which they did to at least 6,000 persons. They shewed their manner of sitting in council, their dances, their war whoop, with the noises, gesticulations, etc. of the sentinels on the sight of an approaching enemy. They were in a state of perfect nudity, except a piece of red flannel around their waist and passing between their legs. They afterwards performed at the house of his Excellency M. Hyde de Neuville. They were painted horribly, and exhibited the operation of scalping and tomahawking in fine style.[1]

The Indians were among a number of groups brought to the nation's capital during the 1820s and 1830s for prestige or diplomatic reasons. Among those whose likenesses may be recognized here are the Eagle of Delight, the woman sitting in the group at left; Generous Chief, in feather bonnet at lower left; and Chou-man-i-case, wearing a horn headdress in the center of the dancers. President Monroe is faintly penciled in in the background, with several escorts. Probably the central background figure, shown in a long coat, is the baron Hyde de Neuville, husband of the artist.[2]

Inscriptions/Marks: In ink in the lower margin is "Danse Militaire des Sauvages devant Le President J. Monroe 1821." The primary support is of French origin;[3] it incorporates the partially discernible watermark of a complex figurative design over the letters "E P" and "N E."

Condition: In 1983 E. Hollyday removed linen tapes from the reverse of the primary support, dry-cleaned unpainted areas, reduced creasing, and re-adhered flaking areas of paint. Modern replacement ¾-inch gilded cyma recta frame.

Provenance: De Neuville family member(s), Paris; E. De Vries; I. N. Phelps Stokes, New York, N.Y.; Kennedy & Company, New York, N.Y.; Edith Gregor Halpert, Downtown Gallery, New York, N.Y.[4]

Exhibited: "Baroness Hyde de Neuville: Sketches of America, 1807–1822," Jane Voorhees Zimmerli Art Museum, Rutgers, State University of New Jersey, New Brunswick, June 10–August 19, 1984, and New-York Historical Society, New York, N.Y., November 8, 1984–March 17, 1985, and exhibition catalog, pp. 28–29, 36, no. 35, illus. on p. 28; "The Capital Image: Painters in Washington, 1800–1915," National Museum of American Art, Smithsonian Institution, Washington, D.C., October 19, 1983–January 22, 1984; "An Exhibition of Contemporary Drawings of Old New York and American Views," Kennedy & Company (now Kennedy Galleries, Inc.), New York, N.Y., April 1–30, 1931, and exhibition catalog, no. 31; Pollock Galleries, and exhibition catalog, no. 3; Remember the Ladies; Washington County Museum, 1965.

Published: AARFAC, 1957, p. 152, no. 76, illus. on p. 153; De Pauw and Hunt, p. 167, no. 223, illus. on p. 132; Alvin M. Josephy, Jr. et al., *The American Heritage Book of Indians* (New York, 1961), illus. on p. 248.

[1] W. Faux, *Memorable Days in America* (London, 1823), pp. 378–381, as quoted on p. 28 of the catalog for the exhibition "Baroness Hyde de Neuville: Sketches in America, 1807–1822."

[2] Except for the Faux quote, information for this entry is from AARFAC, 1957, p. 152.

[3] Thomas L. Gravell to AARFAC, May 27, 1983.

[4] The piece's provenance prior to Halpert is documented by Stokes and Haskell, p. 85, and by the Kennedy & Company exhibition catalog indicated under *Exhibited* above.

Richard Dummer Jewett, Jr.
(1792–1814)

The artist was born September 8, 1792, in Ipswich, Massachusetts. He was the son of Lucy Kinsman Jewett and Richard Dummer Jewett, Sr., the latter being a doctor and a Revolutionary War veteran. Several letters written by the younger Jewett to his parents survive in the collections of the Ipswich Historical Society, the first being inscribed Salem, February 26, 1807. The fourteen-year-old boy may have been in school in Salem, or by then he may already have embarked on his brief career as a sailor.

Jewett's second extant letter was also written from Salem. Dated December 16, 1811, it states the boy's intention to depart shortly aboard the brig *Reward* under Captain Hill, the ship being bound for "some port in Europe" via New Orleans.

Festering hostilities between America and England erupted in the War of 1812, and Jewett's March 6, 1813, letter related that his ship had been captured by HMS *Surprise* en route to the West Indies.[1] He and his fellow American sailors were committed to Bridgetown Prison, Barbados, on January 26, 1813.

A June 15, 1813, letter confirmed that he was still imprisoned at Bridgetown, along with "about five hundred [other] prisoners . . . some of which were captured in August last." He complained of the lack of government intervention to relieve their plight, signing his despairing note with the words, "God knows when I shall return." Yet on an overleaf dated July 5, he added, "Yesterday we celebrated the day as well as our situation would admit, an Oration delivered and all hands merry this morning. Arrived here a Carteel [cartel] ship Perseverance from New York which will take the first on the List and our delivery will be soon We hope. All well. I expect to send this by the Carteel."

Evidently his hopes were well founded, for he was free by November 25, at least, when he wrote from Boston regarding future sailing jobs. Boston letters of December 7 and December 14 indicate that he planned to leave port aboard the *Milo*, bound for New Orleans, then France. The *Milo* left Boston later that month and made New Orleans. But the ship was lost at sea en route to Europe, and Jewett is presumed to have died at that time.[2]

[1]The March 6, 1813, letter is quoted in Thomas Franklin Waters, *Ipswich in the Massachusetts Bay Colony*, II (Ipswich, Mass., 1917), pp. 420–421. Except for the June 15, 1813, letter, which is owned by the Folk Art Center, other letters mentioned herein are owned by the Ipswich Historical Society.
[2]Except for data taken from his letters, biographical information herein is taken from Mrs. Forbes Durey to AARFAC, May 6, 1975.

155 *Constitution* and *Java* 57.311.1

Richard Dummer Jewett, Jr.
Bridgetown, Barbados, April 19, 1813
Watercolor and ink on laid paper
18³⁄₁₆″ x 23⁹⁄₁₆″ (46.2 cm. x 59.9 cm.)

This is the only known watercolor by Jewett. As indicated by his marginal inscriptions, he was indeed imprisoned in Barbados when he executed the work, a fact confirmed by letters written from prison and dated both before and after the watercolor.

Jewett could not have witnessed the December 29, 1812, naval engagement he depicted, for it occurred off the coast of Brazil, and his March 6, 1813, letter reveals nothing of the incident, mentioning instead his December 27 departure from Boston bound for Madeira.[1] After various incidents at sea, including capture of the British ship *Neptune* on January 9, he related that his own ship was taken by the HMS *Surprise,* and he and his fellow American sailors were imprisoned as described in the artist's biography preceding this entry.

Although Jewett complained later that the only news the captive Americans received was "trifling," they surely heard exuberant reports of the previous December's engagement between the *Constitution* and the *Java* from fellow countrymen thrown into irons after them.[2] Probably inspired by one of these verbal accounts, one imagines that Jewett derived great satisfaction and consolation from depicting the British humiliation so graphically. He portrayed the proud American frigate *Constitution* with all flags flying, riding high on the crest of a great rolling wave. By contrast, the miserable hulk of the defeated *Java* flounders in a trough, scarcely noticeable because of her reduced profile and the darkness of the surrounding sea.

155

156

The two ships had been fairly evenly matched at meeting, but the *Constitution* was handicapped early in the engagement when her wheel was shot away, and Captain William Bainbridge had to steer by using men at the rudder tackles two decks below where he stood giving orders. Nevertheless, the three-and-a-half-hour battle terminated in the *Java*'s total surrender, and the *Constitution* came away with the nickname Old Ironsides because of her hull's stout resistance to the enemy's cannonballs.

Inscriptions/Marks: In ink in script in the lower margin is "Painted at Bridgetown Prison island of Barbados April 19 1813 by an American prisoner" and at far right in the same margin is "Richard D Jewett, S[c]ulpt." In ink in large block capital letters in a colored margin immediately below the composition is "UNITED STATES FRIGATE CONSTITUTION CAPTURING HIS BRITANIC MAJESTY FRIGATE JAVA." The primary support bears the watermark "J Whatman/1808" and the countermark of a fleur-de-lis and cypher respectively above and below a diagonally striped shield.[3]

Condition: In 1960 Christa Gaehde removed a backing paper that had been glued to the primary support; cleaned the primary support; filled and inpainted extensive losses, particularly along an old vertical center fold; repaired several edge tears; and backed the primary support with Japanese mulberry paper. Period replacement 1⅜-inch gilded cyma recta frame.

Provenance: Old Print Shop, New York, N.Y.

[1]This letter is quoted in Thomas Franklin Waters, *Ipswich in the*

Massachusetts Bay Colony, II (Ipswich, Mass., 1917), pp. 420–421.

[2]Jewett's June 15, 1813, letter was acquired by the Folk Art Center along with his watercolor; it mentions that crews from five American privateers and others from merchant ships had been imprisoned at Bridgetown.

[3]Another example of the countermark used is illustrated in Thomas Balston, *James Whatman, Father and Son* (London, 1957), p. 158, fig. 9.

Emily Marshall
(active probably 1820–1835)

156 Calypso and Ulysses 58.301.5

Emily Marshall
America, probably northeast or mid-Atlantic states, probably 1820–1835
Watercolor, gouache, and gold paint on wove paper with some pencil guidelines
18¹³⁄₁₆″ x 23¾″ (47.8 cm. x 60.3 cm.)

The bright color notes of Calypso's yellow waistband and Ulysses' red-sashed blue tunic initially draw one's

157

attention in this otherwise somber scene predominated by earth tones.

The sorrowful hero of Homer's *Odyssey* reclines upon a seaside rock bank, while the goddess Calypso stands beside him in a posture of entreaty. The story of Calypso's seven-year detainment of Ulysses on the island of Ogygia is told in Book V, and later recounted by Ulysses in Book VII, of the *Odyssey*.

Despite a bold signature in gold paint, nothing is known of the artist of this scene.

Inscriptions/Marks: In gold paint and ink or black watercolor on the recto of the primary support are, at lower left, "Calypso and Ulysses" and, at lower right, "Emily Marshall." Faint traces of obliterated lettering beneath the artist's name are visible. A watermark in the upper edge of the primary support reads: "T GILPIN & CO BRA[NDYWINE]."

Condition: In 1958 Christa Gaehde cleaned parts of the primary support, repaired edge tears, and flattened a vertical crease through the center. In 1974 E. Hollyday dry-cleaned some areas of the surface of the primary support and repaired tears. The replacement 2¾-inch gilded cyma recta frame with stepped inner liner probably dates from the mid–nineteenth century.

Provenance: J. Stuart Halladay and Herrel George Thomas, Sheffield, Mass.

Exhibited: AARFAC, New Canaan; AARFAC, September 15, 1974–July 25, 1976; Artists in Aprons; Halladay-Thomas, New Britain, and exhibition catalog, no. 142; Pine Manor Junior College.

Published: AARFAC, 1974, p. 55, no. 52, illus. on p. 56; Dewhurst, MacDowell, and MacDowell, Artists in Aprons, illus. as fig. 54 on p. 71.

J. Osborne
(active ca. 1832)

157 Wasp and Frolic 64.311.1

J. Osborne
America, 1832
Watercolor and ink on wove paper
10¼" x 13⅝" (26.0 cm. x 34.6 cm.)

Nothing is known about the artist. It is possible that Osborne copied one of many widely circulated prints depicting the famous naval engagement between the *Wasp* and the *Frolic,* but no exact source for the watercolor composition has been identified to date.

The sea battle occurred October 18, 1812, about five days' sail off the coast of Virginia. The American sloop of war *Wasp* was commanded by Captain Jacob Jones, while the British brig *Frolic* fell under the direction of Captain Thomas Whinyates. The *Frolic,* having received much of the *Wasp*'s punishing fire broadside, was forced to surrender in forty-three minutes. The victory was greatly acclaimed by the American public; in his *History of the Navy of the United States of America,* James Fenimore Cooper considered it instru-

mental in destroying the idea of British invincibility on the seas and, thus, in giving an important boost to the young nation's self-confidence.[1]

[1]Cooper's opinion is expressed in Museum of Fine Arts, Boston, *M. and M. Karolik Collection of American Paintings, 1815 to 1865* (Cambridge, Mass., 1949), pp. 111–112, where a fuller account of the engagement is given and a painting of the subject by Thomas Birch is illustrated.

Eunice Pinney
(1770–1849)

See Pinney entry in "Scenes of Everyday Life" for biographical information.

158

158 Valencourt and Emily 58.301.4

Attributed to Eunice Pinney
Connecticut, probably 1805–1825
Watercolor, ink, and pencil on wove paper
12⁵⁄₁₆″ x 10″ (31.3 cm. x 25.4 cm.)

Pinney's meticulous rendering of detail and her careful control of the watercolor medium rank this example among the artist's more polished works. Myriad, finely executed aspects of costume decoration, such as the heroine's flower-embroidered cap and her dress's neck ruffles and sleeve ruches, all contribute to a sense of the exactitude with which Pinney approached her project, while they also create visual interest and heighten the piece's value as a record of clothing styles.

The streaky rendition of the lower left foreground is one of the most successful of several means that Pinney used to depict grasses. She appears to have achieved the effect by stroking a nearly dry brush laden with green over a yellow background wash. A fine, uneven green line running through this foreground section and the separation of levels of drybrush strokes both convey a realistic sense of irregular terrain. Frequently, as in this case, Pinney combined a variety of ground and grass treatments in a single composition.

The watercolor illustrates an incident from Chapter 38 of Ann Radcliffe's Gothic romance titled *The Mysteries of Udolpho.* The book was first published in London in 1794, but it achieved an extraordinary degree of popularity and reappeared in numerous subsequent editions through the nineteenth century and, indeed, into the twentieth. According to Radcliffe's story, Udolpho was a medieval castle in the Apennines, where mysterious dealings with the forces of evil occurred in the seventeeth century. The chief victim of these supernatural powers was an innocent English girl, Emily St. Aubert, depicted here in a fainting slump. Behind her, her noble and courageous lover, the chevalier de Valencourt, attempts to revive her with a glass of water, while to the viewer's right and left, respectively, stand other characters in the story, the count de Villefort and his son, Henri. (Ultimately, Valencourt breaks the spell of Udolpho or, rather, he exposes the fact that its "mysteries" can all be explained in rational terms.)[1] Certainly Pinney derived her studied composition from a printed illustration of the Udolpho incident, but no book plates checked to date have corresponded with the watercolored scene.

Inscriptions/Marks: The block letters in the oval surround read: "Valencourt and Emily soon after her return from the castle of Udolpho./At the sound of his voice she rais'd her eyes but soon closed them and again fainted."

Condition: Treatment by Christa Gaehde in 1958 included cleaning, repairing tears, and backing the primary support with Japanese mulberry paper. Period replacement ¾-inch molded and gilded frame.

Provenance: J. Stuart Halladay and Herrel George Thomas, Sheffield, Mass.

Exhibited: AARFAC, April 22, 1959–December 31, 1961; Halladay-Thomas, Albany, and exhibition catalog, no. 81; Halladay-Thomas, Hudson Park; Halladay-Thomas, New Britain, and exhibition catalog, no. 127; Pine Manor Junior College; Smithsonian, American Primitive Watercolors, and exhibition catalog, p. 9, no. 38; William Penn Museum.

Published: AARFAC, 1959, p. 26, no. 18; Lipman, Pinney, p. 221, no. 44.

[1]The synopsis of the story is taken from William S. Walsh, *Heroes and Heroines of Fiction* (Philadelphia, 1914), p. 366. Identification of the characters is based on pp. 248–249 of an 1824 J. Limbird (London) edition of *The Mysteries of Udolpho.*

tails of the combatants' costumes also mark it as one of Pinney's more painstaking and ambitious efforts.

A print most likely served as the basis for Pinney's composition, although such a source has not yet been identified. The scene illustrates lines 423–451 from Book XX of Homer's *Iliad*, wherein Hector hurls his spear at Achilles, but the weapon is deflected by Athene's breath. The goddess is easily identified by one of her attributes, the owl, which hovers behind her in this watercolor interpretation.

Condition: Unspecified treatment by Christa Gaehde in 1957 included repairing tears and backing the primary support. Probably period replacement 2-inch gilded frame with gadrooned inner and outer borders.

Provenance: J. Stuart Halladay and Herrel George Thomas, Sheffield, Mass.

Exhibited: AARFAC, May 10, 1964–December 31, 1966; Halladay-Thomas, New Britain, and exhibition catalog, no. 138 (titled *Siege of Troy*).

Published: Lipman, Pinney, p. 221, no. 43 (titled *The Storming of Troy*).

159 Hector and Achilles 58.301.9

Attributed to Eunice Pinney
Connecticut, probably 1805–1825
Watercolor on wove paper
16⅛" x 20" (41.0 cm. x 50.8 cm.)

In terms of the size of the primary support and the relative scale of the figures, this is the largest Pinney watercolor recorded to date. The intricacy of the de-

160 Mrs. Clarke, the York Magnet 58.300.8

Eunice Pinney
Connecticut, probably 1821
Watercolor, pencil, ink, cutout engraved collage, and thread on wove paper
9⅞" x 9¹⁵⁄₁₆" (25.1 cm. x 25.2 cm.)

159

MrCLARKE the York MAGNET. See my Dol

Eunice Pinney's drawing, October 4. 1821

160

One presupposes Pinney's reliance upon a print source in composing this curious picture, for several reasons. First, the National Gallery of Art owns an attributed watercolor that is virtually identical to *Mrs. Clarke* in almost every major compositional detail, and its size and square format also compare closely.[1] In addition, a child in an undedicated memorial attributed to Pinney poses in exactly the same stance as the young girl here, suggesting derivation from the same source.[2] Finally, the woman's affected pose and the complexity of the sofa's carving and upholstery incline one to assume a printed visual reference.

What sort of print might Pinney have used then? The question may relate to the subject's identity. There seems little doubt that the artist's marginal title refers to Mary Anne Clarke (1776–1852), who was the mistress of Frederick, duke of York, in the early years of nineteenth-century London. As commander in chief, the duke had considerable patronage at his disposal, and it was widely known that Mrs. Clarke accepted bribes from aspiring military officers in return for promises of favorable influence with his lordship. The arrangement assumed the proportions of public scandal in 1809, when Colonel G. L. Wardle brought charges of abuse of military patronage against the duke in the House of Commons. The charges ultimately were unproven, but the basic issue and the host of corollary claims and countercharges that it spawned provided grist for the political satirists' mills.[3] One such printed satire may have served as Pinney's compositional source, although the twelve-year time lapse between the height of the affair and the date of the watercolor is problematic;[4] but whether Pinney relied upon a satire for her composition or not, certainly the shrewd, tongue-in-cheek description of Mrs. Clarke as a "York magnet" harks back to such an origin.

Another possibility is that Pinney derived her composition from a print unrelated to Mrs. Clarke and linked the amusing title with it on a whim;[5] the Grecian sofa in the assumed print may have recalled the Clarke scandal to her mind (see note 3). Prints of young matrons dandling children on Greek-style furniture abounded in the early nineteenth century; for instance, similar idealized domestic scenes created by Adam Buck were extremely popular in England and America, particularly in the form of decorations for transfer-printed ceramic tea services.[6]

A very different aspect of Pinney's inventive assim-

ilation of printed source material is illustrated by the circular scene in the upper left corner of *Mrs. Clarke*. Obviously intended to represent a picture hanging on the wall, the charming illustration of figures in a garden is actually part of a larger, engraved reward of merit. An uncut specimen of the printed reward shows four decorative scenes in the upper margin, each depicting figures engaged in activities appropriate to the seasons inscribed on a banner above them.[7] The engraved scene used in *Mrs. Clarke* illustrated "Spring" in its original context. Interestingly, "Winter" from the same reward was used in a similar manner in another Pinney watercolor, one depicting a scene from Goethe's *Sorrows of Werther*.[8]

Originally, the black wall behind Mrs. Clarke was painted light blue, the present color of the upholstery, and a window with foliage visible through it was painted adjacent to the door frame. Pinney altered these features by pasting a separate piece of paper over the window, first cutting it around Mrs. Clarke's contours, then covering the entire rear wall with ink. Perhaps she felt that the central foliage distracted attention from Mrs. Clarke and that the pale, white-dressed figure needed a stronger contrast than the initial light blue background offered.

Inscriptions/Marks: A post horn watermark appears in the primary support. Below the figure, to the right of center, appears the recto ink inscription: "Eunice Pinneys drawing October 4 1821." Below this, on a separate piece of wove paper basted to the first with thread, is the additional recto ink inscription: "Mʳˢ CLARKE the York MAGNET. See my Dol/Eunice Pinneys drawing, October 4, 1821."

Condition: Restoration by Christa Gaehde in 1958 included removing stains in the lower margin and backing with Japanese mulberry paper. In 1974 E. Hollyday reduced acidity, staining, buckling, and creasing. Period replacement 1-inch silver-leafed cyma recta frame.

Provenance: J. Stuart Halladay and Herrel George Thomas, Sheffield, Mass.

Exhibited: Halladay-Thomas, Albany, and exhibition catalog, no. 83 (titled *The York Magnet* and dated 1805); Halladay-Thomas, Hudson Park; Halladay-Thomas, New Britain, and exhibition catalog, no. 122 (titled *The York Magnet* and dated 1801 [believed to be a typographical error for 1810]); Halladay-Thomas, Syracuse, and exhibition catalog, no. 65 (titled *The York Magnet* and dated 1810); Pine Manor Junior College; Pollock Galleries; "Women Artists of America, 1707–1964," Newark Museum, April 2–May 16, 1965, and exhibition catalog, p. 26, illus. on p. 29.

Published: Robert Bishop, *Centuries and Styles of the American Chair, 1640–1970* (New York, 1972), illus. as fig. 475 on p. 296; Black and Lipman, illus. as fig. 103 on p. 120; Lipman, Pinney, p. 220, no. 8; Karen Petersen and J. J. Wilson, *Women Artists: Recognition and Reappraisal from the Early Middle Ages to the Twentieth Century* (New York, 1976), illus. as fig. V, 17 on p. 72.

[1]The National Gallery of Art's watercolor measures 9¾″ x 9¾″ and is titled *Forlorn*. Its major compositional deviation lies in the fact that the sofa on which the adult subject reclines has been truncated to a chair form.

[2]The child in the memorial holds an adult's hand in her extended one, not a doll, but the posture is the same. She holds twigs or branches in the folds of her gathered apron, just as the girl here

holds grasses or straw in hers, possibly copied identically from the original print. The memorial is in the collection of the New York State Historical Association, Cooperstown, N.Y.

[3]Interestingly, as a result of one of these corollary actions, that of an upholsterer against Wardle, Mrs. Clarke's extravagant furnishings were discussed in court with some thoroughness, and specific items were singled out for scrutiny, among them two "Grecian sofas." The sofa in no. 160 would have been described just so and is, in fact, similar to several pictured in known engraved satires of Mrs. Clarke. Illustrating the popularity of the affair as a subject for satire is the fact that, in 1947, the British Museum owned 121 printed satires dealing with Mary Anne Clarke published in 1809 alone (she was, of course, caricatured in preceding and subsequent years as well, although in lesser numbers). See Mary Dorothy George, *Catalogue of Political and Personal Satires Preserved in the Department of Prints and Drawings in the British Museum*, VIII (London, 1947), p. 998.

[4]See also note 8 below, which describes a link between *Mrs. Clarke* and another Pinney watercolor dated 1810, a date that makes more sense than 1821 in terms of the subject matter of the Folk Art Center's watercolor. Yet the *Clarke* inscriptions appear consistent with an example of Pinney's hand recorded in the 1820s, and there is no present reason to doubt their authenticity. If *Mrs. Clarke* dates from ca. 1810 rather than 1821, a rationale for adding the later inscriptions remains unknown.

[5]See *Inscriptions/Marks*. The fact that the lower margin consists of a separate piece of paper basted to the larger sheet with thread reinforces the title's identification as an afterthought, as does the redundancy of the two name and date inscriptions.

[6]For ceramic prints after and in the style of Adam Buck, see for instance J. Jefferson Miller II, *English Yellow-glazed Earthenware* (London, 1974), pp. 36, 64, 75, 84–85; and Geoffrey A. Godden, *British Porcelain: An Illustrated Guide* (London, 1974), pp. 163, 339–340.

[7]A complete reward of merit is owned by the American Antiquarian Society, Worcester, Mass., and was brought to the attention of AAR-FAC staff through the kind assistance of Georgia B. Bumgardner, Curator of Graphic Arts at that institution. Abner Reed has been suggested as the reward's possible engraver. Georgia B. Bumgardner to AARFAC, April 25, 1974.

[8]However, in her *Lolotte et Werther*, Pinney retained the printed, inscribed banner appearing above the pictorial scene in assimilating the collage element, and she also added the convincing touch of a watercolor painted "frame" around the engraved cutout. *Lolotte et Werther* is dated 1810, and it is in the collection of the National Gallery of Art, the gift of Edgar William and Bernice Chrysler Garbisch.

Reuben Law Reed
(1841–1921)

Reuben Law Reed was born in Acton Center, Massachusetts, April 26, 1841, the son of William Reed and Anna Gleason Reed. His ancestors had fought at the battles of Lexington and Bunker Hill, and he is said to have had "an ardent and life-long interest in historical matters."[1] When he died in South Acton January 22, 1921, he was a member of the Bunker Hill Historical Association, the Sons of the American Revolution, and the Reed Genealogical Society. He was a granite

161

worker early in life, and he was instrumental in having markers placed on the hitherto undesignated graves of fallen local soldiers.

Later in life, Reed was a housepainter by trade, and he painted pictures as a pastime. In addition to the Folk Art Center's example, at least one other picture of his was known to family descendants in 1946, but its subject matter is unknown.

[1]All information is from the artist's grandson Paul J. Reed to AAR-FAC, July 20, 1946.

161 Washington and Lafayette at the Battle of Yorktown

31.101.1

Reuben Law Reed
Acton, Massachusetts, probably 1860–1880
Oil and gold paint on cotton twill canvas
22¼″ x 33⅞″ (56.5 cm. x 86.0 cm.)

Reed's colorful painting shows the American and French generals surveying the progress of the land seg-

ment of the single most decisive engagement of the American Revolution. The battle of Yorktown culminated in Cornwallis's surrender October 18, 1781, and peace negotiations between Britain and America commenced months later.

The artist's grandson recalled that this painting hung over the sofa in the living room of his grandparents' house in South Acton, Massachusetts, and was well known to many townspeople as well as to the artist's immediate family. It was sold out of Reed hands only after the artist's death in 1921. Modern-day family members believe the painting was executed when Reed was young, "probably some time between 1860 and 1880," and further, that it "was painted from a description of the Battle of Yorktown given by an eyewitness, who it is said congratulated him later on the likeness."[1]

Condition: In 1954 Russell J. Quandt cleaned the painting, inserted adhesive beneath paint cleavage where practical, lined the canvas, and inpainted scattered areas of paint loss, most notably in the white horse's tail, along the lower stretcher line, in the grass in the lower right corner, in the tree in the upper left corner, and in the background in front of Washington's face. The original frame was

replaced by a 1⅞-inch, black-painted cyma recta molded frame with applied gold beading that possibly dates to the second half of the nineteenth century.

Provenance: Reuben Law Reed, South Acton, Mass.; William R. Pecord, probably Harvard, Mass.; Fridenberg Galleries, New York, N.Y.; Helen Hackett; Edith Gregor Halpert, Downtown Gallery, New York, N.Y.

Exhibited: AARFAC, April 22, 1959–December 31, 1961; AARFAC, September 15, 1974–July 25, 1976; "American Art, Four Exhibitions," Brussels Universal and International Exhibition, April 17–October 18, 1958, and exhibition catalog, p. 49, no. 95; American Folk Art, Traveling; "Parade of Patriots," Grand Central Art Galleries, New York, N.Y., May 21–June 5, 1942, and exhibition catalog (unpaginated and unnumbered, titled *Washington and Lafayette at the Battle of Brandywine*); William Penn Museum.

Published: AARFAC, 1940, p. 20, no. 34, illus. on p. 20 (titled *Washington and Lafayette at the Battle of Brandywine*); AARFAC, 1947, p. 16, no. 34, illus. on p. 11; AARFAC, 1957, p. 86, no. 45, illus. on p. 87; AARFAC, 1959, p. 44, no. 48, illus. on p. 45; AARFAC, 1974, p. 59, no. 59, illus. on front cover; Cahill, American Folk Art, p. 31, no. 18, illus. on p. 64 (titled *Washington and Lafayette at the Battle of Brandywine*); Cogar, illus. on p. 182; *Early American Life*, VII (February 1976), illus. on front cover; Cyril Falls, ed., *Great Military Battles* (London, 1969), p. 109, illus. on p. 108; *Gazette of the American Friends of Lafayette*, XXXIV (May 1970), illus. on p. 2; "George Washington in 19th-Century Popular Art," *American History Illustrated*, XV (August 1980), p. 35; Michael Kammen, *A Season of Youth: The American Revolution and the Historical Imagination* (New York, 1978), pp. 85–86, illus. as fig. 12 on unnumbered p.; "Nineteenth-Century Americana," *Newsweek*, XLIX (February 25, 1957), illus. on p. 109.

[1] All information is from the artist's grandson Paul J. Reed to AARFAC, July 20, 1946.

J. Taylor
(active ca. 1851)

162 The Peter Francisco Incident 58.101.1

J. Taylor
America, probably 1851
Oil on canvas
27⅜" x 36¼" (69.5 cm. x 92.1 cm.)

J. Taylor's colorful painting is a close copy of a combination etching and engraving published December 1, 1814, by James Webster of Philadelphia. The painting extends the printed composition at bottom and left, places a bust-length portrait of Washington (found in the lower margin of the print) in the pictorial area proper, and alters a few minor aspects of the depiction, but major elements remain the same.[1] Unfortunately, nothing is known of the painter beyond his signature found here. A similar oil—signed G. Pierson—has been recorded.[2]

The event portrayed occurred in 1781 and is detailed in a number of sources. One of the earliest is an article in the *Richmond Enquirer* for February 23,

1813, in which James Webster and James Warrell propose "publishing by subscription a print representing Peter Francisco's gallant action with nine of Tarleton's Cavalry, in sight of the whole troop of 400 men, from an original picture by James Warrell, . . . —From the details given by Francisco himself." Another is given in Francisco's petition to Congress dated February 28, 1828.[3]

Peter Francisco (ca. 1760–1831) was the adopted son of Judge Anthony Winston of Buckingham County, Virginia, having been kidnapped from an unidentified foreign country, possibly Portugal, at age five or so, brought to City Point (now Hopewell), Virginia, and abandoned on the docks there. As an adult, his patriotism, large size, and great physical strength made him a legendary figure of the Revolution. He participated in numerous military engagements before and after being held by nine British dragoons, who chanced upon him as he rested alone at Benjamin Ward's tavern in Amelia (now Nottoway) County. Francisco killed or wounded several of his captors. By shouting to comrades-in-arms he pretended were nearby and urging them to attack, he frightened off the other redcoats, even though by then their main troop of about four hundred men under Lieutenant Colonel Banastre Tarleton had ridden into sight. In the resulting confusion, Francisco escaped with only a bullet graze along his side.[4]

Inscriptions/Marks: Painted in the lower right corner is lettering that appears to read: "J. Taylor painter 1851." The initial, the first and last three letters of the surname, and the third digit of the date are quite difficult to read and should remain open to reinterpretation.

Condition: Linen patches were applied to the reverse and the painting was touched up by an unidentified conservator prior to acquisition. In 1960 Russell J. Quandt replaced the original stretchers, cleaned and lined the canvas, removed old surface coatings and the former conservator's repaints, and filled and inpainted minor scattered areas of paint loss, most notably in the center tree and in the sky to the right of that tree.[5] Modern replacement 2½-inch molded black-painted cyma reversa frame with a gilt liner.

Provenance: Old Print Shop, New York, N.Y.

Exhibited: "American Painters of the South," Corcoran Gallery of Art, Washington, D.C., April 23–June 5, 1960, and exhibition catalog, p. 36, no. 112.

Published: Kathleen Halverson Hadfield, ed., *Historical Notes on Amelia County, Virginia* (Amelia, Va., 1982), illus. on p. 33; Mervyn Williamson, "Washington's One-Man Regiment," *The Iron Worker*, XXXVI (Autumn 1972), illus. on front cover.

[1] AARFAC owns an impression of the print (acc. no. 58.1100.2). It is marked "Design'd by Warrell[,] Drawn by Barralett [and] Engraved by D. Edwin." A smaller print, differing in very minor aspects of the composition and "respectfully inscribed by James Webster and Ja' Warrell" is known; see entry no. 100 and cover illus. of *Bookworm and Silverfish*, cat. no. 22 from book dealer Jim Presgraves of Wytheville, Va.

[2] However, the location of this painting is unknown. It appears to have belonged to M. Knoedler & Co., of New York City, when it was reproduced whole in James R. V. Daniel, "The Giant of Vir-

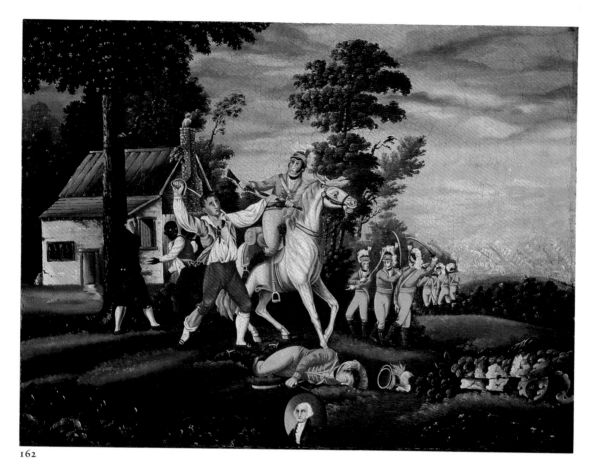

162

163

The Lady of the Lake

E. A. Waters. 1848.

ginia," *Virginia Cavalcade,* I (Autumn 1951), p. 36; it was reproduced with the lower inscription cropped (and was miscredited to the Folk Art Center) in Richard M. Ketchum et al., *The American Heritage Book of the Revolution* (New York, 1958), p. 341.

[3]The *Richmond Enquirer* account appears in Marion McCain Horsley, "Art in Richmond, Virginia, 1800–1860" (M.A. thesis, University of Virginia, 1974), pp. 84–86. AARFAC files contain a photocopy of a copy of Francisco's petition to Congress.

[4]Among the many sources of biographical information on Francisco are Nannie Francisco Porter and Catherine F. Albertson, *The Romantic Record of Peter Francisco, "A Revolutionary Soldier"* (Staunton, Va., 1929); and Henry Howe, *Historical Collections of Virginia* (Charleston, S.C., 1845), pp. 207–209.

[5]In the course of conservation, Quandt discovered that the artist's original composition included a turreted castle in the far distance on the right side. At a later date, the artist apparently covered this detail and introduced the troop of Tarleton's cavalry. AARFAC files contain a Quandt photograph showing some of the overpaint removed to reveal the castle. The area was re-covered with new paint after photography.

E. A. Waters
(active ca. 1843)

163 The Lady of the Lake 79.301.3

E. A. Waters
America, 1843
Watercolor on wove paper
10⅛″ x 14″ (25.7 cm. x 35.6 cm.)

E. A. Waters's simple watercolor depicts the meeting of James Fitz-James, the knight incognito, and fair Ellen, daughter of the banished Douglas, on the shore of Scotland's Loch Katrine. *The Lady of the Lake,* a long poem by Sir Walter Scott (1771–1832), achieved great popularity during the rise of Romanticism in literature in the first half of the nineteenth century. An illustration from one of the many available editions of Scott's poem undoubtedly was the source of E. A. Waters's picture. The simplicity of this amateur work imparts a charming directness to the watercolor.

Information about E. A. Waters has not been located.

Inscriptions/Marks: In penciled script at the center of the lower margin is "The Lady of the Lake." Also penciled in script and placed below the lower right corner of the image is "E. A. Waters. 1843."

Condition: The surface and verso of the primary support were dry-cleaned by E. Hollyday in 1982; at the same time, the picture was backed with Japanese mulberry paper for additional support. Probably original 1½-inch molded silver-leafed frame.

Provenance: Isabel Carleton Wilde, Cambridge, Mass.; acquired from John Becker, New York, N.Y., November 28, 1932, and used at Bassett Hall, the Williamsburg home of Mr. and Mrs. John D. Rockefeller, Jr.

Exhibited: American Primitives; "Exhibition of American Folk Painting in Connection with the Massachusetts Tercentenary Cele-

bration," Harvard Society for Contemporary Art, Cambridge, Mass., October 15–31, 1930, and exhibition catalog, no. 97; Wilde, and exhibition catalog, no. 56.

Published: American Primitives, p. 76; Ford, Pictorial Folk Art, p. 129.

Unidentified Artists

164 Liberty 58.401.1

Artist unidentified
America, probably 1800–1830
Paint on velvet
21½″ x 16¾″ (54.6 cm. x 41.6 cm.)

The widespread popularity of Edward Savage's now-unlocated oil painting *Liberty — In the form of the Goddess of Youth; giving Support to the Bald Eagle* and his engraving after it, published by him in Philadelphia June 11, 1796, can be illustrated by the existence of numerous close copies of the composition and by a number of other depictions that are more loosely related in compositional terms but that nevertheless owe an inspirational debt to Savage. In addition to the Folk Art Center's work on velvet, other relatively close copies noted to date include an oil on canvas, six paintings on glass, a painting on silk, two watercolors on paper, five paintings on velvet, and seven needlework pictures.[1]

In addition to copying Savage's primary allegorical figures of Liberty and the eagle, the Center's unidentified painter on velvet retained other symbols of his as well: a liberty cap atop the pole of the new nation's flag; a broken scepter on the ground at right; and under the maiden's right foot, the key of the Bastille close beside a star or sunburst decoration (here more reminiscent of a flower) on a trailing sash or ribbon. The intended meaning of the star or sunburst remains speculative since Savage failed to mention it in his notes regarding the composition in an 1802 exhibition catalog. However, he does tell us there that the distant townscape is "Boston harbor representing the Evacuation of the British fleet" and that "the Goddess of Liberty is supposed to be on Beacon-hill."[2]

The Center's painting appears to have been created with the aid of stencils. The lines of the maiden's footwear suggest sandals, but in apparent misunderstanding of this, the artist covered the figure's feet with bright-blue paint.

Condition: In 1974 E. Hollyday removed adhesive and a sheet of corrugated cardboard from the reverse of the velvet, stitched the

164

dess," *Antiques*, XXVI (October 1934), p. 151; Betty Ring, "School-girl Embroideries: A Credit to the Teachers," *Worcester Art Museum Journal*, V (1981–1982), p. 25, fig. 8; and Sotheby Parke Bernet, Inc., *The Theodore H. Kapnek Collection of American Samplers*, catalog for sale no. 4531Y, January 31, 1981, lot no. 35.

The painting on silk based on Savage appears in Sotheby Parke Bernet, Inc., *Americana*, catalog for sale no. 3596, January 24–26, 1974, lot no. 553.

The oil on canvas based on Savage appears in Eileen P. Birk, "Current and Coming," *Antiques*, XCV (March 1969), p. 338.

²See Jones for a discussion of Savage's composition and derivations thereof, as well as Savage's partial quote.

165 Charlotte Weeping over Werter's Tomb

63.301.1

Artist unidentified
America, probably 1807–1825
Watercolor and ink on wove paper
13″ x 16¹⁄₁₆″ (33.0 cm. x 40.8 cm.)

The enormous popularity of *The Sorrows of Werther* by Johann Wolfgang von Goethe (1749–1832) is indicated by the many late-eighteenth- and early nineteenth-century watercolors and embroideries illustrating incidents from the romantic novel, first published in Leipzig in 1774. Driven to distraction by his love for the married Charlotte, Werther kills himself at the end of Goethe's story. The watercolor shows Charlotte mourning at his graveside.

The right-hand portion of the Folk Art Center's watercolor compares closely with the engraved frontispiece to an edition of the book translated by "Dr. Pratt," published by Richard Scott, and printed by McFarlane & Long, New York City, in 1807.[1] The banded grave, the kneeling woman with a hand to her heart, the Gothic church in the background, and the shouldered-arch tombstone with a branching evergreen tree behind it are all very similar in both renderings. However, the engraved frontispiece terminates at left just behind the heroine's foot, whereas the Center's picture and at least three other watercolor versions all include an extended landscape occupying one-third to one-half of the left-hand side of the completed composition. The four watercolors also show an angel hovering over Charlotte's head, and none is included in the engraved scene. These divergences suggest that the recorded watercolors all derive from a still-unlocated print source, one that remains unidentified but that is close to the 1807 engraved frontispiece in its major compositional aspects.[2]

Inscriptions/Marks: In ink in script in the lower margin is "Charlotte Weeping over Werter's Tomb."
Condition: Unspecified treatment by an unidentified conservator, probably Christa Gaehde, included mending several edge tears.

velvet to muslin, and stretched same over rag board. In some places, ⅛ to ½ inch of the painted surface has been turned over the edges of the present backing. Probably period replacement 2-inch gilded cyma recta frame.
Provenance: J. Stuart Halladay and Herrel George Thomas, Sheffield, Mass.
Exhibited: AARFAC, September 15, 1974–July 25, 1976; "The Eye of the Law," University Museums, University of Mississippi, University, Miss., October 2–December 4, 1978, and exhibition catalog, p. 36, no. 3, illus. as fig. 2 on p. 20; Halladay-Thomas, New Britain, and exhibition catalog, no. 71.

¹An illustration of Savage's engraving appears in Homer Eaton Keyes, "Liberty in the Chinese Taste," *Antiques*, XX (November 1931), p. 298.

For paintings on velvet based on Savage, see Sotheby Parke Bernet, Garbisch II, lot no. 187; Sotheby Parke Bernet, Halpert, lot no. 228; Jones, p. 42, figs. 8, 9; and Mary James Leach, "From Kentucky's Collectors," *Antiques*, LII (November 1947), p. 352.

For glass paintings based on Savage, see *Antiques*, XCIX (February 1971), front cover and p. 237; Jones, p. 41, fig. 4; Homer Eaton Keyes, "Liberty in the Chinese Taste," *Antiques*, XX (November 1931), p. 298; and "More Liberty and a Little Hebe," *Antiques*, XXI (June 1932), p. 258. Jones, p. 41, also mentions in text that two additional such paintings are in the collection of the Metropolitan Museum of Art.

For watercolors on paper based on Savage, see "More Liberty and a Little Hebe," *Antiques*, XXI (June 1932), p. 259; and Robert W. Skinner, Inc., *Fine Americana*, catalog for sale no. 928, October 28, 1983, lot no. 254.

For needlework pictures based on Savage, see the catalog for Christie's sale of April 11, 1981, lot no. 324; Eleanor H. Gustafson, "Museum Accessions," *Antiques*, CXXVII (January 1985), p. 136; Jones, p. 42, figs. 6, 7; "Random Observations: A Persistent God-

Charlotte Weeping over Werter's Tomb

165

In 1981 E. Hollyday dry-cleaned unpainted areas; cleaned, re-aligned, and remended the edge tears; and backed the primary support with Japanese mulberry paper. Period replacement 1³⁄₁₆-inch cyma recta frame, painted black, with gold-painted flat outer edge.

 Provenance: Old Print Shop, New York, N.Y.

 Published: Rumford, Memorial Watercolors, p. 688, illus. pl. I on p. 690.

¹A copy of the book is in the collection of the American Antiquarian Society, Worcester, Mass.

²One of the other watercolors was sold at auction and is illustrated in Sotheby Parke Bernet, Inc., *Fine Americana*, catalog for sale no. 4211, January 31–February 3, 1979, lot no. 717; it is inscribed on the reverse: "Cordelia Hale." Another watercolor appeared in Halpert Folk Art Collection, lot no. K293, but its present location is unknown. The third watercolor is owned by the Corning Museum of Glass, Corning, N.Y.

166 George Washington and His Family
79.301.9

Artist unidentified
America, ca. 1810
Watercolor and pencil on wove paper
21³⁄₄″ x 30¹⁄₄″ (55.3 cm. x 76.8 cm.)

An amateur artist produced this watercolor inspired by a widely distributed engraving titled *The Washing-*

ton Family that was drawn and engraved by Edward Savage.¹ The unidentified artist's placement of highlights and shadows in an effort to achieve contoured forms created a composition that is livelier and less somber than the printed source. Details of the print were faithfully copied, but the transfixed stares on the faces and carefully drawn hairstyles are departures that give this picture its own distinctive character.

 Abby Aldrich Rockefeller also acquired an embroidered picture based on the same print source (see no. 167); both pictures, and a nineteenth-century lithograph of the same subject, still hang in close proximity at Bassett Hall, the Williamsburg home of the Rockefeller family.

 Condition: In 1982 E. Hollyday removed wooden spacing strips, repaired marginal tears, cleaned the surface of the primary support, filled in small scattered losses with pastels, and mounted the primary support on a nonacidic backing with hinges of Japanese mulberry paper. Probably original 2¹⁄₂-inch molded and regilded frame with applied rope twist plaster decoration at center.

 Provenance: Acquired from Edith Gregor Halpert, Downtown Gallery, New York, N.Y., in November 1936 for use at Bassett Hall, the Williamsburg home of Mr. and Mrs. John D. Rockefeller, Jr.

¹*The Washington Family* was based on a painting also by Edward Savage (1761–1817); the stipple engraving was published by Savage and Robert Wilkinson in London on March 10, 1798.

167 George Washington and His Family

79.601.7

Artist unidentified
Probably New England, ca. 1810
Silk embroidery and watercolor on silk
20¾″ x 20″ (52.7 cm. x 50.8 cm.)

The design source for this embroidery was a popular print titled *The Washington Family*, engraved after the well-known oil painting by Edward Savage (1761–1817) and published by the artist and Robert Wilkinson in London on March 10, 1798. While the original stipple engraving has a horizontal format, the unidentified artist for no. 167 tightened the composition to create an almost square picture. The floor in the print appears to be marble squares, but the needle-

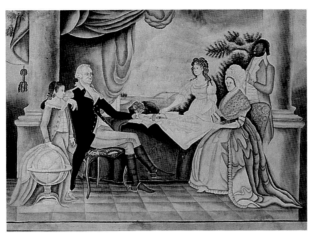

166

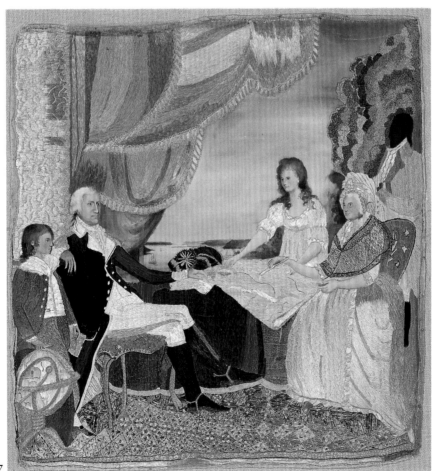

167

worker substituted an intricately patterned carpet, as did Jane Thompson Reynolds of Boston in another picture of the subject dated 1807 and Mary Follansbee of Newburyport, Massachusetts, in an 1812 embroidery.[1]

Condition: The primary support and a linen secondary support were mounted on a nonacidic backing, and surface dirt was removed by E. Hollyday in 1982. Modern replacement 3-inch molded and gilded frame.
 Provenance: Found in Roxbury, Mass.; acquired from Katrina Kipper, Accord, Mass., in November 1936, for use at Bassett Hall, the Williamsburg home of Mr. and Mrs. John D. Rockefeller, Jr.
 Published: Rumford, Bassett Hall, illus. as fig. 8 on p. 59; and Ring, Needlework, illus. as pl. VIII on p. 479.

[1]*The Washington Family* by Jane Thompson Reynolds (1791–1864) is in a private collection and is illustrated in Deutsch and Ring as pl. II on p. 404. Mary Follansbee's picture is in a private collection also and is illustrated in Sotheby Parke Bernet, Garbisch II, as lot no. 14, p. 7. Compare no. 166 for a watercolor derived from the same print source.

168

168 Miss Liberty 35.301.4

Artist unidentified
America, possibly New Jersey, probably 1810–1820
Watercolor and ink on wove paper with pinpricking
10 1/16" x 8 1/16" (25.6 cm. x 20.5 cm.)

Interesting details of this small watercolor include the figure's clocked stockings and a dress that is delicately and imaginatively pinpricked. Pricking from the front outlines the dress and its blue sash and forms part of two cords hanging at the figure's side next to her flag and liberty poles. Pricking from the reverse creates other details of the dress, including a scalloped design at the hemline, a ruffled collar, and an overall sprig pattern.

 A number of scholars have published research on the symbolism and evolution of the personification of America, as well as of liberty, peace, independence, plenty, victory, and other concepts associated with the country in the early years of her nationhood.[1] Although no precise, direct compositional source for *Miss Liberty* has been identified to date, the similarity between the figure's stance, garb, and attributes and those of numerous other images, both printed and freehand, is obvious.[2] Thus, while some details of this composition may well have derived from the artist's imagination, it seems likely that an existing print, drawing, or painting served as a source of inspiration and provided guidelines for other features.

Inscriptions/Marks: On the front in ink in script in the bottom portion of the composition to either side of the figure are "Liberty and/Independence" and "Ever Glorious/Memory." In ink or watercolor in block letters beneath the preceding is "UNITED STATES AMERICA 1776." In ink or watercolor in the lower right corner is the single letter *F.*
 Condition: Unspecified treatment by an unidentified conservator (probably Christa Gaehde) between 1953 and 1959 included the removal or reduction of sizable stains near the center of the upper edge and in the background above the palm branch and of smaller stains scattered elsewhere, notably in the figure's skirt. Treatment by E. Hollyday in 1975 included dry-cleaning unpainted areas, backing several edge tears with Japanese mulberry paper, and filling a small loss in the right edge below center. Possibly original 15/16-inch pine frame with an applied cyma recta molded mahogany face.
 Provenance: Found in New Jersey and purchased from Edith Gregor Halpert, Downtown Gallery, New York, N.Y.
 Exhibited: AARFAC, April 22, 1959–December 31, 1961; William Penn Museum.
 Published: AARFAC, 1940, no. 78, p. 27; AARFAC, 1947, no. 78, p. 25; AARFAC, 1957, no. 100, p. 196, illus. on p. 197; AARFAC, 1959, no. 12, p. 22; Black and Lipman, p. 160, illus. as fig. 150 on p. 166; Grace Rogers Cooper, *Thirteen-Star Flags: Keys to Identification* (Washington, D.C., 1973), pp. 7, 9, illus. as fig. 6 on p. 7; Jones, p. 42, illus. as fig. 13 on p. 43; Michael Kammen, *A Season of Youth: The American Revolution and the Historical Imagination* (New York, 1978), p. 96, illus. as fig. 19 on unnumbered p.

[1]Two of the most relevant of these are Jones; and E. McClung Fleming, "From Indian Princess to Greek Goddess: The American Image, 1783–1815," *Winterthur Portfolio,* III (1967), pp. 37–66. See Fleming especially for insights regarding the difficulty of precise

identification of personifications because of the swapping and sharing of attributes among figures.

[2]One composition that is notably similar in terms of the design of the flag and its billowing shape and the position of the flag and liberty poles is *Emblem of Peace*, illus. on p. 38 of *Antiques*, LXXIV (July 1958). A watercolor on silk in the Van Alstyne Collection appears to show a similar air-filled flag; see Peter C. Welsh, *American Folk Art: The Art and Spirit of a People from the Eleanor and Mabel Van Alstyne Collection* (Washington, D.C., 1965), no. 88, illus. as fig. 49.

169 Contemplation 31.101.4

Artist unidentified
Probably vicinity of Boston, Massachusetts, probably 1810–1825
Oil on heavy paper glued to plywood panel of Douglas fir
15″ x 21⅛″ (38.1 cm. x 53.7 cm.)

Maria and Sylvio are the subjects of this composition, as they are of no. 173, where a more complete accounting is given of their history and derivation. The young woman and her pet dog appear briefly in *A Sentimental Journey through France and Italy*, a romantic novel by Laurence Sterne (1713–1768) that was first published in 1768. According to the popular story, Maria's despondency over a thwarted love affair resulted in the loss of her senses, whereafter she wandered purposelessly through the countryside playing airs on a pipe and accompanied by Sylvio, the successor to an unfaithful pet goat.

In close agreement with a written description of her provided by Sterne's character Mr. Yorick, the unidentified artist of this oil painting has rendered Maria dressed in white, with loose hair, and with her pipe suspended from one shoulder by a pale green ribbon ending at the waist. At far left, a carriage is barely distinguishable from the townscape of Moulins; it can be identified as Yorick's vehicle, a familiar feature of many Maria illustrations.

Tiny raised dots of paint outline Maria's body here. These may have served as or resulted from a guide used by the artist in transcribing the figure from a pictorial source, possibly an engraving by Robert Sayer or some other print based on Sayer.[1]

Condition: The painting was revarnished at some point prior to acquistion. The 2¼-inch splayed frame is grain-painted with a flat, black-painted outer edge; it is a replacement that probably dates to ca. 1840.
Provenance: Found in Boston, Mass., and purchased from Edith Gregor Halpert, Downtown Gallery, New York, N.Y.
Exhibited: American Folk Art, Traveling.
Published: AARFAC, 1957, p. 76, no. 40, illus. on p. 77; Cahill, *American Folk Art*, p. 34, no. 29.

[1]See no. 173 and especially notes 2 and 3 of same.

169

170

170 Illustrious Chief of Troy 59.301.2

Artist unidentified
America, probably 1810–1825
Watercolor and ink on wove paper
16⅝" x 21¾" (42.2 cm. x 55.3 cm.)

The man's colorful costume is emphasized by the pale garb of the other figures and the grisaille rendering of the architectural backdrop.

The inscription in the lower margin represents Alexander Pope's translation of Homer's *Iliad,* Book VI, lines 594–599, and the pictorial composition of the four figures is based closely on the frontispiece to *The Works of Alexander Pope,* VII (Boston, 1808), an engraving signed by William S. Leney and published by W. Durrell, New York.[1] Several embroidered pictures whose figures were based on the same source have been recorded.[2]

The transcribed lines of the *Iliad* recount a brief respite from battle enjoyed by the Trojan leader, Hector. His wife, Andromache, stands close by his side, while the soldier's advance frightens the couple's infant son, Astyanax, who clings to his nurse's neck.

Inscriptions/Marks: In ink in script in the lower margin is "Thus having spoke, the illustrious chief of Troy/Stretch'd his fond arms to clasp the lovely boy/The babe clung crying to his nurse's breast/Scar'd at the dazzling helm, and nodding crest/With secret pleasure each fond parent smil'd/And Hector hasted to releive [*sic*] his child."
Condition: In 1958 Christa Gaehde cleaned unpainted areas of the primary support, repaired tears, and mounted the piece on Jap-

anese mulberry paper. Possibly original 1⁷⁄₁₆-inch flat frame, painted black with gold stenciled decoration, and a brass hanging ring at center top.
Provenance: Robert Carlen, Philadelphia, Pa.
Exhibited: Pine Manor Junior College; Smithsonian, American Primitive Watercolors, and exhibition catalog, p. 7, no. 28, illus. on p. 15.

[1] An imprint of the volume is in the collection of the American Antiquarian Society, Worcester, Mass.
[2] One of these was executed by Sally Wheeler of Lynn, Mass., before 1815; it belongs to Old Sturbridge Village and was illustrated in Jane C. Nylander, "Some Print Sources of New England Schoolgirl Art," *Antiques,* CX (August 1976), p. 297, fig. 8. Another was executed by Martha Bowers Merwin of Middletown, Conn.; it was illustrated as lot no. 370 in Sotheby Parke Bernet, Inc., *Important American Furniture, Folk Art, Silver, Chinese Export Porcelain and Rugs,* catalog for sale no. 5282, January 31–February 2, 1985. Another was illustrated as lot no. 110 in Sotheby Parke Bernet, Garbisch I. Another was illustrated, and a fifth mentioned, in Ring, Virtue, p. 199.

171 The Lady of the Lake 32.301.2

Artist unidentified
America, probably 1811–1825
Watercolor on wove paper
13⅜" x 13⁹⁄₁₆" (34.0 cm. x 34.5 cm.)

See no. 163 for background information and for a different interpretation of the same moment from *The Lady of the Lake,* a romantic poem by Sir Walter Scott (1771–1832). Numerous nineteenth-century compositions illustrating the poem are known. Some of them, such as the watercolor shown here, appear to have

171

been based upon David Edwin's engraving after G. Fairman, an image that served as the frontispiece to several editions of the poem. The Edwin engraving illustrates a passage describing the meeting of fair Ellen and James Fitz-James in stanza XX, canto I: "Then safe tho fluttered and amazed,/She paused and on the Stranger gazed."[1] However, in keeping with the description of her given in stanza XVIII, canto I, this watercolor and several other similarly composed pictures show Ellen dressed in plaid,[2] unlike the Edwin engraving, which depicts her draped in plain fabrics.

Inscriptions/Marks: A watermark in the right edge of the primary support reads: "J WHATMAN/1808."
Condition: In 1955 Christa Gaehde cleaned the sheet and removed a secondary support. In 1981 E. Hollyday dry-cleaned unpainted areas, set down flaking paint, repaired brad holes in the edges, and backed the primary support with Japanese mulberry paper. Period replacement 1¹⁄₁₆-inch gilded and molded cyma recta frame.
Provenance: Isabel Carleton Wilde, Cambridge, Mass.; John Becker, New York, N.Y.
Exhibited: Wilde, and exhibition catalog, no. 67.
Published: AARFAC, 1940, p. 27, no. 80; AARFAC, 1947, p. 25, no. 80; AARFAC, 1957, p. 362, no. 267; Ford, *Pictorial Folk Art,* illus. on p. 128.

[1]AARFAC files contain a photograph of the frontispiece to a volume published by P. H. Nicklin of Baltimore and printed in 1811 by Ezra Sargent of New York City and by Joseph Cushing of Baltimore; the American Antiquarian Society, Worcester, Mass., owns the volume. The engraving was brought to the attention of the Folk Art Center by Jane C. Nylander.
[2]Stanzas XVII and XIX are cited in Elinor Robinson Bradshaw, "American Folk Art In the Collection of the Newark Museum," *The Museum New Series,* XIX (Summer–Fall 1967), pp. 35–36, and another example of Ellen in plaid is illustrated and described there.

172 Bonaparte in Trouble 34.301.1

Artist unidentified
America, probably 1812–1820
Watercolor and ink on wove paper
11¾″ x 14⅞″ (29.9 cm. x 37.8 cm.)

This watercolor is a close copy of Amos Doolittle's etching of the subject published by the Connecticut firm of Shelton & Kensett.[1] The only significant deviation is that the watercolorist chose to show half of the "Infernal spirit" hidden by clouds, whereas Doolittle exposed the devil completely. The slavishness of the copy is illustrated by the far left tree trunk, which the watercolorist abruptly terminated just where the etched impression ends. With exceptions of spacing and a few minor alterations of spelling, all inscriptions are the same.

A second close copy of the Doolittle composition is inscribed differently in the lower margin; there it reads only: "Presented by W J Armstrong to N B Marshall."[2] A much more imaginative work after Doolittle is the pen and wash drawing *Gen^l Jackson in Trouble* by thirteen-year-old W. Bell.[3]

Inscriptions/Marks: A banderole at upper center in the composition is inscribed in ink: "BONAPARTE IN TROUBLE"; and other banners are inscribed: "RUSSIA," "PRUSSIA," "AUSTRIA," "ROME," "ITALY," "FRANCE," and "LOUIS XVIII." A pedestal at far right bears the words: "SPAIN/&/PORTUGAL"; various figures within the composition appear beneath the numerals: "1," "2," "3," "4," "5." In the lower margin is written in ink: "EXPLANATION 1 The Infernal spirit enticing Bonaparte with the Crown of Russia — 2 Bonaparte arrested in his progress by the Russian Bear — /3 The British Lion attacking him in the rear, having already Wrested from his power the Crowns of Spain & Portugal — 4 The Confederated Eagles/of Austria & Prussia plucking the feathers of the Rhinish Confederation — 5 The Genius of Europe breaking the scepter of Bonaparte/and loudly proclaiming LOUIS the XVIII."
Condition: In 1955 Christa Gaehde removed stains and surface dirt, replaced a missing triangular section of the primary support in the lower right corner (including five letters of the lower margin inscription) and a narrow vertical strip in the upper left corner, and backed the piece with Japanese mulberry paper. In 1980 E. Hollyday dry-cleaned unpainted areas of the front and back, removed traces of mold, and mended several tears with wheat-starch paste. The 1⅝-inch splayed frame is painted to resemble bird's-eye maple; it is a replacement that may date from the period of the watercolor, but it was "antiqued" with dark brown paint, probably in recent years.
Provenance: Edith Gregor Halpert, Downtown Gallery, New York, N.Y.
Published: AARFAC, 1940, p. 31, no. 111 (attributed to Amos Doolittle); AARFAC, 1947, p. 28, no. 111 (attributed to Amos Doolittle); AARFAC, 1957, p. 363, no. 270; American Art Association-Anderson Galleries, Inc., *Pictorial Americana,* catalog for sale no. 4116, May 17–18, 1934, p. 30, no. 89, illus. as frontispiece (attributed to Amos Doolittle).

[1]The etching is usually dated ca. 1814 (see Wendy J. Shadwell, comp., *American Printmaking: The First 150 Years* [New York, 1969], p. 50, no. 97; and lot no. 143 in Sotheby Parke Bernet, Inc., *American Historical Prints, Books, Broadsides, and Maps from the Collection of Ambassador and Mrs. J. William Middendorf II,* catalog for sale no. 3523, May 18, 1973), but it presumably does not

EXPLANATION *1 The Infernal spirit enticing Bonaparte with the Crown of Russia — 2 Bonaparte arrested in his progress by the Russian Bear. 3 the British Lion attacking him in the rear, having already Wrested from his power the Crown of Spain & Portugal — 4 The Confederated Eagles of Austria & Prussia plucking the feathers of the Rhenish Confederation — 5 The Genius of Europe breaking the scepter of Bonaparte and loudly proclaiming LOUIS the XVIII*

172

predate 1812, when Thomas Kensett (1786–1829) joined the firm of Shelton & Kensett, map and print publishers of Cheshire, Conn., whose names appear in the lower margin. Amos Doolittle was born in Cheshire in 1754 and died in New Haven in 1832. The etching was described as Doolittle's "third cartoon" in *The Old Print Shop Portfolio*, VI (March 1947), p. 162.

[2] The present whereabouts of the Armstrong-Marshall work is unknown. It appears to have been in the collection of the Old Print Shop, New York, N.Y., in the early 1950s; AARFAC files contain a photograph.

[3] The Bell work belongs to the Western Reserve Historical Society in Cleveland. It incorporates several of the same pictorial motifs but interprets the horseback rider as General Andrew Jackson and the devil as Martin Van Buren; the latter's enticement is the state of New York, rather than Russia. Among other features, Bell changed the Russian bear to "the Pennsylvania Panther" and the British lion to "the Southern Alligator." An illustration appears in Robert Doty, *American Folk Art in Ohio Collections* (Akron, Ohio, 1976), no p., no no.

173 Maria 31.301.7

Artist unidentified
Possibly Concord, Massachusetts, probably ca. 1815
Watercolor and pencil on laid paper
12 1/16″ x 12 15/16″ (30.6 cm. x 32.9 cm.)

Two extraordinarily popular novels made their French heroine, Maria, a familiar figure among literary audiences of the late eighteenth and early nineteenth cen-

turies. Laurence Sterne's (1713–1768) *Life and Opinions of Tristram Shandy, Gentleman* and its sequel, *A Sentimental Journey through France and Italy*, were first published in 1767 and 1768 respectively, but the imaginative, romantic tales appeared in numerous subsequent editions as well. In them, melancholy over a thwarted love affair caused Maria to lose her wits and wander aimlessly through the countryside playing mournful tunes on a pipe. In Sterne's first novel, she kept a pet goat for company, but in *Sentimental Journey*, the reader discovers that this animal had been "as faithless as her lover, and [that] she had got a little dog [Sylvio] in lieu of him, which she kept tied by a string to her girdle." [1]

Inspired by the stories and usually guided by one of numerous published illustrations, amateur artists on both sides of the Atlantic Ocean enthusiastically rendered Maria in such diverse materials as oil paints, watercolors, silk threads, and wool yarns. Most depictions of Maria and her pet show Sylvio rather than the goat, and most of these appear to derive from one of at least five different engravings. [2]

The watercolor shown here corresponds closely to an engraving published by Robert Sayer in London in 1787, although the amateur artist's reversal of the Sayer composition suggests reliance upon another, as yet unidentified, form of the printed picture. [3] To

173

from Ryland, one can be associated with Hill, two are based on the engraving owned by Mount Vernon, and eight remain unclearly linked with specific design sources. Included among the unlinked eight is a now unlocated watercolor by Eunice Pinney that is the only picture recorded to date showing Maria's goat rather than her dog and thus deriving from *Tristram Shandy* rather than from *Sentimental Journey.*

[3]Since the Tiebout (see note 2 above) remains unlocated, its possible compositional connections with recorded Maria derivations remain unknown. However, brief descriptions suggest that it is close to Sayer, but reversed (C. R. Jones, New York State Historical Association, to AARFAC, February 25, 1980).

[4]The first of these is Lydia Hosmer's well-known silk embroidery in the Museum of the Concord (Mass.) Antiquarian Society (which is, however, believed to have been worked while she was away from Concord at school). The second is a now unlocated watercolor by Sarah Lawrence of Concord that was illustrated as lot no. 548 in Sotheby Parke Bernet, Inc., *Fine Americana,* catalog for sale no. 4116, April 27–29, 1978.

date, two depictions of Maria are known to have been worked by Concord, Massachusetts, women.[4] A third picture, no. 169, was found in nearby Boston, leading one to assume special interest in Sterne's heroine in that area of the country in the early nineteenth century.

Condition: Unspecified treatment by Christa Gaehde in 1956 included cleaning, repairing some tears, and backing the primary support with Japanese mulberry paper. In 1980 E. Hollyday drycleaned the primary support where possible and touched in minor scattered paint losses with pastels. Period replacement 1-inch cyma recta gilded frame.

Provenance: Found in Concord, Mass., and purchased from Edith Gregor Halpert, Downtown Gallery, New York, N.Y.

Exhibited: Washington County Museum, 1965.

Published: AARFAC, 1957, p. 364, no. 282.

[1]*Tristram Shandy,* Book IX, Chapter 23, contains an account of the hero's meeting with Maria and her goat. In *Sentimental Journey,* Shandy's friend Mr. Yorick encounters Maria and Sylvio in the subsection of the book titled "Moulines." The quote is taken from *Sentimental Journey.*

[2]Of the numerous possible print sources noted in AARFAC files to date, only those following bear clear compositional links to any of the painted or stitched Maria pictures also recorded there: an engraving published July 23, 1787, by Robert Sayer, 53 Fleet Street, London (print no. 1477, Lewis Walpole Library, Farmington, Conn.); an engraving by William Wynne Ryland after Angelica Kauffman, published April 12, 1779, by "the Proprietor," No. 159 Strand, London (British Museum, London); the frontispiece to *Massachusetts Magazine* for August 1793 engraved by S[amuel] Hill (Rare Book Division, New York Public Library); an unlocated print described as being large-scale and marked "Tiebout," for Cornelius Tiebout, ca. 1773–1832 (C. R. Jones, New York State Historical Association, to AARFAC, February 25, 1980); and a 12⅛-inch diameter engraving owned by the Mount Vernon Ladies' Association.

Twenty-seven painted or stitched Maria compositions have been noted in AARFAC files to date. Of these, ten appear to have been based on Sayer or on an as yet unidentified print similar to Sayer (possibly Tiebout, also see note 3 below), while six plainly derive

174 Aurora 37.401.2

Artist unidentified

New England, possibly Massachusetts, ca. 1820
Watercolor and gold paper collage on silk
14½" x 14¼" (36.8 cm. x 36.2 cm.)

Called *Chariot in the Clouds* in the 1930s, this picture was more narrowly defined in the 1950s as *Venus Drawn by Doves,* on the assumption that the goddess depicted had some connection with the sailing ship below her. Aphrodite, assimilated into Roman mythology as Venus, was said by Hesiod to have been born of the foam of the sea,[1] and the Levantines believed she had the power to protect ships on their voyages.[2]

However, two very similar compositions discovered since the 1950s bear printed verses identifying the figure as Aurora, goddess of the dawn. A third similar composition bears a blank space along its lower edge apparently intended — but never used — for the addition of such an inscription. A fourth piece, like the Folk Art Center's, is painted to the lower edge of the composition.[3] Known to the Greeks as Eos, Aurora was usually depicted drawn by horses, and research has not yet revealed the circumstances by which she came to be drawn by birds in these five closely related depictions. Presumably some print source was used as a compositional guide by the artists, perhaps as part of a classroom exercise.

Condition: In 1977 E. Hollyday removed a wood backboard to which a linen edging had been glued; vacuumed the front and back of the primary support; re-adhered loose gold foil with wheatstarch paste; stitched the linen-edged silk support to a muslin-covered, acid-free board along with a second piece of unpainted silk originally placed behind the first; and added a window mat. Period replacement 2-inch gilded cyma recta frame with leaf and applied rope twist moldings.

174

Provenance: Found in Quincy, Mass., and purchased from Bessie J. Howard, Boston, Mass.; given to the Museum of Modern Art in 1939 by Abby Aldrich Rockefeller; turned over to Colonial Williamsburg in June 1954.

Exhibited: AARFAC, South Texas; AARFAC, April 22, 1959–December 31, 1962; Flowering of American Folk Art; Goethean Gallery; William Penn Museum.

Published: AARFAC, 1957, p. 228, no. 114, illus. on p. 229; AARFAC, 1959, p. 22, no. 13; Black and Lipman, p. 207, illus. as fig. 195 on p. 214; Bryan Holme, *Creatures of Paradise: Animals in Art* (London, 1980), p. 80, illus. on p. 81; Lipman and Winchester, *Folk Art,* p. 80, illus. as fig. 117 on p. 89; Mark P. O. Morford and Robert J. Lenardon, *Classical Mythology* (New York, 1971), illus. on front cover; Karen Petersen and J. J. Wilson, *Women Artists: Recognition and Reappraisal from the Early Middle Ages to the Twentieth Century* (New York, 1976), pp. 69–70, illus. as fig. V, 19, on p. 72; *Spinning Wheel,* XIII (May 1957), illus. on front cover; Stebbins, p. 95, illus. as fig. 65 on p. 96.

[1]Charles Mills Gayley, *The Classic Myths* (Boston, 1893), pp. 31–34.

[2]*The Old Print Shop Portfolio,* I (April 1942), p. 1.

[3]The verses read: "Hail, bright Aurora, fair goddess of the Morn!/ Around thy splendid Car, the smiling Hours submissive wait attendance, ascend — and/reillume the face of Nature with thy refulgent beams, & from the Arch of Heaven banish night." In both instances, the verses are printed on scraps of paper glued to the center lower edge of the silk. One of the two paintings is believed to retain its original frame, which bears a label stating: "STILLMAN LOTHROP,/ Looking-Glass Store/No. 71, Market Street/Boston." According to Ring, *Looking-Glass,* p. 1187, Lothrop used the above address in the period 1818–1822. Both paintings are in private collections, one being in the hands of a descendant of Ruth Downer (1797–1833) of Vermont, who is believed to have been responsible for the unlabeled piece having a blank lower edge space; the latter is owned by the Rhode Island School of Design. The fourth related piece is privately owned and was executed by Eliza Ann Robeson (1798–1834) of Fitzwilliam, N.H.

175 Entry of Napoleon

60.301.1

Artist unidentified
America, probably 1822–1835
Watercolor and ink on wove paper
15¼″ x 19⅝″ (38.7 cm. x 49.9 cm.)

Napoleon Bonaparte (1769–1821) was exiled to the island of Elba following his abdication as emperor of France in April 1814, but he wasted no time plotting a return to power. Having sailed from Elba with several hundred soldiers on February 26, 1815, he landed in southern France and marched unopposed to Paris, whereupon Louis XVIII fled and Napoleon reinstated himself there on March 21, beginning his reign of the Hundred Days.

The inscription on this watercolor errs in naming the year of Napoleon's return from Elba, as does the artist's print source, the engraved frontispiece by Isaac Sanford (d. ca. 1842) that appeared in Dr. B. E. O'Meara, *Memoirs of the Military and Political Life of Napoleon Bonaparte* (Hartford, Conn., 1822).[1] The watercolor follows the printed composition fairly closely, except that in the former, many more buildings were added above the carriage horses, and large circular clouds were placed on the horizon immediately beyond Napoleon, perhaps to serve as a backdrop for the primary figure. The decorative upper border with a floral spray was also added by the watercolorist.

Inscriptions/Marks: In ink and watercolor in the lower margin is "ENTRY OF NAPOLEON INTO PARIS FROM ELBA 1814."

Condition: In 1961 Christa Gaehde cleaned the primary support, removed adhesive tape from it, and repaired several tears. In 1980 E. Hollyday dry-cleaned unpainted areas, cleaned and mended tears, filled and inpainted losses in the upper margin and lower right corner, and backed the piece with Japanese mulberry paper. Probably period replacement 1¾-inch molded frame, painted black.

Provenance: Old Print Shop, New York, N.Y.; Mr. and Mrs. Bertram K. Little, Brookline, Mass.

Exhibited: Smithsonian, American Primitive Watercolors, and exhibition catalog, p. 8, no. 31.

[1]The Library of Congress owns a copy of the book. AARFAC files contain a photograph of the frontispiece.

175

176 Paul and Virginia 32.301.3

Artist unidentified
America, probably ca. 1825
Watercolor and pencil on wove paper
12 15/16" x 17 1/16" (32.9 cm. x 43.3 cm.)

Like no. 153, this work illustrates a scene from *L'Histoire de Paul et Virginie* by J. H. Bernardin de Saint-Pierre (1737–1814). The watercolor is a close copy of plate no. 3 in a series of six colored stipple engravings by J. Duthe after Lambert;[1] titled *Le Repos de Virginie* ("*Virginia's Resting Place*"), the plate shows a youthful Paul presenting a bird's nest to his beloved Virginia while their dog, Fidèle, jumps up at her knee. The slaves, Mary and Domingo, pursue their work in the right half of the picture, while an infant, probably their child, plays at Mary's feet. At left stands one of Virginia's goats.

In the romantic novel, "Virginia's Resting-Place" was a beautiful, quiet reserve on the island of Mauritius, whence the heroine often repaired to wash linen, to pasture her goats, or simply to rest. Observing Virginia's fondness for the place, Paul often brought there the nests of various birds, who soon established themselves in the bower and became the girl's pets.

The watercolor's most significant compositional deviations from the print source are the addition of shoes for Paul and Virginia and the deletion of a skein of yarn that in the engraving projects from the workbasket by Virginia's side.

Inscriptions/Marks: A watermark in the lower left corner of the primary support reads: "[J] WHATMAN/TURKEY MILL" for the Maidstone, Kent, England, firm operated by the Hollingworth brothers between 1806 and 1859.
Condition: In 1955 Christa Gaehde mended small tears, backed the primary support with Japanese mulberry paper, and adhered the paper to a secondary support. In 1978 E. Hollyday flattened creases and cockles, dry-cleaned unpainted areas, mended edge tears, and inpainted small areas of paint loss in scattered scratches. In 1979 E. Hollyday removed the modern secondary support and traces of glue from the reverse of the primary support, then hinged the latter to acid-free board. Replacement 1 1/4-inch gilded cyma recta frame; although possibly dating to the period of the watercolor, it probably was added by the Old Print Shop, New York City, in the 1950s.
Provenance: Isabel Carleton Wilde, Cambridge, Mass.; John Becker, New York, N.Y.
Exhibited: Wilde, and exhibition catalog, no. 59.
Published: AARFAC, 1940, p. 27, no. 86; AARFAC, 1947, p. 26, no. 86; AARFAC, 1957, p. 176, no. 88, illus. on p. 177.

[1]An entire series of the engravings is owned by the Metropolitan Museum of Art, New York, N.Y.

176

177

177 Battle of Lake Erie
70.111.1

Artist unidentified
America, probably 1856–1880
Oil on canvas
27" x 36½" (68.6 cm. x 92.7 cm.)

Determining the date of execution of this painting is complicated by the existence of two closely corresponding print sources dated twenty-two years apart. The February 2, 1856, issue of *Ballou's Pictorial Drawing-Room Companion* carried a double-page illustration of the scene engraved by William Wade after John Andrew, but a similarly composed lithograph published by J. Perry Newell of Newport, Rhode Island, was copyrighted in 1878. The Folk Art Center's oil painting could have been inspired by either of these prints. However, the artist's misidentification of the left foreground ship suggests that the source may have been a third, as yet unidentified print, one that bore the same error. Both the 1856 and 1878 prints correctly identify the ship as the British *Detroit*, while the oil painter labeled her on the prow "VIC-TORIR" (Victoria).

The naval battle between British and American forces over possession of Lake Erie was fought September 10, 1813. In the engagement, American Commander Oliver Hazard Perry (1785–1819) defied surrender by resorting to a longboat when his flagship, the *Lawrence*, was irreparably damaged by the British *Detroit* and *Queen Charlotte*. Perry then boarded and took command of the *Niagara*, from which vantage point he not only defeated his two recent pursuers but also captured two other British vessels attempting to escape. Both identified prints and the oil painting show Perry en route to the *Niagara* in his longboat.

Inscriptions/Marks: Painted on the stern of the far right ship is "NIAGARA." On the bow of the center ship is "LAWREN . . ." and on the left foreground ship is "VICTORIR." "DONT GIVE/UP THE/SHIP" is lettered on the banner flying from the *Lawrence*'s broken mast. At lower right in the composition is painted: "BATTLE, OF, LAKE, ERIA [*sic*]."

Condition: In 1970 Bruce Etchison lined the painting, cleaned it, removed numerous flyspecks, and inpainted a large number of minor losses in the paint surface. Modern 2¼-inch cyma recta frame painted black with half-round outer molding and half-round inner molding painted white.

Provenance: Unidentified owner, New York, N.Y.; Joseph and Maurine Boles, St. Augustine, Fla.

178 Russian Squadron in New York Harbor

58.101.13

Artist unidentified
America, probably 1863–1875
Oil on canvas
34″ x 34″ (86.4 cm. x 86.4 cm.)

This unidentified painter derived his composition from an engraving that appeared on pages 72 and 73 in *Frank Leslie's Illustrated Newspaper*, XVII, no. 421 (October 24, 1863). Although the derivation follows the print fairly closely in the placement of the ships, the oil painter added all the foreground elements up to the rowboat and tug, giving his composition a square format rather than the rectangular one assumed by the engraving. The Russian ships portrayed are identified from left to right as *Vitiaz, Peresvet, Osliaba,* and the flagship *Alexander Nevsky.*

The 1863 newspaper illustration was prompted by the unexpected arrival of the Russian Atlantic fleet in New York harbor in September of that year. The American public was electrified by the event. Why had the ships come? Rumors were rife, but positive. It was generally assumed that the visit was a gesture of friendly support for the Union cause, and the Russians were swept into a mad whirl of official ceremonies and social celebrations. It was a misguided welcome, however, for in 1915 the true cause of the Russian visit was made known. Fearing reprisals from various European nations for Russian intervention in Poland's affairs, the czar had ordered his fleet into friendly foreign harbors so that it could not be trapped in home ports by the enemy.[1]

Condition: The painting is in its original condition. Period replacement 3-inch molded frame, painted gold.
Provenance: J. Stuart Halladay and Herrel George Thomas, Sheffield, Mass.[2]

[1]Historical data is taken from Marshall B. Davidson, "A Royal Welcome for the Russian Navy," *American Heritage,* XI (June 1960), pp. 38–41, 107. The engraving from *Frank Leslie's Illustrated Newspaper* is reproduced there on pp. 40–41, but it is cropped in both dimensions.
[2]A November 1, 1945, letter in AARFAC files, written by Bessie Sawyer, Saratoga Springs, N.Y., and addressed to Herrel George Thomas, implies that Halladay and Thomas purchased the painting either from Bessie Sawyer or from her father.

178

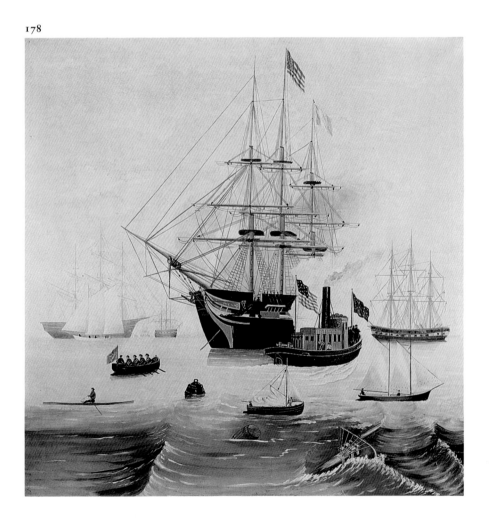

179

179 *Monitor* and *Merrimac* 58.111.2

Artist unidentified
America, probably 1891–1910
Oil on canvas
38″ x 59⅞″ (96.5 cm. x 152.1 cm.)

Several oil versions of this composition are known, and they are believed to have been derived from an 1891 colored lithograph advertising McCormick harvesting machinery. The dramatic 1862 encounter between the iron-clad Union and Confederate ships had left an indelible impression of indestructibility on the American public, and McCormick obviously capitalized on this impression by noting that "the War Ship of the future must be — like the McCormick Harvester — a Machine of Steel."

The Folk Art Center's oil painting follows the composition of the 1891 lithograph closely, but it is greatly simplified in detail. The sailing ships and particularly the stylized sailors convey a cartoonlike quality; only the convincing billows of smoke suggest the degree of accomplishment found in the printed source.[1]

Condition: An unidentified conservator applied three canvas patches to the reverse and inpainted small areas of the sky prior to acquisition. Modern replacement ¾-inch flat frame with quarter-round outer edge, painted black.

Provenance: Nina Fletcher Little, Brookline, Mass.

Published: T. Harry Williams, "A War Out of Control," *New York Times Book Review,* May 26, 1963, illus. on p. 1.

[1]In addition to the inscription partially quoted in the above commentary, the 1891 lithograph bears the notation that it was "copied by permission/from the/Cyclorama of the/Monitor and Merrimac/on Exhibition at/Toledo, Ohio." No painting identifiable as that used in the cyclorama has been found to date. The 1891 lithograph is owned by the Mariners Museum, Newport News, Va. Other oil paintings believed to have been derived from the lithograph are lot no. 610 included in Sotheby Parke Bernet, Inc., *Fine Americana,* catalog for sale no. 4211, January 31–February 3, 1979; and a painting by J. G. Tanner illustrated in *National Gallery of Art, American Paintings and Sculpture: An Illustrated Catalogue* (Washington, D.C., 1970), p. 115, no. 1242. It should also be noted that the blazing three-masted ship, pictured at far left in both the oil paintings and the 1891 lithograph, is an element that can be found in a still earlier print, an 1889 colored lithograph issued by Kurz & Allison of Chicago. Because Kurz & Allison compressed the events of two days' time span into one view, the ship cannot be positively identified, but it is probably the *Congress,* possibly the *Cumberland.* The 1889 lithograph was formerly in the collection of the Mariners Museum, and its present location is unknown.

VI Biblical Subjects

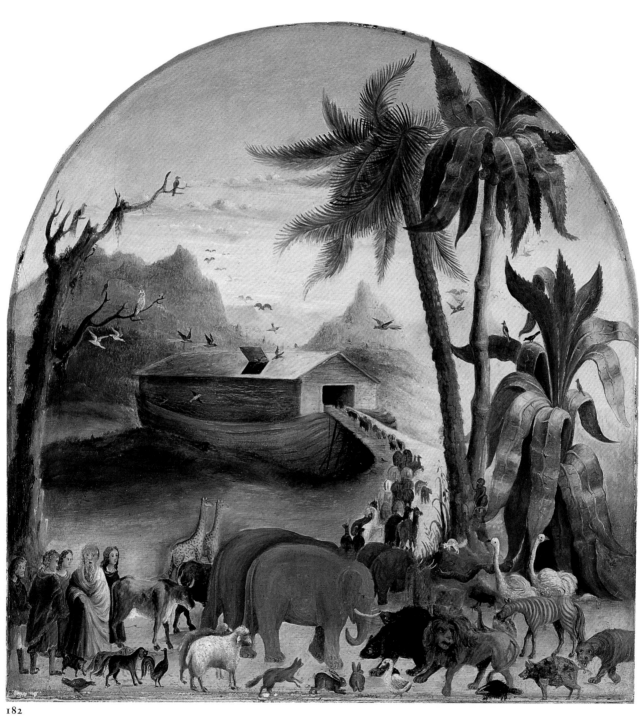

Studies of religion as reflected in American art generally have focused on overriding theological principles and their academic expression or interpretation. The biblical works shown in this catalog stem from a far less sophisticated but broader-based impulse, that is, from traditional and popular conceptualizations of Old and New Testament stories and teachings.

Through the late eighteenth and early nineteenth centuries, thorough knowledge of the Good Book was taken as a fundamental sign of rectitude or, at the very least, of aspiration to a virtuous life. The inextricable linkage of these concepts drove parents and teachers to take great pains to imbue their young charges with the necessary groundwork for correct moral choices, society's acceptance, even life eternal. As was frequently illustrated by the parable of the prodigal son, opportunities to indulge sin and wickedness beckoned youth at every turn. Stringent guidelines were needed to navigate the dangerous waters, and the Bible unfailingly provided these. Youngsters painted, drew, and stitched illustrations of biblical passages to reinforce the teachings they heard, read, memorized, and recited. The tangible images helped them visualize the events of an exotic place and a distant time, just as they rendered difficult theological concepts more understandable to simple, searching minds.

Literalness of interpretation often enhanced instructional value by providing distinctive, easily recognized attributes or clues for identifying the Bible's dizzying array of characters and events. Yet the Book's rich imagery also provided ample opportunity for the expression of creativity, and many renderings include imaginative answers to design problems, even when a specific print source has been identified.

Erastus Salisbury Field
(1805–1900)

Erastus Salisbury Field lived most of his ninety-five years in Leverett, the small western Massachusetts town where he was born in May 1805. He and his twin sister, Salome, were the third and fourth of nine children born to their parents, for whom they were named. Field's early talent for drawing and painting was recognized by his family, and in 1824, at age nineteen, he was sent to New York City to study with Samuel F. B. Morse (1791–1872). His apprenticeship was terminated after only three months when the studio was dissolved owing to the sudden death of Morse's young wife. Field returned to Leverett in the spring of 1825 and painted the first of his known works, a tightly drawn, smoothly painted likeness of his maternal grandmother, Elizabeth Billings Ashley. The portrait indicates that at the outset of his career, Field had already developed the assured brushwork that characterizes his painting style. At about the same time, he began traveling up and down the Connecticut River valley in search of the portrait commissions that formed the bulk of his early work. Late in 1831, he married Phoebe Gilmer of Ware, Massachusetts, and their only child, Henrietta, was born the next year. The decade following his marriage was an extraordinarily productive and prosperous time for Field, and nine of his oil portraits from the period 1831–1841 are owned by the Folk Art Center.

Field lived and painted at various addresses in New York City during the period 1841–1848, but after 1842, his listing was changed from "portrait painter" to "artist" in city directories, an alteration that hints at his growing interest in literary and historical subject matter. While in New York City, Field probably also saw the first sacred drama produced in America, an 1842 performance of *The Israelites in Egypt or Passage of the Red Sea*; the theme was to inspire a series of his paintings in later life, including the Folk Art Center's sole nonportrait work by Field, his *Death of the First Born* (no. 180).

Although Field continued to paint portraits after returning to Massachusetts in 1848 to manage his ailing father's farm, his later likenesses were based on daguerreotype images and are stiff and somber compared with earlier examples by him. Field's reliance on print sources for the compositions of his growing number of subject pieces seems not to have altered his style so drastically, for his figures in them are distinctively monumental and sculptural, and his colors are bright and strong. The best-known work from his later life is his heroically scaled complex architectural fantasy titled *The Historical Monument of the American Republic*,[1] which measures nine feet three inches in height by thirteen feet one inch in width.[2]

[1]Now owned by the Museum of Fine Arts, Springfield, Massachusetts.

[2]This entry has been adapted from Black, Field; and from AARFAC, 1981, where the Folk Art Center's portraits by Field are illustrated on pp. 94–101.

180 Death of the First Born 57.101.3

Attributed to Erastus Salisbury Field
Plumtrees, Massachusetts, ca. 1865–1880
Oil on canvas
34⅞" x 35" (88.6 cm. x 88.9 cm.)

This painting is one of a series depicting the plagues of Egypt that Field apparently intended to be hung on the walls of the North Amherst Church. Only nine works in the series survive. These include a second version of *Death of the First Born*, a group scene set in a monumental Egyptian palace, and one other painting (*Mine Eyes Have Seen the Glory [Death of the Twins]*) set in a room interior reminiscent of that in the Folk Art Center's work. A relatively wide date range of ca. 1865–1880 is ascribed to the entire series of paintings because wide variations in quality suggest that they were executed over an extended period. No print source for the composition of the Folk Art Center's painting is known. The subject is taken from Exod. 12:29–30.[1]

Condition: Treatment by Russell J. Quandt in 1959 included lining, cleaning, patching a hole at upper center, replacing the auxiliary support, and minor inpainting. Modern replacement 1-inch chamfered frame, painted gold.

Provenance: Found in Amherst, Mass., and purchased from Edith Gregor Halpert, Downtown Gallery, New York, N.Y.

Exhibited: "American Primitive Art," Museum of Fine Arts, Houston, Tex., January 6–29, 1956, and exhibition catalog, no. 36 (titled *Interior*); "Erastus Salisbury Field, 1805–1900: A Special Exhibition Devoted to His Life and Work," AARFAC, January 20–March 17, 1963, and exhibition catalog, no. 103; "Erastus Salisbury Field: Visionary Folk Artist," traveling exhibition organized by Mary Black and the Museum of Fine Arts, Springfield, Mass., February 5, 1984–March 10, 1985.

Published: Black, Field, pp. 51, 110, no. 89, illus. as pl. 29 on p. 89; Mary Black, "Erastus Salisbury Field and the Sources of His Inspiration," *Antiques*, LXXXIII (February 1963), p. 204, illus. as fig. 7 on p. 203; Reginald F. French, "Erastus Salisbury Field, 1805–1900," *Connecticut Historical Society Bulletin*, XXVIII (October 1963), p. 129, no. 258.

[1]The other version of *Death of the First Born* is owned by the Metropolitan Museum of Art, gift of Edgar William and Bernice Chrysler Garbisch in 1966; *Mine Eyes Have Seen the Glory (Death of the Twins)* is owned by the Museum of Fine Arts, Springfield, Mass., the Morgan Wesson Memorial Collection 63.17. Information in this entry is from Black, Field.

180

Ruby Devol Finch
(1804–1866)

Aruba ("Ruby") Brownell Devol was born in West-
port, Massachusetts, on November 20, 1804, the sec-
ond of seven offspring of Benjamin Devol, Jr., and
Elizabeth Rounds Devol.[1] On November 8, 1832,
Ruby Devol married William T. Finch of New Bed-
ford. One child — a daughter, Judith, who eventually
settled in New Bedford herself — was born to the cou-
ple. Ruby Finch died in New Bedford on July 7, 1866,
age sixty-one, her death attributed to a tumor. The
city's vital statistics indicate that Ruby was a widow
and that she had resided in New Bedford for an un-
specified period of time. However, except for a land
transaction she made late in life, remaining biograph-
ical details are now obscure; nothing has been ascer-
tained concerning her husband's occupation, vital
statistics, probate record, or how long the couple lived
in Westport, where Ruby seems to have drawn and
painted most of the artworks she created for her
friends and neighbors.[2]

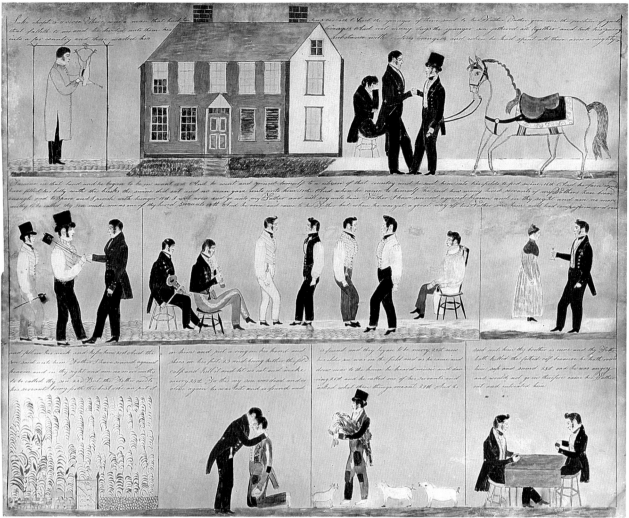

181

Where Ruby Devol was first introduced to water-color painting and how and by whom she was encouraged to go beyond any rudimentary art exercises she might have been exposed to at school are undetermined. The earliest dated recorded work (no. 286) features a decorated register for Silas Kirby's family. Finch's other recorded works, which date from ca. 1830 to 1843, include two versions of the story of the prodigal son (for one, see no. 181) and seven profile portraits of friends and neighbors in the Westport/ Westport Point community.[3]

In general, one might characterize her artwork as amateurish and her poetry as charming and quaint — and sometimes abominable. But her works possess a degree of truthfulness that evidently made them acceptable to — if not admired by — her Westport neighbors; this quality is also balanced by a visually playful decorativeness that makes them especially appealing to contemporary collectors. Unlike many other women who dabbled in watercolor and ink at this period in the nineteenth century, Ruby Devol Finch shows no dependence on prints or other prescribed sources of inspiration; instead, her works are truly inventive pieces that convey a strong sense of personal involvement. Although the facts known of Finch's life itself are indeed slight, her surviving artwork perhaps tells us more about her than the written record might, while simultaneously unfolding a unique personal visual record that helps to plot the network of relationships among members of a small New England village society.

[1]Details of the artist's life and a discussion of all her recorded works are given in Walters, Finch, pp. 1C–4C.

[2]The area called Westport was actually defined geographically by a relatively narrow strip of land about four miles wide and thirteen miles in length between the east and west branches of the Westport River. There were two small villages in the town, one at the head of the east branch and the other at Westport Point. The village at the head of the east branch was about eight miles from New Bedford.

[3]The other version of *The Prodigal Son* is privately owned. Three portraits are at AARFAC: acc. no. 66.300.1, the double portrait *Hannah and Elijah Robinson*, and acc. no. 66.300.2, *Susannah Tripp;* and two are in the collection of Bertram K. and Nina Fletcher Little. The remaining two portraits are privately owned.

181 The Prodigal Son 36.301.1

Attributed to Ruby Devol Finch
Vicinity of Westport Point, Massachusetts,
probably 1830–1835
Watercolor, gouache, and ink on wove paper
18¾″ x 22¹¹/₁₆″ (47.6 cm. x 57.6 cm.)

Ending her interpretation with verse 28, Finch illustrates the story of the prodigal son (Luke 15:11–32) in nine colorful scenes that are updated to a semblance of the artist's surroundings by costumes, props, and activities. The dance depicted at center is especially interesting, for it seems to show an Irish jig, a forerunner of the clog step used by modern American square dancers.

Finch's text is taken directly from the Bible; each line reads horizontally across the entire sheet in the first two bands of script, but the lower band is broken into four blocks, and all lines within each must be read before proceeding to the next block. Uncorrelated to the text arrangement, her illustrations must be read clockwise beginning at center top, continuing around the perimeter, and ending in the central block. Thus, the text does not always pertain to the scene directly below it. Reading from left to right, the episodes depicted are the slaughtering of the fatted calf, the prodigal's departure from his father's house, the father discussing the prodigal's return with the older brother, the celebration with servants after the prodigal's return, reveling with a harlot, a cornfield, the father welcoming his son upon his return, the prodigal with swine, and finally, gambling and loose living.

A second Finch watercolor of the story of the prodigal son is more clearly organized. In it, biblical texts have been replaced by the artist's own poetry, and inscriptions do correlate to the scenes directly below them.[1]

Inscriptions/Marks: A watermark at upper right reads: "J Whatman/Turkey Mill/1830." A penciled inscription on the reverse reads: "I am 115 years old 1896/and was painted by Ruby Devoll." Running horizontally on the obverse in three bands of inked, script lines is the following inscription: "Luke chapt, 15. 11 verse There

was a man that had two Sons veres [*sic*] 12 And the younger of them said to his Father Father give me the portion of goods/that falleth to me and he divided unto them his living. 13 And not many days the younger son gathered all together and took his journy [*sic*]/into a far country and there wasted his substance with riotous living. 14 and when he had spent all there arose a mighty/Famine in that land and he began to be in want 15th And he went and joined himself to a citizen of that country and he sent him into his fields to feed swine. 16th. And he fain would/have filled his belly with the husks the swine did eat and no man gave unto unto [*sic*] him. 17th And when he came to himself he said how many hired servants of my Fathers have bread/enough and to spare and I perish with hunger 18th I will arise and go unto my Father and will say unto him Father I have sinned against heaven and in thy sight and am no more/worthy to be called thy son make me as one of thy hired Servants 19th And he arose and came to his Father but when he was yet a great way off his Father saw him and had compassion and ran/and fell on his neck and Kisse [*sic*] him 21st And the son said unto him Father I have sinned against/heaven and in thy sight and am no more worthy/to be called thy son 22d But the Father said to his servant bring forth the best robe an [*sic*] put it/on him and put a ring on his hand and/shoes on his feet. 23 and bring hither the fat[t]ed/calf and kill it and let us eat and make/merry 24th For this my son was dead and is alive again he was lost and is found and/is found [*sic*] and they began to be merry 25th now his eldest son was in the field and as he came and/drew near to the house he heard music and dan/-cing 26th and he called one of his servants and/asked what these things meant. 27th And he/said unto him thy brother is come and thy Father/hath killed the fatted calf because he hath recievd [*sic*]/him safe and sound. 28th and he was angry/and would not go in therefore came his Father/out and entreated him."

Condition: Treatment by Christa Gaehde in 1954 including cleaning; reducing stains; fumigating; mending tears; filling and inpainting several large losses, especially in the center horizontal band and mostly in unpainted areas except for the back of the woman's head; backing with Japanese mulberry paper; and hinging to rag board. Possibly original 2¼-inch splayed mahogany frame with flat outer edge.

Provenance: Sallie H. Andrews, Ashaway, R.I.

Exhibited: AARFAC, American Museum in Britain; AARFAC, Minneapolis; AARFAC, June 4, 1962–April 17, 1963; Amon Carter; Dallas, and exhibition catalog, no. 31; "New Bedford and Old Dartmouth: A Portrait of a Region's Past," Whaling Museum, New Bedford, Mass., December 4, 1975–April 18, 1976, and exhibition catalog, p. 34, no. 24, illus. on p. 35.

Published: National Antiques Review, VI (September 1974), illus. on front cover; Walters, Finch, illus. as fig. 8 on p. 4C.

[1]All information is taken from Walters, Finch, where an extensive account of the artist's life is given along with a description and analysis of her painting style. Signed and attributed works are illustrated therein, including the other *Prodigal Son*, which is privately owned.

Joseph Henry Hidley
(1830–1872)

See Hidley entry in "Views of Towns" for biographical information.

182 Noah's Ark 57.101.8

Attributed to Joseph Henry Hidley
Probably near Troy, New York, 1865–1872
Oil on wood panel
25¾" x 26¾" (65.4 cm. x 68.0 cm.)
(Reproduced on page 232)

This landscape scene showing the biblical story of Noah and his family preparing for the Flood and the loading of the ark with animals originally served as a fireboard in a farmhouse near Troy, New York. Several other decorative paintings on wood signed by the artist were found in the same house. According to a former owner, Hidley was paid one dollar a day and room and board for the work he did in the house after it was built about 1865.[1]

No specific print source has been identified for Hidley's painting, although it is likely that he was inspired by some illustration of the event. His painted version has an almost surreal quality due to the vast empty and pastel-colored atmospheric space immediately behind the ark and the blasted tree trunk to the left. Noah is the only figure in the group facing the viewer, and his open mouth gives the impression that he is, in fact, addressing the viewer. Hidley used a variety of positions for the animals along the lower edge, perhaps to demonstrate his ability in portraying their lifelike movements and gestures. The towering palmetto-type trees and the large exotic plant beside them are picked out in the same shades of green seen in the artist's other paintings. Of his known panel pictures, this ranks among the important examples because of the fine quality of brushwork and the choice of subject.

Condition: The painting is in its original condition and has some wear at the extreme edges of the painted surface. Modern 3-inch cove-molded frame, painted black.
Provenance: Purchased by Harold Cranston, Troy, N.Y., from Paul Springer, occupant and owner of the farmhouse, in 1915; William A. Morrill, Jr., Poestenkill, N.Y.; Harry Stone, New York, N.Y.; J. Stuart Halladay and Herrel George Thomas, Sheffield, Mass.; M. Knoedler & Co.[2]
Exhibited: AARFAC, April 22, 1959–December 31, 1961; American Folk Painters; Hebrew Bible, and exhibition catalog, no. 21.
Published: Black and Lipman, illus. as no. 164 on p. 185; Tikva Frymer-Kensky, "What the Babylonian Flood Stories Can and Cannot Teach Us About the Genesis Flood," *Biblical Archaeology Review*, IV (November/December 1978), pp. 32–41, illus. on p. 33; Lipman and Armstrong, illus. on p. 99.

[1]According to AARFAC research notes provided by Harold Cranston, Paul Springer purchased the farm from the Casler family; Springer reported to Cranston the information about Hidley's wages and other panels that were originally in the house. See *Provenance* for this history.
[2]See also note 1.

Mary L. Ingraham (active ca. 1820)

183 Holy Family 35.601.1

Mary L. Ingraham
Probably Portland, Maine, possibly ca. 1820
Silk embroidery and watercolor on silk
15" x 16¾" (38.1 cm. x 42.6 cm.)

Much of the embroidery in this picture appears quite crudely worked. The trunk and leaves of the tree at right are executed entirely in French knots, as is a large portion of the base of the edifice at left. The occasional use of crimped floss helps relieve the monotony of the satin stitching that fills most of the rest of the needle-worked areas. The figures, arch, and waterfall at right, distant trees, and sky are all rendered solely in watercolor.

Mary Ingraham's name appears on a list of day scholars who attended the school of the Misses Martin in Portland, Maine, at some point during the period 1804–1829. The silk embroidery is assumed to have been worked while she was a student there, but no genealogical information about her has been found to date.[1]

Inscriptions/Marks: Indecipherable remnants of a pencil or ink inscription remain in the lower margin of the silk ground. Wording on the modern glass mat duplicates that found on an earlier, possibly original mat; script lettering in gold paint on the glass reads: "Holy Family, By Mary L. Ingraham."
Condition: Unspecified treatment has been accomplished by an unidentified conservator, probably Kathryn Scott in the 1950s. The lower margin of the silk ground has been trimmed, but tacking edges remain at top and sides. The silk ground and its original secondary support of silk have been stitched to linen and stretched over cardboard. A large tear in the sky at upper right has been backed with net, filled with similar silk, and inpainted. In other areas of the sky, smaller tears have been inpainted but not filled. The painted glass mat is a modern replacement. Possibly original 1⁵⁄₁₆-inch, cove-molded gilded frame with applied rope twist molding and quarter-round outer edge.
Provenance: Katrina Kipper, Accord, Mass.[2]
Published: AARFAC, 1940, p. 29, no. 102; AARFAC, 1947, p. 27, no. 102; AARFAC, 1957, p. 373, no. 355.

[1]The names of Mary Ingraham and Ann Ingraham (possibly Mary's sister) appear on a list of day scholars who attended the Misses Martin's Female Academy on King Street (corner of King and Newbury streets) in Portland between the years 1804 and 1829. The printed pamphlet is owned by the Maine Historical Society, Portland. It was brought to AARFAC's attention in Betty Ring to AARFAC, November 29, 1977; in the same letter, Ring noted a similarity between the background design found in *Holy Family* and that found in *The Rose and the Lily*, a needlework picture that she states has a history of having been worked at the Misses Martin's school. The latter picture is illustrated as lot no. 154 in Sotheby Parke Bernet, Garbisch II.
No connection is known between AARFAC's picture and the embroidered depictions of *Charity* and *Hope* that were executed by

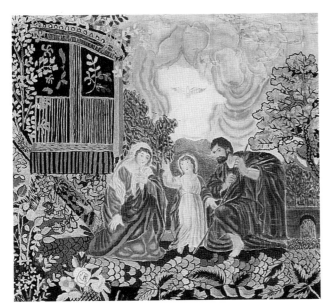

183

one Mary Ingraham and included in Sotheby Parke Bernet, Inc., *Important American Furniture*, catalog for sale no. 3371, May 19–20, 1972, lot nos. 77–78. The Mary Ingraham who executed them may have been one of the Misses Ingraham known to have attended Susanna Rowson's Academy in Boston and its vicinity (Elias Nason, *A Memoir of Susanna Rowson* [Albany, 1870], p. 204); the frames of both auctioned pictures bore the labels of James McGibbon of Boston.

²The form of Mrs. Rockefeller's notes suggests that the piece may have been owned by another individual in Accord prior to Kipper.

ings. Nothing is known of Ann Johnson beyond her name on the picture's glass mat.

Inscriptions/Marks: Lettered in gold paint on the modern glass mat is "ANN JOHNSON BAPTISAM OF OUR SAVOUR."³
Condition: Treatment by Christa Gaehde in 1955 included flattening the primary support and mending several edge and corner tears. The black-painted glass mat is a 1955 replacement. Possibly original 2⅞-inch splayed gilded frame with rounded outer edge.
Provenance: Found near Middletown, Conn., and purchased from Edith Gregor Halpert, Downtown Gallery, New York, N.Y.
Exhibited: AARFAC, Minneapolis; "Children in American Folk Art," Downtown Gallery, New York, N.Y., April 13–May 1, 1937, and exhibition catalog, p. 6, no. 11, illus. on p. 7; Hand and Spirit, and exhibition catalog, p. 98, no. 43, illus. on p. 99; Reflections of Faith.
Published: AARFAC, 1940, p. 29, no. 101; AARFAC, 1947, p. 27, no. 101; AARFAC, 1957, p. 206, no. 105, illus. on p. 207; Dewhurst, MacDowell, and MacDowell, Religious Folk Art, p. 57, no. 55; Dillenberger and Taylor, p. 98, no. 43, illus. on p. 99; Carol Fowler, "American Religious Art: Window on the Spirit," *Face to Face*, VI (April 1974), illus. on p. 20; Schorsch and Greif, p. 96.

¹Backing the picture inside the frame were found the following newspapers: *Poughkeepsie Telegraph*, July 10, 1844; *Hudson Chronicle*, Westchester County, October 22, 1844; *New York Aurora*, June 11, 1844, and July 9, 1844; *Daily Albany Argus*, June 17, 1844; and *Albany Weekly Patriot*, September 12, 1843.
²The Library of Congress owns an impression of the lithograph; it attributes the work to John Baker on the basis of a signed companion print, *The Last Supper*. See Dillenberger and Taylor, p. 100. A second depiction after Baker is known, but the artist is unidentified. See Tillou, no. 127.
³AARFAC file photos show the original glass mat to have borne lettering very similar in spacing and style to that on the present reproduction mat but to have read: "ANN JOHNSON. BABTISAM OF OUR SAVOUR."

Ann Johnson
(active ca. 1840)

184 Baptisam of Our Savour 39.301.1

Ann Johnson
America, probably New York State, probably 1836–1844¹
Watercolor and pencil on wove paper
19⅞" x 26" (50.5 cm. x 66.0 cm.)

Except for a very few touches of yellow, the greens of the foliage and the bright royal blues of several costumes constitute the only strong color notes in this picture.

The watercolor is a close copy of a lithograph copyrighted in 1836 and attributed to John Baker (active 1831–1841).² The inscription in the lower margin of the print includes "THE BAPTISAM OF OUR SAVIOUR!" as well as a transcription of Matt. 3:16–17, the biblical verses that form the subject of the render-

Betsy B. Lathrop
(active ca. 1812)

185 Jephthah's Return 39.401.1

Betsy B. Lathrop
Probably New York State or New England, possibly 1812
Watercolor on silk with gold-painted paper collage elements
20⅞" x 25⅜" (53.0 cm. x 64.5 cm.)

The existence of a very similar picture (no. 207) suggests that the two pieces were executed as an academy exercise. Both illustrate Judg. 11: 30–34, wherein the Gileadite Jephthah vows that, if the Lord will grant him victory over the Ammonites, then he will sacrifice whatever first emerges from his house to meet him on his return from war. His only child — a daughter — comes forth to greet him with timbrels and dances upon his return.

The Old Testament story must have been a popular subject with schoolgirl artists; in addition to the Folk Art Center's two closely related works, three other versions have been recorded.[1] None of the other three contains the particular building at upper left, which has been identified as a temple built in the 1730s at Stowe in Buckinghamshire, England. The Center's two silk pictures show a temple quite similar to the English edifice as illustrated in B. Seeley's 1773 guide to Stowe, although it is possible that another view may have been used as a prototype as well.[2]

Inscriptions/Marks: In ink in script on a paper label once affixed to the backboard is "The work of — Betsey Lathrope/in 1812 — /Japhthah's,—'Daughter came/out to meet him,'/Judges — XI 34, — ." Said to have been written in ink on the now missing backboard is "Painted by Betsy B. Lathrop. Given to M. A. Cornwell."[3] Many if not all of the collage elements in the painting are gold paint over a paper bearing printed wording; although some of the lettering is legible through the paint, it is too fragmented to be meaningful and has not been transcribed.

Condition: The silk support was trimmed prior to acquisition, and several collage elements are now missing. The silk support was reinforced with Japanese mulberry paper and hinged to rag board by E. Hollyday in 1977. The 2¼-inch splayed gilded frame with a flat outer edge probably dates from the first half of the nineteenth century, but it was added to the picture in 1939.[4]

Provenance: Mary Cornwell or Cornwall, Quogue, Long Island, N.Y.;[5] Mrs. A. P. (Josephine H.) Fitch, Illahee Shop, Montauk Highway, Quogue, Long Island, N.Y.

Exhibited: AARFAC, April 22, 1959–December 31, 1961; Amon Carter; Artists in Aprons; Dallas, and exhibition catalog, no. 30; Flowering of American Folk Art; Hand and Spirit, and exhibition catalog, p. 81, no. 30, illus. on p. 83; Hebrew Bible, and exhibition catalog, no. 104; William Penn Museum.

Published: AARFAC, 1940, p. 30, no. 106; AARFAC, 1947, p. 28, no. 106; AARFAC, 1957, p. 252, no. 126, illus. on p. 253; AARFAC, 1959, p. 18, no. 8; Black and Lipman, pp. 171–172, illus. as fig. 156 on p. 177; Dewhurst, MacDowell, and MacDowell, Artists in Aprons, pp. 69, 73, illus. as fig. 57 on p. 72; Dillenberger and Taylor, pp. 32, 81, no. 30, illus. on p. 83; Edith Gaines, ed., "Collectors' Notes," *Antiques,* XCI (February 1967), p. 240; Lipman and Winchester, Folk Art, p. 76, illus. as no. 101 on p. 78; Schorsch and Greif, p. 67; Marcus Whiffen, "James Gibbs and Betsy Lathrop," *Antiques,* LXVI (September 1954), p. 212.

[1]Two of the other three versions appear to have been based upon the same compositional source. One — a needlework picture — was credited to the Index of American Design when it was illustrated in Ford, Pictorial Folk Art, p. 132. The other, a watercolor ascribed to Emily Patton of Pennsylvania, was part of the collection of Edgar William and Bernice Chrysler Garbisch when it was included in Virgil Barker, "Colloquial History Painting," *Art in America,* XLII (May 1954), p. 121. The third picture, a watercolor, was also part of the Garbisch collection before it was sold at auction (see Sotheby Parke Bernet, Inc., *Fine Americana,* catalog for sale no. 4116, April 27–29, 1978, lot no. 446).

In addition to the foregoing, a small watercolor on paper showing two female figures quite similar to the two in the foreground of the Folk Art Center's two silk pictures is known. This privately

184 *Baptisam of Our Savour*, Ann Johnson

185 *Jephthah's Return*, Betsy B. Lathrop

owned watercolor shows the two figures in a very simplified land-scape setting; possibly the piece served as a guide or study sketch for one or both of the Center's pictures.

[2]The illustration from B. Seeley, *Stowe, a description of the Magnif-icent House and Gardens of the Rt. Hon. Richard . . . Earl Temple* (London and Buckingham, 1773), is included in Marcus Whiffen, "James Gibbs and Betsy Lathrop," *Antiques*, LXVI (September 1954), p. 212. Another source for the building is suggested in Edith Gaines, ed., "Collectors' Notes," *Antiques*, XCI (February 1967), p. 240.

[3]Different spellings of the artist's name are as cited. The inscription on the now missing backboard is taken from transcriptions believed to have been made from the original and first cited in AARFAC, 1940, p. 30. Note, however, that early records of Mrs. Rockefeller's give the spelling of the recipient's name as Cornwall. Note, too, that this picture has been titled *Japhthah's Return* in recent years, based, it is believed, on the spelling on the backboard label; a reversion to the more common spelling, Jephthah, has been made here, as the label is not known to have been inscribed by the artist.

[4]Edith Gregor Halpert to James L. Cogar, November 24, 1939.

[5]Mrs. Rockefeller's early records state that Cornwall (or Cornwell, see note 3) was the artist's great-niece.

Hadassah Moody
(1787–?)

186 Holy Family G71–1756

Hadassah Moody
South Hadley, Massachusetts, probably 1805–1810
Watercolor and pencil with embroidery in silk and silk chenille on a silk ground
15⅝″ x 12⅝″ (39.7 cm. x 32.1 cm.)

Hadassah Moody must have been about twenty years old, at least, when she created this needlework picture. Perhaps her age partially accounts for the fineness of

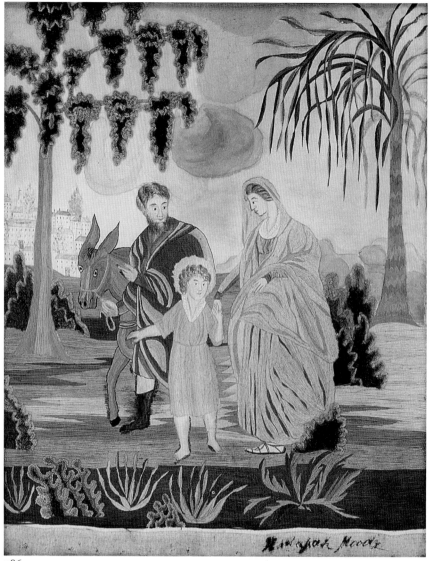

186

the picture's workmanship, which is evidenced by small, neat, uniformly worked stitches; precise outlines; handsome effects of shading; and a sophisticated manipulation of stitchery to suggest contour and dimension, as in the donkey's face and the folds of Mary's robe. Care and thought were given to pleasing effects of texture and contrast, as illustrated by the leaves of the two trees; at right, delicate ribbonlike palm fronds are rendered in plain silk threads, while at left, dense hanging clusters of foliage are more effectively suggested by chenille ones. The flatness of the foreground is relieved by two shrubs meticulously executed in French knots.

The picture is also important as a document of technical practices of the period. Points of contact between needlework and watercoloring indicate that the latter was added after the stitching, perhaps — as was

often done — by the girl's teacher or by the picture framer. Strips of linen whipstitched to all sides of the silk ground were used as a tacking edge when the framer secured the piece to a backboard; before that, they probably also secured the silk in Hadassah Moody's openwork frame while she embroidered the picture. The linen strip that now forms a visually inappropriate lower margin originally was covered by black-and-gold painting on the reverse of the picture glass. Lettering on the glass may have given a date or a picture title; in any case, it probably repeated Hadassah's name as inscribed on the linen.

Hadassah Moody was born June 29, 1787, the daughter of Seth and Mary Pomeroy Moody of South Hadley, Massachusetts. Stylistically the picture can be linked with the needlework done at Abby Wright's School in South Hadley.[1]

Inscriptions/Marks: In ink in script on the linen strip added to the lower margin of the picture is "Hadassah Moody." In ink in script on the original paper backing of the frame are several inscriptions that are quite difficult to read; part at lower right appears to read: "Burr & Smith/in the north part of North [illegible material]/ Northampton —"[2] A column of figures runs perpendicular to the inscriptions on the sheet. At middle right, the inscriptions may read, in part: "Making in all [illeg.] J. Bivor/by Asa Jony. Bivor/G [illeg.]." At center the name may be "James Harri [illeg.]" over several indecipherable words.

Condition: In 1980 E. Hollyday removed the piece from a wood backboard, mechanically removed debris from the sky area, stitched the piece to muslin, and stretched the muslin over rag board. The glass is original and retains remnants of its black-and-gold mat paint. The 1⅝-inch black painted cyma recta frame is original; gilding on the flat inner and outer edges has been covered subsequently with gold paint; two clinched wire hanging hooks remain at top.

Provenance: Anonymous donor.

Exhibited: "A Recent Gift," AARFAC, January 14–March 11, 1973.

[1]We are indebted to Betty Ring for linking the picture to Abby Wright's School, for clarification of Hadassah Moody's name, and for genealogical information in the entry (Betty Ring to AARFAC, July 14, 1984; in the same letter, Ring quoted Abby Wright as having described her students in 1804 as ranging "from 14 to 21 years old and upwards"). See Ring, Virtue, pp. 256–259, for a scholarly description of period framing techniques used on needlework pictures such as Moody's.

[2]George Burr and Elisha Smith maintained their looking-glass factory in Northampton, Mass., during the period November 1809– ca. June 1810. For more information, see Ring, Looking-Glass, p. 1180.

Jenny Emily (Merriman?) Snow (active ca. 1850)

See Snow entry in "Views of Towns" for biographical information.

187 Belshazzar's Feast 58.101.4

Attributed to Jenny Emily (Merriman?) Snow
Possibly Hinsdale, Massachusetts, possibly ca. 1850[1]
Oil on canvas
18" x 24" (45.7 cm. x 61.0 cm.)

Unlike most amateur artists who used black-and-white prints to guide their own versions in paint, Snow made no attempt to introduce color into her *Belshazzar's Feast.* The oil is executed in grisaille. Perhaps she felt that the extreme tonalities of black and white helped heighten the drama of the scene. Or perhaps she had run short of colors!

In any event, Snow's composition is a close copy, albeit reversed, of a famous oil completed in 1820 by

187

188

the English painter John Martin (1789–1854). Martin's composition was reproduced in several forms over a number of years,[2] and no doubt Snow derived her painting from one such print that flopped, or reversed, the design. The Folk Art Center has an engraving after Martin, but the example it owns does not reverse the original composition.[3]

The theme that inspired Martin, Snow, and other artists is found in Dan. 5:1–13, 24–28. The passage relates the feast of King Belshazzar, at which he served himself and his guests from gold and silver goblets taken from the temple in Jerusalem by his father, Nebuchadnezzar. Afterward the fingers of a large hand wrote on the wall an unintelligible message, which was interpreted to the frightened gathering by Daniel as this: "God hath numbered thy kingdom, and finished it. Thou art weighed in the balances, and art found wanting. Thy kingdom is divided, and given to the Medes and Persians."

Condition: Unspecified treatment by Russell J. Quandt in 1960 included cleaning the painting, lining the canvas, filling and inpainting scattered areas of very minor paint loss, and replacing the auxiliary support. Possibly original 2⅜-inch molded and gilded frame.

Provenance: J. Stuart Halladay and Herrel George Thomas, Sheffield, Mass.

Exhibited: Artists in Aprons; "Biblical Themes in American Folk Art," Jewish Museum, New York, N.Y., April 20–June 15, 1954, and exhibition catalog, no. 23, illus. on unnumbered p.; Halladay-Thomas, Albany, and exhibition catalog, no. 26 (dated 1845); Halladay-Thomas, New Britain, and exhibition catalog, no. 74 (dated 1845); Halladay-Thomas, Syracuse, and exhibition catalog, no. 17 (dated 1850).

Published: Dewhurst, MacDowell, and MacDowell, Artists in Aprons, p. 94, illus. as fig. 81 on p. 95; Ford, Pictorial Folk Art,

illus. on p. 109; William H. Gerdts, "Allston's 'Belshazzar's Feast,' " Art in America, LXI (March–April 1973), p. 62, illus. on p. 63; Henry A. La Farge, "Reviews and Previews: Biblical Themes," Art News, LIII (May 1954), p. 44.

[1]See note 4 of Snow's biographical entry, which cites Halladay and Thomas's belief that the artist completed Belshazzar's Feast in 1845 when she was fifteen years old. Since they dated the painting 1850 later, when they exhibited it at Syracuse, they must have found insufficient grounds to substantiate their earlier claim.

[2]The historical popularity of the subject of Belshazzar's feast and particularly renderings of the theme by Martin and Washington Allston are discussed in William H. Gerdts, "Allston's 'Belshazzar's Feast,' " Art in America, LXI (March–April 1973), pp. 59–66; and in William H. Gerdts, "Belshazzar's Feast II: 'That Is His Shroud,' " Art in America, LXI (May–June 1973), pp. 58–65.

[3]AARFAC's print (acc. no. 74.1100.1) was engraved by Adam B. Walter (1820–1875) and published by J. C. McCurdy & Co. of Philadelphia.

Mrs. H. Weed
(active ca. 1800)

188 Death of Abel 57.601.1

Mrs. H. Weed
America or England, probably 1790–1810
Silk embroidery and watercolor on silk
24⁹⁄₁₆″ x 29⅛″ (62.4 cm. x 74.0 cm.)

In the late eighteenth and early nineteenth centuries, it was somewhat unusual for married women to undertake pictorial embroideries, for generally only young girls had the leisure to devote to such time-consuming,

genteel pursuits. Mrs. H. Weed may have been a young widow; in any case, she probably belonged to a well-to-do family.

The print source for this ambitious floss and chenille embroidery with watercolor has not yet been identified, but the scene's sentimentality is quite compatible with a written description given by Salomon Gessner in *The Death of Abel*, which was first translated into English in 1761.[1] The biblical account appears in Gen. 4:1–16.

Inscriptions/Marks: The glass mat is lettered in gold paint: "DEATH OF ABEL" between the phrases "EMBROIDERED BY" and "Mrs H. WEED."

Condition: The piece retains most of an original secondary support of linen. Unspecified treatment by Kathryn Scott in 1957 and 1961 included replacing most of the upper left quarter of the linen secondary support with silk, probably in order to provide a sympathetic surface for inpainting several losses and tears in the sky, and adhering the piece to muslin and cardboard with a synthetic adhesive. In 1976 E. Hollyday removed the cardboard backing and sewed the muslin to rag board covered with an additional piece of muslin. The painted glass is a modern replacement. Probably period replacement 2-inch gilded and lacquered flat frame with liner and half-round molding trimming the outer edge.

Provenance: A direct descendant of the maker, Kingston, N.Y.; unidentified owner;[2] Edith Gregor Halpert, Downtown Gallery, New York, N.Y.

Exhibited: "Biblical Themes in American Folk Art," Jewish Museum, New York, N.Y., April 20–June 15, 1954, and exhibition catalog, no. 3; Hand and Spirit, and exhibition catalog, p. 94, no. 40, illus. on p. 95; Reflections of Faith.

Published: Dewhurst, MacDowell, and MacDowell, Religious Folk Art, p. 102, no. 129; Dillenberger and Taylor, p. 94, no. 40; Schorsch and Greif, p. 43.

[1]See Dillenberger and Taylor, p. 94, for the pertinent passage quoted from Gessner. This source states that Gessner's book was translated into English in 1778, but it also cites the third edition as having been published in London in 1762. The British Museum, *General Catalogue of Printed Books to 1955*, X (New York, 1967), p. 44, lists an English translation published in 1761, presumably the first.

[2]Information about the picture's first two owners is from Halpert notes on file at AARFAC.

Unidentified Artists

189 Adoration of the Magi 64.101.1

Artist unidentified
New York State, probably Schenectady,
possibly ca. 1740
Oil on canvas
29¾" x 36⅝" (75.6 cm. x 93.0 cm.)

Although the artist remains unidentified to date, several other scripture paintings stylistically attributable to the artist are known.[1] The inscription in the lower margin refers to the second chapter of the evangelist Matthew, where the biblical account of the adoration of the Magi appears. The story, however, includes no allusion to the group of soldiers, whose spears create such dramatic silhouettes here. Their appearance in the painting is believed to be a continuance of a Re-

189

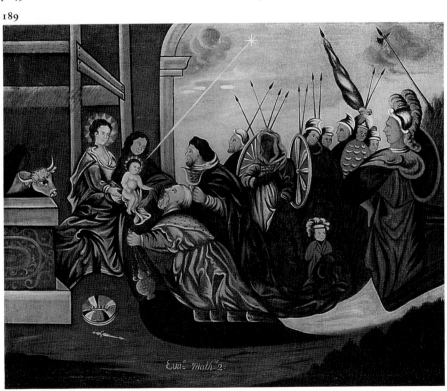

naissance convention that symbolized Herod's decree of slaughter for all the young children of Bethlehem. The round object on the ground at left is the kneeling Magus's crowned hat.

Inscriptions/Marks: In white paint in the lower margin is "Eva$\overline{\underline{n}}$ Math = 2." In black paint on the reverse of the upper frame member are the initials "E S."

Condition: Treatment by Russell J. Quandt in 1964–1966 included lining, replacing the original strainers, cleaning, and filling and inpainting relatively minor paint losses, most notably along the lines of the strainers. The original 3¼-inch cove-molded, black-painted frame has flat inner and outer edges; it has been stripped and repainted, and its corner splines have been replaced.

Provenance: Descended in the Glen-Sanders family, Scotia, N.Y.

Exhibited: AARFAC, September 15, 1974–July 25, 1976; "The Glen-Sanders Collection from Scotia, New York," AARFAC, January 23–28 and January 30–February 4, 1966, and exhibition catalog, p. 11, no. 5; Hand and Spirit, and exhibition catalog, p. 36, no. 2, illus. on p. 37; "Merchants and Planters of the Upper Hudson Valley, 1700–1750," AARFAC, January 15–February 26, 1967, and exhibition checklist; "A Remnant in the Wilderness: New York Dutch Scripture History Paintings of the Early Eighteenth Century," traveling exhibition organized by the Albany Institute of History and Art, Albany, N.Y., November 15, 1979–June 30, 1980.

Published: AARFAC, 1974, p. 59, no. 56, illus. on p. 60; Dewhurst, MacDowell, and MacDowell, Religious Folk Art, p. 73, no. 96; Dillenberger and Taylor, p. 36, no. 2, illus. on p. 37; Piwonka and Blackburn, Remnant, p. 35, no. 14; Schorsch and Greif, illus. on p. 90.

[1] A thorough analysis and contextual interpretation of this painting and related works may be found in Piwonka and Blackburn, Remnant, which is also the source of the history of the motif of the soldiers. For additional comment, see Dillenberger and Taylor, p. 36.

190 The Finding of Moses 64.101.2

Artist unidentified
New York State, probably Schenectady, possibly ca. 1740
Oil on blue and white plain linen
27¼" x 35⅛" (69.2 cm. x 89.2 cm.)

This painting is the Folk Art Center's earliest rendering of Exod. 2:1–10. It bears close stylistic and technical relationships to the museum's other early painting *Adoration of the Magi* (no. 189), yet different artists are believed to have been responsible for the two.[1]

The Finding of Moses seems to have been based on an illustration in one of two nearly identical editions of a Dutch Bible produced by Pieter and Jacob Keur of Dortrecht; the first appeared in 1719,[2] the

190

191

second in 1730. It has been suggested that the painter may have used a concave lens to facilitate translation of the print's vertical format into the oil's horizontal one, but it is also possible that some other, as yet undiscovered, version of the early print was used.

Inscriptions/Marks: In white paint in the lower margin is "Exodus−2 = ."

Condition: Treatment by Russell J. Quandt in 1964–1966 included lining and cleaning the canvas, mounting same on new stretchers, and very extensive filling and inpainting of areas of loss. Modern replacement 3¼-inch, cove-molded, black-painted frame, with flat inner and outer edges.

Provenance: Descended in the Glen-Sanders family, Scotia, N.Y.

Exhibited: "The Glen-Sanders Collection from Scotia, New York," AARFAC, January 23–28 and January 30–February 4, 1966, and exhibition catalog, p. 11, no. 4; Hand and Spirit, and exhibition catalog, p. 38, no. 3, illus. on p. 39; "Merchants and Planters of the Upper Hudson Valley, 1700–1750," AARFAC, January 15–February 26, 1967, and exhibition checklist; "A Remnant in the Wilderness: New York Dutch Scripture History Paintings of the Early Eighteenth Century," traveling exhibition organized by the Albany Institute of History and Art, Albany, N.Y., November 15, 1979–June 30, 1980.

Published: Dillenberger and Taylor, p. 38, no. 3, illus. on p. 39; Piwonka and Blackburn, Remnant, p. 34, no. 13; Schorsch and Greif, illus. on p. 69.

[1]A thorough analysis and contextual interpretation of this painting and related works may be found in Piwonka and Blackburn, Remnant.

[2]The 1719 Bible illustration is reproduced in Piwonka and Blackburn, Remnant, on p. 34.

191 The Prodigal Son Reveling with Harlots 59.301.4

Artist unidentified
Probably Pennsylvania, possibly Lancaster County, possibly ca. 1790
Watercolor and ink on laid paper
5¹⁵⁄₁₆" x 7" (15.1 cm. x 17.8 cm.)

Not only brightly and imaginatively colored but also replete with decorative detailing, this watercolor of a frolicking foursome is presumed to represent the episode of the prodigal son reveling with harlots as incorporated in the complete parable related in Luke 15:11–32. Youth's downfall into decadence is illustrated by the figures' suggestive poses and a blatant display of wine bottles and glasses; beneath the table, a gaunt cat clutches a hapless mouse in its jaws and perhaps symbolizes impending despair. However, the ladies' cheerful sprigged dresses, the men's blue and red dashed stockings, and the extensive use of vivid primary colors in sometimes unexpected combinations all serve to create an atmosphere of gaiety and conviviality.

Inscriptions/Marks: A largely illegible and unidentifiable watermark, perhaps a fleur-de-lis, is visible at middle right in the primary support.

Condition: In 1959 or 1960, Christa Gaehde removed a secondary support; cleaned the primary support; repaired several tears; and filled and inpainted a number of losses, including a 3-inch horizontal one above center in the primary support, most of the larger man's right shoe, and most of the left margin. In 1980 E. Hollyday removed some old fills and inserted new ones; reduced stains; realigned and repaired tears; and backed the primary support with Japanese mulberry paper. Probably period replacement 1-inch gilded cyma recta frame with gadrooned outer edge.

Provenance: Found in Lancaster County, Pa.; Elie Nadelman, Riverdale, N.Y.; Martin Grossman, New York, N.Y.

Exhibited: Flowering of American Folk Art; Washington County Museum, 1965.

Published: Black, Folk Artist, illus. on p. 90; Book Preview, 1966, p. 126, illus. on p. 126; Booth, illus. on p. 213; Dewhurst, MacDowell, and MacDowell, Religious Folk Art, p. 120, no. 157; Stanley Kunitz, "Words for the Unknown Makers," *Craft Horizons,* XXXIV (February 1974), p. 34; Lipman and Winchester, Folk Art, p. 78, no. 102; Harold Rosenberg, *Art on the Edge: Creators and Situations* (New York, 1971), pp. 290, 292, illus. on p. 291.

The Parable of the Good Samaritan

Artist unidentified
Probably New England, possibly Vermont, possibly 1795–1815
Oil on maple panels
19⅝" x 27⅛" (49.9 cm. x 68.9 cm.)
20" x 27 1/16" (50.8 cm. x 68.7 cm.)
20" x 27 1/16" (50.8 cm. x 68.7 cm.)
20" x 27⅛" (50.8 cm. x 68.9 cm.)
19½" x 27" (49.5 cm. x 68.6 cm.)
19⅛" x 27 3/16" (48.6 cm. x 69.1 cm.)

An amateur painter's reliance upon available models ensured that exotic subjects were often reinterpreted in terms of the artist's everyday life. Thus, the series of paintings illustrating the parable of the Good Samaritan (Luke 10:30–34) includes details more appropriate to late eighteenth- or early nineteenth-century America than Jerusalem in Jesus' time: for instance, architectural features of the inn and its signboard, individual structures included in the townscapes, and details of the figures' attire.

While the costumes suggest a late eighteenth-century date, conservative, slightly outmoded garb may have been considered appropriate to the subject matter well into the nineteenth century. However, the turban worn by one of the thieves, and certainly the men's beards, would appear to be conscious attempts to evoke a biblical atmosphere, since neither was common near the turn of the century in eastern America.

A skilled and meticulous hand is evident in the paintings' beautifully executed inscriptions and in many fine details, such as the Samaritan's facial features in no. 195. Yet little understanding of basic painterly techniques is shown in the unconvincing shallowness of the picture plane and in the flat treatment of the foliage. Inept attempts at foreshortening are especially evident in the body of the horse in no. 195, where the effort contributes to the beast's very startled appearance.

Inscriptions/Marks: On the reverse of no. 195 in large brush strokes and possibly in the same black paint as that used on the frames is "$30," followed by an illegible marking in the same paint. In black paint in script in the paintings' lower margins appear the following inscriptions, one on each panel in consecutive order: "And Jesus answering said, A certain man went down from Jerusalem to Jericho, Luke, C. 10. V. 30." "And fell among thieves, which stripped him of his raiment, and wounded him, and departed, leaving him half dead. Luke C. 10. V. 30." "And by chance there came down a certain Priest that way; and when he saw him, he passed by on the other side. Luke, 10. 31./And likewise a Levite, when he was at the place, came and looked on him, and passed by on the other side. Luke, 10. 32." "But a certain Samaritan, as he journeyed, came where he was: and when he saw him, he had compassion on him, Luke, 10. 33./And went to him, and bound up his wounds, pouring in oil and wine, Luke, 10. 34." "And set him on his own beast, Luke, 10, 34." "And brought him to an inn, and took care of him. Luke, 10. 34."

Condition: The panels have been cleaned and inpainted, but the respective work of the following individuals cannot be precisely defined. Treatment may have been undertaken by an unidentified conservator in Hartland, Vt., prior to acquisition.[1] David Rosen worked on the panels probably in or shortly before 1936, as did Russell J. Quandt in 1955. The amount of inpainting varies from relatively little in no. 195 to very extensive in no. 197. Most areas of inpainting are small and scattered except for the upper and lower edges of the panels, where strips about ⅜ inch wide have been completely inpainted. The paintings are in a matched set of probably period replacement 3-inch, black-painted cyma recta frames with remnants of leather hanging straps on the backs of the upper members; silver-lacquered liners appear to have been added to the frames at some later date.[2]

Provenance: The paintings are said to have hung originally in an inn at Woodstock, Vt.; they were owned by an unidentified Mississippi collector before being found in Hartland, Vt., and purchased from Edith Gregor Halpert, Downtown Gallery, New York, N.Y.[3]

Exhibited: Number 194 only: "The Nude in American Painting," Brooklyn Museum, October 9–December 7, 1961, and exhibition catalog, no. 3.

Published: AARFAC, 1940, p. 23, nos. 42–47, no. 194 only illus. on p. 22; AARFAC, 1947, pp. 18–19, nos. 42–47, no. 194 only illus. on p. 18; AARFAC, 1957, pp. 58–63, nos. 27–32; Dewhurst, MacDowell, and MacDowell, Religious Folk Art, no. 194 only illus.

192

193

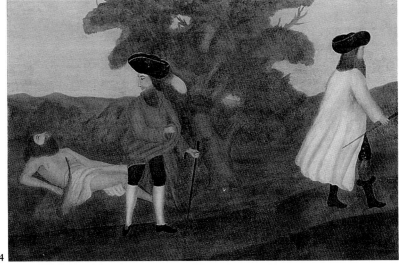

194

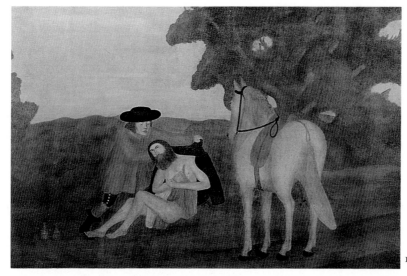

195

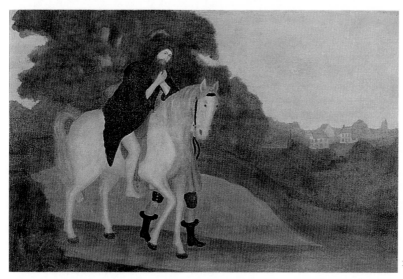

196

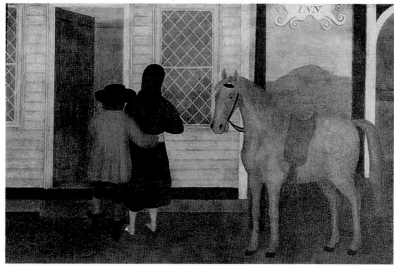

197

as fig. 156 on p. 120; "Native Primitives Complement the Williamsburg Restoration," *Art News*, XXXVII (April 15, 1939), p. 12, nos. 195 and 197 only illus. on p. 13; Schorsch and Greif, no. 194 only illus. on p. 113 and no. 197 only illus. on p. 92.

[1]See *Provenance*. Halpert notes on file at AARFAC indicate that the paintings had been sent to Hartland, Vt., "for restoration."

[2]As evidenced by corresponding markings and discoloration on the reverses of both frames and panels, the paintings appear to have hung in their present frames for some time, although probably not before the liners were added. Regularly spaced nail holes in the side edges of all panels and the absence of original paint on upper and lower panel edges suggest that originally the scenes were secured within some other type of framework.

[3]Photocopies of Halpert records are on file at AARFAC.

198 Absalom Slain by Joab 39.301.2

Artist unidentified
Probably New England, possibly Massachusetts, possibly 1800–1820
Watercolor, ink, and pinpricking on wove paper
7¾" x 5¾" (19.7 cm. x 14.6 cm.)

According to the Old Testament, Absalom was King David's third son. He was strikingly handsome and especially noted for his abundant hair, although this feature perhaps proved his downfall in the rebellion he fomented against his father. In an attempt to escape the forces of Joab, King David's commander in chief, Absalom caught his head — tradition says his hair — in the branches of a tree, and he was held fast until Joab drew nigh and struck him through the heart with three darts.[1]

An anonymous engraving in an English Bible published in London between 1675 and 1682 shows a composition identical to that here, but possibly some later, intermediary print was used as a guide by the artist of the Center's piece. The inscriptions below the engraved and watercolored compositions differ somewhat, and the subjects' costumes are significantly updated in the latter.[2]

The watercolor has long been ascribed to Caroline Joy (1819–1842), and this attribution remains a possibility. However, the evidence for it is circumstantial, and details of the figures' costumes suggest a date earlier than she would have been active.[3]

Inscriptions/Marks: In ink in the upper margin is "ABSALOM slain by JOAB." In ink in the lower margin in script is "And Absalom rode upon a mule, and the mule went under/the bows of a great Oak and his head caught hold of of [*sic*] the oak and he was/taken up between the heaven and the earth: and the mule that was under him/ went away. II Sam. Chap. 18th/ver. 9."
Condition: Unspecified treatment by Christa Gaehde in 1955 included cleaning, reducing water stains, and hinging to a backing. In 1974 E. Hollyday replaced the earlier hinges, and in 1977 she dry-cleaned unpainted areas and flattened the primary support.

198

Probably period replacement 1-inch, black-painted frame with flat outer edge enclosing two half-round moldings.
Provenance: Found in Andover, Mass., and purchased from Bessie J. Howard, Boston, Mass.
Exhibited: AARFAC, September 15, 1974–July 25, 1976; Artists in Aprons.
Published: AARFAC, 1940, p. 30, no. 105; AARFAC, 1947, p. 28, no. 105; AARFAC, 1957, p. 136, no. 68, illus. on p. 137 (attributed to Caroline Joy); AARFAC, 1974, p. 57, no. 53, illus. on p. 57 (attributed to Caroline Joy); Dewhurst, MacDowell, and MacDowell, Artists in Aprons, illus. as fig. 55 on p. 71 (attributed to Caroline Joy); Schorsch and Greif, p. 77, illus. on p. 76 (attributed to Caroline Joy).

[1]E. S. Whittlesey, *Symbols and Legends in Western Art* (New York, 1972), p. 3, and 2 Sam. 18:9–14.

[2]The engraving appears as pl. 44 in a Bible owned by the Prints Division of the New York Public Library in New York City. The inscription below it is a composite of lines from 2 Sam. 18:9, 10, 14, whereas the watercolor version shows wording taken only from verse 9.

[3]Attribution of the piece to Caroline Joy has been based on the fact that a Joy family record was found in the frame behind the Absalom picture, along with a separate slip showing the name Caroline written repetitively. Several different hands are evident in the record inscriptions, none of them appearing to match that on the watercolor. According to the record, Caroline and her twin sister, Emeline, were born June 15, 1819, the fourth and fifth children of Leonard Joy and his wife, Polly Warner Joy (both b. 1790), who

199

were married in 1811. The Joy family lived in Plainfield, Mass., according to Lucien C. Warner and Josephine Genung Nichols, comps., *The Descendants of Andrew Warner* (New Haven, 1919), p. 397.

199 Moses in the Bulrushes 58.601.2

Artist unidentified
Connecticut, ca. 1805
Watercolor and sequins with embroidery in silk, silk chenille, and metallic threads on a silk satin-weave ground
16⅞" x 15⅝" (42.9 cm. x 39.7 cm.)

Several elements link this embroidered picture to others thought to have been worked at the Misses Patten's School in Hartford about the same time: the hovering raised-work eagle executed in metallic threads at center top, the floral swag he appears to hold in his beak, and the U-shaped border of flowers and wheat stalks below the oval.[1]

See nos. 190, 200, and 212 for other renderings of the story of Pharaoh's daughter's discovery of the infant Moses floating in the Nile as recounted in Exod. 2:1–10.

Inscriptions/Marks: Lettered in gold paint on the eglomise mat is "MOSES IN THE BULLRUSHES."

Condition: Unspecified treatment by Christa Gaehde in 1958 or by an unidentified conservator prior to that included partially trimming the two linen strips originally sewed to the top and bottom edges of the silk to form tacking surfaces; sewing a linen strip to the right (selvage) edge of the silk; and sewing and gluing the object to muslin glued to matboard. The eglomise mat is a replacement whose wording probably duplicates that found on the original glass. Probably period replacement 1⅝-inch gilded cove-molded frame with decorative gouge carving in the quarter-round outer edge.

Provenance: J. Stuart Halladay and Herrel George Thomas, Sheffield, Mass.

Exhibited: Halladay-Thomas, New Britain, and exhibition catalog, no. 60.

Published: Dewhurst, MacDowell, and MacDowell, Religious Folk Art, illus. as fig. 56 on p. 57; Schorsch and Greif, p. 61.

[1]Too many related pieces have been recorded to list them individually, but included among the more direct comparisons are Lucretia Colton's nearly identical picture (see Harbeson, fig. no. 1 facing p. 83); Sally Ely's *David and Jonathan* (see Israel Sack, Inc., *Opportunities in American Antiques* [brochure no. 34 for May 1, 1980], p. 40); and four renderings called *Charity*. One *Charity* was worked by Sarah Marshall and was illustrated in Elisabeth Donaghy Garrett, "American Samplers and Needlework Pictures in the DAR Museum, Part I: 1739–1806," *Antiques*, CV (February 1974), pl. II on p. 359; a second *Charity* was worked by Louisa Bellows and illustrated in Israel Sack, Inc., *Opportunities in American Antiques* (brochure no. 28 for May 1, 1976), p. 20; Mary Hathaway's *Charity* is owned by the New-York Historical Society, New York City; and a *Charity* by Eliza Stone is owned by the Cincinnati Art Museum.

For a discussion of the Misses Patten's School and the characteristics of its needlework, see Deutsch and Ring, p. 406.

200

200 Moses in the Bulrushes 31.401.3

Artist unidentified
America, probably ca. 1810
Watercolor on silk
21⅛" x 17⁷⁄₁₆" (53.7 cm. x 44.3 cm.)

Pastel hues of pink and blue-green watercolor combine with deft linear treatment of the figures to convey a particular sense of lightness and delicacy in this rendering of Exod. 2:1–10. (For other versions of the subject at the Center, see nos. 190, 199, and 212.)

Condition: The silk has been trimmed on all edges. Treatment by Kathryn Scott in 1954 or 1955 included mending several tears, most notably two horizontal ones near center, and adhering the support to paper-covered cardboard. In 1954 or 1955 the Old Print Shop flush-mounted the stretched work within a cardboard surround. The black-and-gold eglomise mat was added in 1954. Period replacement 1½-inch splayed gilded frame.
Provenance: Found in New Haven, Conn., and purchased from Edith Gregor Halpert, Downtown Gallery, New York, N.Y.[1]
Exhibited: AARFAC, South Texas; AARFAC, April 22, 1959–December 31, 1961; American Folk Art, Traveling; Amon Carter; Goethean Gallery; Hebrew Bible, and exhibition catalog, no. 57; William Penn Museum.
Published: AARFAC, 1940, p. 30, no. 104; AARFAC, 1947, p. 28, no. 104; AARFAC, 1957, p. 238, no. 119, illus. on p. 239; AARFAC, 1959, p. 18, no. 7, illus. on p. 19; Cahill, American Folk Art, p. 36, no. 49, illus. on p. 83; Ford, Pictorial Folk Art, illus. on p. 110; Schorsch and Greif, p. 26.

[1] Cahill's statement that this piece was "found near Wells, Maine," is believed to be in error (see Cahill, American Folk Art).

The Parable of the Prodigal Son

201	The Prodigal Son Receiving His Patrimony	34.301.2
202	The Prodigal Son Reveling with Harlots	34.301.3
203	The Prodigal Son in Misery	34.301.4
204	The Prodigal Son Reclaimed	34.301.5

Artist unidentified
America, possibly Connecticut,[1] ca. 1810
Watercolor on wove paper
11¹³⁄₁₆" x 9¹⁵⁄₁₆" (30.0 cm. x 25.2 cm.)
11¾" x 10" (29.9 cm. x 25.4 cm.)
12" x 10¹⁄₁₆" (30.5 cm. x 25.6 cm.)
11¹⁵⁄₁₆" x 9⅞" (30.3 cm. x 25.1 cm.)

The same hand is evident in these serial illustrations of the parable of the prodigal son (Luke 15:11–32), and presumably the four were meant to be hung as a set despite the fact that only the first and third were drawn within spandrel formats.

The subject was a favorite among nineteenth-century amateur artists, who often based their compositions upon available prints. These watercolors appear to have derived from a set that was engraved by W. B. Walker and published in London June 17, 1805.[2]

Inscriptions/Marks: In pencil in script in a lower margin reserve on the first picture is "The Prodigal Son Recieving [sic] his Patrimony." Faint signs of a now illegible pencil inscription appear below the second pictorial composition. In pencil in script in a lower margin reserve on the third picture is "The Prodigal Son in misery.—" In the blank lower margin of the fourth picture in penciled script is "The Prodigal Son Reclaimed.—"
Condition: Treatment by Christa Gaehde in 1954 included removing nos. 201, 203, and 204 from wood secondary supports, reducing stains, fumigating, and mending edge tears. In 1980 E. Hollyday dry-cleaned unpainted areas, remended tears, filled and inpainted small losses, and backed the primary support with Japanese mulberry paper. Period replacement 1½-inch red painted, flat, mahogany-veneered frames.
Provenance: Edith Gregor Halpert, Downtown Gallery, New York, N.Y.
Exhibited: AARFAC, April 22, 1959–December 31, 1961.
Published: AARFAC, 1940, p. 30, nos. 107–110 (attributed to Amos Doolittle); AARFAC, 1947, p. 28, nos. 107–110 (attributed to Amos Doolittle); AARFAC, 1957, pp. 192–195, nos. 96–99; AARFAC, 1959, p. 20, no. 10; American Art Association–Anderson Galleries, Inc., *Pictorial Americana,* catalog for sale no. 4116, May 17–18, 1934, p. 30, no. 88 (attributed to Amos Doolittle), no. 204 only illus. on p. 29; Ford, Pictorial Folk Art, no. 204 only illus. on p. 108.

[1] The pictures were purchased in 1934 bearing modern framer's labels reading: "J. Francis Saunders/Picture Frame Shoppe/189 Church St./Hartford/Conn."
[2] AARFAC owns an impression of the engraving (transferred to glass and reverse-painted) that served as the compositional source for watercolor no. 204 only; the print, like the watercolors, is assumed to have been one of a set of four.

201

202

203

204

205 Ruth and Boaz 79.601.6

Artist unidentified
Probably New England, ca. 1810
Silk embroidery and watercolor on silk
19⅞" x 23¾" (50.5 cm. x 60.3 cm.)

Biblical stories inspired many schoolgirls' needlework projects early in the nineteenth century. Here Boaz has discovered Ruth in his field gleaning after the reapers. Crinkly silk chenille thread predominates in the embroidery and creates a rich surface texture. The contrasting effect of smooth silk thread used for a patch of golden wheat in the middle ground attracts the viewer's attention to the central figures. Facial expressions and background details, including the figures of three reapers resting at right, are painted on the silk ground. An illustration that probably inspired the unidentified needleworker has not been located.

Condition: The primary support has been stitched to a linen secondary support. In 1983 E. Hollyday removed an acidic backing, dry-cleaned the surface, and mounted the embroidery on a nonacidic support. Possibly original 2-inch, bird's-eye maple cyma reversa frame.

Provenance: Found in Hingham, Mass.; acquired from Katrina Kipper, Accord, Mass., January 30, 1936, for use at Bassett Hall, the Williamsburg home of Mr. and Mrs. John D. Rockefeller, Jr.

206 Encampment Scene 58.401.2

Artist unidentified
America, probably 1810–1830
Watercolor and cut gold paper on silk
11⅞" x 14⅞" (30.2 cm. x 37.8 cm.)

No print source for this composition has been found to date, and identification of the subject remains inconclusive. Another version of the same scene has been

205

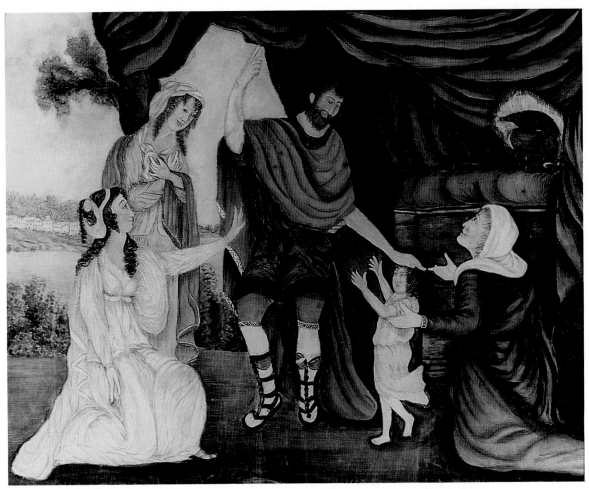

206 *Encampment Scene*

207 *Jephthah's Rash Vow*

identified tentatively as the biblical story of Japhthah's rash vow (Judg. 11:30–34), but since amateur artists of the nineteenth century usually depicted Japhthah's daughter as a young woman rather than a child, some doubt is cast on the hypothesis.[1]

Condition: Unspecified treatment by Kathryn Scott in 1961 included adhering the silk to muslin and the muslin to a cardboard backing. In some areas, small portions of the painted silk ground were turned over onto the reverse. Glass was secured over the face of the painting by masking tape at the outer edges; the subsequent removal of this tape has resulted in some losses in the edges of the silk ground, mostly unpainted portions. Modern replacement 1½-inch cyma recta gold-painted frame with applied beading and lamb's-tongue decoration.
Provenance: J. Stuart Halladay and Herrel George Thomas, Sheffield, Mass.

[1]The other version of the same scene is a watercolor on paper owned by Old Sturbridge Village, Sturbridge, Mass. See Schorsch and Greif, p. 68.

207 Jephthah's Rash Vow 83.401.1

Artist unidentified
Probably New York State or New England, possibly 1812
Watercolor on silk with gold paper collage elements
21⅜" x 24¹⁵⁄₁₆" (54.3 cm. x 63.3 cm.)

Not only is this piece compositionally very similar to no. 185, but the painting techniques used to create the two are also closely related. In fact the execution of the faces of the figures in both appear to have been done by the same hand, perhaps by the instructor in the artists' drawing class.

Inscriptions/Marks: The printed legend on a paper scrap glued at lower center in the picture reads "JEPHTHAH'S RASH VOW./'O! Father of light; said the conquering Chief,/The vow which I made, I renew,/The first being I meet, when I welcome again/The Land of my Fathers — I left not in vain, — /With the flames on thy altar shall rise.'/O listen! at distance, what wild music sounds,/And at distance what maiden appears?/See forward she comes, with a light springing bound,/And casts her mild eyes in fond extacy [*sic*] round,/For a parent is seen coming near!/In wild horror he starts — as a fiend had appeared;/His eyes in mute agony close,/'My daughter! O God!' — not the terror of fight,/While legions on legions against him unite,/Could bring to his soul such alarms."
Condition: Tears in the silk support were secured with both masking tape and adhesive tape, and tears in the drapery at right were disguised by a similarly colored backing prior to acquisition. Modern replacement 1⅜-inch flat frame, painted gold.
Provenance: Mr. and Mrs. Lincoln C. Haynes, Springfield, Mass.; gift of Ralph L. and Rachel H. Shriner, Dallas, Tex.[1]

[1]Rachel H. Shriner (1901–1980) was the daughter of Mr. and Mrs. Lincoln C. Haynes. The painting is believed to have hung in the Hayneses' Springfield home from the late nineteenth century ("the painting was in the home of Mr. and Mrs. Lincoln C. Haynes . . . for about 100 years [?]." Ralph L. Shriner to AARFAC, May 15, 1983).

208 Rebecca at the Well 31.301.1

Artist unidentified
Probably New England, probably ca. 1815
Watercolor and pencil on wove paper
15" x 18⁷⁄₁₆" (38.1 cm. x 46.8 cm.)

The existence of another rendition of this composition supports the assumption that some print source guided the artist.[1] In the Folk Art Center's version, the striated shading and careful stippling of much of the vegetation simulates the appearance of silk embroidery.

The watercolor illustrates Genesis, chapter 24, in which Abraham sends a servant to his homeland to find a wife for his son, Isaac. When Rebecca fulfills the sign by which she is to be recognized — drawing water for the servant and his camels — he presents her with gold bracelets and an earring. The biblical passage makes no mention of the black child shown extending the gold adornments, and it is possible that the original creator of the composition misunderstood the allusion to a "servant."

Inscriptions/Marks: A partial watermark at lower right is not entirely legible; it appears to read "R[oot?] & T[i . . .]/ . . . 80. . . . "
Condition: Treatment by Christa Gaehde in 1955 included mending several tears. In 1976 E. Hollyday set down flaking paint, leached out acidity in the primary support, filled and inpainted brad holes around the perimeter, reduced insect stains, and backed the sheet with Japanese mulberry paper. Possibly original 1⅞-inch, cove-molded gilded and painted frame with applied rope-twist molding.
Provenance: Found in Bridgeport, Conn., and purchased from Edith Gregor Halpert, Downtown Gallery, New York, N.Y.
Exhibited: AARFAC, April 22, 1959–December 31, 1961; American Folk Art, Traveling; "American Art, Four Exhibitions," Brussels Universal and International Exhibition, April 17–October 18, 1958, and exhibition catalog, p. 41, no. 64; Pine Manor Junior College; William Penn Museum.
Published: AARFAC, 1940, p. 29, no. 103; AARFAC, 1947, p. 28, no. 103; AARFAC, 1957, p. 156, no. 78, illus. on p. 157; AARFAC, 1959, p. 17, no. 4; Cahill, American Folk Art, p. 36, no. 48, illus. on p. 82; Schorsch and Greif, p. 54.

[1]A nearly identical composition is owned by the New York State Historical Association, Cooperstown, N.Y., and it is signed on the eglomise mat: "Mary Parke."

209 Joseph Interpreting Pharaoh's Dreams 31.301.2

210 Joseph Introducing His Brethren 31.301.3

Artist unidentified
Probably Pennsylvania, New York State, or New England, possibly ca. 1815
Watercolor, ink, and pencil on laid paper
8¹³⁄₁₆" x 11¹⁄₁₆" (22.4 cm. x 28.1 cm.)
8¹³⁄₁₆" x 11³⁄₁₆" (22.4 cm. x 28.4 cm.)

208 *Rebecca at the Well*

These companion paintings show nearly identical interiors, with Pharaoh, his throne, and his guards evidently based on the same print source in both scenes. Much of their rich coloration remains undiminished by early stains and discoloration, and carefully reproduced details of the throne, its dais, its canopy, and especially the figures' costumes deserve close attention. Penciled guidelines are still visible in some areas. In others, opaque watercolor seems to have been applied directly, and deftness and conviction are evident in many strokes, such as the dais decoration and the near lion's leg in the first painting.

Inscriptions/Marks: A partial watermark of a shield and fleur-de-lis is visible in the lower part of the primary support of no. 209, and the bottom or topmost edge of an indecipherable lettered watermark is visible at top center in no. 210. Inked script inscriptions in the lower recto margins of both read, respectively, "Joseph interpreting pharaoh [*sic*] dreams./And Joseph Said unto pharaoh, the dream of pharaoh is one: god hath shewed pharaoh what he is/about to do./Genesis Chap. XLI. verse 25 — " and "Joseph introducing five of his Brethren, and Jacob his father into the presence/of pharaoh. and Joseph brought in Jacob his father, and set him before pharaoh: and Jacob/blessed pharaoh./Genesis Chap. XLVII. verse 7."
Condition: In both cases, treatment by Christa Gaehde in 1955 included cleaning, inpainting, and reducing stains, especially — for no. 209 — severe water stains in the lower margin and — for no. 210 — a large oil stain in the upper half of the right side. Number 210 received extensive inpainting in the latter area, especially in the

kneeling figure second from right. For both pieces, treatment by E. Hollyday in 1976 included cleaning, setting down flaking paint, reducing stains and acidity, mending tears, inpainting small losses, sizing, backing with Japanese mulberry paper, and hinging to rag board. Probably period replacement ⅝-inch, black-painted, cove-molded frames with reeded inner and outer edges.
Provenance: Found near Ogunquit, Maine, and purchased from Edith Gregor Halpert, Downtown Gallery, New York, N.Y.
Exhibited: American Folk Art, Traveling; Hebrew Bible, and exhibition catalog, nos. 53 and 55; no. 209 only: Reflections of Faith.
Published: AARFAC, 1940, p. 29, nos. 98, 99; AARFAC, 1947, p. 27, nos. 98, 99; AARFAC, 1957, pp. 184–187; Cahill, American Folk Art, p. 36, nos. 50, 51; no. 209 only: Dewhurst, MacDowell, and MacDowell, Religious Folk Art, p. 59, no. 60; no. 209 only: Ford, Pictorial Folk Art, p. 110; no. 209 only: Schorsch and Greif, p. 60.

211 Ruth and Naomi 32.401.1

Artist unidentified
America, probably ca. 1825
Paint on velvet
21″ x 26½″ (53.3 cm. x 67.3 cm.)

The second chapter of Ruth proved quite popular as a subject for stencil painting in the first half of the nineteenth century. Several theorem versions of this same composition are known, all of them closely based on

Joseph interpreting Pharaoh dreams.
And Joseph said unto pharaoh, the dream of pharaoh is one. god hath shewed pharaoh What he is about to do.
Genesis Chap. XLI. verse 25.

209 *Joseph Interpreting Pharaoh's Dreams*

210 *Joseph Introducing His Brethren*

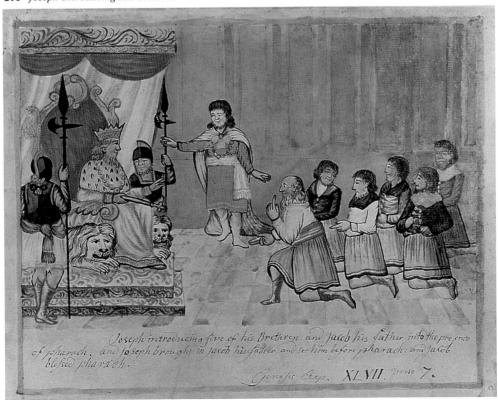

Joseph introducing five of his Brethren and Jacob his father into the presence of pharaoh. and Joseph brought in Jacob his father, and set him before pharach: and Jacob blessed pharaoh.
Genesis Chap. XLVII. verse 7.

211

an engraving of the subject. The companion engraving, *Ruth and Boaz,* was also frequently used as a source of inspiration by amateur artists working with paints or needle and thread, although Williamsburg's composition on this subject derives from a different source (see no. 205).[1]

Condition: The primary support has been trimmed. Probably it was Kathryn Scott who, about 1954, stitched the velvet to a linen backing, which was then tacked to a cardboard tertiary support. In 1974 E. Hollyday removed wood strips that had been tacked to the outer edges of the stretched velvet to act as matting strips in earlier framing. Period replacement 1½-inch splayed gilded frame with quarter-round outer edge.

Provenance: Elie Nadelman, Riverdale, N.Y.; Edith Gregor Halpert, Downtown Gallery, New York, N.Y.

Exhibited: AARFAC, September 15, 1974–July 25, 1976; American Folk Art, Traveling; Museums at Sunrise.

Published: AARFAC, 1940, p. 36, no. 151; AARFAC, 1947, p. 33, no. 151; AARFAC, 1957, p. 232, no. 116, illus. on p. 233; AARFAC, 1974, p. 55, no. 51; Cahill, American Folk Art, p. 41, no. 108, illus. on p. 102.

[1]Lorenzo State Historic Site, Cazenovia, N.Y., owns a pair of the prints that, according to their inscriptions, were engraved by H. Gillbank after H. Singleton and published in London in 1805 (Russell A. Grills, Lorenzo State Historic Site, to AARFAC, September 7, 1984).

Old Sturbridge Village owns paintings on velvet based on both the above prints. Other velvet paintings that appear to have been at least partially stenciled and that are based on the same print sources include two *Ruth and Naomi* renderings that were illustrated in Sotheby Parke Bernet, Halpert, lot nos. 226 and 310. A third appeared in Sotheby Parke Bernet, Inc., *The American Heritage Society*

Auction of Americana, catalog for sale no. 3691, November 12–16, 1974, lot no. 1287. The latter alludes to similar examples at the Shelburne Museum, Shelburne, Vt., and the Museum of Fine Arts, Boston. The Henry Ford Museum, Dearborn, Mich., owns a *Ruth and Naomi,* and the New York State Historical Association, Cooperstown, N.Y., owns a *Ruth and Boaz.* The Charleston Museum, Charleston, S.C., owns a *Ruth and Naomi* rendered in embroidery but based on the same printed composition.

212 Moses in the Bulrushes 62.301.1

Artist unidentified
America, probably ca. 1825
Watercolor, gold foil, ink, and gouache on wove paper
14⅛″ x 15″ (35.9 cm. x 38.1 cm.)

See also nos. 190, 199, and 200 for the Folk Art Center's three other versions of the event related in Exod. 2:1–10 — Pharaoh's daughter's discovery and rescue of the infant Moses afloat in the Nile River.

Although crudely executed, this vividly colored work achieves some dramatic impact through the use of towering bulrushes set about the figures, among whom pharaoh's daughter is distinguished by a gold collage-crown. The existence of at least one other closely related figural grouping gives credence to the

212

supposition that some as yet unidentified popular print guided several contemporary artists.[1] Of added interest is the similarity between Moses' ark and the woven baskets so frequently depicted by amateur still life painters of the same period; see, for example, that in no. 98.

Inscriptions/Marks: A partial watermark at lower right in the primary support reads "J WH[ATMAN]/18. . . . "

Condition: Treatment by E. Hollyday in 1977 included removing an acidic backing; dry cleaning where possible; mending numerous edge tears; backing the primary support with Japanese mulberry paper and sizing same with gelatin solution; and filling and inpainting the most obtrusive losses. The gold- and black-painted glass appears to be a modern replacement, but the gilded and gold-painted 2⅜-inch, cove-molded frame with applied rope twist and anthemion moldings may be original to the picture.

Provenance: Gift of Mrs. Charles F. Pease, Melrose, Mass.

[1]The related piece was illustrated in a flyer advertising an auction by Robert Skinner, Bolton, Mass., on July 24, 1975. AARFAC files contain a photocopy of the flyer.

213 *Hagar and Ishmael*

213 Hagar and Ishmael 35.401.2

Artist unidentified
America, possibly ca. 1835
Paint on velvet
19⅜" x 27" (49.2 cm. x 68.6 cm.)

Broad areas of paint generally have been applied with the aid of stencils, although to left of center, the green coloring of the tree leaves has been brushed on freehand in a loose, sketchy manner that appears out of keeping with the picture's otherwise crisp outlines. Black, brown, and blue-green are the only hues used to depict this episode from Genesis, chapter 21.

Condition: The primary support has been trimmed close to the margins of the pictorial composition. In 1954 Kathryn Scott stitched the velvet to a linen backing and tacked the piece to a cardboard tertiary support. Period replacement 3-inch gilded frame with cove molding to either side of a half-round molding.
Provenance: R. C. Hurry, New York State.
Exhibited: Hebrew Bible, and exhibition catalog, no. 36.
Published: AARFAC, 1957, p. 369, no. 312.

214 Christ and the Woman of Samaria 35.601.2

Artist unidentified
America, probably ca. 1845
Wool and silk embroidery with watercolor on silk
19⅝" x 21³⁄₁₆" (49.9 cm. x 53.8 cm.)

Wool work was more often done on linen or canvas than on silk, and the impracticality of pulling such bulky yarns through a fragile silk support is demonstrated by the deteriorated condition of this piece. Except for the collars on the costumes of the two figures, all needlework is executed in wool. The figures' hair and flesh and the sky are rendered in watercolor. The episode is from John, chapter 4.

Condition: The silk ground was originally whipstitched to a secondary support of linen; the margins of the latter have all been trimmed close to the edges of the pictorial composition. Probably it was Kathryn Scott in the 1950s who stitched the secondary support to a second piece of linen, stretching same over a cardboard backing; netting was applied over several areas of tearing silk in both figures' heads and in the sky at upper middle; inpainting directly onto the secondary support was done in many areas of loss and tearing in watercolored portions of the picture. Probably period replacement 3³⁄₁₆-inch mahogany frame of a cove molding followed by a flat step and half-round outer edge, with gilded liner.
Provenance: The Century House, Charleston, S.C.
Exhibited: Southern Book.
Published: AARFAC, 1940, p. 31, no. 112; AARFAC, 1947, p. 28, no. 112; AARFAC, 1957, p. 244, no. 122, illus. on p. 245; Schorsch and Greif, p. 121.

215 The True Cross 32.101.5

Artist unidentified
America, possibly Pennsylvania, probably 1880–1900
Oil and resin on bedticking
22⅝" x 32½" (57.5 cm. x 82.6 cm.)

Whether through deliberation, carelessness, lack of alternate materials, or lack of concern, the technical construction of this painting includes several rather unconventional features. For instance, the top paint layer contains a high proportion of soft resin, and it appears to have been applied in a very thin, diluted state, with wet colors worked into and against one another in a manner more typical of watercolor than oil; bits of dried paint and trash are incorporated in an under layer of paint, producing a very uneven surface; and the primary support was soaked with a nondrying oil before painting.[1]

A very limited, rather drab palette contributes to the somber tone of the scene, while the figures' deepset, black-shaded eye sockets produce a macabre effect.

Inscriptions/Marks: On a banner at lower left in the composition is "SPQR," and on the two side crosses in the composition are "DISMAS" and "GESTAS." Over the head of Christ is "FATHER — / FORGIVE/THEM: FOR THEY/KNOW NOT/WHAT THEY/DO. — /LUKE/ 23.34." In the lower margin of the picture is "THE TRUE CROSS/JESUS SAITH. I THIRST. SO THEY PUT A SPONG [*sic*] FULL OF VINEGAR. UPON A REED AND GAVE HIM TO DRINK.'"
Condition: The primary support appears to have been mounted on stretchers while the painting was executed, but following completion, the fabric was tacked directly to the back of the frame. In 1943 Sheldon Keck set down cupping paint with a gelatin solution and filled and inpainted small scattered paint losses. In 1955 Russell J. Quandt lined the painting, mounted it on stretchers, and probably cleaned and inpainted small areas of loss as needed. Probably original 3-inch white pine frame with deep hand-cut "chip" carving or sawtooth molding decorating the entire outer edge.
Provenance: Found near Doylestown, Pa., and purchased from Edith Gregor Halpert, Downtown Gallery, New York, N.Y.[2]
Exhibited: American Ancestors, and exhibition catalog, no. 6; American Folk Art, Detroit, and exhibition catalog, p. 3, no. 10; American Folk Art, Traveling; Centennial Exhibition, and exhibition catalog, p. 8, no. 57; Reflections of Faith.
Published: AARFAC, 1957, p. 357, no. 229; Cahill, American Folk Art, p. 33, no. 23, illus. on p. 69; Dewhurst, MacDowell, and MacDowell, Religious Folk Art, p. 125, no. 167; Ford, Pictorial Folk Art, illus. on p. 109.

[1]Notes made by Russell J. Quandt in 1955 and filed at AARFAC.

[2]The given provenance is from Halpert notes on file at AARFAC; it is not known why Cahill, American Folk Art, p. 33, states: "found near New Hope, Pennsylvania."

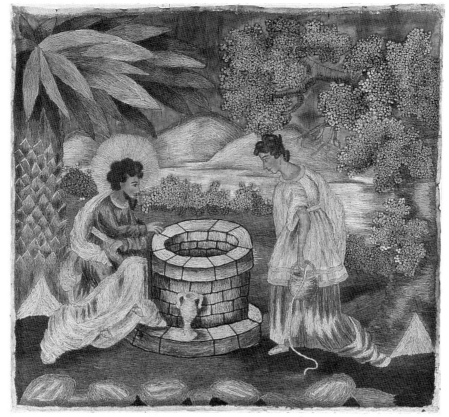

214

215

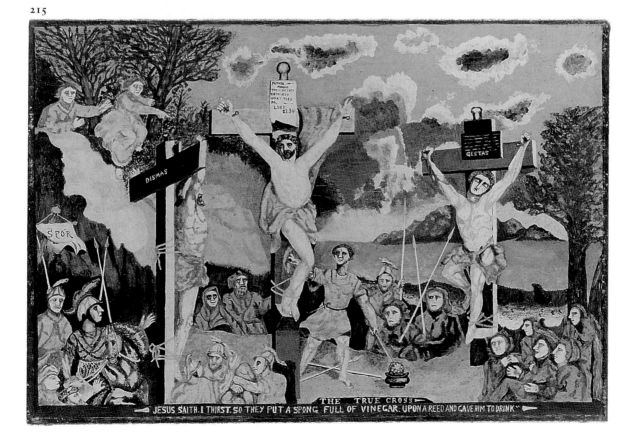

JESUS SAITH. I THIRST. SO THEY PUT A SPONG FULL OF VINEGAR. UPON A REED AND GAVE HIM TO DRINK"

VII Paintings by Edward Hicks

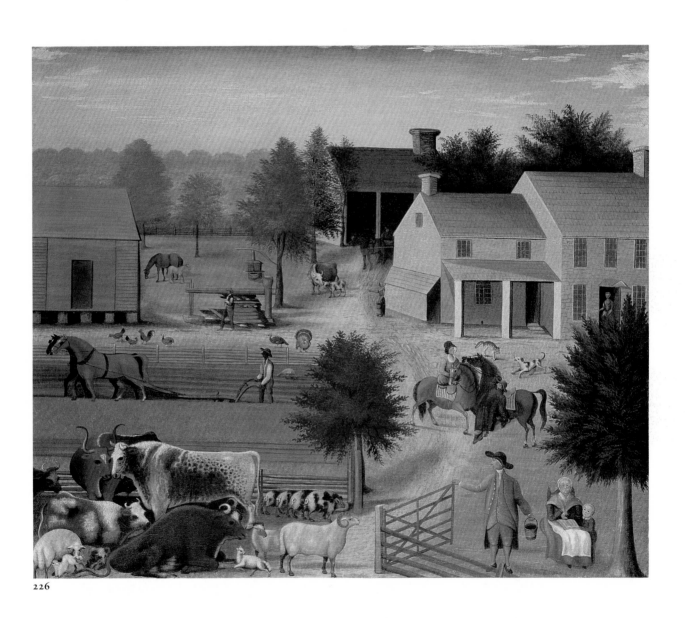

226

Edward Hicks
(1780–1849)

It seems ironic that the man who called himself "but a poor old worthless insignificant painter" in 1846 was destined to become, by the early twentieth century, one of the best-known and -loved of America's folk painters.[1] His multifaceted career and complex personality have been chronicled in numerous publications, culminating in the recent important volume on his life and a comprehensive discussion of all his extant works by the Hicks experts, Eleanore Price Mather (a descendant of the artist) and Dorothy Canning Miller. Miller's study of Hicks began early in this century, about the time of the landmark exhibitions on American folk art held in the 1930s at the Newark Museum in New Jersey and later at the Museum of Modern Art in New York City.[2] A number of the paintings in the entries that follow were featured in those shows, since Abby Aldrich Rockefeller was one of the first to collect works by Hicks. The subsequent acquisition of other paintings by the artist has made the Folk Art Center's holdings the largest single collection of his works.

Hicks was the son of Isaac and Catharine Hicks and the grandson of Gilbert Hicks, a local judge and a man of wealth from Bucks County, Pennsylvania. Edward was born on his grandfather's estate in Langhorne on April 4, 1780, but his life in this household and his association with his parents was short-lived. With the exception of his maternal grandmother, his relatives were Anglicans and supported the Tory cause; both his grandfather and father were forced into hiding during the Revolution. Edward's mother died when he was about eighteen months old. Family friends, Elizabeth and David Twining, took the young child into their home and raised him with their four daughters. The comfort, love, and security that Hicks experienced as a youngster in this Quaker household were recalled fondly throughout his lifetime and are visually manifested in his four extant paintings of the Twining farm as he remembered it from about 1787 (see, for example, no. 226). It was also in this household that Hicks probably received his first religious education.

William and Henry Tomlinson, local coachmakers in Langhorne, Pennsylvania, took Edward Hicks as an apprentice when he was thirteen years old. He spent a total of seven years in their shop learning the trade, and presumably it was here that Hicks discovered his particular talent for decorative painting, the craft that he would pursue for the rest of his life. But, as Mather

and Miller point out, it was also here that Hicks was exposed to other aspects of social life, including gaming, dancing, and drinking. His love of frolics and city taverns continued for about three years after he had terminated his apprenticeship. Then, there was a period of personal introspection and repentance, and finally his acceptance into the Society of Friends. The importance of this single event cannot be overestimated, for Hicks's avowed religion would be all-consuming, would affect every aspect of his life, and would influence much of his artistic work, particularly the many versions of the peaceable kingdom he created from about 1820 to the very eve of his death.

Hicks's biographers have shown that Quakerism probably attracted the artist because it fulfilled his need for inward peace and very likely his yearning for some direct and immediate relationship with God. The latter was central to the Quaker belief that held that the "light within" was the Holy Spirit. The Quaker meeting was essentially a gathering where believers sat in silence awaiting a message from the Lord that would be shared aloud by individual recipients with all attending; they would therefore share the "light" or "inner light." The ability to give utterance to the Lord's message varied from person to person. Hicks was one who possessed extraordinary ability. In 1812 the Middletown meeting recognized his special gift by recording him as a minister.

His service as a Quaker minister did not mean that he prepared sermons to be given regularly from the pulpit; rather, he was expected to share the "light" at home meetings as well as farther afield by traveling around the country. As early as 1813, and for most of the rest of his life, Hicks followed this calling and became one of the most important and respected ministers of his sect — but he did not achieve this without personal sacrifice. Quaker ministers were not compensated for their work, and Hicks, who had married Sarah Worstall in 1803, already had four children to support by 1813. He had also established a shop as a coach-and-decorative painter in Milford, and his ministry took him from the enterprise that furnished the family income.

While his debts mounted, Hicks began to expand his repertoire of work to include sign painting and the decorating of household wares, such as fire buckets and painted furniture. Apparently some of these works included elaborate representations, and it was either through self-assessment and/or the urgings of his fel-

low Quakers that Hicks recognized an ethical conflict between his painted embellishments and the simple ways he advocated as a Quaker minister. About 1814 he quit the painting business, purchased land, and attempted farming. The venture was unsuccessful and temporary, for by 1817 the artist was advertising in Bucks County papers that he did ornamental coach and sign painting of all sorts. He had begun to do easel painting by this time, and about 1820 he began to experiment with the peaceable kingdom theme, one that could be reconciled with his religious convictions.

The artist's wealthy cousins, Isaac and Samuel Hicks of Long Island, New York, and John Comly, a Bucks County friend, were instrumental and generous in providing monies to pay off the artist's sizable debts, which by 1817–1818 had accumulated to five thousand dollars. During the early 1820s, Hicks continued his traveling ministry, visiting as far north as New York. But in February 1822, while serving a meeting in Philadelphia, he experienced a great setback when his painting shop and all of his equipment were destroyed by fire. The shop was rebuilt and his business was reestablished, but there were spiritual and religious conflicts emerging for the artist-minister that would have a profound effect on Quakerism and his life.

In 1820 Edward Hicks met with his Long Island cousin Elias Hicks, a controversial man whose outspoken opposition to the ways preferred by many prominent Quaker brethren eventually resulted in the separation of the so-called Hicksites from the Orthodox Quakers. Although the artist supported his cousin and the Hicksite cause, as did most of the Bucks County Friends, the controversy created tensions between Hicks and prominent Philadelphia Quakers who professed orthodoxy but were also his long-time associates. Ultimately, these tensions and the artist's continued reflections on his own spiritual well-being were reflected in his paintings. Hicks never completely achieved the goal of inner peace during his lifetime, although in his last years his paintings and his writings reflect greater acceptance of life's conditions.

Hicks continued his work as an ornamental and coach painter well into the 1840s. For most of the years before his death, in 1849, he also continued to minister, attend his local meeting, and produce a variety of paintings for friends and relatives. He began writing his memoirs in 1843, and although these were completed before his death, they were not published until 1851. They chronicle not only his inner struggle and religious concerns as they evolved over the years but also contain interesting comments about persons he knew and particularly those involved in the Hicksite versus Orthodox Quaker controversy.

The night before his death he was working on a *Peaceable Kingdom* for his favorite daughter, Elizabeth. According to Mather and Miller, "the painter told his family that he had paid his last visit to his shop, and that his son, Isaac, could put the finishing touches on this kingdom."

[1]As quoted in Mather and Miller, p. 78, originally published in *Edward Hicks, Memoirs of the Life and Religious Labours of Edward Hicks of Newtown, Bucks County, Pennsylvania* (Philadelphia, 1851), p. 149.
[2]All information for this entry has been summarized from Mather and Miller, pp. 15–91.

216 Peaceable Kingdom of the Branch 67.101.1

Attributed to Edward Hicks
Bucks County, Pennsylvania, 1820–1830
Oil on canvas
32¼″ x 37¾″ (81.9 cm. x 95.9 cm.)

This painting is believed to be the earliest of the four kingdoms by Hicks in the Folk Art Center's collections. The format and general composition, however, were used by the artist in three other early paintings, all of which have lettered borders and show the Natural Bridge of Virginia in the background, with William Penn and the signing of the peace treaty just below the bridge.[1] The group also shares a similar arrangement of the animals, but no. 216 is the only one of this or any type of the kingdoms that shows the child in contemporary nineteenth-century dress.[2]

Edward Hicks was fully aware that Penn's historical event had not taken place in Virginia, but the artist apparently believed that one of God's magnificent natural creations was a fitting backdrop for the prophecy of Isaiah as symbolized by the child and the animals in the foreground and the treaty group in the background. His version of the Natural Bridge was probably borrowed from a similar design appearing on Henry Tanner's 1822 map of Virginia printed in Philadelphia; the treaty scene, a common feature in Hicks's kingdom pictures, is believed to have been inspired by a popular print by John Hall after Benjamin West's *William Penn's Treaty with the Indians*.[3]

The title of no. 216 and similar versions of the kingdom, as assigned by the artist, derives from the clustered grapes and vine held by the child and running over his shoulder and onto the cliff behind. This motif was borrowed from a Bible engraving by Richard Westall, a member of England's Royal Academy, and then altered slightly to suit Hicks's needs.[4] The plant and fruit symbolize the redemptive blood of Christ on the cross and for most Christians, the Holy Com-

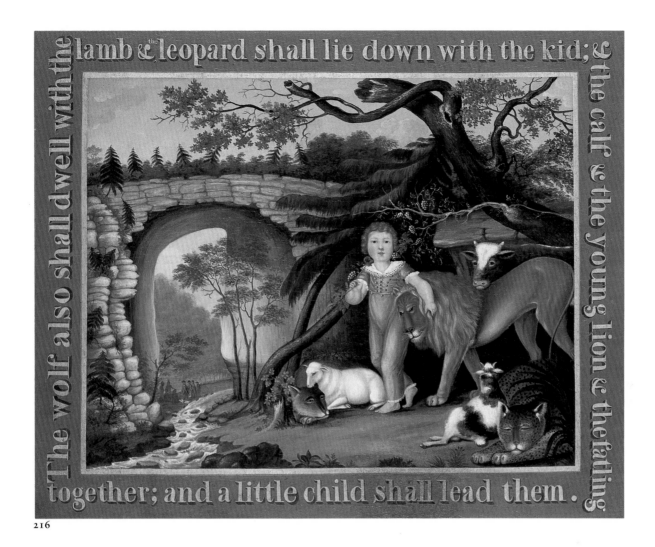

216

munion. As Mather and Miller point out, this was a most unusual choice by Hicks, a Quaker minister, since the Friends did not advocate or practice outward sacraments.[5]

The colors here are especially rich and pleasing, with warm browns for the leopard, lion, wolf, and calf at right, balanced by the fall foliage on the oak tree above the group and the muted green and ocher shades for the ground on which they stand. The expressions on the faces of Hicks's animals and their positions changed over the years in which he created the kingdom pictures. Here, the leopard sleeps quietly at lower right, and the wolf nestles close to the lamb. And, as the biblical inscription from Isaiah lettered around the composition relates, a little child leads them.

Inscriptions/Marks: Lettered in black paint across the top is "THE PEACEABLE KINGDOM OF THE BRANCH." Beginning at the lower left corner and running around the painted brown border are the gold letters: "The wolf also shall dwell with the lamb & the leopard shall lie down with the kid; & the calf & the young lion & the fatling together; and a little child shall lead them."

Condition: In 1968 Russell J. Quandt cleaned the painting; repaired tears in the support through the streambed at lower left, in the words "with the" at upper left and "wolf" at the left; and filled and inpainted extensive losses in these areas as well as in the lower border beneath "together; and a little child"; the painting was lined and miscellaneous small areas of lifting paint were secured. The painted border was probably meant to serve as a visual frame originally; a modern ½-inch flat and black-painted wood molding was added to protect the edges of the support.

Provenance: Chester R. Smith, Indianapolis, Indiana.

Published: AARFAC, 1975, illus. on p. 21; Brown, illus. on p. 734; Mather and Miller, illus. as no. 3 on p. 96, and pl. II.

[1] See Mather and Miller, pp. 95–98, illus. as nos. 2, 4, 5.

[2] Ibid., p. 96.

[3] Ibid., p. 48. The Hall print was published by John Boydell in London, England, in 1775.

[4] For a discussion of the Westall engraving and Hicks's use of it, see Mather and Miller, pp. 19–20. The print appeared in *The Holy Bible, Containing the Old and New Testaments and the Apocrypha Embellished with Engravings by Charles Heath from Designs by Richard Westall, R.A.* The work was published in three volumes in 1815 by the London firm of White, Cochrane and Company.

[5] Mather and Miller, p. 19.

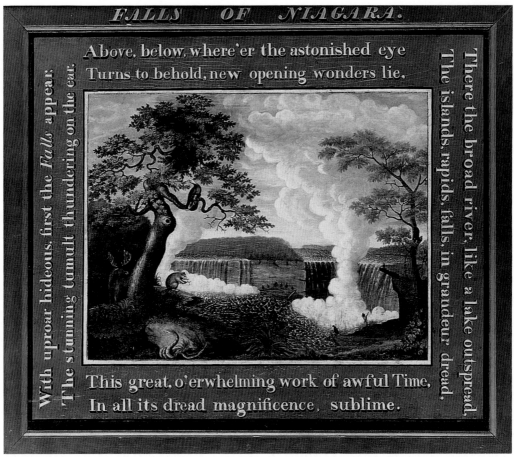

FALLS OF NIAGARA.

*Above, below, where'er the astonished eye
Turns to behold, new opening wonders lie,*

With uproar hideous, first the Falls *appear;
The stunning tumult thundering on the ear.*

*There the broad river, like a lake outspread.
The islands, rapids, falls, in grandeur dread.*

*This great, o'erwhelming work of awful Time,
In all its dread magnificence, sublime.*

217

217 Niagara Falls 59.102.3

Attributed to Edward Hicks
Bucks County, Pennsylvania, 1825–1826
Oil on yellow poplar panel
22¾″ x 30⅛″ (57.8 cm. x 76.5 cm.)

Two extant and very similar painted fireboards featuring Niagara Falls were created for the artist's friend and physician, Dr. Joseph Parrish.[1] One of them, owned by the Metropolitan Museum of Art in New York City, is dated 1825 in its decorative border; scholars believe that no. 217 was created about the same time.[2]

Edward Hicks had visited the falls in 1819–1820 while preaching and visiting Friends meetings in the area. It was also just after this, in 1822, that the Henry S. Tanner map with its cartouche showing both the falls and the Natural Bridge of Virginia was published in Philadelphia.[3] Hicks used the Natural Bridge in several of his kingdom pictures, as illustrated in no. 216. His view of the falls, as derived from the Tanner print, appears only on the two fireboards.

It was typical of the artist and his religious persuasion to regard the great natural wonder as the mighty work of God and to thus provide further explanation of the place by rhymed verses inspired by Alexander Wilson's poem "The Foresters," which was reprinted in a Newtown newspaper in 1818.[4] The composition of both fireboards was based almost entirely on Tanner's cartouche, which also includes the beaver, eagle, moose, snake, and three small human figures in the distant foreground. The crisp sienna browns, yellow ochers, and various colors of green for the landscape elements and the animals, and the soft pinks and blues for the sky were Hicks's addition to the scene, however, and they relate closely to the rich coloration of his early kingdom pictures.

Inscriptions/Marks: The verses in gold paint in the border read: (left) "With uproar hideous, first the *Falls* appear;/The stunning tumult thundering on the ear."; (top) "Above, below, where'er the astonished eye/Turns to behold, new opening wonders lie,"; (right) "There the broad river, like a lake outspread,/The islands, rapids, falls, in grandeur dread,"; (bottom) "This great, o'erwhelming work of awful Time,/In all its dread magnificence, sublime."
Conditon: In 1960 Russell J. Quandt cleaned the painting, removed inpainting and glazing added by a previous unidentified

restorer, and filled and inpainted various small losses. The frame is original, except for the lower member, which was apparently replaced sometime in the late nineteenth century; 2⅝-inch molded frame with outer bead painted green, brown, and black, with the gold letters: "FALLS OF NIAGARA." at the top.

Provenance: Dr. Joseph Parrish; to a descendant, Helen Parrish; to Dr. Arthur Edwin Bye, and then purchased by Edward R. Barnsley.

Exhibited: AARFAC, American Museum in Britain; AARFAC, Hicks, and exhibition catalog, illus. as no. 17 on p. 13; AARFAC, June 4, 1962–April 17, 1963; AARFAC, June 4, 1962–November 20, 1965; "American Landscape: A Changing Frontier," National Collection of Fine Arts, Smithsonian Institution, April 27–June 19, 1966, and exhibition catalog, illus. as fig. 7 in unpaginated section; Pennsylvania Artists.

Published: Black and Lipman, p. 143, illus. as fig. 131 on p. 149; Ford, Edward Hicks, illus. as no. 11 on p. 143; Hicks, Kane, Pippin, illus. on p. 13; Mather and Miller, p. 203, no. 114.

[1]Mather and Miller, p. 23.

[2]Ibid., p. 203.

[3]For an illustration of the cartouche, see Mather and Miller, p. 22, and the discussion on p. 23.

[4]Ibid., p. 202.

218 The Peaceable Kingdom 33.101.2

Edward Hicks
Bucks County, Pennsylvania, 1826–1827
Oil on canvas
29¼″ x 35¼″ (74.3 cm. x 89.5 cm.)

Among the early kingdoms by Hicks is a series of seven featuring similar pictorial compositions and rhymed lettered borders interpreting Penn's treaty and the prophecy of Isa. 11:6–9.[1] In most, the child is simply dressed in a white, nondescript frock and rests its arm across the head or neck of the lion in a manner similar to that of the child in no. 220. The figure is sometimes referred to as the Divine Child, since the artist's intention was to interpret biblical scripture rather than represent the Christ Child. The grapevine and fruit are evident here but are less prominent than in no. 216. The animals, while positioned in the traditional manner of Hicks's early works, are more alert

218

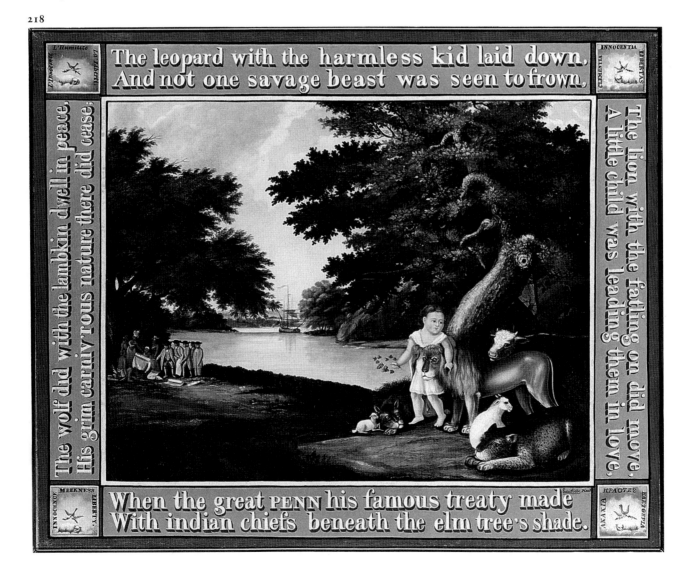

and forecast the creatures' expressions as evolved in the 1830s kingdoms (see, for example, no. 220).

This painting is noteworthy for the superb quality of the lettering and the decorative corner blocks in the borders — all indications of Hicks's skillful work as a sign, coach, and decorative painter. The dove of peace, with an olive branch in its beak and above a recumbent lamb, appears in all four corners. Hicks undoubtedly knew the motif from the design vocabulary used by sign painters and inherited from craftsmen working in Europe,[2] but it was especially meaningful for his kingdoms. Hicks surrounded the symbolic device with the words "Innocence," "Meekness," and "Liberty" in French, Latin, Greek, and English. The familiar scene of Penn's treaty is depicted in the middle ground at left.

The lush greens and rich shades of brown and ocher make this one of the handsomest of the early kingdoms, as does the meticulously detailed foliage, which does not appear in such profusion in the six related works.

Inscriptions/Marks: Within the four corner blocks are "Innocence/Meekness/Liberty" in English (lower left), in French (upper left), Latin (upper right), and Greek (lower right). The border at the top has in gold letters: "The leopard with the harmless kid laid down,/And not one savage beast was seen to frown,"; in similar letters on the border at right: "The lion with the fatling on did move,/A little child was leading them in love,"; on the border at left: "The wolf did with the lambkin dwell in peace,/His grim carniv'rous nature there did cease"; and in the lower border: "When the great PENN his famous treaty made/With indian chiefs beneath the elm tree's shade." Inscribed in black paint above "made" in the lower border is "Edw. Hicks Pinx.[t]."

Condition: Unspecified treatment by Russell J. Quandt in 1957 included cleaning, lining, and filling and inpainting scattered losses, including an area on the extreme left border that had been damaged at an undetermined date by fire. The decorative border on this painting was probably intended to function as its frame; a mid-nineteenth-century, 2-inch cyma reversa molded gilt frame was added in the 1950s to protect its support edges.

Provenance: Rhode Island School of Design, Providence.

Exhibited: AARFAC, Hicks, and exhibition catalog, p. 10, no. 7; AARFAC, April 22, 1959–December 31, 1961; AARFAC, June 4, 1962–April 17, 1963; AARFAC, September 1968–May 1970; Hebrew Bible, and exhibition catalog, illus. no. 105; "A Mirror of Creation," Vatican Museums, Vatican City State, Italy, September 24–November 23, 1980.

Published: AARFAC, 1940, p. 22, no. 37, illus. on p. 21; AARFAC, 1947, pp. 16–17, no. 37; AARFAC, 1957, p. 355, no. 220; Mather and Miller, illus. on p. 105, no. 12; *A Mirror of Creation: 150 Years of American Nature Painting* (New York, 1980), no. 8; Rumford, Folk Art Center, illus. on p. 60.

[1]Mather and Miller, pp. 100–106, illus. as nos. 7, 8, 9, 10, 11, 13.
[2]Ibid., p. 58.

219 Penn's Treaty with the Indians 58.101.3

Attributed to Edward Hicks
Bucks County, Pennsylvania, 1830–1835
Oil on canvas
17⅝" x 22¾" (44.8 cm. x 57.8 cm.)

Thirteen paintings featuring William Penn's famous treaty with the Indians have been assigned to Edward Hicks, indicating that it was one of his most popular subjects.[1] The paintings date between about 1830 and 1847, and one served as a signboard for a tavern in Chester, Pennsylvania, originally known as the Pennsylvania Arms.[2] Hicks varied the details in these pictures, but the basic elements of the buildings in the background, a single large tree, the Delaware River with various boats, and the principals involved in the historic event are present in all but one of the works, the signboard.

Like his other paintings depicting historic events and places (see nos. 221, 227, and 228), Hicks derived the basic composition from a print source, most likely John Hall's 1775 engraving published by John Boydell in London after Benjamin West's celebrated *William Penn's Treaty with the Indians,* now in the collection of the Pennsylvania Academy of Fine Arts in Philadelphia.[3]

The event itself was significant for Pennsylvania Quakers, particularly those living in Bucks County, which had been named by Penn after his native Buckinghamshire, England, as well as the place where he built his home, Pennsbury. For Hicks and possibly others, Penn probably also represented a religious philosophy closer to the Hicksites' beliefs than to those held by Orthodox Quakers. It is also significant that Edward Hicks associated Penn's treaty with the fulfillment of God's peaceable kingdom on earth as related in the biblical verses of Isaiah and as documented in the kingdoms he painted with rhymed borders (see no. 218).[4]

Most of the treaty pictures are colorful, with touches of red in the Indians' costumes and brightly lit skies, but Penn himself is dressed in the traditional subdued earth colors preferred by Quakers, as are most of the colonists in his entourage. The faces in no. 219 and in most of the other versions are generally nondescript and highly stylized.

Inscriptions/Marks: In black paint on the scroll within the painting at right foreground is "Charter of/Pennsylvania/in North America/Treaty with/the Indians in —/1681 without an/oath & never bro[ken]; Wm. Penn/Tho.[s]/Lloyd/James Logan/Tho[s] Story/Tho[s] Janney/W[m] Markham."
Condition: In 1959 Russell J. Quandt cleaned the painting, mounted it on a Masonite panel, and filled and inpainted various small losses throughout, principally at the edges. Original 2½-inch,

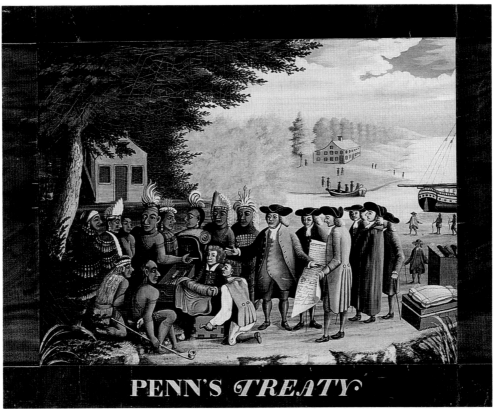

PENN'S TREATY

219

mahogany-veneered flat frame with corner blocks and "Penn's Treaty." lettered in yellow paint across the bottom member; the frame was probably made by Hicks's assistant Edward Trego.[5]

Provenance: Unidentified New York dealer; Charles Montgomery; J. Stuart Halladay and Herrel George Thomas, Sheffield, Mass.

Exhibited: AARFAC, American Museum in Britain; AARFAC, Hicks, and exhibition catalog, illus. as no. 22 on p. 15; AARFAC, Minneapolis; AARFAC, June 4, 1962–April 17, 1963; American Folk Painters; "Edward Hicks: A Gentle Spirit," Andrew Crispo Gallery, New York, N.Y., May 16–June 28, 1975; Halladay-Thomas, Albany, and exhibition catalog, no. 12; Halladay-Thomas, Hudson Park; Halladay-Thomas, New Britain, and exhibition catalog, no. 93; Halladay-Thomas, Syracuse, and exhibition catalog, no. 4; Halladay-Thomas, Whitney, and exhibition catalog, p. 29, no. 3; William Penn Museum.

Published: Andrew Crispo Gallery, illus. as no. 30; Black and Lipman, p. 159, illus. as fig. 145 on p. 163; Kerr, p. 18, no. 1; Lipman and Armstrong, illus. on p. 90; Mather and Miller, illus. on p. 171.

[1]Mather and Miller, pp. 171–183, illus. as nos. 82–94; versions are represented in the public collections of the Thomas Gilcrease Institute of American History and Art, Tulsa, Okla.; Bayou Bend Collection, Museum of Fine Arts, Houston, Tex.; Bucks County Historical Society, Doylestown, Pa.; Wolfgram Memorial Library, Widener College, Chester, Pa.; Shelburne Museum, Shelburne, Vt.; Edgar William and Bernice Chrysler Garbisch Collection, National Gallery of Art, Washington, D.C.

[2]Mather and Miller, illus. as no. 90 on p. 179.

[3]Ibid., the Hall print is illus. on p. 48.

[4]For a discussion of this see ibid., pp. 30–32, 49.

[5]Mather and Miller, p. 171.

220 The Peaceable Kingdom 32.101.1

Attributed to Edward Hicks
Bucks County, Pennsylvania, 1832–1834
Oil on canvas
17¼" x 23¼" (43.8 cm. x 59.1 cm.)

During the first years of the 1830s, Edward Hicks evolved a format for his kingdoms that features a seated lion. His earlier use of borrowed motifs from print sources, such as one by Richard Westall (see no. 216), was gradually and systematically replaced by the composition and arrangement here, and it was thoroughly Hicks's in concept and design. Mather and Miller relate this to the years following the separation of Hicksites and Orthodox Quakers, noting that Hicks rejected the use of the grapevine in these pictures as a symbolic proclamation of salvation achieved through outward sacraments; instead, he favored one that brought salvation from the "light within." The prominent seated lion has ears of grain in his mouth, a pictorial representation of Hicks's interpretation of the biblical prophecy in Isaiah. The lion, disobeying nature's law, has chosen grains instead of his usual diet of red meat. Thus, he has yielded his self-will to the divine will of God, the very heart of Quaker theo-

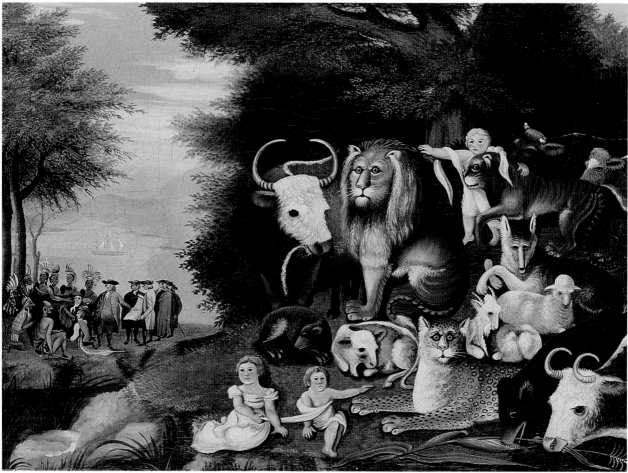

220

logical teachings. Further, as the controversy between the two Quaker factions continued during these years, the expression "the inner light" became associated with the Hicksites, while "the blood of Christ" came to represent orthodoxy. As a supporter of the Hicksite movement, the artist must have felt compelled to incorporate symbolism that appropriately reflected his partisan views.[1]

Other changes evident in kingdoms of Hicks's middle years, as seen in no. 220, include the smaller size and less prominent placement of the child who leads the animals. It is the animals that occupy most of the space, and it is their beautifully detailed fur and intense gazes, particularly those of the lion and the leopard, the fiercest creatures, that capture the viewer's attention. These changes are also closely tied to Hicks's growing need to express verbally in his ministry and visually in paint his anxiety surrounding the Quaker controversy.

It is difficult to view these creatures without sensing a kinship with them and something in the nature of an unspoken dialogue. For Hicks these were the souls of mankind in symbolic form; perhaps we also respond to these meanings, although we remain forever removed from the fears and struggles so carefully intermingled among the colors and wonderful textures captured in his painting.

Condition: Unspecified conservation treatment in the 1930s by David Rosen included lining the painting and probably some cleaning; unspecified treatment by Russell J. Quandt in 1956 included cleaning and filling and inpainting small areas of paint loss throughout. Period replacement 3½-inch, mahogany-veneered flat frame.

Provenance: Edith Gregor Halpert, Downtown Gallery, New York, N.Y.

Exhibited: AARFAC, April 22, 1959–December 31, 1961; American Ancestors, and exhibition catalog, p. 1, no. 1; American Folk Art, Detroit, and exhibition catalog, p. 3, no. 1; American Folk Art, Traveling; Art in Our Time; Centennial Exhibition, and exhibition catalog, p. 8, no. 58; Trois Siècles, and exhibition catalog, p. 53, no. 243, illus. as fig. 69; William Penn Museum.

Published: AARFAC, 1957, p. 82, no. 43, illus. on p. 83; Cahill, American Folk Art, p. 31, no. 21, illus. on p. 67; Mather, Primitive Quaker, illus. on p. 18; Mather and Miller, p. 125, illus. as no. 32; MOMA, illus. no. 6; Schorsch and Greif, illus. on p. 89.

[1]For a complete discussion of the "Seated Lion" and the kingdom pictures of these years, see Mather and Miller, pp. 43–48.

221 Declaration of Independence 57.101.7

Attributed to Edward Hicks
Bucks County, Pennsylvania, 1840–1844
Oil on canvas
24″ x 34¾″ (61.0 cm. x 88.3 cm.)

This version of Hicks's painting of the Declaration of Independence was originally painted for his son, Isaac, and then was owned by the artist's grandson and subsequently his great-granddaughter. It relates closely to two other paintings by Hicks, one of which is owned by the Chrysler Museum in Norfolk, Virginia. The location of the other, dated by the artist 1844, is currently unknown, but it was formerly in the collection of L. L. Beans.[1] All were based on John Trumbull's *Declaration of Independence*, which adorns the rotunda of the Capitol building in Washington, D.C. Trumbull was commissioned to do the scene and three others in 1817, but they were not completed until seven years later. A print after Trumbull's picture published in 1829 was probably Hicks's source.[2]

The Folk Art Center's version is notable for its fine passages of painting and harmonious coloration, while most of the signers have similar stylized faces that bear no relationship to Trumbull's faithful likenesses or those recorded by the engraver of the print. Hicks did attempt to individualize the prominent members of the drafting committee, who stand in front of the table at center right. Both Benjamin Franklin, at extreme right, and Thomas Jefferson, who stands next to Franklin, are recognizable, as is John Adams, who stands at the left in the group.

In the Trumbull scene and in the print source, the back wall of the room is decorated with various crossed flags and other emblems of war and patriotism, but Hicks replaced these with the more symbolic American eagle brandishing a banner with the new country's motto and beneath it the title of the painting. The eagle appears in one of the other two known versions but in slightly altered form.[3]

Inscriptions/Marks: In black paint on the banner held by the eagle is "E PLURIBUS UNUM. IN UNITY, THERE IS STRENGTH"; in black paint below this is "THE DECLARATION OF INDEPENDENCE JULY 4 1776."
Condition: Unspecified conservation treatment by an unknown source at an unknown date prior to acquisition probably included cleaning and filling and inpainting small losses throughout. Possibly original 2⅝-inch, mahogany-veneered, cove-molded frame with corner blocks.
Provenance: Isaac Hicks; to his son, Edward Hicks; to his daughter, Mary Barnsley Hicks Richardson; Captain Richard A. Loeb; Mr. and Mrs. Howard Lipman; Mary Allis, Southport, Conn.
Exhibited: AARFAC, Hicks, and exhibition catalog, p. 16, no. 27; AARFAC, September 15, 1974–July 25, 1976; Pennsylvania Artists; Texas Technological College.
Published: AARFAC, 1974, p. 59, no. 57, illus. on p. 15; Hicks, Kane, Pippin, illus. on p. 17; Lipman and Winchester, Primitive Painters, illus. on p. 48; Mather and Miller, illus. as no. 77 on p. 167.

[1]See Mather and Miller, illus. no. 78 on p. 168, for the L. L. Beans version, which was owned by Hirschl & Adler Galleries, Inc., New York, N.Y., in 1981; and see no. 76 illus. on p. 166 for the painting owned by the Chrysler Museum, Norfolk, Va.
[2]Mather and Miller, p. 166; the authors explain that the engraved print, by the firm of Illman and Pilbrow, was used as the frontispiece for the book *Lives of the Signers to the Declaration of Independence*, written by Charles A. Goodrich and published in 1829; Hicks owned a copy of this volume, the current location of which is unknown.
[3]Mather and Miller, illus. on p. 168.

221

222 The Peaceable Kingdom 61.101.2

Edward Hicks
Bucks County, Pennsylvania, 1844
Oil on canvas
24″ x 31¼″ (61.0 cm. x 79.4 cm.)

In 1844 Joseph Watson, a wealthy Middletown Friend and colleague of Hicks's, built a new house and commissioned this painting from the artist. In fact, the picture was delivered to the Watson household in September 1844, by the painter's son, Isaac.[1] An accompanying letter from the artist to Watson stated: "It is one of the best paintings I ever done."[2]

Scholars describe this picture as one of the most puzzling kingdoms by the artist, principally because it has not one but two leopards. The first of these is seen in the foreground, arched and apparently snarling at the second, which is recumbent beneath and behind it. In terms of color and composition, the standing leopard is prominently placed and one of the strongest focal points in the picture. Mather and Miller equate the peculiarities of this leopard and its placement with a passionate sermon that Hicks had preached at Goose Creek Meeting in Loudon County, Virginia, in 1837.[3] His remarks centered on "the nature of man and his relationship to the divine in terms of the Kingdom animals."[4] The animals, according to Hicks, were symbolic of the four medieval humors, and all mankind was ruled by these. The melancholic was associated with the wolf, the sanguine with the leopard, the phlegmatic with the bear, and the choleric with the lion. As Mather and Miller explain, Hicks believed that if man allowed these temperaments to exist, he would destroy himself; if, however, men were allowed to be guided by the divine will, they would be "reborn into the gentle spirit of the lamb, the kid, the cow, or the ox."[5]

It seems clear that Hicks had these concepts in mind when he created the kingdom picture for the Watson family, for the standing leopard, despite his natural savage expression, is balanced and surrounded

222

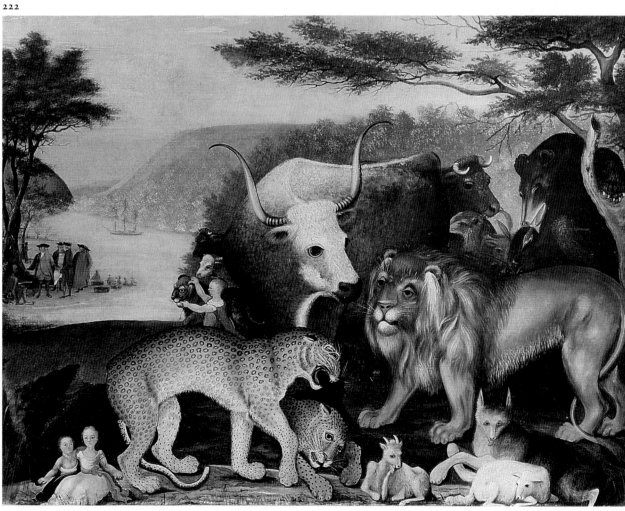

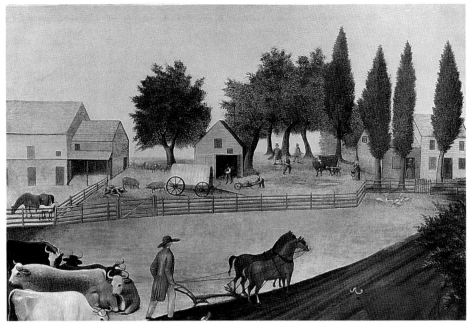

223

by other creatures, including one of his own species, which have disavowed self-will for that of the divine. They appear submissive, gentle, and gathered in peace.

In the middle ground at left is the familiar scene of William Penn negotiating his treaty with the Indians, a historic event that Hicks considered significant for all Quakers, since he believed it symbolized the fulfillment of Old Testament prophecy of the peaceable kingdom on earth.

Condition: Unspecified conservation work by a Mr. Ireland of Philadelphia prior to 1961 included cleaning and lining. Original walnut 3⅛-inch chamfered frame with outer bead made by Edward Trego, an employee in Edward Hicks's shop.

Provenance: Commissioned by Joseph Watson (1805–1886); to his daughter, Mary Elizabeth Watson; to her sister, Susanna Watson Hancock; to her great-niece, Jane Watson Taylor Brey; purchased from Mabel Zahn by Charles Sessler, Inc., Philadelphia, Pa.

Exhibited: AARFAC, September 15, 1974–July 25, 1976, Atlanta show only; American Folk Painters; "American Folk Painting," Time-Life Exhibition Center, Rockefeller Center, New York, N.Y., October 14–November 20, 1966; Atwater Kent Museum, Philadelphia, Pa., Winter 1936–1937; "Far Country," home of Charles F. Jenkins, Germantown, Pa., 1938; U.S. Mission.

Published: Black, Folk Artist, illus. on p. 94; Black and Lipman, p. 175, illus. as fig. 168 on p. 188; Book Preview, 1966, illus. on p. 127; Lipman and Armstrong, illus. on p. 91; Mather, Peaceable Season, illus. on front cover; Mather, Primitive Quaker, illus. on p. 19; Mather and Miller, illus. as no. 47 on p. 140; "Special Events," *Antiques,* LXXIX (May 1961), p. 480.

[1]Mather and Miller, p. 140.
[2]Edward Hicks to Joseph Watson, September 23, 1844. The original letter is in the AARFAC archives, having descended in the Watson family.
[3]Mather and Miller, p. 74.
[4]Ibid., p. 68.
[5]Ibid.

223 The Residence of Thomas Hillborn

61.101.1

Edward Hicks
Bucks County, Pennsylvania, 1845–1846
Oil on canvas
23⅝" x 31⅞" (60.0 cm. x 81.0 cm.)

The Hillborn family farmhouse was built in 1792–1793 and still stands today near Newtown, Pennsylvania. Hicks's view of the place was the first of seven farmscapes that he painted during the last years of his life. Family descendants have identified the man at the plough as Thomas Hillborn, while his wife, Margaret, stands in the door of the house. The other figures in the painting are believed to be their children. Daughter Sarah is seen near the end of the house by the watering hole with a pail in hand, while sons Thomas, Joseph, Mahlon, Cyrus, and Samuel are seen at various tasks beyond her in the background.[1]

A letter written by Thomas Hillborn to Edward Hicks in January 1846 may refer to this picture, although the reference is unclear. Hillborn, a Quaker, was in Philadelphia and apparently had received a letter from Hicks about a painting in December. Hillborn noted: "I have waited in expectation of receiving the Canvas referred to in it from thy friends in New York [probably cousins of Hicks's visiting him in Pennsylvania] but have as yet rec'd none — When it reaches me I will forward it by C. Higgs as requested — ."[2]

No information on Higgs or the likelihood that he or someone else was the recipient of the "Canvas" has been found. It is interesting, however, that Thomas Hillborn had experienced financial setbacks in the 1820s, which forced him to sell the farm. His son Cyrus purchased it in 1846 and, according to the inscription on the stretcher of the painting, commissioned Hicks to paint the view as it showed the place in 1821. Perhaps Higgs was an intermediary who was to deliver the picture to Cyrus.[3]

Hillborn farm, like the other Hicks farmscapes, is depicted as a neat, quiet environment where the simple values of work and family relations are of utmost concern. Its colors are subdued and principally earth tones of greens, pale blues, browns, and grays. It is an unusual composition for Hicks, since he rarely used diagonals as strong as the one presented by the ploughed field and Hillborn with his team of horses in the foreground. Most of his paintings emphasize overlapping horizontal layers of animals and other elements that recede into the background. Hicks was probably experimenting here, striving to incorporate farm activities of many kinds into a pleasing composition. His animals, while seen in great number throughout the canvas, are not as prominent as they are in the other farmscapes (see nos. 226 and 229).

Inscriptions/Marks: In large ink or black-painted letters on the top member of the original stretchers, now stored off the painting at AARFAC, is "Purchased by his son Cyrus Hillborn in 1845, when/this Picture was painted, by Edward Hicks in his 66th year." Inscribed in a similar manner on the bottom stretcher is "The Residence of Thomas Hillborn in Newtown Township/Bucks County Pennsylvania, in the Year 1821."

Condition: In 1977–1978, Charles H. Olin removed the picture from a ¼-inch Masonite panel, which had been attached to the painting at an unknown date by unidentified persons; he also removed various adhesive tapes along the edge of the painting, repaired two large tears in the support, removed old varnish and inpainting (including a fence), cleaned and relined the picture, provided new stretchers, and filled and inpainted the tears and other small losses throughout. Original 3³⁄₁₆-inch walnut splayed frame with outer bead.

Provenance: Cyrus Hillborn; to his brother, Samuel Hillborn; to his son, Isaac Hillborn; to his daughter, Martha Hillborn Tomlinson; to her children: Ruth, Carolina, Ella, Anna, and Harvey Hillborn Tomlinson.

Exhibited: Pennsylvania Artists; "Pennsylvania Folk Art," William Penn Memorial Museum, Harrisburg, Pa., December 14, 1974–February 2, 1975.

Published: Ford, Edward Hicks, p. 97, illus. as fig. 18 on p. 147; Hicks, Kane, Pippin, illus. on p. 21; Mather and Miller, p. 190, illus. as no. 101; "Special Events," Antiques, LXXIX (May 1961), p. 480.

[1]Harvey Hillborn Tomlinson to AARFAC, January 9, 1961.

[2]The letter is owned by Hillborn descendants; a photocopy of it is in AARFAC research files.

[3]Harold F. Round to AARFAC, December 18, 1971; this letter contains a complete history of the Hillborn house and its various owners from 1792–1793 to 1966.

224 Pastoral Landscape 56.102.6

Attributed to Edward Hicks
Bucks County, Pennsylvania, 1845–1849
Oil on yellow poplar panel
16¾" x 20" (42.6 cm. x 50.8 cm.)

This serene view featuring farm animals and a shepherd with his flock in the distant left background was painted for Charles Leedom — the son of Mary Twining Leedom and her husband, Jesse Leedom. It is one of four known small landscapes surviving by the artist that seem to have no immediate reference to religious themes, specific places, or historic events, although it has many of the elements that Hicks employed in both his kingdom and farmscape pictures.[1] The gnarled and blasted tree at right is seen in a few of his other works, but has greater prominence here.

Easel painting, which implied art for purely aesthetic purposes to most Quakers, was frowned on by many of Hicks's brethren, although the useful branches of painting for signs, coaches, and other items generally were considered permissible.[2] That Hicks could justify his kingdom pictures and other didactic works — which recorded important historic and nationalistic events within the Quaker context — is understandable, but both the farmscapes and charming pastoral scenes such as no. 224 must have evoked criticism from some of his colleagues. For Hicks, however, these works featuring men and animals in harmony with the land were probably as much a reflection of his faith and preoccupation with Isaiah's prophecy and peace on earth as they were attempts to produce purely decorative pictures.

Condition: Unspecified conservation treatment by an unknown source prior to 1933 probably included cleaning and stabilizing the wood panel by gluing two wood braces on the verso. Probably original 1⅞-inch walnut splayed frame.

Provenance: Charles Leedom; to his granddaughter, Mrs. Lydia L. Knight; Carl Lindborg; Edith Gregor Halpert, Downtown Gallery, New York, N.Y.; John D. Rockefeller, Jr., for Abby Aldrich Rockefeller, becoming part of the folk art collection given to Colonial Williamsburg in 1935; loaned to, then purchased by Mr. Rockefeller for use at Bassett Hall, the Rockefellers' Williamsburg home; and given to the Abby Aldrich Rockefeller Folk Art Collection (now Center) in 1956.

Exhibited: AARFAC, Arkansas; AARFAC, Hicks, and exhibition catalog, p. 17, no. 30; Pennsylvania Artists; Pine Manor Junior College.

Published: AARFAC, 1957, p. 355, no. 215; Ford, Edward Hicks, p. 157, illus. as no. 33; Hicks, Kane, Pippin, illus. on p. 24; Mather, Peaceable Season, unpaginated; Mather and Miller, p. 200, illus. as no. 111; Anita Schorsch, "The Lamb in American Art," American Antiques, VI (March 1978), pp. 28–32, illus. on p. 29; Schorsch, Pastoral, illus. on p. 45.

[1]Mather and Miller, pp. 198–201, illus. as nos. 109, 110, 112; two of the other three are privately owned, and one was owned by the Coe Kerr Gallery, New York, N.Y., in 1983.

[2]Mather and Miller, pp. 18–19.

224 *Pastoral Landscape*

225 James Cornell's Prize Bull 58.101.11

Edward Hicks
Bucks County, Pennsylvania, 1846
Oil on yellow poplar panel
12″ x 16⅛″ (30.5 cm. x 41.0 cm.)

The original receipt of payment for this painting was pasted to the reverse of the panel, probably by the first owner, and reads "James Cornell/To Edward Hicks Do/To painting his prize bull. $15.00/Rec 5th mo 16th 1846 the above in full; of all demands by me/Edward Hicks."[1] Actually, this was a large sum for the size and complexity of the picture, since Hicks is known to have charged twenty-five dollars for one of his best kingdoms.[2] James C. Cornell was a successful farmer living in Bucks County, and his animals won awards in the agricultural fairs of 1848 and probably before if the title of this picture, assigned by either Hicks or the owner, is any indication.[3] Two years after the prize bull rendering, Cornell commissioned Hicks to paint a large landscape showing his entire farm and herd.[4]

It is difficult to determine whether Hicks actually visited the Cornell farm and sketched or painted the prize bull from life, since he sometimes based his animals on print sources. Certainly the markings were faithful to the actual Cornell bull, but the pose may have been borrowed from some unidentified print in the artist's possession. It is a lifelike portrayal, however, with meticulous detailing, unlike the more stylized creatures he included in some of the farmscapes and kingdom pictures. The sheep surrounding the bull undoubtedly reflected livestock owned by Cornell, but their poses and specific positions were borrowed from print sources and placed so as to balance and fill out the composition.[5]

Inscriptions/Marks: In black paint on the reverse of the panel is "Prize Bull/Edw. Hicks/1846."

Condition: In 1959 Russell J. Quandt cleaned the painting, filled and inpainted various small losses throughout caused by fly-specks, and probably removed the original receipt from the verso. Probably period replacement 1⅜-inch, cove-molded frame, painted black.

Provenance: James C. Cornell; an unidentified descendant; Lillian Harney, Trenton, N.J.

Exhibited: AARFAC, Hicks, and exhibition catalog, p. 17, no. 31; Pennsylvania Artists.

Published: Haverstock, illus. on p. 148; Hicks, Kane, Pippin, illus. on p. 22; Mather and Miller, illus. on p. 82, and p. 197, no. 108.

225

[1]The receipt is in the AARFAC research files and was probably removed during Russell J. Quandt's treatment of the picture in 1959.

[2]See no. 222, the *Peaceable Kingdom* for Joseph Watson, whose price Hicks mentions in his September 23, 1844, letter to the owner.

[3]Ford, *Edward Hicks*, p. 108.

[4]Mather and Miller, illus. as no. 106 on p. 195 and as pl. VIII. The Cornell farmscape is in the Edgar William and Bernice Chrysler Garbisch Collection, National Gallery of Art, Washington, D.C.

[5]Eleanore Price Mather visited the Folk Art Center on February 4, 1981, and allowed staff to photocopy several early nineteenth-century prints that she had found among papers collected by her grandfather James M. Price (1825–1899) of West Chester, Pa. Among them were two prints, featuring sheep, with the artist's or engraver's name: "Gustave Canton." Both show sheep in positions identical to those of the ram and two ewes in the foreground of no. 225. No information has been found about Canton or whether Hicks actually owned or had access to such prints.

226 The Residence of David Twining 33.101.1

> *Attributed to Edward Hicks*
> Bucks County, Pennsylvania, 1846–1847
> Oil on canvas
> 26½" x 31⁹⁄₁₆" (67.3 cm. x 80.2 cm.)
> *(Reproduced on page 264)*

Edward Hicks's lifelong affection for Elizabeth and David Twining and the fond memories he held of the years spent in their family household are best expressed in the artist's painted views of their Bucks County farm.[1] It was here that Hicks grew up and here that he formed a sibling bond with the Twinings' four daughters — Elizabeth, Sarah, Mary, and Beulah.

Mary, who is shown on horseback at center right, was Hicks's favorite, and she appears again as a much older woman in the artist's masterpiece *Leedom Farm* (see no. 229). Mounting the horse beside Mary is her husband, David Leedom. The particular arrangement and position of the couple and their horses were based on a similar vignette in Thomas Sully's 1819 painting titled *Washington at the Passage of the Delaware*, now in the collection of the Museum of Fine Arts, Boston. Hicks undoubtedly owned or saw an engraving of the picture since he made use of it, either in whole or part, throughout his career (see no. 228).[2]

David Twining is dressed in the typical plain clothing of Quakers of the period and stands with his hand on the gate at lower right foreground looking toward his orderly gathering of livestock. Nearby, his wife, Elizabeth, sits quietly in a ladder-back chair with young Edward by her side. She is probably reading from the Bible. Hicks warmly recalled such moments in his memoirs when he wrote: "How often have I stood or sat by her, before I could read myself, and heard her read, particularly the 26th chapter of Matthew."[3]

The serene, dreamlike quality of this painting and of *Leedom Farm* could be attributed to the artist's general method and style of painting, but with Hicks, style was ruled by emotions and personal experience, and thus was ever changing despite the technical similarities observed from picture to picture. *James Cornell's Prize Bull* (no. 225), for instance, was cre-

ated about the same time as this picture, but the light is sharper and the anatomical details of the bull are more refined because its purpose was different from that of the Twining farm view. A carefully worked out memory picture, the Twining farm view reflects the quiet, simple place where Hicks's life had been secure and where his earliest religious ideas had been formulated. Also, the painting was probably commissioned by Charles Leedom, Mary's son.[4]

Condition: Unspecified conservation treatment by William Suhr, probably during 1933, included cleaning, lining, and filling and inpainting scattered losses. Original 3-inch oak frame with outer bead and with the gold-leaf lettering "THE RESIDENCE OF DAVID TWINING 1787." and gold pinstriping.

Provenance: Probably commissioned by Charles Leedom, Newtown, Pa.; then to his granddaughter, Lydia L. Knight; Carl Lindborg; given to the Museum of Modern Art in 1939 by Abby Aldrich Rockefeller; transferred to the Metropolitan Museum in 1949; turned over to Colonial Williamsburg in April 1955.

Exhibited: AARFAC, Hicks, and exhibition catalog, p. 19, no. 36; AARFAC, June 4, 1962–April 17, 1963; American Folk Painters; Art in Our Time; Trois Siècles, and exhibition catalog, p. 52, no. 242.

Published: Black and Lipman, p. 96, illus. as fig. 90 on p. 107; Blum, p. 201, no. 7, illus. on p. 200; Booth, illus. on p. 7; Brant and Cullman, p. 97, no. 166; Arthur Edwin Bye, "Edward Hicks, Painter-Preacher," *Antiques*, XXXIX (January 1936), illus. as fig. 6

on p. 16; Ford, Edward Hicks, p. 156, no. 32; Ford, Pictorial Folk Art, illus. on p. 98; Kerr, p. 19, no. 4; Lipman and Armstrong, illus. on p. 94; Jean Lipman, *Provocative Parallels* (New York, 1973), p. 24, no. 15; Mather, Peaceable Season, unpaginated; Mather, Primitive Quaker, illus. on front cover, and p. 14; Mather and Miller, p. 194, no. 105; MOMA, illus. as no. 5.

[1]Two of the three other versions are in the following collections: Museum of Art, Carnegie Institute, Howard N. Eavenson Americana Collection, Pittsburgh, Pa.; and Andy Williams, Los Angeles, Calif. The location of the third version is unknown, but see Mather and Miller, illus. as no. 102 on p. 191.
[2]Mather and Miller, p. 191.
[3]Ibid., pp. 81–82.
[4]Ibid., p. 194.

227 The Grave of William Penn 32.101.2

Edward Hicks
Bucks County, Pennsylvania, 1847
Oil on canvas
24″ x 30″ (61.0 cm. x 76.2 cm.)

Six versions of Hicks's small view of William Penn's grave are known, and all feature this basic format with slight alterations in the positions and number of ani-

227

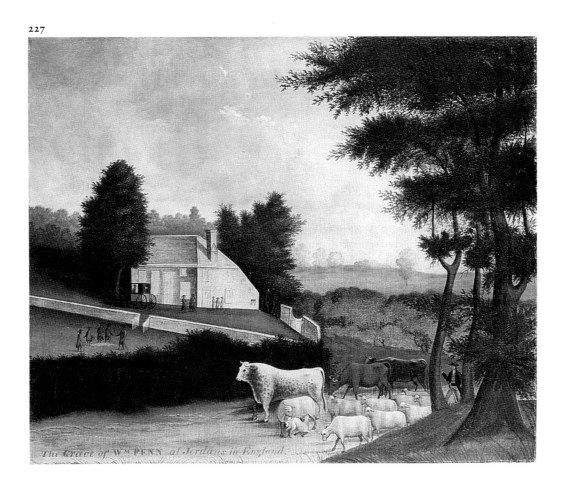

The Grave of Wm PENN at Jordans in England.

mals and in the smaller details of foliage, the road in the foreground, and the sky.[1] The artist derived his painted view from Paul Cauci's lithograph after Hendrik Frans de Cort's painting by the same title, which was given to the Historical Society of Pennsylvania in Philadelphia in 1834 by Granville Penn, a descendant of William.[2] Hicks added the bull in front of the herd of animals, as well as the ewe and the lamb, animals frequently seen in other works by the artist.

Mather and Miller relate the Penn's grave series with other pastoral works by the artist and note that the meetinghouse representing that at Jordans, England, where William Penn was buried in the nearby graveyard, is the only building of its kind that Hicks ever painted.[3] Also, in several of the Penn's grave paintings, Hicks erroneously noted in the inscriptions that J. J. Gurney and other Friends were represented by the figures in front of the fence at left. The de Cort view shows the coach of the French philosopher baron de Montesquieu in front of the meetinghouse and the baron as the major figure by the graveside, not Joseph John Gurney, an English Friend whose leadership was well known but not admired by Hicks.[4]

Like the other five versions of the view, no. 227 was rendered primarily in earth tones, most of which are cool and subdued, except for the pink and blue colors for the sky and occasional touches of bright greens for the foliage and grass.

Inscriptions/Marks: In brown paint at the bottom of the painting is "The Grave of W^m PENN at Jordans in England." On the top member of the original stretcher is lettered in black paint: "Painted by E. Hicks in his 68th year, For his friend Ann Drake."
Condition: Unspecified conservation treatment by Borwin Anthon about 1935 probably included mounting the picture on a Masonite panel, filling and inpainting small scattered losses throughout, and setting down flaking paint. Original 3⅝-inch splayed mahogany-veneered frame with a quarter-round molding at outer edge.
Provenance: Ann Drake; to an unidentified descendant; Edith Gregor Halpert, Downtown Gallery, New York, N.Y.
Exhibited: AARFAC, American Museum in Britain; AARFAC, Minneapolis; AARFAC, Hicks, and exhibition catalog, p. 18, no. 34; AARFAC, June 4, 1962–November 20, 1965; American Folk Art, Detroit, and exhibition catalog, p. 3, no. 12; American Folk Art, Traveling; Centennial Exhibition, and exhibition catalog, p. 8, no. 59; William Penn Museum.
Published: AARFAC, 1940, p. 22, no. 38, illus. on p. 18; AARFAC, 1947, p. 17, no. 38, illus. on p. 19; AARFAC, 1957, p. 116, no. 61, illus. on p. 117; Andrew Crispo Gallery, illus. as no. 27A; Cahill, American Folk Art, p. 33, no. 22, illus. on p. 68; L. L. Beans, *The Life and Work of Edward Hicks* (Trenton, N.J., 1951), illus. as on p. 25; Mather, Peaceable Season, unpaginated; Mather and Miller, p. 184, illus. as no. 95.

[1]See Mather and Miller, pp. 184–189, illus. as nos. 95–100; owners of the five other versions are the Newark Museum, Newark, N.J.; Edgar William and Bernice Chrysler Garbisch Collection, National Gallery of Art, Washington, D.C.; Yale University Art Gallery, New Haven, Conn.; and two private collections.
[2]Mather and Miller, pp. 87, 184.

[3]Jordans Meeting House was built in 1688 near Beaconsfield, Buckinghamshire, England, and is still extant. The graves of William Penn, his two wives, and five children are located there. For additional information, see Anna L. Littleboy, *A History of Jordans* (London, 1959), pp. 3–20.
[4]Mather and Miller, p. 87.

228 Washington at the Delaware 57.101.1

Edward Hicks
Bucks County, Pennsylvania, 1848–1849
Oil on canvas
36⅛" x 47⅜" (91.8 cm. x 120.3 cm.)

Edward Hicks's various paintings of George Washington in this format were all based on Thomas Sully's well-known *Washington at the Passage of the Delaware*, completed in 1819 and owned by the Museum of Fine Arts in Boston, Massachusetts. The painting was familiar to most Americans through prints engraved after it, particularly one by George S. Lang,[1] and Hicks probably knew it from such a source.

Two of the earliest versions of the composition by Hicks were for signboards that originally stood at either end of the bridge that crossed the Delaware River from Taylorsville, Pennsylvania, to New Jersey.[2] It seems likely that the signs with their colorful inscriptions may have encouraged others to commission similar pictures of the nation's hero from the artist since seven have been recorded. There are small variations among the group, and the Center's example is not one of the best, although it is one of four that are signed by the painter, and the only one that gives information about the original owner.

That Hicks probably spent little time and effort on the Center's version is obvious in the large expanses of paint that were quickly modeled and are devoid of the artist's usual amount of fine detail. When Russell J. Quandt treated the painting in 1960, he made several notes on Hicks's technique, which help to explain the smoothness as well as the thinness of some of his areas of paint.[3] In most of the farmscapes and some of the kingdoms, for instance, Hicks conceived and fully painted in the landscape and large background elements first and then added the animals and human figures over those areas. In the Washington painting, however, the principal figural elements were painted in, if not fully developed, first. In the latter, the artist used his finger, probably his thumb, to blend the large expanses of paint for the horses and some other areas, as evidenced by the fingerprints that Quandt found in the paint. The same technique was used for the brown-and-white cow in *Leedom Farm* (no. 229).

228

Inscriptions/Marks: Inscribed in black paint at lower left is "Painted by Edw. Hicks in the 69th year of his age/for Doctor M. Linton of Newtown, son of his/old Friend & fellow Soldier, James Linton," and in the center below the horse is "George Washington with his army crosing [*sic*] the Delaware/at McConkey Ferry the night before he took the Hessians, Dec. 25, 1776."

Condition: In 1960 Russell J. Quandt lined the painting; cleaned it; set down flaking paint; and filled and inpainted large areas of loss, particularly on the left side of the painting, extending from about an inch below the moon to the lower tack edge and from the left tack edge to just above the tail of Washington's horse. Modern 1-inch flat frame, painted brown.

Provenance: Dr. Maurice Linton; to his nephew, Henry Ridge; M. Knoedler & Co., New York, N.Y.

Exhibited: AARFAC, Hicks, and exhibition catalog, p. 14, no. 19; AARFAC, June 4, 1962–April 17, 1963; "Edward Hicks: A Gentle Spirit," Andrew Crispo Gallery, New York, N.Y., May 16–June 28, 1975; Texas Technological College; William Penn Museum.

Published: Andrew Crispo Gallery, illus. as no. 34; Mather and Miller, p. 184, illus. as no. 95.

[1]Mather and Miller, p. 154.
[2]Ibid., pp. 58–59, illus. as nos. 62 and 63 on pp. 155–156; one of

the signboards is in a private collection, and the other is owned by the Mercer Museum of the Bucks County Historical Society, Doylestown, Pa.

[3]Undated and unpublished notes prepared in 1960–1961 by Russell J. Quandt, AARFAC research files.

229 Leedom Farm 57.101.4

Edward Hicks
Bucks County, Pennsylvania, 1849
Oil on canvas
40⅛" x 49¹⁄₁₆" (101.9 cm. x 124.6 cm.)

Mather and Miller have correctly observed that *Leedom Farm*, the last of the artist's farmscapes, is a summation of his previous domestic views.[1] It is the most dreamlike and tranquil of the group, with its expansive early spring sky of pale blues, pinks, and tints of

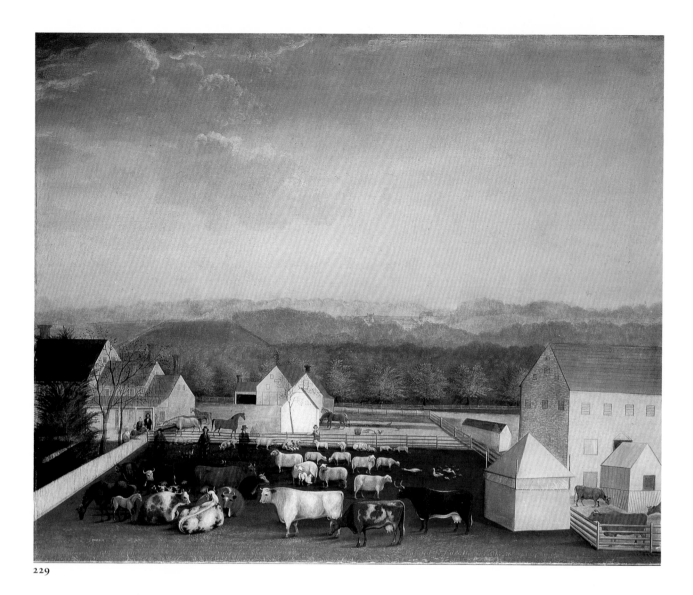

229

green, and the soft atmospheric hills receding beyond the fertile green lands and pristine complex of buildings in the foreground. Perhaps better than any of his other pictures, it captures Quaker quietism and the innate concern for order, simplicity, and man's good works on earth. These qualities and the remarkable skill with which Hicks rendered them make *Leedom Farm* a masterpiece of his surviving paintings and of folk painting in general.

But the importance of *Leedom Farm* goes beyond its aesthetic qualities since it was not only the last of the artist's known farmscapes, but one of the last, if not the last, painting he completed before his death, in 1849.[2] It had special meaning for Hicks because it was commissioned by David Leedom, the son of the artist's childhood friend and favorite Twining daughter, Mary, and her husband, Jesse Leedom. It was therefore a family picture, and one that is marked by re-

membrance. The lengthy inscription below the livestock tells us who is present. In addition to David and his wife and other living members of the family, Hicks included Mary Twining Leedom and Jesse Leedom, both of whom had died before 1849. But their inclusion was appropriate and meaningful since the farm had been their home before it was inherited by David in 1845.

In *Leedom Farm*, unlike his other farm views, no one is engaged in work. The plough sits idle in the field at the center of the picture, and the family members, lined up from the house door down along the fence and standing in the foreground pasture, are simply gesturing toward one another or to the various animals. It is thought that Hicks envisioned this gathering of loved ones and the gentlest of animals, several of which suckle their young, as a final and highly personal statement on the serenity he sought and advo-

cated for so many years, and perhaps found to some extent in his final days of 1849.

Inscriptions/Marks: At lower left in yellow paint is "A May morning view of the Farm and Stock of David Leedom of Newtown Bucks County — Pennsylvania/with a representation of Himself. Wife. Father. Mother. Brothers. Sisters and nephew." On the right-hand side in yellow paint is "Painted by Edw. Hicks in the 70th year of his age."

Condition: Unspecified conservation treatment by Russell J. Quandt in 1960 included cleaning, filling and inpainting small losses throughout, and lining. Original 4½-inch mahogany-veneered splayed frame with outer bead.

Provenance: Mr. and Mrs. John Law Robertson, Scranton and Montrose, Pa.

Exhibited: AARFAC, American Museum in Britain; AARFAC, Hicks, and exhibition catalog, illus. on cover, and p. 19, no. 38; AARFAC, Minneapolis; AARFAC, June 4, 1962–April 17, 1963; AARFAC, September 15, 1974–July 25, 1976, Atlanta show only; Pennsylvania Artists.

Published: Andrew Crispo Gallery, illus. as no. 21A; Black and Lipman, p. 96, illus. as fig. 89 on p. 106; Hicks, Kane, Pippin, illus. on p. 35; Mather, Peaceable Season, unpaginated; Mather and Miller, illus. on cover, and p. 196, no. 107; Barbara Snow, "Living with Antiques: The Home of Mr. and Mrs. J. Stanley Lee, Newtown, Pennsylvania," *Antiques,* LXXVIII (September 1960), illus. on p. 243.

[1] Mather and Miller, p. 196.

[2] See ibid., p. 153, and illus. no. 60 on the same page for the *Peaceable Kingdom* that Hicks was working on the evening before his death. The artist advised his family that he had not finished it and that his son, Isaac, could do so.

VIII *Family Records and Related Decorative Pictures*

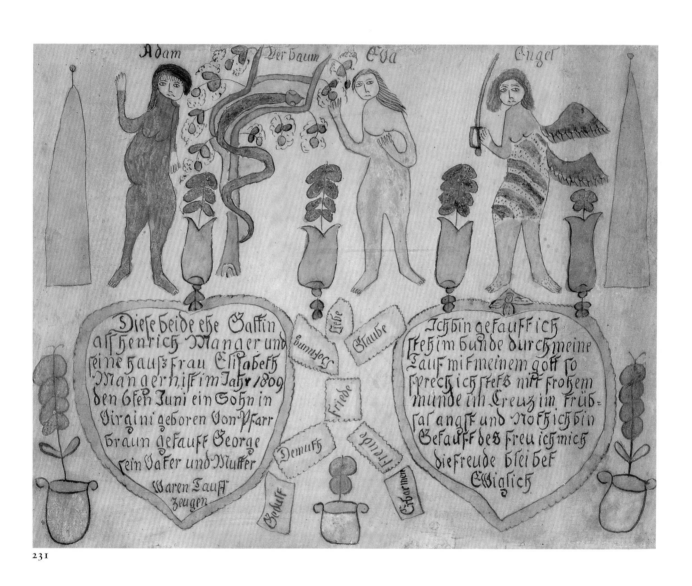

231

The use of inherited forms and traditional motifs in folk art is nowhere better illustrated than in the variety of family-oriented records produced in America probably from its early years of permanent settlement, although no extant examples from the seventeenth century are known. They comprise many types and were made by and for persons of German extraction as well as families with roots in England, Ireland, and Scotland. The non-German certificates are less well known and have received no serious study. Birth and baptismal records and family registers were the most common formats for obvious reasons. The documentation of both familial relations and physical proof of birth, baptism, and other important dates was often necessary for everyday transactions in the eighteenth and nineteenth centuries, just as it is today. For instance, the many German birth and baptismal records and English-oriented family registers that are now in the National Archives in Washington, D.C., were submitted in the eighteenth century by Revolutionary War veterans or their legal heirs in order to prove their age, citizenship, and eligibility to receive pension pay.[1]

But records of this sort also served other functions: as moralistic and religious teachings, as decorative and festive celebrations of important moments in life, and as tokens of love passed among friends and family. Related to the rich variety of records, the best of which are highly ornamented and exhibit fine calligraphic work, are a number of watercolor and pen and ink renderings. Some of these were produced by well-known record artists, most of whom also worked as schoolteachers, ministers, or professional painters and whose repertoires included portraiture and other formats. Still other works were made by amateurs who were inspired by the work of more practiced hands and by schoolchildren as examples of drawing and penmanship.

As a group, these generally small, sometimes amateurish, and highly appealing pictures express much about our ancestors' proclivity for record keeping, their fondness of traditional motifs and symbolism, and their expertise with the least expensive and simplest of art-making materials — pen, ink, brush, watercolors, and paper.

[1]Only the Revolutionary War pension applications have been examined at this time, although scholars believe additional decorated records may be discovered in the Archives' War of 1812 and Civil War application records.

Frakturs

Friedrich Bandel
(active ca. 1810)

230 Birth and Baptismal Certificate for David Wetzel

84.305.1

Attributed to Friedrich Bandel
Probably Shenandoah County, Virginia,
probably 1809–1815
Watercolor and ink on laid paper
12⁷/₁₆″ x 15⁷/₁₆″ (31.6 cm. x 39.2 cm.)

Hand-drawn birth and baptismal certificates in the German tradition in America rarely feature human figures of the type used by Bandel. The couple featured in this example, perhaps George and Rebecca Wendel Wetzel, the child's parents, are dressed in detailed costumes and seated in yellow-painted, Windsor-style chairs. The lady's frilled collar probably represents the top of a finely pleated lawn tucker worn under high-waisted dresses during the period. She carries a handkerchief in her hand. Her companion wears top boots with breeches and a riding or morning coat. The areas surrounding the figures and the inscription are decorated with motifs more common to fraktur.

George Wetzel (b. 1775) and his wife, Rebecca, lived in Shenandoah County, Virginia, and their son David was born there on June 6, 1809. In 1835, David married Margaret Hartmann (Hartman, or Hardman; 1813–1900). David Wetzel died on November 27, 1882, and was buried in the cemetery on his wife's family farm in Lewis County, West Virginia. It is not known when he moved his family to that area.

The Folk Art Center owns a *Goettelbrief,* or "godparents' letter," that records the birth and baptism of David's father, George Wetzel, as well as a birth and baptismal certificate for Daniel Hartmann (b. 1786), who is believed to have been David's father-in-law. All three pieces were acquired from the same source but appear to have been executed by different artists. Of the three decorators, only Friedrich Bandel has been identified by name.

Inscriptions/Marks: On the back of the fraktur, along with various ink scribbles, is "David Whetzel." In German, the ink inscription on the front reads: "Diese beide ehe gattin/Als Gorg Wetzel und Rebecca/Wendel verehlichte Wetzeln ist im/Jahr 1809 den 6ten Juni ein sohn in/Virgini geboren war getauft von/Pfarr Hannickel Schmucker seine/Eltern waren zeugen und/Nandten ihm David."

The English translation reads: "To these two married people, namely George Wetzel and Rebecca Wendel, married Wetzel, a son was born in the year 1809, June 6, born in Virginia, was baptized by Pastor Hannickel Schmucker. His parents were his sponsors and named him David."

Condition: In 1984 E. Hollyday removed old tape, dry-cleaned the front and verso, removed old paper patches on the verso, reduced stains and acidity, and hinged and mounted the work on acid-free mat board. Period replacement 1⁷/₈-inch, tiger maple–veneered frame.

Provenance: Mary K. Holt, Weston, W.Va.

231 Birth and Baptismal Certificate for George Manger

59.305.1

Attributed to Friedrich Bandel
Probably Rockingham County, Virginia,
ca. 1810
Watercolor and ink on laid paper
11⁷/₈″ x 15¹/₈″ (30.2 cm. x 38.4 cm.)
(Reproduced on page 284)

Representations of the Garden of Eden and the Fall of Man are seen on numerous objects made by early Americans of both German and non-German origins, as well as on imported wares, such as ceramics. Other fraktur examples also exist, but rarely was this biblical theme used on birth and baptismal certificates.[1] Bandel's selection of the composition was possibly prompted by a religious broadside or a similar printed piece he had seen. Because his rendering is somewhat crude and the figures are awkwardly positioned, one suspects that Bandel's interpretation of the theme was based on memory and not copied directly from any pictorial source.

The two hearts contain inscriptions relating to Manger's birth and baptism (left) and a popular baptismal hymn verse (right). Love, faith, peace, hope, and the names of other Christian virtues appear in the small blocks scattered between the hearts. Characteristics that identify the certificate as the work of Bandel include the pots at the lower corners and center with very indistinct round leaf forms. Similar foliage also issues from the four tulips above the hearts. The small round fruits on two-leafed stems hanging from the tree at the top are also indicative of Bandel's style, although these often look more like flowers in other pieces by the artist.

George Manger was the son of Henrich Manger and his wife, Elisabeth Pence Manger, of Rockingham County, Virginia. Pastor Johannes Braun, who baptized their son, served a number of congregations in Rockingham as well as in adjoining areas.[2]

230

[2]Klaus Wust to AARFAC, September 1, 1983. Wust notes that a record of the parents' marriage is contained in the register of Peaked Mountain Church in Rockingham County. For additional information on the Manger family and Braun's pastorate, see Klaus Wust, *Shenandoah Valley Family Data, 1799–1813, from the Memorandum Book of Pastor Johannes Braun* (Edinburg, Va., 1978).

232 Birth and Baptismal Certificate for Aaron Banger

83.305.1

Attributed to Friedrich Bandel
Virginia or West Virginia, 1815
Watercolor and ink on wove paper
7⁹/₁₆″ x 12³/₈″ (19.2 cm. x 31.4 cm.)

The wording and style of lettering used for the text, the particular decorative motifs, and their treatment are all factors that substantiate an attribution of this certificate to the little-known fraktur artist Friedrich Bandel. Two of Bandel's other four known works were made for boys born in 1809 in Virginia, a designation that would have included present-day West Virginia as well as Virginia (see nos. 230 and 231). George Daniel Flohr, the pastor who baptized Aaron Banger, is known to have led congregations in both states between 1799 and his death in 1826.[1]

Bandel's two remaining frakturs were executed in 1818 for Ohio-born subjects.[2] One of these, made for Anna Linn in 1814, bears the inscription: "Gemacht in Jahr 1818 Friedrich Bandel" ("Made in the year 1818 by Friedrich Bandel").

Inscriptions/Marks: The word "Tauffschein" is inscribed in ink within the crown at the top, with "1815" above it. At the bottom within the heart is "Gott allein/die/EHR." The German text, also in ink, reads: "Diese beide ehe gattin als der ehren Veste Johan Banger und die Tugend/saame Jungfer Eva Haussin ver ehlichte Johan banger ist im Jahr/Christi 1804 den ii ten May ein Sohn geboren in Virgine/war getauft Aaron von Pfaar herr Flohr laut dem/Evangelio Lucae am 18ten cap vers 16 lasset die kindlein zu mir kommen./sein Petter Jacob Banger und seine haus frau Goth."[3]

232

Inscriptions/Marks (no. 230)

Inscriptions/Marks: In German, the ink inscriptions read: (extreme top) "Adam," "Der baum," "Eva," "Engel"; (heart, left) "Diese beide ehe Gattin/als henrich Manger und/seine haussfrau Elisabeth/Mangern, ist im Jahr 1809/den 6ten Juni ein Sohn in/Virgini geboren Von Pfarr/braun getauft George/sein Vater und Mutter/waren Tauff/zeugen"; (small blocks between hearts) "Liebe," "Glaube," "Hoffnung," "Friede," "Demuth," "Freude," "Gedult," "Erbarmen"; (heart, right) "Ich bin getauft ich/steh im bunde durch meine/Tauf mit meinem gott so/sprech ich stets mit frohem/munde im Creuz im trüb=/sal angst und noth ich bin/Getauft des freu ich mich/die freude bleibet/Ewiglich."

The English translations read: (extreme top) "Adam," "The tree," "Eve," "Angel"; (heart, left) "To these two married people, namely Henrich Manger and his wife Elisabeth Mangern a son was born in the year 1809, the 6th of June, in Virginia, baptized George by Pastor Braun. His father and mother were baptismal sponsors"; (small blocks between hearts) "love," "faith," "hope," "peace," "humility," "joy," "patience," "mercy"; (heart, right) "I am baptized, I stand united through my own Baptism with my God; And therefore joy my tongue has guided, Although in fear and pain I've trod; I am baptized; there's joy in me, The joy that lasts eternally."

Condition: In 1960 Christa Gaehde removed an old mounting, cleaned, mended tears, fumigated, and backed the primary support with Japanese mulberry paper. Conservation treatment by E. Hollyday in 1978 included dry cleaning, setting down flaking paint, and remounting the primary support to four-ply conservation board using Japanese mulberry paper hinges and wheat-starch paste. Probably period replacement 1½-inch oak frame with applied mahogany corner blocks and applied mahogany hearts at top and bottom center.

Provenance: L. L. Beans, Trenton, N.J.

Exhibited: AARFAC, South Texas; "Folk Art: The Heart of America," Museum of American Folk Art, New York, N.Y., June 26–October 15, 1978; "Virginia Fraktur," Duke Fine Arts Gallery, Harrisonburg, Va., November 12–December 14, 1973.

Published: Elaine Eff, "Folk Art: The Heart of America," *The Clarion,* Summer 1978, illus. on p. 27; Lloyd E. Hawes, "Adam and Eve in the Decorative Arts," *Antiques,* LXXXIV (September 1963), p. 280, illus. as fig. 10 on p. 282; Robert Morton, *Southern Antiques and Folk Art* (Birmingham, Ala., 1976), illus. on p. 214; Schorsch and Greif, illus. on p. 50; Wust, p. 14, no. 20.

[1]Number 231 is the only birth and baptismal record of this type recorded in the AARFAC archives to date. See no. 244 for a birth and marriage record employing the same theme.

"Tauffschein" translates as "baptismal certificate," while the inscription within the heart translates: "To God alone be glory." The English translation of the main text reads: "To these two married people, the honorable Johann Banger and the virtuous virgin [young woman] Eva Haus, married to Johann Banger, a son was born in the year of Christ 1804, May 11, in Virginia. He was baptized Aaron by Pastor Flohr, according to the gospel of Luke, chapter 18, verse 16, 'Let the little children come unto me.' His godfather [was] Jacob Banger and his wife, godmother."

Condition: In 1983 the modern cracked glass in the frame was replaced with new glass, and an old wood backboard was removed and replaced with acid-free mat board. Modern ⅝-inch, black-painted frame with beading on inner edge.

Provenance: Marilyn Idle, Dayton, Ohio.

[1] See William Edward Eisenberg, *The Lutheran Church in Virginia, 1717–1962* (Roanoke, Va.: Trustees of the Virginia Synod, Lutheran Church in America, 1967), p. 88, for additional information on Flohr and his ministry; see also pp. 55, 128, 297–298, 331, 429–430, 448, 460, 490, 562, 564, 569, 576, 578–581, 586–587.

[2] These two frakturs are owned by the Free Library in Philadelphia, Pa. See Weiser I, illus. as nos. 127, 128.

[3] The rare German words "petter" and "Goth" also reinforce the attribution of this fraktur to Bandel since he was one of only a few decorators who used them.

David Bixler
(active ca. 1828–1862)

In 1977, Miriam E. Bixler published a short article giving as much information as is currently known about her ancestor and his work.[1] His birth and death dates have not been discovered, but his signed frakturs and sketches indicate that he was working from about 1828 to as late as 1862 in the Brecknock Township area of Lancaster County, Pennsylvania. His biographer identifies his father as Abraham (d. 1847), and his grandfather was also named Abraham. David's brother, Absolam Bixler (d. 1884), is well known for his pottery, toys, and other crafted items.

David Bixler was probably raised on his father's farm, established in 1822 and located on Muddy Creek in Brecknock Township. Presumably, the fraktur artist continued to live in this area for the rest of his life.

One source claims that Bixler did portraits, maps, and other pictorial work in addition to frakturs. The pieces identified by his biographer remain the only ones known and include purely decorative pictures (such as no. 233), *Taufscheine* ("baptismal certificates"), a decorated auction bill, pencil-sketched portraits, and several religious texts.

[1] All biographical information for this entry is taken from Miriam E. Bixler, "David Bixler, Folk Artist," *Journal of the Lancaster County Historical Society,* LXXXI (1977), pp. 30–38.

233

233 Horseman 58.305.9

Attributed to David Bixler
Pennsylvania, ca. 1850
Watercolor and pencil on wove paper
4¹⁵⁄₁₆″ x 6⅜″ (12.5 cm. x 16.2 cm.)

This watercolor drawing is attributed to David Bixler on the basis of its similarity to another example owned by the Henry Francis du Pont Winterthur Museum. Winterthur's drawing was purchased from a granddaughter of the artist in 1926, and on its verso bears the twentieth-century pencil inscription: "Made by David Bixler ʸʳ 1833 Ephrata/bought from his granddaughter in Ephrata/ In 1926." Both frakturs have similar horses, saddles, and harnesses, but the two riders are posed and dressed differently. Additionally, no. 233 is distinguished by the double outlines for the horse's legs. Whether this was an attempt by the artist to suggest the animal in motion is unknown. If it was a mistake in drawing, Bixler made no attempt to erase or cover up the error.

Condition: Conservation treatment by Christa Gaehde in 1959 including cleaning and mounting on Japanese mulberry paper. Dry-cleaning unpainted areas, removing an old secondary support, mending tears, mounting on four-ply rag board using Japanese paper hinges, and flattening were included in conservation treatment performed by E. Hollyday in 1974. Modern replacement 1-inch flat pine frame.

Provenance: Arthur J. Sussel, Philadelphia, Pa.

Exhibited: Washington County Museum, 1965.

Published: Miriam E. Bixler, "David Bixler, Folk Artist," *Journal of the Lancaster County Historical Society,* LXXXI (1977), illus. on p. 33; Parke-Bernet, no. 288, p. 48.

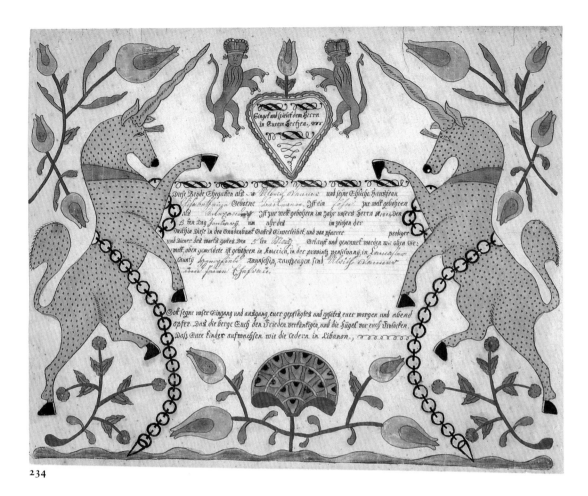

234

C. M. Artist and Unidentified Scrivener
(active ca. 1800)

234 Birth and Baptismal Certificate 35.305.1
for Alexander Danner

*Attributed to the C. M. Artist and an
unidentified scrivener*
Probably Lancaster County, Pennsylvania, ca.
1800
Watercolor, lead pencil, and ink on laid paper
12½" x 15⅝" (31.8 cm. x 39.7 cm.)

The fine condition of this brightly colored birth and
baptismal certificate for Alexander Danner makes it
an exceptional example of fraktur and of the C. M.
Artist's work in general. Two of the artist's nearly
identical frakturs featuring rampant spotted unicorns
survive: a birth and baptismal certificate for Anna
Maria Schmit, born in 1797 in Dauphin County, Penn-

sylvania;[1] and a birth certificate for Johannes Kellin-
ger, also born there in the same year.[2] Other works by
the artist are in private collections.

Recorded frakturs in other formats associated
with the C. M. Artist prove his versatility in combining
a variety of motifs including architectural elements,
human figures, mermaids, chained hearts, celestial
bodies, and highly stylized angels, birds, and fish.[3]
One of these is signed: "written by C. M. as school-
master in Lancaster County, Mount Joy Township
Anno 1796."[4]

Other frakturs by the artist giving Lancaster
County place names have been identified, as have frak-
turs by him for townships in Dauphin County and
areas of Dauphin that are now a part of Lebanon
County. Whether or not C. M. served as a schoolmas-
ter in any of these locations, in addition to his Mount
Joy position of 1796, is undetermined. His work
ranges in date from about 1790 to 1802.

Notable characteristics of this decorator's unusu-
ally crisp and symmetrical style as seen in this example
include the chains on the unicorns, the calligraphic

border between these animals and separating the main text from the heart above, the triangular shape of the heart with its outer border of double scallops, and the peculiar little curls on either side of the lions' paws. Very simple, yet neatly drawn and colored flowers on thick, sparsely leafed stems are also typical of the artist's work.

Inscriptions/Marks: In German, the ink inscriptions read: (within heart) "Singet und spielet dem Herrn/in Eurem Hertzen.,"; (below heart) "Diese Beÿde Ehegatten als Ullrich Danner und seine Ehliche hausfrau/Elisabeth eine Geborne Beckeren Ist ein sohn zur welt gebohren/als Alexander Ist zur welt gebohren im Jahr unsers Herrn 1804⁵ Den/3 ten Tag January um [blank] uhr des [blank] in zeichen der [blank]/Mithin Diese in den Gnadenbunt Gottes Einverleibet, und von Pfarrer [blank] Prediger/und Diener des worts gottes den 5 ten May Getaufft und genennet worden wie oben Ge-/-melt, oben gemeldete ist gebohren in America, in der provintz pensilvany, in Lancaster/Cauntÿ Hempfield Taunschip, Taufzeugen sind Ulrich Danner/und seine Ehefrau./ Gott segne unser Eingang und ausgang, euer gepflügtes und gesätes, euer morgen und abend/opfer. Das die berge Euch den Frieden verküntigen, und die Hügel vor euch Frolocken./Dass Eure kinder aufwachsen wie die cedern in Libanon."

The English translations read: (within heart) "Sing and make melody to the Lord in your hearts." (Ephesians 5:19); (below heart) "To these two married people, namely Ullrich Danner and his lawful wife, Elisabeth, née Beckeren, a son was born into the world, namely Alexander was born into the world in the year of our Lord 1804, the 3rd day of January at [blank] o'clock in the [blank] in the sign of [blank] Whereupon he was engrafted into God's covenant of grace and baptized the 5th of May by Pastor [blank], preacher and servant of the Word of God and named as above stated. The above named was born in the province of Pennsylvania, in Lancaster County, Hempfield Township. Sponsors are Ulrich Danner and his wife. God bless our going out and coming in, Your plowing and seedtime, Your morning and evening sacrifice, That the mountains bring you tidings of peace And the hills dance before you, That your children grow up like the cedars of Lebanon."

Condition: Conservation treatment by E. Hollyday in 1976 included removing a wood-pulp mat and lining the original support with Japanese mulberry paper before hinging the original support on acid-free mat board. In 1977 Hollyday set down flaking ink in the chain of the unicorn at right, along its nose, on the bottom central flower, and in the heart and calligraphic flourishes below. Modern 1½-inch flat wood frame, painted black.

Provenance: Found by Holger Cahill in Winston-Salem, N.C., and purchased from a dealer there named Davis; given to the Museum of Modern Art in 1939 by Abby Aldrich Rockefeller; turned over to Colonial Williamsburg in 1954.

Exhibited: AARFAC, New Jersey; "American Master Drawings and Watercolors: Works on Paper from Colonial Times to the Present," a traveling exhibition organized by the American Federation of Arts, New York City, September 1, 1976–April 17, 1977.

Published: AARFAC, 1957, illus. as no. 129; Ford, *Pictorial Folk Art,* illus. on p. 147; Kerr, illus. on p. 19; Rumford, *Folk Art Center,* illus. on p. 63; Stebbins, p. 87, illus. as fig. 57.

¹Owned by the Pennsylvania Farm Museum of Landis Valley, Lancaster, Pa.
²Owned by the Free Library of Philadelphia; see Weiser II, illus. as no. 209.
³See Weiser I, illus. as nos. 44, 45, 46.
⁴Ibid., illus. as no. 44.
⁵The C. M. Artist wrote "17" and an unidentified source crossed it out and added "1804." The C. M. Artist was not responsible for the cursive penmanship on this piece. The artwork and formal German writing were done about 1800 by the C. M. Artist.

William A. Currier
(active ca. 1830)

235 Friendship
63.305.11

Possibly William A. Currier
Probably New England, ca. 1830
Watercolor and ink on wove paper
12⅞" x 16½" (32.7 cm. x 41.9 cm.)

A possible attribution of this calligraphic drawing to William A. Currier is based on its close similarity to one other known and signed example by the artist.¹ Both have the large confronting birds on branches at the top of the composition, and the details of the various leaves, fruits, and flowers as well as the fine delineation of the birds' feathers are nearly identical. They differ in the selection of motifs used in the lower center in that no. 235 has an oval vine wreath interspersed with various small birds and, at the top of the oval, a bird's nest; the signed example has two large birds, perhaps quail, with spread wings.

Currier's title, *Friendship,* suggests that he, or perhaps the intended recipient, had planned to add a motto or rhyme appropriate to the subject in the blank oval at the bottom, but for unknown reasons this was never done. Such decorative drawings with inscriptions often were given as tokens to friends and loved ones, and surviving early nineteenth-century examples vary in format and design. The wreath with small birds was an unusual choice for the text panel surround, but it is also one of the most appealing and whimsical aspects of the picture.

Inscriptions/Marks: Inscribed in ink within the vine banner held by the top birds is "Friendship."

235

236

237

Condition: In 1980 E. Hollyday reduced acidity and staining throughout, mended small tears and losses, lined it with Japanese mulberry paper, and sized it with a weak gelatin solution. Probably original 1¼-inch cyma recta gilded wood frame.

Provenance: Edith Gregor Halpert, Downtown Gallery, New York, N.Y.

[1]Sotheby Parke Bernet, Inc., *Howard and Jean Lipman Collection of Important American Folk Art and Painted Furniture,* catalog for sale no. 4730Y, November 14, 1981, lot no. 199.

Georg Adam Derr
(1753– after 1777)

Little information is available on this fraktur artist, who probably worked exclusively in the Upper Hanover Township area of Montgomery County, Pennsylvania. The son of Johan Georg Derr (d. 1779) and Barbara Derr, Georg was born on August 10, 1753, in Macungie Township in Northampton County, Pennsylvania (now in Lehigh County).[1]

The recorded work by Derr includes three birth and baptismal certificates — one for himself (no. 236) and two for his children, Johan Georg Derr (no. 237) and Ana Barbara Derr, who was born on July 2, 1777.[2]

[1]Information courtesy of Pastor Frederick S. Weiser, in a telephone interview, 1984.

[2]Ana Barbara Derr's certificate is in the collections of the Philadelphia Museum of Art, acc. no. 59-92-250.

236 Birth and Baptismal Certificate for Georg Adam Derr 66.305.1

Georg Adam Derr
Probably Upper Hanover Township,
Montgomery County, Pennsylvania, 1779
Watercolor and ink on laid paper
13½″ x 8⅝″ (34.3 cm. x 21.9 cm.)

Derr's own certificate, created twenty-six years after his birth, was undoubtedly occasioned by the two he had made in April 1779 for his son, Johan Georg Derr, baptized on April 22 (see no. 237) and his daughter, Ana Barbara. Ana Barbara Derr was born in 1777, but her certificate was not drawn by her father until April 23, 1779.

Of the three, the father's and the daughter's records are closest in format and decoration. Both boast peculiarly shaped pots bearing the date 1779, with two pairs of flanking birds, and vines with flowers as heading. Below these is Derr's typical rectangular block of

script with a hatched border and the recipient's name in decorative uppercase Gothic script at the top.

Certain aspects of Derr's work suggest that he had more experience as a calligrapher than as a fraktur decorator. His script, made in a variety of letter types and styles and usually with exacting strokes, proves his ability in writing, but his birds, and particularly the vines flanking the text block, are less skillfully rendered.

Inscriptions/Marks: In German, the ink inscriptions read: (heading) "17 Tauffschein 79"; (below heading within border) "Georg Adam Derr/Gebohren von Ehrlichen Eltern Im Magunschie/Taunschib Northemtaun Caunti/Im Jahr Christi/1753 den 10 Augusti seine Eltern sind/Georg Derr und seine frau Barbara/und ist nach Christlichem gebrauch zur Heilich-/en Tauff Bestattet worden Ihm seinen/Peter und Getel heissen Adam Gramus und seine/frau Gertraut."

The English translations read: (heading) "Baptismal Certificate 1779"; (below heading within border) "Georg Adam Derr born to honorable parents in Macungie Township, Northampton County in the year of Christ 1753, the 10th of August. His parents are Georg Derr and his wife, Barbara, and was received by Holy Baptism according to Christian usage. His Petter [male sponsor] and Getel [female sponsor] are named Adam Gramus and his wife, Gertraut."

Condition: Conservation treatment by E. Hollyday in 1975 included dry cleaning, reducing acidity and stains, mending tears, filling and inpainting losses, backing with Japanese mulberry paper, and flattening. Modern replacement 2-inch flat wood frame, unpainted.

Provenance: Richard Wood, Baltimore, Md.

237 Birth and Baptismal Certificate for Johan Georg Derr 66.305.2

Georg Adam Derr
Probably Upper Hanover Township,
Montgomery County, Pennsylvania, 1779
Watercolor and ink on laid paper
13⅝" x 8½" (34.6 cm. x 21.6 cm.)

Georg Adam Derr's birth and baptismal certificate for his son, Johan Georg Derr, features one of the two prominent decorative formats preferred by the artist — a large crown-shaped device with text below. The elaborate "Taufschein" heading at the base of the design makes clear the purpose of the fraktur and was used for his daughter's certificate and the artist's own certificate (see no. 236). The flowers and leafy vines filling the lobes of the crown, the hatched border surrounding the text, and the style of lettering used for the recipient's name compare favorably with Derr's other known works.

At the lower right corner, a later hand apparently added "1870" and beneath it, "1779" — the year of Johan Georg Derr's birth. This may be a subtraction to determine the recipient's age at the time of death,

probably in 1870. The purpose of the "6" and above it, "87" at far right below the border is unknown.

Inscriptions/Marks: In German, the ink inscriptions read: (heading within base of crown) "Tauffschein"; (below crown within border) "Johan Georg Derr/Gebohren von Ehrlichen Reformirten Eltern in Ober-/Hanober Taunschib philatelfia Caunti/Im Jahr Christi 1779/den 25 februarius um: 11: uhr nachts Seine Eltern sind/Georg Adam Derr und seine Frau Christina/und ist nach Christlichem gebrauch zur heiligen Tauff Bestattet worden den 18 April/Ihm seinen Petter und Getel heissen Lenhart Schneiter und/(seine frau) Barbara/Geschrieben von Georg Adon Derr den 22 Apriel im iahr 1779/Gott allein die Ehr und niemant anders mehr."; (lower right corner) "1870" and "1779."

The English translations read: (heading within base of crown) "Baptismal Certificate"; (below crown within border) "Johan Georg Derr born to honorable Reformed parents in Upper Hanover Township, Philadelphia County [now Montgomery] in the year of Christ 1779, the 25th of February at 11 P.M. His parents are Georg Adam Derr and his wife, Christina, and was received by Holy Baptism according to Christian custom on April 18. His Petter [male sponsor] and Getel [female sponsor] are named Lenhart Schneiter and his wife, Barbara. Written by Georg Adam Derr April 22 in the year 1779. To God alone the glory and to no one else."

Condition: Conservation treatment by E. Hollyday in 1975 included cleaning, reducing acidity and stains, mending tears, filling and inpainting losses, backing with Japanese mulberry paper, sizing, and flattening. Modern replacement 2-inch flat wood frame, unpainted.

Provenance: Richard Wood, Baltimore, Md.

Ehre Vater Artist (active ca. 1785–1810)

The name Ehre Vater Artist was assigned to this unidentified decorator in 1961 by Donald B. Shelley.[1] The pseudonym reflects the artist's frequent use of the heading "Ehre Vater und Mutter" ("Honor Father and Mother") on *Taufscheine*, although phrases such as "Jesus meine Freude" ("Jesus my Joy") and "Jesus meine Zuversicht" ("Jesus my Confidence") also appear with some regularity.

Scholars have recorded about thirty works by this hand in recent years, all of which are *Taufscheine*. About half of these pieces were executed for children born in Virginia, North Carolina, and South Carolina, with the remaining documented to families living in Bucks, Berks, Cumberland, Dauphin, Lancaster, Northampton, and Somerset counties in Pennsylvania. Whether the artist visited all of these areas is undetermined, but the preponderance of Pennsylvania pieces and the presence of a North Carolina watermark on one *Taufschein* for that area support the theory that he visited those two regions. Several pieces executed for children born in Pennsylvania, but whose families moved to Canada, have also been identified.

While the artist's identity still eludes scholars, most concur that he was itinerant and perhaps served as a Lutheran minister, a schoolteacher, or possibly both. With the exception of several certificates drawn for North Carolina Moravian subjects, most of his identified *Taufscheine* were created for children baptized by Lutheran and Lutheran Reformed ministers.

Much of the existing research on this artist is credited to John Bivins, Jr., of the Museum of Early Southern Decorative Arts in Winston-Salem, North Carolina, and the subsequent discovery of South Carolina examples by John Christian Kolbe.[2] In his 1975 article, Bivins discussed a number of techniques and motifs favored by the artist, including a preference for vertical formats and the use of bold mottoes as headings. The thin pointed leaves observed in his work are often veined, sometimes executed in as many as three shades of green paint, and stem from thin vines surrounding the main text. An unusual partially opened tulip with lobed central petals, a smaller flower resembling a pansy, parrots, scrolls, and a wide range of geometric devices were also employed by the Ehre Vater Artist.

[1]Shelley, Fraktur-Writings, illus. as no. 206.
[2]See John Bivins, Jr., "Fraktur in the South: An Itinerant Artist," *Journal of Early Southern Decorative Arts,* I (November 1975), pp. 1–23.

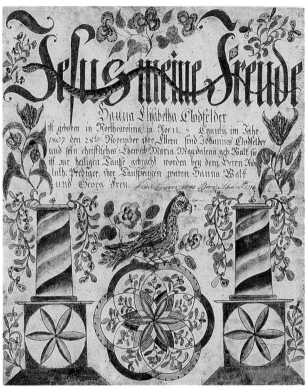

238

238 Birth and Baptismal Certificate 60.305.3
for Hanna Elisabetha Clodfelder

Attributed to the Ehre Vater Artist
Rowan County, North Carolina, ca. 1807
Watercolor and ink on laid paper
15⅛" x 12⅜" (38.4 cm. x 31.4 cm.)
(*Reproduced in color on page xii*)

Hanna Clodfelder's certificate is one of several frakturs by the Ehre Vater Artist identified with the area of central North Carolina encompassing the towns of Bethania, Bethabara, Friedberg, and Salem (now a part of Winston-Salem). Its numerous ornamental devices and its unusual masthead with a snake intertwined among the large letters make it one of the finest of the group now attributed to this hand. The snake, a symbol for Satan, has the "Jesus meine Freude" superimposed on it, signifying that Christ is the conqueror.

The architectural plinths topped by rainbow-colored columns and the geometric design between them were laid out with a compass and rule, tools that were often employed by a number of decorators. Of particular interest here, however, is the way in which

some elements are shaded in several colors or differing intensities of the same color to give three-dimensional form. This is most prominent in the larger leaves, on the backs of the parrot and snake, and in the geometric star designs in the plinths. Other fraktur artists also attempted to render mass through shading, but few were as successful as the Ehre Vater Artist.

A number of characteristics typical of this hand are evident in the Clodfelder certificate, including a vertical format, a bold masthead, and the peculiar shape of the multilobed tulips.

Inscriptions/Marks: In German, the ink inscriptions read: (bold heading with snake intertwined) "Jesus meine Freude"; (under bold heading) "Hanna Elisabetha Clodfelder/ist geboren in Northcarolina, in Roen Caunty, im Jahr/1807 den 28ten November ihre Eltern sind Johannes Clodfelder/und sein christliches Eheweib Maria Magdalena geb: Walk, sie/ist zur heiligen Tauffe gebracht worden bey dem Herrn Ridi/luth: Prediger, ihre Tauffzeugen waren hanna Walk/und Georg Frey." The last sentence is written in English: "Jacob Craver was Born April 13th 1796."

The English translations read: (bold heading with snake intertwined) "Jesus My Joy"; (under bold heading) "Hanna Elisabetha Clodfelder is born in North Carolina in Rowan County in the year 1807 the 28th of November. Her parents are Johannes Clodfelder and his Christian wife, Maria Magdalena, born Walk. She was brought to Holy Baptism by Mr. Ridi, Lutheran preacher. Her baptismal sponsors were Hanna Walk and George Frey."

Condition: Conservation treatment by Christa Gaehde in 1960 included cleaning, filling and inpainting losses, and mounting on Japanese mulberry paper. Paper tapes at the corners and at top and bottom center edges were removed, paper inserts were re-adhered,

and the primary support was hinged to conservation board in treatment performed by E. Hollyday in 1976. Probably period replacement 1½-inch beveled pine frame, unpainted.

Provenance: Robert Carlen, Philadelphia, Pa.

Exhibited: AARFAC, September 1968–May 1970; American Fraktur, and exhibition catalog, p. 11, no. 21; Smithsonian, American Primitive Watercolors, and exhibition catalog, p. 10, no. 44; "Southern Frakturs," Museum of Early Southern Decorative Arts, Winston-Salem, North Carolina, February 4–March 4, 1972.

Published: John Bivins, Jr., "Fraktur in the South: An Itinerant Artist," *Journal of Early Southern Decorative Arts,* I (November 1975), p. 19, illus. on p. 12 as fig. 6; Frederick S. Weiser, "North Carolina Fraktur," *Der Reggeboge,* V (Summer 1972), p. 6, illus. on pp. 2–3.

John Conrad Gilbert
(1734–1812)

In 1981 and 1982, the Folk Art Center staff collaborated with Pastor Frederick S. Weiser in mounting a small but important exhibition to announce the identification of John Conrad Gilbert as the fraktur artist previously known as the Bern Township Artist. Weiser's discovery of the artist and his careful research of Gilbert's frakturs were subsequently published as an article in *Der Reggeboge* that serves as the source for this entry.[1] Gilbert was the son of Johann George Gilbert (1698–1753) and Anna Elisabeth Gruber Gilbert (1702–1766) and was born in the village of Hoffenheim, southeast of Heidelberg, Germany, on April 29, 1734. The family, including other sons and an uncle, immigrated to America in 1750. They settled in Douglas Township in what is now Montgomery County, Pennsylvania. Conrad was naturalized as a citizen there on September 24, 1760.

The fraktur artist was still living in Douglas Township as late as 1774, when he was taxed for twenty-three acres of land and two cows. A Conrad Gilbert listed as a private in the Pennsylvania navy during 1776 and 1777 is believed to be the fraktur artist, although no other sources refer to such service.

Gilbert married Anna Elisabetha Steltz in New Hanover, Pennsylvania, on April 19, 1757. Thirteen children were born to the couple between 1758 and 1783. By the late 1770s, Gilbert and his family had moved to Brunswick Township, Berks County, where he is listed as a schoolmaster at the Zion Lutheran Church in 1778. Weiser's research findings place him as a teacher in Tulpehocken Township, Berks County, at Altalaha Lutheran Church from June 1779 to March 1783, and at Christ, Little Tulpehocken Church from 1783 to 1793. Gilbert kept the parish registers at both of these churches and at the latter

called himself a schoolmaster. He was in Braunschweig Township, Schuylkill County, by 1800 and may have been teaching in Berks County just prior to 1800. His will was made on January 7, 1809, and the inventory of his estate was taken on March 14, 1812.

Weiser identified the artist as Gilbert when he noticed that the handwriting in the Little Tulpehocken register matched that on frakturs in the Bern Township Artist group. Additionally, Weiser discovered that several of the frakturs were made for members of the schoolmaster's family. Finally, the block-style lettering in the first line of Gilbert's handwritten will also matched that on his frakturs and thus confirmed the identification.

Three types of frakturs have been associated with the artist — *Taufscheine,* bookmarkers, and miscellaneous decorative drawings. Twenty-two examples attributable to his hand are known today. Weiser notes that various elements used by Gilbert on *Taufscheine* were derived from the works of two other fraktur artists: Henrich Otto's printed certificates, and examples drawn by Daniel Schumacher, the pastor of Zion Church during the period that Gilbert was in Brunswick Township, Berks County (see no. 249). Other works by Gilbert, such as *Easter Rabbit* (no. 239), seem to be products of his own creativity.

[1]See Weiser, Gilbert, pp. 33–34 and cover.

239 Easter Rabbit 59.305.3

Attributed to John Conrad Gilbert
Berks (now Schuylkill) County, Pennsylvania, probably 1795–1800
Watercolor and ink on laid paper
3³⁄₁₆″ x 3³⁄₁₆″ (8.1 cm. x 8.1 cm.)
(*Reproduced in color on page 3*)

This tiny picture is the earliest-known portrayal of the mythical Easter rabbit known in American art. Pennsylvania Dutch folklore held that the rabbit laid the eggs that he delivered to children for Easter. The legend probably stems from the Teutonic era in Germany, when it was believed that such furry creatures laid eggs in springtime to honor the goddess Ostara, from whose name the word "Easter" derives. Ostara is credited with having transformed birds into animals.

Gilbert's sprightly rabbit boasts an appropriately festive dotted-and-hatched-striped coat. His basket contains multicolored eggs and is harnessed across his back. The decoration on the basket is similar to some of the border motifs that Gilbert used around the crowns on his birth and baptismal certificates.[1] *Easter*

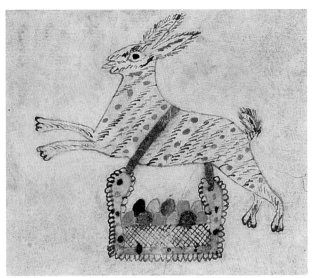

239

Rabbit was probably made as a token or gift to delight a child, perhaps a member of the Bolich family (see *Inscriptions/Marks*) in Brunswick Township, Berks County.

Inscriptions/Marks: Written in ink in German on the reverse: "Johannes Bolig in Braunschweig Daunschib Bercks Kaundi." The English translation is "Johannes Bolich, in Brunswick Township Berks County."
 Condition: In 1974 E. Hollyday cleaned, mended tears, removed an old mount, filled and inpainted losses, backed the primary support with Japanese mulberry paper strip hinges. Remounted in a rag-board mat by E. Hollyday in 1979. Mid-nineteenth-century, ¾-inch gilded and molded wood frame.
 Provenance: L. L. Beans, Trenton, N.J.
 Exhibited: "Meeting the Animals," Wadsworth Atheneum, Hartford, Conn., February 4–March 12, 1961; "The Pennsylvania Germans: A Celebration of Their Arts 1683–1850," a traveling exhibition organized by the Philadelphia Museum of Art and the Henry Francis du Pont Winterthur Museum, Winterthur, Del., October 17, 1982–January 29, 1984.
 Published: *Der Reggeboge*, V (March 1971), illus. on cover; Beatrice B. Garvan and Charles F. Hummel, *The Pennsylvania Germans: A Celebration of Their Arts 1653–1850* (Philadelphia, 1982), pp. 156, 184, no. 193, illus. as pl. 116 on p. 148; Weiser, Gilbert, illus. as fig. 17 on p. 45.

[1]See Weiser, Gilbert, fig. 11, illus. on p. 42, for example.

Arnold Hoevelmann
(1749–1804)

Most of the information available on Hoevelmann is contained in Robert M. Kline and Frederick S. Weiser's article published in 1970.[1] Before the discovery of his name, the scrivener was called the York County General Artist because many of his frakturs showed a male figure in military attire and one of the earliest discovered examples came from York County, Pennsylvania.

The identification of Hoevelmann as the artist is based on two assumptions: that the stamens of some of his flowers are cleverly constructed to form the first initial, *H*, of his surname; and that the handwritten "Hoevelmann" found on one of Henrich Otto's printed frakturs indicates the name of the artist who added decoration to the piece. On the same fraktur, Otto's printed name was lined out and "Hoevelmann" placed below it.[2]

According to Kline and Weiser, the only likely person who can be associated with the fraktur group is Arnold Hoevelmann (Hebelman, Heffleman). An unsubstantiated family legend indicates that Hoevelmann was born in Prussia in 1749 and arrived in America with General Lafayette to support the colonial American forces in the fight for independence. Descendants also called Hoevelmann a doctor, but no record of this profession has been found.

Documented sources reveal that Hoevelmann had a wife named Eva Susanna and at least three children. Two of their sons were baptized at Trinity Church in Lancaster, Pennsylvania, in 1780 and 1793. Hoevelmann may have lived in Lancaster during a portion of this time, but in the 1790 census he is listed as a resident of Dauphin County, probably living in or near Lebanon since many of his frakturs were done for families in that area.

The Hoevelmann family had moved to Allen Township in Cumberland County, Pennsylvania, by 1797, where they were attending Friedens Church. The artist died intestate in April 1804.

[1]See Kline and Weiser, pp. 1–5.
[2]Ibid., p. 3.

240 Peter Hoffmann Baptismal and 58.305.3
 Birth Certificate

Attributed to Arnold Hoevelmann
Pennsylvania, possibly Dauphin County, ca. 1793
Watercolor and ink on wove paper
13" x 16⅜" (33.0 cm. x 41.6 cm.)

The military figure shown on this example is one of two types used by the artist and probably represents a cavalry officer as indicated by the spurs and boots, cut of the trousers, and cap feather.[1] The object in his left hand is probably a targe, a small round shield used against lances and swords.

240

Peculiar to Hoevelmann's work is the manner in which he drew certain flowers, including one four-petaled variety, two examples of which are located on the right side of the large vine in this certificate. An exaggerated and distorted version of the same flower appears across the top and center of the drawing. The stamens in the small flower at lower right on the vine are configured in the letter *H*. On the other side of the vine, paralleling this motif, is another very odd flower that is rarely seen in the artist's work. One wonders if this might not represent an *A* for Arnold, the artist's first name.

In addition to flowers, vines, and military figures, other frakturs attributed to Hoevelmann illustrate barnyard fowl and various types of birds, and at least one representation of a deer or stag is known.[2]

Inscriptions/Marks: In German, the ink inscription reads: "Diese beÿden Ehegatten als Georg Hoffmann/und seine Ehe Frau Maria/ist ein Sohn zur Welt gebohren als Peter/ist gebohren im Jahr Christi 1793 den 8 Tag/September um 3 Uhr morgens im Zeichen der Waag/Getauft durch Pfarrherr Friderich Illin d. 27/Taufzeugen Johannes Keller und seine Ehe Frau Catharina/Gebohren im Staat Pensilvanien/in Bercks Cauntÿ in Robeson Taunschip/Gott allein die Ehre."

The English translation reads: "To these two married people, namely George Hoffmann and his wife, Maria, a son was born into the world, namely Peter, was born in the year of Christ 1793 the eighth day of September at three o'clock A.M. in the sign of Libra. Baptism by Pastor Friederich Illin the 27th. Sponsors Johannes Keller and his wife, Catharine. Born in the state of Pennsylvania in Berks County in Robeson Township. Glory to God alone."

Condition: Unspecified conservation treatment by Christa Gaehde in 1959 probably included cleaning, filling and inpainting losses, and backing the fraktur with Japanese mulberry paper. Probably period replacement 1¾-inch splayed wood frame, painted black.

Provenance: Robert Carlen, Philadelphia, Pa.

Exhibited: Smithsonian, American Primitive Watercolors, and exhibition catalog, p. 9, no. 43; Washington County Museum, 1966.

Published: Kline and Weiser, illus. on p. 5.

[1]See Kline and Weiser, illus. on cover.
[2]Ibid.

Susanna Hübner
(1750–1818)

Susanna Hübner was the daughter of Hans Christopher Hübner (1718–1804) and his wife, Barbara Schultz Hübner (1720–1786). After her mother's death, Susanna continued to make her home with her father, who was a prominent copyist and a student of Schwenkfelder hymnody.

241

1794), Susanna (b. 1797), Debora (b. 1799), Abraham (b. 1802), David (b. 1805), and Maria (b. 1807). Probably others were made for Abraham's sons Isaac (b. 1791) and Jacob (b. 1793), although their whereabouts are currently unknown. As a group, these works represent one of the cycles of fraktur she created for the same family members; other formats include a series of New Year's greetings for each person and a series of biblical passages that begin with the names of Abraham Hübner's children.[1]

Many of her typical fraktur decorations are incorporated in this example, a bookplate that was made for her niece's prayer book. The delicate geometric border, the two small trees at the bottom, the elaborate vines on the tulips, and the type of lettering are all characteristic of her style.

Inscriptions/Marks: In German, the ink inscription reads: "Dieses/Gebet/Büchlein/Gehöret mir/Susanna H. Hübner."

The English translation reads: "This little prayer book belongs to me Susanna H. Hübner."

Condition: In 1974 E. Hollyday removed the bookplate from a wood-pulp backing and hinged it to an acid-free mat board; stains in the lower corners were reduced and the surface dry-cleaned.

Provenance: Mary Allis, Fairfield, Conn.

Exhibited: AARFAC, New Jersey; AARFAC, September 15, 1974– July 25, 1976; Washington County Museum, 1966.

Published: AARFAC, 1974, p. 69, no. 68, illus. on p. 68.

[1]All information for this entry was provided by Pastor Frederick S. Weiser to AARFAC, November 1985.

All of the known dated examples of her work were created between 1807 (shortly after her father's death) and 1810, when she observed her sixtieth birthday. She died unmarried in 1818.[1]

[1]All biographical information for this entry was furnished by Pastor Frederick S. Weiser to AARFAC, November 1985.

241 Bookplate 63.305.1,5

Attributed to Susanna Hübner
Montgomery County, Pennsylvania, 1805– 1810
Watercolor and ink on laid paper
5½" x 3¼" (14.0 cm. x 8.3 cm.)

There are only a few surviving works by Susanna Hübner, although she is considered one of the most celebrated of the Schwenkfelder sect artists. The Schwenkfelder Library in Pennsburg, Pennsylvania, owns a set of six identical bookmarkers made by her for the children of her brother Abraham: Sarah (b.

Abraham Huth
(active ca. 1805–1829)

No documents or other sources containing information on this artist have been discovered to date. Therefore, what is known about Huth is confined to conclusions reached in analyzing a large selection of his known work. The thirty examples recorded in the Folk Art Center's archives suggests that Huth traveled to and/or resided in two or more Pennsylvania counties during his lifetime.[1] Works by him are chiefly from Lebanon and Berks counties, with some documented from Lancaster County and only a few recorded from Dauphin County. An 1820 birth and baptismal certificate for Lea Jacky, owned by the Henry Francis du Pont Winterthur Museum, carries the inscription: "Drawn and to be had from Abraham Huth, Lebanon Township, Lebanon County, Kimmerling Schoolhouse."[2]

As Huth's style matured during the 1820s, he introduced more elaborate elements such as small cityscapes or townscapes and clusters of wisteria blos-

soms. Number 242 lacks these innovative elements since it was produced earlier in Huth's career.

[1] The large number of works of Abraham Huth's actually surviving has never been computed, but the works are widely dispersed among private and public collections.

[2] Kimmerling's, in Quitophilla, was a Reformed congregation in Lebanon Township dating from about 1750. See Charles H. Glatfelter, *Pastors and People: German Lutheran and Reformed Churches in the Pennsylvania Field, 1717–1793*, I (Breinigsville, Pa.: Pennsylvania German Society, 1980), p. 333.

242 Birth Certificate for Nancy Loeffler 31.305.2

Attributed to Abraham Huth
Probably Lancaster County, Pennsylvania, ca. 1805
Watercolor and ink on wove paper
12¼″ x 15³⁄₁₆″ (31.1 cm. x 38.6 cm.)

Nancy Loeffler's certificate is attributed to Abraham Huth because of its stylistic relationship to a signed *Geburtsschein* ("birth certificate") and *Taufschein* for Lea Jacky of Cocalico Township, Lancaster County, Pennsylvania.[1] The Jacky example has a subject birth date of November 25, 1820, and bears the inscription: "Drawn and to be had from Abraham Huth, Lebanon Township, Kimmerling's Schoolhouse."[2] Huth may have served as a schoolteacher for Kimmerling's Reformed congregation in Lebanon County during this year and possibly others. Unfortunately, no mention of his name or any details of his life have been found in reference to Kimmerling's or other Reformed churches in the area.[3]

More than thirty examples have been assigned to Huth in past years, and the likelihood of others being attributed to him is certain.[4] He may have lived in or traveled to nearby counties during the period he was executing frakturs. The examples currently identified bear birth dates ranging from 1805 to 1829 for families living in Lancaster, Berks, Dauphin, and Lebanon counties.[5] Interestingly, most of Huth's work was created for Lebanon County families, and Lebanon, then as now, is surrounded by Lancaster, Dauphin, and Berks counties. If he lived there, or in Berks County, the area claiming the second highest percentage of his frakturs, then the reference to Kimmerling's is especially significant since this congregation was located near the Lebanon–Berks County line and therefore shared ministers with a number of established churches in Berks County.

Huth's designs and formats, and the quality of his drawing, remained virtually the same during his career, making it especially difficult to establish dating on the basis of stylistic change or evolution. Some of the decorative elements characteristic of his work are seen here and include the red, yellow, and green coloration; the sawtooth border surrounding the centrally placed script; the base with two large, stippled four-petaled flowers below the script block; the highly stylized birds at either side at top; and the multipointed flower at center top. Like most of his work, the overall arrangement is symmetrical.

The information regarding baptism is appropriately left blank on this certificate since the practice did not exist among Mennonites. The unidentified scrivener's use of the word "sect" instead of "church" to identify Nancy Loeffler's religious affiliation is unusual and rarely seen on birth certificates from the early nineteenth century.

242

Inscriptions/Marks: Within the sawtooth border, the German inscription reads: "Nancy Loeffler - - - ist von christliche und/Eheliche der Menonister Secte [blank] Relion zugedane/Eldern geboren im Jahr unsers-Herrn 1805 den/10ᵗᵉⁿ Januar - - des Kindes Eldern waren/William Loeffler - - - und desen Ehefrau/Maria [blank] ein geborne Winger. [Blank] diese ist/gebohren in Cocallico Taunschip in Lancaster/Cauntÿ und ward gedauft von Her Pr/[blank] den [blank] ᵗᵉⁿ [blank] die/Taufzeugen waren [blank]/und [blank]."

The English translation reads: "Nancy Loeffler was born to Christian and legally married parents belonging to the Mennonite sect in the year of our Lord 1805, January 10. The parents of the children were William Loeffler and his wife, Maria, née Winger. She was born in Cocalico Township in Lancaster County and was baptized by Pastor [blank] the [blank] ᵗʰ [blank] the sponsors were [blank] and [blank]."

Condition: Conservation treatment by Christa Gaehde in 1955 included removing an acidic pulp mount, cleaning, mending tears, and backing with Japanese mulberry paper. In 1974 E. Hollyday cleaned the primary support and hinged it to conservation board. Modern replacement 1⅝-inch flat grain-painted frame.

Provenance: Purchased from Edith Gregor Halpert, Downtown Gallery, New York, N.Y.; given to the Museum of Modern

Art in 1939 by Abby Aldrich Rockefeller; transferred to the Metropolitan Museum of Art in 1949; turned over to Colonial Williamsburg in June 1954.

Exhibited: AARFAC, September 15, 1974–July 25, 1976.

Published: AARFAC, 1957, no. 371, p. 377; AARFAC, 1974, no. 74, p. 71, illus. on p. 14.

[1]The birth and baptismal certificate for Lea Jacky is owned by the Henry Francis du Pont Winterthur Museum, Winterthur, Del. Donald A. Shelley, writing in 1961, did not know of the Jacky example but identified another signed example by Huth then in the Unger Collection. Attempts to locate this piece have been fruitless. See Shelley, Fraktur-Writings, catalog no. 212, and pp. 118, 121, 130, 131, 132, 179. Shelley, a noted fraktur authority, is credited with the identification of much of Huth's work and was the first to publish information on the artist.

[2]As quoted from the Jacky certificate discussed in note 1 above.

[3]See Charles H. Glatfelter, *Pastors and People: German Lutheran and Reformed Churches in the Pennsylvania Field, 1717–1793,* I (Breinigsville, Pa.: Pennsylvania German Society, 1980), pp. 24, 29, 58, 114, 144, 150, 170, 329, 333, for a discussion of the Kimmerling's congregation and its ministers.

[4]AARFAC files contain a list of thirty attributable Huth frakturs in both private and public collections.

[5]Twenty-four of the thirty Huth examples recorded by AARFAC name the counties where the children cited on the certificates were born. Twelve mention Lebanon County; seven cite Berks; Lancaster County is named on three; and Dauphin is listed on one.

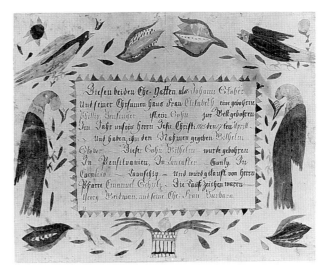

243

Andreas Kessler (von Kessler) (active ca. 1805)

243 Birth and Baptismal Certificate for Wilhelm Stober

66.305.9

Attributed to Andreas Kessler (von Kessler)
Southeastern Pennsylvania, ca. 1805
Watercolor and pencil on laid paper
12⅝″ x 15½″ (32.1 cm. x 39.4 cm.)

Nothing is known about the life of Andreas Kessler, or von Kessler, other than what can be derived from a group of frakturs now attributed to him and previously ascribed to the Flat Parrot Artist. Of his birth and baptismal certificates, examples from Lebanon, Dauphin, and Lancaster counties have been recorded.[1]

Most of the attributed works, like the Wilhelm Stober certificate illustrated here, date before 1815, and all feature rather crudely drawn decorations. Elongated, vertically positioned parrots usually clutch at thin, sparsely foliated and/or berried vines at either side of the central text or in the lower corners of the certificates. Large and small flowers and buds, an occasional star or stylized sunflower, and flanking birds also typify Kessler's work, but most are rough in configuration and rarely identifiable in design. His texts were sometimes enclosed by a rectangle formed by a sawtooth border of three alternating colors or within a heart created by two concentric lines with a series of small dots between them.

Inscriptions/Marks: In German, the ink inscription reads: "Diesen beiden Ehe = Gatten als: Johann Stober/Und seiner Ehrsamen haus Frau Elisabeth eine gebohrne/Phillip Bensinger ist ein Sohn zur Welt gebohren/Im Jahr unsers herrn Jesu Christi 1805 den 27ten Aprill/Und haben ihm den Nahmen gegeben Wilhelm/Stober Dieser Sohn Wilhelm wurde gebohren/In Pensilvanien In Lancaster Caunty, In/Cocalico Taunschip. Und wurd getauft, von herrn/Pfarre Emanuel Schulz Die Tauf = zeichen waren/Georg Weidman und seine Ehe = Frau Barbara."

The English translation reads: "To these two married people namely Johann Stober and his honorable wife, Elisabeth, born [to] Phillip Bensinger, a son was born into the world in the year of our Lord Jesus Christ 1805 the 27th of April and have given him the name Wilhelm Stober. The son Wilhelm was born in Pennsylvania in Lancaster County in Cocalico Township, and was baptized by Pastor Emanuel Schulz. The sponsors were Georg Weidman and his wife, Barbara."

Condition: Conservation treatment by E. Hollyday in 1977 included removing adhesive tape, bleaching to reduce stains and foxing, filling minor losses, and inpainting. The work was backed with Japanese mulberry paper and sized with a gelatin solution and then flattened and dried. Period replacement 2-inch beveled wood frame cut down to fit.

Provenance: Richard Wood, Baltimore, Md.

Exhibited: AARFAC, New Jersey; Washington County Museum, 1966.

[1]See Shelley, Fraktur-Writings, illus. as no. 210. See Weiser, Fraktur, illus. on p. 90; Kline and Weiser, p. 11, gives a discussion on the attribution of fraktur to Kessler (von Kessler).

Friedrich Krebs
(possibly 1770–1815)

Friedrich Krebs of Pennsylvania is often credited as America's most prolific fraktur artist. His birth date and place are unknown, but his earliest fraktur is believed to have been made in 1790.[1] He married a woman named Anna Maria and had at least two children, sons Joshua and Frederich Carl (b. ca. 1799). Most sources rely on entries in surviving account books for the *Reading Adler,* an inventory of his estate taken in 1815, and on an 1805 property assessment list for details about Krebs's life and fraktur work.[2] Various recordings in the account books place Krebs in Dauphin County, Pennsylvania, in the early 1800s. The 1805 assessment list for property in Swatara Township, Dauphin County, cites him as a schoolmaster owning three acres of land. Presumably, this was the same property that Krebs purchased in 1796 between Harrisburg and Hummelstown.

The inventory of Krebs's estate, taken on July 29, 1815, reveals that he had on hand large quantities of materials associated with his fraktur work, including "a lot of pictures and clean paper, a third lot of clean paper and paper for birthday, a lot of papers picterd and papers for birth Dayes, a lot of papers pictered." Although these descriptions are brief, some probably refer to printed forms ordered by the artist from local printers. References in the *Reading Adler* accounts show that Krebs had three prints run off in 1804 totaling 1,987 pieces. From September 16, 1801, to July 8, 1813, the *Reading Adler* supplied Krebs with 6,974 printed *Taufscheine.*

The fraktur scholar Donald A. Shelley was one of the first to analyze the artist's style as it evolved over a number of years. Shelley called Krebs typical of Reading, Pennsylvania, decorators who used applied cutout designs and noted that Krebs may have originated this kind of embellishment in Pennsylvania. In the early years of his career, Krebs used borders consisting of a single color line that wove in and out of small comma-shaped motifs in another color. He later augmented this design with block stamps or cutouts in his certificates predominated by heart-shaped compositions. About 1790 or just before, he began to use woodcut copies of Henrich Otto's bird and tulip motif as well as a freehand version of Otto's chain of leaves. From about 1790, Krebs used all of these devices and methods, and added motifs, such as parrots and crowns, that were inspired by the work of other decorators. Krebs's totally freehand drawings, including depictions of the prodigal son, George and Martha

Washington, the spiritual clock, and other scenes, rank among his best work.

[1]All biographical information for this entry is taken from Shelley, Fraktur-Writings, pp. 64–67, 99, 125–129, unless cited otherwise.
[2]See also Garvan, p. 362.

**244 Birth and Marriage Certificate 66.305.3
for Christian Steltz**

Attributed to Friedrich Krebs
Pennsylvania, probably ca. 1799
Watercolor, ink, and paper cutouts on laid paper
16″ x 12¾″ (40.6 cm. x 32.4 cm.)

A prominent feature of this example is Krebs's use of several cutout designs — the peacock, turkey, and flying birds. These were cut from imported Dutch papers embossed with motifs. No materials of this sort are listed in the artist's estate inventory, but his continual use of them indicates that he must have kept quantities on hand throughout his career. In Europe such papers were generally used for bookbindings and endpapers.

244

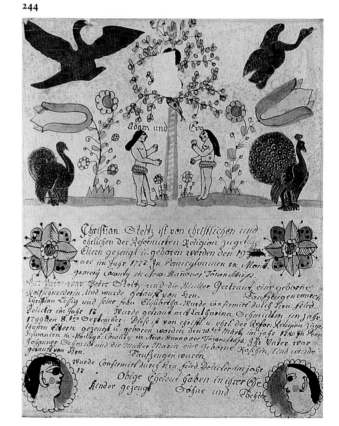

The central design featuring Adam and Eve was a popular decoration on a variety of objects in Pennsylvania during the eighteenth and nineteenth centuries and is occasionally seen in fraktur drawings (see no. 231). Its use on Steltz's certificate is symbolic, since the fraktur records the recipient's marriage as well as birth. The overall arrangement — with profile likenesses flanking the lower corners, matching flowers at either side of the top of the text, and applied birds surrounding the hastily worked flowers and Garden of Eden — is typical of Krebs's ability to create distinctive and often original compositions.

Inscriptions/Marks: In German, the ink inscriptions read: (above the two figures) "Adam und Eva"; (under the Garden of Eden scene) "Christian Steltz ist von christlichen und/ehrlichen der Reformirten Religion zugethan/Eltern gezeugt u. geboren worden den 19 febru=/ari im Jahr 1777. In Pennsylvanien in Mont=/gomerÿ County in New=Haňover Townschip./Der Vater war Peter Steltz und die Mutter Gertraut eine geborne/Reifschneiderin. Und wurde getauft von hrn. [blank] Taufzeugen waren/Christian Lessig und seine frau Elisabetha. Wurde Confirmirt durch hrn. fried./Delicker im Jahr 17 [blank]. Wurde getraut mit Catharina Schmidtin im jahr/1799 den 8ᵗᵉⁿ September. Diese ist von christl. u. ehel. der Refor: Religion zuge=/thanen Eltern gezeugt u. geboren worden den 20ᵗᵉⁿ Märtz im jahr 1780 In Penn=/sylvanien in Montgo: Cownty in New=Hannover Townschip. Ihr Vater war/Johannes Schmidt und die Mutter Maria eine geborne Roschin. Und wurde/getauft von hrn. [blank] Taufzeugen waren [blank]/wurde Confirmirt durch hrn. fried. Delicker im jahr/17 [blank]. Obige Eheleut haben in ihrer Ehe/Kinder gezeugt [blank] Söhne und [blank] Töchter."

The English translations read: (above the two figures) "Adam and Eve"; (under the Garden of Eden scene) "Christian Steltz was born to Christian and honorable parents belonging to the Reformed religion, begotten and born the 19th of February in the year 1777 in Pennsylvania, in Montgomery County, in New Hanover Township. His father was Peter Steltz and his mother Gertraut, née Reifschneiderin. And was baptized by Mr. [blank]. Baptismal sponsors were Christian Lessig and his wife Elisabetha. Was confirmed by Mr. Fried. Delicker in the year 17 [blank]. Was married to Catharina Schmidtin in the year 1799, the 8th of September. She was born to Christian and honorable parents belonging to the Reformed religion, begotten and born the 20th of March in the year 1780 in Pennsylvania in Montgomery County in New Hanover Township. Her father was Johannes Schmidt and her mother Maria, née Roschin. And was baptized by Mr. [blank]. Baptismal sponsors were [blank]. Was confirmed by Mr. Fried. Delicker in the year 17 [blank]. The above married people in their marriage have been the parents to children, sons and daughters."

Condition: Conservation treatment by E. Hollyday in 1976 included reducing acidity and stains, mending tears, re-adhering the paper cutouts, backing with Japanese mulberry paper, sizing, drying, and flattening. A loss at the top of the tree, which included part of the snake, was filled and inpainted. Period replacement 2½-inch splayed mahogany-veneered frame.

Provenance: Robert Wood, Baltimore, Md.

Jessie Larey (or Laury) (active possibly ca. 1838)

245 Irrgarten 63.305.2

Possibly Jessie Larey (or Laury)
Probably Pennsylvania, possibly 1838
Watercolor and ink on wove paper
15¾" x 12¾" (40.0 cm. x 32.4 cm.)

A signature on the back of this piece and the inscribed date 1838 may refer to the maker and year of execution, although the handwriting is difficult to decipher. No early history regarding the piece's provenance is known, and no other examples by this hand have been recorded to date.

The *Irrgarten* ("Maze") was but one of several fraktur types devoted almost exclusively to religious and moralistic teaching. Most are labyrinthian in form and many, such as no. 245, utilize various stanzas from popular hymns. This example combines verses from two hymns that were published in most early German language hymnals in colonial America.[1]

The format and some of the design elements used here compare closely with other known American *Irrgartens,* especially one example owned by the Free Library of Philadelphia.[2] The two share identical labyrinths, and both feature vases with flowers in their interior corners and hearts with flowers issuing from their tops. Although by different hands, their similarity suggests a common source of design known to both makers from either handmade pieces or possibly printed examples. The highly refined script and delicate drawing for no. 245 indicate an experienced maker and quite likely a schoolmaster.

Inscriptions/Marks: An ink inscription on the back of the support reads: "Jessie Larey [possibly Laury]/1838." In German, the ink inscriptions read: (heading) "Irrgarten."; (first hymn, stanzas 1–9 within labyrinth) "1 Wie sicher lebt der mensch der staub sein leben ist ein fallen laub und dennoch schmeigelt er sich gern der tag des todtes sei noch fern 2 der jüngling hoft des greises ziel der mann noch seine Jahre viel der greis zu vielen noch ein jahr und keiner nimmt den irrthum wahr, 3 Sprich nicht, ich denk in glück und noth im herzen oft an meinen tod der todt nicht weiser hat nie mit ernst an ihn gedacht, 4. wir leben hier zur ewigkeit zu thun was uns der herr gebeut und unsers lebens kleinster theil Ist eine frist zu unserm heil. 5. Der todt rückt seelen vor gericht Da bringt gott alles an das licht und macht was hier verborgen war den rath der her:/ :zen offenbar. 6. Drum da dein todt dir täglich dräut so sey doch wacker und bereit prüf deinen glauben als ein christ ob er durch liebe thätig [ist]. 7. ein seufzer in der letzten not ein wunsch des, durch erlösers todt vor gotes thron gerecht zu seÿn Dies macht dich nicht von sünden rein, 8 ein herz dass gottes stimme hort Ihr folgt und sich vom bösen kehrt ein gläubig herz von lieb erfüllt dies ist es was in christo gilt, 9. Die heiligung offenbart müh Du wirkst sie, nicht gott, wirket sie du aber ringe stets nach ihr, als wäre sie ein werk von dir"; (first hymn, stanzas 10–14 along the labyrinth bor-

245

der in block form) "10, der ruf des lebens dass du lebst dein höchstes ziel/nach dem du strebst und was/dir ewig glück verschaft, ist/tugent durch des glaubens kraft./11. Ihr alle seine tage weihn/beisst einge-denk des todes/feÿn, wachsen in der heiligung/ist wahre todes erin:/ :nerung,/12 Wie oft vergess ich diese/pflicht herr geb mir mir [sic] nicht,/ins gericht drück selbst des todes bild in mich dass ich dir wandle würdiglich/13 Das ich mein herz mit,/jedem tag, vor dir o gott er:/:forschen mag ob liebe, demut,/fried und treu,/die frücht/ des geistes in ihm sey/14, das ich zu dir um gnade fleh/stets meine schwachheit/widdersteh und einstens, durch/des glaubens mach[t] mit freu:/:den ruf, es ist vollbracht."; (second hymn, stanzas 1-3 along the labyrinth border in block form) "1 Nun, sich der tag geendet/hat und keine sonn mehr scheint/schläft alles was sich ab:/ :gemacht auch was zuvor/geweint;/2. nur du, mein gott, hast kei:/ :ne rast, du schläfst und schlu:/:mmerst nicht, die finsternis/ist dir verhasst weil du/bist selbst das licht;/3, gedenke, herr, doch auch/an mich in dieser dunklen/nacht und schenke mir/gnädiglich den schirm, von deiner macht."

The English translations read: (first hymn, stanzas 1-9 within labyrinth) "1 How confidently man lives, whose life is dust, a fallen branch, and yet deceives himself with thinking that the day of death is still far off., 2 A youth hopes to attain old age, an adult man a good many years more, an old man thinks too much of one more year and none is aware of the foolishness of it all., 3 Do not say, I shall think of my death by chance or dire straits. Whoever is not made wise by death, has never thought seriously about it., 4. We live here to eternity to do what pleases God. And the smallest detail of our lives is ordained for our eternal good., 5. Death escorts souls to judgment where God brings everything to light. And the counsels of the heart, so secret here, shall there be revealed., 6. Therefore since your death presses you daily, be awake and ready. Test your faith as a Christian, whether it is active in love., 7. A sigh upon the

verge of death, a hope to stand acquitted before God's throne by the Redeemer's death will not suffice to make you free from sin., 8. A heart perceiving God's voice, following it and converting from evil, a believing heart filled with love, is what counts in Christ., 9. Sanc-tification reveals effort; you don't achieve it, God does. You, how-ever, struggle constantly for it, as if it were a work of yours."; (first hymn, stanzas 10-14 along the labyrinth border in block form) "10. O God, each day examine my heart to find out whether love, humil-ity, peace and trust, the fruits of the Spirit, are there., 14. That I may flee to you for grace and overcome constantly my weakness, and at last in the power of faith shout with joy: it is finished."; (second hymn, stanzas 1-3 along the labyrinth border in block form) "1. Since now the day is over, and the sun no longer shines, everything sleeps which settles itself down, even what once cried., 2. Only you, my God, you take no rest, you slumber not nor sleep, darkness is hateful to you, since you alone are light., 3. Think on me, too, Lord, in this dark night; provide me graciously the shelter of your might."

Condition: Unspecified conservation treatment by Christa Gaehde in 1967 probably included mending tears, mounting, and backing with Japanese mulberry paper. In 1978 E. Hollyday dry-cleaned the piece, removed an old mount, remended edge tears, and hinged it to four-ply conservation board. Modern replacement 1-inch oak frame.

Provenance: Robert Carlen, Philadelphia, Pa.

Exhibited: American Fraktur, and exhibition catalog, no. 16, p. 11, illus. on p. 5.

[1] Frederick S. Weiser to AARFAC, 1983.
[2] See Weiser I, illus. as no. 267.

Daniel Otto
(ca. 1770–ca. 1820)

246 Lions and Tulips

59.305.2

Attributed to Daniel Otto
Probably Pennsylvania, ca. 1820
Watercolor, pencil, and ink on laid paper
8⅛″ x 13¼″ (20.6 cm. x 33.7 cm.)

Daniel Otto, once known as the Flat Tulip Artist, produced some of the most colorful and interesting pieces that survive from central Pennsylvania and particularly the Centre County area.[1] Most of the frakturs assigned to him date from about 1800 to 1820.

Otto's work ranges from decorative pictures featuring the bright yellow and wide-eyed, rampant lions featured here to *Taufscheine* with complex crowns and parrots and fanciful beasts, which probably were meant to represent dragons.[2] The artist's style is very distinctive and consistent. The small round flowers and slightly larger carnations with paired leaves on single-line stalks, and the wide-open, two-lobed tulip with part or all of the petals divided into small blocks of alternating colors, predominate Otto's work. While the various design elements used are simple in configuration, their arrangement and generally bright coloration usually guarantee their appeal.

Inscriptions/Marks: A watermark in the primary support reads: "C & S."
Condition: Conservation treatment by Christa Gaehde in 1960 included removing adhesive tape, mending tears, cleaning, fumigating, mounting on rag board, and probably backing with Japanese mulberry paper. In 1975 E. Hollyday dry-cleaned unpainted areas, remended tears, filled and inpainted losses, removed an old mount, and remounted on four-ply conservation board using Japanese paper hinges. Tears were remended by E. Hollyday in 1980. Modern replacement 2½-inch flat curly maple frame with beveled edge and inset corner blocks.

246

Provenance: L. L. Beans, Trenton, N.J.
Exhibited: Smithsonian, American Primitive Watercolors; Washington County Museum, 1966.

[1]Information provided by E. Bryding Adams Henley and Frederick S. Weiser, November 1985.
[2]See Weiser I, illus. as no. 106; Weiser, Fraktur, illus. on pp. 24, 94; Shelley, Fraktur-Writings, illus. as no. 213. Another Otto fraktur with rampant lions that is similar to no. 246 is owned by the Henry Ford Museum in Dearborn, Mich.

Francis Portzline
(1771–1857)

Ruthann Hubbert's 1982 article on Francis Portzline serves as the chief source for this entry since it provides the most complete information on the artist's family and a summary of his professional activities.[1] Portzline's descendants living in Snyder County, Pennsylvania, claim that the artist was smuggled in a false-bottomed cracker barrel aboard a ship bound for America, but the date of this event remains unknown. The earliest reference to him in America dates from 1800, when he was listed as a storekeeper and as unmarried in the York County tax records for Monaghan Township. A year later, on May 14, Portzline married Sabina Heiges, daughter of George Heiges (d. 1804) and Margareta Heiges (d. 1808), all of York County.

Portzline's European origins are indicated in the naturalization records for York County in 1804, where the artist is recorded as "owing allegiance to the Duke of Palacia in the Empire of Germany" (i.e., the Palatinate). Family tradition also indicates that Francis's father was well educated, had served as the principal or headmaster of a French school, and had some political involvement in the French Revolution that necessitated the family's remove to America.

Hubbert's research on the artist included locating the Portzline family Bible and a store ledger used by him. Recorded in the Bible and probably in the artist's hand are the names of his children: George; Wilhelmine; Francis, Jr.; Elisabeth; Wilhelm; Abraham; and Maria. The fraktur decorator's own birth date and place were recorded as October 4, 1771, in Solingen, "near Dizeldorf at the river Rhine in Europa."

Portzline and his family continued to live in York County, Pennsylvania, until sometime in 1812, when he sold land there and subsequently purchased a tract in Tyrone Township, Perry County. By 1815 the family had moved to Mahantango Township in Union (now Snyder) County. Sometime later they moved to Perry Township in the same county. The various tax

lists and land records searched by the artist's biographer reveal that Portzline had a number of occupations. In addition to listings calling him a storekeeper or merchant from 1800 to 1812, he was referred to as a farmer in 1817, and from 1823 to 1824, Portzline was listed as a schoolteacher in Mahantango Township.

The artist's last will and testament was written two years before his death in 1857.

¹All biographical information for this entry is taken from Ruthann Hubbert, "Francis Portzline (1771–1857)," *Snyder County Historical Society Bulletin*, 1982 (1983), pp. 19–29. Dr. Donnel B. Portzline, a descendant of the artist, continues to research his ancestor and his fraktur work.

247 Birth and Baptismal Certificate 39.305.1 for Elisabeth Portzline

Attributed to Francis Portzline
Probably York County, Pennsylvania, ca. 1810
Watercolor and ink on wove paper
13⅛″ x 16¼″ (33.3 cm. x 41.3 cm.)

Elisabeth Portzline was the daughter of Sabina Heiges Portzline and the fraktur artist Francis Portzline. She was born on December 1, 1809, and baptized by Pastor Ettinger of the Reformed Church in York County on January 1, 1810. Certificates made by the artist for other members of the Portzline family include one for the other daughter, Maria; one for a son, Abraham; and similar records for Benjamin and Heinrich Franklin Portzline, whose relationships to the artist are undetermined.[1]

The possible early date of this example may account for its dissimilarity with other frakturs assigned to the artist, most of which were produced in the 1840s and 1850s. However, the style of execution and the placement of the design elements in Elisabeth's *Geburtsschein* and *Taufschein* support an attribution to her father.

Portzline's work tends to be precise in drawing with the watercolor paints brushed neatly within the contours of each outlined element. He favored long, attenuated, and gently curved vines where each leaf, bud, and flower is given equal attention and each seems suspended in space. Few of these elements overlap. There is no appreciable depth of field in his work since all elements are flat and depend on either the application of dark paints or nearly opaque coats of paint for decorative effect. The rich coloration often observed in his later work is absent here, but the density of paint in no. 247 is similar despite its muted browns and greens.

On those rare occasions where vines or other elements intersect or overlap, Portzline articulated their meeting with great care, allowing confusion as to the far and near elements. The fine quality of his work, even in this early example, suggests that he spent considerable time making each fratkur.

Inscriptions/Marks: In German, the ink inscription reads: (within block) "Diesen beiden Ehgatten als frantz/portzline und seine eheliche hausfrau/Sabina, eine geborne Heigesin [above "geborne"]. ist eine Tochter zur/welt geboren als. Elisabeth portzline ist zur/welt geboren im Jahr unsers herrn Jesu/1809 den 1 ten Tag Decemberum 11 Uhr abends/und von hernn Ettinger pfarrer der/Reformirten Gemeine den 1 ten Tag Jenner/1810 getauft und gene-

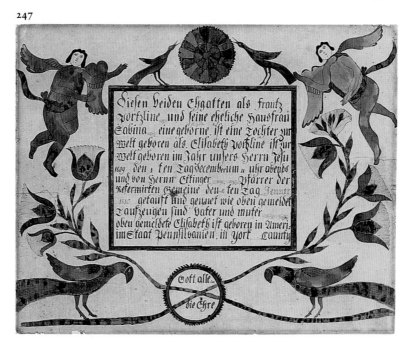

247

248

net wie oben gemeldet/Taufzeugen sind vater und muter/oben ge-
meldete Elisabeth ist geboren in Ameri:/im Staat pennsilvanien. in
york caunty." Within circle at bottom: "Gott. allein/die Ehre."

The English translation reads: (within block) "To these two
married people, namely Frantz Portzline and his lawful wife Sabina,
née Heiges, a daughter was born into the world, namely Elisabeth
Portzline was born into the world in the year of our Lord Jesus
1809, the 1st day of December at 11 o'clock at night and baptized
by Mr. Ettinger, Pastor of the Reformed congregation January 1,
1810, baptized and named as above stated. Sponsors were father
and mother. The above named Elisabeth was born in America in the
state of Pennsylvania in York County." Within circle at bottom:
"To God alone be glory."

Condition: Conservation treatment by Christa Gaehde in 1955
included mounting on heavy wove paper and inpainting minor
losses. In 1977 E. Hollyday dry-cleaned unpainted areas, mended
tears, and remounted the primary support on four-ply conservation
board with Japanese mulberry paper hinges. Probably period re-
placement 1½-inch, mahogany-veneered frame with an added ⅞-
inch gilded liner.

Provenance: Found in Chambersburg, Pa., and purchased from
Edith Gregor Halpert, Downtown Gallery, New York, N.Y.

Exhibited: AARFAC, New Jersey; Washington County Museum,
1966.

Published: AARFAC, 1947, no. 144, p. 31, illus. on p. 31; AAR-
FAC, 1957, p. 274, no. 133, illus. on p. 275; Cogar, illus. on p. 181.

¹Maria's certificate is in the collection of the Dartmouth College
Museum, Hanover, N.H.; Abraham's is in the collection of the Free
Library of Philadelphia (see Weiser II, illus. as no. 387); Benjamin
Portzline's *Taufschein* is owned by the Philadelphia Museum of Art
(see Garvan, p. 309, illus. as no. 44); Heinrich Franklin Portzline's
certificate is illus. as no. 97 in Tillou.

248 Birth and Baptismal Certificate for Jonathan Schaffer
63.305.5

Francis Portzline
Probably Synder County, Pennsylvania, 1844
Watercolor, pencil, and ink on wove paper
12⅜" x 15¼" (31.4 cm. x 38.7 cm.)

Jonathan Schaffer's colorful birth and baptismal cer-
tificate, signed in Portzline's neat script at lower left,
displays many of the design elements characteristic of
the artist's style in the 1840s and 1850s. Typically
precise in execution, with dense applications of paint,
Portzline's flanking peacocks are the most elaborate of
the birds he used on certificates. Here they frame the
main text within a heart format, and their tiny feet
break into the heart's border to cleverly draw the
viewer's attention to the written message.

The interlaced design at the base of the heart and
below the cursive script is but one of several similar
fancy calligraphic flourishes observed in Portzline's
work. His birds on slender twigs and the woman hold-
ing the wreath (with bird) at lower right were un-
doubtedly inspired by the hand-drawn and/or printed
certificates of other fraktur artists, but the interpreta-

tion here is innovative and clearly Portzline's own. Numerous examples by the artist have a circular design at the top center, sometimes as a flower and on other occasions as a geometric device. The two large-leafed plants surrounding this are probably lily of the valley.

Inscriptions/Marks: In German, the ink inscriptions read: (heading within heart) "Geburt und/Tauf schein"; (script below heading within heart) "Diesen beiden Ehegatten/als. Wilhelm Schäffer und/seine Eheliche hausfrau barba/:ra eine [above "n" in "ein"]. Tochter von Johan/German ist ein Sohn zur welt Geboren den 14 ten august/im Jahr unsers Erlösers 1844 dieser Sohn ist Geboren in/ Perry taunschip in Uni on Caunty im Staat Pennsyl:/:vania und ist Getauft worden von dem Ehrwürdigen Prediger/G. Erlenmeier und erhielt durch die heilige Taufe den na:/:men jonathan die taufzeu gen waren Johan. German und/barbara seine Ehfrau. Ich bin getauft in deinem Namen Gott Vater Sohn/une Heiliger Geist, ich bin ge- zählt zu deinem Saamen, zum Volck das/dir geheiliget heist. O, welch ein glück ward dadurch/mein Herr lass mich desen würdig seyn,"; (signature in lower left-hand corner) "Francis Portzline."
The English translation reads: (heading within heart) "Birth and Baptismal Certificate"; (script below heading within heart) "To these two married people, namely Wilhelm Schäffer and his lawful wife, Barbara, a daughter of Johan German, a son was born into the world the 14th of August in the year of our Redeemer 1844. This son was born in Perry Township in Union County in the state of Pennsylvania, and was baptized by the Honorable Preacher G. Er- lenmeier and received the name Jonathan in Holy Baptism. The sponsors were Johan German and Barbara his wife. Baptized into Thy name most holy, O Father, Son, and Holy Ghost, I claim a place, though meek and lowly, Among Thy seed, Thy chosen host. Buried with Christ and dead to sin, Thy Spirit now shall live within."
Condition: Unspecified restoration treatment by Christa Gaehde in 1968 probably included cleaning and mounting the frak- tur to rag board with PVA glue. In 1975 E. Hollyday removed the piece from its mount and dry-cleaned the unpainted areas. Possibly original 2¾-inch molded wood frame, painted black.
Provenance: Herbert Schiffer, Whitford, Pa.
Exhibited: AARFAC, New Jersey.

Daniel Schumacher
(ca. 1729–1787)

Little is known about Daniel Schumacher's origins, although scholars believe that he probably immigrated to North America from Germany and was born about 1729.[1] He arrived in Nova Scotia in 1751 but presum- ably moved to Pennsylvania several years later and before 1754. Today he is noted as one of the earliest fraktur artists, if not the earliest, to work in America.

Schumacher served as a Lutheran clergyman in Pennsylvania until his death in 1787. His congrega- tions numbered as many as twenty and were located in Berks, Lehigh, Northampton, and Schuylkill coun- ties. Among the most notable of his surviving fraktur works are five eighteenth-century registers of bap- tisms, which he maintained and decorated for several

of his churches from 1754 to 1773, and his personal register of baptisms and confirmations.[2] He is credited as having made more than 250 birth and baptismal certificates, the earliest of which date from 1754.[3] A versatile folk artist, Schumacher also produced confir- mation certificates, decorative pictures, house bless- ings, and New Year's wishes. A map of the vicinity of Bunker Hill prepared by him also survives.

[1]All information for this entry is taken from Weiser I, pp. xxii–xxiv, and a four-page brochure written by Pastor Frederick S. Weiser and printed for "The Work of Daniel Schumacher," an exhibition held at the Abdel Ross Wentz Library, Lutheran Theological Seminary, Gettysburg, Pa., in 1970.
[2]These churches include Friedens (White) Church at Stony Run (Wernersville), Albany Township, Berks County; Zion (Red) Church, Brunswick Township, Schuylkill County; Weisenberg Church, Weisenberg Township, Lehigh County; Jerusalem (Red) Lutheran Church, near Wisnersville; and Saint Michael's Church, Tilden Township, Berks County.
[3]In his baptismal registers, Schumacher placed a small circle next to the names of the children to whom he had given certificates. The earliest recipients are listed for 1754. See Weiser I, p. xxii. For additional information, see Frederick S. Weiser, *The Pennsylvania German Society* (Allentown, Pa., 1986), pp. 203–207.

249 Napthali 61.305.3

Attributed to Daniel Schumacher
Pennsylvania, ca. 1770
Watercolor and ink on laid paper
7⅜" x 11⅞" (18.7 cm. x 30.2 cm.)

The style of the handwritten inscription across the bot- tom of this drawing as well as the loose and attenuated rendering of forms support the current attribution to Daniel Schumacher. No other similar works by his hand or by other fraktur artists have been located.

The late John Joseph Stoudt, a well-known Penn- sylvania German scholar, interpreted no. 249 as a symbolic representation of the Apocalypse and based much of his theory on Jacob Boehme's explanation of the testament of Jacob as published in *Mysterium Magnum*.[1] The testament gives allegorical meaning to each of Jacob's sons. Napthali, the tenth son, repre- sented the "time of great wonder," when the Anti- christ would appear. Stoudt believed that Napthali, the hind as shown here, was raising his hooves to pound an "erupting, trembling earth, and the houses of disputation."[2]

This theory, and Stoudt's discussion of it, is diffi- cult to support for several reasons.[3] Leaping deer, stags, or hinds appear consistently on many household and decorative items made and used by German Amer- icans in both the eighteenth and nineteenth centuries with no overt reference to the Apocalypse. As a Chris-

249

tian symbol, its religious significance was sometimes made obvious by an accompanying inscription such as Schumacher's. But in this example, as elsewhere, the symbolic inference probably goes no further than the literal translation of the inscription: "Napthali is a fast deer and gives beautiful words." Given Schumacher's background as a minister, one would not expect any rendering by him of the Apocalypse to be as subtle as this, where the deer gracefully leaps over an otherwise tranquil and nondescript plain. The church building at left is distorted but evokes no unpleasant sensation as claimed by Stoudt. Schumacher, while perhaps the earliest of American fraktur artists, was not a gifted draftsman. The poor perspective and alignment of the building probably reflect nothing more than his lack of skill in drawing.

Inscriptions/Marks: Written in script in German at the bottom of the fraktur is "1. Buch Mose Cap 49 v.21 — Napthali ist ein Schneller Hirsch und gibt Schöne Rede." The English translation reads: "Genesis (1 Moses) 49:21 Napthali is a fast deer and gives beautiful words." An unidentified watermark in the center of the primary support includes a crown with circles enclosing an animal that resembles a pig, and several fleurs-de-lis.

Condition: Treatment by Christa Gaehde in 1961 included cleaning, mending minor tears, and mounting. In 1981 E. Hollyday dry-cleaned, remended tears, filled losses with strips of Japanese mulberry paper, and remounted the work on Japanese Usagami paper. Possibly period replacement 1¼-inch unpainted molded wood frame with ¼-inch chip-carved inner edge.

Provenance: Herbert Schiffer, Whitford, Pa.

Exhibited: AARFAC, New Jersey; "The Work of Daniel Schumacher," Lutheran Theological Seminary, Gettysburg, Pa., October 15–November 30, 1970; Pine Manor Junior College; Washington County Museum, 1965.

Published: John Joseph Stoudt, *Pennsylvania German Folk Art, An Interpretation* (Allentown, Pa., 1966), p. 229, illus. on p. 229.

[1]See John Joseph Stoudt, *Pennsylvania German Folk Art, An Interpretation* (Allentown, Pa., 1966), p. 229, for Stoudt's analysis of no. 249.

[2]Ibid.

[3]The Pennsylvania German scholar Pastor Frederick S. Weiser also disagrees with Stoudt's interpretation of no. 249. Weiser to AARFAC, 1983.

Stoney Creek Artist
(active ca. 1790–1824)

The name of the Stoney Creek Artist still eludes historians despite the impressive number of fraktur works now attributed to his hand and biographical information gathered on families for which he made certificates and other pieces.[1] Often credited as the most accomplished and prolific of the Virginia fraktur decorators, the Stoney Creek Artist worked exclusively in Shenandoah County, and more than half of the works now identified as his were created for families attending Zion Lutheran and Reformed Church in Stoney Creek. That he may have had some formal association as a minister or teacher with the church or its school on Schwaben (Swover) Creek has been suggested but remains unproved.[2]

Supporting this theory, however, is the survival of Levi Rinker's school cyphering book, now owned by the Virginia State Library in Richmond, Virginia.[3] Rinker was born on April 19, 1809, and was a member of Zion Lutheran and Reformed Church. Three of

the pages from his book, including a cover dated January 1, 1822, have flower and vine motifs closely resembling fraktur decoration used by the Stoney Creek Artist. Of particular note is the large stylized flower, probably a rose, that appears on Rinker's "frontis piece" and on many of the certificates produced by the fraktur artist.

Klaus Wust, a noted authority on Virginia frakturs, has observed that none of the artist's baptismal certificates has an execution date, while the day, month, and year are given on his bookplates. Some of the certificates were done in German, while others appear in English. Wust also observes that his earliest fraktur formats were executed on half-folio sheets and based on Pennsylvania prototypes in which the text is encircled with leaves or within three hearts. The "heavenly curtain" design, used in no. 250, was a later development and usually was drawn on smaller sheets of paper.[4]

[1]Wust, p. 17. The author notes that about forty frakturs by the artist have been identified.

[2]Ibid., p. 18. Wust states that the artist's last works date about 1824, and in the spring of that year the Zion Church school was without a schoolmaster.

[3]John Christian Kolbe to AARFAC, 1983.

[4]Wust, p. 19, gives these dimensions as 20 cm. x 33 cm. for half-folio sheets, and 20 cm. x 25 cm. for the smaller sheets used for the heavenly curtain design.

250 Birth Certificate for Joseph Kauffman

61.305.4

Attributed to the Stoney Creek Artist
Probably Shenandoah County, Virginia, ca. 1815
Watercolor and ink on laid paper
8³⁄₁₆" x 10" (20.8 cm. x 25.4 cm.)

The "heavenly curtain" framing the upper portion of this fraktur, and the two large flowers on either side at the bottom, are but two distinctive motifs employed by the Stoney Creek Artist. Most of his work also includes the small five-petaled rose seen in the lower left and right corners.[1] These flowers and the artist's tulips are frequently colored by hatched lines. The winged angel at the top between the tassels invariably appears in this position on pieces with the curtain motif. A striking and often overlooked feature of the artist's work is the use of subdued pastel colors for the background, curtains, and some of the flowers. Violets and pinks are common colors in his development of such areas.

The text with the heart is laid out in typical fashion for this hand. Although he was equally adept in using the common cursive and elaborate German Gothic scripts, here the artist employed an English

250

text. In formats of this type in either language, the artist consistently placed the child's name in bold capital letters at the head of the text.

Inscriptions/Marks: The inscription on the front reads: "JOSEPH KAUFFMAN/Was born in Virginia Shenandoah County/January the 30th ["th" is above "30"] anno Domini 1804 his pa = /rents are Adolph Kauffman and his — /beloved wife Barbara his sponcers/are his parents he was/Babtized by the Rev/Bernhart/Willy." A watermark in the primary support reads: "J V R," for John Van Reed, Jr., a papermaker from at least 1812 until his death in 1823.[2]

Condition: Prior to acquisition, numerous edge tears had been mended with brown paper tape. Conservation treatment by E. Hollyday in 1976 included reducing acidity and discoloration, removing brown tape, filling and inpainting losses, and mounting on four-ply conservation board using Japanese paper hinges. Period replacement 1½-inch flat frame repainted brown with raised corner blocks repainted black.

Provenance: Robert Carlen, Philadelphia, Pa.

Exhibited: Virginia Sampler, and exhibition catalog, no. 42; Washington County Museum, 1966.

[1]See Wust, p. 19, for a discussion of the rose and other motifs as their design evolved over the years of the artist's career.

[2]Where John Van Reed, Jr., first conducted business is uncertain, but in 1820 he purchased a Berks County, Pennsylvania, papermill from his father, John Van Reed, Sr. The Van Reed papermill described in no. 52 was a separate operation; that mill was also originally owned by John Van Reed, Sr., and was also located in Berks County but on a different parcel of land. The owner, Henry Van Reed, was a brother of John Van Reed, Jr. (Thomas L. Gravell and George Miller, *A Catalogue of American Watermarks, 1690–1835* [New York, 1979], p. 200).

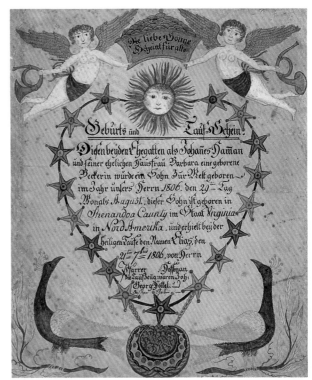

251

Strasburg Artist
(active possibly ca. 1805)

251 Birth and Baptismal Certificate 81.305.1
for Elias Hamman

Attributed to the Strasburg Artist
Shenandoah County, Virginia, possibly 1806
Watercolor, gouache, and ink on wove paper
15¹⁄₁₆″ x 12⁹⁄₁₆″ (38.3 cm. x 31.9 cm.)

The text within the heart-shaped wreath was written in the meticulous fraktur lettering taught in the Strasburg German School maintained jointly by the Lutheran and Lutheran Reformed congregations in Shenandoah County. In terms of coloring and ornamentation, the work of this hand is strikingly different from other frakturs assigned to the Virginia valley, although clearly inspired by that of Pennsylvania decorators. Three other works by the artist, including birth and baptismal certificates for Maria Magdalena Overbeck of Bucks County, Pennsylvania, and Daniel Afflerbach of Springfield Township, Bucks County, have been identified.[1] Whether or not the artist ac-

tually worked in both Pennsylvania and Virginia has not been determined.

The fine quality of the Strasburg Artist's work is due, in part, to the selection of bright colors and to his crisp, assured drawing and penmanship. Particularly noteworthy is the convincing manner in which overlapping forms are handled, as illustrated in the arms with ribbons behind and in the hands of the angels flanking the crown at center top.

The previous attribution of this example to Barbara Becker Hamman, the mother of Elias Hamman, is now considered unlikely.[2]

Inscriptions/Marks: In German, the ink inscriptions read: (within crown) "Die liebe Sonne/Scheint für alle"; (heading below sun) "Geburts und Tauf = Schein"; (text below heading) "Diesen beÿden Ehegatten als Johañes Hamañ/und seiner ehelichen Hausfrau Barbara eine geborene/Beckerin wurde ein Sohn Zur Welt geboren/im Jahr unsers Herrn 1806. den 29ᵗᵉⁿ Tag/Monats August. dieser Sohn ist geboren in/Shenandoa Caunty im Staat Virginia/in Nord Amerika. und erhielt beÿ der/heiligen Taufe den Namen Elias, den/21ᵗᵉⁿ 7ᵇʳⁱˢ 1806, von Herrn/Pfarrer Hoffman/die Taufzeug waren Joh:/Georg Hottel: und/dessen Gattin."

The English translations read: (within crown) "The dear sun shines for all"; (heading below sun) "Birth and Baptismal Certificate"; (text below heading) "To these two married people, namely Johannes Hamman and his lawful wife Barbara, née Becker, a son has been born into the world, in the year of our Lord 1806, the 29th day of the month of August. This son was born in Shenandoah County in the State of Virginia in North America and received the name Elias through Holy Baptism on the 21st of September 1806,

from Pastor Hoffman. The sponsors were Joh: Georg Hottel and his wife."

Condition: Restoration treatment by an unidentified conservator prior to acquisition probably included cleaning, mending numerous edge tears, filling and inpainting losses, and backing with Japanese mulberry paper. Tears were remended in 1981 by E. Hollyday. Nineteenth-century replacement 3-inch splayed, grain-painted frame with flat outer edge.

Provenance: Edgar William and Bernice Chrysler Garbisch, New York, N.Y.; Mr. and Mrs. W. E. Wiltshire III, Richmond, Va.

Exhibited: "American Folk Painting: Selections from the Collection of Mr. and Mrs. William E. Wiltshire III," traveling exhibition organized by the Virginia Museum, Richmond, Va., November 29, 1977–January 8, 1978; American Fraktur, and exhibition catalog, no. 30, p. 12; "'A Share of Honour,' Virginia Women, 1600–1945," traveling exhibition organized by the Virginia Women's Cultural History Project, Richmond, Va., November 10, 1984–January 15, 1985 (Virginia Museum only); Virginia Sampler, and exhibition catalog, no. 44.

Published: Mirra Bank, *Anonymous Was a Woman* (New York, 1979), illus. as frontispiece; Bishop, illus. as fig. 237 on p. 159; Dewhurst, MacDowell, and MacDowell, Religious Folk Art, p. 71, no. 90; Lebsock and Rice, illus. on p. 73; Harry L. Rinker, "The Fraktur Market," *Maine Antique Digest* (July 1981), pp. 32A–34A, illus. on p. 34A; Sotheby Parke Bernet, Garbisch II, lot no. 114; *American Folk Paintings and Watercolors,* catalog for sale no. 4593M, April 30, 1981 (New York: Sotheby Parke Bernet, Inc., 1981), lot no. 24; Richard B. Woodward, comp., *American Folk Paintings: Selections from the Collection of Mr. and Mrs. William E. Wiltshire III* (Richmond, Va., 1977), p. 40, no. 15, illus. as fig. 15 on p. 41.

[1] The Overbeck certificate is owned by the Philadelphia Museum of Art, Pa.; the Afflerbach certificate is owned by the Bucks County Historical Society. The current location of the other certificate — for Christina Becker of Virginia, Elias Hamman's first cousin — is unknown.

[2] The attribution to Barbara Becker Hamman was based on the fact that she was an excellent writing student, as proved by an extant writing exercise she did in 1785 at age twelve, and that no. 251, done for her son, also displays fine calligraphy.

Jacob Strickler
(1770–1842)

Less than a dozen fraktur writings and drawings have been identified for Jacob Strickler, who ranks as the most imaginative of all fraktur artists who worked in Virginia.[1] Three of these, plus five incomplete frakturs attributed to the artist (see pages 3–4), are in the Folk Art Center collections.

Strickler was born on November 24, 1770, the son of Abraham and Anna Strickler of the Massanutten area in Shenandoah County (now Page County), Virginia. They were descendants of a German family by the same name that immigrated to America from Switzerland in the early eighteenth century. The earliest member of the fraktur artist's family in Virginia was probably Abraham Strickler (d. 1746), who moved there in 1733 from Lancaster County, Pennsylvania. His relationship to Jacob is undetermined.

The Massanutten area in which Strickler lived his entire life was settled principally by Mennonites, but whether the artist or his family belonged to their congregation is unknown. Certain aspects of his fraktur work lend credence to the theory that Strickler may have served as a Mennonite preacher and/or schoolteacher. Additionally, the artist's personal library, now housed at the Rockingham County Historical Society, contains a significant number of religious titles and a book of sermons printed in Hamburg that is inscribed "Jacob Strickler, Sein Predigt Buch" ("Jacob Strickler, His Sermon Book").[2] The other books and printed items in the collection also have inscriptions and examples of Strickler's writing that served previous scholars in identifying his fraktur work.

Of the pieces now ascribed to Strickler, the *Vorschrift* ("writing exercise") featured in no. 252 remains the earliest as based on the 1787 date of execution inscribed by Strickler. The variety of motifs and subjects seen in his later work proves Strickler's versatility as well as his ability to provide innovative interpretations of more common embellishments used by other decorators before and after his years of activity. Strickler was on one occasion boastful of these talents, when he wrote on a 1794 fraktur that "the paper is my field and the pen is my plow. This is why I am so clever. The ink is my seed with which I write my name."[3]

The artist married Anna Rothgeb on July 3, 1819. Mary Strickler, their only child, was born on January 8, 1822. Jacob died on June 24, 1842, and was buried in the family cemetery on his Mill Run property in what is now Page County, Virginia.

[1] All biographical information for this entry is taken from AARFAC archives and from Walters, Strickler, pp. 536–543, unless noted otherwise.

[2] See Walters, Strickler, p. 537, for a list of the library holdings. S. H. Modisett, a descendant of the artist, presented the collection to the Rockingham County Historical Society in 1944.

[3] As quoted from a fraktur by Jacob Strickler, in the collection of the Henry Francis du Pont Winterthur Museum, Winterthur, Del. According to Frederick S. Weiser, Strickler borrowed the phrase from a popular poem and other fraktur artists also used this and similar verses.

252 *Vorschrift* 74.305.10

Jacob Strickler
Shenandoah (now Page) County, Virginia, 1787
Ink, watercolor, and resin on laid paper
7¾" x 12⅜" (19.7 cm. x 31.4 cm.)

This *Vorschrift,* or "writing exercise," is the earliest example of Strickler's work recorded to date. Preceding the alphabets and numerals that are typical of *Vor-*

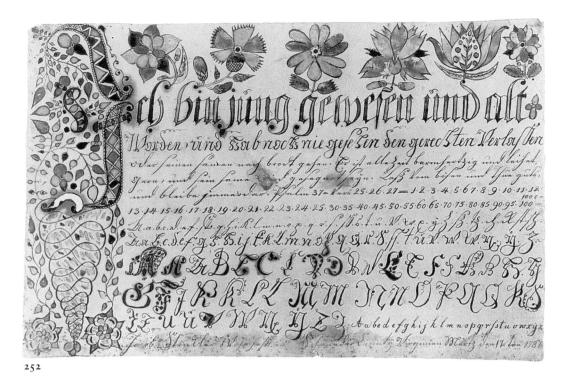

252

schriften is the German text of Ps. 37:25–27, which begins: "I was once young and have grown old. . . ." The selection of these verses seems especially ironic since Strickler was only sixteen years old at the time he made the *Vorschrift*. The ease and sureness of the writing indicate that he had acquired considerable expertise in drawing and penmanship by 1787.

It is not known whether the artist based this elaborate exercise on an existing pattern, or whether it simply reflects his own inventiveness. In either case, the wealth of embellishment here, particularly in the initial letter of the Psalm verse and throughout the uppercase alphabet at bottom, forecasts his later work — for example, the ornate writing exercise he made in 1794.[1]

Inscriptions/Marks: In German, the ink inscription reads: "Ich bin jung gewesen und alt/Worden, und hab noch nie gesehen den gerechten Verlassen/oder seinen samen nach brodt gehen. Er ist allezeit bermhertzig und leihet/gern und sein same wird gesegnet seÿn. Lass vom bösen und Thue guts, und bleibe jmmerdar. Psalm 37, Vers 25, 26, 27 [numerals, several alphabets]/Jacob Strickler wohnhaft in Schanendor Caunty Virginien Mertz den 17ten 1787."
The English translation reads: "I have been young, and now am old; yet I have not seen the righteous forsaken of his children begging bread. He is ever giving liberally and lending, and his children become a blessing. Depart from evil, and do good; so shall you abide for ever. Psalm 37:25–27 [numerals, several alphabets] Jacob Strickler residing in Shenandoah County, Virginia, March 17, 1787."
Condition: Conservation treatment by E. Hollyday in 1976 included dry-cleaning the front and verso, setting down flaking paint, filling and inpainting losses, and backing with Japanese mulberry paper. Period replacement 2-inch molded wood frame cut down to fit, painted brown.

Provenance: Jesse Modisett, Luray, Va.
Exhibited: American Fraktur, and exhibition catalog, p. 11, no. 5; "Folk Art Exhibition," Scottsville Museum, Scottsville, Va., July 4–6, 1975.
Published: Walters, Strickler, p. 539, illus. on p. 538 as pl. I.

[1]The writing exercise is owned by the Henry Francis du Pont Winterthur Museum, Winterthur, Del.

253 The Daring Hero 74.305.9

Jacob Strickler
Shenandoah (now Page) County, Virginia, 1792
Watercolor, resin, and ink on laid paper
13¼″ x 16½″ (33.7 cm. x 41.9 cm.)

This powerful and bizarre drawing is signed by Jacob Strickler and dated at the bottom 1792 and 1793. Its assigned title reflects the artist's own choice as inscribed at upper left, although scholars theorize that the figure on horseback represents Saint George, who like "the daring hero," fought a large and dangerous dragon.[1]

Close examination of the piece reveals a heavy scribed line around the horse and rider, suggesting that Strickler used a pattern of some sort, perhaps printed, to trace this part of the design. Similar figures appear on frakturs by Friedrich Krebs and on the work of a few other decorators, but none is as large in scale as Strickler's hero.

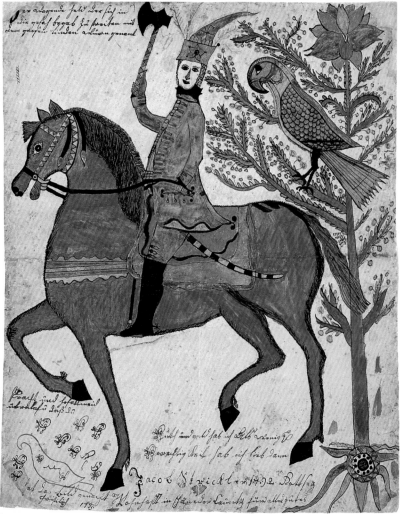

253

Certain details in this example may have been added after 1793, while other areas seem to have been left incomplete for no apparent reason. The outline of a bird at lower left, and the various calligraphic devices within the outline and surrounding it, along with the 1793 date, were probably later additions. More curious, however, are the arrangement and content of the inscriptions throughout. These also seem unclear and incomplete. Perhaps Strickler, having begun and finished the principal part of the work in 1792, later became dissatisfied with the fraktur. This might explain his inscription on the verso that reads: "I have not done it right."[2]

The flowers blossoming at the top of the tree and the sawtooth pattern in the horse's harness, in the ax handle, and at the tree base are characteristic of Strickler's motifs and style. The large decorative parrot was undoubtedly inspired by printed *Taufscheine* and possibly the fraktur drawings of Henrich Otto.[3]

Inscriptions/Marks: In German, the ink inscriptions read: (upper left) "der wagende held der sich in/die gefah begab zu streiten mit/dem grosen linden wurm genant"; (under horse's raised foot, left) "Pracht und hofattmeid/überlafu dass du"; (under the other feet) "Guth und geld hab ich als wenig/Verachtig keit hab ich lieb dann/Jacob Strickler 1792 Gott sey/hat das Bild gemacht Wohnhaft in Schänedor Caunty für alles gutes/christilich 1793."

The English translations read: (upper left) "The daring hero who puts himself in danger to battle with the great dragon named"; (under horse's raised foot, left) "Ostentation and pride"; (under the other feet) "I have little property and money/I like contemptuousness then/Jacob Strickler 1792/made the picture residing in Shenandoah County/God be for all good Christians 1793." The text is not always clear or apparently complete.

A watermark in the primary support reads: "A KELLER" and includes a tulip design for the Abraham Keller firm, which began papermaking about 1781 and operated at least until 1810 in Exeter Township, Berks County, Pa.

Condition: Previous conservation by an unidentified conservator included the addition to the verso of a 5-inch brown paper patch across top center, a 2-inch brown paper patch across bottom center, and a large patch across the center verso holding the two halves together. Conservation treatment by E. Hollyday in 1975 included removing brown paper patches, dry cleaning the front, reducing impurities and discoloration, mending tears, filling and inpainting

minor losses, sizing, and backing with Japanese mulberry paper. Probably period replacement 2-inch molded wood frame, painted black and green with a ¼-inch sawtooth decorated inner edge.

Provenance: Jesse Modisett, Luray, Va.

Exhibited: "Pennsylvania German with a Southern Accent," Heritage Center of Lancaster County, Inc., Lancaster, Pa., May 1–November 15, 1981.

Published: Thomas Minor Anderson, Jr., "Shenandoah Folk Traditions," *23rd Washington Antiques Show* (Washington, D.C., 1978), illus. on p. 93 as fig. 2; Walters, Strickler, p. 540, illus. on p. 539 as pl. III.

[1]Walters, Strickler, p. 540 and note 13 on p. 543.
[2]Ibid., p. 541.
[3]Ibid.

254 Winged Dragon 74.305.6

Jacob Strickler
Shenandoah (now Page) County, Virginia,
probably ca. 1803
Ink on laid paper
13¼″ x 16½″ (33.7 cm. x 41.9 cm.)

Fragmentary, disjointed inscriptions on both front and back of *Winged Dragon* indicate that Strickler treated this uncolored and perhaps unfinished drawing almost like scratch paper. The front bears phrases of a religious nature and, upside down at the top, a greeting. On the back, Strickler noted certain verse selections from Old Testament books and various hymns below them.

It cannot be assumed that any of the inscriptions, including the 1803 date, were made at the time Strickler drew the dragon. Creatures of a similar type appear

in the work of a small group of decorators from Pennsylvania, but no other examples are known from Virginia. Perhaps Strickler meant this as a companion piece to "the daring hero who himself deliberately sought danger in order to fight with the great dragon named," featured in no. 253. Whatever its purpose, it remains one of the most intriguing examples of his extant work.

Inscriptions/Marks: The German texts on the front and reverse of this piece are mostly illegible, partly because a corner has been cut or torn away. The translations below are generally word for word. The texts on the reverse are the first lines of German hymns and a list of Bible passages. In German on the front the inscriptions read: (under the dragon) "gut ists weil von dem"; (under the border) "Aber lasset uns Gott Lieben"; (above dragon's wings) "Es ist Dier besser wan/berin fes und bleibt/Mahr t. beier/Ein freund liesen gruss und ich/Wan du so gut wid s[illegible material] so[illeg.]ble/mut uf ist viel besser swar[illeg.]." In German on the reverse the inscriptions read: "Wo soll Ich hin wer hilft mir zu niemand/als zu dir allein Herrr Ich mich befehl/ 5 b m C 19 V 14 [5te Buch Mose Capital 19 vers 14] 5 b m C 27 V 17 [5te Buch Mose Capital 27 vers 17] Hiob C 24 v 2/Spruch Salomo C 22 V 28 C 23 v 10/Sofia C 5 v 10/Wer nur den lieben Gott läst walten und hoft/JACOB STRICKLER wohn/In schänedor Caunty Virginien April/[folded over here] tag ein tausend acht huntert und dreÿ/Herr Jesus Christ zu uns wend den Heiligen Geist zu/Seelen Brätigam Jesu Gottes lamm/Ach alles was Himmel."

The English translations from the front read: (under the dragon) "it's good because from the"; (under the border) "but let us love God"; (above dragon's wings) "It is better for you when [illeg.] and remains [illeg.] A friend sends greetings and I, When you so well [illeg.]." The English translations from the reverse read: "Where shall I flee? Who helps me? To no one but to you alone, Lord, I commit myself/Deuteronomy 19:14/Deuteronomy 27:17/Job 24:2/Proverbs 22:28 23:10/Wisdom 5:10/If you but trust in God to guide you and hope/Jacob Strickler lives/in Shenandoah County, Virginia, April [folded over the day]/one thousand eight hundred and three/Lord Jesus Christ, be present now/Jesus still lead on . . . [the last two lines are the melody from the hymn "Jesus still lead on"]/Oh, everything which heaven. . . ."

A watermark in the primary support reads: "A KELLER" and includes a tulip design for the Abraham Keller firm, which began

254

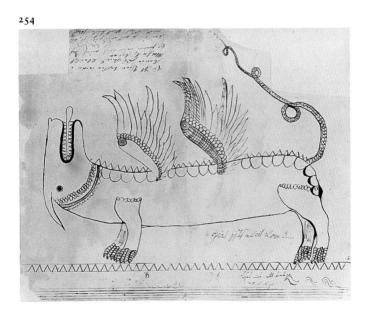

papermaking about 1781 and operated at least until 1810 in Exeter Township, Berks County, Pa.

Condition: Conservation treatment by E. Hollyday in 1975 included dry cleaning the front and verso, reducing water stains, repairing tears, backing with Japanese mulberry paper, sizing the front, and flattening. Period replacement 2-inch molded wood frame painted black and green with a ¼-inch sawtooth decorated inner edge.

Provenance: Jesse Modisett, Luray, Va.

Exhibited: Virginia Sampler, and exhibition catalog, no. 43, illus. as no. 43.

Published: Walters, Strickler, p. 541, illus. as fig. 3 on p. 537.

255 Birth Record for Martin Kaufmann 74.305.5

Attributed to Jacob Strickler
Probably Shenandoah (now Page) County, Virginia, possibly 1840
Ink and watercolor on laid paper
15⅜″ x 9⅜″ (39.1 cm. x 23.8 cm.)

Martin D. Kaufmann's birth occurred in 1815, but his record attributed to Jacob Strickler probably was made some thirty years later. Kaufmann's courtship of and ultimate marriage to Strickler's daughter, Mary (b. 1822), in 1840 may have occasioned the piece. A Strickler record for Kaufmann's sister Anna (b. 1810) also exists and probably was created by Strickler about the time he drew her brother's.[1]

The decorative hearts with flowers in their interiors and the style of Gothic writing are typical of Strickler's other known work. The decorator often favored small, delicate elements. Here, the tiny flowers within larger flowers, as seen in the two confronting tulips at top and bottom, and the little buds terminating the calligraphic embellishments above and below the text illustrate two ways in which he used such motifs.

Inscriptions/Marks: In German, the ink inscription reads: "Martin Kauf:/mann ward geboren/in schenändoah caunty/virgi-nien: den fünfzehn/ten tag jener im jahr chri/stiein tausend acht hun:/dert und fünfzehn: seine/eltern waren jacob kauf:/:mann und sein ehe weib barbara."

The English translation reads: "Martin Kaufmann was born in Shenandoah County Virginia the fifteenth day of January in the year of Christ one thousand eight hundred fifteen. His parents were Jacob Kaufmann and his wife Barbara."

Condition: Conservation treatment by E. Hollyday in 1974 included dry cleaning; mending numerous edge tears; rejoining the top and bottom halves of the primary support, which had been torn horizontally; flattening creases; and filling and inpainting minor losses. The frame is a 3-inch mahogany cyma reversa molded replacement that probably dates from the period of the drawing.

Provenance: Jesse Modisett, Luray, Va.

Exhibited: American Fraktur, and exhibition catalog, p. 11, no. 20, illus. on p. 9; "Folk Art Exhibition," Scottsville Museum, Scottsville, Va., July 4–6, 1975; Virginia Sampler, and exhibition catalog, no. 41.

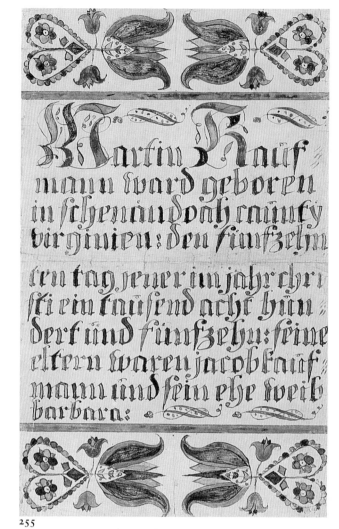

255

Published: Walters, Strickler, p. 541, illus. as pl. IV on p. 539.

[1]Anna Kaufmann's record is privately owned; see Walters, Strickler, illus. as fig. 4 on p. 540.

Sussel-Washington Artist (active 1775–1800)

The identity of the artist responsible for an impressive group of frakturs related to no. 256 still eludes historians, although most of the known pieces can be associated with Lebanon and Lancaster counties, Pennsylvania, and most date from the last quarter of the eighteenth century. The modern pseudonym Sussel-Washington Artist derives from Arthur J. Sussel, an early fraktur collector in Philadelphia and the former

owner of no. 256, which depicts General George Washington and his wife. The decorator is also referred to as the Bee Bonnet Artist because of the elaborate crosshatch renderings of headdresses that frequently appear on his female subjects.

Although most of his known work consists of *Taufscheine,* he drew several other pictures of persons mounted on horses, an Adam and Eve, and a series of small drawings of animals that are extremely whimsical.

256 Exselenc Georg General Waschingdon and Ledy Waschingdon

58.305.18

Attributed to the Sussel-Washington Artist
Pennsylvania, probably Lebanon or Lancaster County, ca. 1780
Watercolor and ink on laid paper
8″ x 6½″ (20.3 cm. x 16.5 cm.)

Stiff, frontal poses; bright blues, yellows, and reds; other details; and rather heavy outlining characterize this example and other frakturs now attributed to the Sussel-Washington Artist. Similar standing human figures dominate much of the decorator's known work with some variation in poses, costumes, and coloration, although at least one profile view of a man, a lady on horseback, and a picture of George Washington on horseback were also created by this hand.[1] All of the figures wear eighteenth-century attire, and all of the male figures are shown in military dress.

The fine quality of execution exhibited here is consistent with known pieces attributed to the artist. By comparison with the work of other fraktur decorators, such as Arnold Hoevelmann (see no. 240), working in the late eighteenth century in Pennsylvania, the Sussel-Washington Artist was more adept in drawing and perhaps more experienced. The sureness of his lines and the precision of repeated motifs is evident throughout, especially in Lady Washington's dress and where hatched and crosshatched lines were used to provide detail and pattern.

Baptismal wishes (*Tauf-wunsch*) and birth and baptismal certificates comprise the majority of formats produced by the artist. Purely decorative pieces, such as this, may have been created as gifts or simply for personal enjoyment. In either case, the work of this hand ranks among the most aesthetically pleasing and well known of all the frakturs that survive from Pennsylvania.

Inscriptions/Marks: The inscription in ink written in the upper

left corner reads: "Ledy/Waschingdon," and in the lower right corner reads: "Exselenc/Georg/ General/ Waschingdon."

Condition: In 1959 Christa Gaehde inpainted minor losses and backed the painting with Japanese mulberry paper. Conservation treatment by E. Hollyday in 1975 included mending small tears and rebacking with Japanese mulberry paper. Probably modern replacement 1⅝-inch molded and unpainted pine frame.

Provenance: Arthur J. Sussel, Philadelphia, Pa.

Exhibited: AARFAC, American Museum in Britain; AARFAC, June 4, 1962–April 17, 1963; "American Pioneer Paintings," Harry Stone Gallery, New York City, 1932, and exhibition catalog, no. 34; Flowering of American Folk Art; Smithsonian, American Primitive Watercolors, and exhibition catalog, p. 7, no. 27.

Published: AARFAC, 1965, illus. on cover; AARFAC, 1975, illus. on p. 18; Ira Aaron, *Triumphs* (Glenview, Ill., 1976), illus. on p. 62; *American Historical Review,* LXXXII (February 1977), illus. on cover; *Antiques,* XXXVII (February 1940), illus. on p. 60; Black, *Watercolors,* p. 81, illus. on p. 65; Black and Lipman, p. 160, illus. as fig. 148 on p. 165; Joseph P. Cullen, "Brandywine Creek," *American History Illustrated,* XV (August 1980), illus. on p. 36; Ruth Davidson, "Features," *Antiques,* LXXXIV (November 1963), p. 599; Linda Grant De Pauw, *From Founding Mothers* (Boston, 1975), illus. on p. 480; Carl W. Drepperd, *American Pioneer Arts and Artists* (Springfield, Mass., 1942), illus. on p. 148 and on the endpages; "The Flowering of American Folk Art: 1776–1876," *Early American Life,* V (February 1974), illus. on cover; Henry Kauffman, *Pennsylvania Dutch American Folk Art* (New York, 1946), illus. on p. 128; Jean Lipman, *American Folk Decoration* (New York, 1951), illus. as fig. 170 on p. 151; Jean Lipman, *Bright Stars: American Painting and Sculpture Since 1776* (New York, 1976), illus. on p. 36; Lipman and Winchester, *Folk Art,* p. 114, no. 150; Parke-Bernet, illus. as lot no. 294; Lloyd Saxton, *The Individual, Marriage, and the Family* (Belmont, Calif., 1980), illus. on p. 5; J. J. Stoudt, *Pennsylvania Folk Art* (Allentown, Pa., 1984), illus. on p. 249; J. J. Stoudt, *Pennsylvania German Folk Art, An Interpreta-*

256

tion (Allentown, Pa., 1966), illus. on p. 243; *Virginia Cavalcade,* XXXI (Spring 1982), illus. on back cover; Alice Winchester, "The Flowering of American Folk Art: 1776–1876," *The Art Gallery,* XVII (February 1974), illus. on p. 58.

[1]The lady on horseback is titled *Malley Queen of Sedburg* and is privately owned; the fraktur featuring Washington on horseback is in the collection of Independence National Historic Park, Philadelphia, Pa. A *Tauf-wunsch* ("baptismal wishes") for Stovel Christophe Emrick, no. M 58.120.15 a,b, is owned by the Henry Francis du Pont Winterthur Museum; it has three standing figures, one of which is a man in profile.

257

John Van Minian
(active ca. 1791)

257 Birth Record for Sara Harley 58.305.14

John Van Minian
Pennsylvania or Maryland, 1791
Watercolor and ink on laid paper
15¼" x 12¼" (38.7 cm. x 31.1 cm.)

No information regarding John Van Minian's life has been found, although a number of highly decorative drawings by him are known.[1] Most of these have either a Berks County, Pennsylvania, or Baltimore County, Maryland, provenance.

Sara Harley's birth record typifies the best of the artist's work in terms of design motifs and overall composition. A central arched block dominates the picture and focuses attention on the text recording Sara's birth. Van Minian combined nationalistic emblems such as the spread eagle and stars with the inscription "Epluribus Unium" below and the all-seeing eye of God with traditional German flower, heart, and geometric devices. By ordering and symmetrically balancing the design elements within a series of decorative borders, he achieved a very pleasing arrangement.

The sprouting vine of cloverlike foliage and small flowers used throughout the record are common characteristics of Van Minian's work, as are the figures in profile. Sometimes the latter appear in full length, as opposed to the bust-length size used in this example.

Sara Harley was the fourth child of Samuel Harley (1758–1839) and his wife, Catherine Sauer Harley (1761–1823), all of Montgomery County, Pennsylvania. The parents were interred at Klein's Brethren Meeting House in Franconia Township. Sara married Samuel B. Johnson and died on November 1, 1869. Neither the date and place of her marriage nor her place of residence after marriage is known.[2]

Inscriptions/Marks: Written in ink at upper left is "Done by me John Van Minian." The inscription at center reads: "Epluribus

Unium/Sara harley/She Commenced her/mortal Existence on/the for-teenth day of may/in the year one thousand/seven hundred and Nine/ty one." The heart at upper left has the inscription: "Says David to Solomon/with his heart full of love/since we two are chosen/by the powers above that/great architecture of/honour we see/he gave/all/the." The heart at upper right reads: "Pattrens/in writing/to me king solomon a letter/to Tyre did send requesting/king Hiram for him to be/friend he was willing for/to join and relieve/send him/that/[illegible material]/[illeg.]." At lower left the heart reads: "Craftsman called hir/ = am the Brave he was a/son of a widdow of the dau/ =ghters of Dan and in every/particular he acted a/man — ." The heart at bottom right bears the inscription: "All things was/put to him/found Nothing a miss he — /Exceeded them all in the Casting/of Brass he cast us two fine pil = / =lars Eighteen Cubits in hight /he finished them off/and he/set them/[upright]."[3]

Condition: Restoration treatment by Christa Gaehde in 1959 included removing the primary support from an acidic backing, cleaning it, mending edge tears, and remounting the sheet on Japanese mulberry paper. In 1977 E. Hollyday dry-cleaned, remended old tears, filled minor areas of paint loss, and remounted the painting. Probably modern replacement 1¾-inch unpainted and molded pine frame.

Provenance: Arthur J. Sussel, Philadelphia, Pa.

Exhibited: AARFAC, New Jersey; Smithsonian, American Primitive Watercolors, and exhibition catalog, p. 9, no. 42; Washington County Museum, 1966.

Published: Black and Lipman, p. 192, no. 176, illus. on p. 198.

[1]Twelve examples have been recorded in the Folk Art Center's archives, including several in the M. & M. Karolik Collection. See Karolik Collection, p. 281, no. 1340, illus. as fig. 359 on p. 282. Others are privately owned.

[2]John McElhiney, a descendant of Sara Harley, to AARFAC, July 23, 1976.

[3]The inscriptions within the hearts seem to be a poem, but the printed or written source for it is unidentified.

Jacob Weiser
(active ca. 1803)

258 Merman
57.305.10

Possibly Jacob Weiser
Probably Pennsylvania, 1803
Watercolor and ink on laid paper
5⅝″ x 5″ (14.3 cm. x 12.7 cm.)

Mermaids and mermen appear on some frakturs and on numerous objects created in America during the late eighteenth and early nineteenth centuries. All of the fraktur examples recorded to date by Folk Art Center staff have Pennsylvania or Maryland origins, while the objects, such as weather vanes and tombstones, have either New York or New England provenances. Without documentation on the specific meaning of symbolic inferences these images had for Americans, one can only guess that here, as in Europe, the half-human, half-fish creatures were tied to traditional folklore and mythological tales in which their beauty and allure enticed seafarers into danger and even death.

There were several Pennsylvania fraktur artists who popularized such images, including George Friederich Speyer, working principally in Lancaster County in the late eighteenth century; Henrich Otto, who preceded Speyer in the same county; the C. M. Artist and Friedrich Krebs, whose works may have been inspired by Speyer's and/or Otto's frakturs. Additional examples by unidentified artists also survive.[1]

The name Jacob Weiser is inscribed below this jaunty little creature and is thought to be that of the maker, most likely a descendant of John Conrad Weiser (1696–1760) of Pennsylvania. There were several Jacobs in the family, but research has failed to prove which of them created the *Merman*.[2] No other examples by Weiser have been identified. The quality of his drawing is somewhat uneven but displays a clear knowledge of popular fraktur motifs. The lobed flowers on stems with leaves terminating in pronounced curls or dots, the dots and dashes used to create fins along the figure's sides, and the multicolored bands on the body are embellishments used by other artists during the period.

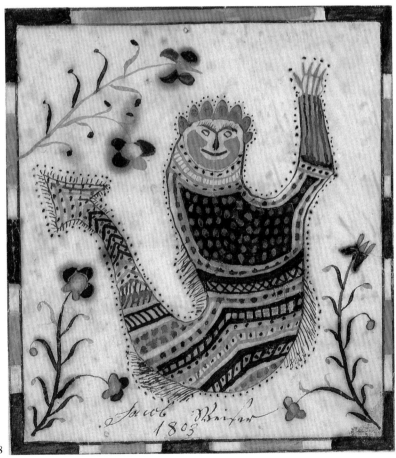

258

Inscriptions/Marks: The ink inscription at center bottom reads "Jacob Weiser/1803." On the reverse of the support is an inscription in Old German handwritten script and untranslated to date.

Condition: Conservation treatment by Christa Gaehde in 1958 probably included cleaning, repairing minor tears, inpainting losses, and backing with Japanese mulberry paper. Probably period replacement 1½-inch splayed mahogany frame with ¼-inch beveled inner edge.

Provenance: Previous record of ownership unrecorded.

Exhibited: AARFAC, New Jersey.

Published: Frederick S. Weiser, *A Weiser Family Album* (Manheim, Pa., 1971), n.p.

[1]See Weiser II, illus. as nos. 348–349, 933–934.

[2]See Frederick S. Weiser, *A Weiser Family Album* (Manheim, Pa., 1971).

Henry Young
(1792–1861)

Considerable debate and confusion about the attribution and dating of Henry Young's work existed until 1977, when E. Bryding Adams published new findings on the artist's life and career.[1] Before this, Paul M. Auman, a collector of frakturs and other Pennsylvania materials, theorized that there were two known artists involved, an H. Young and his son, Reverend Young. Additionally, some of the works were assigned to an unidentified hand known as the Anchor Artist.[2] Donald Shelley's review of the frakturs in question, in his *Fraktur-Writings*, added support to a three-artist theory by attributing them to the Anchor Artist, the Early Centre County Artist, and the Late Centre County Artist. Adams's investigation of more than 150 works associated with these various artists revealed that they were executed by one man, Henry Christian Andrew Harmon Young, who is usually referred to by the abbreviated name Henry Young.

Young was born on March 12, 1792, in Wilsdruff, Saxony. He immigrated to America in 1817 and immediately settled in Union County, Pennsylvania. Existing records show that he served as a teacher at the German school in Mifflinburg, West Buffalo Township, as early as 1819. He also played the organ at the Lutheran and Reformed Church with which the school was affiliated. Adams concludes that he also may have served on occasion as a pastor there, since it was not uncommon for German schoolmasters to assume some ministerial responsibilities. He may also be the Mr. Jung who sought ordination at the Reformed Synod in the 1820s.[3]

Young married Frances Priscilla Slater on April 28, 1820.[4] He had filed for naturalization at the Centre County Courthouse three years before, but did not receive his citizenship until 1823.

Young and his family may have moved their residence several times after 1823, probably living in Lycoming County from 1825 to 1835 and in Adamsburg, Spring Township, in Union County for some portion of 1835. The father was listed on the Haines Township tax assessment list in Aaronburg, Centre County, in 1845. By 1849, they had apparently bought property in Gregg Township, where Young also was listed among taxed residents. At the time of his death, in 1861, he was living on land owned by John Vore in Millheim, Penn Township, in Centre County.

Attributions to Young are based on an analysis of his style as it developed from 1823, the year of his earliest documented work,[5] to the various formats and devices he gradually developed and used during subsequent decades. Thirteen fraktur formats were employed by the artist, and they show continuity of form and the intricately changing decorations that Young adopted over a number of years.

[1]All information for this entry is from the exhibition catalog AARFAC, Young, pp. 1–6.

[2]The Anchor Artist pseudonym derives from a ship's anchor drawn on some of Young's birth and baptismal certificates.

[3]For a discussion of other evidence supporting the theory that Young served as a minister, see the exhibition catalog AARFAC, Young, p. 4.

[4]The couple had eight children born between 1820 and 1844; only three — William H. Young, Margret Ellen Young, and Elizabeth Young — are fully documented as their offspring; see no. 262.

[5]His earliest work, a miniature portrait of Ludwig Albrecht Wilhelm Ilgen, is privately owned and is inscribed: "H. Young. Fecit. 1823." See the exhibition catalog AARFAC, Young, illus. as fig. 2, p. 3.

259 Birth Certificate for Joseph Scott Fritz

76.305.1

Attributed to Henry Young
Lycoming County, Pennsylvania, possibly 1827
Watercolor and ink on wove paper
9¹⁵⁄₁₆″ x 7⅞″ (25.2 cm. x 20.0 cm.)

The date of this example, and of the frakturs attributed to Young in the following entries, is based on a combination of criteria — specifically the area of residence of the subject or recipient of the certificate and the various motifs used by the artist. Young's birth certificate for Joseph Scott Fritz is the only one known by the artist that features a circus woman on horseback. The inscription below the figure reads: "Mrs. Yeaman vaulting." Mrs. Yeaman was the wife of George Yeaman, who was known as the Flying Horseman. George Yeaman worked with various circus companies in America from 1816 until his death, in 1827. His wife first exhibited her talents in horseman-

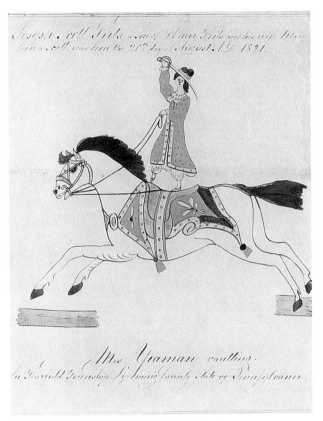

259

Published: Barons, p. 67, no. 74, illus. on p. 68; Sarah B. Sherrill, "Pennsylvania Fraktur Artist," *Antiques,* CXII (October 1977), illus. on p. 600.

[1]George C. D. O'Dell, *Annals of the New York Stage,* III (New York, 1928), pp. 213–214.

[2]All biographical information on the Yeamans is from Richard W. Flint, Margaret Woodbury Strong Museum, Rochester, N.Y., to AARFAC, April 25, 1977.

260 Birth Certificate for Anna Fritz 76.305.2

Attributed to Henry Young
Probably Lycoming County, Pennsylvania,
ca. 1827
Ink and watercolor on wove paper
9⅞" x 8" (25.1 cm. x 20.3 cm.)

E. Bryding Adams established thirteen distinct formats or categories of frakturs used by the artist during his period of activity in Pennsylvania.[1] This example falls in category two, which is characterized by the use of hearts with birds and flowers. More than fifteen examples have been recorded for the group, and most have two eight-pointed stars with alternating blue and red points and yellow centers. Other characteristics include specific color patterns for the upper and lower

ship in New York City in December 1825.[1] She worked with a number of the same companies that had employed her husband, George, and in 1828, she married the circus owner Asa T. Smith. His enterprise eventually became known as the Yeaman Circus, and records show that it toured the country and gave various performances until 1833.[2]

This rare and unusual birth record shows the horse in full gallop, with Mrs. Yeaman wielding a sword and standing on his back. She is dressed in a robe with yellow trim and wears a blue turban on her head.

Inscriptions/Marks: An unidentified watermark in the center of the primary support reads: "C & S." Above the picture is "Joseph Scott Frits a son of Henry Frits and his wife Mary/born a Scott, was born the 20th day of August A.D. 1821." Below the picture is the inscription: "Mrs. Yeaman vaulting./In Fearfield Township Lycoming Caunty State of Pennsylvania."

Condition: Conservation treatment by E. Hollyday in 1976 included removing a wood secondary support, dry-cleaning unpainted areas, hinging the fraktur with Japanese mulberry paper, and filling and inpainting several areas of support loss, including one in the lower left corner and several at center. Original 1¼-inch molded wood frame, painted red.

Provenance: Lawrence E. King, Monroe Center, Ill.

Exhibited: AARFAC, Young, and exhibition catalog, p. 11, illus. on rear cover, and exhibition checklist under Type Eight—Circus Woman on Horseback; Flowers, and exhibition checklist, no. 23.

260

pairs of birds; the alternating yellow, red, and blue points around the perimeter of the two hearts; the stylized pink roses with small yellow and green leaves; and the yellow and blue daisies clutched by the lower birds.

Inscriptions/Marks: Written at the top of the picture is "Soli Deo Gloria." The small top heart reads: "Mary Frits"; the large heart reads: "Anna Fritz a/Daughter of Henry Frits and his wife/ Mary a born Scott, was born/the 16th Day of July in the/year of our Lord 1823 in/Fearfield Township/Lycoming County/State of Penn-/ sylvania."
Condition: In 1976 E. Hollyday dry-cleaned the front and back of the piece, reduced staining and acidity, and hinged the piece with Japanese mulberry paper. Probably original 1-inch reeded frame, painted red.
Provenance: Lawrence E. King, Monroe Center, Ill.
Exhibited: AARFAC, Young, and exhibition catalog, illus. as fig. 5 on p. 12, and exhibition checklist, under Type Two — Hearts with Birds and Flowers.
Published: Barons, no. 76, illus. on p. 70; "Flowers in Art," *The New Book of Knowledge Annual 1981* (Grolier, Conn., 1981), illus. on p. 282.

[1]See the exhibition catalog AARFAC, Young, pp. 6–8.

261 Birth Certificate for Huldah Fritz 76.305.3

Attributed to Henry Young
Lycoming County, Pennsylvania, possibly 1827
Watercolor and ink on wove paper
9⅞" x 8" (25.1 cm. x 20.3 cm.)

Huldah Fritz's certificate, with its drawing of a single woman in the center of the composition, represents the third type of fraktur produced by Henry Young. Many of the motifs seen in no. 260 also are present here, including almost identical birds and roses, although the roses lack inked veining and other refinements.

Young invariably drew the single woman in profile, and surviving examples with this motif show the figures facing either left or right. As seen here, the women usually hold in one hand a bouquet of four flowers — a pink rose, a spray of blue and yellow daisies, a yellow tulip, and a fanciful multicolored flower — while the hand closest to the viewer is dropped to the side and grasps a small purse or basket. All of the ladies have similar coiffures, with the hair piled high on the head and held by a comb and with two small curls covering the temple. Young used several colors for the dresses, usually blue, red, or yellow. In some other examples, the dress is further embellished with small flowers.

Most of Young's frakturs in this format are documented to Lycoming County. Two examples from Lehigh and Northumberland counties are known.[1]

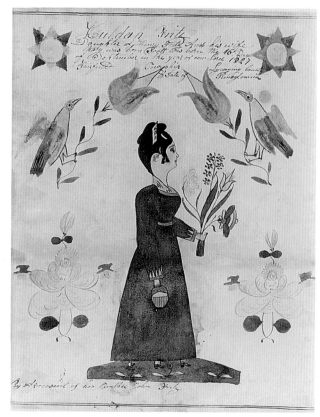

261

Inscriptions/Marks: The ink inscription in the top margin reads: "Huldah Fritz/Daughter of Henry Fritz And his wife/Mary was born Scott was born the 16th Day/of September in the year of our Lord 1827/Fairfield Township Lycoming County/State of Penn-/ sylvania." An inscription at lower left reads: "By A present of her Brother John Fritz."
Condition: Cleaning, reducing stains and acidity resulting from an acidic wood backing, and hinging with Japanese mulberry paper were included in conservation treatment by E. Hollyday in 1976. Original 1⅛-inch molded wood frame, painted red.
Provenance: Lawrence E. King, Monroe Center, Ill.
Exhibited: AARFAC, Young, and exhibition catalog, illus. as fig. 7 on p. 14, and exhibition checklist, under Type Four — Single Woman.
Published: Barons, no. 75, illus. on p. 69.

[1]See the exhibition catalog AARFAC, Young, p. 14.

262 Birth and Baptismal Certificate 78.305.1
for Margret Ellen Young

Attributed to Henry Young
Possibly Centre County, Pennsylvania, ca. 1840
Watercolor and ink on laid paper
12¾" x 7⅞" (32.4 cm. x 20.0 cm.)

Young's birth and baptismal certificate for his second youngest daughter features the typical facing-man-and-woman-in-profile format that the artist used ex-

tensively during his career. The two figures, representing the happy parents of the newborn, have no distinguishing features that would lead us to identify them as Young and his wife. As in similar certificates by the artist, the drawing of eyes, ears, hands, and mouths is stylized and impersonal.

The most unusual aspect of this example is that Young did not complete the text of the certificate by filling in the date and place of his daughter's birth or the name of the pastor who baptized the child.

Inscriptions/Marks: The inscription on the front reads: "Certificate of Birth and Baptism/Miss Margret Ellen Young, a daughter of Mr. Henry/Young, and his wife Frances, born a Slater, was/born [blank] the [blank] A.D. 18 [blank] in [blank] County,/State of Pennsylvania, and baptized by [blank]."
Condition: Conservation treatment by E. Hollyday in 1979 included dry cleaning where possible and reducing stains and creases. Modern replacement ¾-inch cyma reversa wood frame, painted black.
Provenance: Gift of Mr. and Mrs. Stanford R. Minsker, Towson, Md.

262

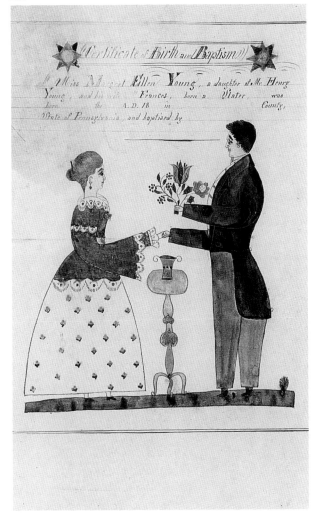

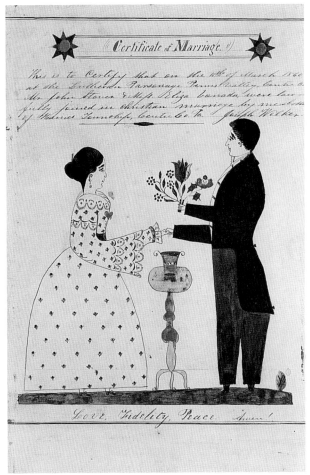

263

Exhibited: AARFAC, Young, and exhibition catalog, illus. as fig. 12 on p. 19, and exhibition checklist under Type Eleven — Man and Woman with Flowers; "The Pennsylvania Germans: A Celebration of Their Arts 1683–1850," an exhibition organized by the Philadelphia Museum of Art, Philadelphia, Pa., and the Henry Francis du Pont Winterthur Museum, Winterthur, Del., October 17, 1982–January 29, 1984.
Published: "Museum Acquisitions," *Antique Collecting,* VIII (January 1979), illus. on p. 19; Beatrice B. Garvan and Charles F. Hummel, *The Pennsylvania Germans: A Celebration of Their Arts 1683–1850* (Philadelphia, 1982), no. 216 on p. 185.

263 Marriage Certificate for John Stover and Eliza Vonada Stover 59.305.8

Attributed to Henry Young
Probably Centre County, Pennsylvania,
ca. 1860
Watercolor and ink on wove paper
11⅞" x 7¾" (30.2 cm. x 19.7 cm.)

This is one of two known marriage certificates by Henry Young that employ his well-known format of a man and woman in profile standing in front of a table

and with the characteristic bouquet of flowers in the gentleman's left hand. As in other examples, the couple holds hands, and a vessel with a rolled rim is on the table before them. The lady's floral dress is especially appealing with its simulated rows of lace at the collar, shoulder, and sleeve. The heart motif at her breast is unusual but appropriate for the occasion celebrated by the certificate. As if to emphasize further the virtues of marriage, Young inscribed the words "Love, Fidelity, Peace" at the base of the drawing.

Inscriptions/Marks: The inscription above the picture reads: "Certificate of Marriage/This is to certify that on the 11ᵗʰ of March 1860/at the Lutheran Parsonage Penns Valley, Centre Co/Mr. John Stover & Miss Eliza Vonada were law-/fully joined in christian marriage by me — born/of Haines Township, Centre Co. Pa. Joseph Welker." An inscription below the picture reads "Love, Fidelity, Peace. Amen!"

Condition: Treatment by Christa Gaehde in 1960 included cleaning and mounting. Probably period replacement 1-inch molded wood frame, painted black.

Provenance: Robert Carlen, Philadelphia, Pa.

Exhibited: AARFAC, New Jersey; AARFAC, Young, and exhibition checklist under Type Eleven — Man and Woman with Flowers; Hollins College, 1975, and exhibition catalog, no. 8; Washington County Museum, 1966.

Unidentified Artists

264 Birth Record for Peter Gottschalk 66.306.1

Artist unidentified
Probably Pennsylvania, probably 1769
Watercolor and ink on laid paper
4¼" x 6¼" (10.8 cm. x 15.9 cm.)

Scherenschnitten (decorative paper cutwork) of the early date of Peter Gottschalk's birth record are rare for America, although this piece's simple cutwork pattern and crudely painted designs do not make it a successful example of the technique. The maker apparently had little or no experience in making such pictures, yet was familiar with some ornaments, such as hearts and flowers, used by more adept artists. Nothing is known about Gottschalk, and no other cutwork examples by this hand have been located.

Inscriptions/Marks: Most of the German script in the center panel is illegible, but reads in part: "Peter Gottschalk ist/Gebohren: G 23 [illegible material]/N [illeg.] 1769." On the verso of the record and inscribed in ink is "12 January 1804," "Peter Gottschalk," and various other words that are now illegible.

Condition: In 1978 E. Hollyday mended a ¾-inch tear in the center left margin and small tears throughout, dry-cleaned the sur-

face, removed adhesive tapes, and reduced creasing and cockling. Early twentieth-century, ⅞-inch stained frame.

Provenance: Richard Wood, Baltimore, Md.

Exhibited: AARFAC, New Jersey.

265 Lover's Rebus 58.305.22

Artist unidentified
America, ca. 1780
Watercolor and ink on laid paper
6" x 7¾" (15.2 cm. x 19.7 cm.)

The exchange of notes and tokens between loved ones has a long history in European societies of both English and non-English origins. In England and America, such objects were often made and presented on Saint Valentine's Day, although a suitor or loved one might bestow a romantic rebus or some other form of amorous expression at any time.

Rebus texts, as illustrated here, were usually composed of a riddle or poem in which pictures or symbols were substituted for words or phonetic sounds approximating part or all of a word. Far more elaborate American examples do survive, but few take this format and include painted framed likenesses — presumably those of the suitor and the young lady of his affection.

When solved, the gist of the text seems to say that the writer has been crossed in love and that he hopes the rebus, his token of affection, will cause her to recognize his true feelings and return to him.

Inscriptions/Marks: The text on the front reads: "You r a X a X Xic, you/ r a X to X none but me,/You r a [heart] a [heart heart] I fear;/O [heart] O [heart] O [heart heart] forbear./I c you r yy for me,/But if in [heart] you bb,/You c or know in mind,/The grief of [heart] ؛. I do find,/But if you love me; as I/love ye, What a loving/ Couple we should be."

A modern interpretation, or solution, to the rebus might be: "You are a cross a double cross I see, you are a cross to cross none but me, You are a heart a double heart I fear, Oh heart oh heart, oh double heart forbear, I see you are too wise for me, But if in heart you double be, You see or know in mind, The grief of heart what I do find, But if you love me; as I love ye, What a loving Couple we should be."

Condition: Dry cleaning, setting down flaking paint, reducing acidity, and backing the primary support with a sheet of Japanese mulberry paper were included in conservation treatment by E. Hollyday in 1980. Reproduction ⅞-inch pine frame, painted red.

Provenance: Arthur J. Sussel, Philadelphia, Pa.

Exhibited: Arkansas Artmobile; Washington County Museum, 1966.

Published: Harold Lowenstein, "Tokens of Love No. 1: Messages," *The Lady* (October 13, 1960), p. 465; Parke-Bernet, p. 50, no. 296.

264 *Birth Record for Peter Gottschalk*

265 *Lover's Rebus*

266 Religious Text
33.305.3

Artist unidentified
Probably Pennsylvania, 1794
Watercolor and ink on laid paper
16⅛″ x 13″ (41.0 cm. x 33.0 cm.)

An array of leafy vines, birds, tulips, and other flowers was symmetrically placed to frame this religious text that may be of Mennonite origin.[1] Unlike *Vorschriften* (see no. 252, for example), which usually combined illuminated scripture or hymn verses with alphabets, religious texts lacked alphabets. Like *Vorschriften*, however, they were often given as merit rewards or presentation pieces to schoolchildren and were usually created by a schoolmaster.

The precision of the calligraphy seen in this work is common to such pieces, since they served as exam-ples of good penmanship for the student. Thus, the quality of the writing, as well as the religious and moralistic message it carried, was meant as an inspirational source for the receiver.

The angel at the center top serves as the focal point of this example and was probably inked and painted before the surrounding arch and small border below the figure were drawn, since both wing tips and the left foot break into these areas. The angel also unites the surrounding decoration, as its hands clutch the two terminating vines, just above the tulips — a posture not observed elsewhere in American fraktur. The artist's interpretation of some motifs in the composition might aid scholars in eventually identifying other works by this hand. They include a large, five-lobed tulip invariably with one or more lobes outlined in a series of dots; a complex ten-lobed flower that has

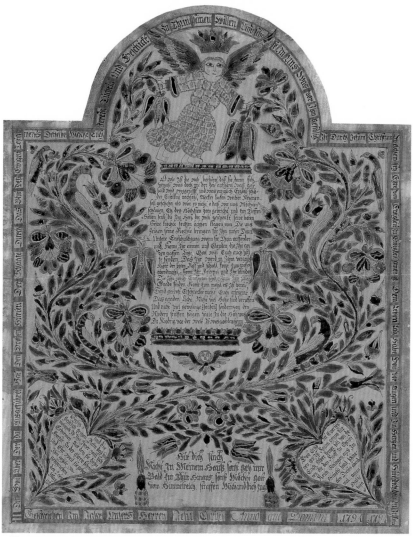

266

similar dot treatment plus wavy bands in some lobes; and sleek and rather ill-defined birds (possibly peacocks) of different sizes, usually paired and with short hatched tails and wings. A small bookplate–birth record for Catharine Schmid of ca. 1800, owned by the Free Library of Philadelphia, has large tulips similar to those in no. 266, but the central inscription does not appear to be by the artist responsible for the religious text.[2]

Inscriptions/Marks: In German, the ink inscriptions read: (heart, left) "Seelig/sind die/geistlich armen, Dann das him/melreich ist Ihr, Ihrer will sich/Erbamen, Aus dem sie ziehn/Herfür, zu der Glorie Schmuck/und Ehr, weil sie geben/Ihm gehör./Geschrieben/den 2ten/May/1794"; (at bottom center) "Hüt dich fluch/Nicht in Meinem Hauss, sonst geh nur/Bald zur Thür Hinaus sonst Möchte Gott/vom Himmelreich straffen Mich und dich zugleich."; (heart, right)"Gott Erhö/ret Euer seh/nen, Es, Ist Raum genug für/Euch, Aber keiner soll von de/nen die den Ruff zu Christi/Reich Schlagen aus Im/Himmels Saal, schme/cken Diesen Abend/mal . . . amen/Halle/lujah."; (in the outer border, beginning at bottom left-side

corner) "Dem Gott aber der da Ausgeführet hat den grosse Hürten der Schaafe durch das Blut der Ewigen Testa/ments Derselbe Mache Euch Fertig Tüchtig und Geschickt zu Thun seinen Willen Und Schafe In Uns Was vor Ihm gefüllig Ist Durch Jesum Christum Welchem sey Ehre von Ewigkeit zu Ewigkeit Amen Dein Leben Lang Habe Gott vor Augen und Im Hertzen und Hüte dich dass du In keine Sünde willigest. Geschrieben Im Jahr unsers Herrn Jesu Christi Anno que Domini 1794 1794"; (under the angel) "O wie Ist die welt bethöret dass sie daran sich/vergaft, was doch mit der Zeit aufhöret, was gar/bald wird weggerafft, und was ewigllich Ergötzt, schö/der Eitelkeit nachsetzt, Aecker kaufen Weiber Nehmen — /soll geschehn als wär es nicht. O dass wir uns Möchten/schämen, Eh des Höchsten zorn gebricht und zur Tieffen/Höllen senkt die Ihr Hertz der Welt geschenkt, seine boten/Seine knechte seufzen, achtzen klagen nun, Die uns/zeigen seine Rechte bringen für Ihn unser Thun/Unsere Entschuldigung, wann sie Thun afforder/ung. Komt Ihr armen und Elenden die Ihr an/den gassen Liegt, Gott will auch hül/fe senden Dass Ihr werd in Ihm vergnügt/Hört der boten Ruf und schall kommt zum grossen/abendmahl. Komt Ihr Krippel und Ihr blinden/Die Ihr noch Entfernet seyd, Komt Ihr sollet/Gnade finden Komt zum mahl es ist bereit/Seyd getrost Erschrecket nicht Euch erscheint/Das gnaden Licht. Nicht viel Hohe sind beruffen/Und nicht viel gewaltige [sonsen] sondern von den/Niedern stuffen, steigen viele In die Höh was/Da Niedrig vor der Welt ist was Gott dem Herrn/gefiel."

The English translations read: (heart, left) "Blessed are the spiritually poor, for the Kingdom of Heaven is theirs, mercy will be shown to them from Him in Whom they have their source, to the adornment of glory and honor because they fix their minds on Him. Written on the 2nd of May 1794"; (at bottom center) "Beware of cursing in my house, else walk right out the door! Otherwise God in Heaven will punish you and me alike"; (heart, right) "God hears your longing. There is room enough for you. No one who hears the call to the Kingdom of Christ shall be denied the heavenly banquet in the marriage hall. Amen. Hallelujah."; (in the outer border) "To God Who has led us, the great shepherd of the sheep, through the blood of the eternal covenant, may He make you ready, diligent and able to do His will and create in us what is pleasing before Him through Jesus Christ to Whom be honor for ever and ever Amen. Your whole life through keep God before your eyes and in your heart and keep yourself from falling into sin. Written in the year of our Lord Jesus Christ Anno que Domini 1794 1794"; (under the angel) "Oh, how foolish is the world to take time for the things which will soon cease, which will soon be taken away, those things which seem to charm eternally, but are sheer vanity, buying land, taking women — such things go on as if there were no tomorrow. Oh, that we should be ashamed of those things before the wrath of the Almighty breaks and sends them to deepest hell. If your heart is given to the world, pay heed to the groanings, sighings, and lamentings of His messengers, His servants, who point out His righteousness and bring our doings before Him and bring about our pardon, if we heed. Come you poor and wretched who lie in the streets. God will send you help so that you find delight in Him. Hear the watchman's cry and call, come to the high communion. Come you cripples and blind ones who are still far off, come and you will find grace. Come to the meal, it is prepared, be comforted, do not fear. The light of grace shines forth for you. Not many of high estate are called and not many powerful ones, but from the low estates many rise to prominence, for what is lowly to the world counts before God."

Condition: Conservation treatment by Christa Gaehde in 1955 included cleaning and backing with Japanese mulberry paper. In 1981, E. Hollyday removed the old mount, set down flaking paint, dry-cleaned the pictorial area, and backed the primary support with a sheet of Japanese mulberry paper. Original 1¾-inch flat mahogany-veneered frame.

Provenance: Edith Gregor Halpert, Downtown Gallery, New York, N.Y.

Published: AARFAC, 1947, no. 138, p. 31; AARFAC, 1957, no. 370, p. 377.

[1]Shelley, *Fraktur-Writings,* pp. 107–112.
[2]Weiser II, illus. as no. 722.

267 *Vorschrift* 74.305.8

Artist unidentified
Probably Shenandoah (now Page) County, Virginia, 1801
Ink and watercolor on laid paper
7½″ x 12¾″ (19.1 cm. x 32.4 cm.)

As indicated by the inscription along the bottom, the artist responsible made this *Vorschrift* as a presentation piece for Jacob Strickler, the well-known Virginia fraktur artist. Certain motifs, such as the two flowers in the upper right corner and the stylized rose above "Rejoyce," are similar to designs used by Strickler, although here the configurations are simpler. This may have been a copy exercise prepared by a young student who either knew or was taught by Strickler. Note the error made between the uppercase *L* and *M* in the last line of the alphabet and cleverly turned into a decorative device.

267

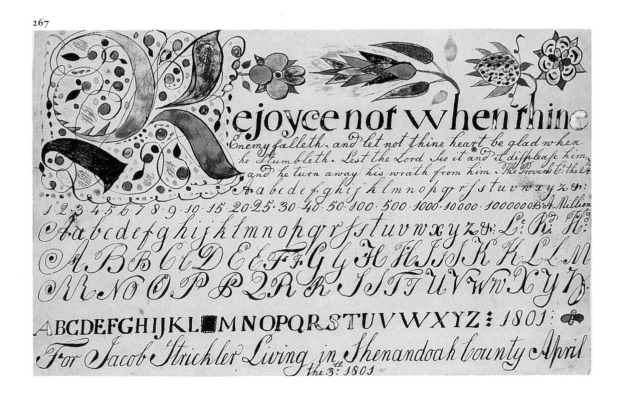

Inscriptions/Marks: The ink inscription on the front includes four styles of alphabet and, above them, a biblical verse that reads: "Rejoyce not when thine/Enemy falleth, and let not thine heart be glad when/he Stumbleth. Lest the Lord See it and it displease him,/ and he turn away his wrath from him. The Proverb Ch: the 24." Beginning at the end of the last line of alphabet is the inscription: "1801: For Jacob Strickler Living in Shenandoah County April/the 3:ᵗʰ 1801 = ."

Condition: Conservation treatment by E. Hollyday in 1978 included dry cleaning and setting down flaking paint. Modern replacement 1¼-inch molded wood frame, painted black.

Provenance: Jesse Modisett, Luray, Va.

Published: Walters, Strickler, p. 539, illus. as pl. II on p. 538.

268 Bookmarker 63.305.1, 6

Artist unidentified
Probably Bucks County, Pennsylvania,
1800–1810
Watercolor and ink on laid paper
4⅛" x 2¾" (10.5 cm. x 7.0 cm.)

The crisp drawing and painting of no. 268, along with its very formal symmetrical design, compare closely with numerous examples executed in the Bucks County area of Pennsylvania that date from the same year.[1] Whether or not they were all executed by the same hand is unknown, but their obvious stylistic association suggests either one artist or several who intimately knew one another's work. All are characterized by a large five-lobed tulip with the three prominent petals picked out in two colors, or in some cases only one color. Long stems, drawn with the aid of a straightedge and with alternating leaves and calligraphic flourishes, are consistently used for the tulips. This example has no inscription, but others exhibit considerable mastery of lettering in a variety of styles.

Condition: In 1974 E. Hollyday removed the bookmarker from a wood-pulp backing and hinged it to acid-free mat board; the surface was dry-cleaned and minor stains reduced.

Provenance: Mary Allis, Fairfield, Conn.

Exhibited: AARFAC, New Jersey; AARFAC, September 15, 1974–July 25, 1976; Washington County Museum, 1966.

Published: AARFAC, 1974, p. 69, no. 68, illus. on p. 68.

[1]See Weiser I, illus. as nos. 184, 195, 196, 197.

269 Bookmarker 63.305.1, 1

Artist unidentified
Southeastern Pennsylvania, ca. 1810
Watercolor and ink on laid paper
3⁷⁄₁₆" x 2⅛" (8.7 cm. x 5.4 cm.)

This simple drawing with watercolor decoration featuring tulips, pansylike flowers, and vertical bor-

ders of paired leaves probably was created by a schoolmaster. No other examples by this hand have been identified.

Condition: In 1974 E. Hollyday removed the bookmarker from a wood-pulp backing and hinged it to acid-free mat board; small tears were repaired and the surface dry-cleaned.

Provenance: Mary Allis, Fairfield, Conn.

Exhibited: AARFAC, New Jersey; AARFAC, September 15, 1974–July 25, 1976; Washington County Museum, 1966.

Published: AARFAC, 1974, p. 69, no. 68, illus. on p. 68.

270 Bookmarker 63.305.1, 2

Artist unidentified
Southeastern Pennsylvania, ca. 1810
Watercolor and ink on laid paper
6" x 2¹¹⁄₁₆" (15.2 cm. x 6.8 cm.)

The shape and drawing of the central motif sprouting from the heart in this example may represent a flower, although its detailed configuration suggests a pineapple. Similar devices are seen infrequently on frakturs by other hands, including a birth and baptismal certificate for Jacob Benner by the B. M. Artist.[1] Another *Taufschein*, executed in 1808 by an unidentified artist for Margareth Mayer, has two of these motifs.[2]

Condition: In 1974 E. Hollyday removed the bookmarker from a wood-pulp backing and hinged it to acid-free mat board; small tears were repaired and the surface dry-cleaned.

Provenance: Mary Allis, Fairfield, Conn.

Exhibited: AARFAC, New Jersey; AARFAC, September 15, 1974–July 25, 1976; Washington County Museum, 1966.

Published: AARFAC, 1974, p. 69, no. 68, illus. on p. 68.

[1]Weiser I, illus. as no. 71.
[2]Ibid., illus. as no. 70.

271 Bookmarker 63.305.1, 3

Artist unidentified
Southeastern Pennsylvania, 1810–1830
Watercolor and ink on laid paper
4⅜" x 2⅛" (11.1 cm. x 5.4 cm.)

Although less precise in drawing and less refined in the application of watercolor paints than many, this bookmarker is typical of the hundreds of examples made in southeastern Pennsylvania, particularly in Mennonite communities, during the first half of the nineteenth century. A central stalk topped by a tulip, and with flanking branches of tulips or other flowers, was one of the most popular designs used by both schoolmas-

268

269

270

271

272

ters and schoolchildren for their bookmarkers and bookplates.

Condition: In 1974 E. Hollyday removed the bookmarker from a wood-pulp backing and hinged it to acid-free mat board; small tears were repaired and the surface dry-cleaned.
Provenance: Mary Allis, Fairfield, Conn.
Exhibited: AARFAC, New Jersey; AARFAC, September 15, 1974–July 25, 1976; Washington County Museum, 1966.

272 Bookmarker 63.305.1, 4

Artist unidentified
Southeastern Pennsylvania, 1810–1830
Watercolor and ink on laid paper
4$\frac{1}{16}$″ x 2$\frac{11}{16}$″ (10.3 cm. x 6.8 cm.)

The overall good quality of this bookmarker suggests an artist with some previous experience in decorative drawing. One other example, possibly by this hand, has been identified.[1] Similarities between the two include the meandering borders with alternating dots in another color, and the shape and size of the leaves.

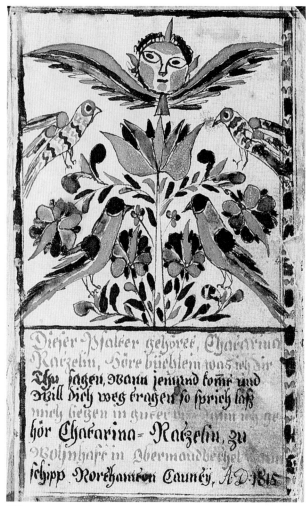

273

inks were used in alternating fashion for the text, a technique common to pieces of this type and also observed on *Vorschriften*. The same colored inks and yellow ocher watercolor were used for the symmetrical decoration featuring a winged angel, birds, flowers, and foliage. The precise lettering indicates an experienced hand, perhaps that of a schoolmaster, since bookplates and bookmarkers were often presented as rewards of merit to young students attending parochial schools in early Pennsylvania.

Inscriptions/Marks: In German, the ink inscription reads: "Dieser Psalter gehoret Chatarina/Ratzelin, höre büchlein was ich dir/Thu sagen, wann jemand komt und/will dich weg tragen so sprich lass/mich liegen in guter ruh dann ich ge:/hör Chatarina = Ratzelin zu/Wohnhaft in Obermondbethel Taun/schipp Northamton Caunty, A:D: 1815."

The English translation reads: "This psalter belongs to Chatarina Ratzelin. Hearken, little book, to what I say to you: If anyone comes and would carry you away, you say: let me lie in good rest [alone], for I belong to Chatarina Ratzelin, residing in Upper Mount Bethel Township, Northampton County, A.D. 1815."

Condition: Minor tears appear along all edges. The piece has never received any conservation treatment.

Provenance: Richard Wood, Baltimore, Md.

274 Flowers and Birds 58.305.19

Artist unidentified
Probably Pennsylvania, ca. 1820
Watercolor and ink on laid paper
6⅜" x 8" (16.2 cm. x 20.3 cm.)

The stylized, highly individualistic interpretation of the motifs used in this picture do not compare closely with any decorations on other Pennsylvania frakturs

274

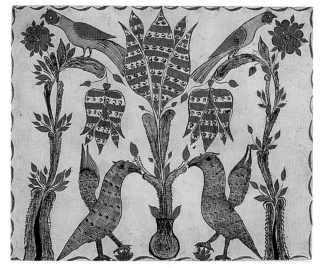

Condition: In 1974 E. Hollyday removed the bookmarker from a wood-pulp backing and hinged it to acid-free mat board; small tears were repaired and the surface dry-cleaned.

Provenance: Mary Allis, Fairfield, Conn.

Exhibited: AARFAC, New Jersey; AARFAC, September 15, 1974–July 25, 1976; Washington County Museum, 1966.

¹The similar example is in a private collection.

273 Bookplate for Chatarina Ratzelin 66.305.5

Artist unidentified
Probably Northampton County, Pennsylvania,
1815
Watercolor and ink on laid paper
5¾" x 3½" (14.6 cm. x 8.9 cm.)

This bookplate and one other in the Center's collection (acc. no. 66.305.6) remain affixed as decorative frontispieces in the small psalters and hymnals once used by their Pennsylvania German owners. Red and black

known to Center staff. The birds flanking the vase at bottom appear to be eagles judging from the talons and the shape of their heads. The five-lobed tulips are commonly seen on American frakturs, but the segmented and stumplike stems seen here are unusual.

Condition: Conservation treatment by an unknown conservator at an undetermined date included backing the primary support with Japanese mulberry paper and mounting the piece on mat board. In 1980 E. Hollyday removed the mounting, dry-cleaned the unpainted areas, and removed insect debris. Late-nineteenth-century bead molded replacement frame of 1 1/16-inch maple.
Provenance: Arthur J. Sussel, Philadelphia, Pa.
Exhibited: Washington County Museum, 1966.
Published: Parke-Bernet, p. 50, no. 296.

275 Hansel and Gretel 81.305.3

Artist unidentified
Possibly Bucks County, Pennsylvania, 1823
Watercolor and ink on wove paper
12 3/8″ x 15 13/16″ (31.4 cm. x 40.2 cm.)

The artist for this handsome and amusing fraktur remains unidentified, although the delicate style of writing and certain of its flower and leaf designs bear some similarity to those found on pieces documented to Bucks County, Pennsylvania. Additionally, *Hansel and Gretel* is said to have descended through the same family with the birth and baptismal certificate for Enoch Scheib of Bucks County described in no. 279.

The brief inscriptions beside the two decorative figures serve to identify them as Hansel and Gretel, generalized German names for a boy and a girl that

were used in much the same way as the English Jack and Jill. The wording in the central section represents a flirtatious dialogue between the two figures, although the spacing of the words suggests that they can be read in a second and as yet undeciphered manner. Such word games delighted both young and old in many Pennsylvania German societies.

Inscriptions/Marks: In German, the ink inscriptions read: (next to woman on left) "Ich bin das Gretel"; (left column) "Guten Abend mein/schön Dank mein/Heunt ist der erste abend dass/Warum Bist nit/wann ich gleich kommen wer/Hättst/Probieren steht gar eben an steh/heunt nit was wilt/Ich, will dir küssen dem rothen/es braucht nit/Gelt du hast mich gestern Sehen/Es verdreusst mich. Ja un thut mir/Geh weck ich wills nimmer Thun/Heunt Nät/stehst du nit auf und Lässt mich nein/magst Thun"; (next to man on right) "Ich bin der/Hansel"; (right column) "Schatz/Herr/ich dich gesehen habe/Kommen ein/hättst mich mehr gelassen ein/Probirt/auf und lass Mich nein/Darinnen Thun/Mund dazu dein bäckelein/bey eine anden stehen/weh geld es verdreusst dich/steh auf und Lass mich nein/so geh ich zu einer Andern nein/Geschriben Im Jahr. 1823."

In English the translations read: (next to woman on left) "I am Gretel"; (next to man on right) "I am Hansel"; (conversation between the man and woman) "Good evening my dear. Thank you sir. Today is the first evening that I have seen you. Why do you not come in? If I had come right away, you would not have let me in. You should have tried. Try was what I was to do. Stand up and let me in. Not today. What do you want to do inside? I want to kiss your red mouth and also your little cheeks. It is not necessary. Isn't it true, you saw me yesterday standing with another? It annoys me, yes and makes me sad. It annoys you, doesn't it? Go away because I do not want to do it ever again. Get up and let me in. Not today. If you don't get up and let me in I will go to someone else. You may. Written in the year 1823."

Condition: In 1981 E. Hollyday dry-cleaned the fraktur, removed it from a wood-pulp cardboard backing, reduced stains, and treated the surface with a solution to protect the colors; small losses were filled and inpainted, and minor tears mended with Japanese mulberry paper; the primary support was backed with Japanese mulberry paper. Modern 1 7/8-inch grain-painted wood frame with 1 7/8-inch square corner blocks.
Provenance: Vernon Schreiner, Blackwood, N.J.

275

276

276 Flowers, Birds, and Figures 58.305.12

Artist unidentified
Probably Pennsylvania, ca. 1825
Watercolor and ink on laid paper
7⅝" x 12¾" (19.4 cm. x 32.4 cm.)

An impressive number of purely decorative drawings produced by early German Americans survive, and most feature a combination of common designs such as flowers, birds, hearts, occasionally human and geometric forms, and various animals such as horses, pigs, and lions. These drawings are invariably organized around a central motif, such as a figure or a pot of flowers, a heart, or some other symmetrical combination of elements. Few approximate the random arrangement seen in no. 276.

Flowers, Birds, and Figures may have served its creator as a practice sheet or sampler of motifs. Some elements, such as the cock at center, seem capably drawn, while others, such as the two tulips at right top, are crude. The row of tiny fifers led by a kilted drummer is an intriguing and rare pictorial element for fraktur.

Inscriptions/Marks: A partially legible inscription in ink on the reverse includes the name "Mary" and may be a later addition.
Condition: Conservation treatment by Christa Gaehde in 1959 included removing an old mounting, cleaning, mending tears, and backing with Japanese mulberry paper. In 1981 E. Hollyday dry-cleaned, mended tears, filled and inpainted losses, set down flaking paint, and backed the primary support with a sheet of Japanese mulberry paper. Modern replacement 1¼-inch flat maple frame.

Provenance: Arthur J. Sussel, Philadelphia, Pa.
Exhibited: Smithsonian, American Primitive Watercolors, and exhibition catalog, p. 9, no. 41.
Published: Parke-Bernet, p. 52, no. 304.

277 Bird in Basket of Flowers 58.305.10

Artist unidentified
Probably Pennsylvania, 1827
Watercolor and ink on wove paper
6¼" diam. (15.9 cm. diam.)

An outer border of blue followed by a wider circle of red watercolor encloses this simple, small composition of a bird perched on two sticks (or plant shoots) sprouting out of a basket. As distinctive and nicely executed as the details are, indicating an experienced maker, no related pieces by this hand have been located.

Circular formats of various types were used by fraktur artists throughout the eighteenth and nineteenth centuries, but were usually placed within a larger, rectangular composition. The use of round or circular paper supports for entire pictorial areas was apparently uncommon, even for decorative pieces without texts.

Inscriptions/Marks: Written in ink below the basket is "1827."
Condition: Conservation treatment by Christa Gaehde in 1959 included filling and inpainting losses and lining with Japanese mulberry paper. In 1980 E. Hollyday removed an acidic wood-pulp

277

Inscriptions/Marks: Portions of a lettered watermark are visible on the left edge of the primary support but have not been identified.

Condition: In 1981 E. Hollyday removed an old mounting; dry-cleaned where possible; set down flaking paint; reduced acidity, staining, and foxing; mended edge tears, and backed the primary support with Japanese mulberry paper. Modern replacement 1-inch splayed pine frame.

Provenance: Found in Pennsylvania; Robert Carlen, Philadelphia, Pa.

Exhibited: Pine Manor Junior College; Washington County Museum, 1966.

[1]See Weiser II, illus. as nos. 563–650, for a wide range of types.
[2]Ibid., illus. as no. 563.
[3]A photograph of this example is in AARFAC research files. According to notes on the back, it came to the Schwenkfelder Museum from the Pennypacker Collection and is numbered 113.

backing; set down flaking paint in the head, wing, and tail areas; cleaned; reduced stains; and relined the primary support with Japanese mulberry paper. Modern replacement 1⅝-inch curly-maple frame with raised half-round outer molding.

Provenance: Arthur J. Sussel, Philadelphia, Pa.
Exhibited: Washington County Museum, 1966.
Published: Parke-Bernet, p. 48, no. 292.

278 Birds and Sunflowers 58.305.4

Artist unidentified
Southeastern Pennsylvania, ca. 1830
Watercolor and ink on wove paper
7⅞" x 6½" (20.0 cm. x 16.5 cm.)

No information leading to the identity of the artist responsible for *Birds and Sunflowers* or its specific provenance in Pennsylvania has been discovered to date. Numerous small pictures featuring birds and flowers or just flowers have survived from southeastern Pennsylvania, and most date from the first half of the nineteenth century.[1] Only one of three owned by the Free Library of Philadelphia seems to bear any strong compositional similarity to this watercolor, but it has no birds.[2] A second example, owned by the Schwenkfelder Museum and Library in Pennsburg, Pennsylvania, includes two facing birds perched among similar flowers and leaves.[3] Certain distinctions among the three pieces indicate that they probably were not executed by the same artist but possibly by individuals within the same community.

279 Birth and Baptismal Certificate 81.305.2 for Enoch Scheib

Artist unidentified
Probably Bucks County, Pennsylvania, ca. 1830
Watercolor and ink on laid paper
15¹⁵⁄₁₆" x 12½" (40.5 cm. x 31.8 cm.)

The unidentified artist responsible for Enoch Scheib's *Taufschein* was probably a schoolmaster in northern Bucks County, Pennsylvania, as evidenced by the place

278

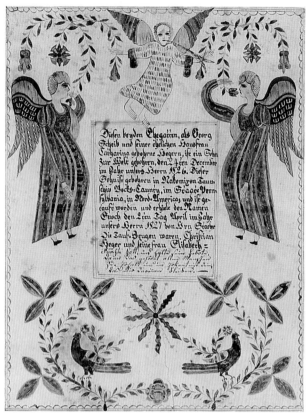

279

Bucks County, in the state of Pennsylvania in North America, and was baptized and received the name Enoch on the 2nd day of April in the year of our Lord 1827 from Mr. Staehr. The sponsors were Christian Heger and his wife, Elisabeth. Fear God and keep his commandments for that belongs to all mankind. [Eccles. 12:13] Keep us in the knowledge of you that we remain within them."

Condition: In 1981 E. Hollyday removed the fraktur from a cardboard secondary support, mended small tears, filled and in-painted scattered small losses, and hinged the piece with Japanese mulberry paper. Modern 1 9/16-inch flat oak frame with a half-round outer molding, painted black.

Provenance: Vernon Schreiner, Blackwood, N.J.

[1] Weiser I, illus. as no. 119.
[2] For examples, see Weiser II, illus. as nos. 487–493, 496–499, 501–505, 509–511.

280 The Crucifixion 31.305.1

Artist unidentified
Pennsylvania, 1847
Watercolor and ink on wove paper
13 7/8" x 10 3/4" (35.2 cm. x 27.3 cm.)

The small stylized figures in this fraktur illustrate a series of events that occurred during the Crucifixion of Christ and are accompanied by biblical verses from Luke 23 and John 19 that record the scene. The script in the arch above Christ's head makes note of the two murderers crucified with him (John 19:18), while Golgotha, the Place of Skulls, is referred to below his cross. The three soldiers at left and the two at right are dividing Christ's garments, as referred to in John 19:24. These figures are clothed in military uniforms more contemporaneous with the nineteenth-century date of the fraktur than with biblical times.

Only a few frakturs illustrating the Crucifixion and produced in Pennsylvania survive or have been discovered to date. This example is one of three works attributed to the same hand, two of which date to 1847.[1] All share similar compositions, treatments of the figures, coloration, and border motifs. Invariably, such formats served principally as religious inspirational pieces, while the intent of the ornamentation was as much didactic as it was decorative.

The work of this unidentified artist is distinguished by the use of three types of borders — a dentil-like, or sawtooth, pattern; a series of blocks alternating in various and sometimes random color combinations; and an undulating scalloped design, which appears on an example now in a private collection. Others include the arrangement and number of figures; the soldier at left and his long, extended sword piercing Christ's side; and the fan-shaped elements in the upper corners.

of birth cited for the child and because one other example that compares closely with no. 279 also has a Bucks County history of origin. This similar fraktur was drawn for Elias Strauss, who was born August 29, 1828, in Tinicum Township and baptized by Mr. Staehr, the same pastor who baptised Enoch Scheib.[1]

Both pieces have colorful, delicately drawn ornamentation of the type seen here, and both reveal their maker's reliance on contemporary printed certificates for design elements.[2] The arrangement and the imaginative interpretation of these motifs make this artist's work especially appealing.

Inscriptions/Marks: In German, the ink inscription reads: "Diesen beyden Ehegatten, als Georg/Scheib und seiner ehelichen Hausfrau/Catharina gebohrne Hegern, ist ein Sohn/zur Welt gebohren, den 24ten December/im Jahr unsers Herrn 1826. Dieser/Sohn ist gebohren in Nakomixon Taun = /schip Bocks = Caunty, im Staate Penn:/sylvania, in Nord = America; und ist ge = /tauft worden und erhielt den Namen/Enoch den 2ten Tag April im Jahr/unsers Herrn 1827 von Hrn Staehr/die Tauf = Zeugen waren Christian/Heger und seine frau Elisabeth = /Fürchte Gott, und halte seine Gebote,/dann das gehöret allen Menschen/zu. Erhalt uns im Erkenntniss dein/das wir darinnen bleiben."

The English translation reads: "To these two married people, namely George Scheib and his lawful wife, Catharina, born Hegern, a son was born into the world, on the 24th of December in the year of our Lord 1826. This son was born in Nakomixon Township,

332 / *American Folk Paintings*

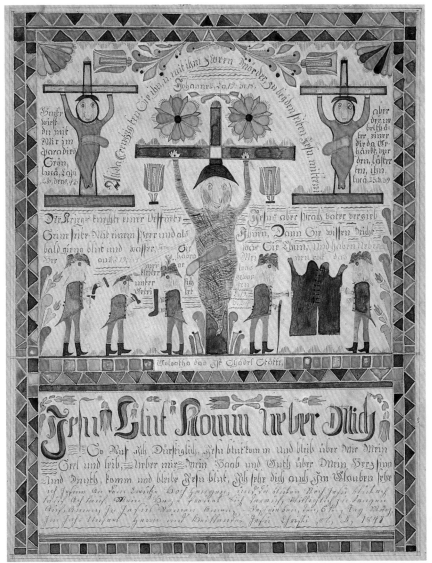

280

Inscriptions/Marks: In German, the ink inscriptions read: (in arch) "Allda Creutzigten Sie ihn, u. mit ihm zween Mörder, zu bey den seiten Jesu, mitten i"; (above flowers within arch) "Johannes, Ca 19. vs. 18"; (upper left) "Heute/wirst/du mit/mir im/Paradies/ Seÿn./lucä, Capi./23, vers, 43"; (upper right) "aber/der ue/bel thä =/ ter einer/dir da ge =/hänkt, var/den, läster/ten ihn./lucä 23; v. 39"; (surrounding Christ) "Der Kriegs knechte einer Ueffnete/Seine seite Mit einem speer und als/bald gieng blut und waser; Joh./Heraus C. 19, 34/Jesus aber sprach Vater vergieb/Ihnen, Dann Sie wissen nicht/ was Sie Thun und haben ueber/meinen rock das/loos/gewor/fen L 19,/V 24/Sir/haben/meine/kleider/unter sich/geteilet"; (below Christ's Cross) "Golgatha das Ist Shädel Stätte"; (lower text) "Jesu Blut Komm ueber mich/So Ruf ich Dürstiglich, Jesu blut komm und bleib über mir mein/Seel und leib, ueber mir mein Haab und Guth über mein Herz sinn/und Duuth, komm und bleibe Jesu blut, Ich sehe dich auch Im Glauben sehe/ich Jesum an dem Creutze Hoch hangen, und da bluten Noch Jesu blut ach/lauf, ach lauf, mein Herze freuet sich darauf, Williglich zu langen/auf, Amen, In Jesus Namen Amen. Geschrieben den 5ten Tag März/Im Jahr unsers Herrn und Heillandes Jesu Christi; A, D, 1847."

The English translations read: (in arch) "There they crucified him and with him two murderers at each side, Jesus in the middle. John 19:18"; (upper left) "Even this day you will be in Paradise with me. Luke 23:43"; (upper right) "but one of the evildoers that were hanged with him mocked him. Luke 23:39"; (surrounding Christ) "The soldier pierced his side with a spear and at once blood and water came forth. John 19:34. But Jesus said: 'Father forgive them for they know not what they do. They have divided my garments among themselves and have drawn lots for my cloak.' John 19:24"; (below Christ's cross) "Golgotha, that is Place of Skulls."; (lower text) "Jesus' blood, come over me. I call thirstily. Jesus' blood, come and remain over me, my soul and body, over me, my possessions and property, over my heart, my reason, my doings, come and remain, Jesus' blood. I also see you in faith, I see Jesus hanging high on the cross and bleeding there still. Jesus' blood, ah flow, ah flow, my heart rejoices over that, willingly to remain, amen. In Jesus' name amen. Written the 5th day of March in the year of our Lord and Savior Jesus Christ, A.D. 1847."

Condition: Conservation treatment by E. Hollyday in 1980 included removing the piece from an old mounting, dry-cleaning the

281

front, reducing acidity and stains, mending small tears, backing the support with a sheet of Japanese mulberry paper, filling nail holes along the edges, and flattening the support. Period replacement 2⅜-inch, mahogany-veneered frame.

Provenance: Found in New York State and purchased from Edith Gregor Halpert, Downtown Gallery, New York, N.Y.

Exhibited: AARFAC, New Jersey; AARFAC, South Texas; AARFAC, April 22, 1959–December 31, 1961; American Folk Art, Traveling; American Primitive Painting, and exhibition catalog, no. 32; Dallas, and exhibition catalog, no. 32; Goethean Gallery; Hand and Spirit, and exhibition catalog, p. 138, no. 84, illus. on p. 139; Southern Book; Trois Siècles, and exhibition catalog, p. 52, no. 237; William Penn Museum.

Published: AARFAC, 1957, p. 270, no. 131, illus. on p. 271; AARFAC, 1959, p. 36, no. 35, illus. on p. 37; Cahill, American Folk Art, p. 38, no. 73, illus on p. 92; Dillenberger and Taylor, p. 138, no. 84, illus. on p. 139.

[1]The other three examples include one owned by the Metropolitan Museum of Art and two in private collections.

281 Three Horsemen 58.305.8

Artist unidentified
Pennsylvania, 1849
Watercolor and ink on wove paper
7⁹⁄₁₆″ x 12⁵⁄₁₆″ (19.2 cm. x 31.3 cm.)

Decorative pictures featuring soldiers on horseback and similar to no. 281 have been recorded from Pennsylvania but none is thought to be by the artist respon-

sible for this appealing example, and none features several horses with riders in a line.

The drawing and painting of *Three Horsemen* is confident and consistent in repeated details, indicating that the artist had perfected the stylized designs through continued use and practice. In fact, the silhouettes of the figures are so similar that one suspects that a prepared pattern was traced to attain the basic outlines before ink and paint were applied. The Gothic script used in the date below further attests to this scrivener's skill.

The relatively late date of *Three Horsemen* illustrates the endurance of traditional pictorial imagery among Pennsylvania Germans and their descendants. Military officers dressed in eighteenth-century uniforms almost identical to those here appear on other, much earlier, Pennsylvania frakturs and on blanket chests dating about 1775.

Inscriptions/Marks: Below the picture in brown ink is "March the 8th, 1849" with what appear to be the letters "E" to the left of the ink inscription and "B" to the right.

Condition: Previous restoration by an unidentified conservator included filling and inpainting losses in the primary support mainly on the horses. Conservation treatment by E. Hollyday in 1974 included removing an old mount, dry cleaning, and hinging the primary support to four-ply conservation board. In 1976 E. Hollyday mended tears at the upper edges where unhinging had occurred. Period replacement 2-inch molded wood frame, painted black.

Provenance: Robert Carlen, Philadelphia, Pa.

Exhibited: AARFAC, September 15, 1974–July 25, 1976; Washington County Museum, 1965.

Published: AARFAC, 1974, p. 38, no. 32, illus. on p. 39; *Antiques*, LXX (December 1956), illus. on p. 530.

Family Records

John T. Adams
(active ca. 1844)

282 Putman Family Record 57.305.1

John T. Adams
Probably New York State, 1844
Watercolor and ink on wove paper
20¼″ x 14⅞″ (51.4 cm. x 37.8 cm.)

282

The John T. Adams who signed and dated this pleasing family record probably was related to the Miss Hannah Adams who married Peter D. Putman on October 18, 1809, as inscribed in the central large heart, although no additional information on either the Adams or Putman family has been located.

The overall design of the record and many of its individual motifs relate it to the family registers made by a number of different artists working in New York State and New England, particularly William Murray (1756–1828) from the Mohawk River valley area of New York State.[1] Adams may have derived his record format from Murray, since the latter's career dates earlier. Adams, however, simplified most of his borrowed motifs, including the borders for the hearts and the meandering vine with alternating small, oval, red flowers. His decorative scheme for the lower extreme left and right hearts, attached to the coffin-and-script blocks, differs significantly from Murray's treatment, in which a variety of borders predominate.

Inscriptions/Marks: An ink inscription in the lower right heart of a cluster of four hearts reads: "Drawn by John T./Adams April 26th in the [year]/of our Lord 1844." The inscriptions in the three remaining clustered hearts read, from top to bottom, left to right: "Miss. Mary. M. Putman was/born March the 24th in the/year of our Lord 1830"; "Miss Hannah Putman was/born November the 19th in/the year of our Lord 1834"; "Mr Squire P. Utley/was born June the 24th in [the]/year of our Lord 1836."

Ink inscriptions in the left vertical row of hearts, from top heart to bottom heart read: "Mr. David P. Putman was/born May the 17th in/the year of our Lord/1810"; "Miss Nancy C. Putman was/born April the 12th in the/year of our Lord 1813."; "Mr. John Putman was born/September the 22d in the/year of our Lord 1818"; "Miss Roxcena H Putman was/born February the 10th in the/year of our Lord 1826"; "Mr. Squaire P Utley departed/this life the 21ˢᵗ day of Sep A.D./1846 Aged 10. years 2/months and 27. days"; (below the last heart and within the block topped by a coffin) "[blank] departed this/life the [blank] day of [blank] in the/year of our Lord [blank] Aged [blank] year/[blank] months and [blank] days."

Ink inscriptions in the right vertical row of hearts, from top heart to bottom heart read: "Miss. Eliza Ann Putman was/born

October the 10th in the/year of our Lord 1811"; "Miss. Maria Putman was/born December the 17th in/the year of our Lord 1816"; "Miss Clarrisa U Putman was/born April the 28th in the/year of our Lord 1823"; "Miss. Margaret Putman was/born September the 28th in the/year of our Lord 1828"; "Miss Margaret Putman departed/this life the 21st day of August A.D./1830 Aged one year 9/months and 23 days." Below the last heart and within the block topped by a coffin is an inscription identical to that below the left row of hearts.

The large central heart has the following inscribed in ink: "Mr. Peter. D. Putman was born March the 27th A.D./1789 & Joined in the holy bands of matrimony to/Miss Hannah Adams October the 18th A.D. 1809/Miss Hannah Adams consort of P.D.P/was born July the 29th A.D. 1792 and/Joined in the holy bands of matrimony/October the 18th A.D. 1809."

Condition: In 1974 E. Hollyday dry-cleaned the surface, removed adhesive tapes from the verso, mended edge tears with Japanese mulberry paper, and hinged the piece to acid-free mat board; in 1977 Hollyday did additional dry cleaning, mended small tears, reduced acidity and staining, and backed the piece with Japanese mulberry paper. Possibly original flat 1-inch wood frame, painted sienna.

Provenance: Edith Gregor Halpert, Downtown Gallery, New York, N.Y.

Exhibited: AARFAC, American Museum in Britain; AARFAC, Minneapolis; AARFAC, June 4, 1962–April 17, 1963; AARFAC, September 15, 1974–July 25, 1976.
Published: AARFAC, 1974, p. 71, no. 71, illus. on p. 70; Arthur B. and Sybil B. Kern, "Painters of Record: William Murray and His School," *The Clarion,* XII (Winter 1987), illus. on p. 33.

[1]See Arthur B. and Sybil B. Kern, "Painters of Record: William Murray and His School," *The Clarion,* XII (Winter 1987), pp. 28–35.

Elizabeth Potter Clark
(1824–1894)

283 Clark-Potter Family Record 58.605.1

Elizabeth Potter Clark
New London, Connecticut, 1835
Silk embroidery on a linen or cotton ground
15¾" x 16¼" (40.0 cm. x 41.3 cm.)

In general there is much overlap between embroidered family records and watercolored ones in terms of composition and motifs.[1] Although Elizabeth Clark's work is much more closely related to traditional sampler formats than some, and although its dominant visual impact emphasizes the rigidity of design enforced by cross-stitching, it is shown here as a variant form of decorative genealogical recording.

In addition to the embroidered data provided, surviving records indicate that Elizabeth's father and mother died July 2, 1883, and March 9, 1882, respectively. William was a shoemaker who maintained both shop and home at 38 Truman Street in New London. On June 30, 1844, Elizabeth married David (or John?) G. Stratton (1819–1906) of Groton; she died December 1, 1894, and she and her husband were both buried in Cedar Grove Cemetery in New London, along with her parents and at least one sister, Ann Holt Clark Burr.[2]

Note that one recorded birth and one recorded death fall after 1835. The thread color of these birth and death dates agrees with one of two hues (both dark brown) used for the earlier inscriptions, and it cannot be determined whether Elizabeth or someone else added them. Yet clearly Elizabeth did not plan on so many siblings when she laid out the design for her embroidery, for Alexander Merrell's inscription runs through the treetops and is broken by the balustrade on top of the house.

Inscriptions/Marks: Embroidered in cross-stitch through the central section of the work is "FAMILY RECORD/William Holt Clark was/born September 6 1795/Susan Potter was born/January 1 1798/

Was married Febuary 3 1822/Mary Stockman was born November 20 1822 died Sep 3 1823/Elizabeth Potter was born Febuary 17 1824/William Stockman was born August 15 1825 died Nov[r] 8 1826/Ann Holt was born September 1 1827/Susan was born July 14 1832/Ellenor Holmes was born June 3 1834 died March 2 1839/Alexander Merrell was born Oct 28 1836." Across the bottom of the sampler is cross-stitched: "elizabeth Potter Clark her record Made in the 12 Year of her age NeW LoNdoN 1835."

Condition: Unspecified treatment possibly conducted prior to acquisition included stitching the primary support to acidic cardboard. In 1976 E. Hollyday removed the secondary support, stitched the piece to muslin with cotton thread, and stretched the work over mat board. Probably period replacement 2¼-inch splayed mahogany-veneered frame.

Provenance: J. Stuart Halladay and Herrel George Thomas, Sheffield, Mass.

Exhibited: Arkansas Artmobile.

[1]See, for example, the embroidered family records shown in Anne Sebba, *Samplers: Five Centuries of a Gentle Craft* (New York, 1979), pp. 106, 109.
[2]Genealogical data were provided from various records by Elizabeth B. Knox, New London County Historical Society, to AARFAC, July 17, 1976. Therein Knox indicated that Elizabeth's husband's name had been given as David G. Stratton on his gravestone and as John G. Stratton in his and Elizabeth's marriage notice in the *People's Advocate & New London County Republican* for July 3, 1844.

Justus Dalee
(active 1826–1847)

The earliest dated record of Justus Dalee's activity is a fifty-two-page sketchbook titled *Emblematic Figures, Representations, &, to Please the Eye.*[1] This homemade, hand-sewn volume with a Palmyra, New York, history contains twenty-two pages showing finished watercolor and ink compositions, pencil or watercolor and ink renderings, and unfinished or preliminary sketches in pencil. The illuminated title page is dated "May 19th, 1826," and the latest dated drawing in the book is inscribed "February 12th, 1827." Several of Dalee's drawings are signed in full, and on one page he titled himself Professor of Penmanship. Inscriptions in the sketchbook do indeed show Dalee to have been an accomplished penman at that date, although his drawings are generally naive in composition and awkward in rendering. "Professor" Dalee — still, practically speaking, an art student himself — copied at least four drawings from printed plates in an early edition of an art instruction manual, *The Oxford Drawing Book.*

By the mid-1830s, Justus Dalee was working in the Albany, New York, area; seven family records drawn and signed by him at nearby West Troy and Cambridge, New York, locations have survived. Dalee used a partially printed, engraved stock register, which he subsequently colored by hand, filling in the births,

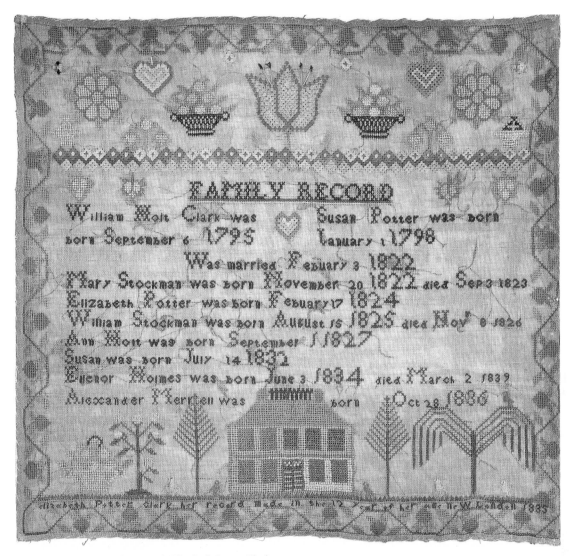

283 *Clark-Potter Family Record*, Elizabeth Potter Clark

marriages, and deaths of the client's family members, combining ornamented block letters with his graceful cursive script.

About the same time, Dalee began focusing as a professional artist on painting miniature watercolor portraits. Although dated portraits do not survive before 1839, hairstyles and costumes depicted in some uninscribed examples indicate he had started painting portraits regularly by about 1835. The works that fall into this category generally combine a half-length, full-frontal body with the head described in profile.

Dated portraits fall into the period from May 1839 to 1845. By 1840 Dalee was working in Rochester, New York, where he executed at least two known portraits in that year. In 1841 he is listed in *King's Rochester City Directory and Register* at 17 Adams Street as a Side Portrait Painter, an apt descrip-

tion of his use of profile portraiture at that time. In July 1842, Dalee had worked his way across New York and appeared in Cabotville (now Chicopee), Massachusetts, just north of Springfield. By 1843 he was back in Rochester, and in 1847 he was listed as a portrait painter in the *Commercial Advertiser Directory for the City of Buffalo*. The 1848–1849 Buffalo directory listed him as a grocer, a change of occupation that would explain the lack of later examples of his work.[2] Works that are either inscribed by Dalee or have fairly reliable histories indicate that he was an active itinerant artist who produced portraits and family records as he moved along the main routes across upper New York State into western Massachusetts and down into central Connecticut. He may have painted as far south as New York City. Although numerous works by Dalee have been recorded, many questions

concerning his life and his whereabouts at certain times remain unanswered.

[1] This sketchbook is in the Walters Art Gallery, Baltimore.

[2] Research by Jack T. Ericson uncovered these two references to Dalee in the *Commercial Advertiser Directory for the City of Buffalo*, published by Jewett, Thomas & Co., and T. S. Cutting. The 1847 directory reference appears on p. 38; the 1848–1849 one on p. 137.

284 Brust Family Record 39.305.2

Justus Dalee
West Troy (now Watervliet), New York,
ca. 1835
Watercolor and ink on printed wove paper
13½″ x 11⅝″ (34.3 cm. x 29.5 cm.)

Justus Dalee is known more for his small portraits than for his decorative family records, although a number of the latter group survive, and the two featured in nos. 284 and 285 demonstrate his ability to provide handsome details to preprinted and rather standardized forms.[1] Like other record artists, Dalee used traditional symbolic motifs. These include the intermeshed hearts at the top, emblems of love and marriage; the man with the anchor at upper left and the cradle below him, symbolizing hope and birth; and on the right, a woman in mourning beneath a stylized willow bough and the coffin below her, which relate to the last column of the record, titled "Died."

All of the Dalee family registers identified in the Center's research files are in this format and have very similar details in addition to the symbolic motifs already noted. Dalee's shaded lettering in the masthead "IN GOD WE HOPE" appears on each, as does the keystone embellished with large and small branches and a pair of doves. The columns with leaf-and-flower roping, and the scalloped borders used inside the arch and above the columns, are nearly identical in each of the known records.

Inscriptions/Marks: Printed and decorated in ink for the masthead is "IN GOD WE HOPE"; in ink below the arch is inscribed: "Honour thy Father and thy Mother."; printed and decorated in ink within the arch is "FAMILY RECORD"; in ink inscriptions at the head of each column are the words: "Parents, Born, Married, Died." The ink inscriptions contain the following information on the family: George Brust, parent, was born May 18, 1764, and died October 27, 1841; his wife, Christianna File, was born July 17, 1775, and died April 9, 1857; they were married October 11, 1789. Their children were Catharine Brust, born August 15, 1790; Elizabeth Brust, born December 6, 1792, and died July 1810; Christianna Brust, born July 24, 1795; Rebecca Brust, born November 26, 1797, and died March 31, 1822; Isaac Brust, born February 15, 1800; Anna Brust, born October 15, 1802; Eve Brust, born February 6, 1805; Mary Brust, born September 9, 1809, and married February 18,

284

285

1822; George Brust, Jr., born March 20, 1812, and married April 21, 1832.

The artist's inscribed signature at lower right reads: "J. Dalee W. Troy."

Condition: In 1974 E. Hollyday hinged the record to acid-free mat board. Probably period replacement 1³/₁₆-inch flat molded frame with beading, painted black.

Provenance: Edith Gregor Halpert, Downtown Gallery, New York, N.Y.

Exhibited: AARFAC, September 15, 1974–July 25, 1976; "Vital Statistics," Downtown Gallery, New York, N.Y., December 1936, and exhibition checklist, illus. on cover.

Published: AARFAC, 1940, p. 32, no. 137; AARFAC, 1947, p. 30, no. 137; AARFAC, 1957, p. 367, no. 307; AARFAC, 1974, p. 71, no. 70.

¹The Rensselaer County Historical Society, Troy, N.Y., owns a record for the family of Alvin Cushing of that city; the New York State Museum, Albany, N.Y., collection includes a record for the Ammon Hammond family, provenance unknown; the Munson-Williams-Proctor Institute, Utica, N.Y., owns a record for the Isaac Peckham family of Cambridge, N.Y.; a record for the Robert Washburn family, also of Cambridge, is privately owned (see Sotheby Parke Bernet, Garbisch II, lot no. 161, p. 65); a record for the Josiah Rich family of Cambridge is privately owned.

285 Potter Family Record 58.305.2

Justus Dalee
Cambridge, New York, ca. 1835
Watercolor and ink on printed wove paper
14″ x 11¾″ (35.6 cm. x 29.9 cm.)

Freehand motifs on this record are nearly identical to those on no. 284. Minor variations include the dash-like pattern on the cradle, probably an attempt to simulate wood grain; additional detail in the willow bough behind the woman at upper right; and the size and shape of the large leafy bough at the top of the keystone. This is one of four certificates by the artist believed to have been executed in Cambridge, New York, a small town near Troy.

Inscriptions/Marks: For the masthead, see *Inscriptions/Marks* for no. 284. Inscribed in ink at lower right is "J. Dalee Cambridge." The information on the family states that Lucius E. Potter was born August 27, 1808, and married on October 22, 1833, to Adaline M. Burr, born June 27, 1813.

Condition: In 1960 Christa Gaehde dry-cleaned the surface, removed old adhesive tapes, treated for microbiological growth, and hinged the piece to acid-free mat board. Possibly original flat 1½-inch frame with inner bead and gold stenciled decoration on a black painted ground.

Provenance: J. Stuart Halladay and Herrel George Thomas, Sheffield, Mass.

Exhibited: Halladay-Thomas, New Britain, and exhibition catalog, no. 141.

Ruby Devol Finch
(1804–1866)

See Finch entry in "Biblical Subjects" for biographical information.

286 Kirby Family Record 58.305.25

Ruby Devol Finch
Westport, Massachusetts, 1831
Watercolor and ink on wove paper
20½″ x 16¼″ (52.1 cm. x 41.3 cm.)

This family record is the earliest dated work of Ruby Devol Finch's that has been recorded, as well as her only known signed creation.

Most of Finch's well-known personalized watercolor memorials, portraits, depictions of the story of the prodigal son (see, for example, no. 181), and family records were executed for friends and neighbors in the area of her Westport, Massachusetts, home. The Kirbys' farm was close to that owned by the artist's father, and this family record was drawn for the Kir-

286

bys a year before the artist married William T. Finch of New Bedford.[1]

The Jack-and-the-Beanstalk-like vines at either side of the Kirby record appear in other works by Finch, as does the naively rendered eagle at center top. Characteristically, the artist depicted the bird's plumage in a way that more closely resembles scales than feathers.

Inscriptions/Marks: Within the text block below the eagle in ink and watercolor is "SILAS KIRBY,/was born june 23ᵈ 1788. died, 23ᵈ Apr. 1866/PATIENCE SHERMAN/was born November 22ᵈ 1789 died the 15th of February 1853/joined in marriage Nov' 1809."[2] The artist divided her columns according to gender as follows, beginning at the left: "Births/Masculine Gender; Marriage/Masculine G; Deaths/Masculine G; Births/Feminine; Marriage/Feminine; Deaths/Feminine." In the column for masculine births is "Perry Kirby/was born July/the 4th day 1810/Tillinghast Kir-/by was born the/22d day of March/1816." In the feminine birth column is inscribed: "Nancy Sherm/an was born/the 25th day of/March 1814/Mary Ann/Kirby was/born the 1st day of March/1821." Under feminine deaths is recorded: "Nancy Sher-/man Kirby/died the 27th/of May 1814/9 weeks old on/the day of her/Death./Mary Ann/Kirby deceased/October the 2d/AD 1835 on/the 6th day of the/week about 12 O'clock/[illegible material]." At the bottom of the register, below the columns, is the ink inscription: "Drawn by R[e?]uby Deuel [*sic*] of Westport November 19th 1831 Silas Kirbys Family Record Forever."

Condition: In 1977 E. Hollyday dry-cleaned the surface, repaired edge tears throughout, set down flaking paint, and hinged the piece to acid-free mat board. Modern 1½-inch splayed frame, painted orange.

Provenance: Arthur J. Sussel, Philadelphia, Pa.

Published: Walters, Finch, pp. 1C–4C, illus. as fig. 1 on 1C.

[1]Walters, Finch, pp. 1C–4C.

[2]The inscriptions for the parents' death dates are not in Finch's handwriting and probably were added by members of the Kirby family; Mary Ann Kirby's death entry is also in a hand other than the artist's.

William Holmes
(active ca. 1795–ca. 1810)

Nothing has been discovered about William Holmes's life or career despite the impressive number of decorative family records now attributed to his hand. The quality of his work, however, indicates that he was an experienced and practiced calligrapher who also knew how to use watercolor paints.

Only one signed example by Holmes, a record for the Finch family of Stanwich, Fairfield County, Connecticut, is known.[1] Others, such as no. 287, are attributed to him, and they share similar designs and identical handwriting to the Finch record. Most of the records are for families living in southeastern New York State and in neighboring towns in Connecticut, lending credence to the theory that Holmes lived in

this area and possibly served as a schoolteacher in one or more communities.[2] Ornamented family registers similar to Holmes's but by other hands also exist, and one of these is signed "Hawley."[3]

[1]The signed example, dating ca. 1804, is in the collections of Greenfield Village and the Henry Ford Museum.

[2]In addition to no. 287 and the signed example cited in note 1, fifteen records attributed to Holmes have been recorded in the Folk Art Center's research files. Of these, seven are in the collection of the National Archives, Washington, D.C.; three are privately owned; and the current locations of five are unknown.

[3]Judy Lenett, Ridgefield, Conn., to AARFAC, August 27, 1982.

287 Rider Family Record 58.305.24

Attributed to William Holmes
Probably Dutchess County, New York, or Danbury, Connecticut, ca. 1805
Watercolor and ink on laid paper
13¹⁵⁄₁₆" x 9⅞" (35.4 cm. x 25.1 cm.)

The Rider family record incorporates one of several decorative arch formats used by the artist. Here, the compass-drawn design features a band of red and blue lines topped by alternating red and blue colored

287

wedges with scalloped upper edges. Other works by Holmes show arches of diamonds, and one boasts an intricate series of hearts. The floral, or starburst, designs at the upper corners and a variation of the same at either side of the large arch are but two of several devices he preferred for these positions. On other examples, the areas at the sides of the arch are decorated with stars or treelike motifs; and on one record, the artist used Masonic symbols. Holmes used basically the same arcaded arrangement below the main text to set up the various columns of information. The first two columns are usually headed with floral designs as seen here, and the intertwined hearts and hourglass are always seen in the last two columns. Occasionally Holmes would use the intertwined hearts at either side of the marriage date.

Inscriptions/Marks: A watermark in the primary support reads: "Hayes & Wise 1799." Lettered in ink within the large arch is "A/Family Record" and below this is "John Rider was Born in South East Dutchess County State of New York March 28th 1760./ Mary Jarvis was Born in Danbury Fairfield County State of Connecticut November 20th 1760." In large letters: "Married November 1st 1783." is followed by: "John Rider died January 15th 1833. aged nearly 73 years./Mary Rider died September 26th 1845. aged nearly 85 years."[1] In the columns below, headed "Names, Births, Marriages, Deaths," the information within indicates that John Rider, Jr., was born on December 2, 1784, married on December 22, 1808, and died on September 26, 1849; Polly Rider was born on September 21, 1786, married on April 15, 1804, and died on February 1, 18[41?]; Stephen J. Rider was born on November 1, 1788, married June 13, 1813, and died in September 1864; Rachel Rider was born on September 11, 1790, and died unmarried on June 14, 1865; Ralph Rider was born on July 11, 1793, married on October 8, 1816, and died August 27, 1841; George Rider was born on June 9, 1796, and died unmarried in Postsea [?] in October 1843; William H. Rider was born on August 4, 1798, married on March 28, 1826, and died on October 11, 1854; twin to William, Mary H. Rider was born on August 4, 1798, married on May 18, 1825, and died in June 1868; Charles Rider was born January 24, 1801, and married on May 30, 1831.

Condition: In 1958 unspecified conservation treatment by Christa Gaehde probably included dry cleaning, mending and filling three small edge tears, repairing small losses throughout, reducing staining and acidity, laying down flaking paint, and hinging the piece with Japanese mulberry paper. Possibly original 1-inch cyma reversa frame, painted black.

Provenance: J. Stuart Halladay and Herrel George Thomas, Sheffield, Mass.

Exhibited: Halladay-Thomas, New Britain, and exhibition catalog, no. 139.

[1]The death inscriptions for the parents are not in the artist's hand; neither are any of the other inscriptions under "Marriages" and "Deaths."

Unidentified Artists

288 Birth Record for Martha Hillier 63.305.6

Artist unidentified
Possibly New Jersey, ca. 1774
Watercolor and ink on laid paper
9¾" x 7⅞" (24.8 cm. x 20.0 cm.)

Five additional records by the hand responsible for no. 288 have been recorded in the Center's research files, and all are drawn in the basic three-part horizontal format seen here.[1] The artist consistently used the upper section for the child's name, the middle area for text, and the lower portion for decorative scenes or geometric and floral designs and often a verse or motto appropriate to the occasion. A number of the pieces documented have human figures in contemporary eighteenth-century dress standing or seated in the lower section, in addition to the large vase of flowers seen in Hillier's record.

Characteristics associated with this unidentified artist's work include the scalloped borders, the style of lettering, the floral branches above (and on other examples often intermingled with) the child's name, and small animals and winged angels placed near or below the vase of flowers.

Inscriptions/Marks: In ink, beginning at the top, are the lettered and inscribed words: "MARTHA HILLIER/Daughter of Isaac Hillier & Sarah his wife/Was Born December ẏ 5th, Anno Domini, 1774/ Perhaps this my Name, and Age may Shew/When I am Dead, and in my Grave below."

Condition: In 1974 E. Hollyday removed the record from a parchment-type backing, reduced acidity and stains, aligned and mended small tears throughout, filled and inpainted minor losses,

288

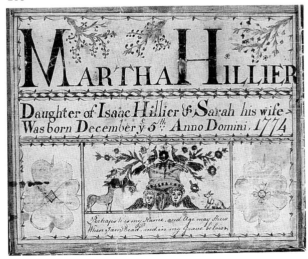

289

Inscriptions/Marks: Within the shield at center, inscribed in ink is "A Record of Birth's/Joseph Porter Decr 25th1766/Olive Bechley 17th June 1765 Horace Porter 25th Nov 1788/Clarissa Porter 10th Nov 1790/Liman Porter 16th Sep 1792"; in the panel on the sarcophagus is "Death's Liman Porter No 1792/Clarissa Porter 29 Jany 1794."
Condition: In 1980 E. Hollyday dry-cleaned the surface and mended small tears along the edges. Possibly original 1½-inch flat wood frame with banded inlay at outer and inner edges.
Provenance: Old Print Shop, New York, N.Y.

290 Birth Record for Thomas Chute 58.305.20

Artist unidentified
Probably New England, ca. 1803
Watercolor and ink on laid paper
9″ x 7″ (22.9 cm. x 17.8 cm.)

The existence of several towns called Windham in New England leaves the exact location of Chute's birth and the probable origin of the record uncertain. Delicate, finely detailed floral sprays featuring roses, which at one time may have been pink, are set within a handsome border of repetitive sprigs and half circles inside a row of alternating double dots and small S-shaped pen strokes. The precision of the work approximates line engraving, although all of it was executed by hand with pen and ink.

290

and hinged the piece to acid-free mat board. Mid-nineteenth-century, 1⁷⁄₁₆-inch gilded cyma recta frame.
Provenance: Herbert Schiffer Antiques, Whitford, Pa.

¹The five other certificates are examples for Sarah Compion, born November 10, 1777, and Charity Earling, born August 1774, acc. nos. M58.120.16 and M57.99.1, owned by the Henry Francis du Pont Winterthur Museum, Winterthur, Del.; a record for John Budd Goldy, born March 12, 1791, in the collection of the National Archives, Washington, D.C.; a record for John Mason, born January 3, 1767, in the collection of the Monmouth County Historical Society, Freehold, N.J.; and a record for Elizabeth Wills, born in April 1776, formerly in the Lorimer Collection, Philadelphia, Pa., and illus. as no. 299 in Shelley, Fraktur-Writings. Shelley attributed the Wills record to New Jersey, and both the Mason and Earling records were found in New Jersey. Based on this information, a New Jersey provenance is tentatively assigned to no. 288.

289 Porter Family Record 60.305.1

Artist unidentified
America, 1800–1820
Watercolor and ink on wove paper
12½″ x 17″ (31.8 cm. x 43.2 cm.)

No other records of this particular format or by this hand have been identified, although the elaborate composition suggests that the artist either copied or was inspired by a printed form or vignettes from several prints. The architectural elements, the woman holding an anchor at left, and the angel of death mourning beneath a willow tree and next to the deceased's sarcophagus are typical of such records and are seen later in the work of Justus Dalee (see nos. 284 and 285). The recorded dates for the family range from 1766 to as late as 1794, but the style of the women's clothing indicates that the record was made later, probably during the first two decades of the nineteenth century.

291

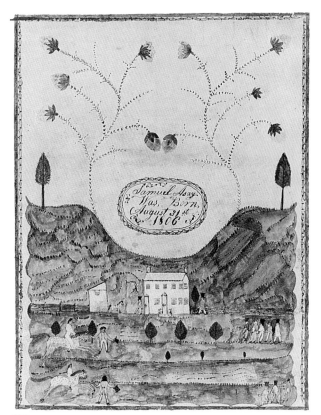

292

Inscriptions/Marks: The inked letters in the center read: "THOMAS CHUTE Jn⪦/Born August 12 1803;/In WINDHAM."

Condition: In 1959 unspecified conservation treatment by Christa Gaehde included cleaning and hinging the work with Japanese mulberry paper; in 1977 E. Hollyday dry-cleaned some areas, repaired small tears on the left and top sides, and rehinged the piece to acid-free mat board. Late nineteenth-century, ¹³/₁₆-inch molded frame, painted black.

Provenance: Arthur J. Sussel, Philadelphia, Pa.

291 Birth Record for Rebecca Hammell
33.305.1

292 Birth Record for Samuel Asay
33.305.2

Artist unidentified
America, 1810–1825
Watercolor and ink on wove paper
8⅞" x 7⅛" (22.5 cm. x 18.1 cm.)
8¹⁵/₁₆" x 7⅛" (22.7 cm. x 18.1 cm.)

Birth and family records produced by and for non-Germans in America are often highly individualistic in format and subject. The reasons for this are not clear, but their distinctive designs may reflect English, Scottish, and Irish customs and iconography that have received little or no research. The absence of the strong and binding religious traditions that motivated and influenced much of German production must also be considered as a reason why these pieces often seem so innovative and unusual. Only rarely do non-German illustrated records make use of biblical themes or inscriptions paraphrasing or quoting scripture and hymn verses. Overt religious symbolism is usually minimal, while landscape settings, figures engaged in a variety of activities, architectural elements, and secular motifs dominate.

These two examples probably represent the efforts of a non-German maker. The most prominent features are the landscape vistas, one showing a stag hunt and the other a horse race. The latter includes a large building in the center middle ground bearing a sign that may identify the structure as an inn or tavern. The relevance of the scenes to the embellished motifs above heralding Hammell's and Asay's births seem remote to modern viewers but undoubtedly had some significance for the maker and the children's families.

The unusual compositions have no known precedent in either print or drawn form, nor have any additional works by the same hand been identified by Center staff. The flowering vines, small decorative borders used in both examples, and the hearts surrounding Rebecca's name are, however, common to both frakturs and other non-German decorated rec-

ords produced during the eighteenth and early nineteenth centuries.

Inscriptions/Marks: The ink inscription inside the scalloped circle formed by hearts on no. 291 reads: "Rebecca,/Hammell/Was, Born/March, 10ᵗʰ/1810." The ink inscription inside the bordered circle on no. 292 reads: "Samuel Asay./Was, Born,/August 31ˢᵗ/1806." The watermark in the support of no. 292 reads: "JM."

Condition: Unspecified treatments for both pieces in 1955 by Christa Gaehde included mounting on Japanese mulberry paper. In 1976 E. Hollyday removed no. 291 from acidic rag board, removed cellulose tape and strips of wood nailing the work to the rag board, repaired nail holes, added a sheet of 18-percent, calcium-carbonate-filled paper behind the support to absorb any remaining acidity, and mounted the work on acid-free mat board. The same year, Hollyday removed no. 292 from an identical type of old mounting, mended some small edge tears with Japanese mulberry paper, repaired nail holes, and provided a similar mounting. Possibly mid-nineteenth-century, 1⁵⁄₁₆-inch flat mahogany frames.

Provenance: Edith Gregor Halpert, Downtown Gallery, New York, N.Y.

Exhibited: Arkansas Artmobile, no. 292 only; Washington County Museum, 1965; Washington County Museum, 1966, no. 291 only.

Published: AARFAC, 1957, no. 291, p. 363, no. 269 and no. 292, p. 362, no. 268.

293 Russell Family Record 62.305.1

Artist unidentified
Probably Yarmouth, Massachusetts,
1813–1815
Watercolor and ink on laid paper
14³⁄₈" x 11⁷⁄₈" (36.5 cm. x 30.2 cm.)

Nothing is known about the Russell family listed on this record beyond the place and persons' names cited, and no other works by the yet to be identified artist have been located. The assigned date is based on the style and fine quality of writing used for the earliest entries, which fill the first column and part of the second. The last of these, for Mary Russell, is dated 1813, while the one following hers is by a different hand and for 1815.

The prominent bird at top center required several different penwork designs, including patterned circles with interior dots for the creature's side, hatching for the tail, thighs and wing with solid passages at the tip and shoulder, and solid inked areas for the head and breast.

Inscriptions/Marks: Beginning with the left column, top to bottom, are the following inscriptions in ink: "A Record of the births & deaths/ in the Family of John Mahew Russell/& Patience his wife of the state of/Massachussetts district of Maine/County of Cumberland & Town/of N. Yarmouth./John Mahew Russell was/Born January 13ᵗʰ 1770/Patience his Wife Was Born/July 19ᵗʰ 1781/John Mahew Russell & Patience/Roberts were married Augᵗ 15ᵗʰ 1804/William Russell Was Born/August 1ˢᵗ 1805/James D. Russell Was Born/September 6ᵗʰ 1806/John Russell Was Born/November 3ᵈ

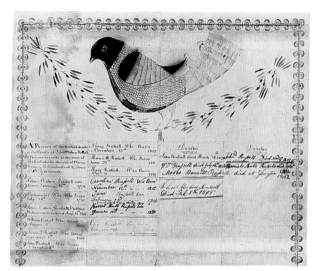

293

1808/Nancy Russell Was Born/November 15ᵗʰ 1809/Moses B. Russell Was Born/June 22ⁿᵈ 1811/Mary Russell Was Born/Nov! 11 1813."; (the following entries were written by different hands) "Caroline Russell Was Born/November 12ᵗʰ——1815/Jane Russell born/February 25ᵗʰ——1818/John Russell Borne Novʳ 27 1819/Harriot Hull Russell born/December 15ᵗʰ——1820/John Russell Was Born/November 3ʳᵈ 1808." Under the first column inscribed "Deaths" is "John Russell died March 16ᵗʰ, 1809/Wᵐ. Russell died July 16ᵗʰ 1826/Moses Bennett Russell died at Gloucester 1842/John Mahew Russell/Died Feb 8ᵗʰ 1848." In the last column, inscribed "Deaths," is "John 2ᵈ Russell Died Novʳ 27 1819/Harriet Bull Russell died Apl 11ᵗʰ 1822."

Condition: In 1974 E. Hollyday dry-cleaned the nondesign areas and verso, removed insect debris, reduced stains, mended small tears, filled small losses, and hinged the piece to acid-free mat board. Late-nineteenth-century, 2-inch cyma reversa gilded wood frame.

Provenance: Gift of Mrs. Jason R. Westerfield, Camden, Maine.

294 Birth Record for James Park 57.305.3

Artist unidentified
Probably Windham, New Hampshire, ca. 1820
Watercolor and ink on wove paper
19" x 14¹¹⁄₁₆" (48.3 cm. x 37.3 cm.)

James Park's attractive and capably drawn certificate generally relates to English-style records created by a number of artists in the New York State and New England area during the first half of the nineteenth century, although no other examples by this particular hand have been identified. The use of such devices as a compass and rule, a sextant, and the directional compass indicating north, south, east, and west is not uncommon among such decorative records. Presumably they symbolized the recipient's intended vocation or that of the father. In this case, however, the James

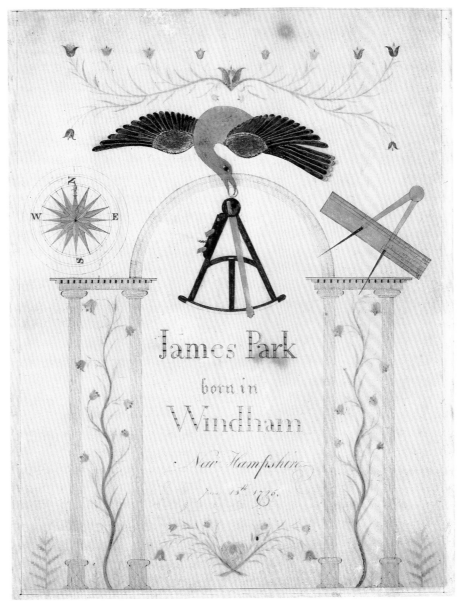

294

Park named on the certificate may have been the son of Alexander Park of Windham, born on June 13, 1795, instead of 1796. This James Park inherited his father's farm, which he managed until he moved with his wife, Sarah Webber, to Lowell, Massachusetts, in 1868. There is no evidence that Park was a mariner or involved in seafaring activities during his lifetime.[1]

The architectural columns with connecting arch are also common motifs on New England records of the first half of the nineteenth century. Here, they are rendered in a precise series of ruled lines.

Inscriptions/Marks: In ink on the front is lettered: "James Park/born in/Windham/[and in script below] New Hampshire/June 13th, 1796."

Condition: In 1974 E. Hollyday dry-cleaned the surface and hinged the record to an acid-free mat board; in 1976, Hollyday rehinged the record with Japanese mulberry paper and repaired some small edge tears. Probably original 2 1/16-inch wood frame, painted red and yellow-green with carved scallops separating the two colors and painted fan motifs in each corner.

Provenance: Holger Cahill, New York, N.Y.; M. Knoedler & Co., New York, N.Y.

Exhibited: AARFAC, Minneapolis; AARFAC, June 4, 1962– March 31, 1965; AARFAC, May 10, 1964–December 31, 1966; AARFAC, September 15, 1974–July 25, 1976; "Vital Statistics," American Folk Art Gallery, New York, N.Y., December 2–31, 1936.

Published: AARFAC, 1974, p. 71, no. 72, illus. on p. 72; Black and Lipman, p. 193, illus. as fig. 183 on p. 204.

[1] John F. Page, New Hampshire Historical Society, to AARFAC, January 18, 1980.

Calligraphy

295

295 Birth Record for Mary E. Wheelock

58.305.23

Artist unidentified
America, 1830–1835
Watercolor, ink, and pencil on laid paper
5¾″ x 7⅛″ (14.6 cm. x 18.1 cm.)

Mary E. Wheelock's birth record is one of the smallest in the Folk Art Center's collection but also one of the most appealing in terms of its crisp lettering and drawing and its well-preserved blue, pink, and yellow paint colors. The circular format is not commonly seen for records of this period, and no other similar examples have been located.

The outer geometric border of interlaced lines features a design more common to carved fretwork and inlays on furniture dating from the mid–eighteenth century through the first decade of the nineteenth century, although it also appears in borders for printed newspapers and broadsides over a broader date range. The calligraphic scroll at right, just below "Wheelock," terminates in what appears to be a boar's head, the significance of which is unknown.

Inscriptions/Marks: "MARY E. WHEELOCK" is lettered in ink above the banner, beneath which is "Born May 4ᵗʰ." Below the bird, in large inked numbers, is the date: "1830." A lettered inscription in pencil on the front edge of the support reads: "SHAFTSBURY—VT. MARRIED RICHMON[D] GHU[KSON?]."
Condition: In 1958 Christa Gaehde dry-cleaned the surface, removed stains created by old adhesive tape on the verso, and hinged the piece to acid-free mat board; in 1978 E. Hollyday cleaned the nondesign areas, reduced stains, lined with Japanese mulberry paper, and hinged it to acid-free mat board. Possibly original 1¹⁄₁₆-inch molded wood frame, painted black.
Provenance: J. Stuart Halladay and Herrel George Thomas, Sheffield, Mass.

[?] Bailey (active ca. 1880)

296 Leaping Deer and U.S. Shield

64.312.1

Possibly [?] Bailey
America, ca. 1880
Ink on wove paper
23¾″ x 39″ (60.3 cm. x 99.1 cm.)

As the most accomplished of the calligraphy works in the Folk Art Center's collection, no. 296 displays a great variety of the techniques employed by artists of the nineteenth century and the high degree of both fanciful and realistic effects that could be achieved. The flags, the eagle and its rocky perch, and the landscape setting are finely detailed and required considerable time in the rendering of light and shadow and the various textures of feathers, stone, and furled cloth. The deer comprise the fanciful elements of this composition and feature pen work commonly associated with calligraphy exercises.

The piece is tentatively assigned to an artist whose last name, Bailey, appears on an unfinished drawing that is nearly identical in both the pen work and the overall composition.[1] No other examples by Bailey or closely related in style to no. 296 have been located.

Inscriptions/Marks: The watermark in the primary support reads: "J Whatman/1858," for the Maidstone, Kent, England, firm operated by the Hollingworth Brothers between 1806 and 1859.
Condition: In 1978 E. Hollyday dry-cleaned the nondesign areas, reduced stains and acidity, mended various edge tears, and hinged the piece to acid-free mat board. Modern 1½-inch molded wood frame with fake silver gilt and gray paint.
Provenance: Leon Stark, Philadelphia, Pa.

[1]The second drawing signed "Bailey" was formerly in the collection of Edith Gregor Halpert, New York, N.Y., and is now in a private collection (AARFAC research files).

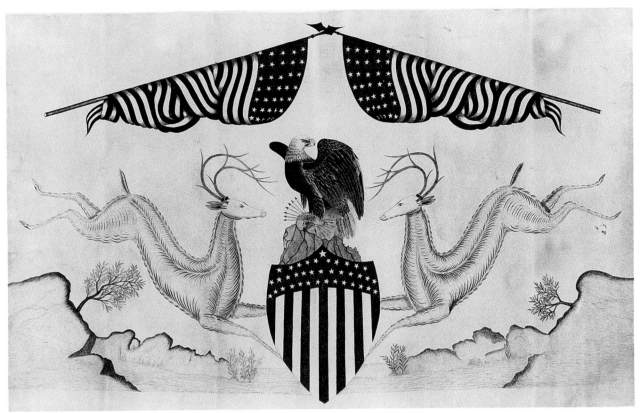

296

297

Warren Bradley
(active ca. 1860)

297 Napoleon on His Steed 63.312.1

Warren Bradley
Probably New England, ca. 1860
Colored inks on wove paper
15⅛″ x 19⅝″ (38.4 cm. x 49.9 cm.)

Like many of the calligraphy exercises in the Folk Art Center's collection, this decorative rendering of Napoleon on horseback was undoubtedly copied from or inspired by a popular print based on Jacques Louis David's celebrated oil portrait of the French leader that is in the Musée de Versailles in France. One other American drawing similar to Bradley's has been located, and the maker's name, "Geo. F. Babbitt," is inscribed at its bottom. Both were found in New England, although no documentation exists that would associate them with a specific location, drawing master, or academy.

Bradley's skill is evident in the dappled effect of the horse's body; the finely hatched areas of the mane, the Frenchman's jacket, and the horse's legs and

hooves; and in the stippled technique used for much of Napoleon's coat. The delicate undulating vine surrounding the figure, and the fancy inscription block below, unify the composition and are further indications of Bradley's dexterity with a pen.

Inscriptions/Marks: In ink, below the composition and within the wreath, is "Drawn with a Steel Pen/by Warren Bradley."
Condition: In 1974 E. Hollyday dry-cleaned the surface, set down flaking ink, mended edge tears and creases, and hinged the piece to acid-free mat board. Probably original 1¼-inch, black-painted and molded frame with gilded inner and outer borders.
Provenance: Edith Gregor Halpert, Downtown Gallery, New York, N.Y.
Exhibited: AARFAC, September 15, 1974–July 25, 1976, Atlanta show only.

the use of the scalloped outline for the horse (as opposed to the more common and simpler line outlines seen in nos. 297 and 302) and the delicate geometric designs used in each loop of the scrolls throughout the body.

Inscriptions/Marks: The ink letters at center between the horse's legs read: "H. G. Cuddeback."
Condition: In 1974 E. Hollyday dry-cleaned the unpainted areas, removed old adhesive tapes, reduced creases and buckling in the support, and hinged the piece to acid-free mat board. Probably period replacement 2½-inch cyma reversa gilded frame.
Provenance: Leon Stark, Philadelphia, Pa.
Exhibited: AARFAC, September 15, 1974–July 25, 1976.
Published: AARFAC, 1974, p. 67, no. 67, illus. on p. 66.

[1]For the example similar to no. 298, see Calligraphy, p. 17, no. 182.

H. G. Cuddeback
(active ca. 1865)

298 Caparisoned Horse 64.312.3

H. G. Cuddeback
Possibly Cuddebackville, New York, ca. 1865
Ink on wove paper
18¹¹⁄₁₆″ x 24″ (47.5 cm. x 61.0 cm.)

One other pen and ink drawing by Cuddeback, attributed to Cuddebackville, New York, has been recorded, and it also features a similar horse.[1] The excellent quality, elaborate style, and density of pen work seen throughout the horse's body, its finely hatched tail and mane, and the meticulous work at the bottom suggest that Cuddeback may have taught calligraphy. Some of the small details are especially noteworthy, including

A. F. Davenport
(active ca. 1850)

299 The Duke of Orleans 57.312.2

A. F. Davenport
Probably Massachusetts, ca. 1850
Ink on wove paper
18¼″ x 22⅞″ (46.4 cm. x 58.1 cm.)

A. F. Davenport is known as a North Adams, Massachusetts, teacher of "Plain and Ornamental Writing" from an inscription that appears on a caparisoned horse by him that is now in the Karolik Collection at the Museum of Fine Arts, Boston.[1] Two other examples by Davenport are known, including one that served as a merit award for his student Joel Lobdell

298

299

for "improvement in Penmanship in his class during a time of twelve lessons."[2] The merit award is dated September 18, 1856, when Davenport added that he was at a town named Sternsville, the location of which is unknown. He may have traveled to a number of New England towns during this period.[3]

The artist was obviously talented and experienced in calligraphy as proved by the fine control and technical proficiency of his pen work and the delicate tonal relationships he achieved in rendering three-dimensional form. The arched border of flourishes and a wispy vine add interest to what would otherwise be a stark white background for this example. He also used a similar device for the drawing in the Karolik Collection.

Davenport's *The Duke of Orleans* may represent Ferdinand-Philippe-Louis-Charles-Henri (1810–1842), who received his title in 1830, although it is not known whether the artist owned or referred to a print of this nobleman or others who held the title before 1830 and after 1842.

Inscriptions/Marks: In ink letters below the horse at left is "THE DUKE OF ORLEANS"; on the lower right in inked letters is "BY A. F. DAVENPORT."

Condition: In 1974 E. Hollyday dry-cleaned the nondesign areas, realigned and mended numerous edge tears, backed the support with Japanese mulberry paper, and hinged the piece to an acid-free mat board. Modern 1⅜-inch molded stained wood frame with gilded inner liner.

Provenance: Edith Gregor Halpert, Downtown Gallery, New York, N.Y.

Exhibited: "American Folk Art: Painting and Sculpture," Downtown Gallery, New York, N.Y., May 4–23, 1954; Calligraphy, and exhibition catalog, p. 10, no. 5; "New Acquisitions," Downtown Gallery, New York, N.Y., June 1955.

[1]See Karolik Collection, p. 308, illus. as no. 381 on p. 309.

[2]For Davenport's merit-award drawing of an eagle, see Sotheby Parke Bernet, Garbisch II, lot no. 133, on p. 55; this example reappeared in Sotheby Parke Bernet, Inc., *Americana*, catalog for sale no. 4663Y, July 9–10, 1981, lot no. 362. The second drawing, featuring a bird and a fish, is published in Halpert Folk Art Collection, illus. as K305.

[3]A man named A. F. Davenport, probably Dr. Arthur F. Davenport, is listed in the 1881 North Adams, Massachusetts, City Directory at 101 Main Street, with his dental practice at 87 Main Street; in the 1882 directory he is listed at Church Street. This same individual and Charlotte Augusta Dunton compiled a book, *A Sketch of the Origin and Growth of the Catamount Hill Association of Colrain, Massachusetts* (North Adams, Mass., 1901), in which Davenport claims on p. 28 to have followed "various pursuits" until he began studying dentistry in 1855. He notes further that he spent most of his life in New York and North Adams and that he married Julia M. Walden of the latter town. Information courtesy of Susan D. Stein, North Adams Public Library, Mass., to AARFAC, February 13, 1978.

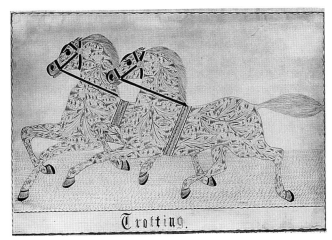

300

Frank H. Fitch
(active ca. 1863)

300 Trotting Horses 63.312.2

Frank H. Fitch
America, 1863
Colored inks on wove paper
13⅞" x 20⅝" (35.2 cm. x 52.4 cm.)

The creators of most fancy calligraphy drawings usually signed or lettered their names in prominent text, but Frank H. Fitch's signature is in tiny script and is barely discernible at lower right. The simple outlines of the horses were probably drawn or traced first in pencil and then finished in ink before the bodies were decorated with the elaborate calligraphic motifs. The large leaves on the bodies are set against a background of lines and small dashes that were considered good exercises to strengthen muscle control in the maker's wrist.[1] Blue, brown, and red inks were combined by Fitch in both the drawing of the horse and in the title at bottom.

Inscriptions/Marks: Beneath the horses, in large multicolored inks, is "Trotting." At lower left, in ink, is "Aug 20th, 1863," and at lower right, "Frank H. Fitch."

Condition: In 1974 E. Hollyday dry-cleaned the unpainted areas on the front and the verso, reduced stains and acidity, and hinged to acid-free mat board. Probably original 1½-inch shallow molded and black-painted frame with gilded liner.

Provenance: Gift of Mrs. Daryl Parshall, Millbrook, N.Y.

Exhibited: AARFAC, June 4, 1962–November 20, 1965; Calligraphy, and exhibition catalog, p. 10, no. 8, illus. on p. 11.

[1]For examples of recommended exercises, see A. R. Dunton, *Free-Hand Series of Writing Books, The Original Duntonian System of Rapid Writing* (Boston, 1873), p. 1.

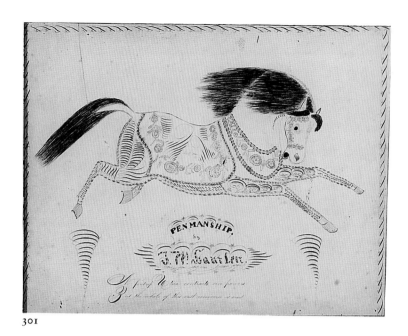

301

J. W. Hamlen
(active ca. 1850)

301 Horse with Trappings 57.312.3

*J. W. Hamlen
Possibly New England, ca. 1850
Ink on wove paper
15¾" x 20¼" (40.0 cm. x 51.4 cm.)*

Hamlen's unusually pleasing calligraphic drawing of a horse successfully combines very intricate pen-work motifs with a simple outline of the animal and the hatched work for the tail and mane. His name is prominently placed and decorated with surrounding flourishes and ornate letters.

The verse inscribed by the artist at the bottom of the drawing was composed by Jonathan Mitchell Sewall for his "Prologue to Addison's *Cato*," which served as a preface to a play at the Bower Street Theatre in Portsmouth, New Hampshire, about 1800.[1]

Inscriptions/Marks: The various ink block and scripted words at lower center are "PENMANSHIP./by/J. W. Hamlen./No pent up Utica contracts our powers/But the whole of this vast universe is ours."

Condition: In 1978 E. Hollyday dry-cleaned the surface, removed a wood-pulp cardboard backing and adhesive residues, repaired miscellaneous small edge tears, and hinged the piece with Japanese mulberry paper. Period replacement 2¹⁄₁₆-inch cove and cyma molded gilded frame.

Provenance: Edith Gregor Halpert, Downtown Gallery, New York, N.Y.

[1]Burton Stevenson, comp., *The Macmillan Book of Proverbs, Maxims and Famous Phrases* (New York, 1948), no. 10 on p. 1857.

J. G. (or P. G.) Morse
(active ca. 1850)

302 All with a Pen 39.312.1

*J. G. (or P. G.) Morse
America, ca. 1850
Ink and ink wash on wove paper
14⅜" x 26¼" (36.5 cm. x 66.7 cm.)*

Two mounted horsemen dressed in military uniforms and brandishing swords frame the central and somewhat elaborately scripted signature and title lines on this example. Small details — such as the hearts on the left horse's girth and the right horse's breastplate and saddle, and the dove on the forepart of the saddle at left — may have been creative touches added by the maker to what were probably figural designs copied from an unidentified print source.

This piece served as both a writing and drawing exercise since the calligraphic motifs are restricted primarily to the text, and the two soldiers and their mounts are rendered as sketches in which light, shadow, and three-dimensional form were of more concern than rhythmic and repetitive pen strokes.

Inscriptions/Marks: Inscribed in ink between the two horsemen is "ALL/WITH A PEN./BY J. G. [or P. G.] Morse/Writing Academy/By J. G. [or P. G.] Morse."

Condition: Unspecified conservation treatment — including the repair of a vertical tear above the left horse's head running to the edge and a horizontal tear at right, from the military officer's left shoulder to the edge — was probably completed by Christa Gaehde in 1955. Probably late-nineteenth-century, 2-inch gilded cyma reversa molded frame.

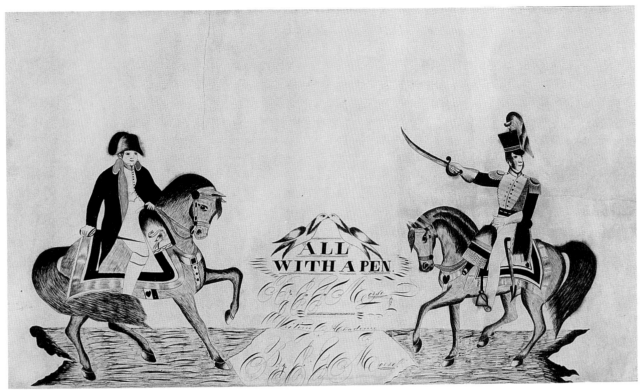

302

Provenance: Found in Boston, Mass., and purchased from Edith Gregor Halpert, Downtown Gallery, New York, N.Y.
Exhibited: Arkansas Artmobile.
Published: AARFAC, 1957, p. 377, no. 372.

J. D. Nattensberger
(active ca. 1855)

303 Drawn with a Pen 58.312.1

J. D. Nattensberger
America, ca. 1855
Colored inks on wove paper
11 5/16″ x 15″ (28.7 cm. x 38.1 cm.)

The large herds of buffalo roaming in the midwestern plains of America during the nineteenth century symbolized for some the untamed and spacious, as well as treacherous, aspects of frontier life. Many artists were inspired by these creatures and the native American Indians who peopled the land. Well-known academic painters such as George Catlin made numerous sketches of Plains Indians, buffalo, and the land which subsequently served as the basis for printed illustrations. F. O. C. Darley was one of several nineteenth-century artists to copy the works of Catlin and other artists for illustrations in popular periodicals; it was his *Hunting Buffalo*, which appeared in an 1844 issue of *Graham's Magazine*, that probably served as the basis for Nattensberger's *Drawn with a Pen*.[1]

The animated and balanced composition cannot be credited to Nattensberger since he copied it, although his stippling is accomplished and does convey three-dimensional form, particularly in the horse's legs. The bold lettered inscription is also well done, and all the capital letters are pierced by arrows — no doubt a whimsical touch added by the maker to relate this area to the theme of the picture.

Inscriptions/Marks: At the bottom in inked letters is "Drawn With a pen By J D Nattensberger."
Condition: In 1974 E. Hollyday reduced acidity and stains, flattened the piece, and hinged it to acid-free mat board; excessive cockling in the support was further reduced by Hollyday in 1981. Period replacement 1⅞-inch cyma reversa gilded frame.
Provenance: J. Stuart Halladay and Herrel George Thomas, Sheffield, Mass.
Exhibited: Calligraphy, and exhibition catalog, p. 10, no. 6; Halladay-Thomas, New Britain, and exhibition catalog, no. 95; Washington County Museum, 1965.
Published: Paul Chadbourne Mills, "The Buffalo Hunter and Other Related Versions of the Subject in Nineteenth Century American Art and Literature," *Archivero I: Research Papers on Works of Art in the Collection of the Santa Barbara Museum of Art* (Santa Barbara, Calif., 1973), illus. as fig. s on p. 165.

[1] See the illus. titled *Hunting Buffalo* in *Graham's Magazine*, XXVI (September 1844), illus. opposite p. 9.

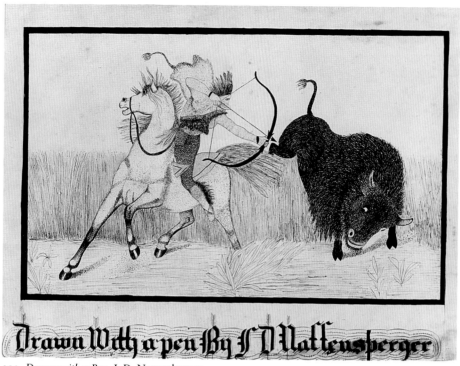

303 *Drawn with a Pen*, J. D. Nattensburger

W. E. Pittenger
(active ca. 1872)

304 Eagle 64.312.2

W. E. Pittenger
Woodhull, New York, 1872
Ink on heavy paper
15¹⁵⁄₁₆″ x 24″ (40.5 cm. x 61.0 cm.)

Penmanship instructors often rewarded the achievements of their students by gifts of drawings, such as no. 304, which is inscribed to Anson J. Hopper from his teacher, W. E. Pittenger. As might be expected, the pen work for the various scrolls and small vine designs on the eagle, and the script below it, are skillful and carefully balanced. The head of the bird is particularly well executed in the highlights on the beak and forehead and in the subtle gradations of dark-to-light hatch work, which give three-dimensional form.

Inscriptions/Marks: Inscribed below the eagle in ink is "For Supreme Improvement in Plain Penmanship in/The Class of The Winter Term of 1871–2 of The Woodhull Academy in/Woodhull, Steuben Co., N.Y. This is Awarded to Anson J. Hopper By W. E. Pittenger, Mar. 4ᵗʰ, 1872."
Condition: In 1974 E. Hollyday dry-cleaned the piece and hinged it to acid-free mat board. Probably late-nineteenth-century

replacement 2¾-inch cyma reversa frame, painted black, with inner and outer bands of gilt.
 Provenance: Leon Stark, Philadelphia, Pa.
 Exhibited: AARFAC, September 15, 1974–July 25, 1976, Atlanta show only.

Amos S. Smith
(active ca. 1830)

305 Battle on Horseback 57.312.1

Amos S. Smith
Lancaster County, Pennsylvania, 1820–1850
Colored inks on wove paper
18¼″ x 22⅝″ (46.4 cm. x 57.5 cm.)

Amos S. Smith's pen work indicates that he was more adept at lettering and making decorative flourishes than in drawing complex figural elements, although his stiff and stylized combatants and their elaborately blanketed mounts are among the most appealing calligraphy works in the Folk Art Center's collection. The kicking position of the horse at right probably was not dictated by any source the artist consulted for the composition, but probably was imposed by the size of the paper.

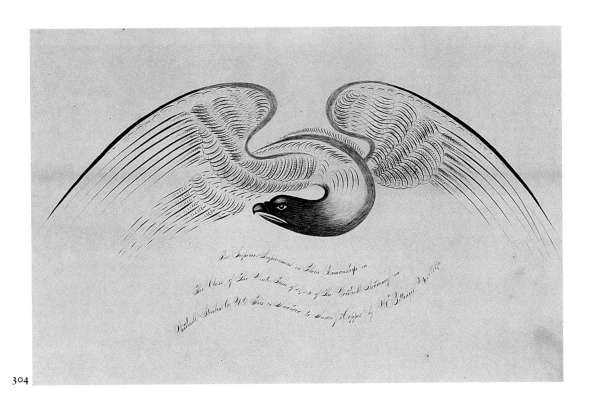

304

305

Indians riding in this position with a bow and arrow are occasionally seen in calligraphic drawings and on other early nineteenth-century objects such as weather vanes. No printed source has been discovered for the figure despite its obvious popularity. According to the previous owner, the Indian in this drawing symbolizes the American colonies, while the bearded man on the other horse represents England. The coiled snake beneath that rider might also suggest England's acts of aggression against the colonies. Other motifs that probably have related symbolic meaning include the eagle above the Indian and the two doves on his horse's blanket. Various colored inks were used in the drawing, including blues and reds.

Inscriptions/Marks: In the banner at the bottom is the inked inscription: "Executed by Amos, S Smith of Lancaster Co.ᵗ Penn.ᵃ"
 Condition: In 1959 Christa Gaehde dry-cleaned the surface, repaired miscellaneous tears along all edges, and hinged the piece to acid-free mat board; in 1974 E. Hollyday dry-cleaned the surface and provided a new acid-free backing for the support. Probably mid-nineteenth-century replacement gilded 1-inch frame.
 Provenance: Edith Gregor Halpert, Downtown Gallery, New York, N.Y.
 Exhibited: AARFAC, New Jersey; AARFAC, April 22, 1959–December 31, 1961; "Amateur Art," Downtown Gallery, New York, N.Y., September 1952; "Pennsylvania Folk Art," Allentown Art Museum, Allentown, Pa., October 20–December 1, 1974; William Penn Museum.
 Published: AARFAC, 1959, p. 28, no. 21; "Amateur Standing," *Art News,* LI (October 1952), illus. on p. 8; Barons, illus. as no. 88 on p. 82.

Unidentified Artists

306 Liberty and Independence 35.312.1

Artist unidentified
Possibly Pennsylvania, 1849
Watercolor and ink on wove paper
21⅝" x 16⅛" (54.9 cm. x 41.0 cm.)

Patriotic themes and mottoes were an important source of design for calligraphers and calligraphy teachers during the early nineteenth century. This drawing is based on an engraving of the Pennsylvania coat of arms. The state's seal was first engraved in 1778 and subsequently was used in varying sizes and with slight changes in detail on legal documents, broadsides, and other public records.[1]
 A very similar drawing of the coat of arms, signed by C. Scherich in 1851, is in the M. & M. Karolik Collection at the Museum of Fine Arts in Boston. Another calligraphy drawing by Scherich, also in the Karolik Collection, is inscribed: "Drawn by C. Scherich under/The Tuition of J. Eichelberger/Jan 24th 1851."[2] The hand responsible for no. 306 may also have attended Eichelberger's school.
 Most of the flourishes within the horses' bodies — and the fine line detailing of their manes and tails, and

306

307

of the eagle above — were expertly executed, but the artist encountered a space problem with the lettered motto, which in completed form reads: "VIRTUE LIBERTY AND INDEPENDENCE." Although the initial idea may have been to unfurl the lettered areas of the banner ends behind the horses' heads with no regard for the display of the full text, the artist added a tiny "v" before "UE" on the left to identify the word "VIRTUE."

Inscriptions/Marks: Lettered in ink on the banner between the horses is "v[IRT]UE LIBERTY AND INDEPENDEN[CE] 1849."

Condition: In 1955 Christa Gaehde cleaned the picture and made unspecified repairs; in 1974 E. Hollyday dry-cleaned the non-design areas and hinged the piece to acid-free mat board. Modern 1⅞-inch wood molded frame gilded recto with black painted sides.

Provenance: Edith Gregor Halpert, Downtown Gallery, New York, N.Y.

Exhibited: Calligraphy, and exhibition catalog, p. 10, no. 7.

Published: AARFAC, 1940, p. 34, no. 145; AARFAC, 1947, p. 32, no. 145; AARFAC, 1957, p. 377, no. 373.

[1]Eugene Zieber, *Heraldry in America* (New York, 1969), pp. 173–177.
[2]Karolik Collection, nos. 1401, 1402, p. 311; no. 1402 illus. as no. 383 on p. 311.

307 Horse 31.312.1

Artist unidentified
Possibly Pennsylvania, ca. 1850
Watercolor and ink on wove paper
22⅞" x 17⅝" (58.1 cm. x 44.8 cm.)

This calligraphy horse was found in Holicong, Bucks County, Pennsylvania, and may have been executed in or near there since penmanship was routinely taught in German parochial, as well as secular, schools. Both

students and their instructors produced works of often exceptional quality, but without any additional history and/or a signature of the maker, it is difficult to determine whether fine examples, such as no. 307, were produced by youngsters or their masters.

Horses, birds (see no. 304), and leaping deer (see no. 308) were among the most popular designs used in training students since the natural curves of the animals' bodies suited the repetitive and rhythmic flourishes necessary to the development of a sure and relaxed style of writing. Similar calligraphic drawings of horses survive for Pennsylvania and other regions with a wide range of dates from the mid to late nineteenth century.[1] Most were undoubtedly copied from or inspired by print sources, although the exact source for this example has not been identified.

The artist used a combination of red and green for the horse's trappings. The saddle blanket has a blue tassel, and the ground below the figure is black at its base with light green above to represent grass.

Condition: In 1980 E. Hollyday dry-cleaned the surface, relaxed some warped areas in the support, and reinforced the piece with Japanese mulberry paper on the reverse. Early twentieth-century, 1¾-inch chamfered mahogany-stained wood frame.

Provenance: Found in Holicong, Bucks County, Pa., and purchased from Edith Gregor Halpert, Downtown Gallery, New York, N.Y.; given to the Museum of Modern Art in 1939 by Abby Aldrich Rockefeller; transferred to the Metropolitan Museum of Art in 1949; turned over to Colonial Williamsburg in April 1955.

Exhibited: AARFAC, American Museum in Britain; AARFAC, Minneapolis; AARFAC, New Jersey; AARFAC, June 4, 1962–April 17, 1963; AARFAC, June 4, 1962–November 20, 1965; AARFAC, September 1968–May 1970; American Ancestors, 1931, and exhibition catalog, no. 18; American Folk Art, Traveling; American Primitive Painting, and exhibition catalog, no. 30; Art in Our Time, and exhibition catalog, no. 10; Trois Siècles, and exhibition catalog, p. 52, no. 238.

Published: AARFAC, 1957, p. 268, no. 130, illus. on p. 269; Cahill, American Folk Art, p. 38, no. 72, illus. on p. 91; Cahill, Early Folk Art, illus. on p. 267; Ford, Pictorial Folk Art, illus. on p. 141; Haverstock, illus. on p. 126, titled *Caparisoned Horse;* Henry Kauffman, *Pennsylvania Dutch American Folk Art* (New York, 1946), illus. on p. 55.

[1] A calligraphy horse (acc. no. 1937-1923) owned by the New-York Historical Society is signed: "Drawn by James G. Sales under the tuition of J. G. Gray," and is nearly identical to no. 307.

308

Artist unidentified
America, ca. 1860
Ink on wove paper
21⅞" x 29⅛" (55.6 cm. x 74.0 cm.)

Steadiness of hand and a good deal of previous practice with a steel pen were required to produce *Leaping Deer,* which is composed of many small free-flowing strokes in imitation of line engravings.

Numerous examples of leaping deer in this style and basic composition have been recorded in the Folk Art Center's files. Some exist as single figures, such as no. 308, while others exist as confronting pairs within more complex formats featuring banners, eagles, and patriotic motifs (see no. 296). The leaping deer or stag apparently was a favorite form for drawing classes and probably was popularized by printed examples contained in writing manuals that proliferated during the mid to late nineteenth century. Although the exact source of inspiration for this example has not been identified, its similarity to other drawings produced throughout the northeastern states confirms the presence of such a prototype.

Condition: In 1955 unspecified conservation treatment by Christa Gaehde probably included repairing small edge tears and dry-cleaning the surface; in 1974, E. Hollyday dry-cleaned the surface, mended small tears, reduced acidity, and hinged the drawing to acid-free mat board. Probably replacement mid-nineteenth-century, 1½-inch chamfered maple frame.
Provenance: Edith Gregor Halpert, Downtown Gallery, New York, N.Y.
Exhibited: AARFAC, September 15, 1974–July 25, 1976; Pine Manor Junior College; William Penn Museum.
Published: AARFAC, 1974, p. 67, no. 66; AARFAC, 1975, illus. on p. 20; Booth, illus. on p. 71; Marshall B. Davidson, et al., eds., *The American Heritage History of the Artists' America* (New York, 1973), illus. on p. 156; Haverstock, illus. on p. 127; Myrna Kaye, "Pen and Pencil Flourishing," *Yankee,* XXXI (September 1967), pp. 42–44, illus. on p. 44.

Copybook Exercises

William Parish
(?–possibly 1790)

Three of the Folk Art Center's nine sheets containing sketches and computations believed to have been made by William Parish of Raritan (later Somerville), New Jersey, follow.[1] Biographical information about the artist gleaned from the two preceding owners of the Center's pieces is sparse, sometimes conflicting, and — for the most part — has not been verified. But it seems in agreement that Parish was a schoolteacher in the Raritan community in the late eighteenth century. One of these sources indicates that Parish died in 1790 "at a fairly ripe age." Another states that "he was twenty-six [at what date is not specified] and did these [the Folk Art Center's acc. nos. 59.305.4–6, none of which is included in this catalog; see note 1 below] over a period of ten years from 1780 to 1790."[2]

Parish's occupation is verified by two published sources that also seem to confirm a late-eighteenth-century date for his work by stating that the particular schoolhouse in which he taught was replaced by another "about 1795." These also describe Parish as "a man of considerable attainment."[3] The Folk Art Center's works demonstrate Parish's graceful, sure script, his head for figures, and his knack for enhancing interest in his lessons by casting arithmetical problems in believable, everyday situational details illustrated by decorative, sometimes whimsical, drawings.

[1] In addition to the three pieces included in this catalog, the Folk Art Center owns the following works assigned to Parish: *Time* (a table of equivalents with a sketch of a bird), acc. no. 57.305.4; *Single Rule of Three/Indirect* (mathematical computations with a sketch of a running man), acc. no. 57.305.5; *Arithmetical Progression* (the title framed by sketches of flowers and hearts, with mathematical computations on the reverse), acc. no. 57.305.9; *Navigation: Of Plain Sailing* (two facing pages from a notebook giving definitions of longitude, latitude, etc., and signed and dated "William Parish/ Sept. 2ᵈ 1790"), acc. no. 59.305.4; *Navigation: H. Table* (a navigation lesson illustrated by a mariner's compass), acc. no. 59.305.5; and *The Mariner's Compass* (a mariner's compass signed and dated "William Paris/1790"), acc. no. 59.305.6.

Still another piece (a multiplication table decorated with confronting birds and a flower vase) is in the Eleanor and Mabel Van Alstyne American Folk Art Collection at the National Museum of American History, Smithsonian Institution; it is not signed or dated but was described as William Parish's work on a modern label, information that may have originated with Fred J. Johnston of Kingston, N.Y., a possible former owner and the preceding owner of three of the Folk Art Center's works.

Note that Parish himself spelled his name both with and without an *h* in the signatures on two of the Folk Art Center's works. Two late-nineteenth-century published references spell his last name "Parrish"; see the following two volumes by Rev. Abraham Messler:

309

310

Centennial History of Somerset County (1878), p. 158, and First Things of Old Somerset (1899), p. 110. No further publication facts are known. Photocopies of the respective pp. are in AARFAC files and were supplied by the Somerset County Library, Somerville, N.J.

[2]The information that Parish died in 1790 in his old age derives from AARFAC file notes apparently taken from verbally relayed information provided by the Stony Point Folk Art Gallery, Stony Point, N.Y., the source of six of the Folk Art Center's Parish works. The statement that he was twenty-six and did at least three pieces in the period 1780–1790 comes from Fred J. Johnston, Kingston, N.Y., the former owner of three of the pieces (Fred J. Johnston to AARFAC, November 20, 1958). In his letter, Johnston further states: "Am sending you today by express the three mariner fracturs [AARFAC acc. nos. 59.305.4–6] together with the title page which gives his [Parish's] birth date." The "title page" remains unidentified and unlocated.

[3]The published sources are the works by Rev. Abraham Messler cited in note 1 above. Both state exactly the same wording with reference to Parish.

309 Pence Table 57.305.7

Attributed to William Parish
Probably Raritan (now Somerville), New Jersey, probably 1780–1790
Ink and watercolor on laid paper
11⅞" x 7⁷/₁₆" (30.2 cm. x 18.9 cm.)

Flowering vines curve up and around the circular frame of the pence table, and two birds perch near the tops of the stems to help fill out the width of the design. The birds' red bodies, blue wings, and green tails strike the brightest color notes on the page, although some other details are also filled with hue. The amusing head below the pence table appears to be trying to absorb the orderly columns of figures above it. The table itself gives equivalences in pounds, shillings, and pence. The main titles "Interest" and "Division" have been transferred to this sheet from another and give a misleading impression of the purpose of the table in the lower half of the page.

Inscriptions/Marks: All are in ink. On the reverse beneath the decorated script title "Addition" are columns of figures that have been added together and that are not transcribed here. At the top on the front is "Interest," and below this is "Division." One horizontal row of numbers separates the preceding two words, and three hori-zontal rows of numbers appear below the second word. No numbers are transcribed here, including those in the circular frame in the lower half of the composition below the title: "Pence Table." The columns of figures in the pence table are variously headed with the letters *D* or *S* or the symbol £.

Condition: Prior to acquisition, an unidentified hand cut the strips of paper bearing the words "Interest" and "Division" from some other sheet (apparently another of Parish's) and glued them on top of the primary support. The top strip is 2¼ inches tall, and the lower is 2 inches tall; each runs the width of the primary support, and it is not known what the strips cover. In 1958 treatment by Christa Gaehde included removing a backing, cleaning, and repairing tears. In 1981 E. Hollyday set down flaking ink with a gelatin solution, dry-cleaned undecorated areas of the support, re-adhered loosened inserts, and repaired tears with Japanese mulberry paper and wheat-starch paste. The replacement 1-inch bolection molded frame is painted black and probably dates from the late eighteenth or early nineteenth century; it is now glazed on both sides.

Provenance: Stony Point Folk Art Gallery, Stony Point, N.Y.

310 Notation 57.305.8

Attributed to William Parish
Probably Raritan (now Somerville), New Jersey, probably 1780–1790
Ink and watercolor on laid paper
5¼" x 7⁷/₁₆" (13.3 cm. x 18.9 cm.)

The absurd proportions, posture, and anatomy of Parish's figure of a man must have brought peals of delighted laughter into his classroom. The design of the zany character may have been transferred from another source, a possibility suggested by a row of tiny pinpricks that outline his shape.

Inscriptions/Marks: All are in ink except for a few light arithmetical computations in pencil that are mostly illegible and are not transcribed here. The ink script inscriptions on the reverse (a lesson in writing numbers) also are not transcribed here. In bold, filled, block letters below the man's figure is "NOTATION." In script below the preceding is "Notation teacheth how to express any proposed number,/either by words or characters."

Condition: In 1980 E. Hollyday flattened the piece and re-aligned tears and mended them with Japanese mulberry paper and wheat-starch paste. The replacement 1⁵/₁₆-inch flat frame is painted black and possibly dates from the first half of the nineteenth century; it is now glazed on both sides.

Provenance: Stony Point Folk Art Gallery, Stony Point, N.Y.

IX Paper Cutwork, Valentines, and Miscellaneous Decorative Pictures

*M*ost of the works in this section probably originated as simple expressions of creativity and in response to a basic love of decoration. These factors remain paramount among myriad lesser ones, such as the intent to instruct, amuse, or divert. Several examples represent sincere efforts to develop or improve innate artistic ability, particularly those derived from print sources or other earlier compositions. Some, including the valentines and a few others, were created as gifts for family and friends. Some were a means of preserving or sharing an image. Some fulfilled a school assignment or a parental expectation. Some, perhaps, were consciously created for posterity.

Self-reliance, self-confidence, and ability varied greatly from one artist to another, but even copyists managed to express much about their perceptions of the world through their works. Comparisons between sources and derivations reveal illuminating distinctions, and by looking beyond the copyist's occasional misunderstanding of the mechanics of the original, one sometimes discovers innovative, visually pleasing solutions to aesthetic problems.

Within the universal urge to create, different factors assume different relative weight and importance according to individualistic need and specific circumstance. In earlier periods, when the services of professional artists were dearer and when pictorial images in general were scarcer, few hesitated to try painting, drawing, or stitching a picture of their own for their parlor walls. Modern technology makes professional artistic effort available to almost all levels of society with the turn of a dial or a page. In the resulting bombardment of imagery, when decoration per se is as easy as mail order, many contemporary folk artists create out of a heightened need to assert their individuality and personalize their environments.

Paper Cutwork and Valentines

W. Chand . . .
(active ca. 1753)

311 Cutwork Valentine 57.306.1

W. Chand . . .
Pennsylvania, probably Philadelphia, 1753
Watercolor and ink on laid paper
13″ diam. (33.0 cm.)

The sixteen numbered verses inscribed on the pinked arcs of the face of this piece are a tribute to "E.S.," who has long been identified by verbal tradition and by an old label as Elizabeth Sandwith (1753–1807). On January 13, 1761, Elizabeth married a fellow Phildelphia Quaker, Henry Drinker (1734–1809), and it was once thought that the latter made the valentine. However, partially obliterated inscriptions on both front and back indicate that another suitor of Elizabeth's fashioned the love token instead.

Elizabeth Sandwith Drinker's cutwork valentine descended through the family for many years prior to its ownership by Mr. and Mrs. John Law Robertson. It is an important survival because of its fine quality and because it is one of the earliest of its type known to scholars. The artist used the popular motifs of tulips, hearts, and flowers to create his token of affection. The central portion of the greeting, as well as the flowers and hearts, is painted red, while the tulips and the various bands and borders are in shades of red, green, and yellow.[1]

For its period, the Drinker valentine is also an exceptionally intricate example of *Scherenschnitt*, or "scissor cutting," which required considerable skill in both the cutting away of paper and the layout of the designs prior to cutting. The small cupid figures with bows flanking four of the intersecting bands that radiate from the center are the most unusual motifs, while the elaborate foliage that fills the outer band is reminiscent of similar leafage seen on early frakturs.

Inscriptions/Marks: In ink in script at the center of the front of the piece is the largely obliterated name "W[illegible material]" over the date "1753." In ink in the interior scallops, the script reads: "This morning as I lay in bed/Engag'd in thoughtfull muse,/It gently came into my head/A Valentine to choose,/Swift as the fleeting th[ts] [thoughts] of man/My roving fancy flew,/And of bright nymphs a numero/=us clan/Presented to my view." In the interior white band spanning the circumference of the piece, in ink, is inscribed: "Long time in deep suspence I stood/Before I gave my voice,/At length

resolv['d] this fair one should/Determine my choice,/One quite averse to envious hate,/Hyprocrisy and pride,/In all the methods of deceit/And calumny untry'd,/But all my searches were in vain,/Without the least exception,/For none among the blooming train/Wou'd answer the description[.]/Despairing of success I cry'd/Not one this title bless — /There is my friendly muse reply'd/Her name it is: E S:." In ink in script on the reverse of one of the pinked inner rims of the valentine is "[illeg.] Chand[illeg.] to" and opposite this is "E: S: February 14, 1753."

An old, torn, and cropped paper label that has been detached but still accompanies the valentine reads in ink in script: "[illeg.]al Valentine/sent to/Miss Elizabeth Sandwith/Feb 14th 1753/She was afterward wife of Henry Drinker and mother of Sarah Sandwith Drinker who/married Jacob Downing./Lent by [remainder now missing]."

Condition: In 1976 E. Hollyday removed the valentine and its old velvet support from a cardboard backing, removed surface dust with a brush, repaired minor tears and breaks, and remounted the valentine and its velvet support on acid-free mat board covered with unbleached muslin. In 1986 Michelle Basch-Pagan replaced the velvet secondary support with nonacidic velvet. Late nineteenth-century, 2-inch gilded and black-painted reeded frame.

Provenance: Mr. and Mrs. John Law Robertson, Scranton and Montrose, Pa.; M. Knoedler & Co., New York, N.Y.

Exhibited: Remember the Ladies.

Published: De Pauw and Hunt, p. 160, no. 4, illus. on p. 13.

[1]Biographical information on Henry Drinker and the history of the valentine is from Henry Drinker Biddle, "The Drinker Family in America, To and Including the Eighth Generation," unpublished manuscript compiled in 1893, research files, AARFAC.

Hannah Cope
(active ca. 1793)

312 Ribbon and Fabric Collage 67.306.1

Hannah Cope
Probably Pennsylvania, 1793
Cut fabrics, ribbon, and paper lace with
embroidery floss and ink
8″ x 9⅜″ (20.3 cm. x 23.8 cm.)

A 1957 postcard mailed from Philadelphia to the previous owner of no. 312 notes that Hannah Cope may have been the daughter of Nathan and Amy Bane Cope and a first cousin of Thomas, Israel, and Jasper Cope; she married Isaac Pim.[1] No other information on the artist has been located, but the Cope and Pim names are documented in Pennsylvania, and the piece was collected there.

Cope assembled a variety of textile scraps to create her flowers, birds, and berries, giving them inter-

312

The printed gold and black medallion at the upper center is believed to have served as the frame for a small portrait of Clarissa Ann Viele. This is substantiated by an inscription on the backboard of the piece that notes that the cutwork was done by Clarissa and that the "Insert is her picture." Other cutwork compositions incorporating miniature likenesses are known, but the majority date later than this example.

The composition here is basically symmetrical and required only one center fold of the paper prior to cutting. The various family members' initials within the two large hearts and circular pots, or bases, of the flowering branches at lower left and right and the artist's name and date were probably cut after the rest of the composition had been completed and the piece was unfolded. There are many fine details, particularly the sawtooth edges of numerous leaves and other elements, that further enhance the overall delicate and complex quality of Viele's family tree.

Thus far, no further information on Clarissa Ann Viele or the M. Kip name (see *Inscriptions/Marks*) inscribed on the backboard of the piece has been located.

esting texture and design. The basket was constructed from a delicate white paper lace backed with a salmon-colored textile ribbon, and edged with gold embroidery floss and bits of maroon-colored fabric. The basket is set on a bed of grass composed of green threads.

The picture apparently was made as a presentation piece to a friend since Cope inscribed it: "H Cope to A Heas." It is a rare early survival of the particular cut-and-paste technique employing both paper and textiles.

Inscriptions/Marks: A watermark in the support is covered by the grass and illegible. At the top, inscribed in ink, is "H Cope to A Heas." To the right of the basket and partly obliterated is "Hannah Cope['s] Picture" and below it, "1793."

Condition: In 1974 E. Hollyday dry-cleaned the undecorated areas, reduced acidity and stains, adhered loose collage elements, mended small edge tears, reduced creases in the support, backed the piece with Japanese mulberry paper, and hinged it to acid-free mat board. Modern 1-inch oak frame with beaded recto and black-painted chamfered front edges.

Provenance: Gift of Joseph H. Price, Plymouth Meeting, Pa.

[1]"H.E." to Joseph H. Price, April 23, 1957, AARFAC research files.

Inscriptions/Marks: In the cutwork at lower margin is "1832. CLARISSA. ANN. [the "N"s are backward] VIELE. SEP. 30." Cut within the left round shape on the ground are the initials: "R.V/M.V"; and within the right one: "J.V/J.V." Within the left heart are cut the initials: "J.V/PV.JBV/JV.CV/C.V" [the "P" and "B" are backward]; in the right heart is "C.V/AV.JV/DV.GV/R.V." The printed gold letters "H" and "S" were applied near the ground line. In pencil on the backboard is inscribed: "The Viele Family Tree/made by my grandmother/Clarrisa [*sic*] Anne Viele (Murphy)/(my mother's mother)/ Insert is her picture/My great grandmother/M Kip."

Condition: The paper has some discoloration and a few small tears and is missing its portrait piece on the front. Probably original 1¼-inch, mahogany-veneered flat frame.

Provenance: Gift of Mr. and Mrs. Theodore T. Gore, West Dover, Vt.

Clarissa Ann Viele
(active ca. 1832)

313 Cutwork Family Tree 82.306.1

Clarissa Ann Viele
Probably Pennsylvania, New York State, or
New England, 1832
Wove paper with printed black and gold paper
medallion
7" x 8³⁄₁₆" (17.8 cm. x 20.8 cm.)

313

314 Cutwork Picture

63.306.1

Artist unidentified
Probably Pennsylvania, ca. 1860
Wove paper with printed and embossed paper ornaments
15" x 19" (38.1 cm. x 48.3 cm.)

One other example by the unidentified artist responsible for this decorative cutwork picture has been recorded in the Center's research files.[1] They both have silhouetted figures in a central arcaded panel with a pole and an American flag, similar vine and flower borders with a variety of animal and bird forms, the central vignette of facing peacocks in the lower panel, and applied printed and embossed details such as the flag and flowers either held or worn by the women.

It is the wide range of design elements and their fanciful arrangement that makes this example successful, since the cutting was less time-consuming and intricate than required for examples such as Clarissa Ann Viele's family tree, illustrated in no. 313. Squir-

rels, five types of small birds, large peacocks, hens with chicks, carnations, and a variety of flowers and leaf forms proliferate among the borders. As in no. 313, a single center fold was used to achieve the symmetrical pattern of these elements while the silhouetted human figures, dog, cat, and flagpole were cut directly on the unfolded sheet. The flag and the flowers were undoubtedly glued on after all cutting was completed. The gentlemen's arms and hands were also cut as separate pieces and then applied to the bodies.

Condition: In 1976 E. Hollyday removed the cutwork from an acidic backing, removed glue from the verso, mended small tears, and hinged the piece to a sheet of Canson Ingre black paper mounted on acid-free mat board. Probably early twentieth-century, 1⅞-inch frame, with printed burled walnut paper over gesso, floral sprigs carved through the printed paper at corners, all inner and outer recto edges painted black, and fitted with an inner gilded liner.
Provenance: Robert Carlen, Philadelphia, Pa.
Published: Stebbins, illus. as fig. 61 on p. 92.

[1]Sotheby Parke Bernet, Inc., *The Fred Wichmann Collection of Pennsylvania-German and Related Decorative Arts,* catalog for sale no. 5079, June 9, 1983, lot no. 18.

314

Decorative Pictures

Eddie Arning
(b. 1898)

Eddie Arning was born in Austin County, Texas, near the town of Kenney in 1898. His parents were both German immigrants, his father having come to America in 1874 and his mother in 1887. As a teenager, Arning helped on the family farm, but his increasingly disturbing bouts of depression, withdrawal, and self-imposed isolation led his parents to put him in the state mental institution several times for varying periods. They finally committed him to the institution when he was about thirty years old, and for the next forty-five years, Arning remained in mental institutions or nursing homes.

Arning resisted most staff attempts to involve him in recreational or occupational therapy. Finally, in late 1964, under the encouragement of an aide, Helen Mayfield, he began first to color in books and then to use crayons for freehand drawing. Mayfield was impressed by his work and, in the summer of 1965, arranged for a showing of his drawings at the Methodist Student Center on the University of Texas's Austin campus. It was this showing that first brought Arning into the public eye.

Arning's first drawings featured farm animals and inanimate objects that he remembered from his childhood. Gradually he introduced human figures into his schemes and, still later, portrayed figures in contact with one another. Mayfield offered the guidance and support that Arning needed to develop his own highly personal style. Filling sheet after sheet of paper with rich hues, Arning switched from wax crayons to oil pastels in 1969.

Arning continued drawing tirelessly for almost ten years, ultimately producing a collection of about two thousand works. In 1973 he left the private nursing home in which he had been staying to live with his widowed sister, Ida Buck, in McGregor, Texas. Once at his sister's home, he relaxed, lost the incentive to work, and gradually stopped drawing altogether, saying that drawing was "hard work." At this writing, Arning still lives with his sister in McGregor.[1]

[1]All information is from conversations with Dr. Alexander Sackton, 1982–1984. Fuller discussions of Arning and his work, including a means of dating the majority of Arning's drawings, can be found in the catalog for AARFAC, Arning.

315 The Not Hot Hot Dog 84.201.1

Eddie Arning
Austin, Texas, July 19–26, 1968
Wax crayon and pencil on wove mulberry-colored paper
22″ x 16″ (55.9 cm. x 40.6 cm.)

A comparison between Arning's drawing and his source of inspiration (an advertisement for Hormel) reveals many significant compositional alterations, among them movement of the package of hot dogs from off-center placement in the margin to a position overlapping the figure at front. In terms of design integration, Arning thereby compensated for his uplift and extension of the figure's arms, which in the newspaper advertisement are drawn tight against the boy's body. In the drawing, a narrow pale-blue line separates the body from its dark background and further dramatizes the figure's posture.[1]

315

Inscriptions/Marks: In pencil in script on the reverse is "Eddie, Arning." In block letters in crayon along the top edge of the composition is "ThE.NOT.hot.hot.Dog.From horm." In the lower quarter of the picture over the hot dog package is "HORMEL/ALLMEAL [*sic*]". On the reverse in ink is the inventory number "955."

Condition: Except for matting, the drawing is in original condition. The modern 1¼-inch flat, black-painted frame is an addition made by the Folk Art Center following acquisition.

Provenance: The drawing was acquired directly from the artist by Dr. and Mrs. Alexander Sackton of Austin, Tex., who in turn donated the work to the Folk Art Center.

Exhibited: AARFAC, Arning, and exhibition catalog, p. 37, no. 11, illus. as no. 11 on p. 25.

[1]The newspaper clipping of the Hormel hot dog advertisement that inspired Arning is in AARFAC files. The name and date of the newspaper have not been determined.

316 Gravedigger 84.201.3

Eddie Arning
Austin, Texas, August 1–7, 1969
Oil pastel and pencil on wove green paper
19¾" x 25⅝" (50.2 cm. x 65.1 cm.)

Based on remarks that Arning made to Alexander Sackton when this drawing was executed, Sackton wrote the following notes on the magazine page that included the artist's source of inspiration: "Only one grave ('footstone' Eddie called it) has an identity: 'J. L.' was a man who lived at Central Texas Nursing Home with Eddie. He took lots of snuff. He was young, maybe 50. One day he was found dead outside

lying in mud. They spent hours trying to bring him back to life but 'they couldn't put any life into him.' "[1]

Both men appear to be gravediggers in Arning's drawing, but in the magazine illustration, the one at left is an onlooker who merely rests his hand on the shovel handle. The supplicating posture of Arning's figure in black conveys succinctly the questioning nature of this character as manifested in a poem that accompanies the magazine illustration, which, however, shows him in a resigned, hunched, closed posture. Perhaps in this instance, Arning read the printed text regarding the illustration.

Inscriptions/Marks: In pencil in script on the reverse is "Eddie, Arning." The inventory number "1195" appears in ink and also in pencil on the reverse. Three headstones within the composition are each lettered "BORN" and one footstone is lettered "JL." Impressed lettering in the primary support reads vertically in the left margin: ANC^ne MANUF^re CANSON & MONTGOLFIER VIDALON-LES-ANNONAY ANC^n . . . "

Condition: Except for matting, the drawing is in original condition. The modern 1¼-inch flat, black-painted frame is an addition made by the Folk Art Center following acquisition.

Provenance: The drawing was acquired directly from the artist by Dr. and Mrs. Alexander Sackton of Austin, Tex., who in turn donated the work to the Folk Art Center.

Exhibited: AARFAC, Arning, and exhibition catalog, p. 38, no. 14, illus. as no. 14 on p. 26.

Published: Barbara Paulen, "Eddie Arning: The Unsettling World of a Texas Folk Artist," *Texas Journal,* VIII (Fall/Winter 1985–1986), p. 37, illus. on p. 34.

[1]Arning's source of inspiration was a double-exposure color photograph by Gordon Parks reproduced on p. 118 of an article about the photographer: "Return of the Prodigy: A Many-talented Man Mirrors His Own Life," *Life,* LX (November 15, 1968).

316

317

317 Birds and Tree 84.201.2

Eddie Arning
Austin, Texas, September 25–October 3, 1969
Oil pastel and pencil on wove tan paper
19⅝" x 25¹¹⁄₁₆" (49.9 cm. x 65.3 cm.)

Arning can read, but the fact that he often ignored any text accompanying his sources of inspiration is illustrated by *Birds and Tree,* as well as by a number of other works. In this instance, Arning's source — a magazine illustration of a crayon drawing by an eleven-year-old — was clearly labeled *Leaves.* Yet when Arning turned his interpretation over to Alexander Sackton, he told the latter he had not known whether the irregular shapes in the sky in the magazine picture were leaves or birds.[1]

Bright colors and a lively sense of movement conveyed, in part, by the scalloped background bands make this an especially cheerful picture.

Inscriptions/Marks: In script in pencil on the reverse is "Eddie, Arning." The inventory number "1227" appears in ink on the reverse. Impressed lettering reading vertically in the left margin is " . . . ᶜ MANUFʳᵉ CANSON & MONTGOLFIER VIDALON-LES-ANNONAY ANCⁿᵉ MA . . . " A blind stamp in the lower left corner of the reverse shows a circular design over two sheets of paper and reads: "[LES PAPIERS]/CANSO[N]."
Condition: Except for matting, the drawing is in original condition. The modern 1¼-inch flat, black-painted frame is an addition made by the Folk Art Center following acquisition.

Provenance: The drawing was acquired directly from the artist by Dr. and Mrs. Alexander Sackton of Austin, Tex., who in turn donated the work to the Folk Art Center.
Exhibited: AARFAC, Arning, and exhibition catalog, p. 39, no. 15, illus. as no. 15 on p. 26.

[1]Arning's source of inspiration was a photographic illustration in color in *McCall's,* XCVI (September 1969), p. 34; the magazine's regular feature called "Junior McCall's Club" showed a crayon drawing by Paula Taccone of Stamford, Conn. A tear sheet is in AARFAC files.

318 Two Geese 84.201.4

Eddie Arning
Austin, Texas, February 19–26, 1970
Oil pastel and pencil on laid olive-green paper
22" x 32" (55.9 cm. x 81.3 cm.)

Instead of placing his two geese face-to-face on the same ground level as was done in the original magazine illustration that inspired this work, Arning staggered the positions of his birds so that the head and neck of one curve over those of the other in a seemingly protective manner. The upper edge of the middle background color follows the lines of their bodies and accentuates their closeness.[1]

Inscriptions/Marks: In pencil in script on the reverse is "Eddie, Arning." The inventory number "1300" appears in ink on the reverse.

318

319 Man Fishing from Rocky Coast 84.201.5

Eddie Arning
Austin, Texas, April 2–9, 1970
Oil pastel and pencil on laid green paper
22″ x 32″ (55.9 cm. x 81.3 cm.)

A black background lends crisp definition to the green and white abstract shapes in the lower left diagonal half of the composition. Representing rocks along a streambed in Arning's source of inspiration,[1] these simple configurations rank among the artist's most pleasing stylizations. Undulating ribbons of white, blue, green, and black represent the water at upper right and visually form a satisfying contrast with the precise rock shapes.

320 Girl with Fruits 84.201.6

Eddie Arning
Austin, Texas, August 12–20, 1970
Oil pastel and pencil on wove gray-green paper
19¹¹⁄₁₆″ x 25⅝″ (50.0 cm. x 65.1 cm.)

A pale-blue background color encircles the orange globes in short, choppy strokes creating visual vortices that draw the eye into the picture. At the same time, the circles decrease in size from right to left, producing the illusion of receding space. The olive-green swath through the center of the picture is a fortuitous addition, one probably created by Arning to fill space and

319

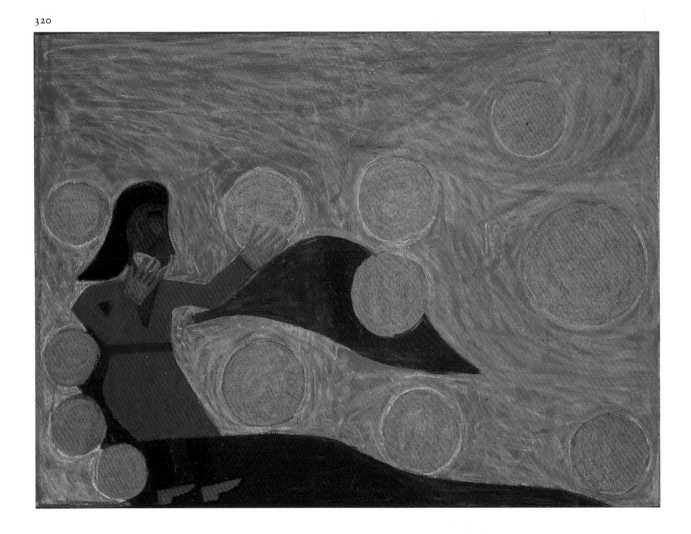

320

increase color contrast. Shadows in the photograph that originally inspired him may have suggested the addition as well.[1]

Inscriptions/Marks: In pencil in script on the reverse is "Eddie, Arning." The inventory number "1410" appears on the reverse in ink. An illegible blind stamp in the lower left corner and illegible impressed lettering in the left margin probably are identical to the paper manufacturer's markings found in no. 317.
Condition: Except for matting, the drawing is in original condition. The modern 1¼-inch flat, black-painted frame is an addition made by the Folk Art Center following acquisition.
Provenance: The drawing was acquired directly from the artist by Dr. and Mrs. Alexander Sackton of Austin, Tex., who in turn donated the work to the Folk Art Center.
Exhibited: AARFAC, Arning, and exhibition catalog, pp. 15, 46, no. 29, illus. as no. 29 on p. 31.

[1] Arning's source of inspiration was a two-page photographic illustration in color in an unidentified magazine. AARFAC files contain the clipping. The original picture was a Menley and James advertisement for Love's Lemon Fresh Cleanser.

Sophia Burpee (1788–1814)

Sophia Burpee's childhood home and the house she and her husband occupied after their marriage were both still standing in Sterling, Massachusetts, as of 1976.[1] Sophia was the daughter of a Revolutionary War veteran, Corporal Moses Burpee (1750–1827), and his wife, Elizabeth Kendall Burpee (1752–1833), who was originally from Leominster. Two different sets of church records give the date of Sophia's baptism in Sterling as April 13, 1788, and April 11, 1789. A 1788 birth is indicated by an inscription on her tombstone in the Kendall Hill (Chocksett) Cemetery in Sterling; there she is said to have died on October 29, 1814, age twenty-six years and seven months. A number of Sterling inhabitants died of "typhus" (presumably typhoid fever) during the period 1812–1815, including Sophia's sister Relief (1790–1814) and her sister-in-law Polly Conant (?–1814). The same disease may well have taken Sophia that year.[2]

On April 26, 1810, Relief Burpee married Jacob Conant (?–1839) of Sterling, and in October of 1813, Sophia married Jacob's brother Samuel, Jr. (1780–1824). Six oil portraits believed to represent these four subjects, Polly Conant, and a Thomas Wright (whose connection to the Conants, if any, has not been established to date) were painted by the same artist about 1810–1814.[3]

A number of pictures executed by Sophia Burpee survive in addition to the Folk Art Center's single watercolor. Two pieces — a silk embroidery and a watercolor signed by the artist and dated October 1, 1806 — are owned by the New York State Historical Association, Cooperstown, New York, and the town of Sterling possesses two watercolors and two painted fire screens. One of the Sterling watercolors is signed by the artist, and the other is ascribed to her in another hand. All inscriptions give the artist's maiden name.

[1] All data in this entry are from the following correspondence from Frances P. Tapley, Historical Commission of the Town of Sterling, to AARFAC: May 23, 1976; June 1, 1976; August 8, 1976; August 15, 1976; November 7, 1976.
[2] Sophia's father made out his will December 14, 1814, in evident preparation for death; however, he survived another thirteen years.
[3] A number of other portraits by this distinctive but unidentified hand have been recorded, but none is owned by the Folk Art Center. Sophia's portrait is owned by the National Gallery of Art, Washington, D.C., the 1953 gift of Edgar William and Bernice Chrysler Garbisch. The portraits believed to represent Polly, Jacob, Samuel, Jr., and Relief Burpee Conant and Thomas Wright are the property of the town of Sterling.

321 Morning 31.301.6

Attributed to Sophia Burpee
Sterling, Massachusetts, possibly 1806
Watercolor and ink on wove paper
11⅞" x 9¾" (30.2 cm. x 24.8 cm.)

The title and basic composition of no. 321 derive from one of a pair of prints published in March 1800 by P. Stampa of 30 Leather Lane, London. The companion print (of which no copy by Burpee is known) represents Evening.[1] Impressions of both prints retaining poems titled "Morning" and "Evening" affixed to the backs of their frames survive.[2] Burpee updated the costumes and hairstyles of her figures and made other relatively minor deviations from her print source, but basically the watercolor and published composition are very similar.

The New York State Historical Association, Cooperstown, New York, owns Burpee's signed and dated watercolor of a lone shepherd, whose figure is closely related to that of the man in no. 321. *Morning* is assumed to have been done about the same time as Cooperstown's picture, which is inscribed in the lower margin: "Shepherd/Drawn by Sophia Burpee October 1st 1806."

Inscriptions/Marks: The tops of a few letters remain in the now trimmed lower margin of the primary support, but they are indecipherable.
Condition: The lower margin was trimmed prior to acquisition. Unspecified treatment by Christa Gaehde in 1954 included backing the primary support with Japanese mulberry paper. In 1975 E. Hollyday set down flaking paint. The glass mat is a modern

321

replacement. Period replacement ⅞-inch gilded cyma recta frame with applied rope twist molding.

Provenance: Found in Concord, Mass., and purchased from Edith Gregor Halpert, Downtown Gallery, New York, N.Y.

Exhibited: Remember the Ladies.

Published: De Pauw and Hunt, p. 167, no. 213; Schorsch, *Pastoral*, p. 59.

[1]One set of the prints — hand-colored engravings with etching — was issued by Stampa March 21; another set — mezzotint engravings — was issued March 24. The Folk Art Center owns an impression of one of the March 21 sets (acc. no. 56.1100.3).

[2]A set of the prints with poems was recorded as in private ownership in New Hope, Pa., in 1955. The poem texts are recorded at AARFAC, and photographs of the prints are filed there.

Caleb Davis
(1769–1834)

Caleb Davis was born in 1769 in Oldtown (Allegheny County), Maryland, the son of Isaac and Elizabeth Davis.[1] Where and from whom he learned the trades of clockmaker and silversmith remain unknown, but family descendants claim that the Davises came to the area of Woodstock (Shenandoah County), Virginia, by way of Pennsylvania. In 1792 he married Mary

Upp, by whom he eventually had six children: John (1797–1863), Elizabeth, Rezin, Ann, Margaret, and Minerva.[2]

Davis appears in Shenandoah County, Virginia, personal property tax lists in the late 1790s, and he is presumed to have remained there at least until 1816, when he sold a lot in the town.[3] By 1820 he and his family appear to have removed to the area of present-day Clarksburg, West Virginia. The *Clarksburg Intelligencer* for July 3, 1824, indicated that Davis carried on the business of a clockmaker and watchmaker, silversmith, and jeweler in all its branches three doors west of the courthouse. He died April 25, 1834, in Clarksburg. His will of August 29, 1827, mentioned four daughters and a grandson, Edward Caleb Reed, to whom he bequeathed "all my silversmithing Tools to be his when he arrives at the age of Twenty-one years."[4]

Other than the Folk Art Center's example, no oil paintings on canvas by Davis are known.

[1]Most information in the entry is from George Barton Cutten, *The Silversmiths of Virginia (Together with Watchmakers and Jewelers) from 1694 to 1850* (Richmond, Va., 1952), pp. 218–219. Brooks Palmer, *The Book of American Clocks* (New York, 1950), p. 178, states that Davis was born in Annapolis, Md.

[2]The names of Davis's children are from Jack Sandy Anderson to AARFAC, September 28, 1984.

[3]Gusler, p. 30.

[4]Among other information given, Cutten, *The Silversmiths of Virginia*, states that Davis and his son John moved to Clarksburg "about 1820" and that Davis bought a lot there December 20 of that year.

322 Lady Reading in a Garden 65.101.1

Attributed to Caleb Davis
Probably Woodstock, Virginia, probably 1800–1815
Oil on canvas
44¾" x 52⅛" (113.7 cm. x 132.4 cm.)

Attribution of the painting to Davis is based mainly on family tradition,[1] although some similarity can be noted between elements of the oil on canvas and the designs painted on two clockfaces produced by Davis either alone or in partnership with Jacob Fry (?–1814). For instance, the large buds in the basket on the plinth in the canvas work are quite like those used on the dial of a tall clock signed "Caleb Davis" on its face. A tall clock that bears a dial signed "Fry and Davis" also bears similar buds in its lower spandrels; at the top, it exhibits an oval painting of a shepherdess seated beneath a tree with two lambs at her feet. The techniques used in rendering this clockface vignette

appear much looser than those used in the oil on canvas, but the rippled effect of the dress folds and the animals' fleshy hocks combined with thin lower legs are elements that compare well. A considerable difference in scale may account for some disparity in technique.[2]

The source of Davis's design for the Folk Art Center's large oil painting remains unidentified, and its symbolic meaning, if any, unknown.

Condition: The painting appears to have been cleaned at some point prior to acquisition. Treatment by Bruce Etchison in 1968 included removing a number of various types of patches from the reverse of the canvas; lining and cleaning the canvas; extensive filling and inpainting of numerous breaks and losses in the canvas and reinforcing the largest of these areas with Mylar on the reverse; repairing and strengthening the original yellow poplar strainers and remounting the canvas on them; and renailing the frame to the strainers as it had been originally. Original 2½-inch, black-painted molded cyma recta frame with flat outer edge.

Provenance: Descended in the family of the artist to AARFAC's donor, Mrs. Charles (Julia Davis) Healy, Princeton, N.J.

Published: Black, Folk Painting, p. 8, illus. as fig. 4 on p. 9; Gusler, p. 30, illus. as fig. 17 on p. 32.

[1]AARFAC's donor was a great-great-granddaughter of Caleb Davis.

[2]The two privately owned clocks are discussed in Gusler, p. 30, and illustrated therein as figs. 15–16 on pp. 29, 31. AARFAC files contain photographs of details of the clockfaces.

B. (or M.) John Donalds (active possibly ca. 1785)

323 Figures in a Landscape 58.305.13

B. (or M.) John Donalds
Possibly Pennsylvania, possibly 1780–1795
Watercolor and ink on laid paper
10⅞″ x 14½″ (27.6 cm. x 36.8 cm.)

Despite extensive restoration, this depiction of three figures in a landscape remains a visually delightful interplay of line and surface pattern. The male figures' gaily decorated waistcoats, and the boy's matching trousers, would certainly draw attention from their female companion's attire were it not for the compelling mass represented by her black apron and neckerchief. Her costume appears quite outdated for the suggested period of execution, which is more in agreement with the man's and boy's garb.

Unfortunately, nothing is known of the John Donalds who clearly signed the piece. The curious angular facial structure exhibited by all three figures may help

322

323

in identifying other renderings of his, but at present no record has been made of any other works that are attributable to his hand.

Inscriptions/Marks: In ink in script on the right side of the lower margin is "B. [or M.?] John Donalds."

Condition: Treatment by Christa Gaehde in 1959 included removing the piece from a wood secondary support; cleaning; mending tears, especially a vertical one nearly severing the entire right side; backing with Japanese mulberry paper; and filling and inpainting extensive losses in the primary support, the most notable of these including the upper left corner, the lady's cap, a quarter-size area of the background to the right of the lady's raised hand, the lower left corner, scattered areas of the upper margin, and a 1½-inch rectangular loss in the lower margin. Probably period replacement ⅞-inch molded cyma recta frame, painted black.

Provenance: Arthur J. Sussel, Philadelphia, Pa.

Exhibited: Washington County Museum, 1965.

Published: Parke-Bernet, p. 55, no. 314.

Samuel Folwell
(1764–1813)

The versatile Samuel Folwell and his role in transforming traditional mourning arts into a new and immensely popular expression of feminine accomplishment have been subjects of extensive study in recent years.[1]

Folwell's parents' names and his place of birth are unnoted, but his forebears were among those who had settled in the Quaker community of Burlington, New Jersey, in the early eighteenth century. Samuel was born in 1764. He soon embarked upon a career as a traveling painter, silhouettist, hair worker, limner, drawing master, and engraver and was patronized by the well-to-do of New York City, Philadelphia, Baltimore, and Charleston, S.C. He is also cited as having worked in New Hampshire.[2] He worked part time in Philadelphia from 1786 to 1788 and joined the militia there in 1789. Although some later travels are noted, he appears to have made Philadelphia a permanent home beginning in 1793, when he opened a drawing school for young ladies in that city, holding classes at 51 South Third Street.

Folwell's wife may have helped with his classes from the very beginning. The date of his marriage to Ann Elizabeth Gebler (1770–1824) of Philadelphia is undetermined, but Folwell's first child, a short-lived daughter, was born in 1794. His next three children were baptized in 1799, 1801, and 1803 in the First Reformed Church of Philadelphia, and Samuel himself

was baptized in that church in 1802, thereby joining a widespread movement away from the Society of Friends that had begun about 1790.

Signed artwork and stylistic associations coupled with an important newspaper advertisement of September 18, 1813, suggest that — at least by the latter phase of his career — Folwell was designing the compositions for the silk pictures worked by the students at his and his wife's school and that he was adding to these pictures significant details of his own painting. The notice in *Poulson's American Daily Advertiser* credits Mrs. Folwell with running their embroidery school, and notes that with "Mr. Folwell, being a master of Drawing, those Ladies under her tuition will have a double advantage in shading which is all the merit of the picture."[3]

Ann Elizabeth Folwell apparently continued to teach following Samuel's death November 25, 1813, for Philadelphia directories of 1814–1819 list her as "widow, teacher and embroiderer."[4]

[1]Most information in this entry is taken from Schorsch, Key, and from Deutsch, both of which examine Folwell's stylistic characteristics in depth and construct a credible and profusely illustrated basis for attributions to the artist. A Folwell self-portrait is owned by the New-York Historical Society and is illustrated in Schorsch, Key, as fig. 21 on p. 58.

[2]Footnote 6 of Schorsch, Key, p. 46, documents the source of references to many of Folwell's travels. In addition, the files of the Museum of Early Southern Decorative Arts in Winston-Salem, N.C., include advertisements of his that appeared in the *Maryland Journal & Baltimore Advertiser* for August 22, 1788, and in the *Charleston Times* for April 30, 1805.

[3]The partially quoted advertisement appears here as given in Deutsch, p. 422.

[4]Deutsch, p. 423, n. 16.

324 Girl with Fruit on Riverbank 71.601.1

Attributed to Samuel Folwell and an unidentified artist
Probably Philadelphia, Pennsylvania, probably 1800–1813
Silk embroidery and gouache on a satin weave silk ground
21⅞" x 25" (55.6 cm. x 63.5 cm.)

Samuel Folwell's painted vignette is dominated by the blues and greens of his foliage and ground cover, which create the illusion of a child seated in deep, cool shade. The figure-framing tree, the distant shore at right, and the island in the middle ground are all features that appear in another oval silk picture whose needlework, like that of the Folk Art Center's picture, probably was worked under the direction of Ann Elizabeth Folwell to a design of her husband's. Details of the painted scene in the center of the apparently closely related picture are not clearly illustrated, but the view is described as a little girl "touching pears and grapes . . . as large as she is."[1]

The floral surround of the Folk Art Center's picture is finely executed in silk embroidery with the direction of small stitches carefully coordinated to suggest contour and dimension, while subtle shading effects are achieved by gradation and juxtaposition of close tones and hues.

Condition: In the early 1970s, the piece's replacement black-painted glass mat was exchanged for plain glass and a black rag-board oval cut window mat. In 1978 Suzanne Penn, graduate stu-

324

dent in the Conservation of Historic and Artistic Works programs at Cooperstown, N.Y., cleaned the piece; set down flaking paint in the center vignette and inpainted minor scattered losses there; lined the primary support with nylon; covered the original white pine strainers with acid-free paper and stretched over them yellow silk stitched to muslin; tacked the lined primary support over the covered strainers; inpainted small scattered losses in the primary support; and cut away the lining fabric behind three large areas of loss to reveal the yellow silk beneath. Possibly original 3¾-inch molded and splayed gilded white pine frame, repainted with gold paint.

Provenance: Anonymous gift.

[1]The related piece is illustrated and discussed in Harbeson, p. 85, illus. as fig. 1 on p. facing p. 87. Other related pieces are shown and discussed in Deutsch and in Schorsch, Key. Other Folwell pieces that are not as closely related are shown in Deutsch and Ring, pls. X, XI, XII on pp. 416–417.

325

Isabella Hall
(1777–1816)

325 Spring
69.601.1

Isabella Hall
Probably New Jersey or Pennsylvania, ca. 1790
Silk embroidery on a silk ground
17½" x 20¹³⁄₁₆" (44.5 cm. x 52.9 cm.)

A double purpose is served by the scattered stitches that overlie several areas of tree and brush foliage filled with satin stitching in no. 325. Their three-part shape creates the illusion of leaves, while in more practical terms, it helps anchor the lengths of fragile threads exposed by broad areas of satin stitch. The majority of the pictorial silk embroideries of this period and of the early nineteenth century show fine details, particularly flesh and facial features, rendered in watercolor; but here the entire composition is created by silk threads.

Hall's picture apparently was based on one of the engraved versions of *Spring* that formed part of the set of four prints interpreting James Thomson's poem *The Seasons.* Sayer & Bennett published this popular print set in London in 1785, as did Laurie & Whittle in 1794. Other sets may have been available as well. The object the lady and the gentleman are passing between them is a bird's nest.[1]

Information provided by a direct descendant of the picture's maker indicates that Isabella Hall was born May 4, 1777, and on January 16, 1794, she married James Rose (1773–1856). The Roses' daughter Mary B. was born November 19, 1808, at Silver Lake (Susquehanna County), Pennsylvania, and this place

of birth is at present the only indication of where the artist lived either before or after her marriage. Isabella Hall Rose died in 1816. Family tradition states that she began her needlework picture in 1789 and finished it before her marriage.[2]

Inscriptions/Marks: Inscribed in silk thread over faint ink guidelines in the lower margin is "SPRING" and, in the lower right corner, is "Isabella Hall Fecit." A pencil inscription in script on the backboard is largely illegible; it appears to read, in part, "J A R [illegible material] Silver [illeg.]/Springfield/[illeg.]."

Condition: Except for replaced glass, the piece appears to be in its original condition. The edges of the silk ground are tacked to yellow poplar strainers backed with a sheet of basswood. Strips of wallpaper block-printed in a design of white foliage and red and cream blossoms were used to seal a crack in the backboard and all gaps between the strainers and the frame and between the strainers and the backboard. Original 2-inch molded cyma recta silver-lacquered white pine frame.

Provenance: Gift of Winona E. Darrah, Little Silver, N.J.

[1]The Colonial Williamsburg Foundation owns a four-print set published by R. Sayer and J. Bennett on May 12, 1785. *Spring* from this set (acc. no. G1974-627, 1) bears seven lines of Thomson's verse in its lower margin. A set of the hand-colored mezzotint engravings published by Laurie & Whittle in 1794 is illustrated in *The Old Print Shop Portfolio,* XIV (March 1955), p. 164. The printed source for Isabella Hall's *Spring* was brought to AARFAC's attention through the courtesy of Jane C. Nylander.

A number of other compositions appear to have been based on the same print source, among them a now unlocated watercolor formerly in the collection of Edgar William and Bernice Chrysler Garbisch; an embroidery illus. as lot no. 1083 in Sotheby Parke Bernet, 1979; an embroidery worked by Elizabeth Finney at Mrs. Leah Meguier's School in Harrisburg, Pa., in 1807 (see Lipman and Winchester, Folk Art, p. 101, no. 130); and an English embroidery advertised by Shreve, Crump & Low on the back cover of *Antiques,* CXXIII (April 1983).

[2]AARFAC's genealogical information was provided by the donor of the needlework picture, Winona E. Darrah (b. 1906), who is a great-great-granddaughter of the artist.

George Edwin Lothrop
(1867–1939)

George Edwin Lothrop was born in Dighton, Massachusetts, in 1867.[1] His father was a piano polisher in Boston, and it was through him that the son was introduced to the piano business as a carver. Lothrop maintained a strong interest in drama throughout his life, first as a high school student and then as an amateur playwright and poet. He published some fifteen plays and two books of verse at his own expense.

He worked in the navy yard at Charlestown, Massachusetts, during World War I, and then returned to his career as a piano carver. He also held various jobs as a doorman and a watchman. His interest in drama was closely related to his fascination with theater personalities and notorious women, preoccupations that are clearly reflected in his paintings.

His pictures were exhibited in various shows under the aegis of the Society of Independent Artists from 1917 to 1920, but he apparently never sold any of his artwork during these or the ensuing years. He died destitute in Boston on March 9, 1939, and his pictures, which had been left in storage, were later sold at a thrift shop.

[1] All biographical information cited in this entry is from Parke-Bernet Galleries, Inc., *Paintings and Folk Art by J. O. J. Frost of Marblehead and George E. Lothrop of Ruxbury from the Collection of the Late Betty and Albert L. Carpenter, Boston,* catalog for sale no. 3186, April 8, 1971, pp. x, 42.

326

326 The War Amazon 74.101.1

George Edwin Lothrop
Boston, Massachusetts, ca. 1925
Oil on canvas, with small brass plate nailed through canvas
18″ x 13½″ (45.7 cm. x 34.3 cm.)

The War Amazon is, at first, a puzzling picture because its beribboned figure does not seem like the conventional image one associates with the masculine female warriors called Amazons in classical mythology. An intriguing detail, however, is the manner in which Lothrop has terminated some of the ribbon ends to suggest serpent heads. These small configurations, the lurid red colors used on her upper right arm and at the waist, the sword above the word "AMAZON," and her hair streaking wildly behind were surely meant to convey the sinister aspects of war.

The long list of countries listed in a vertical column at the right of the figure probably represents, with the exception of Egypt and Persia, mostly Allied and Central forces involved in World War I. The addition of the metal title plate at the bottom seems to have been an afterthought, since the green paint behind it is uninterrupted.

Inscriptions/Marks: Signed in white paint on the reverse of the canvas is "Geo. E. Lothrop/Boston/Mass"; below this in black paint is "-AMAZON-." The following inscriptions appear on the front: in black paint on metal plate, "WAR AMAZON! [the "z" is backward]/ GEO. E. LOTHROP"; diagonally in upper right corner, "AMAZON [the "z" is backward]"; in vertical column on right side, "All/Bulg[aria]/ Egypt/Poland/Italy/Austria/Armen[ia]/Greec[e]/Persia/Africa/ Canad[a]/Japan/Russia/Englan[d]/France/Belgiu[m]/Ser[b]i[a]/ Germ[any]/Turke[y]/WAR"; at bottom, below figure, is "GEO. E. Lothrop/Boston." The artist covered the back of the painting with a blue-painted wooden panel on which is written, in pencil, "Loaned by/Geo. E. Lothrop/1287 Commonwealth Ave./[illegible material] Boston."

Condition: No evidence of previous conservation. Original 3¹⁄₁₆-inch outer frame, painted flat white. The artist apparently added this frame later, having first displayed the picture with strips of ¼-inch wood, painted white and gold, tacked to its edges as a frame. This inner frame still remains.

Provenance: Unidentified thrift shop, Boston, Mass.; Betty and Albert L. Carpenter, Boston, Mass.; gift of James H. and Judith D. Maroney, New York, N.Y.

Exhibited: "Paintings by Two New England Primitives, J. O. J. Frost and George E. Lothrop," Institute of Contemporary Art, Boston, Mass., November 1948, and exhibition catalog, no. 30.

Published: Parke-Bernet Galleries, Inc., *Paintings & Folk Art by J. O. J. Frost of Marblehead and George Lothrop of Ruxbury from the Collection of the Late Betty and Albert L. Carpenter, Boston,* catalog for sale no. 3186, April 8, 1971, illus. as lot no. 48.

Anny Mohler
(active possibly ca. 1830)

327 Anny's Gift

58.305.15

Anny Mohler
Stark County, Ohio, possibly ca. 1830
Watercolor, pencil, and ink on wove paper
12⅝″ x 15¹¹⁄₁₆″ (32.1 cm. x 39.9 cm.)

The large rose bloom in *Anny's Gift* might have come from a set of stencils used for a conventional nineteenth-century still life, but the other elements in the picture are less commonly found in theorem painting of the period. This fact, combined with the disparate scale and random arrrangement of the motifs, suggests that Anny Mohler designed and cut her own patterns for this token, sent to her cousin in Pennsylvania. The tree at right appears to have been created by daubing a paint-dampened sponge or stiff bristled brush against the paper.

Thus far no genealogical data have been found regarding Anny Mohler.

Inscriptions/Marks: In ink in script in the upper right corner is "A Present by your Cousen [*sic*] Anny Mohler of/Stark County State of Ohio Fer Catherine Smith of Lancaster/County state of Pennsylvania."
Condition: In 1959 Christa Gaehde cleaned the primary support, repaired tears at edges and along fold lines, and backed the sheet with Japanese mulberry paper. In 1978 E. Hollyday dry-cleaned where possible and set down edge tears with wheat-starch paste. Period replacement 1¹³⁄₁₆-inch flat mahogany-veneered frame.
Provenance: Arthur J. Sussel, Philadelphia, Pa.
Exhibited: AARFAC, American Museum in Britain; AARFAC, Minneapolis; AARFAC, June 4, 1962–November 20, 1965; American Primitive Art, and exhibition checklist, no. 5; Artists in Aprons; Flowering of American Folk Art; Flowers, and exhibition checklist, no. 25.
Published: Black and Lipman, p. 193, illus. as fig. 181 on p. 202; Dewhurst, MacDowell, and MacDowell, Artists in Aprons, p. 81, illus. as fig. 67 on p. 82; Lipman and Winchester, Folk Art, illus. as fig. 154 on p. 116; Parke-Bernet, p. 59, no. 334.

327

328

Nancy Myrick
(1792–?)

328 La Chatte Merveilleuse 83.601.1

Nancy Myrick
Portland, Maine, probably 1820–1825
Silk embroidery with watercolor and ink on silk
11 1/16″ x 8 1/2″ (28.1 cm. x 21.6 cm.)

In apparent substantiation of the inscription on an old label still affixed to the backboard of this embroidery, the name Nancy Myrick appears in the *List of Young Ladies Who Attended the Misses Martin's School* in Portland, Maine, during the period 1804–1829. According to the pamphlet, the young woman was a boarder from North Yarmouth.[1] Very few Myrick families lived in North Yarmouth at the time, and only one Nancy of appropriate age has been found. Thus, the following data are presumed to refer to the Folk Art Center's needleworker.[2]

William Myrick and Jane Mitchell were married in North Yarmouth on October 1, 1789. Their son, Charles (b. August 7, 1790), and their daughter,

Nancy (b. August 21, 1792), were both baptized at the First Church in North Yarmouth on April (?) 27, 1794, by which time William had died. A Jane Myrick, probably William's widow, married John Hayes on October 28, 1794, in North Yarmouth. A Nancy Myrick of North Yarmouth married John Shaw of Portland on October 2, 1827.[3]

La Chatte Merveilleuse ("The Marvelous Cat") is presumably based on some printed composition used by the needlework instructor at the Misses Martin's school, but it has not been identified thus far. Number 183 is another needlework picture in the collection that is believed to have been done at the same school.

Inscriptions/Marks: In ink in script on a paper scrap affixed to the backboard is the following: "This peice [*sic*] o[f] Embroidery was/done by Miss [N]ancy Myrick (Your/great Grand[mot]her at the School of Miss M . . . Portland Maine,/about the . . . 1825/ . . . 25th 1 . . . 5" (brackets enclose probable but now missing lettering; ellipses indicate torn sections of the label). Two modern labels below the preceding basically repeat the information found on the earlier paper. In ink in the lower margin of the silk ground is "La Chatte Merveilleuse."

Condition: The silk primary support and an original linen secondary support have been worked together and retain most of their original tacking to a backboard of white pine. The fabric supports have both been trimmed flush with the edges of the backboard. Modern replacement 3/4-inch molded stained frame.

Provenance: Gift of Mr. and Mrs. Theodore T. Gore, West Dover, Vt.

[1] The original pamphlet belongs to the Maine Historical Society in Portland.

[2] Data given are from Mary M. Bell, DAR Library, to AARFAC, September 27, 1984, and were transcribed from sources cited below. Alternate surname spellings have been checked in the process.

[3] Most data are from *Vital Records of North Yarmouth, Maine, to the Year 1850* (Warwick, R.I., 1980), pp. 69, 164, 177, 249, 261, 270. The baptismal notices appear in *Old Times in North Yarmouth, Maine*, VI (1881), p. 944, where Charles and Nancy are described as the children of William Mirick, deceased, and Jane, his widow. Because of the positioning on the page, the month of the baptisms is uncertain.

Eunice Pinney
(1770–1849)

See Pinney entry in "Scenes of Everyday Life" for biographical information.

329 Couple and Casualty 58.301.1

Attributed to Eunice Pinney
Connecticut, probably 1805–1825
Watercolor and ink on laid paper
7 1/4″ x 12″ (18.4 cm. x 30.5 cm.)

329

Pinney may have originated the idea of placing the tumbling horseman on the left and the couple on the right together in one composition, yet it is apparent that the accident portion derives from a print, and it is likely that the couple was copied from such a source, although probably a separate one, as well.[1]

In 1781 in London, Watson and Dickinson published Henry Bunbury's engraving called *Symptoms of Tumbling*, which was number four in a series of *Hints to Bad Horsemen*.[2] Presumably shortly after that, the falling horse and rider illustrated therein were included, reversed, in the decoration of a copperplate-printed English cotton. Pinney's corresponding horse and rider face the direction of the textile print, and although she may have used some other, unidentified reversal of the original Bunbury engraving, several remnants of the printed textile survive in America, indicating sizable importation of it and lending credibility to the possibility that Pinney used it as the inspiration for her watercolor.[3]

The compositional source for Pinney's couple remains unidentified, but the soldier bears some resemblance to one that appears elsewhere in the same copperplate-printed textile and that is also based on a Bunbury figure.[4] Further suggesting a print source is the fact that an unlocated Pinney watercolor shows a standing man and woman in positions quite similar to those seen here.[5] The top hat also appears in both renderings. However, it clearly belongs to the unseated rider in *Couple and Casualty* and, equally clearly, to the standing man — who is bareheaded — in the unlocated piece. Ironically, it is identically juxtaposed to the couple in both scenes. But the missing composition lacks a "casualty" portion and has a more elevated horizon line, making the hat appear to rest on the ground.

Condition: Unspecified treatment by Christa Gaehde in 1958 included dry-cleaning unpainted areas of the primary support. In 1981 E. Hollyday further dry-cleaned unpainted areas of the sheet, mechanically removed insect debris, and mended edge tears. Period replacement 1-inch molded silver-leafed frame.

Provenance: J. Stuart Halladay and Herrel George Thomas, Sheffield, Mass.

Exhibited: AARFAC, American Museum in Britain; AARFAC, Minneapolis; AARFAC, June 4, 1962–November 20, 1965; Halladay-Thomas, Albany, and exhibition catalog, no. 80 (titled *The Impetuous Lover*; Halladay-Thomas, Hudson Park; Halladay-Thomas, New Britain, and exhibition catalog, no. 72 (titled *The Impetuous Lover*); Halladay-Thomas, Syracuse, and exhibition catalog, no. 64 (titled *The Impetuous Lover*).

Published: Black and Lipman, p. 99, illus. as fig. 98 on p. 115; Lipman, Pinney, p. 220, no. 5 (titled *The Anxious Lover*).

[1] An old vertical fold through the primary support once visually separated the two groupings, indicating that they were viewed as unrelated depictions at one point, at least, in their history.

[2] An example of the engraving *Symptoms of Tumbling* is included, as print no. 2748, in the Lewis Walpole Library, Farmington, Conn. D. F. Snelgrove, British Museum, to AARFAC, September 21, 1962, identified the series title as *Hints to Bad Horsemen*.

[3] At least four examples of the textile are believed to rest in American collections. One was illustrated on the cover of *Antiques*, LI (February 1947), credited to the ownership of Mrs. Frank A. Balch, Burlington, Vt. Edith A. Standen, Metropolitan Museum of Art, to AARFAC, April 16, 1958, mentions an example of the textile then owned by the Cooper Union Museum, New York, N.Y. Another example is owned by the Art Institute of Chicago, acc. no. 52.585, the gift of Emily Crane Chadbourne; it is illustrated in Christa Charlotte Mayer, *Masterpieces of Western Textiles from the Art Institute of Chicago* (Chicago, 1969), pl. 151 on p. 195. A fourth example is owned by the Henry Francis du Pont Winterthur Museum, Winterthur, Del., and it is illustrated in Florence M. Montgomery, *Printed Textiles: English and American Cottons and Linens, 1700–1850* (New York, 1970), fig. 268 on p. 262.

[4] The lone copperplate soldier stands directly above the tumbling horseman on the textile; Barbara J. Morris, Victoria and Albert Museum, to AARFAC, September 6, 1962, identified this figure and several others on the textile as having been taken from Bunbury's engraving titled *A Visit to the Camp*. The engraving is illustrated in *Connoisseur*, VI (May–August 1903), p. 86.

[5] The unlocated watercolor is illustrated in Carl W. Dreppard, *American Pioneer Arts and Artists* (Springfield, Mass., 1942), p. 80, and credited therein to the collection of Bessie Howard.

Martin Ramirez
(ca. 1885–1960)

Little is known about Martin Ramirez, except from the brief biographical sketches published about him in various books and articles on twentieth-century American folk art.[1] From these we learn that he was born about 1885 in Mexico, became mute in 1915, was admitted to the Dewitt State Hospital in California in 1935, and remained there until his death in 1960.

Ramirez used stubs of crayons and colored pencils to draw on a variety of scrap pieces of paper, wrapping paper, laundry tickets, old letters, and the like. Occasionally he used collage techniques to combine his drawings with clippings from magazines. The personal significance of his subject matter, which ranged from tigers to trains and religious figures, is difficult to grasp in light of his illness, which was diagnosed as paranoid schizophrenia.[2] But his pictures are compelling in both their directness and compositional organization.

[1]All information for this entry is from Hemphill, p. 8.

[2]A major study of Ramirez culminated in a show of his work at the Goldie Paley Gallery of Moore College of Art, Philadelphia, Pa., September 6–October 18, 1985.

330 Tiger in Tunnel
80.201.1

Martin Ramirez
Probably California, possibly 1953
Crayon, pencil on brown wove wrapping paper
25" x 30⅛" (61.0 cm. x 76.5 cm.)

Tiger in Tunnel is one of the simplest of Ramirez's known works, as well as one of the most appealing. It is carefully drawn and nearly symmetrical in arrangement. The repetitive black crayon lines used for his architectural devices contrast effectively with the soft gradations of gold and yellow crayon in the outer elements and the pinks and blues within the tunnel area.

Other works by the artist are characterized by similar tunnels and repetitive lines. The tiger also appears in seven other pictures by the artist that are now privately owned. The date for no. 330 is tentatively based on a pencil inscription.

Inscriptions/Marks: In pencil on the left border near the lower corner is "12/53."
Condition: The piece remains in original fine condition. Modern 1¾-inch flat frame with silver gilt.
Provenance: Herbert Waide Hemphill, Jr., New York, N.Y.
Exhibited: "Folk Art USA Since 1900 from the Collection of Herbert Waide Hemphill, Jr.," AARFAC, May 25–September 14, 1980.
Published: Hemphill, illus. on p. 5.

330

Polly Ann ("Jane") Reed
(1818–1881)

Polly Reed was born February 3, 1818, the daughter of Zachariah and Phebe Reed. Her conversion to Shakerism occurred in 1825, before she was eight years old. At that time, she joined her parents in listening sympathetically to Elder Calvin Green and a companion who had journeyed from New Lebanon to Fairfield (Herkimer County), New York, on a proselytizing mission. Following the Shakers' talk, Polly's parents declined to join the society, but their young daughter insisted on leaving with the men. She remained a committed Shaker the rest of her life, and in the year of her death, she wrote that she had never regretted her childhood decision.

During the 1840s and 1850s, her occupation within the Shaker community at New Lebanon was listed as that of a tailoress, but she also served as the teacher of the Shaker school for many years. She was a deft scribe and produced beautifully executed music manuscripts as well as a large body of gift drawings that includes some of the most intricate and refined of all Shaker artworks.

In 1855 the society asked Reed to serve as Elder Sister in the First Order, and from 1868, she was one of four members of the Parent Ministry until her death, on November 25, 1881.[1]

[1]Additional information on Reed's life and artwork is given in the source of this entry information, Patterson, pp. 76–85.

331 A Present from Mother Ann to Mary H.

62.305.2

Attributed to Polly Ann ("Jane") Reed[1]
New Lebanon, New York, 1848
Watercolor and ink on wove paper
14" x 14½" (35.6 cm. x 36.8 cm.)

In 1774 Ann Lee led a small band of religious dissenters from England to America to found the first of their communal societies in this country at Watervliet, near Albany, New York. Mother Ann considered herself the daughter of God and advocated celibacy, confession, repentance, and withdrawal from the everyday world. Her followers called themselves Believers in Christ's Second Appearing, but outsiders dubbed them Shakers, or Shaking Quakers, because their spiritual faith manifested itself in visions, miraculous cures, speaking in tongues, and seizures of whirling and shaking.

A gradual relaxation of Shaker principles followed Mother Ann's death in 1784 but was dramatically arrested in 1837. In a trancelike state, a group of schoolgirls forecast Mother Ann's second coming, and the next ten to fifteen years witnessed a remarkable period of revelation and rededication to Shaker teachings throughout the sect's eighteen communities that had been established by then in New York, Maine, Massachusetts, New Hampshire, Ohio, and Kentucky.[2] During this period of exuberant revival, inspirational messages, spiritual presentations, and divine revelations abounded as indicated, in part, by several types of drawings created by and for members of the society.[3]

The Folk Art Center's sole Shaker rendering features a tree of life at center and is one of the more complex types that developed toward the end of the revival period, when millennial laws forbidding ornament and displays were less strictly applied to interpretive drawing. Like many Shaker drawings, it is inscribed as if made by Mother Ann — in accord with these artists' concept of themselves as mere instruments of revelation from a higher, divine source of wisdom. The Mary H. to whom the work was presented was most certainly Mary Hazard (1811–1899) of New Lebanon, who, like Polly Reed, was a well-known instrument.[4]

Inscriptions/Marks: The following inscriptions appear in ink in script. In the lower left corner is "The path to my Kingdom, is pleasant and sure,/Be faithful my child, all trials to endure." In the lower right corner is "I'll watch you by day, I'll guard you by night,/I'll make you a star, to shine clear and bright." At upper center is "Come gather from my Tree of Life sweet fruit, and/eat in remembrance of Me, your Mother, when your/soul is weighed down with deep tribulation/and sorrow." Below and to left of the preceding is "Behold saith the Lord,/I will gather from the/four quarters of the earth/many souls, and they/shall sit down in my/Kingdom of Peace, and/the babes of my pleasure/shall feed them." To right of the preceding is "Receive/this Lamp/from me,/says Father/William, and/remember Christs/word to the/good Sameritan." On the pages of the book at lower center is "I will be unto thee a Parent/and thou shalt be my child/says Mother:/for thy offerings ascend/to my Throne without/spot or blemish./Therefore let thy heart/rejoice, and thy tongue/sound forth praises to God,/while you view and/review the choice treasure/I have selected and brot/unto you from Heav-/ens bountiful stores. I/will daily send my minister-/ing doves to watch over you &/protect you from all harm,/says your loving Mother Ann." Above the book is "A Holy Plant, And fruits of Faith." Within the heart below the book is "Blessed are they whose hearts/are steadfastly set heavenward./Like the evergreen they shall flour-/ish/in the sight of the Lord." Below and to each side of the heart is "Hear me my child says Mother, while I speak unto you. Tho' thy sun may appear to be going down at noon,/and the moon cease to give light, yet with an out-stretched arm and protecting hand, I will/guide you safely thro. the dark wilderness of time. Trim up your lamp and hasten/on, and I will lead you to that bright world, where sorrow/troubleth not the righteous." Within a scalloped reserve below and to left of the book is "A Present/from Mother Ann/to Mary H./Nov 29th 1848." Above the horn blower's head below and to right of the book is "With my shrill/sounding Clavan [Clarion?]/I will fly thro' the Na-/tions & sound an alarm." The banner streaming behind the horn blower reads "Freedom." One of the birds at

331

top holds in his beak a square enclosing the words "A/Song of/ Peace." Associated with various motifs scattered throughout the drawing are the words "Plumb Tree," "Tree of Life," "S i m plic- i- t y," "Union," "Love," "Fair flowers from Heaven above," "Table of Wine," "Plate of Cake," "An Instrument of music/From Father James," "Cherries," "Peaches," "Basket & balls of Love," "Oranges," "Fruit of Purity," and "Fruit of Selfdenial."

Condition: The drawing was hinged to a modern secondary support when acquired. In 1974 E. Hollyday dry-cleaned unpainted areas, replaced the earlier hinges and backing, and provided a window mat. Modern ⅞-inch cyma recta frame, painted gold and yellow.

Provenance: Eldress Francis Hall, Hancock, Mass.; Vincent Newton, Hollywood, Calif.[5]

Exhibited: AARFAC, September 15, 1974–July 25, 1976; "The

Gift of Inspiration: Art of the Shakers, 1830–1880," Hirschl & Adler Galleries, Inc., New York, N.Y., May 3–25, 1979; "The Gift of Inspiration: Religious Art of the Shakers," Hancock Shaker Village, Hancock, Mass., June 27–November 7, 1970, and exhibition catalog, p. 10, no. 41, illus. as pl. 3 on p. 8; Hand and Spirit, and exhibition catalog, p. 140, no. 86; "Shaker Inspirational Drawings," AARFAC, January 21–March 4, 1962, and exhibition checklist, no. 20; Smithsonian, American Primitive Watercolors, and exhibition catalog, p. 8, no. 36.

Published: AARFAC, 1974, p. 69, no. 69; Edward D. Andrews, "Shaker Inspirational Drawings," *Antiques,* XLVIII (December 1945), illus. as fig. 4 on p. 339; Edward D. Andrews, "Shaker Inspirational Drawings," *Country Things from the Pages of the Magazine, Antiques,* ed. Eric de Jonge (Princeton, 1973), illus. as fig. 4 on p. 339; Andrews and Andrews, p. 42, illus. as fig. 7 on p. 43; "Art

Across North America: Outstanding Exhibitions," *Apollo,* XCII (November 1970), illus. as fig. 5 on p 390; Black and Lipman, p. 173, illus. as fig. 159 on p. 180; Dillenberger and Taylor, p. 140, no. 86; Hirschl & Adler Galleries, Inc., *The Gift of Inspiration: Art of the Shakers, 1830–1880* (New York, 1979), p. 27, no. 25; Keyes, illus. as fig. 2 on p. 204; Patterson, p. 84, illus. as pl. I facing title page; Sarah B. Sherrill, "Current and Coming," *Antiques,* XCVIII (September 1970), illus. on p. 306.

[1]Although Edward D. Andrews apparently ascribed the work to Polly Reed at least as early as 1935 when an illustration of the drawing was captioned as such, the attribution remained largely unnoted until Daniel W. Patterson set out to substantiate it by identifying some of the characteristics of Reed's style and by isolating a body of work attributable to her. See Patterson, pp. 11, 17–18, 76–85. For the 1935 article, see Keyes, illus. as fig. 2 on p. 204.
[2]A Shaker society was established in Indiana during the period 1799–1805 but was short lived; see Andrews and Andrews, p. 105.
[3]Five different types of drawings are described in Andrews and Andrews, pp. 69–90.
[4]For a biography of Mary Hazard, see Patterson, pp. 71, 73.
[5]Vincent Newton to AARFAC, October 5, 1961, states that the drawing is one of two that he purchased from Eldress Francis Hall, who claimed that they came from the community at New Lebanon; it is not known why the drawing appears to have been credited to the collection of Mr. and Mrs. Edward D. Andrews in Keyes, p. 204.

Mary Rees
(active ca. 1827)

332 Barnyard Scene 57.602.1

Mary Rees
Probably Pennsylvania, 1827
Silk and wool threads on linen canvas
20¾″ x 22″ (52.7 cm. x 55.9 cm.)

Mary Rees's cross-stitched verse and her pictorial composition are perfectly suited to each other. The former admonishes all living things to praise their Maker, while the latter shows some of the plants and animals requested to pay such tribute.

Careful selection of thread color and the direction and type of stitching make the scene both decorative and naturalistic. The checkered patterning on the tree trunks at upper right is jaunty and stylized in appearance, while ridges of bristly hair on the cattle's spines

332

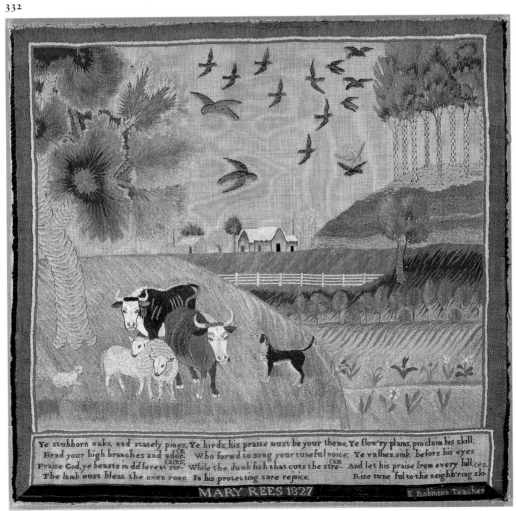

are more realistically represented by rows of diagonally placed, graduated stitches. Nineteenth-century needlework students commonly used French knots to depict the nubby wool of sheep, but Rees further emphasized this quality of their hair by using silk threads for all but the sheep's and lamb's bodies, where she employed wool.

To date, neither Rees nor her teacher, E. Robinson, have been further identified. Stylistic considerations do not refute a Pennsylvania origin for the piece, a presumption primarily based on its having been found in Wyoming County, Pennsylvania, at a relatively early date, probably in the 1940s.

Inscriptions/Marks: "MARY REES 1827" and "E Robinson Teacher" are worked in tent stitch in the bottom margin. The sampler verse cross-stitched above these reads: "Ye stubborn oaks, and stately pines,/Bend your high branches and ador-(e./Praise God, ye beasts in different str-(ains;/The lamb must bleat the oxen roar./Ye birds, his praise must be your theme,/Who form'd to song your tuneful voice;/While the dumb fish that cuts the stre-(am/In his protecting care rejoice./Ye flow'ry plains, proclaim his skill;/Ye vallies, sink before his eyes/And let his praise from every hill,/Rise tune ful to the neighb'ring ski-(es."
Condition: Conservation treatment by Kathryn Scott in 1957 included stitching the ground to a linen backing and restretching. Period replacement 3⅛-inch splayed mahogany-veneered frame.
Provenance: Mr. and Mrs. John Law Robertson, Montrose and Scranton, Pa.
Exhibited: AARFAC, September 1968–May 1970; "American Needlework," Museum of American Folk Art, New York, N.Y., February 6–May 31, 1967.
Published: American Heritage, illus. on pp. 98–99; *The Craftsman in America* (Washington, D.C., 1975), illus. on p. 110; Rumford, Folk Art Center, illus. on p. 63; Schorsch, Pastoral, illus. on p. 5.

Elizabeth T. Smith
(active probably ca. 1805)

333 Wisdom Directing Innocence to the Temple of Virtue 57.601.2

Elizabeth T. Smith
South Hadley, Massachusetts, probably ca. 1805
Watercolor with embroidery in silk, silk chenille, and metallic threads and sequins on a ground of silk and velvet
19⅞" x 26" (50.5 cm. x 66.0 cm.)

Eight compositions are known that are related to this Folk Art Center allegorical picture in terms of subject matter. The sole engraving in the group apparently was not used as the compositional source for any of the watercolor or needlework pieces that make up the remainder of the related works recorded by the museum. However, there is little doubt that all of the latter were based on some such printed image or images.

Four silk embroideries and two watercolors show a full-grown sheep leading the personification of Innocence or Youth; Elizabeth Smith's picture is the only one known to date that clearly portrays this animal as a lamb. Hers is also the only picture that includes, at right, the elaborate draped pavilion from whose steps Wisdom appears to direct her young charge.[1]

333

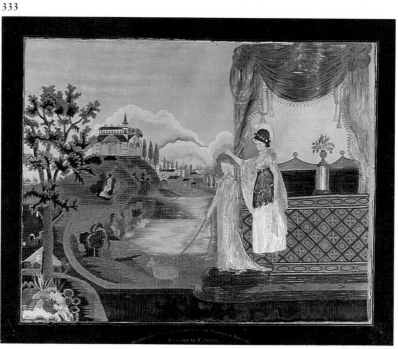

Stitching details, particularly the French knots composing the tree foliage at left, suggest that the Smith picture was worked at Abby Wright's School in South Hadley, Massachusetts,[2] but thus far, no information about the artist has been found.

Inscriptions/Marks: Lettered in gold on the black-painted glass mat is "WISDOM DIRECTING INNOCENCE TO THE TEMPLE OF VIRTUE./ ELIZABETH T. SMITH."
Condition: Treatment by Kathryn Scott in 1957 included removing the original auxiliary support, stitching the original secondary support of coarse linen to a tertiary support of linen, and stretching and tacking the tertiary support over cardboard. The glass mat is original, as is the 1⅞-inch molded cyma recta silver-lacquered frame.
Provenance: Found in New Hampshire, and purchased from Edith Gregor Halpert, Downtown Gallery, New York, N.Y.

[1]The Library of Congress owns v. II of the *New York Weekly Magazine* for 1796–1797, which shows a frontispiece engraved after Tisdale (presumably Elkanah Tisdale [1771–?]) and titled *Youth, accompanied by Virtue, and directed by Experience, Approaching the Temple of Happiness.*
Of the remaining related works, the two that tie most closely to the Folk Art Center's picture in compositional terms are a watercolor by Dorothy Houghenon that is titled, by means of an old label, *Innocence Leading Wisdom to the Temple of Fame* and a very similar silk embroidery titled, via a modern label, *Wisdom Directing Innocence to the Temple of Virtue;* these are owned by the Montgomery County Historical Society at Fort Johnson, N.Y., and by the Museum of Fine Arts, Boston, respectively. At far right in both these compositions, the bare edge of a quoined building is visible.
The Tryon Palace Restoration Complex at New Bern, N.C., owns an embroidery titled on its glass mat *Wisdom Conducting Innocence to the Temple of Virtue.* The Litchfield (Conn.) Historical Society owns a watercolor and an embroidery, both of which show the same basic composition; it is not known by what means the watercolor is titled *Minerva Leading the Neophyte to the Temple of Learning* or the embroidery, *Pointing the Neophyte toward the City of Knowledge.* Historic Deerfield, Inc., owns an embroidery titled on its glass mat *Liberty Guided by the Wisdom of '76.* Least similar to the Folk Art Center's picture in compositional terms is an embroidery worked by Persis Crane in 1812 and titled, via an old label, *Wisdom Leading Youth to Education;* this piece is privately owned.
[2]Attribution of the piece to Abby Wright's School is based on discussions with Betty Ring on January 27, 1977.

J. (or S.) A. Tilles (active ca. 1829)

334 Watch and Fob 31.303.10

Possibly J. (or S.) A. Tilles
Possibly New England or New York State, 1829
Watercolor and ink on wove paper
8¹³⁄₁₆″ x 6¹³⁄₁₆″ (22.4 cm. x 17.3 cm.)

The time shown on the watch face is widely believed to represent the hour of George R. H. Slack's death, on May 8, 1829, or, alternatively, his birth on that

GEORGE R H SLACK'S MAY 8TH 1829.

334

day.[1] However, no genealogical data have been found to confirm either theory to date.

Red pinstripes set off bolder, brighter stripes of yellow and blue in the picot ribbon, which is encircled above its knot by an ornamented, gold-colored slide. A seal and watch key dangle from the ring held by the knot.

Inscriptions/Marks: In the lower margin in ink is "GEORGE R H SLACK'S MAY 8TH 1829," and in very small letters in ink to the right of the preceding is damaged and barely discernible lettering that may read: "J [or S?] A Tilles."
Condition: Treatment by Christa Gaehde in 1954 included repairing tears; cleaning; filling losses in the bottom and sides of the primary support; re-adhering the top edge of the primary support; backing with Japanese mulberry paper; and emphasizing the "R" and "9" in the inscription with pencil. Treatment by E. Hollyday in 1978 included dry cleaning; wet cleaning with wheat-paste poultice where practicable; mending tears; re-adhering old fills in the primary support; and filling edge holes with tinted cellulose pulp. Period replacement 1-inch reeded frame, painted black.
Provenance: Found in Washington, Conn., and purchased from Edith Gregor Halpert, Downtown Gallery, New York, N.Y.; given to the Museum of Modern Art in 1939 by Abby Aldrich Rockefeller; turned over to Colonial Williamsburg in June 1954.
Exhibited: American Folk Art, Traveling; Washington County Museum, 1965.
Published: AARFAC, 1957, p. 190, no. 95, illus. on p. 191; Cahill, American Folk Art, p. 37, no. 71, illus. on p. 90; Ford, Pictorial Folk Art, illus. on p. 139.

[1]Nineteenth-century funeral wreaths sometimes included a clock that pointed to the hour of death (Louis C. Jones, New York State Historical Association, to AARFAC, October 17, 1955). A possibly related custom is that of stopping all clocks in a house at the moment of an occupant's death (Duncan Emrich, *Folklore on the American Land* [Boston, 1972], p. 660). Clocks showing varying times also occasionally appear on birth certificates, which suggests they sometimes indicated the hour of birth.

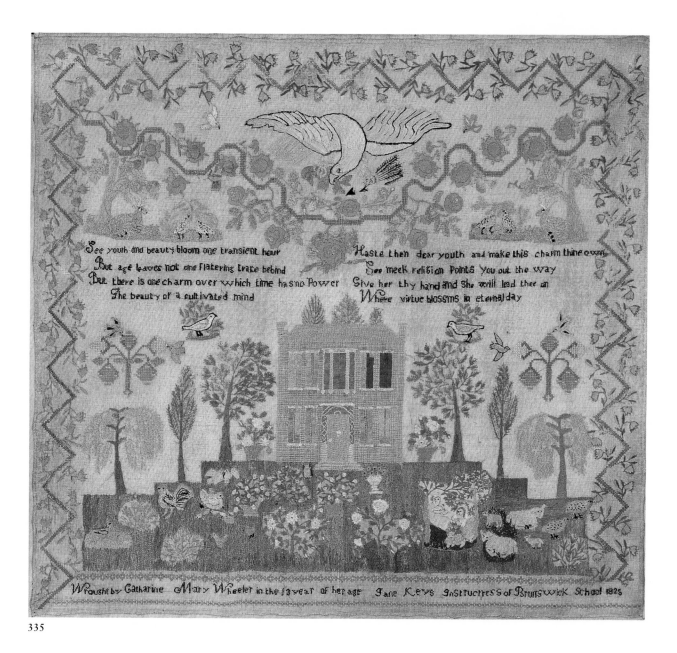

335

In the sampler image, the embroidered verses read:

See youth and beauty bloom one transient hour
But age leaves not one flatering trace behind
But there is one charm over which time has no Power
The beauty of a cultivated mind

Haste then dear youth and make this charm thine own
See meek religion Points you out the way
Give her thy hand and She will lead thee on
Where virtue blossms in eternal day

Wrought by Catharine Mary Wheeler in the 13 year of her age Jane Keys Instructress's of Brunswick School 1825

Catharine Mary Wheeler
(active ca. 1825)

335 Sampler 58.608.1

Catharine Mary Wheeler
Probably New Jersey or Pennsylvania, 1825
Silk embroidery on a cotton ground with silk
appliqué and ink
23½" x 25¾" (59.7 cm. x 65.4 cm.)

The Brunswick School named on Wheeler's sampler
has not yet been located, and nothing is known of the
artist beyond the facts given on her embroidery. The

format of a stepped or terraced lawn with animals
scattered over it appears often in embroideries from
the Delaware River valley area, hence the probability
of New Jersey or Pennsylvania as the piece's place of
origin.[1]

Twelve-year-old Catharine Mary Wheeler seems
to have mixed several shades of blue and green rather
indiscriminately in rendering the ground in front of
the house, the shutters on the building, and some of
the plant life. The small vignette of two shepherdesses
with their charges beneath two trees was worked on a
scrap of silk fabric applied over the larger cotton
ground; flesh, facial features, and some of the shep-
herdesses' hair are described in ink rather than silk
threads.

Interesting details in the lower field include a duck on a nest of ducklings at far left and, nearby, a rooster next to a hen with a brood of chicks, two of whom appear to drink or eat from a dish on the ground. A blue background enhances the fanlight and sidelights surrounding the house's front door, which also boasts a knob and knocker.

Inscriptions/Marks: Worked in black silk threads through the center of the sampler is "See youth and beauty bloom one transient hour/But age leaves not one flat[t]ering trace behind/But there is one charm over which time has no Power/The beauty of a cultivated mind/Haste then dear youth and make this charm thine own/See meek religion points you out the way/Give her thy hand and she will lead thee on/Where virtue blooms in eternal day." In black silk threads in the lower border is "Wrought by Catharine Mary Wheeler in the 13 year of her age Jane Keys Instructress of Brunswick School 1825."
Condition: Unspecified treatment by Kathryn Scott in 1961 included backing a dime-size hole above the eagle with crepeline, stretching the primary support over cardboard, and adhering to the reverse of the cardboard the original tacking edges of linen strips sewn to all four sides. The ¹⁵⁄₁₆-inch gilded cyma recta frame is possibly original, although it has been reglued several times; two hanging rings are missing from the top member.
Provenance: J. Stuart Halladay and Herrel George Thomas, Sheffield, Mass.
Exhibited: AARFAC, New Jersey; AARFAC, September 15, 1974–July 25, 1976.
Published: AARFAC, 1974, p. 67, no. 65, illus. on p. 66; Dewhurst, MacDowell, and MacDowell, Artists in Aprons, illus. as fig. 12 on p. 19.

[1]A Delaware River valley provenance was suggested by Betty Ring in a telephone conversation of November 28, 1984.

Unidentified Artists

336 Happiness 58.601.1

Artist unidentified
Possibly New England, probably 1800–1815
Watercolor and ink with silk embroidery on a silk ground
5⁹⁄₁₆″ x 8⁵⁄₁₆″ (14.1 cm. x 21.1 cm.)

One girl seems perturbed that her pet bird has escaped, the other seems elated in *Happiness*. Both children's dresses were stitched in several separate vertical sections. That on the left was done in three colors to produce a broad stripe, and diagonal stitching in the dress's lower border creates the illusion of a decorative edging. The dress on the right was created in one color, and the separate sections of stitching give the appearance of fabric folds. A townscape is faintly outlined in ink in the background; probably this area was meant to be filled with stitching or watercolor, and why it was left uncompleted is unknown.

A print source for the embroidery is known, although no impression can be located at present.[1]

Inscriptions/Marks: Lettered in gold paint on the black-painted glass mat is "HAPPINESS."

336

[1]Beatrix T. Rumford to AARFAC, September 2, 1965, indicates that the print source is oval shaped and shows three children standing around a wooden cage from which a bird has escaped. Titled *Unlucky Girls,* it was published September 6, 1798, by Mantaunam, London, and was one of a pair seen with a companion print of children playing.

The *Unlucky Girls* print probably also served as the source for a watercolor advertised by Stephen Score and illustrated in *Maine Antique Digest,* VII (March 1979), pp. 16B–17B.

337 The Beehive 79.601.4

Artist unidentified
Possibly New England, 1800–1820
Silk embroidery and watercolor on silk
15¾″ x 19½″ (40.0 cm. x 49.5 cm.)

This meticulous rendering of a garden scene is embroidered against a painted sky. Subtly shaded smooth silk threads predominate, but crinkled chenille threads were used to simulate the rough bark of trees. The unidentified needleworker has demonstrated admirable skill in color selections and in the use of various stitches to achieve appropriate textures. French knots form the curly wool of the sheep; rectangular blocks of stitches produce the brick path; and layers of couched stitches make up the woven beehive. At the center of the picture, tiny cross-stitches depict hover-

337

338

ing bees. The foreground elements of the composition are carefully balanced, and the regularly spaced topiary trees along the background fence create a pleasing rhythm at the horizon. A printed source may have inspired this picture, but it has yet to be identified.

Condition: An acidic backing was removed, and the primary support and linen secondary support were mounted on a nonacidic backing by E. Hollyday in 1981. Probably period replacement 2-inch molded and regilded frame.

Provenance: Found in Accord, Mass., and acquired from Katrina Kipper, Accord, Mass., in August 1935 for use at Bassett Hall, the Williamsburg home of Mr. and Mrs. John D. Rockefeller, Jr.

Published: Ring, Needlework, illus. as pl. XI on p. 481.

338 The Courtship 79.601.1

Artist unidentified
America or England, ca. 1810
Silk embroidery and watercolor on silk
20½″ x 24¾″ (52.1 cm. x 62.9 cm.)

The abrupt change from smooth silk thread at left to bulkier chenille silk thread at right suggests that two embroiderers worked on this picture. The large house in the left portion of the picture features carefully embroidered details. In contrast, a skillfully painted landscape dominates the right portion, almost overwhelming the embroidered couple in the foreground. The tree at right reaches from the embroidered foreground into the painted background by

having branches near the viewer worked in silk and those more distant painted in watercolor. A hilltop castle and a village with a cathedral-like spire are reminiscent of English landscape views.

Condition: The primary support has been mounted on linen in previous framing but no restoration treatment is evident. Possibly original 3-inch molded and gilded frame with applied plaster decoration of anthemion leaves along inner edges and beading within outer edges. Replacement black-and-gold eglomise glass mat.

Provenance: Found in Philadelphia, Pa., and acquired from Arthur J. Sussel, Philadelphia, Pa., January 3, 1935, and used at Bassett Hall, the Williamsburg home of Mr. and Mrs. John D. Rockefeller, Jr.

Published: Ring, Needlework, illus. as pl. XII on p. 481.

339 Pennsylvania Chinoiserie 32.301.6

Artist unidentified
Pennsylvania, possibly Montgomery County,
possibly 1810–1815
Watercolor, gouache, ink, and gold and silver
paint on wove paper
7⅞″ x 10″ (20.0 cm. x 25.4 cm.)

Among this unidentified artist's recorded works, the Folk Art Center's piece is unique in showing a human figure. Nine other watercolors that are stylistically attributable to the same hand all feature exotic birds.[1] One of these is dated 1812 and bears several inscriptions in different hands, including one on an old frame backing paper that reads: "For Martin H Baer Jr/from/

339

His aunt Sarah/drawn by her Father in 181[illegible material]/1812/1812." Six pieces bear inscriptions in their lower margins, and of these, four are in German and two are in English. The Kolb surname that appears on the reverse of the Folk Art Center's example (see *Inscriptions/Marks*) is commonly found in Montgomery County; hence the suggestion of that county as a place of origin.

A typical feature of the artist's work and one that is evident in *Pennsylvania Chinoiserie* is a stratified composition of undulating ground lines that quickly move the eye up and back to create an illusion of steep, choppy terrain within shallow spatial depth. Scattered sprigs of grasslike vegetation and low bushy shrubs dot the landscapes and also break up space. The palm tree at left in *Pennsylvania Chinoiserie* appears in several other works, but more often its trunk is ridged with bristly horizontal growth rings rather than left smooth. Exotic buildings appear in the backgrounds of all but one work. Lower margin reserves are invariably included, even though some of them, like the Folk Art Center's example, are left uninscribed.

Inscriptions/Marks: Penciled inscriptions on the reverse of the primary support are made difficult to read by a backing of Japanese mulberry paper. They appear to be at least three multiplication calculations, some initials (?), possibly one or two words, and the name "John Kolb" in script.

Condition: Treatment by Christa Gaehde in 1955–1956 included cleaning; mending tears; backing with Japanese mulberry paper; and replacing numerous losses of pigment with both watercolor and pastel, especially in the figures' costumes and the green hillside beyond. Treatment by E. Hollyday in 1980 included dry cleaning of unpainted areas. Possibly original 1⅝-inch splayed red-painted frame with flat outer edge.

Provenance: Found on Long Island, N.Y., and purchased from Edith Gregor Halpert, Downtown Gallery, New York, N.Y.

Exhibited: American Folk Art, Traveling.

Published: AARFAC, 1940, p. 34, no. 143 (titled *Promenade*); AARFAC, 1957, p. 364, no. 277; Cahill, American Folk Art, p. 38, no. 77 (titled *Promenade*).

[1]Three of the nine watercolors of birds are illustrated in Sotheby Parke Bernet, Garbisch II, as lot nos. 21, 90, 196. *A Parrot from Guinea* is illustrated in Sotheby Parke Bernet, Garbisch I, as lot no. 105, and on an unnumbered page in Masterpieces of American Folk Art.

Of two privately owned watercolors, one appears to show the same bird as Sotheby Parke Bernet, Garbisch II, lot no. 21. Finally, three different privately owned versions of *Ein Seidenschwantz* ("A Silktail") are known, and one of these bears the lengthy inscription noted in the commentary.

340 The Ample Grove 60.305.2

Artist unidentified
Probably Pennsylvania, possibly 1810–1825
Watercolor and ink on laid paper
9¹⁵⁄₁₆″ x 7¾″ (25.2 cm. x 19.7 cm.)

Puzzles, rhymes, rebuses, and all sorts of word games were playfully composed, decorated, and exchanged by young and old alike in eighteenth-century and early nineteenth-century America. Here the verse describes a geometrical challenge that apparently had to be met before the unnamed suitor could hope to win the hand of the girl he loved. The drawing below the verse proves that he successfully completed the assignment, and one supposes that his clever token of affection met a warm reception.

Two other versions of the same puzzle are known. The first incorporates a similar verse and is likewise illustrated by a grove of trees laid out with the aid of a compass, but large tuliplike flowers fill spaces in its top margin and lower corners.[1] The second is the Folk Art Center's acc. no. 85.305.3, which does not appear in this catalog.

Inscriptions/Marks: In ink in script at the top appears the following verse: "[I] a[m] disposed to plant a grove;/To Satisfy this girl

340

I love,/This ample grove I must compose,/Of nineteen trees in nine straight rows,/Five in each row There must place,/Or never expect to see her face;/Ye sons of Art grant me your aid;/To satisfy This curious maid." In ink in script at the bottom of the grove is "Ample Grove."

Condition: Treatment by Christa Gaehde in 1960 included mending tears, cleaning, filling and inpainting small scattered losses in the primary support, backing with Japanese mulberry paper, and hinging the sheet to a backboard. In 1975 E. Hollyday replaced the earlier hinges and backboard. Possibly original 1¾-inch flat frame with raised corner blocks, painted dark blue-green.

Provenance: Mary Allis, Fairfield, Conn.; Joe Kindig, Jr., York, Pa.[2]

[1]The other version of the puzzle is privately owned and is illustrated on p. 13 of Depauw and Hunt. Its verse reads: "I am constrained to plant a grove,/To entertain the Maid I love,/This grove she says, must be compos'd,/Of nineteen trees and nine straight rows,/Five trees in every Row must place,/Or never expect to see her face,/Ye men of art, and knowledge crown'd,/Help me to work, And try the ground,/That this fantastic grove may hide,/The blushes of my yielding bride."

[2]Kindig's ownership is inferred from inclusion of the piece, credited to the Kindig collection, in Shelley, Fraktur-Writings, no. 59.

341 Fishermen with Net 34.301.7

Artist unidentified
America, probably 1815–1830
Watercolor and ink on wove paper
8½″ x 10¹³⁄₁₆″ (21.6 cm. x 27.5 cm.)

One of Mrs. Rockefeller's early references to this piece indicates that it is signed "H. Ward, Youngstown" (no state is given).[1] However, no trace of such an inscription has been found on the primary support or the picture's frame, and attempts to locate an H. Ward in Youngstown, Ohio, have been unsuccessful to date.

The composition is copied from a print transferred to ceramic tableware by Robert Hamilton of Stoke, England, and perhaps by other potters as well. An indented plate bears the mark "HAMILTON/STOKE," indicating that that piece, at least, was produced in the period 1811–1826.[2]

Condition: Unspecified treatment by Christa Gaehde in 1954 included adding the left margin and lower left corner. Treatment by E. Hollyday in 1974 included dry cleaning, removing insect debris, mending edge tears, filling a semicircular loss in the lower margin, and hinging the sheet to rag board. Probably period replacement 1¹⁄₁₆-inch gilded cyma recta frame.

Provenance: Found in New York State, and purchased from Isabel Carleton Wilde, Cambridge, Mass.

Exhibited: AARFAC, September 15, 1974–July 25, 1976.

Published: AARFAC, 1940, p. 28, no. 90; AARFAC, 1947, p. 26, no. 90; AARFAC, 1957, p. 363, no. 272; Cahill, Early Folk Art, illus. on p. 260.

[1]The Rockefeller information is presumed to be the basis for allusion to an H. Ward of Youngstown, Ohio, who is credited with having painted a watercolor scene in 1840, in Lipman and Winchester, Primitive Painters, p. 181. (The piece has been described as ca. 1840 in previous AARFAC catalogs.)

341

[2]The plate is illustrated and described — and information about Robert Hamilton is given — in A. W. Coysh, *Blue and White Transfer Ware, 1780–1840* (Newton Abbot, England, 1970), pp. 40–41.

342 Building in Landscape 80.301.1

Artist unidentified
America, probably 1815–1840
Watercolor and pencil on wove paper
12½″ x 19½″ (31.8 cm. x 49.5 cm.)

Architectural designs were a somewhat unusual choice of subject matter for the nineteenth-century theorem artist, who painted by using stencils; the technique was far more commonly used to render still-life pictures.

In this instance, the unidentified artist derived inspiration from a printed compositional source, for the stenciled building bears a close resemblance to S. Sulpice, an imposing Parisian edifice graphically rendered by woodblock printing in Joseph Dufour's French scenic wallpaper called the Monuments of Paris, which was first produced about 1814.[1] Whether the stenciler saw and copied an American import of the scenic paper — or some other printed illustration of S. Sulpice — is unknown. However, the general identification of the building seems certain, as a comparison between the watercolor subject and a photograph of the wallpaper detail reveals close similarities between the two.

Inscriptions/Marks: A recto pencil inscription at center front reads: "Lizzie." On the verso are apparently unrelated geometric doodles, and "Warren" appears three times in pencil.

Condition: Treatment by E. Hollyday in 1980 included drycleaning unpainted areas, repairing edge tears and tack holes, and backing the primary support with Japanese mulberry paper. Modern replacement ⅞-inch stained cyma recta frame with flat outer edge.

Provenance: Don and Faye Walters, Goshen, Ind.; unidentified Illinois dealer; Bert and Gail Savage, Kildeer, Ill.; George Schoellkopf, New York, N.Y.

[1]The relationship between the stenciled building and S. Sulpice was brought to AARFAC's attention through the kind assistance of James F. Waite, the Colonial Williamsburg Foundation. See Catherine Lynn, *Wallpaper in America from the Seventeenth Century to World War I* (New York, 1980), p. 195. Although Lynn includes several illustrations of the Monuments of Paris, none of her details includes the building identified as S. Sulpice. The detail can be seen, however, in a modern reproduction of the scenic paper manufactured by the Twigs and used to decorate the Richmond Room at the Metropolitan Museum of Art in New York City. AARFAC files contain detail photographs made from the reproduction there.

342

343 The Shepherd and His Flock 33.301.1

Artist unidentified
Probably New York State or New England,
possibly ca. 1820
Watercolor, ink, and pinpricks on wove paper
12⅛″ x 15³/16″ (30.8 cm. x 38.6 cm.)

Dawn or dusk is suggested by a pink-tinted horizon
and by deep shadows beneath the trees and the two
central figures. Flowering plants, flitting birds, and
paddling ducks create an idyllic mood that appears
incongruous to the principal drama of the profusely
bleeding sheep. Behind the distressed animal, two del-
icately colored seashells appear unexpectedly on the
shoreline.

The sheep's coats, some vegetation at left, and the
shepherd's cloak all have been perforated back to front
with pins to raise and roughen the surface of the paper,
thereby simulating the appearance of embroidered
French knots. Very fine perforations mark the sheep's
bodies, while larger ones distinguish the shrubbery
and cloak. The watercolor stippling used to suggest
tree leaves is also reminiscent of the appearance of
needlework.

Condition: The primary support was hinged to rag board by
E. Hollyday in 1974. Period replacement 1½-inch gilded splayed
frame with flat outer edge.

Provenance: Helen M. Shevlin, Cambridge, Mass.[1]
Exhibited: AARFAC, September 15, 1974–July 25, 1976; South-
ern Book; Washington County Museum, 1965.
Published: AARFAC, 1940, p. 27, no. 84; AARFAC, 1947, p. 25,
no. 84; AARFAC, 1957, p. 168, no. 84, illus. on p. 169; AARFAC,
1974, p. 57, no. 54, illus. on p. 59; Schorsch, Pastoral, p. 39.

[1]Two different sets of Mrs. Rockefeller's notes indicate that the
watercolor was purchased from Shevlin, first "through the Rhode
Island School of Design" and second, "through L. Earle Rowe."

344 Spring Fishing 34.301.6

Artist unidentified
America, probably ca. 1825
Watercolor and pencil on wove paper
8⅜″ x 9⅝″ (21.3 cm. x 24.5 cm.)

The men's vivid blue coats stand out brightly in a
surround of yellow-green vegetation and pale-blue sky
and water. The composition derives from a scene
transfer-printed on ceramic tableware by John Meir of
Tunstall, England, ca. 1810–1820.[1]

Condition: Unspecified treatment by Christa Gaehde in the
1950s included straightening the top edge, which had been folded
under ½ inch from the top; inpainting losses along the old creases;
and filling several losses in the edges. In 1977 E. Hollyday dry-
cleaned the piece, filled and inpainted minor losses (the most notable
being two small areas in the right man's breeches), and flattened the

343

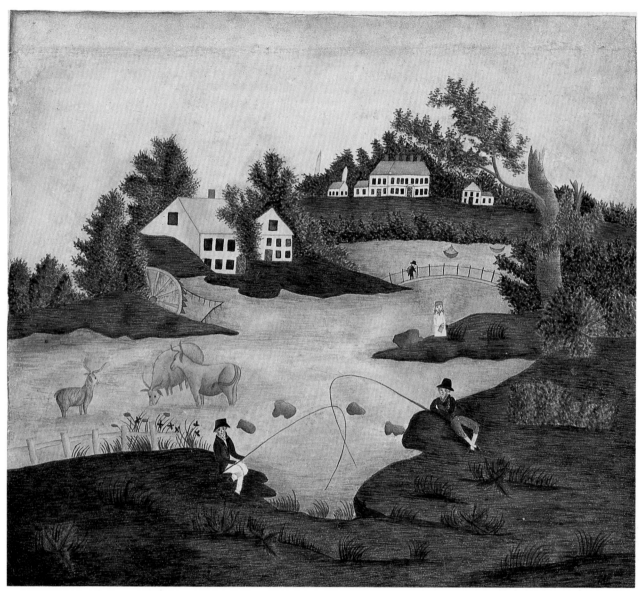

344 *Spring Fishing*

sheet. Modern replacement 1-inch stained cove-molded frame with flat outer edge.

 Provenance: Stephen Van Rensselaer, Williamsburg, Va.[2]

 Exhibited: Washington County Museum, 1965.

 Published: AARFAC, 1940, p. 27, no. 83; AARFAC, 1947, p. 25, no. 83; AARFAC, 1957, p. 162, no. 81, illus. on p. 163; "Folk Art in America," *Ladies' Home Journal*, LXXIV (September 1957), illus. on p. 75.

[1]For a description and illustration of an indented dish showing the pattern and for information about John Meir, see A. W. Coysh, *Blue and White Transfer Ware, 1780–1840* (Newton Abbot, England, 1970), pp. 48–49.

[2]Van Rensselaer located in Williamsburg only during the winter months. Other times, he ran a shop in Peterborough, N.H., and he may well have found the watercolor in New England.

345 Oriental Landscape 57.102.7

Artist unidentified
Possibly New England, possibly 1830–1845
Oil on twill-weave linen canvas
23⅛″ x 31⅝″ (58.7 cm. x 80.3 cm.)[1]

File notes apparently originating with Edith Halpert indicate that this painting was ascribed to a sea captain when she acquired it, but no verification of this has been made, and no print source for the design has been located to date.

 The highly detailed, brightly colored composition reflects a period taste for exotica, and it may well have been executed by some amateur painter who had con-

345 *Oriental Landscape*

nections with the Far East via sea trade. The frame is an unusual survival of custom design.

Condition: Treatment by Cleo Mullins in 1985 included lining the canvas, cleaning, filling and inpainting scattered losses, stretching the lined canvas over a Masonite support, and affixing the painting to the back of its frame in emulation of the original mounting technique. Original 1½-inch black-painted flat frame with raised corner blocks and red-and-yellow-painted decoration on each corner block and in the middle of each frame member; two wire hanging rings were once clinched through the top frame member but are now missing.

Provenance: Found in New England, and purchased from Edith Gregor Halpert, Downtown Gallery, New York, N.Y.

[1] In this instance, sight measurements have been given since the canvas is tacked to the back of the frame rather than stretched over a fixed auxiliary support.

346 View of the Castle of Montgomery 74.110.1

Artist unidentified
Moore, South Carolina, probably ca. 1835
Oil on cotton canvas
36⅛″ x 54¹⁄₁₆″ (91.8 cm. x 137.3 cm.)

According to tradition in the family of the donors, the painting was created as a fireplace enclosure for use at Fredonia, a house that was originally built about 1786 in Spartanburg County, South Carolina, and destroyed by fire in 1977. In 1785 the land on which the house was situated had been a free gift from Charles Moore to his son Thomas, hence the origin of the name Fredonia.[1]

Moore family descendants further believe that the painting was executed locally, a probability that is strengthened by the existence of a nearly identical fireboard made for the Wofford house near Woodruff, South Carolina, only about seven miles from the Fredonia site.[2] The two pieces must have been created by the same hand. However, Wofford tradition holds that its fireboard was painted by the unidentified architect of that house about 1815, when the building was erected. It is speculated that Fredonia's fireboard dates from the 1830s based on painting style, construction techniques, and the perhaps more than coincidental fact that Montgomery was the surname of the new bride brought to the house in 1833. That year Nancy Montgomery became the second wife of Fredonia's occupant, Dr. Andrew Barry Moore.

In the eighteenth and nineteenth centuries, both wood panels and stretched canvases were used as supports for decorative paintings that were used to screen unused fireplaces in warm weather. Landscapes and

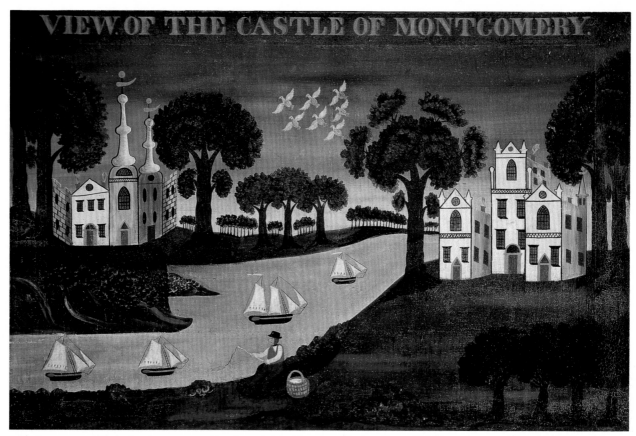

346

flower arrangements frequently appeared in these paintings, but the survival of many other subjects — including trompe l'oeil fireplace openings — suggests that choice was limited only by the artist's or client's imagination. The creator of the Fredonia fireboard is presumed to have drawn inspiration for his idyllic composition from some printed illustration, but the source has not been identified, nor has research conclusively linked the subject of the painting with any castle in fact or literature to date.

Inscriptions/Marks: Painted across the top of the work is "VIEW. OF THE CASTLE OF MONTGOMERY."

Condition: In 1976–1977 the painting received extensive treatment from trainees in the Cooperstown (N.Y.) Graduate Programs for the Conservation of Historic and Artistic Works. Their work included replacing the original yellow pine strainers with an auxiliary support of Hexcel aluminum honeycomb faced on both sides with sheet aluminum and, on the painting side, with glass fabric; flattening distortions in the plane of the canvas; filling losses in the primary support, particularly two large areas in the lower edge, with trimmed scraps of excess original fabric support that had been turned and tacked over the back edges of the strainers; mending tears; lining the primary support; cleaning; inpainting losss; and attaching modern black-painted strips of lath wood to the four edges to protect them as would a frame.

Provenance: Gift of Mr. and Mrs. Thomas A. Moore, Fredonia, Moore, S.C.

Published: American Folk Art, illus. on p. 90; Rumford, Folk Art Center, illus. on p. 61.

[1]Information about Fredonia and the Moore family is from 1974 conversations with the donors and from Thomas A. Moore to AAR-FAC, June 11, 1974.

[2]The Wofford fireboard is owned by the New York State Historical Association, Cooperstown, N.Y., and it is illustrated in Lipman and Winchester, Folk Art, as fig. 267 on p. 199.

347 Cat and Kittens 58.301.10

Artist unidentified
America, probably 1846–1865
Watercolor and pencil on wove paper
10" x 13^{15}/$_{16}$" (25.4 cm. x 35.4 cm.)

This simple picture was created with stencils, although delicate features, such as eyes and whiskers, were added freehand. The composition closely follows a lithograph titled *The Playful Family* that was published by Kelloggs & Thayer in 1846 or 1847.[1]

Condition: Treatment by E. Hollyday in 1975 included dry-cleaning unpainted areas, flattening, and backing the primary support with Japanese mulberry paper. Period replacement 1½-inch ripple-molded frame with gilded liner.

347

Provenance: J. Stuart Halladay and Herrel George Thomas, Sheffield, Mass.

Exhibited: "The Cat in American Folk Art," Museum of American Folk Art, New York, N.Y., January 12–March 26, 1976; "The Fascinating Cat," Mulvane Art Center, Washburn University, Topeka, Kans., September 1–November 15, 1980, and exhibition catalog, p. 5; Halladay-Thomas, Albany, and exhibition catalog, no. 89.

Published: Barbara B. Chiolino, "A Folk Art Trip to New York City," *National Antiques Review,* VII (May 1976), p. 28; Bruce Johnson, *American Cat-alogue: The Cat in American Folk Art* (New York, 1976), no. 101.

[1]Bonnie Rowlands, Medina, Ohio, had an example of the lithograph in 1982. The inscriptions in the print's lower margin read, at left, "Kelloggs & Thayer; 144 Fulton St., N.Y.," and, at right, "D. Needham, 223 Main St., Buffalo." In the center is "E. B. & E. C. Kellogg, 136 [or 138] Main St., Hartford, Conn.," and also, "The Playful Family." See Groce and Wallace, pp. 363–364, 467, for information on the printers and their agent; p. 364 gives active dates of 1846–1847 for the firm of Kelloggs & Thayer.

348 Mrs. Josiah B. Keylor's Cat 73.101.2

Artist unidentified
Possibly Chester County, Pennsylvania,
probably ca. 1850
Oil on canvas
17″ x 14″ (43.2 cm. x 35.6 cm.)

A modern label found on the reverse of the painting when it was acquired still provides the primary source of information for the work. A painting of a cat that is similarly posed and that also has a Pennsylvania history has been recorded, but it appears to have been

executed by a different hand.[1] Mrs. Keylor's cat is shown against a flatly painted black backdrop that gives the appearance of a void and that adds to the surrealistic quality generated by the floating carpet.

348

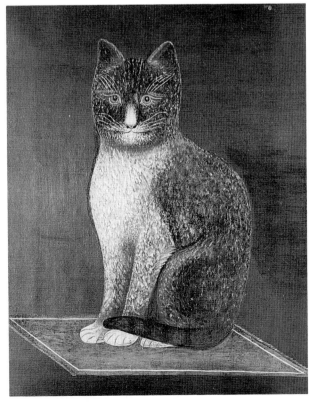

Inscriptions/Marks: A torn label on one of the strainers reads, in part: "... Co./ ... & Weber/ ... Philadelphia/[illegible material]/ ... and Ticken Canvas, also/ ... Canvas and Artists' Materials Generally./Size x/Manufacturers of Artists' Oil and Water Colors." A modern label found on the reverse of the frame when the picture was received read: "This cat was owned by and, perhaps, painted by/the first wife of Dr. Josiah B. Keylor, Cochran-/ville, Pa. Marion Day, my wife, bought this/picture from her cousin, Mrs. David Bair, nee/Keylor, daughter of Dr. Keylor's second wife./Picture probably painted by the first wife before/marriage or by a local Chester Co. artist. Now/estimated to be 113 years or more old./(s) Arnold R. Beardsley (d) 4/24/69."

Condition: The painting appears to be in its original condition. Possibly original 2½-inch, gold-painted frame with elaborate plaster ornamentation of rope twists and leaves.

Provenance: Mrs. Josiah B. Keylor, Cochranville, Pa.; Mrs. David Bair; Mrs. Arnold R. (Marian Day) Beardsley; Phyllis Bartlett Pollard; bequest of Marian Day Beardsley.

Exhibited: "The Cat in American Folk Art," Museum of American Folk Art, New York, N.Y., January 12–March 26, 1976.

Published: Bruce Johnson, *American Cat-alogue: The Cat in American Folk Art* (New York, 1976), no. 56.

[1]The related cat is illustrated in *Antiques*, CIV (November 1973), p. 803.

349 Two Doves 31.303.11

Artist unidentified
Probably New York State or New England,
probably 1860–1890
Watercolor on wove paper
9⅜" x 12" (23.8 cm. x 30.5 cm.)

The particular composition of two doves perched on a bough or branch with their wings spread, as illustrated here, dates back at least to the early nineteenth century, when it was used by Jacob Andreas of Lancaster County, Pennsylvania.[1] However, the exact design source for a large number of similar depictions created with the aid of stencils in the latter half of the nineteenth century has not yet been identified. Among the stenciled examples of this composition that have been recorded are one by Emma Jane Cady (1854–1933) of East Chatham, New York, dated 1890, and one attributed to Ruth Ann Denny Bogardus, whose family lived in Churchville, New York. By means of a framer's label, the latter is dated to the period 1863–1879.[2]

Condition: Treatment by Christa Gaehde in 1956 included cleaning. The 1⁷⁄₁₆-inch splayed grain-painted frame is a replacement that probably dates from about 1825–1845.

Provenance: Found in Noroton, Conn., and purchased from Edith Gregor Halpert, Downtown Gallery, New York, N.Y.

Exhibited: "Birds in American Art," Heritage Plantation of Sandwich, Sandwich, Mass., April 28–October 15, 1978, and exhibition catalog, p. 49, no. 94.

Published: AARFAC, 1957, p. 365, no. 288.

[1]See Weiser I, no. 148. Andreas also featured the two doves composition in an 1822 drawing that is published on p. 91 in Weiser, Fraktur. (Although the 1822 drawing published in Weiser, Fraktur, is attributed to an unidentified artist, the work is credited to Andreas in Frederick S. Weiser to AARFAC, January 9, 1978.)

[2]Cady's composition is shown in Piwonka and Blackburn, Cady, p. 421, pl. IV. Ruth Ann Denny Bogardus's composition appears as no. 28 in *Early Arts in the Genesee Valley: 18th and 19th Centuries* (Geneseo, N.Y., 1974).

349

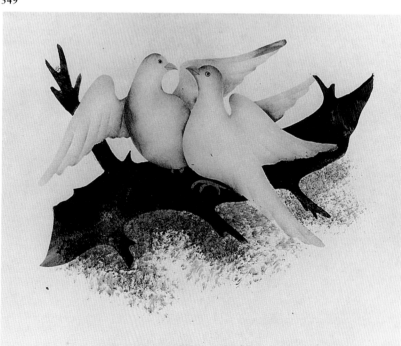

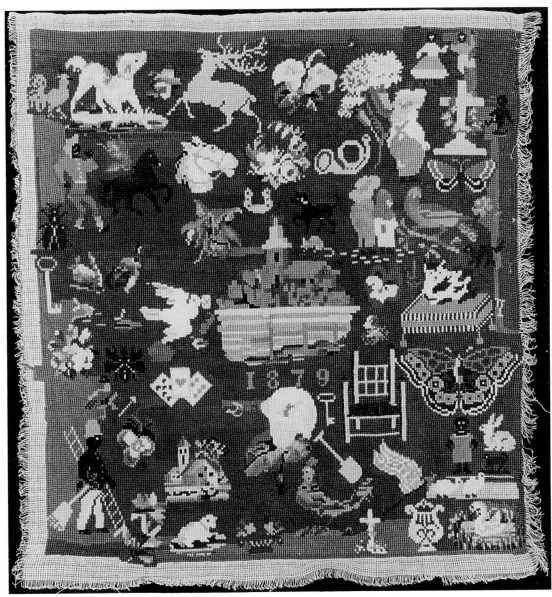

350

350 Sampler Picture 78.608.1

Artist unidentified
America, 1879
Wool and silk threads on cotton canvas
22″ x 21½″ (55.9 cm. x 54.6 cm.)

The vogue for creating such woolwork sampler pictures as no. 350 is not well documented, although two similar pieces have been recorded, one of them dated 1876. All are differently composed but incorporate similar or, in a few cases, virtually identical motifs.[1] The background of the Folk Art Center's picture is worked in maroon primarily, but some patches are filled with other shades of purple.

Inscriptions/Marks: In needlework near the center is "1879." Below and to left of the "1879" is a configuration that may have been intended for the script letter *D*.
Condition: The piece appears to be in original condition and is not framed at present.
Provenance: A Short Hills, N.J., estate sale; Mrs. T. J. Soloway, West Orange, N.J.

[1]See Sotheby Parke Bernet, Inc., *Americana*, catalog for sale no. 4709Y, October 23–24, 1981, lot no. 292; and Sotheby Parke Bernet, Inc., *American Furniture and Decorated Clocks*, catalog for sale no. 4103, April 1, 1978, lot no. 62.

X Mourning Pictures

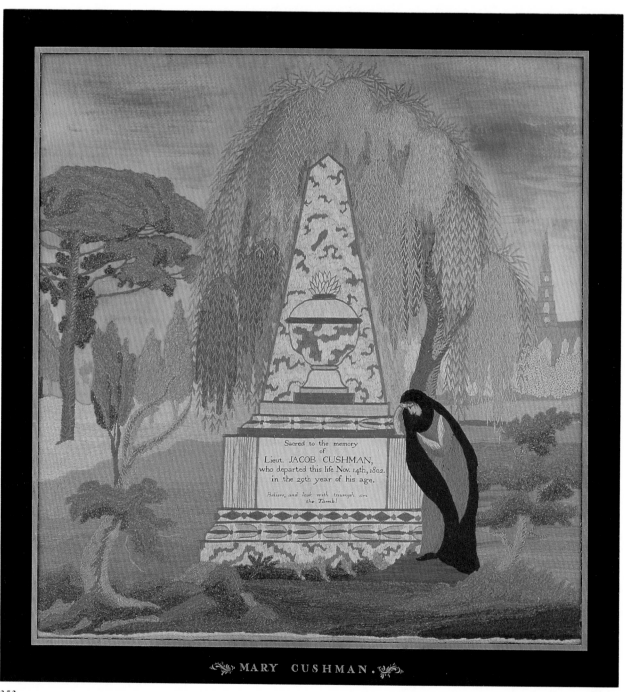

MARY CUSHMAN.

merican mourning pictures derive from late eighteenth-century English and European design sources. They are an expression of the taste for neoclassic forms as popularized by Robert Adam, Josiah Wedgwood, and Angelica Kauffmann. Printed versions of Kauffmann's painting *Fame Decorating the Tomb of Shakespeare* were widely circulated as early as 1782, and some eighteen years later the engraving provided the inspiration for a number of memorials honoring George Washington. Other motifs were appropriated from engraved illustrations in magazines and novels, including Joseph Addison's *Spectator* and translations of Goethe's *The Sorrows of Werther* (see no. 165). This type of artwork was particularly popular in urban communities, where women had time to devote to it, and was frequently an important part of the curriculum in female seminaries. The enormous popularity of memorial scenes featuring weeping willows, funeral urns, and grieving relatives reflects an aspect of romanticism wherein a preoccupation with the inevitability of death is combined with a confident belief in immortality.

Within weeks of the sudden death of George Washington on December 14, 1799, the new nation was flooded with commemorative souvenirs in many mediums honoring the first President. A number of patriotic prints were published, and these promptly inspired countless painted and embroidered pictures that were executed with varying degrees of skill by a generation of young people. Two memorials in this section (nos. 358 and 378) illustrate this point, since both were copied from a print by T. Clarke published in 1801.

Samuel Folwell (see nos. 324, 355, 356, and 357) was an enterprising professional artist who, sensitive to the nation's grief, developed a stock design, "In Memory of the Illustrious Washington," to be embroidered by students at the needlework school he and his wife ran in Philadelphia. He subsequently traveled the East Coast selling the same patterns for silk needlework, but with the background already painted in (he seems to have added his brushwork to the finished embroidered pieces done in Philadelphia).[1] Soon the Folwells, other teachers, and schoolgirls were combining various sources to create pictures that memorialized friends and relatives as well as heroes. Mourning had become fashionable, and the handmade memorial a socially desirable accomplishment to be displayed with pride and sentiment in the best room of the home.

Nonacademic American artists excelled at creating mourning pictures that show an amazing amount of individuality in surprisingly varied combinations of stock elements. Considerable ability was required, and in a stylized way many memorials have an engaging decorative quality. In embroidered memorials, large areas of sky and

background as well as faces and details were often done in watercolor, sometimes by the student but more often by a teacher or local limner or framer who was paid for this work. In some painted memorials, the short, precise brush strokes and areas of pinpricking are intended to imitate embroidery.

Few instructors encouraged their students to devise original designs. Instead, teachers usually pencil-sketched the basic elements onto pieces of silk, velvet, or paper, or provided prints and patterns for students to copy. Students then painted or embroidered the scenes, learning different techniques and stitches as they worked. Often the direct influence of a teacher can be seen in the repetition of certain design elements, stitching patterns, or painting styles in many similar paintings done by different pupils. Today a characteristic stitch or the repetition of a specific architectural detail can be helpful in identifying the school or area where a piece was made.

Frames were usually provided by professional carvers and gilders, some of whom specialized in framing and glazing ladies' needlework. Framing techniques usually exhibit regional characteristics, so an original framer's label is useful in establishing the provenance of a memorial. The application of fancy gilt and black borders reverse-painted on glass came into vogue about 1795, and the technique continued to be used for framing memorials and other pictorial subjects until about 1820.

In the typical mourning picture, grieving figures representing members of the family appear in the foreground, grouped around a tomb that is surmounted by an urn and has an epitaph on its base. A garland of roses or a clump of forget-me-nots is sometimes included, and the drooping willow is invariably a focal point. A church usually appears in the background, and a body of water is often part of the scene. Many of the neatly coiffed mourners hold handkerchiefs to their dry-eyed faces, and the female figures are generally draped in heavy black veils. Costumes can be more useful in dating these pictures than the inscriptions on the tombs, since some compositions were dedicated to people who died before a young artist was born. Many memorials honor departed relatives, but others were left blank, perhaps anticipating future needs. In addition to hand-lettered and embroidered inscriptions, printed dedications are also common. Sometimes printer's type was applied directly to the primary support of a picture; on other examples, funeral cards were carefully cut out and pasted onto the face of the tomb.

Mourning pictures continued to be painted and embroidered until the 1840s, when the development of lithography brought an end to the tradition of hand-made memorials. A dozen or more versions of these inexpensive lithographs were published by several firms during the thirty years they remained popular. The commercial memorials were hand-colored and included the conventional willow, tombstone, and weeping figures arranged in different ways to meet any contingency; they could be framed and hung on parlor walls just as soon as the dear-departeds' names and dates were inscribed on the blank monuments that dominate the scene. Many of the hand-drawn mourning pictures executed after 1835 are derived from the printed examples produced by Nathaniel Currier, D. W. Kellogg and Company, and other lithographers (see nos. 381 and 383).[2]

[1]"Collectors' Notes," *Antiques*, CXXVIII (September 1985), pp. 526–527.
[2]Adapted from Rumford, Memorial Watercolors, p. 688.

Hannah Brown
(active ca. 1814)

351 Memorial to Curtiss Brown 58.304.6

Hannah Brown
Probably Massachusetts or New York State, probably 1814–1815
Watercolor and ink on wove paper
19¼" x 15⁹⁄₁₆" (48.9 cm. x 39.5 cm.)

The straightforward simplicity of this competent but unexceptional memorial, together with the stylistic details of costume and architecture and the awkwardly phrased epitaph, suggest that a sad and bewildered Hannah Brown executed the watercolor shortly after her eight-year-old brother's untimely death. Although the tomb looms large in this composition, it, the church, and the grieving figure are all dominated by the encompassing form of that ubiquitous symbol of mourning, the weeping willow tree. In choosing an oval format, Hannah probably assumed that the unpainted border of her paper would be covered by the black and gilt spandrels of a framing glass.

Inscriptions/Marks: The piece is signed on the recto in pencil in the lower right corner, "Hannah Brown." The ink inscription on the tombstone reads: "A sisters tribute to the mem/ory of her beloved Brother/Curtiss Brown who died/Dcem.ʳ 18ᵗʰ 1814 in the 9ᵗʰ/year of his age — Let this vain world engage no more/Behold the gaping tomb!" Watermarks in opposite diagonal corners of the primary support show two birds facing each other and holding twigs; watermarks in the other corners read: "H & W/Third River."

351

Condition: Conservation treatment by Christa Gaehde in 1958 included surface cleaning, repair of corner and edge tears, and backing the primary support with Japanese mulberry paper. In 1975 E. Hollyday dry-cleaned the unpainted borders and hinged the support to conservation board. Possibly original 1⅝-inch gilded cyma recta frame with applied rope twist molding and leaf decoration and a clinched hanging wire at upper top.

Provenance: J. Stuart Halladay and Herrel George Thomas, Sheffield, Mass.

Exhibited: Mourning Becomes America.

Published: Schorsch, Mourning, unpaginated, no. 208, illus. as fig. 63.

Harriot Amanda Burgess (1800–1870)

Harriot Burgess was the daughter of Benjamin (1770?–1822) and Abigail Mason Burgess (1768/9–1811) of Providence, Rhode Island. She married Daniel Pettis (or Pettey), Jr., on October 31, 1819, about two months after the completion of her work at Miss Mary Balch's school in Providence, where she received (on August 28, 1819) a printed "reward of merit" card that described her as "the young Lady, whom Miss

Balch and her Assistants shall judge most worthy to be honored."[1]

[1]The wording on the card is known only from a quotation of its text that appeared in a *Providence Journal* clipping now mounted in Scrapbook no. 42 in the library of the Rhode Island Historical Society, Providence. The clipping is undated but is believed to have been printed in the summer of 1883. A verse printed on the card is quoted in the clipping as having read: "Let wreaths of laurel twine the brow/Of him who strides in arms;/But Education should endow,/With grace, the female charms;/Be this to Her, who time improves,/Nor in the path of ignorance moves."

The clipping and Burgess family genealogical data were brought to AARFAC's attention by Betty Ring to AARFAC, April 25, 1975.

352 Burgess Memorial 71.604.1

Harriot Amanda Burgess
Providence, Rhode Island, possibly 1819
Silk and silk chenille embroidery with watercolor on a satin-weave silk ground
20 1/16" x 24 1/16" (51.0 cm. x 61.1 cm.)

The distinctive techniques Harriot Burgess used to embroider the exacting tomb inscriptions, to imitate veined marble, and to render the different types of foliage seen in her memorial are among the factors that make this composition readily attributable to Miss Balch's school.[1] Harriot's embroidery was dedicated to two brothers who died as young children and to her mother. The face and hand of the youthful mourner kneeling at the base of the principal monument are painted, as is the sky.

Inscriptions/Marks: Lettered in gold leaf at bottom center of the reverse-painted black glass mat is "HARRIOT A. BURGESS." The left tomb has an embroidered inscription that reads: "Consecrated/to/the memory/of/JOB M. BURGESS,/who was born April 19, 1802./and died May 16th, 1802./aged 27 days./And/BENJAMIN B. BURGESS,/who was born Oct. 23rd, 1803./and departed this life May 3rd, 1806./aged 2 years and 7 months." Below the preceding is "Grieve not fond Parents at thy infants doom,/Early their path was open'd to the tomb,/Early, to thee they bade a last adieu,/And closed their eyes upon this earth and you." The embroidered inscription on the right tomb reads: "Consecrated to the remains/of/Mrs. ABIGAIL BURGESS,/consort of Mr. Benjamin Burgess, who died/Sept. 17th, 1811. in the 43rd year of her age." Below the preceding is "Her tranquil soul has took its flight,/To that immortal rest–/Where troubles cease, and sorrows end,/Within her peaceful breast."

Condition: In 1975 E. Hollyday removed the embroidery from the stretchers to which the silk's linen edging had been nailed and remounted it by stitching the linen edging to muslin-covered conservation board. Original 2-inch gilded cyma recta white pine frame with applied rope twist molding, and reverse-painted black glass mat with gold leaf striping and inscription.

Provenance: Bequest of John Law Robertson, Scranton and Montrose, Pa.

Exhibited: "A Time to Mourn," Brandywine River Museum, Chadds Ford, Pa., January 17–May 17, 1981.

[1]For related examples see no. 353 and Ring, Virtue, fig. 82, p. 178.

352 *Burgess Memorial*, Harriot Amanda Burgess

Mary Cushman
(1799–?)

Mary Cushman was born December 10, 1799, the only daughter of Jacob (1744–1802) and Mary Tiffany Cushman, both of Attleboro, Massachusetts, who were married there June 23, 1799. She married Harvey Ide, also of Attleboro, on June 10, 1822.[1]

[1]These data are from the vital records of Attleboro to 1850 and were supplied by Virginia Bonner, Genealogical Department, Attleboro Public Library, to AARFAC, July 2, 1974.

353 Memorial to Jacob Cushman 39.604.1

Mary Cushman
Providence, Rhode Island, ca. 1815–1820[1]
Silk and silk chenille embroidery with watercolor on a satin-weave silk ground
15 $^{13}/_{16}$" x 15 $^{1}/_{8}$" (40.2 cm. x 38.4 cm.)
(Reproduced on page 400)

The superior quality of the needlework and the distinctive abstract form of the grieving figure beside a large marbleized monument indicate that this mourning embroidery was completed at Miss Mary Balch's school in Providence while Mary Cushman was a student there.[2] Miss Balch's pupils were taught to combine silk threads of contrasting colors to simulate marble tombstones and to produce glistening foliage in the willow trees. There the leaves are worked in a fly-stitch over a partly solid-stitched ground. The meticulous execution of embroidered inscriptions done in very fine black silk is another characteristic of memorials from Miss Balch's school.[3]

After the embroidery was finished it was handsomely framed in a molded black frame with a gilded rope insert and a reverse-painted black glass mat with the maker's name lettered in gold leaf by the Providence firm of Peter Grinnell and Son.

It should be noted that the fashionable marble tomb that Mary carefully embroidered bears no resemblance to the simple, upright limestone slab with a relief-carved swagged urn that still marks Jacob Cush-

man's grave in the Newell Cemetery in South Attleboro, Massachusetts.[4] However, the stone inscription on the grave echoes the same positive attitude toward the hereafter expressed in Mary's embroidered sentiment: "Believe, and look with triumph on the tomb!"[5]

Inscriptions/Marks: Lettered in gold leaf at the bottom center of the reverse-painted black glass mat is "MARY CUSHMAN." The inscription embroidered on the tomb reads: "Sacred to the memory/of/Lieut. JACOB CUSHMAN,/who departed this life Nov. 14th, 1802./in the 29th year of his age./Believe, and look with triumph on the/Tomb!" The original printed framer's label reads: "LOOKING-GLASS & PICTURE FRAME/MANUFACTORY,/PROVIDENCE./Looking-Glasses in Gilt and Mahogany Frames, of/the newest fashions, constantly on hand, at wholesale/and retail; Gilt Frames and Glasses, for all kinds of/Needle Work, Portraits and Pictures; Looking-Glass/Plates, Window-Glass of every size, Linseed, Lamp/and Whale Oil, with a large assortment of Paints,/Ship Chandlery and Hard Ware./PETER GRINNELL & SON,/Main-Street, nearly opposite the Providence Bank."

Condition: Unspecified treatment, probably by Kathryn Scott in the 1950s, included adhering silk-on-linen support to netting. Original reverse-painted glass mat and original 1⅝-inch cyma recta white pine frame, painted black, with applied, gilded rope twist molding.

Provenance: Gift of Mrs. Henry T. Dumbell, Providence, R.I.

Exhibited: AARFAC, September 15, 1974–July 25, 1976; "The Tastemakers," The Virginia Museum of Fine Arts, Richmond, Va., January 18–February 24, 1957.

Published: AARFAC, 1940, p. 28, no. 93; AARFAC, 1957, p. 373, no. 361; AARFAC, 1974, p. 37, no. 29.

[1]The date range given here is based on the period when Peter Grinnell is known to have used the label found on this picture's original frame. See *Inscriptions/Marks* above. A Grinnell label identical to AARFAC's is illustrated as fig. 8 on p. 216 in Ring, Grinnell.

[2]See Ring, Virtue, fig. 36, p. 160, for illustration of a Washington memorial published in 1800 by Akin and Harrison of Philadelphia. This print features the figure of a weeping woman that became the basis for many of the draped figures seen in Balch school embroideries. See nos. 100, 352, 360, and 370 for examples of other embroidered pictures worked at Mary Balch's school; see also Ring, Virtue, fig. 84, p. 180, for a memorial by Almyrah Peck that is very similar to Mary Cushman's.

[3]See Ring, Virtue, pp. 158–161.

[4]Letter and photographs from Virginia Bonner to AARFAC, July 11, 1979.

[5]The rhymed inscription carved on Jacob Cushman's gravestone reads: "Departed friend, why should I mourn/Or tread dark melancholy's plains/Why should I dew with tears the urn you are in/That now preserves thy dear remains."

Isabella Caldwell Dana
(1789–1805)
Sarah Sumner Dana
(1791–1867)

See Dana entry in "Literary and Historical Subjects" for biographical information.

354

354 Dana Family Memorial 79.604.1

Isabella Caldwell Dana and Sarah Sumner Dana
Dorchester, Massachusetts, probably 1804–1806
Silk embroidery and watercolor on a satin-weave silk ground
19½" x 12" (49.5 cm. x 30.5 cm.)

While some mourning pictures honor relatives a young artist never knew, this composition is a poignant reminder that other memorials were worked by schoolgirls while they were grieving over immediate and personal losses. The piece was started by Isabella Caldwell Dana, probably in 1804, or about the same time that her sister, Sarah Sumner Dana, began her handsome needlework picture of Palemon and Lavinia (no. 152). Their embroidery indicates that both girls were students at Mrs. Saunders and Miss Beach's Academy in Dorchester, Massachusetts, a school that encouraged the production of delicate and sophisticated pictorial needlework.[1] In this scene the girls'

white dresses, the entwined oaks, the monument, and much of the landscape are meticulously stitched, while the figures' heads and arms, the sky, a pond that reflects the willow embroidered above it, and a wooded landscape at the right are painted.

The massive, truncated obelisk, which probably derives from an unidentified printed Washington memorial, suggests that Isabella intended to dedicate her picture to her recently deceased father, Josiah Dana (1742–1801), a Congregational minister of Barre, Massachusetts. After Isabella died in 1805, a bereaved Sarah finished her sister's embroidery and added both Isabella's name and that of their mother, Sarah Sumner Caldwell Dana, who died less than two months after her sixteen-year-old daughter.[2]

Inscriptions/Marks: In gold leaf along the lower edge of the black glass mat is "FINISHED BY SARAH S. DANA"; embroidered on the scroll on the monument is " 'Virtue a./lone has ma./jesty in/ Death, and/greater still,/the more the/tyrant Frow./ns' "; on the plinth is "In Memory/of/the Rev^d Josiah Dana Ob^r Oct^r 1^st 1801/AE 59^yrs/of Mrs Sarah Dana who died Nov^r 14^th/1805 AE 51^yrs and of/ Miss I. C. Dana who died Sep^r 21^st/1805 AE 16^yrs"; and at the bottom is "This device was begun by Isabella Caldwell Dana who died ere it was finished/'Early bright transient, chaste, as morning dew,/She sparkled, was exhal'd, and went to Heav'n.' "
Condition: In 1981 E. Hollyday removed the silk embroidery and its linen canvas secondary support from an acidic backing and remounted them onto muslin-covered conservation board. Original 2-inch gilded, cove-molded white pine frame with applied rope twist molding and molded plaster egg and dart motif around the inner edge. The frame also retains its original reverse-painted black glass mat with gold leaf inscription and striping.

355

Provenance: Purchased from Katrina Kipper, Accord, Mass., in February 1935 for use at Bassett Hall, the Williamsburg home of Mr. and Mrs. John D. Rockefeller, Jr.
Published: Ring, Needlework, p. 479, illus. as pl. III on p. 477; Rumford, Bassett Hall, illus. as fig. 4 on p. 58.

[1]See Ring, Needlework, pl. III, p. 477, for information about two similar embroidered memorials done about the same time and attributed to Mrs. Saunders and Miss Beach's Academy.
[2]All data on the Dana family are from Elizabeth Ellery-Dana, *The Dana Family in America* (Cambridge, Mass., 1956), pp. 72–74.

Samuel Folwell
(1764–1813)

See Folwell entry in "Paper Cutwork, Valentines, and Miscellaneous Decorative Pictures" for biographical information.

355 Rest in Peace — Mourning Picture 56.604.2

Attributed to Samuel Folwell and an unidentified needleworker ("K. M.")
Philadelphia, Pennsylvania, 1804
Silk and silk chenille embroidery with ink and watercolor on a satin-weave silk ground
23 ¼" x 23 ¼" (59.1 cm. x 59.1 cm.)

The subtle allegorical allusions, the complexity of the composition, the handling of the painted details, and the manner in which colored silks and stitches are combined in this memorial picture provide convincing evidence that it was designed by Samuel Folwell and worked by an unidentified needleworker under the tutelage of his wife, Ann Elizabeth Gebler Folwell, at her embroidery school in Philadelphia.[1]

Although the romantic landscape setting and charming female figures tend to de-emphasize the mourning iconography, the scene honors the memory of George Washington. His home, Mount Vernon, is depicted in the background, silhouetted against seven flame-shaped poplar trees. The figure enshrined in a small neoclassic temple at the left represents Liberty, shown carrying the manumitting rod and cap that symbolize personal freedom. The young woman holding a slender garland in her outstretched hands personifies Peace, while her companion with the cornucopia is emblematic of Plenty.

The baskets of flowers in the foreground, together with the vignette of a small child hugging a lamb, add

to the scene's pastoral quality, which is further enhanced by abundant foliage and a receding lawn, where stitches, colors, and thickness of thread have been carefully selected to approximate the textures and shadings of nature.

A tiny inscription below the epitaph records that this unusual mourning embroidery was worked by "K. M." in 1804. The extensive use of chenille thread at this early date further substantiates the Philadelphia provenance.[2]

Inscriptions/Marks: The tomb is inscribed in ink: "REST/IN/ PEACE/KM/1804."
Condition: No record of conservation treatment. Modern replacement 2¼-inch gilded flat circular frame of oak or chestnut with molded inner and outer edges.
Provenance: John Kenneth Danby, Wilmington, Del.
Published: Parke-Bernet Galleries, Inc., *Important American Furniture and Decorations . . . : Property of the Estate of the Late John Kenneth Danby, Wilmington, Del. — Part I,* catalog for sale no. 1696, October 11–13, 1956, p. 26, lot no. 174, illus. on p. 25.

[1]Betty Ring to AARFAC, October 5, 1985.
[2]Ibid.

356 Memorial to George Washington 56.604.1

Attributed to Samuel Folwell and an unidentified needleworker
Philadelphia, Pennsylvania, ca. 1805
Silk embroidery with ink and watercolor on a satin-weave silk ground
16⅞" x 20¾" (42.9 cm. x 52.7 cm.)

This allegorical composition is typical of a large group of embroidered memorials honoring George Washington that have long been associated with Philadelphia. Davida Deutsch's research has established that the most accomplished examples of this popular format are the result of an enterprising collaboration between Samuel and his wife, Ann Elizabeth Folwell.[1]

Folwell developed his own designs, sometimes appropriating motifs from printed sources.[2] After sketching a basic layout in grisaille on a silk ground, Folwell then gave the design to a student who worked out her combination of threads, colors, and stitches under Mrs. Folwell's supervision. After the needleworker completed the stitching, Samuel Folwell added painted backgrounds, faces, and other details, and an inscription.

The design of this embroidery is closely related to that of a signed memorial to Washington that Samuel Folwell painted in watercolor on silk about 1800.[3] The mourner (who wears white, with her luxuriant long curls partially covered by a black veil), the monument,

the garland over the urn, the hilly landscape, the crossed tree trunks, and the eagle and cherub emerging from the sky are nearly identical in the two pieces. The chief difference is the addition of the figure of a doleful soldier leaning on the butt of his rifle on the left side of the embroidered piece.[4]

The needlework was proficiently done with carefully stitched, striated bands of color used to define the willow branches and the undulating ground. The small painted portrait of Washington was quickly executed but is nonetheless recognizable. Other painted details include small, finlike hands, profiled heads with classical features, and a cloudy sky partly obscuring an eagle and a trumpeting angel bearing a laurel wreath.

Inscriptions/Marks: An ink inscription on the upper section of the monument reads: "THY/LOSS EVER SHALL/WE/MOURN," and on the face of the plinth below is "SACRED/TO THE MEMORY OF/THE/ ILLUSTRIOUS/WASHINGTON."
Condition: No record of previous conservation treatment. Probably period replacement 1½-inch flat white pine frame with scooped inner lip, quarter-round outer edge, and replacement reverse-painted black glass mat with band of gold leaf striping and spandrel decoration.
Provenance: John Kenneth Danby, Wilmington, Del.
Exhibited: AARFAC, September 15, 1974–July 25, 1976.
Published: AARFAC, 1974, pp. 37–38, no. 30; Thomas M. Boyd, "Death of a Hero, Death of a Friend: George Washington's Last Hours," *Virginia Cavalcade,* XXXIII (Winter 1984), illus. on p. 140; Parke-Bernet Galleries, Inc., *Important American Furniture and Decorations . . . : Property of the Estate of the Late John Kenneth Danby, Wilmington, Del. — Part I,* catalog for sale no. 1696, October 11–13, 1956, p. 27, lot no. 183; Rumford, *Memorial Watercolors,* p. 688, illus. as pl. III on p. 691; Schorsch, *Key,* p. 52, illus. as fig. 16 on p. 53.

[1]Deutsch.
[2]Folwell may have been inspired by a Washington memorial print engraved by E. G. Gridley after a painting by John Coles, Jr., that shows a mourning soldier, a liberty cap, and the partial wording, "truly illustrious George Washington." See *Antiques,* LXIX (February 1956), p. 134.
[3]Schorsch, *Key,* figs. 1 and 2, p. 61.
[4]For related examples attributable to the Folwells, see Schorsch, *Key,* fig. 17, p. 54; Deutsch, fig. 1, p. 420; Deutsch and Ring, pl. XII, p. 417; and Margaret B. Schiffer, *Historical Needlework of Pennsylvania* (New York, 1968), pl. IV, opposite p. 112.

357 Memorial to George Washington 79.604.5

Attributed to Samuel Folwell and Evelina Moore
Philadelphia, Pennsylvania, ca. 1805
Silk and silk chenille embroidery with ink and watercolor on a ground of satin-weave silk pieced out with linen[1]
16⅞" x 22⅜" (42.9 cm. x 56.8 cm.)

356

357

The techniques used to depict the embroidered foliage and the girls' dresses, the design and placement of the neoclassic monument, and the treatment of the painted sky and the girls' hair, faces, and flipperlike hands are characteristics shared by a large number of silk embroideries attributed to the Folwell school in Philadelphia (see also nos. 324, 355, and 356).

Evelina Moore's identity eludes discovery. The verse inscribed on the monument's base reveals that the dejected figure symbolizes Virtue, while the girl decorating the urn represents Glory.[2]

Inscriptions/Marks: Lettered in gold leaf on the replacement black glass mat is "SACRED TO THE MEMORY OF THE ILLUSTRYOUS WASHINGTON./EVELINA MOORE." An ink inscription in the oval reserve on the face of the plinth reads: "Glory bring thy fairest wreath,/Place it on the Hero's urn;/While Virtue's tears attest the worth/Of him, for whom Columbians mourn."

Condition: In 1983 E. Hollyday removed the silk and its linen secondary support from an acidic mount, tacked down loose embroidery threads and resecured a separated area in the pond, and remounted the piece by stitching its linen secondary support to muslin-covered conservation board. Original 3-inch, cove-molded gilded frame with an applied band of molded oak leaves and acorns, with scallop shells at the corners, an egg and dart motif around the inner edge, and a quarter-round outer edge decorated with molded floral ornamentation. Christine J. Steele provided a new black and gold leaf glass mat in 1955.

Provenance: Purchased by Holger Cahill from Madeline Jordan, Washington, D.C., in October 1935 for use at Bassett Hall, the Williamsburg home of Mr. and Mrs. John D. Rockefeller, Jr.

Published: Ring, *Needlework,* p. 480, illus. as pl. VII on p. 479.

[1]The silk ground is pieced out along a selvage edge with a vertically oriented strip of finely woven linen that measures 1⅝ inches wide by sight (its far left edge is under the glass mat).

[2]For other Washington memorials attributed to the Folwells and having similar monuments and positioning of figures, see Deutsch and Ring, pls. X and XI on p. 416.

Oliver B. Goldsmith
(ca. 1815–?)

358 Memorial to George Washington 71.304.1

Oliver B. Goldsmith
Probably New Suffolk, Long Island, New York, 1828
Watercolor, pencil, and ink on wove paper
8⅞″ x 8″ (22.5 cm. x 20.3 cm.)

Young Oliver Goldsmith derived the design of his memorial to the nation's first President from an 1801 engraving by T. Clarke of Boston. The primary elements appear to have been traced directly from the

358

printed source. To compensate for inadequate technical skills, the twelve-year-old used bright colors and eliminated various details found in his model. The figure with the anchor represents Hope; for another version of Hope and the tomb, also copied from the Clarke engraving, see no. 378.

Goldsmith's *Memorial to George Washington* was one of a group of ten drawings by him found in a house in New Suffolk, Long Island, New York; one of the other pieces is dated April 4, 1826.[1] It is not yet known whether the Folk Art Center's artist was the same Oliver B. Goldsmith who produced a number of calligraphic specimens in the mid–nineteenth century.[2]

Inscriptions/Marks: In brown ink in the bottom margin is "Oliver B Goldsmiths Painting Aged 12 year jan.ᵗʰ3 1828"; below the rondel is "Sacred to the Memory of the Illustrious G Washington"; on the face of the tomb is "G WASHINGTON" and "There is/Rest in/Heaven."

Condition: Conservation treatment by E. Hollyday in 1977 included surface-cleaning the primary support, bathing it to reduce acidity and staining, backing it with Japanese mulberry paper, and hinging it to conservation board. Modern ¾-inch cyma recta frame, painted black.

Provenance: Found in New Suffolk, Long Island, N.Y., by Ross and Mildred Piggott, Kinderhook, N.Y.; gift of Mary Allis, Fairfield, Conn.

Published: Rumford, Memorial Watercolors, p. 688, illus. as fig. 2 on p. 689.

[1]The ten drawings are mentioned in the artist's biographical entry in *The Paper of the State,* an unpaginated catalog for an exhibition

held at the Museum of American Folk Art in New York City in 1976 (exact dates unknown); four of these drawings are listed therein as nos. 161–164.

[2]See Oliver B. Goldsmith, *Goldsmith's Gems of Penmanship, Containing Various Examples of the Calligraphic Art, Embracing the Author's System of Mercantile Penmanship* (New York, 1845); Oliver B. Goldsmith, *Gray's Elegy, in Calligraphic Costume* (New York, 1860); and Oliver B. Goldsmith and Willis J. Renville, *Goldsmith's System of Double Entry Bookkeeping . . . Also, a Vocabulary of Mercantile Terms & Various Commercial Calculations* (New York, 1859). An illustration from the first of these citations appears in John and Katherine Ebert, *American Folk Painters* (New York, 1975), p. 169.

Louisa F. Miller
(active ca. 1832)

359 **Memorial to John Constantine Miller** 58.604.1

Louisa F. Miller
Lititz, Pennsylvania, 1832
Watercolor, ink, and embroidery in silk and silk chenille with gold metallic thread and ribbon and sheer silk collage elements on a twill-weave silk ground
18¾" x 19½" (47.6 cm. x 49.5 cm.)

The application of collage elements of ribbon and silk gauze to needlework pictures is a characteristic of embroidery produced at Moravian schools.[1] The collage designs that distinguish this composition include the ribbon-work basket of flowers on the ground at right, the wreath supported by a lyre-shaped device, and the huge spray of pink roses being lifted onto the tomb by the small girl in white.

Nearly identical collage details appear on an unusually well documented and very similar memorial made in 1828 by Catherine Amanda Slaymaker while she was a student at Linden Hall, a Moravian school for girls in Lititz (Lancaster County), Pennsylvania.[2] A check of surviving records for this school confirms that Louisa Miller of York, Pennsylvania, was enrolled at Linden Hall in 1829; her father was listed in the school catalog as "Rev. Constantine Miller."[3] It is hoped that continuing research will eventually uncover biographical information about the maker of this striking embroidery and the circumstances surrounding its creation.

Inscriptions/Marks: An ink inscription on the upper part of the monument reads: "Louisa F. Miller./1832." The base of the monument bears the inscription "In Memory of my beloved Father,/John Constantine Miller,/born Sept. 24th 1762, departed/this Life Sept. 30th 1821./Aged 59 years & 6 days."

359

Condition: Unspecified conservation treatment was performed by Kathryn Scott in 1961. Period replacement 2-inch splayed gilded white pine frame with a scooped inner lip and a quarter-round outer edge.
Provenance: J. Stuart Halladay and Herrel George Thomas, Sheffield, Mass.
Exhibited: Halladay-Thomas, New Britain, and exhibition catalog, no. 64; Hollins College, 1975, and exhibition catalog, no. 2.

[1]Margaret B. Schiffer, *Historical Needlework of Pennsylvania* (New York, 1968), pp. 105–121.
[2]Catherine Amanda Slaymaker's memorial to her father, William, is in a private collection, together with her copybook of letters written from Lititz, wherein she mentions her embroidery several times. In two entries for February 1829, she notes that the piece has been sent to "the painters," which suggests that the church, face, arms, and inscription on Louisa Miller's embroidery may also have been added by a professional artist living in or near Lititz.
[3]Patricia Herr to AARFAC, June 7, 1985.

Sylvia Peirce
(1792–1882)

Sylvia Peirce was about eighteen and a student at Mary Balch's school in Providence, Rhode Island, when she worked her memorial to members of the Tingley family. She was the daughter of Jeremiah (d. 1858) and Martha ("Patty") Tingley Peirce (also spelled "Pierce"; 1767–1849), both of Attleboro, Massachusetts; she married Augustus Sanders of Providence on January 27, 1814.[1]

[1]Marian W. Frye, *The Tingley Family Revised*, I (Ann Arbor, Mich., 1970), pp. 20 and 184.

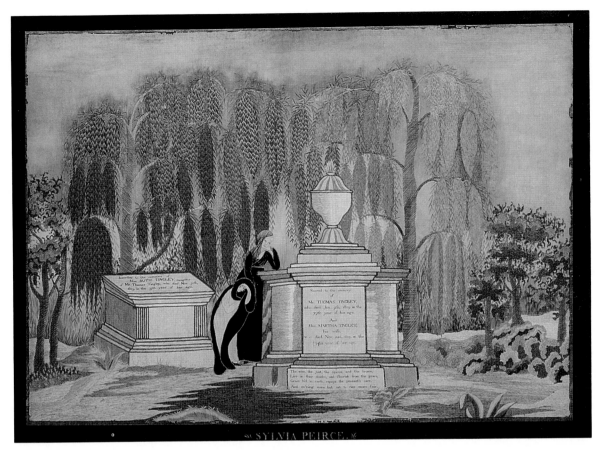

360

360 Tingley Memorial

Sylvia Peirce
Providence, Rhode Island, probably 1809–1813
Silk and silk chenille embroidery with
watercolor on a satin-weave silk ground
20″ x 27¹⁵⁄₁₆″ (50.8 cm. x 71.0 cm.)

79.604.2

Sylvia Peirce worked this mourning embroidery hon-
oring her maternal aunt and grandparents at Mary
Balch's school about a decade before Harriot Burgess
completed hers (see no. 352). While the form and de-
tails of the elaborate monuments and mourners vary,
the pictures share fly-stitched willow branches, care-
fully shaded chenille threads to simulate heavier fo-
liage, and painted skies and flesh.[1] Both scenes are
meticulously embroidered, using many of the same
techniques, and the difficult silk lettering is perfectly
executed.

The slate headstones for Ruth, Thomas, and Mar-
tha Tingley survive in Newell Cemetery, South Attle-
boro, Massachusetts, along with the marker for Jacob
Cushman (see no. 353). None of the actual grave-
stones bears any resemblance to the considerably
larger and more stylish neoclassic monuments de-
picted in the memorials stitched by Cushman and Tin-
gley descendants under the instruction of Miss Balch
and her associates.[2]

Inscriptions/Marks: Old photographs show that the gold inner
border of the reverse-painted glass mat once bore the inscription in
black: "SACRED WILL I KEEP THY DEAR REMAINS." However, only
the first three letters are still visible. Lettered in gold leaf on the
lower border of the black glass mat is "SYLVIA PEIRCE." Stitched in
fine black silk thread on the monument at the left is "Inscribed to
the remains of/Miss RUTH TINGLEY, daughter/of Mr. Thomas Tin-
gley, who died Nov. 3ᵗʰ,/1803, in the 39ᵗʰ year of her age." On the
plinth of the larger tomb is stitched: "Sacred to the memory/of/Mr.
THOMAS TINGLEY,/who died Jan. 9th, 1809, in the/77ᵗʰ year of his
age./And/Mrs. MARTHA TINGLEY,/his wife,/who died Nov. 22d,
1805, in the/[74]th year of her age." On the base of the same tomb
is stitched: "The wise, the just, the copious, and the brave,/Live in
their deaths, and flourish from the grave,/Grain hid in earth, repays
the peasant's care,/And ev'ning suns but set to rise more fair."
Condition: In 1982 E. Hollyday removed the embroidery and
its linen secondary support from wood stretchers and remounted the
piece by stitching the linen to muslin-covered conservation board.
Original 1⅝-inch cyma recta frame, painted black, with applied
rope twist ornament, painted gold, and original reverse-painted
black glass mat with gold leaf decoration. The frame and glass are
attributed to the shop of Peter Grinnell and Son of Providence, R.I.[3]
Provenance: Purchased from Edith Gregor Halpert, Down-
town Gallery, New York, N.Y., on November 17, 1938, for use at
Bassett Hall, the Williamsburg home of Mr. and Mrs. John D.
Rockefeller, Jr.
Exhibited: "Children in American Folk Art, 1725 to 1865,"

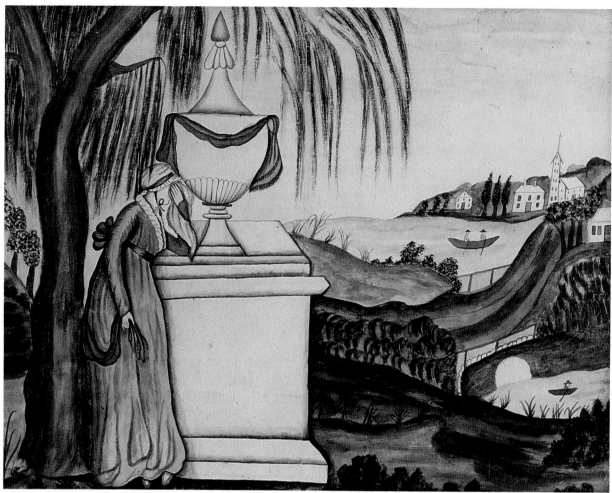

361

Downtown Gallery, New York, N.Y., April 13–May 1, 1937, and exhibition catalog, no. 35.
 Published: Ring, Needlework, p. 480, illus. as pl. V on p. 478.

[1]The design source for the distinctive Balch school monuments has not been identified; see Ring, Virtue, fig. 36, p. 160, for illustration of a printed Washington memorial whose weeping figure inspired the smaller figure in Sylvia Peirce's composition.
 Betty Ring's research has uncovered school bills that indicate that Miss Balch or her assistants painted the pictures' figures for their students. See Ring, Virtue, p. 158.
[2]Virginia Bonner to AARFAC, November 12, 1982.
[3]For information about the Grinnells, see Ring, Grinnell.

Eunice Pinney
(1770–1849)

See Pinney entry in "Scenes of Everyday Life" for biographical information.

361 Willow, Grave, and Woman Weeping 58.304.3

Attributed to Eunice Pinney
Connecticut, ca. 1815
Watercolor on wove paper
12¾" x 15⅞" (32.4 cm. x 40.3 cm.)

Four undedicated memorials by Pinney have been recorded to date.[1] *Willow, Grave, and Woman Weeping* is atypical of the artist's mourning pictures in that it includes a single major figure, rather than a group of them, but the distraught woman's pose is very similar to others created by the artist.[2] Two other Pinney mourning pictures include a distant vignette of figures boating on a body of water with buildings beyond, and one of these, an 1813 memorial that Pinney dedicated to herself, contains a landscape that is nearly identical to the right-hand background seen here.[3]

Condition: Treatment by an unidentified conservator prior to acquisition included backing several tears with paper tapes. In 1974 E. Hollyday removed these tapes, rebacked the tears, filled and inpainted two sizable losses at the upper left corner and in the top edge, reduced acidity and spot-bleached some stains, and mounted the primary support on Japanese mulberry paper. Period replacement 1⅜-inch molded and gilded cyma recta frame.

Provenance: J. Stuart Halladay and Herrel George Thomas, Sheffield, Mass.

Published: Lipman, Pinney, p. 221, no. 34.

[1]The three others are in the Museum of Fine Arts, Boston (acc. no. 52.1632), in the New York State Historical Association, Cooperstown, N.Y. (negative no. L-272), and in a private collection.

[2]Including study sketches, Jean Lipman in 1943 recorded ten mourning pictures by the artist (Lipman, Pinney, p. 221). AARFAC research has located all but one of these (the *Memorial for Oliver Holcombe* that Lipman credited to the collection of Sophia Phelps Tuttle) and has expanded the list by two (although Lipman may have included these in her reference to a number of miscellaneous watercolors for which descriptions were not available). The figure in the Folk Art Center's picture corresponds closely to other Pinney figures seen in the first two watercolors listed in note 1 and to figures in two other works owned by the New York State Historical Association, Cooperstown, N.Y.: a *Memorial (for Herself)* (negative no. L-270) and a *Memorial for Diadama Pinney* (negative no. L-271).

[3]The New York State Historical Association's *Undedicated Memorial* (negative no. L-272) has a landscape background of similar inspiration, while a nearly identical right-hand scene appears in a *Memorial for Eunice Pinney* in the Museum of Fine Arts, Boston (acc. no. 60.472).

Lucinda Storrs
(1792–1814)

362 Memorial to Luther Storrs 79.604.4

Lucinda Storrs
Possibly Lebanon, New Hampshire, 1808
Silk embroidery with watercolor on a satin-weave silk ground and with printed tomb inscriptions on a plain-weave silk ground
18¼" x 18" (46.4 cm. x 45.7 cm.)

A widely circulated Washington memorial print published by Pember and Luzarder in 1800 provided the design source for the tomb, trumpeting angel, and inscription on the angel's banner, which Lucinda Storrs incorporated in this mourning embroidery honoring her older brother Luther (1784–1804), a Dartmouth graduate who taught on Long Island for two years before his sudden death.[1] He was the second and Lucinda the eighth and last child born to Constant (1752–1828) and Lucinda Howe Storrs (1758–1839), who were originally from Mansfield, Connecticut, but

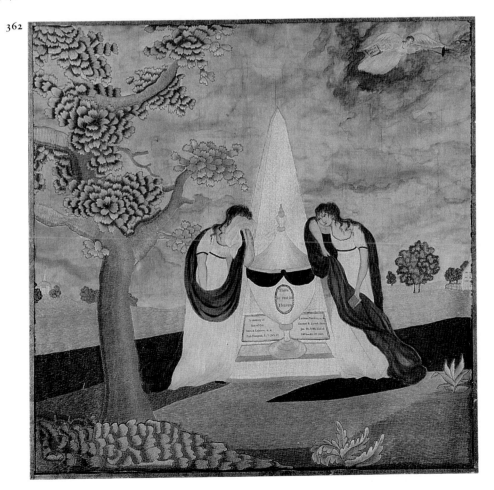

362

who moved to Lebanon, New Hampshire, early in their marriage. Constant Storrs prospered at farming and was a much-respected citizen of Lebanon.

At the time she created Luther Storrs's memorial, Lucinda was probably sixteen and attending a yet to be identified New England school where needlework was an important part of the curriculum. A similarly framed and closely related embroidered memorial featuring the same design elements and distinctive stitchery was made by Sophia Tupper Willis of Rochester, Massachusetts, in 1809.[2]

Inscriptions/Marks: Inscribed in gold leaf on the reverse-painted black glass mat is "Executed by Lucinda Storrs. 1808." There are two inscriptions printed with type on the monument; on the urn is "There/is rest in/Heaven," and beyond it is inscribed "In memory of Luther Storrs, A.B./Son of Col. Constant & Lucinda Storrs/born at Lebanon, N.H. Jan. 18, 1784, died at/East-Hampton, L.I. July 19, 1804 — AEt. 20 years." In ink script on the angel's banner are the words, "Tears of/Affection."

Condition: In 1982 E. Hollyday removed the silk embroidery and its linen secondary support from an acidic mount to which they were nailed; she then remounted the piece by stitching the linen to muslin-covered conservation board. Original 1½-inch cyma recta gilded white pine frame with original reverse-painted black glass mat with gold leaf striping and inscription.

Provenance: Purchased from Edith Gregor Halpert, Downtown Gallery, New York, N.Y., February 19, 1936, for use at Bassett Hall, the Williamsburg home of Mr. and Mrs. John D. Rockefeller, Jr.

Published: Ring, Needlework, p. 479, illus. as pl. I on p. 476.

[1]The Washington memorial print source is illustrated in Ring, Virtue, as fig. 35 on p. 159. Genealogical and biographical information in this entry is from Charles Storrs, *The Storrs Family* (New York, 1886), pp. 312–315. Comments on the premature deaths of Luther and Lucinda appear in an unpaginated manuscript diary kept by their mother and now in the collection of the Connecticut Historical Society, Hartford. Portraits of Constant and Lucinda Howe Storrs by William Jennys are owned by the Pennsylvania Academy of Fine Arts in Philadelphia and are illustrated in the *Connecticut Historical Society Bulletin*, XX (October 1955), as figs. 16 and 17 on pp. 110–111; information about the two paintings appears on p. 128.

[2]Ring, Needlework, p. 476; illustrated in Sotheby Parke Bernet, Inc., *Fine American Furniture and Related Decorative Arts*, catalog for sale no. 4590Y, April 29–30 and May 1, 1981, lot no. 692.

363

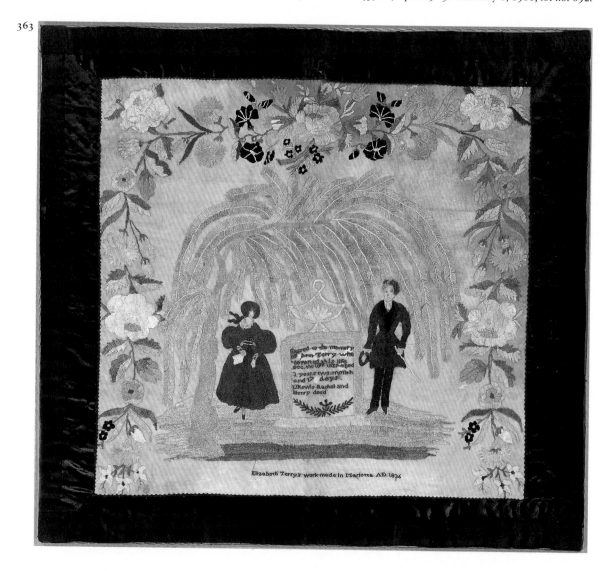

Elizabeth Terry
(active ca. 1836)

363 Terry Family Memorial 62.604.1

Elizabeth Terry
Marietta, Pennsylvania, 1836
Silk embroidery with watercolor, wire, and hair
on a plain-weave linen ground with a silk
ribbon border
17½" x 19" (44.5 cm. x 48.3 cm.)

Although to date no genealogical information has been
found on Elizabeth Terry, almost certainly she was a
student when she worked this piece; she may have
attended Mrs. Buchanan's School, which was in oper-
ation in Marietta at the time. Interestingly, a nearly
identically composed picture made by Mary Belcher is
inscribed with the place name of nearby Maytown and
the year 1838, which suggests that Mrs. Buchanan
shared her pattern with her counterpart there, a Mrs.
Welchan.[1] Pennsylvania characteristics of both pieces
include a black ribbon border and a floral chain dom-
inated by carnations and roses at the top and sides.[2]

In addition to the lengthy gravestone inscription,
several symbols identify Elizabeth Terry's picture as a
memorial: the urn-capped tombstone, a large weeping
willow, and sorrowful figures dressed in black. In this
work, as was frequently done, some features of the
mourners' faces have been painted onto the support
rather than embroidered. The hair on their heads is
real hair worked in satin stitches. A small coil of wire
tucked into the waistband of the woman's dress may
have been intended to represent a pendant, a watch, a
belt buckle, or a chatelaine.

Inscriptions/Marks: An embroidered inscription on the face of
the plinth reads: "Sacred to the Memory/of Ann Terry who/departed
this life/Dec. the 18th 1829 aged/3 years two month/and 17 days./
LIkewis [sic] Rachel and/Henry dec'd"; embroidered below the
mourning vignette is "Elizabeth Terry's work made in Marietta AD
1836".
Condition: In 1975 E. Hollyday removed an acidic secondary
support, surface-cleaned the textile, then stitched the piece to crepe-
line sewn to a muslin-covered conservation board. Period replace-
ment 2-inch gilded cyma recta frame.
Provenance: Mary Jennings, Lahaska, Pa.
Exhibited: AARFAC, New Jersey; AARFAC, South Texas; Goe-
thean Gallery.

[1] Betty Ring to AARFAC, May 24, 1976. The Belcher picture is owned
by the Cooper-Hewitt Museum in New York City.
[2] Margaret B. Schiffer, *Historical Needlework of Pennsylvania* (New
York, 1968), pp. 17–88.

Elizabeth Thurston
(active ca. 1815)

364 Memorial to Pardes Thurston 58.404.1

Elizabeth Thurston
Probably Massachusetts, ca. 1815
Watercolor and ink on a plain-weave silk
ground
18¼" x 22¼" (46.4 cm. x 56.5 cm.)

Good draftsmanship and vibrant colors applied with
a taut, nervous brush are effectively combined in this
unusual composition that is remarkably successful in
expressing a profound sense of personal loss. Presum-
ably the foundering American ship surrounded by
flailing bodies depicts Pardes Thurston's watery fate.
The obvious symbolism of an oak cut down in its
prime indicates that the disconsolate woman is Thur-
ston's widow, whose grief is shared by two woeful
children. The identity of the distant port has not been
established, and no genealogical information on the
Thurston family has been gathered to date.

Inscriptions/Marks: An ink inscription on the tomb states: "In
Remembrance/of/Pardes Thurston." Lettered in silver in the lower
right corner of the glass mat is "Elizabeth Thurston."
Condition: Unspecified conservation treatment by Kathryn
Scott was performed in 1961. Probably original 1⅛-inch silver leaf
cyma recta frame with applied rope twist molding; the reverse-
painted black glass mat with silver leaf decoration is a replacement
that is presumed to copy the original.
Provenance: J. Stuart Halladay and Herrel George Thomas,
Sheffield, Mass.
Exhibited: "Americans and the Sea," Pensacola Museum of
Art, Pensacola, Fla., September 11–October 31, 1982, and exhi-
bition catalog, p. 19, no. 1; Halladay-Thomas, New Britain, and
exhibition catalog, no. 121; "Seascape and the American
Imagination," Whitney Museum of American Art, New York, N.Y.,
June 9–September 7, 1975.
Published: Rumford, Memorial Watercolors, illus. as pl. VII
on p. 695; Roger B. Stein, *Seascape and the American Imagination*
(New York, 1975), p. xxx, no. 98, p. 71, illus. as fig. 72 on p. 73.

Catharine Townsend Warner
(1785–1828)

Catharine Townsend Warner was born in Warwick,
Rhode Island, December 14, 1785, the second of seven
children of Thomas (1757–1815) and Mary Hill War-
ner (1762–1847). She married William Harrison on
January 1, 1816, and died September 10, 1828.[1]

[1] The data are from Florence R. Kenyon to AARFAC, November 19,
1938, and from Ring, Virtue, p. 234.

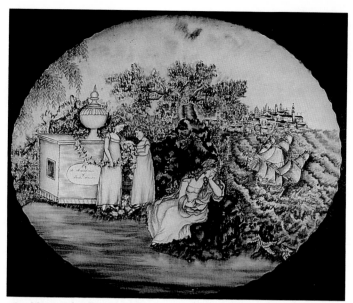

364 *Memorial to Pardes Thurston,* Elizabeth Thurston

365

365 Liberty Crowning Washington 38.604.1

Catharine Townsend Warner
Warwick, Rhode Island, ca. 1809[1]
Embroidery in silk, metallic thread, and metallic
cord with watercolor, gouache, and ink on silk
16⅜″ x 13³⁄₁₆″ (41.6 cm. x 33.5 cm.)

Although Warner's composition was probably based
on a print source, the earlier image has not yet been
identified.[2] A distant debt to Edward Savage's 1796
engraving *Liberty — In the form of the Goddess of
Youth; giving Support to the Bald Eagle* is acknowl-
edged in some details, such as the British fleet setting
sail in the background. The fact that Warner's figure
tramples on the British colors also recalls the action of
Savage's "Youth," who tramples on the key to the
Bastille, a symbol of tyranny.[3]

The liberty cap and pole borne by the Folk Art
Center's "Genius of America" help to identify the al-
legorical figure as Liberty herself. However, the trum-
pet she is also holding is usually associated with the
figure of Fame, and the artist may well have intended
a personification of these dual concepts in her homage
to George Washington.

Warner's embroidery is one of six recorded to date
that form a recognizable Warwick subgroup within
the larger body of embroidery that originated in
Rhode Island schools. The Warwick pieces all appear
to have had painted passages added by the same as yet
unidentified hand, probably the girls' teacher, possibly
Sarah Holden or a "Miss Scott."[4]

Inscriptions/Marks: Wording on the replacement glass mat
reads "THE GENIUS OF AMERICA TRAMPLING ON THE BRITISH COL-
OURS — / — AND PLACING THE LAUREL WREATH ON THE HEAD OF
WASHINGTON.*./ — CATHARINE, T, WARNER." The original printed
framer's label reads "PETER GRINNELL AND SON,/Main-street, Provi-
dence, opposite the Providence Bank,/OFFER FOR SALE,/A COMPLETE
assortment of PAINTS, OIL, WINDOW GLASS,/VARNISHES, and/SHIP-
CHANDLERY/ALSO,/Looking = Glasses,/framed in the newest and
most elegant style, and are warranted to bear the strict-/est exami-
nation. With every other article usually called for in a Ship-Chand-/
lery or Paint Store, as cheap as at any store in the State./They execute
all kinds of/HOUSE, SHIP, SIGN and ORNAMENTAL PAINTING,/polish-
ing and re-silvering old Looking-Glasses, Oil and Burnish-Gilding,
in all/their various branches. Embroidery, Looking-Glasses and Pic-
tures of every/description, framed with enamelled glasses, as usual./
All orders from the country punctually attended to, with a liberal
allowance/made to those who purchase quantities./PRINTED AT THE
PHENIX OFFICE."[5]

Condition: The piece's original painted glass was broken prior
to acquisition of the work but was retained long enough for the Folk
Art Center to have the present, reputedly exact, copy made. Unspec-
ified treatment probably by Kathryn Scott in the 1950s included
trimming the silk primary support to its present dimensions; anchor-
ing a few loose threads; backing two sizable holes in the sky and
inpainting the smaller; backing the silk with Japanese mulberry
paper; and adhering netting from the outer edges of the silk over
onto the extended surface of the Japanese mulberry paper, which
was adhered to a covered board. The Old Print Shop added strips of
wood to the perimeter of the covered board. Original 1½-inch gilded
cyma recta white pine frame with applied rope twist molding.

Provenance: Gift of Florence R. Kenyon, Providence, R.I.[6]

Exhibited: AARFAC, April 22, 1959–December 31, 1961; "Let
Virtue Be a Guide to Thee: Needlework in the Education of Rhode
Island Women, 1730–1830," traveling exhibition organized by the
Rhode Island Historical Society and shown at the Museum of Rhode
Island History at Aldrich House, Providence, R.I., November 1,
1983–January 31, 1984, and, under the title "Rhode Island Needle-
work, 1730–1830," at the Metropolitan Museum of Art, New
York, N.Y., July 19–September 23, 1984; "Seascape and the Amer-
ican Imagination," Whitney Museum of American Art, New York,
N.Y., June 9–September 7, 1975; William Penn Museum.

Published: AARFAC, 1940, p. 28, no. 95; AARFAC, 1947, p. 26,
no. 95; AARFAC, 1957, p. 254, no. 127, illus. on p. 255; AARFAC,
1959, p. 17, no. 3; Jones, illus. on p. 43 as fig. 12; Ring, Virtue, pp.
218 and 234, no. 119, illus. on p. 235; Roger B. Stein, *Seascape and
the American Imagination* (New York, 1975), p. 27, illus. as fig. 27
on p. 30.

[1]See note 5 regarding a date range for the framer's label found on
Warner's piece. Warner's age suggests that she worked her picture
toward the early side of the span; she may even have begun the work
before 1809, when this particular Grinnell label first came into use.

[2]A picture very similar to Warner's was worked by Marcy Arnold,
also of Warwick, and it is noted in Ring, Virtue, p. 234.

[3]See the entry for no. 164, which is a close copy of Savage's compo-
sition and where Savage's symbolism is discussed in greater detail.
In addition to the key to the Bastille, Savage's "Youth" tramples on
a star or sunburst decoration on a sash.

[4]See Ring, Virtue, pp. 217–218.

[5]A label identical to the Folk Art Center's is illustrated in Ring,
Grinnell, as fig. 3 on p. 213. Ring's research indicates that this label
was used between 1809 and about 1812.

[6]The Folk Art Center's donor was a granddaughter of Catharine
Townsend Warner Harrison (Florence R. Kenyon to AARFAC, No-
vember 19, 1938).

Unidentified Artists

366 Howe Memorial 70.604.1

Artist unidentified
Hingham, Massachusetts, probably 1796–1805
Silk embroidery on a satin-weave silk ground
with laid paper mat strips inscribed in ink
9½″ x 15″ (24.1 cm. x 38.1 cm.)

This small mourning embroidery may be the earliest
owned by the Folk Art Center. A fair number of me-
morial pictures commemorate eighteenth-century
deaths, but the vast majority of these appear to have
been executed in retrospect, in the early years of the
nineteenth century, amid the growing fad for such
work that is widely believed to have been initiated by
George Washington's death in December 1799.

However, in recent years, two mourning embroi-
deries bearing firm 1799 execution dates have been dis-
covered, and, interestingly, one of them is specifically

366

dated April 5, 1799, several months before the death of the first President.[1] The Folk Art Center's *Howe Memorial* is stylistically and technically linked to these two embroideries and so is believed to have been created about the same time and under the same circumstances. The two related memorials were both worked at the Derby Academy in Hingham, Massachusetts, where Elizabeth Dawes was the preceptress from 1796 to 1804. Both related pictures are now owned by the Hingham Historical Society; like the *Howe Memorial* — but unlike the majority of later mourning embroideries — they include no human figures, an omission that only heightens the sense of isolation and bereavement communicated by these works.

Inscriptions/Marks: The paper mat strip along the lower edge of the picture is inscribed in ink: "In memory of Mʳˢ Hannah Howe who died Octʳ 10ᵗʰ 1796 on [*sic*] the 74ᵗʰ, year of her age and Miss Mary Howe who died June 2 1792 in the 29ᵗʰ year of her age."[2] Lettered on the face of the tomb in silk thread are the initials "HH" and "MH."
Condition: In 1975 E. Hollyday removed parts of a linen secondary support and a cardboard tertiary support, surface-cleaned the textile, and restretched the piece over muslin-covered conservation board. In 1985 E. Hollyday deacidified and mended the paper mat strips that surround the embroidery, then backed them with Japanese mulberry paper before replacing them over the textile. Probably original 1⅛-inch scooped frame, painted brown, with gold liner.
Provenance: Leon F. S. Stark, Philadelphia, Pa.

[1] Karen M. Jones, "Collectors' Notes," *Antiques,* CXV (June 1979), p. 1243.
[2] Note that the last digit of the year "1796" appears to have been written initially as a "7," then changed, in the same ink, to a "6."

367 Memorial to Robert Steele

58.304.4

Artist unidentified
America, probably 1805–1811
Watercolor and ink on wove paper
10″ x 14″ (25.4 cm. x 35.6 cm.)

An unusual feature of this memorial is the manner in which the inscription was added to the monument. Apparently the picture was not drawn in anticipation of a particular person's death, since the tomb originally had a blank, cutout area in the base. Later, the maker, or perhaps someone else, lettered the dedication to Steele on a small piece of paper that was then inserted into the cutout area. If desired, the inscription could be replaced with another at a later date.

The two most interesting aspects of the Steele memorial are the monument and the bridge scene in the background at left. The tombstone was created entirely of tiny ink dots, probably in imitation of print work.[1] The charming little background scene is neatly done, with considerable attention to detail.

Inscriptions/Marks: Inscribed in ink on a separate small piece of paper glued behind a cutout rectangle of the primary support is "In memory of Robert Steele/who died Oct 25ᵗʰ AD. 1802./aged 43 years." A watermark in the primary support reads: "Ruse & Turners/1805," designating the paper as a product of the Upper Tovil Mill at Maidstone, Kent, England, run by Ruse and Turner and, after 1816, by Ruse, Turner, and Welch.[2]
Condition: Conservation treatment by Christa Gaehde in 1958 included cleaning the primary support, repairing tears, removing Scotch tape, and backing the piece with Japanese mulberry paper. In 1975 E. Hollyday removed or reduced stains and hinged the work to acid-free mat board. The 1½-inch splayed, mahogany-veneered frame is a replacement that possibly dates to the period of the watercolor.
Provenance: J. Stuart Halladay and Herrel George Thomas, Sheffield, Mass.
Exhibited: Mourning Becomes America.
Published: Schorsch, Mourning, no. 132, illus. as fig. 38.

[1] The term "print work" refers to fine silk embroidery executed in grisaille to imitate an engraving on paper.
[2] Thomas L. Gravell to AARFAC, October 28, 1981, notes that ninety-six percent of the Ruse & Turners papers recorded by him had been used within six years of the date of their manufacture.

368 Memorial to John Stedman

36.304.1

Artist unidentified
Probably New England, ca. 1810
Watercolor and ink on wove paper
12¾″ x 14¾″ (32.4 cm. x 37.5 cm.)

The anonymous artist heightened the dismal aspect of this unusual oval memorial by painting the entire scene in shades of gray. The use of a grisaille tech-

367

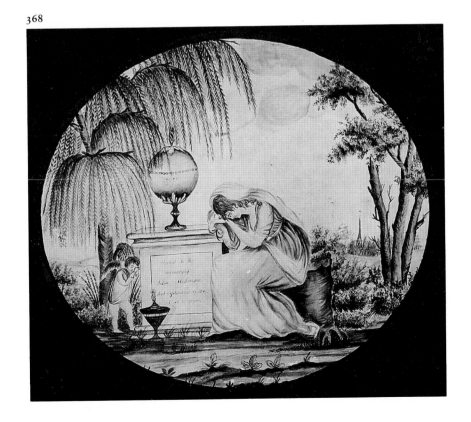

368

nique, the distinctive orb and urn forms, and the sorrowing poses of a classic female figure and a small cupid all suggest that the artist was inspired by an unidentified French engraving.

Inscriptions/Marks: Inscribed on the orb or globe is "YOUTH"; on the tomb is "Sacred to the/memory of/John. Stedman/died September 17 1801/Aged 27 years"; and on the small urn or lamp at the base of the tomb is "RESURGAM" ("I will arise").

Condition: Unspecified conservation treatment by Christa Gaehde in 1956 included backing the primary support with Japanese mulberry paper. In 1977 E. Hollyday cleaned the surface and mended edge tears. The 1³/₁₆-inch concave molded pine frame, with an applied brass foil face stamped in lamb's tongue and acanthus leaf designs and with an eglomise glass mat, is a replacement that probably dates from the 1830s.

Provenance: Fred J. Finnerty, Boston, Mass.

Published: AARFAC, 1940, p. 28, no. 92; AARFAC, 1957, p. 368, no. 311.

369 Memorial to Daniel Ma —— 58.304.5

Artist unidentified
Probably Massachusetts, ca. 1810
Watercolor and ink with pinpricking on wove paper
13³/₈" x 16³/₄" (34.0 cm. x 42.6 cm.)

Old damage to the ink inscription on the central tomb in this memorial has unfortunately obscured much of the family name, and at present nothing more is known about the young man who died in Surinam. The costumes on the two mourning figures, who probably represent the dead youth's parents, suggest that the watercolor was painted about a decade after the 1801 death date inscribed on the monument.

The unidentified artist had a good sense of design and was meticulous in illustrating a variety of architectural elements, fences, and grave markers.[1] Close examination reveals that several details, including cap, stock, handkerchiefs, and a covering festooned over the urn, have been pinpricked to suggest embroidery stitches.

Oval compositions of this type were usually framed with glass that had been reverse-painted black and embellished with gold leaf decorations. In this memorial the lower spandrels are filled with graceful palm branches, while the upper corners feature angels bearing banners inscribed with phrases of consolation.

Inscriptions/Marks: An ink inscription on the face of the tomb reads: "IN MEMO/RY OF/DANIEL MA-/[illegible material] WHO [D]IED IN [SU]RINAM 6ᵗʰ/JAN. 1801 AE 18." The banner at upper left states: "ALL JOIN IN THE ANGEL [illeg.]." The banner at upper right is inscribed: "WHERE WOE CAN NE'ER ASSAIL/NOR BLISS EXPIRE."

Condition: Extensive repairs and surface cleaning were performed in 1960 by Christa Gaehde, who also mounted the primary support on conservation board. In 1975 E. Hollyday mended edge tears along the top, bottom, and sides. Possibly original 1-inch flat frame with beveled lip and raised outer edge, painted gold over gilding.

Provenance: J. Stuart Halladay and Herrel George Thomas, Sheffield, Mass.

369

370

Exhibited: AARFAC, New Jersey; AARFAC, South Texas; AAR-FAC, May 10, 1964–December 31, 1966; Amon Carter; Goethean Gallery.

Published: AARFAC, 1975, illus. on p. 15; Black and Lipman, p. 100, illus. as fig. 106 on p. 123; Rumford, Memorial Watercolors, p. 688, illus. as pl. IV on p. 694.

¹For a discussion of table tombs, see *Antiques*, CXV (June 1979), pp. 1243–1300.

370 Memorial to Mrs. Mary Williams and Mrs. Alice Pitcher 79.604.3

Artist unidentified
Providence, Rhode Island, ca. 1810
Silk and silk chenille embroidery with watercolor on a satin-weave silk ground
17″ x 17⅛″ (43.2 cm. x 43.5 cm.)

This memorial is typical of those produced at Mary Balch's school in Providence (for other examples, see nos. 352, 353, and 360). The figure of a mourner wearing a black veil was derived from Pember and Luzarder's engraved memorial to Washington, published at Philadelphia in 1800.¹ The column at left and the design of the tomb are indicative of a taste for the neoclassic style, which was considered very fashionable in the early nineteenth century.²

The original frame and glass mat for this picture have not survived, and there are no signatures on the embroidery to identify the young woman who worked it. Possibly she was a granddaughter of the two women named on the plinth. Mrs. Alice Pitcher was the wife of Captain John Pitcher of Cranston, Rhode Island.³

Inscriptions/Marks: Stitched in silk on the face of the monument is "Consecrated to the remains/of/Mrs. Mary Williams,/who died June, 1788, in the/66th Year of her age./And/Mrs. Alice Pitcher,/who died Dec. 23d 1805, aged/67 Years, 5 Months, and 21 Days." Below this and also stitched in silk is "Stay, gentle spirit, stay. Can nature find/No charms to hold the once unfetter'd mind?"

Condition: In 1981 E. Hollyday removed the embroidery and its linen secondary support from wooden stretchers; she remounted the piece by stitching the linen to muslin-covered conservation board. Modern replacement 1-inch cyma recta silver gilt frame.

Provenance: Purchased from Mrs. J. W. Haslehurst, March 10, 1934, for use at Bassett Hall, the Williamsburg home of Mr. and Mrs. John D. Rockefeller, Jr.⁴

Published: Ring, Needlework, p. 480, illus. as pl. VI on p. 478.

[1] The engraved memorial is illustrated in Ring, Virtue, as fig. 35 on p. 159.

[2] For similar Balch school memorials that include the column, see Ring, Virtue, no. 79 on p. 175 and no. 93 on p. 189. Also see Mary Kay Davis, *The Needlework Doctor* (Edgewood Cliffs, N.J., 1982), fig. 20-5b.

[3] Ring, p. 478.

[4] Mrs. Haslehurst was said to be a direct descendant of Roger Williams, in whose family the picture had been for many years.

371 Memorial to Richard Waldron 58.304.7

Artist unidentified
Probably Massachusetts or New York State, probably 1811–1820
Watercolor and ink on wove paper
14¼″ x 17¹⁵⁄₁₆″ (36.2 cm. x 45.6 cm.)

Despite the standard attributes of death it incorporates, this well-designed and beautifully executed mourning picture does not create a mood of sadness; rather, it celebrates the pleasures of melancholy.

A comely young woman dressed in white, suggesting innocence, sits in a dreamy trance on a benchlike tomb in a tranquil landscape. Across the stream the hands of the clock in the church tower point to five, while the left foreground shows the base of a tree trunk cut in its prime, symbolizing Richard Waldron's premature death.

The feathery brush strokes and rhythmic patterns of shaded bands in delicate hues of blue, green, and brown are reminiscent of similar effects achieved in silk embroidery during the first quarter of the nineteenth century.

Inscriptions/Marks: An ink inscription on the upper plinth states: "Sacred/to the memory/of/Mr. Richard Waldron/who died Sep. 11ᵗʰ 1811./Aged 61"; the vase on the lower plinth reads: "Death breaks the sullen gloom,/That dims the portals of eternal day;/Bids the freed soul her nobler powers assume,/And wing from woes her heaven directed way." In the upper left corner of the recto sheet, in the margin, there is an embossed paper mark of a crown in a circle with the words "BRISTOL" above and "PAPER" below.

Condition: Conservation treatment in 1977 by E. Hollyday included mending tears, setting down flaking paint, bathing to reduce acidity and discoloration, and backing the support with Japanese mulberry paper. Period replacement 1⅜-inch cyma recta frame, painted bronze over original gilding.

Provenance: J. Stuart Halladay and Herrel George Thomas, Sheffield, Mass.

371

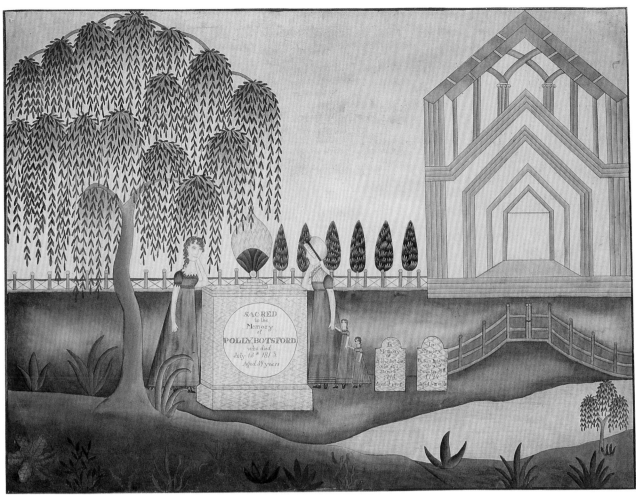

372

372 Memorial for Polly Botsford and Her Children

33.304.1

Artist unidentified
Possibly Newtown, Connecticut, ca. 1815
Watercolor and ink on wove paper
18″ x 23½″ (45.7 cm. x 59.7 cm.)

The picture is extraordinary both in its composition and in its finely rendered, stylized forms. The interplay of the curvilinear and linear elements that create the most interesting geometric shapes in the church contributes to the picture's appeal and to what Mary Black has called "a small masterpiece that presages aspects of modern painting."[1] For instance, the configuration and shape of the large willow tree at left not only balance but also, in its neat curves and rounded forms, reflect the basic church form at right. The church itself is reduced to elements of its framework, functioning more as an idea or a symbolic form than an actual architectural structure.

Genealogical information on Polly Botsford and her two children, Gideon and Polly, remains speculative, although research indicates that the family lived in the Newtown, Connecticut, area. A Pulcrea Fairman, the daughter of Jane and Richard Fairman, was born in Newtown on November 19, 1754, and married Gideon Botsford, Jr., at an unknown date. Among their children were a Gideon and a Polly, presumably the offspring whose names appear on the two smaller tombstones. Pulcrea Botsford may have adopted "Polly" as a nickname.[2]

Inscriptions/Marks: The ink inscription on the large tombstone reads: "SACRED/to the/Memory/of POLLY, BOTSFORD/who died/July 15th 1813/Aged 59 years." The left of the two smaller tombstones is inscribed: "In/Memory/of/Polly Botsford/who died/March 8th/1793/Aged 1 year." The small tombstone on the right bears the inscription: "In/Memory/of/Gideon Botsford/who died/December 18th/1774/Aged 4 months."

Condition: In 1977 E. Hollyday dry-cleaned the support, backed it with Japanese mulberry paper, and inpainted several small losses in the figure at far left beside the large tombstone. Period replacement 2⅝-inch chamfered, mahogany-veneered frame with gold liner.

373

of paper, indicate that this naive memorial was painted about thirty years after Mrs. Fairbanks died.

The avenue of carefully colored poplar trees at left provides visual interest while creating an illusion of depth. The unidentified artist's lack of drafting experience is amusingly evident in the ghoulish face, the two-dimensional tree trunks, and the awkwardly foreshortened church.

Inscriptions/Marks: Written in ink on the lower part of the tomb is "In Memory of Mʳˢ/Mary Fairbanks,/who died May 19ᵗʰ AD 1786,/in the 42ᵈ year of her Age." A partial watermark in the lower left side of the primary support reads: "J WHATMAN."

Condition: Unspecified treatment by Christa Gaehde in 1956 included backing the primary support with Japanese mulberry paper. In 1983 E. Hollyday dry-cleaned the primary support, set down flaking paint, inpainted losses, and hinged the primary support to conservation board. Possibly original 1⅜-inch cyma recta gilded frame with applied rope twist molding.

Provenance: Found in Providence, R.I., and purchased from Dorothy Dudley, Biddeford, Maine; given to the Museum of Modern Art in 1939 by Abby Aldrich Rockefeller; turned over to Colonial Williamsburg in June 1954.

Published: AARFAC, 1957, p. 367, no. 305.

Provenance: Edith Gregor Halpert, Downtown Gallery, New York, N.Y.

Exhibited: AARFAC, American Museum in Britain; AARFAC, June 4, 1962–April 17, 1963; AARFAC, September 1968–May 1970; "American Ancestors: 2nd Exhibition," Downtown Gallery, New York, N.Y., October 3–14, 1933; Art in Our Time; Flowering of American Folk Art; Smithsonian, American Primitive Watercolors, and exhibition catalog, p. 8, no. 34; Trois Siècles, and exhibition catalog, p. 52, no. 232.

Published: AARFAC, 1957, p. 170, no. 85, illus. on p. 171; AARFAC, 1965, illus. as pl. 3; Oto Bihalji-Merin, *Masters of Naive Art: A History and Worldwide Survey* (New York [1971]), illus. as fig. 41 on p. 54; Black, Watercolors, p. 82, illus. on p. 78; Black and Lipman, p. 100, illus. as fig. 105 on p. 122; James Thomas Flexner, "New Bottles for Old Wine: American Artisan, Amateur, and Folk Paintings," *Antiques,* XLI (April 1942), illus. as fig. 5 on p. 249; Stanley Kunitz, "Words for the Unknown Makers," *Craft Horizons,* XXXIV (February 1974), illus. on p. 33; Lipman, *Primitive Painting,* p. 8, illus. as fig. 5 on p. 15; Lipman and Winchester, Folk Art, illus. as fig. 109 on p. 85; Jean Lipman and Helen M. Franc, *Bright Stars: American Painting and Sculpture Since 1776* (New York, 1976), p. 58; MOMA, p. 23, no. 8; Stebbins, p. 94, illus. as fig. 64 on p. 95.

¹Black, Watercolors, p. 82.

²Mary R. M. Goodwin to AARFAC, September 14, 1970.

373 Memorial to Mary Fairbanks 35.304.1

Artist unidentified
Possibly Providence, Rhode Island, ca. 1815
Watercolor and ink on wove paper
17¹¹⁄₁₆″ x 16³⁄₁₆″ (44.9 cm. x 41.1 cm.)

The severely classic form of the monument and the style of the young mourner's dress, as well as the type

374 Memorial to John Baron 79.304.3

Artist unidentified
Probably Connecticut, ca. 1815
Watercolor, ink, and pencil on wove paper
14⅛″ x 18¼″ (35.9 cm. x 46.4 cm.)

A delightful disregard for the rules of perspective and the laws of nature adds to the naive charm of this nicely designed and sensitively colored memorial.

A young woman, modishly attired in black, stands near the tomb, her left hand resolutely pointing toward a group of three shuttered houses that appear to collide with one another, while the fence in front of them seems to have fallen flat. A funeral garland of pink roses drifts endlessly downhill, and similar blossoms can be seen on a bush of gargantuan proportions planted near the church. Tiny boats are shown tacking in all directions on the swollen river.

Despite the fact that the memorial was found in Bridgeport, Connecticut, a search of Fairfield County genealogical sources has not identified a John Baron, and no one there recognizes the churches or other structures in the hilly townscape as Bridgeport landmarks.

Inscriptions/Marks: The original ink inscription on the tomb is now almost totally obliterated, and parts of it were reconstructed or reinforced in pencil at an undetermined time; based on surviving records and the remnants of markings still visible, the inscription has been rendered as: "[illegible material — In memory?]/of John Baron/who Died [illeg.]/May 19ᵗʰ 1807/[illeg. — Aged?]/23 years [illeg. — in?]/[illeg.]."

374

Condition: At an unspecified time prior to acquisition by AAR-FAC, a 2-inch tear at bottom right was repaired; in 1982 E. Hollyday surface-cleaned the primary support and reduced its buckling. Probably original 1¼-inch flat frame with a scooped inner lip and quarter-round outer edge, regilded.

Provenance: Found in Bridgeport, Conn., and purchased from Edith Gregor Halpert, Downtown Gallery, New York, N.Y.; gift of Nelson Rockefeller to Abby Aldrich Rockefeller, ca. 1932, and used at Bassett Hall, the Williamsburg home of Mr. and Mrs. John D. Rockefeller, Jr.

Exhibited: American Folk Art, Traveling.

Published: Cahill, American Folk Art, p. 36, no. 52.

in the Folk Art Center's picture features larger design elements.

The tombstone here is painted white and decorated with flakes of mica, presumably to simulate granite.

Inscriptions/Marks: A watermark in the primary support reads: "J WHATMAN/TURKEY MILLS/1817."

375

375 Mourning Picture: New England Widow 63.304.1

Artist unidentified
Probably New England, probably 1817–1825
Watercolor, ink, and mica chips on wove paper
9⅞" x 11¹/₁₆" (25.1 cm. x 28.1 cm.)

A watercolor and ink drawing of a woman standing beside a nearly identical tomb in the M. & M. Karolik Collection at the Museum of Fine Arts in Boston may have been executed by the same unidentified artist.[1] The Karolik piece was found in the Hudson River valley area of New York State and bears an 1807 watermark from the firm of Edwards & Pine. Similar buildings and vines are seen in both examples, although the floral border surrounding the oval format

Condition: Unspecified conservation treatment was performed by Christa Gaehde in 1968. In 1977 E. Hollyday removed a modern secondary support and adhesives from the verso of the primary support, dry-cleaned the piece where possible, set down flaking mica chips, repaired small edge tears, and backed the picture with Japanese mulberry paper. Period replacement 1⁷/₁₆-inch flat frame, with decorative vinegar painting in red and yellow.

Provenance: Edith Gregor Halpert, Downtown Gallery, New York, N.Y.

¹See Karolik Collection, no. 1199 on p. 196, illus. as fig. 295 on p. 198.

376 Memorial to Elizabeth Farr 32.304.1

Artist unidentified
Probably New England, ca. 1820
Watercolor and ink on laid paper
12⅛" x 15⅝" (30.8 cm. x 39.7 cm.)

This memorial is distinguished by the unusually large number of mourners, possibly intended to represent seven members of Elizabeth Farr's family. The somber character of the tombside gathering is enhanced by the tan paper ground painted with thin washes of red, blue, green, and yellow; these colors have faded with exposure to light over a long period of time, so that black and sepia tones now dominate.

The picture has many of the attributes of amateur work, including the off-center and slightly tilted position of the massive tomb, the use of successive bands or layers (pond, grass, trees, buildings) to indicate depth, and the hiding of hard-to-draw faces behind handkerchiefs while lavish attention is paid to the ladies' hairstyles and the ducks swimming across the foreground.

Inscriptions/Marks: An ink inscription in the center of the tomb states: "The/Memory of/Elizabeth Farr/who died Oct/the ²²

376

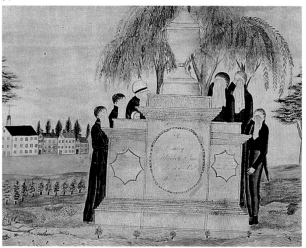

1813." Flanking inscriptions at left and right read: "Her sorrows/now are at an en[d],/The Lord did/for her call," and "And Jesus/is her loving friend/Her life her/health her all."

Condition: Unspecified treatment by Christa Gaehde in 1954 included backing the primary support with Japanese mulberry paper. In 1975 E. Hollyday mended edge tears and hinged the primary support to conservation board. Period replacement 1-inch frame with applied half-round molding, painted yellow.

Provenance: Isabel Carleton Wilde, Cambridge, Mass.; John Becker, New York, N.Y.

Exhibited: American Primitives; Mourning Becomes America; Wilde, and exhibition catalog, no. 58.

Published: AARFAC, 1940, p. 29, no. 96; AARFAC, 1947, p. 27, no. 96; AARFAC, 1957, p. 210, no. 107, illus. on p. 211; Ford, Pictorial Folk Art, illus. on p. 131; Elinor B. Robinson, "American Primitive Paintings," *Antiques,* XIX (January 1931), illus. as fig. 8 on p. 36; Schorsch, Mourning, unpaginated, no. 206.

377 Memorial to Sally Putnam Page 35.304.2

Artist unidentified
Probably Massachusetts,¹ ca. 1825
Watercolor on heavy wove paper with printed inscription
18⅛" x 22¼" (46.0 cm. x 56.5 cm.)

In this beguiling tribute to a fifteen-month-old child, the traditional mourning symbols have been skillfully combined in a romantic landscape setting to create a mood of cheerful resignation that is supported by Sally Page's epitaph, which reads: "Not lost — but gone before."

The composition is an excellent example of seminary art at its best and illustrates what an adept student could achieve when given professional instruction and an opportunity to practice. Soft colors are sensitively combined with fluid brushwork, utilizing several different techniques. The tiny herringbone strokes used to depict the willow's foliage successfully imitate the textured effect of chenille stitches often seen in embroidered memorials of this period.

One wonders whether the sprightly teenage mourner shown draping a garland of roses is intended to represent the unidentified artist or one of her pretty friends.

Inscriptions/Marks: The following inscription is printed on a separate piece of paper pasted on the front of the tomb and outlined in dark watercolor: "SACRED/TO THE MEMORY OF/SALLY PUTNAM PAGE,/Who died July 2, 1808,/AGED 15 MONTHS./Not lost — but gone before." There is an embossed circular stamp in the upper left corner enclosing a crown with the words "BRISTOL" above and "PAPER" below.

Condition: In 1955 the watercolor was lightly surface-cleaned by Christa Gaehde. In 1974 E. Hollyday hinged the primary support to conservation board. Probably period replacement 1³/₁₆-inch cyma recta gilded frame.

Provenance: Found in Charleston, S.C., by C. A. Brett, Fairmount, W.Va.

Exhibited: AARFAC, September 15, 1974–July 25, 1976; "A

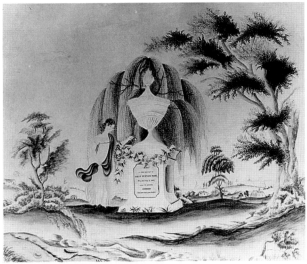

377

"Time to Mourn," Brandywine River Museum, Chadds Ford, Pa., January 17–May 17, 1981.

 Published: AARFAC, 1940, p. 28, no. 94; AARFAC, 1947, p. 26, no. 94; AARFAC, 1957, p. 368, no. 310; AARFAC, 1974, pp. 38, 41, no. 33, illus. as fig. 33 on p. 40; Cogar, illus. on p. 182.

[1]Compare no. 377 with the memorial probably done by Sally F. Cheever of Danvers, Mass., which is shown and described on pp. 65 and 186 of Elisabeth Donaghy Garrett, *The Arts of Independence: DAR Museum Collection* (Washington, D.C.: The National Society, Daughters of the American Revolution, 1985).

378 Memorial to Philo Day and Julia Ann Gilbert 35.404.1

Artist unidentified
Possibly New Jersey, ca. 1825
Gouache and ink on a plain-weave silk ground
18⅝″ x 23⅜″ (47.3 cm. x 59.4 cm.)

In this beautifully designed double memorial, the oval format so effectively frames and balances the strong vertical character of the primary elements, including a familiar Gothic church, that one almost forgets the picture was originally enhanced by a black and gilt glass mat. The scene is predominantly executed with precise brush strokes in monochromatic shades of sepia ink, a medium eminently appropriate to the subject matter.[1]

 The phrase "There is rest in heaven," inscribed on the face of the smaller monument, expresses an attitude toward life and the hereafter shared by many Americans throughout the first quarter of the nineteenth century. Confidence in the Resurrection and the soul's immortality is also evident in the foreground figure of Hope, who is identified by the anchor at her side and who gestures skyward.[2] The drooping plants nearby are reminders of the transitory nature of earthly life. The reduced size of Hope and the tomb

378

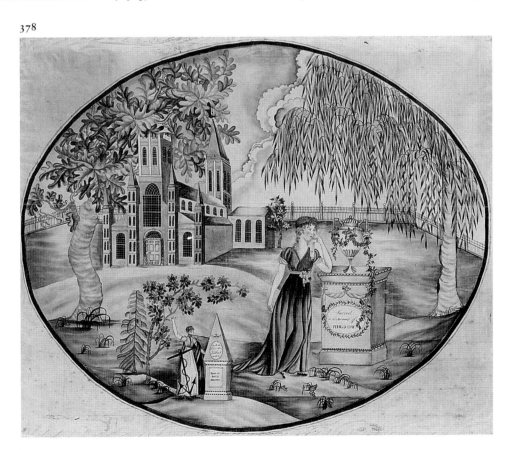

beside her suggest that Julia Ann Gilbert was a child at the time of her death.

Inscriptions/Marks: Ink inscriptions on the tomb at left read: "Julia Ann/Gilbert" and "There is/Rest in/HEAVEN"; an ink inscription on the tomb at right states: "Sacred/to the MEMORY of/PHILO DAY."

Condition: Unspecified treatment by Kathryn Scott in 1957 included stitching the piece to a silk secondary support and stretching these over cardboard. In 1976 E. Hollyday remounted the piece on conservation board covered with muslin. Nineteenth-century replacement 2-inch, cove-molded frame, painted black, with carved, gold-painted liner.

Provenance: Found in New Jersey and purchased from Edith Gregor Halpert, Downtown Gallery, New York, N.Y.; given to the Museum of Modern Art by Abby Aldrich Rockefeller in 1929; turned over to Colonial Williamsburg in June 1954.

Exhibited: AARFAC, April 22, 1959–December 31, 1961; William Penn Museum.

Published: AARFAC, 1957, p. 246, no. 123, illus. on p. 247; AARFAC, 1959, p. 17, no. 5, illus. on p. 16; Black and Lipman, p. 100, illus. as fig. 104 on p. 121; James Thomas Flexner, *Nineteenth Century American Painting* (New York, 1970), illus. on p. 108; Rumford, Memorial Watercolors, p. 688, illus. as fig. 3 on p. 692.

[1]The printed source for this church is unidentified. A less detailed version of the same building appears in no. 380.

[2]The figure of Hope and the adjacent tomb as well as its inscription were derived from the same George Washington memorial (engraved by T. Clarke of Boston in 1801) that was the source for no. 358.

379 Memorial for Josiah Sabin 84.304.1

Artist unidentified
Probably Hamilton, New York, possibly 1832
Watercolor and ink on wove paper
13⅞" x 17½" (35.2 cm. x 44.5 cm.)

The watercolors are still bright in this pleasingly composed memorial. The long flower garland draped over the urn forms a delicate, airy space beneath the density of the overhanging willow; the mourner's black veil echoes the cascades of heavy foliage seen in the tree. The lady wears her hair pulled up and held with a tortoiseshell comb, a popular accessory of about 1825–1835, and the leg-of-mutton cut of her sleeves is another costume detail that substantiates the picture's date. In the background, sharp-peaked mountains, a river, a church steeple, and two tombstones help create a sense of place.

Josiah Sabin died in Hamilton, New York, on February 20, 1832, leaving a widow, Chloe Caulkins Sabin (1796–1882), who later married Philo Doolittle of Poultney, Vermont. Josiah's tombstone was erected in Hamilton on July 18 in the year of his death.[1]

379

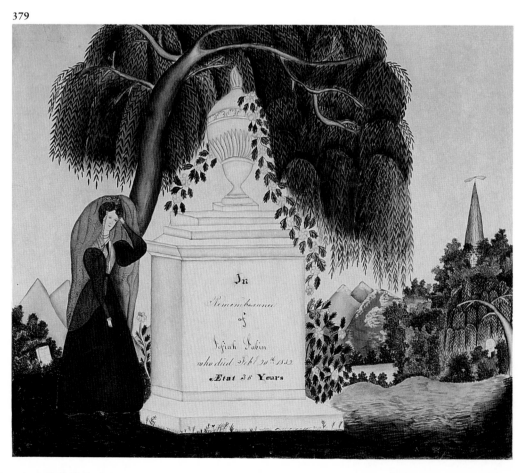

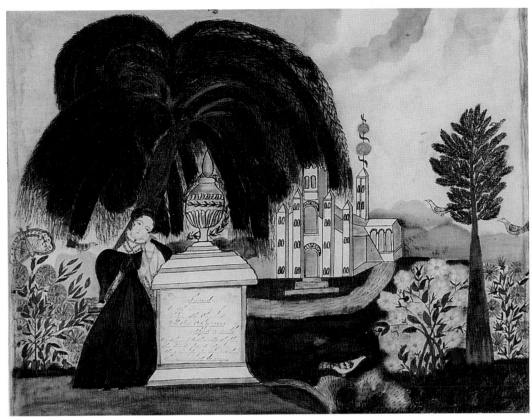

380

Inscriptions/Marks: Lettered in ink on the tombstone is "In/ Rememberance [*sic*]/of/Josiah Sabin/who died Feb^y 20^th, 1832./AEtat 38 Years."

Condition: In 1985 E. Hollyday dry-cleaned the surface, removed a linen backing and adhesive, repaired small edge tears, and backed the support with Japanese mulberry paper. Modern replacement ¾-inch cyma recta frame, painted black.

Provenance: Gift of Dr. Harriet Anne Doolittle in memory of her great-grandmother, Chloe Caulkins Sabin Doolittle.

[1]All biographical information has been excerpted from AARFAC file information supplied by James Doolittle in 1984.

380 Memorial to Eliza H. Osgood 79.404.1

Artist unidentified
Probably Massachusetts, probably 1832–1840
Paint on velvet with ink inscription on wove paper
17¹/₁₆″ x 21⅝″ (43.3 cm. x 54.9 cm.)

This composition, which features a single tomb and mourner with an impressive Gothic church nearby, represents a variation on a popular formula for memorials on velvet. In this and two nearly identical versions of the single-tomb format,[1] a small pine tree with a substantial triangular trunk replaces the second tomb, and several large, multicolored birds are shown in profile. The Osgood memorial is distinguished by a profusion of tall flowering plants and an enormous butterfly, which may symbolize the spirit of the little girl to whom the picture is dedicated.

Inscriptions/Marks: An ink inscription on the paper label glued to the face of the tomb reads: "Sacred/To the Memory of/Eliza H. Osgood./Who died Oct. 7'1832./Aged 18 months./Our Heavenly Father marked the flower/Saw twas to [*sic*] fair to stay./And in a few, few transient hours/He summon'd her away."

Condition: Unspecified conservation treatment, probably by Kathryn Scott and prior to acquisition, included stretching the linen-backed velvet primary support over cardboard. In 1982 E. Hollyday remounted the piece on muslin-covered conservation board. Period replacement 2-inch splayed gilded frame with quarter-round outer edge and scooped inner lip.

Provenance: Found in Holicong, Pa.; Juliana Force, New York, N.Y.; Edith Gregor Halpert, Downtown Gallery, New York, N.Y. Purchased by Abby Aldrich Rockefeller in June 1931 for use at Bassett Hall, the Williamsburg home of Mr. and Mrs. John D. Rockefeller, Jr.

Exhibited: American Folk Art, Detroit.

Published: Cahill, American Folk Art, p. 40, no. 107.

[1]The two related memorials are illustrated as K270 and K392 in Terry Dintenfass, Inc., *Edith Gregor Halpert Folk Art Collection* (New York, 1973).

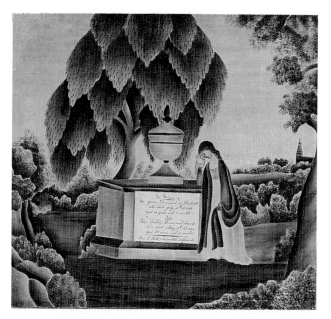

381

381 Davenport Family Memorial 32.404.2

Artist unidentified
Dorchester, Massachusetts, ca. 1840
Paint on velvet with ink on wove paper
13½″ x 15″ (34.3 cm. x 38.1 cm.)

This is one of a large group of somber memorials worked in shades of black on white cotton velvet, dating from between 1835 and 1845 and probably derived from an early lithograph.[1] This example is particularly well executed, and the willow foliage appears to have been made with the aid of stencils.

Inscriptions/Marks: Written in ink on a piece of paper glued to the face of the tomb is "In Memory of/Mr. James Devenport [*sic*] of Dorchester/who died July 15,ᵗʰ AD. 1824,/aged 64 years and 9 months/And/Mrs. Esther Davenport his wife/Who died May 18ᵗʰ AD. 1834./aged 68 years and 8 months./Peace to their departed Spirits."
Condition: Unspecified conservation treatment by Kathryn Scott in 1956 included stitching the velvet to linen and stretching the piece over a tertiary support of cardboard. In 1975 E. Hollyday remounted the linen-backed velvet on muslin-covered conservation board. Period replacement 1½-inch, cove-molded gilded frame.
Provenance: Found in Dorchester, Mass., and purchased from Edith Gregor Halpert, Downtown Gallery, New York, N.Y.
Exhibited: AARFAC, New Jersey; AARFAC, South Texas; AARFAC, September 15, 1974–July 25, 1976 (Atlanta show only); Goethean Gallery; Mourning Becomes America.
Published: AARFAC, 1940, p. 36, no. 156; AARFAC, 1947, p. 34, no. 156; AARFAC, 1957, p. 372, no. 349; Schorsch, Mourning, unpaginated, no. 98.

[1]Typical examples include the Scovill Family Memorial illustrated as lot no. 43, p. 19, in Sotheby Parke Bernet, Garbisch III, and a privately owned memorial illustrated in Claudia Hopf, "Velvet Painting," *Spinning Wheel*, XXVI (July/August 1970), p. 26.

382 Memorial to William Whittingham 57.604.1

Artist unidentified
Probably New York State, Pennsylvania, or New Jersey, ca. 1840
Wool and silk chenille embroidery and oil paint with watercolor and printing on wove paper on a plain-weave linen ground
26¾″ x 35⁵⁄₁₆″ (68.0 cm. x 89.7 cm.)

This late example of a handmade mourning picture is distinguished by its enormous size and the successful combination of painted surfaces and decorative embroidery. Landscape features, buildings, and the mourners' costumes are done in needlework, with naturalistic textures of plants and trees suggested by variously knotted and stitched coarse threads in shades of green and brown. The sky is painted in sunset shades. The inscription was printed on a white card, which was subsequently cut into the shape of a tomb, outlined in gray paint, and then affixed to the memorial with long stitches disguised as willow branches or tufts of grass. The portrait heads are also bits of paper painted in watercolor and sewn in place. Neither Charles Whittingham nor five-year old William has been identified.

Inscriptions/Marks: Printed on the paper face of the tomb is "SACRED TO THE MEMORY/of WILLIAM, only Son of/CHARLES WHITTINGHAM./WHO EXPIRED/August 1st, 1836; aged 5 years, 9 months and 8 days." Below the preceding is "Calm be thy rest, my little one,/Where no rude blast can harm thee;/Where nought on earth of weal or woe/Hath power to alarm thee./For death hath called thee from my arms,/My own, my fondly cherished;/And all that once was bright and fair,/Within the grave hath perished."
Remnants of nineteenth-century newsprint line the frame. No date has been found on them, and their origin is uncertain. However, street names suggest that this was a New York City paper.
Condition: Unspecified conservation treatment by Kathryn Scott in 1957 included stitching the primary support to a piece of linen-covered cardboard. Original 1⅛-inch flat gilded white pine frame with scooped inner lip and a flat, raised outer edge. The reverse-painted black and gold leaf glass mat is a replacement.
Provenance: Edith Gregor Halpert, Downtown Gallery, New York, N.Y.
Exhibited: "Arthur G. Dove: The Years of Collage," University of Maryland Fine Arts Gallery, College Park, Maryland, March 13–April 19, 1967, and exhibition catalog, p. 51, no. 11, illus. on p. 44; Mourning Becomes America.
Published: Rumford, Memorial Watercolors, p. 688, illus. as pl. II on p. 690; Schorsch, Mourning, unpaginated, no. 239.

[1]For a more complex embroidered memorial that shares the same printed source, see Schorsch, Mourning, no. 70.

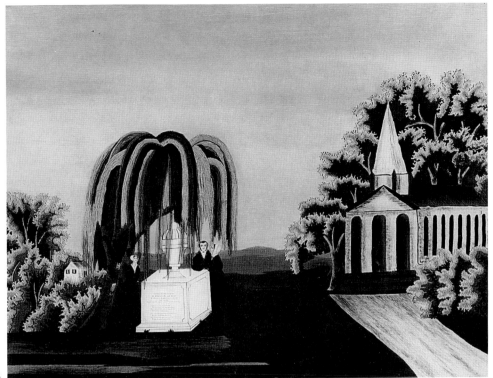

382

383 Memorial to R. A. Mason 31.304.1

Artist unidentified
Possibly New England, ca. 1845
Watercolor on wove paper
13 13/16″ x 17 3/8″ (35.1 cm. x 44.1 cm.)

By 1835 inexpensive printed memorials were readily available, with the result that handmade mourning pictures became for the most part increasingly stereotyped and sentimental. In this example, the combination of soft glowing colors, a rustic graveyard setting, and a pensive figure garbed in black creates a pleasing decorative scene that nonetheless lacks the emotional impact found in some of the inspired memorials produced a generation earlier.

The composition is largely based on a lithographed memorial by Nathaniel Currier. The vignette at left featuring a pond and a vine-covered cottage behind a rail fence was probably inspired by an illustration in a contemporary drawing instruction manual. Nothing is known about R. A. Mason, to whom this memorial is dedicated.

Inscriptions/Marks: An ink inscription on the face of the monument reads: "To the/Memory/of/R. A. MASON." In the lower left corner of the primary support is a partial embossed circular mark of a coat of arms with the lettering "[missing material]D/[S]URFACE/[missing]NG BOARDS."

Condition: Unspecified treatment by Christa Gaehde in 1955 included repair of a 1-inch tear on the left side and surface cleaning. In 1975 E. Hollyday hinged the primary support to conservation board. Modern replacement 1½-inch cyma recta gilded frame.

Provenance: Edith Gregor Halpert, Downtown Gallery, New York, N.Y.

Exhibited: Mourning Becomes America.

Published: AARFAC, 1957, p. 367, no. 306; Rumford, Memorial Watercolors, p. 688, illus. as pl. V on p. 694; Schorsch, Mourning, unpaginated, no. 245.

383

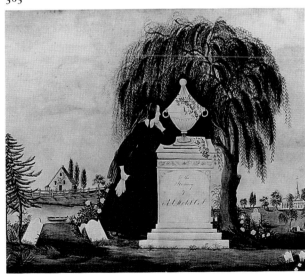

Short Title Lists

Exhibitions

AARFAC, American Museum in Britain
"American Folk Art from the Abby Aldrich Rockefeller Folk Art Collection," American Museum in Britain, Claverton Manor, Bath, England, March 9–November 1, 1961.

AARFAC, Arkansas
"Paintings and Sculptures from the Abby Aldrich Rockefeller Folk Art Collection," traveling exhibition organized by AARFAC in cooperation with the Arkansas Arts Center Artmobile, Little Rock, August 1964–August 1966.

AARFAC, Arning
"Eddie Arning: Selected Drawings, 1964–1973," Abby Aldrich Rockefeller Folk Art Center, Williamsburg, Va., January 20–December 1, 1985, and exhibition catalog.

AARFAC, Hicks
"Edward Hicks, 1780–1849: A Special Exhibition Devoted to His Life and Work," Abby Aldrich Rockefeller Folk Art Collection, Williamsburg, Va., September 30–October 30, 1960, and exhibition catalog.

AARFAC, Minneapolis
"American Folk Art from the Abby Aldrich Rockefeller Folk Art Collection," Minneapolis Institute of Arts, May 19–July 1, 1964.

AARFAC, New Canaan
"Folk Art from the Abby Aldrich Rockefeller Folk Art Collection," New Canaan Library, New Canaan, Conn., January 7–February 8, 1962.

AARFAC, New Jersey
"Selections from the Abby Aldrich Rockefeller Folk Art Collection," New Jersey State Museum, Trenton, January 15–March 12, 1972.

AARFAC, New York
"The Folk Art of New York State," Abby Aldrich Rockefeller Folk Art Collection, Williamsburg, Va., March 15–May 20, 1959, and the New York State Historical Association, Cooperstown, N.Y., June 15–September 15, 1959, and exhibition catalog.

AARFAC, South Texas
"Selections from the Abby Aldrich Rockefeller Folk Art Collection," Art Museum of South Texas, Corpus Christi, October 1–31, 1971.

AARFAC, Young
"Henry Young: Pennsylvania Fraktur Artist," Abby Aldrich Rockefeller Folk Art Center, Williamsburg, Va., October 16–December 4, 1977, and exhibition catalog and exhibition checklist.

AARFAC, April 22, 1959–December 31, 1961
Traveling exhibition organized by AARFAC in cooperation with the American Federation of Arts, New York, N.Y., April 22, 1959–December 31, 1961.

AARFAC, June 4, 1962–April 17, 1963
Traveling exhibition organized by AARFAC, June 4, 1962–April 17, 1963.

AARFAC, June 4, 1962–March 31, 1965
Traveling exhibition organized by AARFAC, June 4, 1962–March 31, 1965.

AARFAC, June 4, 1962–November 20, 1965
Traveling exhibition organized by AARFAC, June 4, 1962–November 20, 1965.

AARFAC, May 10, 1964–December 31, 1966
Traveling exhibition organized by AARFAC, May 10, 1964–December 31, 1966.

AARFAC, September 1968–May 1970
Traveling exhibition organized by AARFAC in cooperation with the Virginia Museum of Fine Arts, Richmond, Va., September 1968–May 1970.

AARFAC, September 15, 1974–July 25, 1976
Traveling exhibition organized by AARFAC, September 15, 1974–July 25, 1976.

American Ancestors
"American Ancestors," Downtown Gallery, New York, N.Y., December 14–31, 1931, and exhibition catalog.

American Folk Art, Detroit
"American Folk Art, Painting and Sculpture," Detroit Society of Arts and Crafts (later the Center for Creative Studies–College of Art and Design), Detroit, Mich., February 22–March 18, 1932, and exhibition catalog.

American Folk Art, Traveling
"American Folk Art: The Art of the Common Man in America, 1750–1900," traveling exhibition organized by Holger Cahill for the Museum of Modern Art, New York, N.Y., November 30, 1932–July 9, 1934.

American Folk Painters
"American Folk Painters of Three Centuries," Whitney Museum of American Art, New York, N.Y., February 26–May 13, 1980.

American Fraktur
"American Fraktur: Graphic Folk Art 1745–1855," Pratt Graphics Center Gallery, New York, N.Y., November 19, 1976–January 8, 1977, and exhibition catalog.

American Primitive Art
"American Primitive Art," Academy of the Arts and the Talbot County Historical Society, Easton, Md., October 4–13, 1962, and exhibition checklist.

American Primitive Painting
"American Primitive Painting of Four Centuries," Arts Club of Chicago, Chicago, Ill., November 2–27, 1943, and exhibition catalog.

American Primitives
"American Primitives: An Exhibit of the Paintings of the Nineteenth-Century Folk Artists," Newark Museum, Newark, N.J., November 4, 1930–February 1, 1931.

Amon Carter
"American Folk Art," Amon Carter Museum of Western Art, Fort Worth, Tex., September 10–November 19, 1967.

Arkansas Artmobile
"American Folk Art," Arkansas Arts Center Artmobile, traveling exhibition organized by the Arkansas Arts Center, Little Rock, September 1, 1976–September 1, 1977.

Art in Our Time
"Art in Our Time: An Exhibition to Celebrate the Tenth Anniversary of the Museum of Modern Art and the Opening of Its New Building," Museum of Modern Art, New York, N.Y., 1939.

Artist Sees the City
"The Artist Sees the City," Amon Carter Museum of Western Art, Fort Worth, Tex., September–October, 1963.

Artists in Aprons
"Artists in Aprons: Folk Art by American Women," Museum of American Folk Art, New York, N.Y., January 14–April 29, 1979.

Calligraphy
Calligraphy: "Why Not Learn to Write," Museum of American Folk Art, New York, N.Y., January 29–March 23, 1975, and exhibition catalog.

Centennial Exhibition
"Centennial Exhibition: American Folk Art," Albright Art Gallery, Buffalo, N.Y., July 1–August 1, 1932, and exhibition catalog.

Dallas
"Religious Art of the Western World," Dallas Museum of Fine Arts, Dallas, Tex., March 23–May 25, 1958, and exhibition catalog.

Flowering of American Folk Art
"The Flowering of American Folk Art, 1776–1876," traveling exhibition organized by the Whitney Museum of American Art, New York, N.Y., February 1–September 15, 1974.

Flowers
"Flowers in Folk Art," Whitney Museum of American Art at Philip Morris, New York, N.Y., March 15–May 9, 1984, and exhibition checklist.

Goethean Gallery
"Paintings and Drawings from the Abby Aldrich Rockefeller Folk Art Collection," Goethean Gallery of Art, Franklin and Marshall College, Lancaster, Pa., January 3–February 10, 1969.

Great Ideas
"Great Ideas of Western Man," Denver Art Museum, Denver, Colo., March 18–May 16, 1958, and exhibition catalog.

Halladay-Thomas, Albany
"American Provincial Paintings, 1700 to 1860: The Halladay-Thomas Collection," Albany Institute of History and Art, Albany, N.Y., October 1–31, 1949, and exhibition catalog.

Halladay-Thomas, Hudson Park
"Early American Painting: The Collection of J. Stuart Halladay and Herrel George Thomas," Hudson Park Library, New York, N.Y., March 1–April 30, 1946.

Halladay-Thomas, New Britain
"American Provincial Paintings, 1680 to 1880: The Halladay-Thomas Collection," The Art Museum, New Britain, Conn., November 1–31, 1947, and exhibition catalog.

Halladay-Thomas, Pittsburgh
"American Provincial Paintings, 1680–1860, from the Collection of J. Stuart Halladay and Herrel George Thomas," Department of Fine Arts, Carnegie Institute, Pittsburgh, Pa., April 17–June 1, 1941, and exhibition catalog.

Halladay-Thomas, Syracuse
"American Provincial Paintings, 1680 to 1880: The Halladay-Thomas Collection," Syracuse Museum of Fine Arts, Syracuse, N.Y., January 23–February 22, 1949, and exhibition catalog.

Halladay-Thomas, Whitney
"American Provincial Paintings from the Collection of J. Stuart Halladay and Herrel George Thomas," Whitney Museum of American Art, New York, N.Y., October 27–November 19, 1942, and exhibition catalog.

Hand and Spirit
"The Hand and the Spirit: Religious Art in America 1700–1900," traveling exhibition organized by the University Art Museum, Berkeley, Calif., June 28–August 27, 1972, and exhibition catalog.

Hebrew Bible
"The Hebrew Bible in Christian, Jewish and Muslim Art," The Jewish Museum, New York, N.Y., February 18–March 24, 1963, and exhibition catalog.

Hollins College, 1974
"American Folk Art," Hollins College and Roanoke Valley Historical Society, Roanoke, Va., May 1–31, 1974, and exhibition catalog.

Hollins College, 1975
"Perspective Folk Art," Hollins College and Roanoke Valley Historical Society, Roanoke, Va., May 7–30, 1975, and exhibition catalog.

Mourning Becomes America
"Mourning Becomes America: Mourning Art in the New Nation," William Penn Memorial Museum, Harrisburg, Pa., March 28–May 23, 1976, and Albany Institute of History and Art, Albany, N.Y., June 1–July 15, 1976.

Museums at Sunrise
"Christmas in the Country," Museums at Sunrise, Charleston, W.Va., November 12, 1980–January 15, 1981.

Pennsylvania Almshouse Painters
"Pennsylvania Almshouse Painters," Abby Aldrich Rockefeller Folk Art Center, Williamsburg, Va., October 1–December 8, 1968, and exhibition catalog.

Pennsylvania Artists
"Hicks, Kane, Pippin: 3 Self-Taught Pennsylvania Artists," Museum of Art, Carnegie Institute, Pittsburgh, Pa., October 21–December 4, 1966, and the Corcoran Gallery of Art, Washington, D.C., January 6–February 19, 1967.

Pine Manor Junior College
"Social and Cultural Aspects of American Life," Pine Manor Junior College, Wellesley, Mass., January 13–February 28, 1963.

Pollock Galleries
"The American Woman as Artist, 1820–1965," Pollock Galleries, Owen Fine Arts Center, Southern Methodist University, Dallas, Tex., January 23–February 1, 1966, and exhibition catalog.

Reflections of Faith
"Reflections of Faith: Religious Folk Art in America," IBM Gallery of Science and Art, New York, N.Y., organized by the Museum of American Folk Art, New York, N.Y., December 6, 1983–January 21, 1984.

Remember the Ladies
"Remember the Ladies: Women in America, 1750–1815," traveling exhibition organized by Conover Hunt for the Pilgrim Society, Plymouth, Mass., June 30, 1976–June 15, 1977.

Smithsonian, American Primitive Watercolors
"American Primitive Watercolors," traveling exhibition organized by the Smithsonian Institution Traveling Exhibition Service in cooperation with AARFAC, October 31, 1964–October 10, 1965, and exhibition catalog.

Southern Book
"Southern Book Competition," Valentine Museum, Richmond, Va., September 24–November 15, 1958.

Texas Technological College
"The Symbols of Our American Heritage," The Museum of Texas Technological College, Lubbock, Tex., September 28–October 31, 1961.

Trois Siècles
"Trois Siècles d'Art aux États-Unis," Musée du Jeu de Paume, Paris, France, May 24–July 31, 1938, and exhibition catalog.

U.S. Mission
"American Folk Art from the Abby Aldrich Rockefeller Folk Art Collection," United States Mission to the United Nations, United Nations Plaza, New York, N.Y., June 1962–February 1965.

Virginia Sampler
"A Virginia Sampler: 18th, 19th, and 20th Century Folk Art," Roanoke Fine Arts Center, Roanoke, Va., March 14–April 24, 1976, and exhibition catalog.

Washington County Museum, 1965
"Folk Art from the Abby Aldrich Rockefeller Folk Art Collection," Washington County Museum of Fine Arts, Hagerstown, Md., July 15–September 15, 1965.

Washington County Museum, 1966
"Folk Art from the Abby Aldrich Rockefeller Folk Art Collection," Washington County Museum of Fine Arts, Hagerstown, Md., November 5–December 31, 1966.

Wilde
"The Isabel Carleton Wilde Collection of Early American Folk Painting," John Becker Galleries, New York, N.Y., November 9–December 5, 1932, and exhibition catalog.

William Penn Museum
"Folk Art from the Abby Aldrich Rockefeller Folk Art Collection," William Penn Memorial Museum, Harrisburg, Pa., July 7–September 30, 1966.

Publications

AARFAC, 1940
Edith Gregor Halpert, comp., *American Folk Art: A Collection of Paintings and Sculpture Produced by Little-Known and Anonymous American Artists of the Eighteenth and Nineteenth Centuries.* Williamsburg, Va.: Colonial Williamsburg, Inc., 1940.

AARFAC, 1947
Edith Gregor Halpert, comp., *A Catalogue of the American Folk Art Collection of Colonial Williamsburg.* Williamsburg, Va.: Colonial Williamsburg, Inc., 1947.

AARFAC, 1957
Nina Fletcher Little, *The Abby Aldrich Rockefeller Folk Art Collection.* Williamsburg, Va.: Colonial Williamsburg, Inc., 1957.

AARFAC, 1959
American Folk Art from the Abby Aldrich Rockefeller Folk Art Collection. Williamsburg, Va.: Colonial Williamsburg, Inc., 1959.

AARFAC, 1965
The Abby Aldrich Rockefeller Folk Art Collection: Gallery Book. Williamsburg, Va.: Colonial Williamsburg, Inc., 1965.

AARFAC, 1974
Folk Art in America, a Living Tradition: Selections from the Abby Aldrich Rockefeller Folk Art Collection, Williamsburg, Virginia. Atlanta, Ga.: High Museum of Art, 1974.

AARFAC, 1975
Beatrix T. Rumford, *The Abby Aldrich Rockefeller Folk Art Collection: A Gallery Guide.* Williamsburg, Va.: Colonial Williamsburg Foundation, 1975.

AARFAC, 1981
Beatrix T. Rumford, ed., *American Folk Portraits: Paintings and Drawings from the Abby Aldrich Rockefeller Folk Art Center.* Boston: New York Graphic Society, 1981.

American Folk Art
"American Folk Art: The Abby Aldrich Rockefeller Folk Art Collection at Williamsburg," *Southern Accents,* II (Winter 1979).

American Heritage
Ralph K. Andrist et al., *The American Heritage History of the Making of the Nation, 1783–1860.* New York: American Heritage Publishing Co., 1968.

American Primitives
American Primitives: An Exhibit of the Paintings of the Nineteenth-Century Folk Artists. Newark, N.J.: Newark Museum, 1930.

Andrew Crispo Gallery
Edward Hicks: A Gentle Spirit. New York: Andrew Crispo Gallery, 1975.

Andrews and Andrews
Edward Deming Andrews and Faith Andrews, *Visions of the Heavenly Sphere: A Study in Shaker Religious Art.* Charlottesville, Va.: University of Virginia Press, 1969.

Barons
Richard I. Barons, comp., *The Folk Tradition: Early Arts and Crafts of the Susquehanna Valley.* Binghamton, N.Y.: Roberson Center for the Arts and Sciences, 1982.

Bishop
Robert Bishop, *Folk Painters of America.* New York: E. P. Dutton, 1979.

Black, Field
Mary Black, *Erastus Salisbury Field: 1805–1900.* Springfield, Mass.: Museum of Fine Arts, 1984.

Black, Folk Artist
Mary C. Black, "The Voice of the Folk Artist," *The Artist in America*, comps. and eds. of *Art in America*. New York: W. W. Norton & Co., 1967.

Black, Folk Painting
Mary Black, "Folk Painting," *Arts in Virginia*, XII (Fall 1971).

Black, Watercolors
Mary C. Black, "American Primitive Watercolors," *Art in America*, LI (August 1963).

Black and Lipman
Mary Black and Jean Lipman, *American Folk Painting*. New York: Clarkson N. Potter, 1966.

Blum
Jerome Blum, ed., *Our Forgotten Past: Seven Centuries of Life on the Land*. London: Thames and Hudson, 1982.

Book Preview, 1966
"Book Preview: American Folk Painting," *Art in America*, LIV (November–December 1966).

Booth
Sally Smith Booth, *Hung, Strung, and Potted: A History of Eating in Colonial America*. New York: Clarkson N. Potter, 1971.

Brant and Cullman
Sandra Brant and Elissa Cullman, *Small Folk: A Celebration of Childhood in America*. New York: E. P. Dutton, 1980.

Brown
Peter A. G. Brown, "Recent Acquisitions at the Abby Aldrich Rockefeller Folk Art Collection," *Antiques*, XCVI (November 1969).

Cahill, American Folk Art
Holger Cahill, *American Folk Art: The Art of the Common Man in America, 1750–1900*. New York: Museum of Modern Art, 1932.

Cahill, Early Folk Art
Holger Cahill, "Early Folk Art in America," *Creative Art*, XI (December 1932).

Chaffin
William L. Chaffin, *A Biographical History of Robert Randall and His Descendants, 1608–1909*. New York: Grafton Press, 1909.

Cogar
James L. Cogar, "Folk Art in Williamsburg," *Southern Literary Messenger*, III (April 1941).

De Pauw and Hunt
Linda Grant De Pauw and Conover Hunt, *Remember the Ladies: Women in America, 1750–1815*. New York: Viking Press, 1976.

Deutsch
Davida Tenenbaum Deutsch, "Samuel Folwell of Philadelphia: An Artist for the Needleworker," *Antiques*, CXIX (February 1981).

Deutsch and Ring
Davida Tenenbaum Deutsch and Betty Ring, "Homage to Washington in Needlework and Prints," *Antiques*, CXIX (February 1981).

Dewhurst and MacDowell, Rainbows
C. Kurt Dewhurst and Marsha MacDowell, *Rainbows in the Sky: The Folk Art of Michigan in the Twentieth Century*. East Lansing, Mich.: Kresge Art Gallery, Michigan State University, 1978.

Dewhurst, MacDowell, and MacDowell, Artists in Aprons
C. Kurt Dewhurst, Betty MacDowell, and Marsha MacDowell, *Artists in Aprons: Folk Art by American Women*. New York: E. P. Dutton, 1979.

Dewhurst, MacDowell, and MacDowell, Religious Folk Art
C. Kurt Dewhurst, Betty MacDowell, and Marsha MacDowell, *Religious Folk Art in America: Reflections of Faith*. New York: E. P. Dutton, 1983.

Dillenberger and Taylor
Jane Dillenberger and Joshua C. Taylor, *The Hand and the Spirit: Religious Art in America 1700–1900*. Berkeley, Calif.: University Art Museum, 1972.

Ford, Edward Hicks
Alice Ford, *Edward Hicks: Painter of the Peaceable Kingdom*. Philadelphia: University of Pennsylvania Press, 1952.

Ford, Pictorial Folk Art
Alice Ford, *Pictorial Folk Art, New England to California*. New York: Studio Publications, 1949.

Garvan
Beatrice B. Garvan, *The Pennsylvania German Collection*. Philadelphia: Philadelphia Museum of Art, 1982.

Gerdts
William H. Gerdts, *Painters of the Humble Truth*. Columbia, Mo.: Philbrook Art Center, University of Missouri Press, 1981.

Groce and Wallace
George C. Groce and David H. Wallace, *The New-York Historical Society's Dictionary of Artists in America, 1564–1860*. New Haven: Yale University Press, 1957.

Gusler
Wallace B. Gusler, "The Arts of Shenandoah County, Virginia, 1770–1825," *Journal of Early Southern Decorative Arts*, V (November 1979).

Halpert Folk Art Collection
Edith Gregor Halpert Folk Art Collection. New York: Terry Dintenfass, 1973.

Harbeson
Georgiana Brown Harbeson, *American Needlework*. New York: Bonanza Books, 1938.

Haverstock
Mary Sayre Haverstock, *An American Bestiary*. New York: Harry N. Abrams, 1979.

Hemphill
Herbert Waide Hemphill, Jr., *Folk Art USA Since 1900 from the Collection of Herbert Waide Hemphill, Jr.* New York: Publishing Center for Cultural Resources, 1980.

Hicks, Kane, Pippin
Hicks, Kane, Pippin: Three Self-taught Pennsylvania Artists. Pittsburgh: Carnegie Institute Press, 1966.

Janis
Sidney Janis, *They Taught Themselves: American Primitive Painters of the 20th Century*. New York: Dial Press, 1942.

Jones
Louis C. Jones, "Liberty and Considerable License," *Antiques*, LXXIV (July 1958).

Karolik Collection
M. & M. Karolik Collection of American Water Colors & Drawings 1800–1875. Vol. II. Boston: Museum of Fine Arts, 1962.

Katz
Martha B. Katz, "J. O. J. Frost: Marblehead Artist." M.A. thesis, State University of New York College at Oneonta, 1971.

Kerr
Joan Paterson Kerr, "Patchwork Primitives," *American Heritage,* XXXII (April/May 1981).

Keyes
Homer Eaton Keyes, "The Coming Shaker Exhibition in Manhattan," *Antiques,* XXVII (November 1935).

Kline and Weiser
Robert M. Kline and Frederick S. Weiser, "A Fraktur-Fest," *Der Reggeboge,* IV (September–December 1970).

Lebsock and Rice
Suzanne Lebsock and Kym S. Rice, *A Share of Honour: Virginia Women, 1600–1945.* Richmond, Va.: Virginia Women's Cultural History Project, 1984.

Lipman, Pinney
Jean Lipman, "Eunice Pinney — An Early Connecticut Water-Colorist," *Art Quarterly,* VI (Summer 1943).

Lipman, Primitive Painting
Jean Lipman, *American Primitive Painting.* London: Oxford University Press, 1942.

Lipman and Armstrong
Jean Lipman and Tom Armstrong, eds., *American Folk Painters of Three Centuries.* New York: Hudson Hills Press, 1980.

Lipman and Winchester, Folk Art
Jean Lipman and Alice Winchester, *The Flowering of American Folk Art, 1776–1876.* New York: Viking Press, 1974.

Lipman and Winchester, Primitive Painters
Jean Lipman and Alice Winchester, eds., *Primitive Painters in America, 1750–1950.* New York: Dodd Mead & Company, 1950.

Little, Country Arts
Nina Fletcher Little, *Country Arts in Early American Homes.* New York: E. P. Dutton, 1975.

Little, Prior
Nina Fletcher Little, "William M. Prior, Traveling Artist, and His In-Laws, the Painting Hamblens," *Antiques,* LIII (January 1948).

Lowry
Robert Lowry, "Steve Harley and the Lost Frontier," *Flair,* I (June 1950).

Masterpieces of American Folk Art
Masterpieces of American Folk Art. Lincroft, N.J.: Monmouth County Historical Association and Monmouth Museum, 1975.

Mather, Peaceable Season
Eleanore Price Mather, *Edward Hicks: A Peaceable Season.* Princeton: Pyne Press, 1973.

Mather, Primitive Quaker
Eleanore Price Mather, *Edward Hicks, Primitive Quaker: His Religion in Relation to His Art.* Wallingford, Pa.: Pendle Hill, 1970.

Mather and Miller
Eleanor Price Mather and Dorothy Canning Miller, *Edward Hicks: His Peaceable Kingdoms and Other Paintings.* Newark, Del.: University of Delaware Press, 1983.

Merritt
Howard S. Merritt, "Thomas Chambers — Artist," *New York History,* XXXVII:2 (April 1956).

MOMA
Art in Our Time: An Exhibition to Celebrate the Tenth Anniversary of the Museum of Modern Art and the Opening of Its New Building. New York: Museum of Modern Art, 1939.

Parke-Bernet
Arts and Crafts of Pennsylvania and Other Notable Americana: Part One of the Collection of the Late Arthur J. Sussel, Philadelphia, catalog for sale no. 1847, October 23–25, 1958. New York: Parke-Bernet Galleries, 1958.

Patterson
Daniel W. Patterson, *Gift Drawing and Gift Song.* Sabbathday Lake, Maine: United Society of Shakers, 1983.

Peluso
A. J. Peluso, Jr., *J. & J. Bard, Picture Painters.* New York: Hudson River Press, 1977.

Piwonka and Blackburn, Cady
Ruth Piwonka and Roderic H. Blackburn, "New Discoveries about Emma Jane Cady," *Antiques,* CXIII (February 1978).

Piwonka and Blackburn, Remnant
Ruth Piwonka and Roderic H. Blackburn, *A Remnant in the Wilderness: New York Dutch Scripture History Paintings of the Early Eighteenth Century.* Albany, N.Y.: Albany Institute of History and Art, 1980.

Quimby and Swank
Ian M. G. Quimby and Scott T. Swank, eds., *Perspectives on American Folk Art.* New York: W. W. Norton & Company, published for The Henry Francis du Pont Winterthur Museum, 1980.

Ring, Grinnell
Betty Ring, "Peter Grinnell and Son: Merchant-Craftsmen of Providence, Rhode Island," *Antiques,* CXVII (January 1980).

Ring, Needlework
Betty Ring, "Needlework Pictures at Bassett Hall," *Antiques,* CXXI (February 1982).

Ring, Virtue
Betty Ring, *Let Virtue Be a Guide to Thee: Needlework in the Education of Rhode Island Women, 1730–1830.* Providence: Rhode Island Historical Society, 1983.

Rumford, Bassett Hall
Beatrix T. Rumford, "Mrs. Rockefeller's Folk Art at Bassett Hall," catalog for *The 26th Annual Washington Antiques Show* (Washington, D.C., 1981), pp. 57–59.

Rumford, Folk Art Center
Beatrix T. Rumford, "Williamsburg's Folk Art Center: An Illustrated Summary of Its Growth," *The Clarion,* Winter 1978.

Rumford, Memorial Watercolors
Beatrix T. Rumford, "Memorial Watercolors," *Antiques,* CIV (October 1973).

Sargeant
Winthrop Sargeant, "Joe Gatto, Primitive," *Life* (November 8, 1948).

Sarno
Martha Taylor Sarno, *Karol Kozlowski, 1885–1969, Polish-American Folk Painter*. New York: Summertime Press, 1984.

Schorsch, Key
Anita Schorsch, "A Key to the Kingdom: The Iconography of a Mourning Picture," *Winterthur Portfolio*, XIV (Spring 1979).

Schorsch, Mourning
Anita Schorsch, *Mourning Becomes America: Mourning Art in the New Nation*. Clinton, N.J.: Main Street Press, 1976.

Schorsch, Pastoral
Anita Schorsch, *Pastoral Dreams*. New York: Universe Books, Main Street Press, 1977.

Schorsch and Greif
Anita Schorsch and Martin Greif, *The Morning Stars Sang*. New York: Universe Books, Main Street Press, 1978.

Shelley, Fraktur-Writings
Donald A. Shelley, *The Fraktur-Writings or Illuminated Manuscripts of the Pennsylvania Germans*. Allentown: Pennsylvania German Folklore Society, 1961.

Shelley, Miller
Donald A. Shelley, *Lewis Miller: Sketches and Chronicles*. York, Pa.: Historical Society of York County, 1966.

Sotheby Parke Bernet, 1978
Fine Americana, catalog for sale no. 4076, February 1–4, 1978. New York: Sotheby Parke Bernet, Inc., 1978.

Sotheby Parke Bernet, 1979
Fine Americana, catalog for sale no. 4268, June 20–23, 1979. New York: Sotheby Parke Bernet, Inc., 1979.

Sotheby Parke Bernet, Garbisch I
Important Frakturs, Embroidered Pictures, Theorem Paintings, and Cutwork Pictures from the Collection of Edgar William and Bernice Chrysler Garbisch, catalog for sale no. 3595, January 23–24, 1974. New York: Sotheby Parke Bernet, Inc., 1974.

Sotheby Parke Bernet, Garbisch II
Important Frakturs, Embroidered Pictures, Theorem Paintings, and Other American Folk Art from the Collection of Edgar William and Bernice Chrysler Garbisch, Part II, catalog for sale no. 3637, May 8–9, 1974. New York: Sotheby Parke Bernet, Inc., 1974.

Sotheby Parke Bernet, Garbisch III
Important Frakturs, Embroidered Pictures, Theorem Paintings, and Cutwork Pictures, and Other American Folk Art from the Collection of Edgar William and Bernice Chrysler Garbisch, Part III, catalog for sale no. 3692, November 12, 1974. New York: Sotheby Parke Bernet, Inc., 1974.

Sotheby Parke Bernet, Halpert
Edith Gregor Halpert Folk Art Collection, catalog for sale no. 3572, November 14–15, 1973. New York: Sotheby Parke Bernet, Inc., 1973.

Stebbins
Theodore E. Stebbins, Jr., *American Master Drawings and Watercolors: A History of Works on Paper from Colonial Times to the Present*. New York: Harper & Row, 1976.

Stein
Aaron Marc Stein, "The Still-Life in American 'Primitive' Art," *The Fine Arts*, XIX (June 1932).

Stokes and Haskell
I. N. Phelps Stokes and Daniel C. Haskell, *American Historical Prints: Early Views of American Cities, Etc., from the Phelps Stokes and Other Collections*. New York: New York Public Library, 1932.

Tillou
Peter H. Tillou, *Nineteenth-Century Folk Painting: Our Spirited National Heritage, Works of Art from the Collection of Mr. and Mrs. Peter Tillou*. Storrs, Conn.: William Benton Museum of Art, University of Connecticut, 1973.

Urbino and Day
L. B. Urbino and Henry Day, *Art Recreations*. Boston: J. E. Tilton and Company, 1868.

Walters, Finch
Donald R. Walters, "Out of Anonymity: Ruby Devol Finch (1804–1866)," *Maine Antique Digest*, VI (June 1978).

Walters, Strickler
Donald R. Walters, "Jacob Strickler, Shenandoah County, Virginia, Fraktur Artist," *Antiques*, CX (September 1976).

Weiser I
Frederick S. Weiser and Howell J. Heaney, *The Pennsylvania German Fraktur of the Free Library of Philadelphia*. Vol. I. Philadelphia: Pennsylvania German Society and the Free Library of Philadelphia, 1976.

Weiser II
Frederick S. Weiser and Howell J. Heaney, *The Pennsylvania German Fraktur of the Free Library of Philadelphia*. Vol. II. Philadelphia: Pennsylvania German Society and the Free Library of Philadelphia, 1976.

Weiser, Fraktur
Frederick S. Weiser, *Fraktur: Pennsylvania German Folk Art*. Ephrata, Pa.: Science Press, 1973.

Weiser, Gilbert
Frederick S. Weiser, "His Deeds Followed Him: The Fraktur of John Conrad Gilbert," *Der Reggeboge*, XVI, no. II (1982).

Wust
Klaus Wust, *Virginia Fraktur, Penmanship as Folk Art*. Edinburg, Va.: Shenandoah History, 1975.

Index

COMPOSITION IN SABON BY DIX TYPE INC.

PAPER SUPPLIED BY S. D. WARREN CO.

COLOR SEPARATIONS AND PRINTING BY VILLAGE CRAFTSMEN/PRINCETON POLYCHROME

BOUND BY HOROWITZ/RAE